P9-CLH-296

EARTH FROM ABOVE

YANN ARTHUS-BERTRAND

365 DAYS

TEXT BY Hervé Le Bras

CAPTIONS EDITED BY Astrid Avundo, Sophie Bily, Séverine Dard, Cyria Emelianoff, Hervé Le Bras, Virginie Lemaistre, Vanessa Manceron, Frédéric Marchand, Marie-Carmen Smyrnellis

HARRY N. ABRAMS, INC., PUBLISHERS

THE EARTH IN NUMBERS

Our apparent wealth is measured by economic growth, which doesn't take into account the state of natural resources. The deforestation of a country is therefore considered to create value.

Worldwide wealth	1990	1999
Worldwide GDP	21 trillion dollars (U.S.)	30 trillion dollars (U.S.)
Annual deforestation between 1990 and 1995: 101 724 km^2 or 20% of France		

However, since the 1970s, the natural wealth of the Earth has been reduced by one third because of man.

Worldwide population	1980	1999
Urban population	40%	46%
Death rate of children younger than 5	123%	75%
Population of 15–64 year olds	2,595 billion	3,761 billion (*1990*)
Active population	2,035 billion	2,892 billion
Women as % of the active population	39%	41%
Children between 10-14 years as % of the active population	20%	12%
Education in the world	**1980**	**1997**
Public spending on education	3.9% of GDP	4.8% of GDP

4.9 billion, or 80% of the population lives in a developing country

- 40% of the world's population does not have electricity–that totals about 2.5 billion people.
- 47% of the world's population lives on less than two U.S. dollars per day.
- The share of the 50 poorest countries in world trade has gone from 4% to 2% over the last decade (until 2000).
- 33% of children under the age of 5 suffer from malnutrition.

- One out of four adults is illiterate in the world.
- One out of five people in the world does not have access to modern healthcare.
- 95% of the people infected with AIDS live in developing countries.
- The foreign debt of developing countries has grown more than 6 times its amount since 1970, totaling 2.8 trillion dollars in 1999.

1.2 billion, or 20% of the population lives in an industrialized country

- Developed countries represent 86% of private expenditure consumption
- OECD countries share 67% of worldwide trade (7 trillion dollars).
- The total wealth of the 200 richest people is 1.14 trillion dollars.
- The unemployment rate is at an historic low, around 4%.

One out of ten U.S. dollars was invested into ethical funds in the United States in 2000, that is 13% of invested money.
Fact: life is possible because of air, land and water. Note: they are in danger, therefore we are threatened.

By suffocation. Today, the atmosphere absorbs one third of the carbonic gases that we produce every year. The two thirds that remain build up and result in, through the greenhouse effect, an off-balance climate that generates natural disasters (floods, storms, droughts, fires, etc.)
- The use of fossil fuels has multiplied by 5 in 50 years. Oil consumption has multiplied by 8 (today we use in 1.5 months the amount of oil that we used in 1 year in 1950).
- Carbonic gas emissions in 1990: 3.3 tons/inhabitant in 1996: 4.0 tons/inhabitant
- Consumption of electricity in 1990: 1,928 Mwh/inhabitant in 1999: 2,053 Mwh/habitant
- The production of wind energy multiplied by ten between 1990 and 2000, becoming 1% of the energy produced in the world in 1999.

By food shortage. Land suitable for cultivation is a limited resource. There is less and less land for more and more inhabitants (every year, the equivalent of 10 French departments turn into desert). As a result, growing land per inhabitant has been cut in two in 50 years. The resources allocated to agriculture in poor countries is too little to compensate for this evolution, which causes famines (in 2000, one third of the world's children younger than 5 suffered from malnutrition).

Evolution of land in the world	1980	1996
Lands permanently being farmed	0.9%	1.0%
Irrigated land	17.8%	19.2%
Arable land	0.24 ha/hab	0.24 ha/hab
Number of tractors for a thousand agricultural workers.	18	20
paved roads	39% of total	43.1% of total

One person in France produces 350 kg of household waste in one year (that is, 1 kg per day).

One person in the United States produces 700 kg of household waste in one year (that is, 2 kg per day).

Almost half of the 17,000 natural reserves in the world are currently being used for agricultural purposes.

By water wars. The quantity of water available per inhabitant has gone down more than 30% since 1970. Today, more than ten conflicts in the world are linked to water: in Turkey, India, Egypt, Israel, and other countries. The number of people that do not have access to potable water has multiplied by four over the past decade, totaling 1 billion people in 2000.

Distribution of water consumption in the world

- One person in France consumes between 150 and 250 liters of water per day. Only 2 liters of this is used for drinking. Therefore, less than 0.5% of the water treated for drinking is in fact drunk.
- The average Kenyan uses 4 liters of water per day.
- One person in New York consumes 680 liters per day.

Evolution of water consumption in the world

Multiplied by 7 since 1900 and by 5 since 1940 (while the population doubled).

Worldwide resources for non-saltwater in 1990: 8,000 m^3 per inhabitant.

Minimum necessary per inhabitant: 1,000 m^3/year.

Less than 10% of the world's cities have purification facilities (treating used water).

Use of non-saltwater in the world

- 70% for agriculture (irrigation, three quarters of which evaporates).
- 22% for industry.
- 8% for household use (50% of which is lost in pipe leaks).

Distribution of the availability of water in the world

Wettest areas: rainfall totaling 20 meters of water per year.

Driest areas: rainfall totaling 50 to 200 millimeters of water per year.

Why is there so much indifference?

One, because most of the deterioration over the last 30 years has occurred in southern countries, which seem far away to us—even if the consequences will affect us directly.

Two, because our way of approaching the environment still stems from a vision inherited from a time when the world's resources seemed endless.

Finally, because we are under the impression—unjustly—that we are helpless in the face of such a large problem. And yet, we can all take action: by reducing our unnecessary consumption and by putting pressure on companies and governments in order to develop a long-lasting system, one that meets the needs we have now, without sacrificing future generations.

The first solution is therefore to make people aware, and, because the environment doesn't come to people, to bring the environment to them.

This is Yann's approach, as you'll see in this book. If we want our children to have a certain quality of life, and if we want to guarantee long-lasting development for ourselves, there will need to be an awakening—sometimes wonderful, sometimes worrisome.

Maximilien Rouer

Founder of BeCitizen.com, website for Développement Durable [Durable Development].

Note: each statistic has a source (sources: World Bank, PNUD [UNDP], PNUE [UNEP], UNESCO, WWF, UICN [IUCN], WorldWatch Institute, OECD, FAO, INSEE, World Health Organization, Unicef, Global Water Supply, UN, GIEC (Intergovernmental group of experts on the evolution of the climate), Worldwide organization of meteorology, ADEME).
When two statistics about the same subject differed, the more moderate statistic was used.

Brazil. Amazonas State. Storm over the Amazon Rain Forest.

Thunderstorms are widespread on Earth, with more than 50,000 occurring every day. Storms form when warm, unstable air, saturated with water vapor, rises rapidly and cools, forming huge cumulo-nimbus clouds that can measure up to 25 kilometers (16 miles) across and 16 kilometers (10 miles) high in the lower latitudes. The build-up of electrical charges in the clouds and on the ground below culminates in lightning strikes—millions of volts of electricity passing between the clouds and the ground—accompanied by thunder, and usually heavy rain. In Amazonia, heavy evaporation from the Earth's surface leads to frequent and often very violent storms. All over the world storms cause serious damage to crops and buildings, disrupt air and land traffic, interfere with communications, and kill hundreds of people and thousands of animals. Climatologists forecast that over the coming decades, pollution will cause the average air temperature to increase by several degrees. As a result, evaporation will increase, leading to greater amounts of rainfall in some areas and drought in others. Climate change will also likely make extreme weather events such as storms, tornadoes, and hurricanes more frequent, increasing the damage they cause. Large insurance companies are already preparing for these risks.

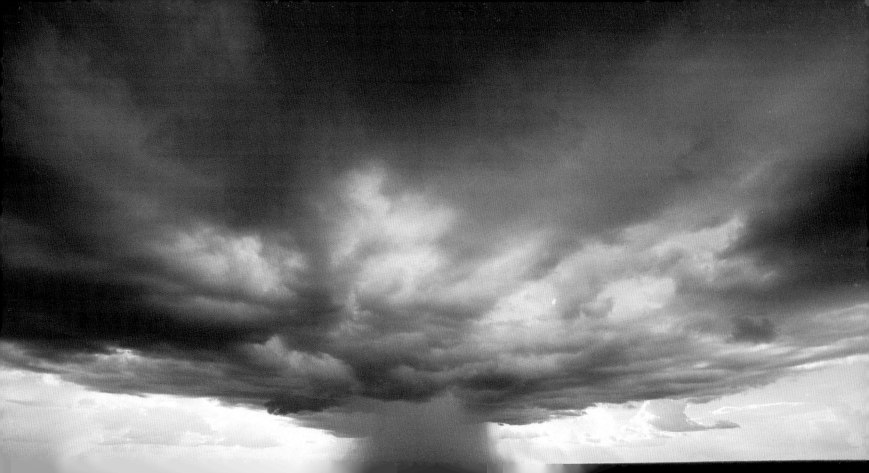

Honduras. San Pedro Sula Region. Lagoon near Lake Los Micos.

Between mangroves and fine sand, the lagoon of Los Micos ("the monkeys") on the Caribbean coast of Honduras is one of the landscapes that typify the Punta Sal National Park, an exceptional reserve of forest land and wildlife. A few recently constructed hotel complexes coexist with the traditional Garifuna villages. The Garifuna still number 90,000 in Honduras. Descended from shipwrecked slaves and Caribbean and Arawak Indians, they were deported from Saint Vincent to the northern coast of Honduras and the Bay Islands in the late eighteenth century. They have retained their African roots through dance (the *punta*), music, religious beliefs, and language, although all primarily speak Spanish. In spite of the region's attractions, tourism is still modest in Honduras, and the economy is dominated by American banana corporations. The situation is unlikely to change, given the natural disasters inflicted on the county with rare violence in 1997 and 1998: huge forest fires brought about by abnormal drought; and, above all, Hurricane Mitch, which left 6,000 dead, 8,000 missing, and one-third of the country's 6 million inhabitants homeless.

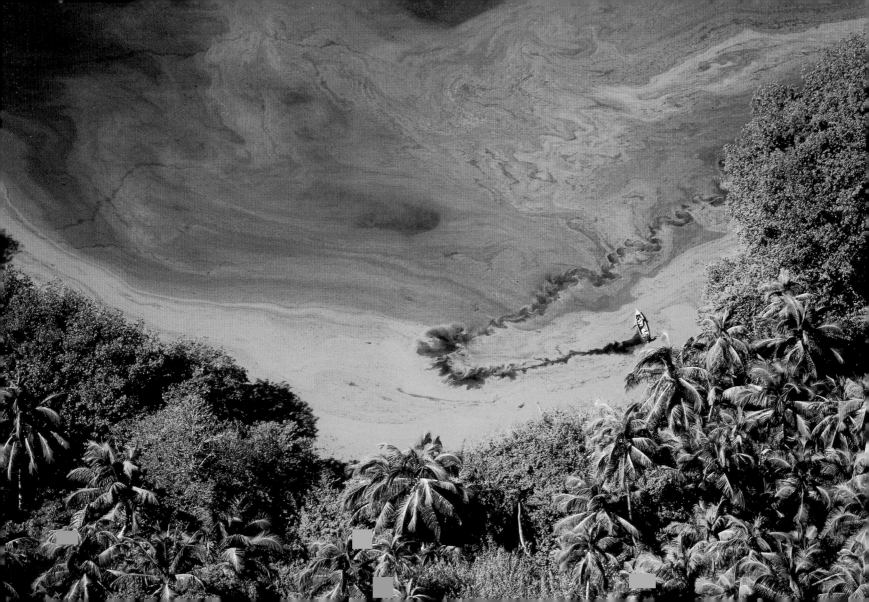

India. Rajasthan. Cotton fabrics drying in the sun in Jaipur.

The state of Rajasthan, in northwestern India, is an important textile-producing area, celebrated for centuries for the Chhipa community's craft of dyeing and printing on cotton and silk. The traditional methods of decorating with wax and printing by hand are facing competition from silkscreen printing, which allows large-scale production, while natural pigments are gradually being abandoned in favor of chemical dyes. On the other hand, fabrics are still soaked several times in order to fix the colors, and are still dried in the sun, as here in Jaipur. The Chhipa women working here belong to the 25 percent of the Indian workforce that are female. In India, as in most countries, women are playing a growing part in the economy, and here as elsewhere, inequality between the sexes is generally diminishing. However, they still suffer discrimination in education, access to jobs, pay, and political representation. Indian girls are traditionally regarded as having a lower economic value than boys, and as in China, but in contrast to the world as a whole, men outnumber women in India.

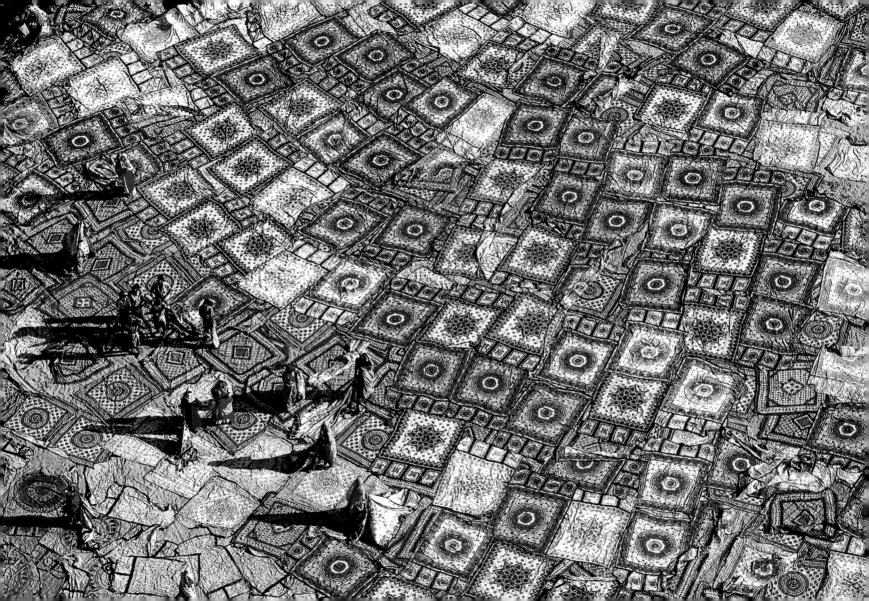

Djibouti. Flock of goats among the rock stacks of Lake Abbe.

The 80,000 nomads who share Djibouti's scant pastureland are comprised of two dominant groups: the Afars (37 percent of Djibouti's population), who also live in neighboring Ethiopia; and the Issas (50 percent), who are related to the Somalis. The tiny Republic of Djibouti is a relic of European imperialism, created, like many other African states, by a stroke of the pen. Djibouti once guarded the trade route to the Indies. Although the route has declined in importance, Djibouti remains an important base for the French Army, and the French make up the country's third principal ethnic group. France trades sophisticated weaponry in exchange for oil from the rich oil-producing states in the nearby Arabian Peninsula. Important military treaties, for example, link France with the United Arab Emirates, which contain the world's second-largest gas field but have a population of barely 200,000 (supplemented by 500,000 foreigners). Not only does the burning of fossil fuels aggravate the greenhouse effect, it also indirectly subsidizes arms manufacturing and the exploitation of foreign workers.

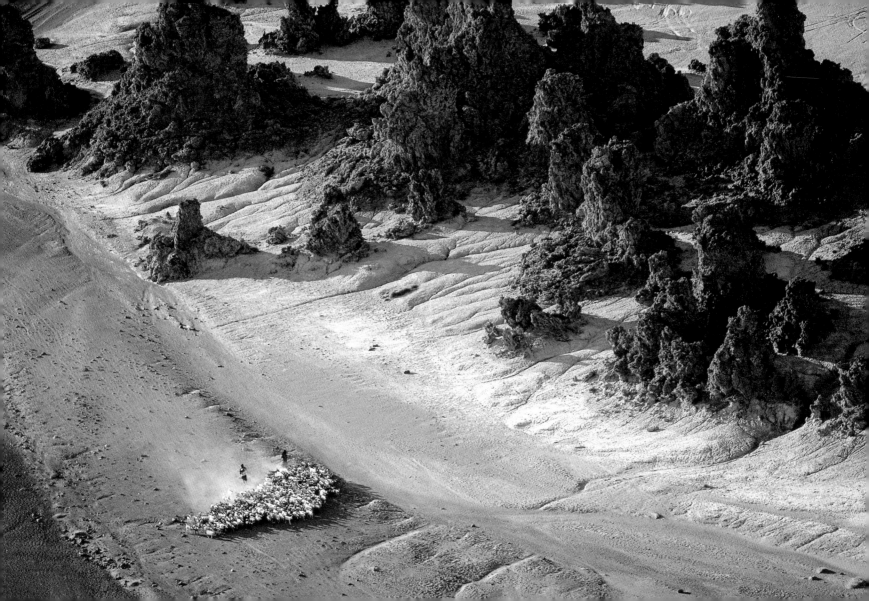

Nepal. Pahar Region. Rice-growing to the south of Pokhara.

The Pokhara Valley in the central Nepalese region of Pahar is traversed by a network of watercourses that nourish its fertile alluvial soil. The hillsides are a mosaic of rice-growing terraces retained by small earthen embankments. In Nepal, where four-fifths of the population live off of agriculture, family cultivation of rice is the country's leading crop, yielding 3.7 million tonnes (four million tons) in 1997. At the end of the 1970s, the peasants had a small surplus that they were able to export, particularly to Tibet. Today, there is a lack of investment in agriculture, especially for the development of irrigation. But in spite of efforts to expand the area under cultivation and use better seed and fertilizer, there is not enough rice to support the Nepalese population. The country is now required to import the grain.

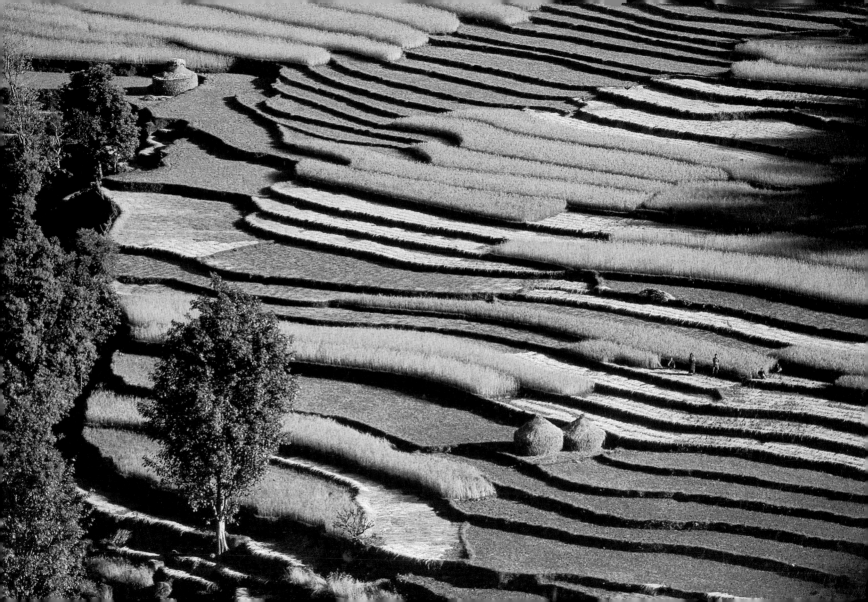

Morocco. Oualidia. Artificial salt pans.

Oualidia is a small seaside resort 175 kilometers (110 miles) southwest of Casablanca. The topographical, climatic, and geological conditions make it an ideal location for evaporation ponds, which need flat, impermeable ground, a climate that encourages evaporation, and the absence of rain over a fairly long period of the year. Huge feeding tanks called *vasais* fill up at spring tides. Shallower compartments or *métières* alternate with them. The water then passes through a succession of shallower and shallower compartments, becoming saltier and saltier until it reaches narrower salinization spaces where the salt is harvested. What today is a cheap product was, until the nineteenth century, a precious commodity, taxed heavily by states and transported by caravans over immense distances across the Sahara.

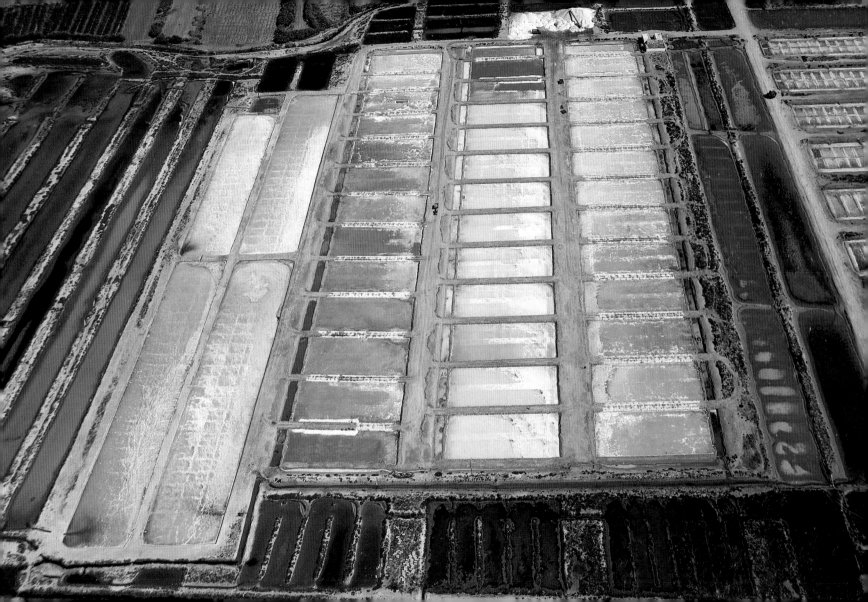

United States. Utah. Moab. A potassium mine.

At the end of the Paleozoic era, the seas covering what is now the state of Utah dried out, leaving a 900-meter- (3,000-foot-) thick deposit of salt. The salt was then covered by 1,500 meters (5,000 feet) of alluvium over the geological periods that followed. The upwelling of the salt layer and its solution in places by underground water led to some chaotic collapses, which have turned the rocks upside down around Moab and given rise to the extraordinary reliefs in the neighboring national parks of Canyonlands and Arches. The potassium, which mixed with the underground salt, concentrated over a surface of some 28,600 square kilometers (11,000 square miles), representing 200 billion tonnes (220 billion tons) – five centuries of world production. Today, it is extracted by injecting Colorado River water into the substrate in order to dissolve the salts. The solution is then pumped to the surface and placed in vast settling tanks. The water evaporates quickly here in the 360 days of sunshine and five percent humidity of the Utah desert. The crystallized potassium chloride, the mineral sylvite, is then collected at the surface.

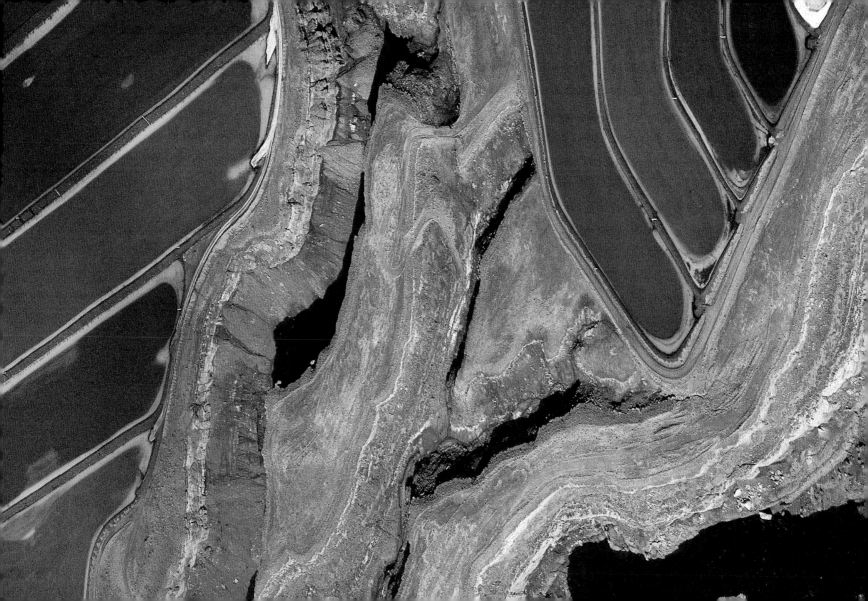

Australia. Kimberley, Halls Creek County. Bungle Bungle National Park.

In the northwest of Australia, in the middle of Bungle Bungle National Park, also called *Purnilulu* by the Aborigines, is a gathering of columns and domes about 100 meters (325 feet) high, forming a labyrinth of gorges over almost 770 square kilometers (300 square miles). These 350-million-year-old, rust-orange sandstone domes are made up of lithified sediments derived from the erosion of former mountains. The rocks were subsequently fractured and lifted up by movements in the Earth's crust, and are now striped black with lichen. Known for millennia to the Aborigines, this site only became known to the general public in 1982, and was designated a national park in 1987.

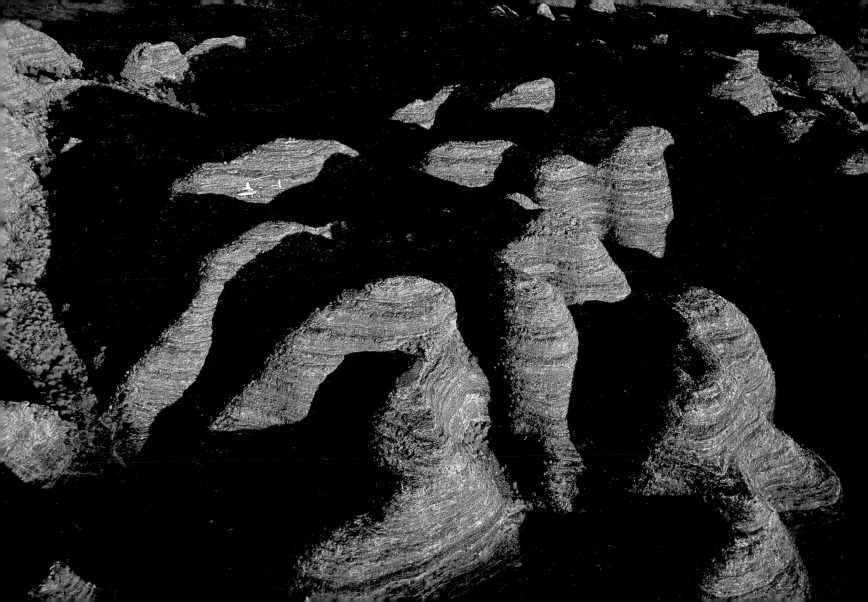

Iceland. Vestmannaeyjar Archipelago. Islet near Heimaey.

In the late ninth century, the Norwegian Viking Ingolfur Arnarson gave the name Vestmannaeyjar to an archipelago of thirteen islands southwest of Iceland. The word means "the isles of the men of the west" and harks back to the early history of Iceland. It was on Heimaey that Ingolfur, the first "colonizer" of Iceland, landed. It was here, too, that the Viking chief captured and massacred the Irish slaves who had accompanied his brother, and then killed him in an ambush, one of the outstanding episodes of that colonization. But the islands of Vestmannaeyjar also testify to an ancient characteristic of Iceland: its volcanic activity. In 1963, 20 kilometers (12 miles) from Heimaey, submarine volcanism gave birth to the island of Surtsey. Ten years later, a powerful volcanic eruption altered the face of Heimaey, adding three square kilometers (one square mile) to the island's surface and endowing it with a new volcano, Eldfell, 223 meters (730 feet) high and still glowing today.

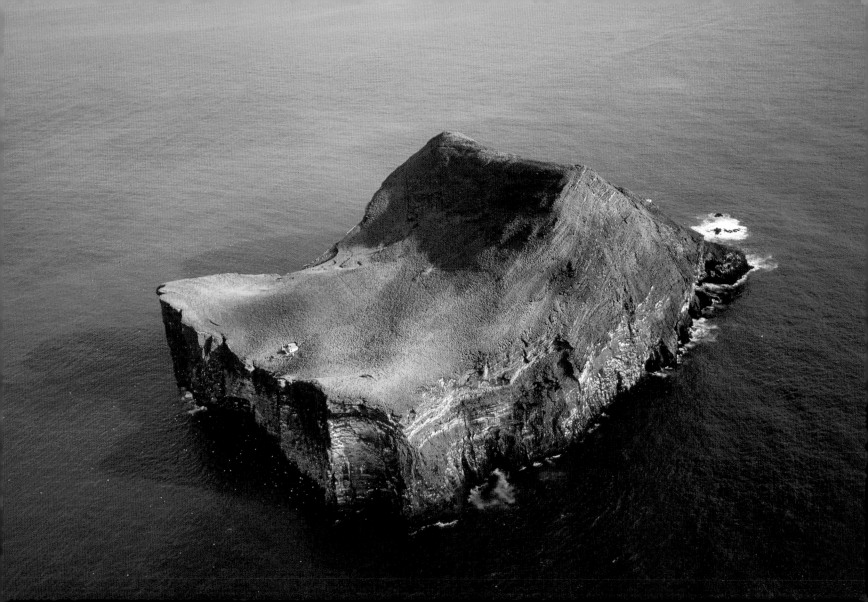

Botswana. Delta of the Okavango. A tributary river in marshland.

At 1,300 kilometers (800 miles) long, the Okavango is the third-longest river in southern Africa. It rises in Angola and opens out in Botswana to form an interior delta covering some 15,000 square kilometers (6,000 square miles). Ninety-seven percent of its annual discharge of seven to 15 million cubic meters (two to four billion gallons) gradually seeps into the sands of the Kalahari Desert or evaporates into the parched air. This "river that never reaches the sea" thus loses itself in a vast marshy labyrinth, inhabited by a prodigious number of wild animals. For more than a century, the Okavango Delta has been threatened by all sorts of predators: ivory poachers at the beginning of the twentieth century, raisers of cattle and sheep in the 1950s, and now those planning to drain the river. Diamond mining, which uses enormous quantities of water (Botswana is the fifth-largest producer of diamonds in the world), also threatens this rich, fragile ecosystem of marshes and estuaries. In fact, this type of precious wetlands is in fast decline worldwide.

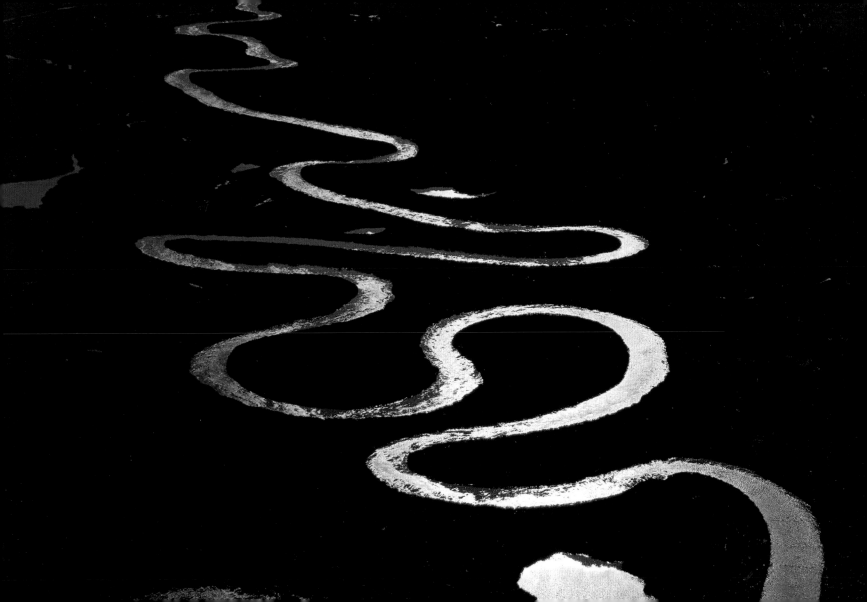

Nepal. Kathmandu. The Stupa at Bodnath, a Buddhist sanctuary.

The town of Bodnath contains one of the most venerated Buddhist sanctuaries in Nepal, particularly valued by the thousands of Tibetans exiled from their homeland in neighboring Nepal. This stupa is a monumental reliquary in the form of a tumulus crowned by a tower, and is supposed to contain a bone fragment from the Buddha. Forty meters (130 feet) in both height and breadth, it is the largest in Nepal. The sanctuary's architecture is entirely allegorical: symbolic referral is made to the cosmos and elements of the universe (earth, water, fire, air, ether); the Buddha's eyes define the four cardinal points; and the various stages toward ultimate knowledge – Nirvana – are represented by the tower's thirteen steps. At religious festivals, the monument is decorated with yellow clay and bedecked with prayer flags. Buddhism is the third largest religion of the world, after Christianity and Islam, with over 325 million followers, 99 percent of them in Asia.

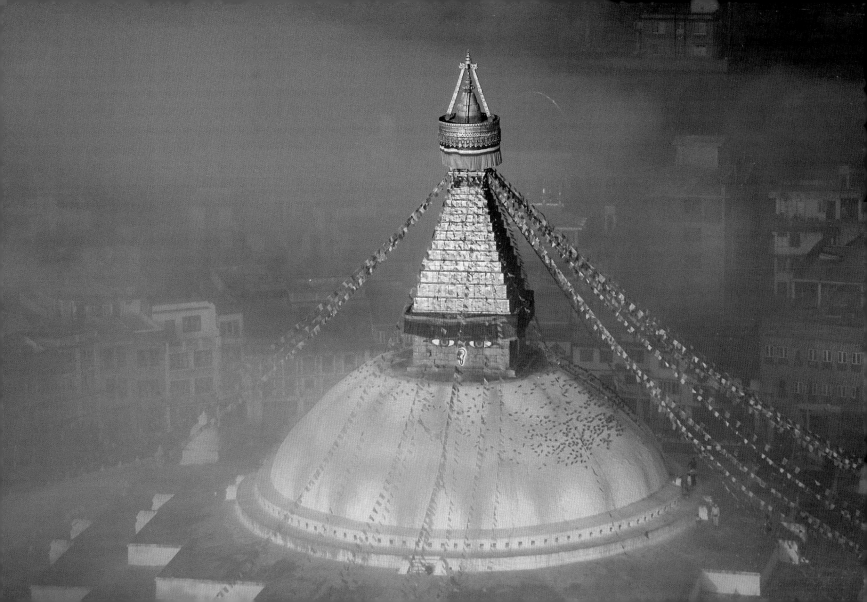

Turkey. The coast of Marmara. Earthquake at Gölcük.

At 3:02 AM on August 17, 1999, an earthquake of magnitude 7.4 on the Richter scale shook the region of Izmit for more than 45 seconds. The epicenter was at Gölcük, an industrial town of 65,000 inhabitants. The earthquake killed at least 15,500 people, crushed and buried in their sleep. The collapse of 50,000 dwellings provoked outrage in which contractors were blamed for ignoring the construction guidelines applying to earthquake zones. Turkey is cut by the North Anatolian Fault, a strike-slip fault very similar to the San Andreas in California. The fault is subject to pressure from the Arabian tectonic plate that is moving northward relative to the Eurasian plate, and the country is therefore frequently a victim of earthquakes (1992: 500 dead; 1995: 100 dead and 50,000 homeless). The boundaries between tectonic plates are especially prone to dangerous seismic activity. Such is the case of the trans-Asiatic zone running from the Azores to Indonesia via Turkey, Armenia, Iran, and India, all of whom have suffered from severe earthquakes in the past decade.

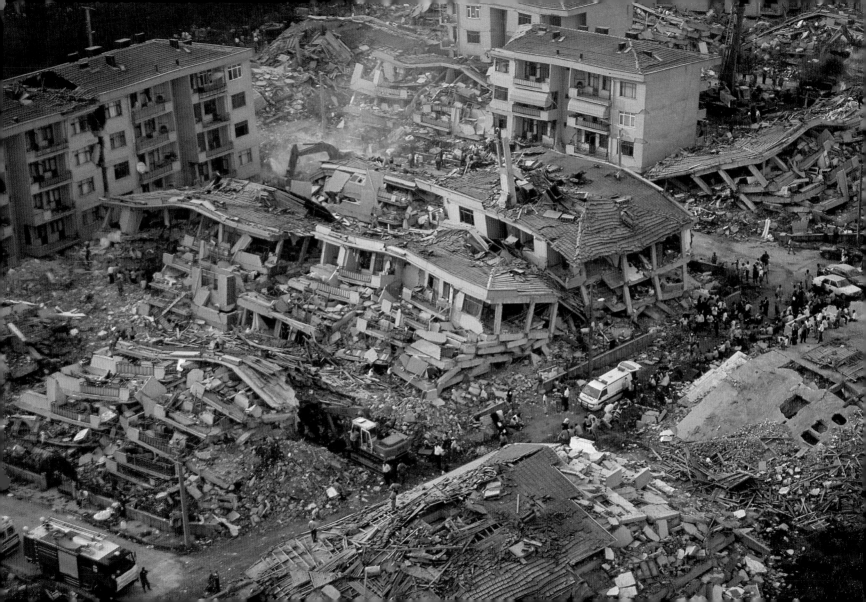

Kuwait. Iraqi tank graveyard in the desert near Jahra.

The Gulf War, triggered on August 2, 1990, by Iraq's invasion of Kuwait, cost more than $1 billion per day and led to thousands of deaths. Iraq's defeat by an alliance of 28 countries above all consolidated the power of the United States which, more than ever, is the sole global superpower. This conflict, which was political as much as economic, also brought into question the handling of information by the media, which in hindsight appeared to act as mouthpieces for the U.S. Armed Forces. At the beginning of the third millennium, armed conflicts are still widespread all over the planet. While wars between countries are relatively rare, civil wars cause enormous devastation. Some of these even become established in the long term as a form of policy, as in Angola or southern Sudan. They cause mass exoduses and produce millions of refugees, who languish in camps in the faint hope of returning home. In the year 2000 there were about 50 million displaced people in the world. More than 75 percent of these were women and children, who are particularly vulnerable to violence and exploitation. The refugees' problems are compounded by that of their own safety in host countries, which are often destabilized by an influx of unwanted foreigners, and which treat refugees with increasing hostility. The United Nations High Commission for Refugees (UNHCR), faced with the problems of war, aims to improve our ability to contain conflicts which reduce the chances of sustainable development of the planet.

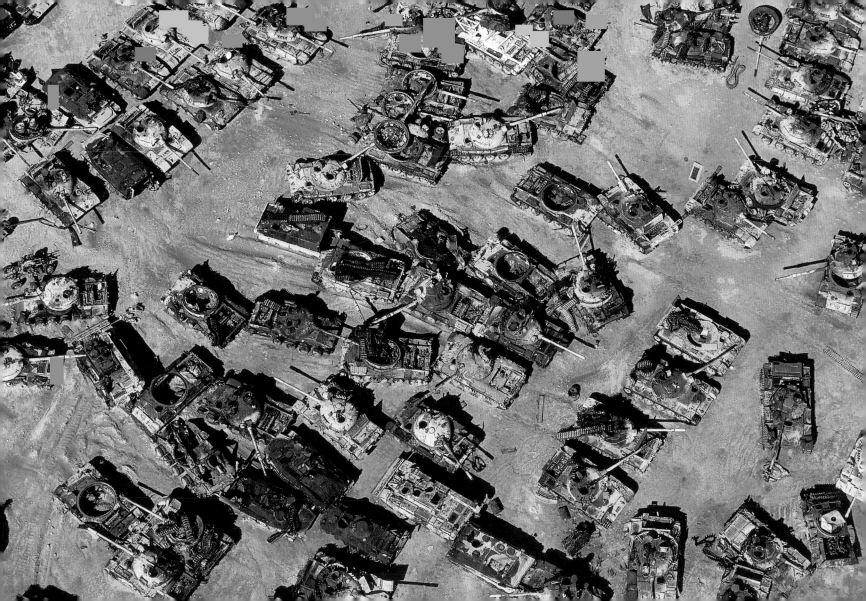

Canada. Quebec Province. Charlevoix forest.

Covering just 6,000 square kilometers (2,300 square miles) in northeastern Quebec, Charlevoix is the smallest territory in the province. Its geological history is somewhat extraordinary, for Charlevoix is actually a vast impact crater, one of the largest on Earth, created when a giant meteorite struck some 350 million years ago. Its beauty is punctuated by mountains and rivers, most notably the Saint Lawrence, and varied vegetation, from stands of elm and ash to tundra and taiga where herds of caribou have lived since their successful reintroduction in the 1960s. In 1989 Charlevoix was designated a UNESCO World Biosphere Reserve, and is now one of 325 such sites around the world.

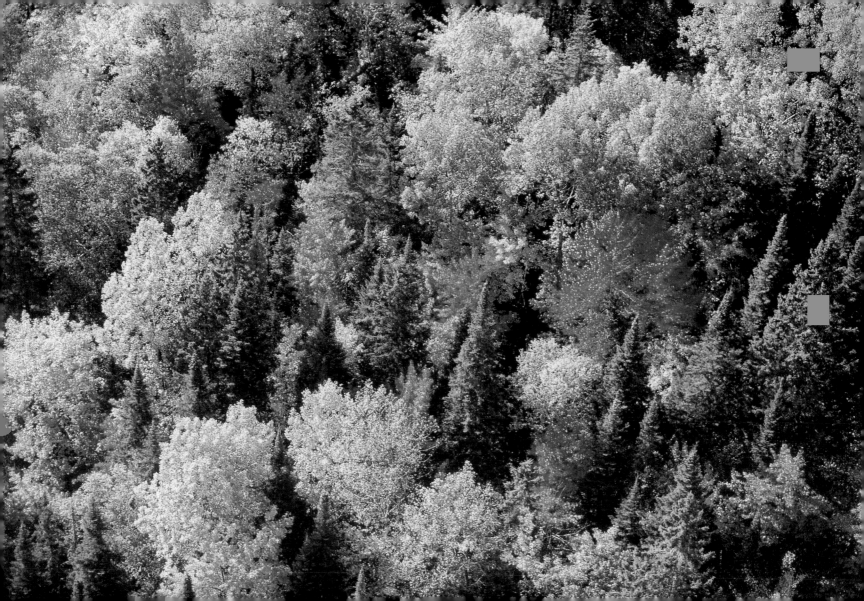

Niger. Detail of a village near Tahoua.

With its cubic houses made out of *banco* (a mixture of earth and plant fiber) and its impressive ovoid granaries, this village near Tahoua in the southwest of Niger is typically Haoussa in its architecture. Most Haoussa (who make up 53 percent of the population of Niger) are settled small farmers. However, their reputation is primarily based on the quality of their craftsmanship and business sense; the Haoussan city-states in northern Nigeria commercially dominated numerous African countries for several centuries. Today the region of Tahoua is crossed by a north-south highway commonly known as the "uranium road;" the ore-rich substrate of the Aïr Massif supplies more than 2,500 tonnes (2,750 tons) of uranium per year, making Niger one of the world's primary producers.

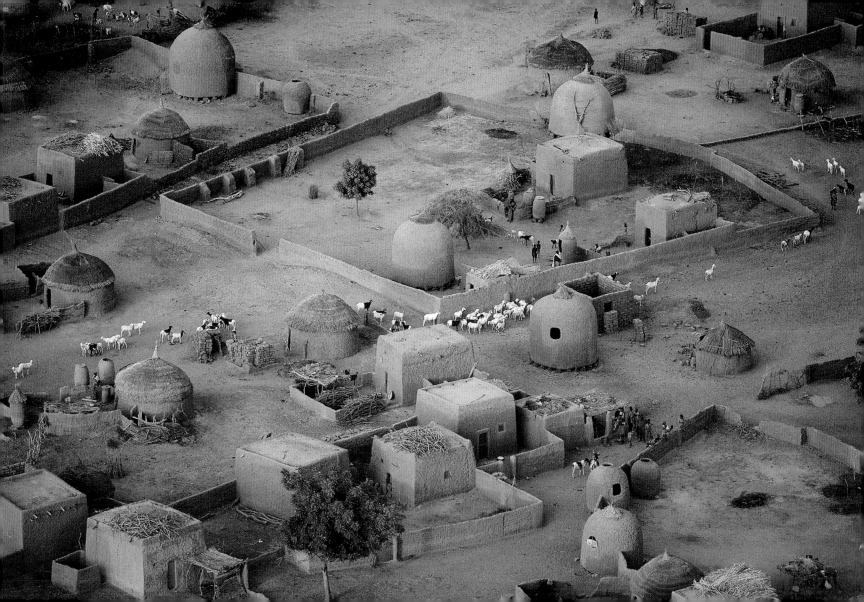

Brazil. São Paulo. São Paulo University swimming pool.

With 15.2 million inhabitants, the São Paulo metropolitan area is the largest in Brazil. Deep social inequalities are leading to increasingly sharp spatial segregation. Districts wholly inhabited by the rich are turning into cities within the city, protected by security guards, watched by cameras, and surrounded by high walls to keep out the violence and misery that surround them. At the other extreme are the shantytowns (*favelas*), which were home to 1.1 percent of the population in 1973, increasing to 19.4 percent in 1993. In this new social partitioning, private enclaves are being created within public space. These are the Brazilian equivalent of the "gated communities" of wealthy suburban America. This spatial fragmentation is accompanied by a privatization of the urban environment which ultimately threatens democracy, as democracy cannot function in the absence of public space.

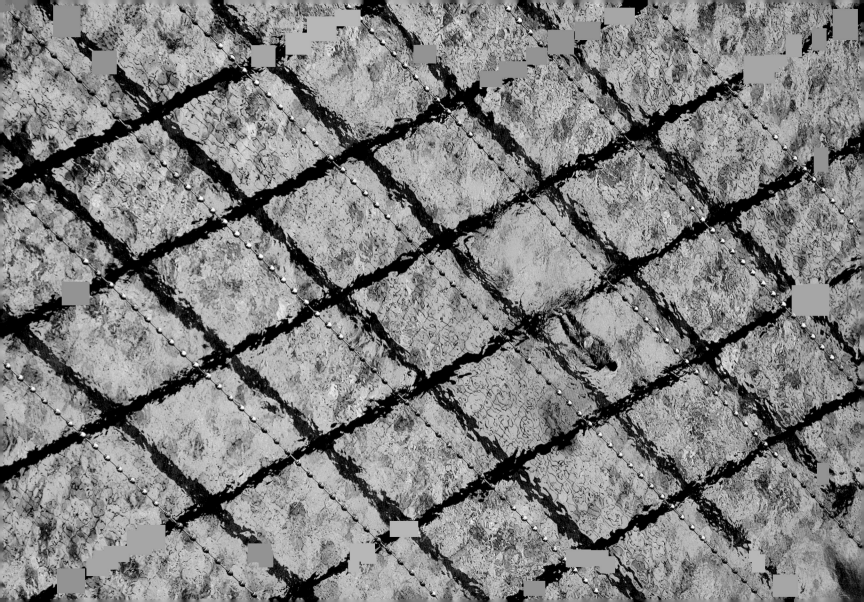

Ukraine. Chernobyl region. Barges beached in a bend on the Pripet River.

The explosion in one of the four reactors of the nuclear power station at Chernobyl on April 25, 1986, was an ecological accident on a continental scale. The radioactive pollution first crossed the frontier with Belorussia, then entered rain clouds, thus contaminating all of northwestern Europe. The extent of the disaster found expression in the popular saying that arose at the time, "Rare is the bird that can cross the Pripet River." It echoes the helplessness felt by the population after the strong radiation that affected the Pripet, a 775-kilometer- (485-mile-) long navigable branch of the Dniepr River on which the power station was built. Entire villages were evacuated when a safety zone was established around the station. It is not unreasonable to be concerned about nuclear power stations elsewhere. Some, such as those in Turkey, are in areas prone to earthquakes; others, as in France, are in flood zones. But the Chernobyl catastrophe was caused by massive human error. Human actions can be more dangerous than either nature or technology, and technology greatly amplifies the consequences of our mistakes.

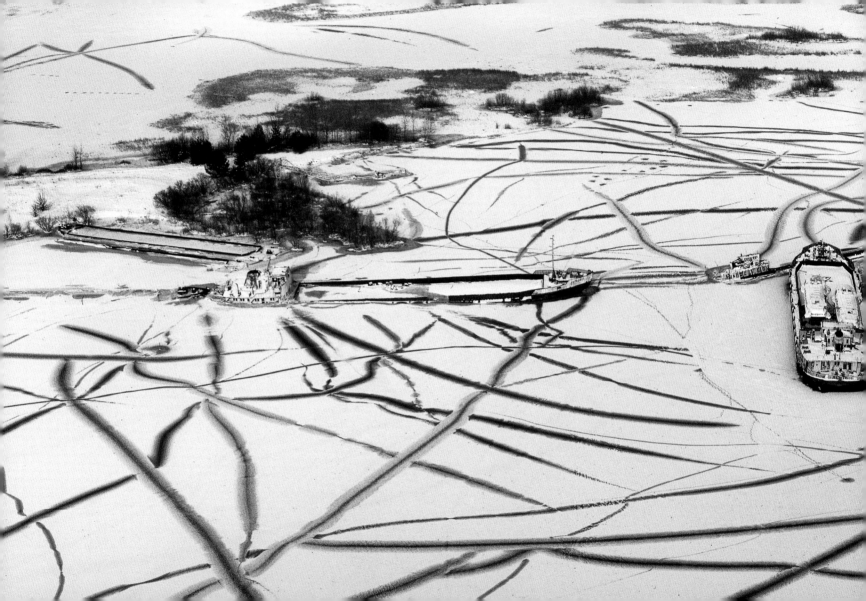

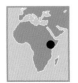

Kenya. Island in the middle of Lake Turkana.

Lake Turkana is also known as "the Jade Sea" for the contrast between its waters and its particularly arid surroundings. Like other great African lakes, it lies in the crater of an extinct volcano. Formerly much larger than it is now, the lake once swarmed with wildlife, whose fossilized bones are to be found in the surrounding sediments. Little by little its surface area shrank, finally isolating it from the Nile. The island in the center, the remains of a smaller volcano, is home to colonies of crocodiles whose eggs and meat are traditionally harvested by the Luo fishermen. However, industrial fishing is on the increase, and may ultimately supplant the ancestral boats. But such exploitation of Lake Turkana may ultimately be compromised by the extent of evaporation which is slowly raising its salinity, dooming it to become another Dead Sea unless the rainfall pattern changes. Droughts, which have increased here over the past five years, ravaging neighboring Ethiopia, seem to be the consequence of the immense fluctuations in equatorial temperatures affecting the Pacific Ocean. This may or may not be indicative of the onset of a vast, long-term change in climate.

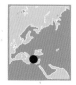

Greece. Lassithi region of Crete. Peasant plowing his field.

Farming is particularly difficult in Crete because of its the steep terrain and dry climate. Here, the donkey, excellently adapted to the island's topography, is the traditional means of travel, transportation, and traction. In spite of the arid climate and the antiquated agricultural practices, 30 percent of the terrain is cultivated, irrigated by a system of wind pumps. Having been the breadbasket of Crete in classical times, the flat, fertile plateau of Lassithi is now an extensive provider of both grains and potatoes. Several years ago, Greece launched a program to modernize agricultural techniques, but progress is slow, especially in Crete, which remains one of the rare regions in Europe where the donkey is still in widespread use.

Scotland. North Sea. Total Oil Marine's Alwyn North offshore platform.

The Alwyn North oil field, 400 kilometers (250 miles) off Aberdeen, Scotland, was discovered in 1975. The sharp rise in the price of oil after the first oil crisis in 1973 set off a search for new reserves, and made the use of sophisticated and expensive exploration and extraction techniques economically viable. The price rise also led to a phenomenon which has lasted half a century, but which few people are aware of: the number of hydrocarbon reserves has grown, favoring increased consumption in the future, which would in turn aggravate the greenhouse effect and disruption of the Earth's climate. Paradoxically, rather than restraining consumption, oil crises allow it to rise in the same way that a crisis in the means of subsistence can stimulate agricultural expansion, allowing the population to increase. The race to drill in ever deeper offshore waters (the current record is 2,000 meters [6,500 feet], off the coast of Angola) and the construction of giant production platforms increase the risk of ecological disasters such as the recent sinking of the giant platform operated by the Petrobras Oil Company.

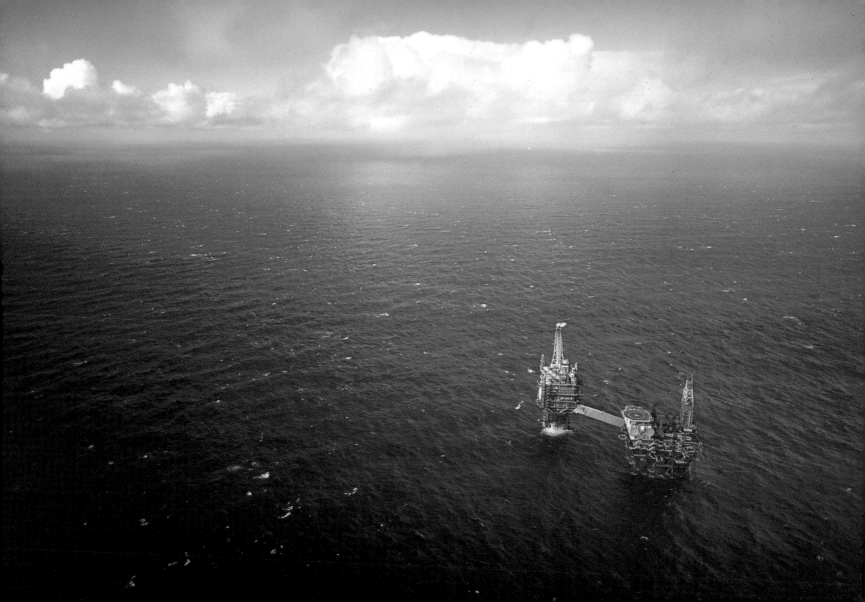

Niger. Aïr Massif. Caravans of dromedaries near Fachi.

For decades now, the Tuaregs of the Aïr have regularly used caravans of dromedaries to travel the 785 kilometers (490 miles) between the town of Agadez and the saltworks of Bilma in northeastern Niger, carrying on the traditional trade in salt, one of the rare commodities in this landlocked country. Attached to one another and guided by a leader at the front, the convoy travels about 40 kilometers (25 miles) each day, in spite of temperatures that can reach 46°C (115°F). Fachi, the only significant locality en route, is an essential stop for both sustenance and trade. Formerly comprising several thousand animals, the salt caravans now barely exceed one hundred. Their loads of nearly 100 kilograms (220 pounds) each are a lot for each animal, but nothing for a motorized vehicle. Little by little, they have been replaced by trucks, each of which transports as much as several hundred dromedaries could.

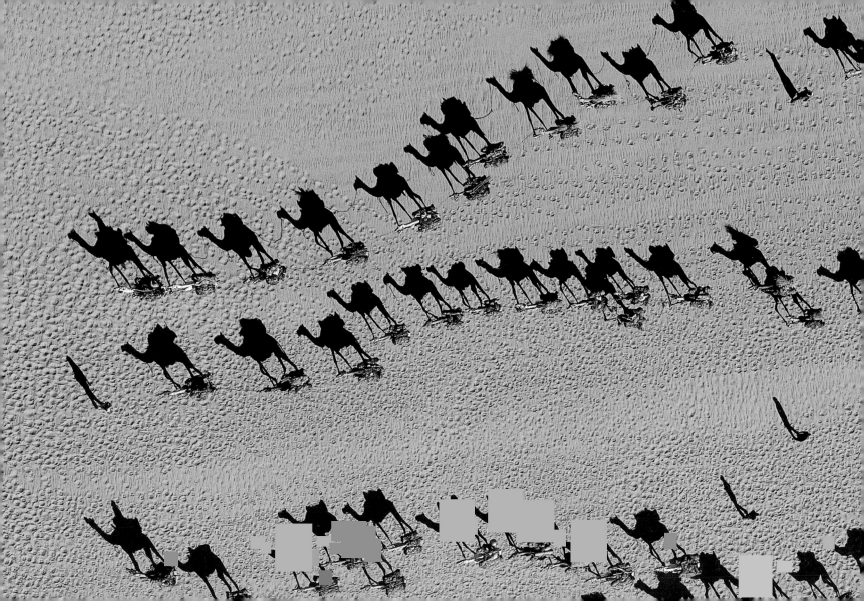

Ivory Coast. Yamoussoukro. Dome of the Basilica of Peace.

On March 21, 1983, Yamoussoukro, "birth village" of President Houphouët-Boigny, replaced Abidjan as the Ivory Coast's official capital. Since the 1970s, it has transformed itself from a village into a town, with an impressive road system and more than 100,000 inhabitants. Within the context of this all-round urbanization, one of the most striking and most controversial creations is Notre Dame de la Paix, the city's huge basilica. Pierre Fakhoury's project was adopted by Houphouët-Boigny in 1986 and inaugurated in 1989. The basilica's design, in particular its 160-meter (525-foot) dome, is modeled on Saint Peter's in Rome. Surrounding the basilica, a vast French-style park is to replace the original coconuts. Although many vacant lots still remain, Yamoussoukro is definitely on the map. Having begun as a potentate's fancy, it may become a true metropolis. The masters always feel a slight fear before the masses of the disenfranchised, and choose to transfer their administration and court to a calm place where they can forget the wretchedness of their subjects. Such is the story of Versailles, Potsdam, Washington, and Canberra.

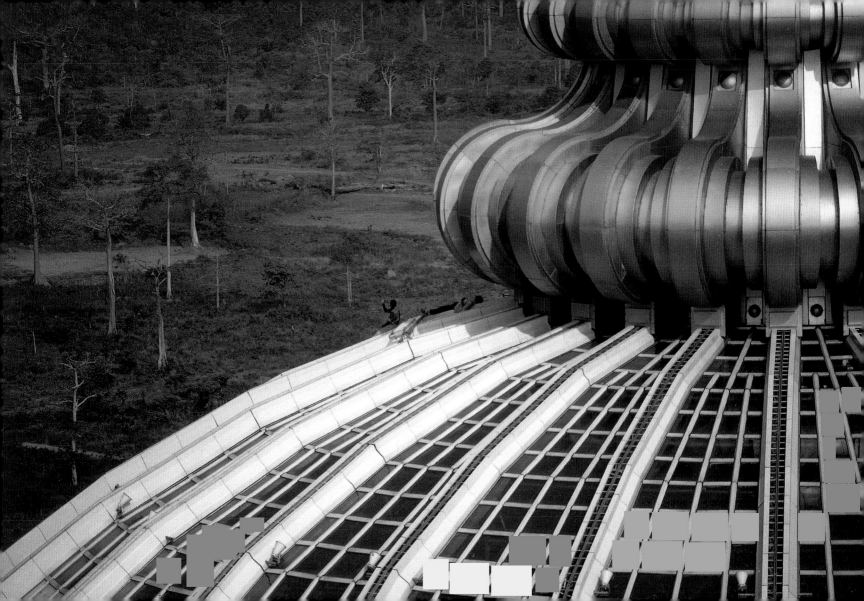

Indonesia. Seaweed production in Bali.

Used exclusively as fertilizer in classical times and as ashes in glass production from the sixteenth century, 97 percent of today's seaweed production goes toward alimentary uses. Of the 30,000 species known, only a few dozen are exploited commercially. Among these are the carrageenophytes (Florideae seaweed rich in mucilage), known as *Chondrus* or Irish moss seaweed and used for gelling, thickening, and stabilizing within the food-processing, pharmaceutical, and cosmetic industries. In the Far East, this type of seaweed is grown on submerged ropes or nets. The main producers are Indonesia with 23 percent of world production, and the Philippines with 65 percent. China, however, is the leading producer when all types of cultivated seaweed (green, red, and brown) are considered together, and Japan is its leading consumer.

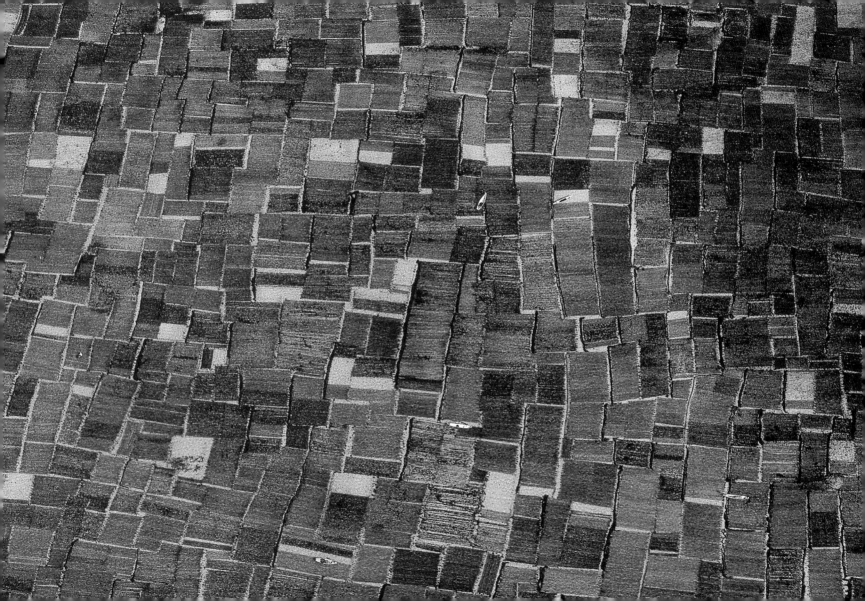

Kenya. Rendille enclosure between Lake Turkana and Marsabit.

In northwestern Kenya, the Rendilles, who are said to descend from the Samburu (with whom they have close kinship and economic links) and the Somali people, comprise some 22,000 camel herders. Their space is organized into large, semi-permanent camps inhabited by married men, women, and children, and mobile encampments entirely made up of young men looking after flocks and searching for new pastures. Every evening the Rendille livestock are rounded up and placed in enclosures of spiny plants to prevent them from wandering and to protect them against predators. The tribe's girls are responsible for the goats and sheep, which they take out to pasture during the day. After the rainy season (June and July), the young herdsmen are able to find pastures closer to the main family encampments and attend the ceremony known as *Almhata*, a ritual feast during which they drink large amounts of milk. The tribe then moves off to a new site.

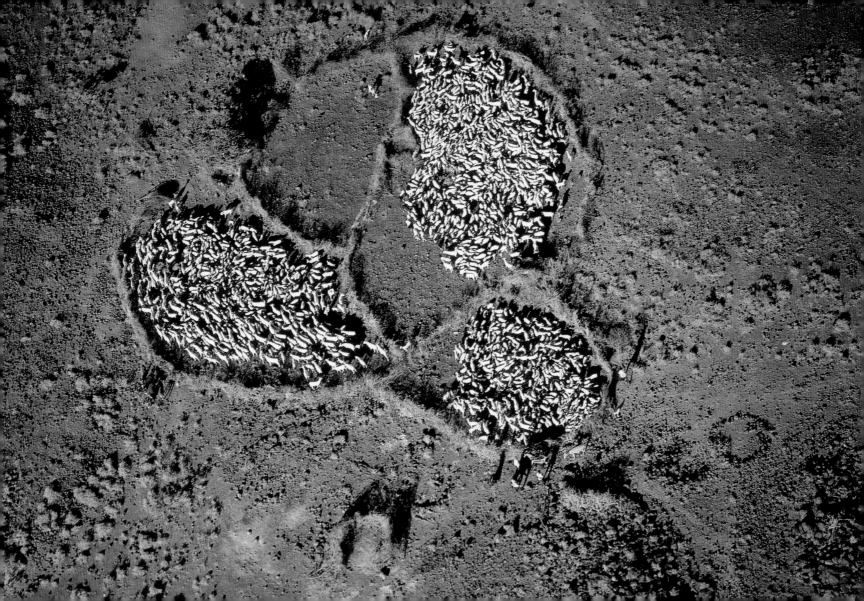

Egypt. Valley of the Nile. Temple of Abu Simbel.

The archaeological site of Abu Simbel in Nubia contains two monumental, rose-colored sandstone temples constructed under Ramses II (1290–1224 BC) to mark the southern border of the Egyptian empire. The facade of the larger of the two, facing the rising sun, comprises four statues of the pharaoh, 20 meters (65 feet) high. When in 1954 it was decided to build the Aswan High Dam on the Nile, a score of nations, alerted by UNESCO, mobilized financial and material means to save this heritage site from being drowned by the waters of the coming lake. The decade from 1963 to 1973 saw an army of 900 workers, guided by experts from 24 countries, cut the temples into 1,305 blocks, each weighing several dozen tons, in order to move them out of the way of the rising water. The temples were reconstructed identically on an artificial cliff sustained by a concrete vault, 60 meters (200 feet) above their original level. Like 630 other sites worldwide, Abu Simbel is a UNESCO World Heritage Site.

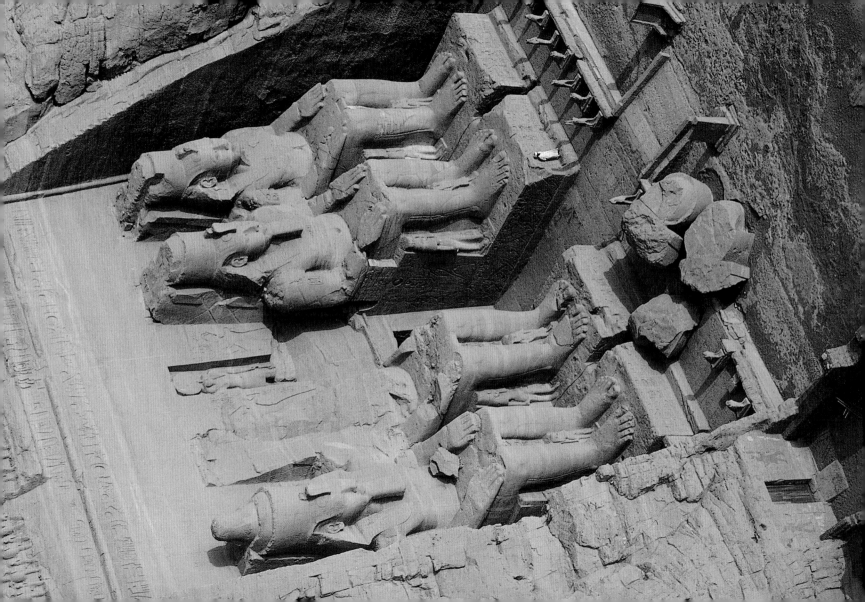

Mali. Gao region. Rose-colored dunes at Koira.

Coming upon the Niger River after more than 1,000 kilometers (600 miles) of the Tanezrouft's monotonous desert, travelers feel they have "reached the sea." The Songhaïs, who made Gao their imperial capital, named the river "Dialika," the one who sings, and the Tuaregs called it "the river of rivers." On the northern side, the long rose-colored dune at Koira is an outpost of the desert. But to the south is a fine verdant ribbon of tropical vegetation, made up of doum palms, acacias, and mango trees. Between the two are islands of marshy ground covered with bourgou, an aquatic grass used to feed cattle. Sometimes long black wooden barges thread in and out of the marsh, on their way downriver with cargoes of cloth, dried vegetables, and everyday utensils. Gao was once ideally situated at the intersection of a parallel and a meridian – the river running west to east, and the north-south trail that led the gold of Bougouni up from the south and the slabs of Taoudenni salt down from the Sahara. As the trades lost all importance, the trails nearly vanished and this river now passes through a somnolent town. From Mauritania to the Sudan, the fringe of the Sahara has become a graveyard of towns.

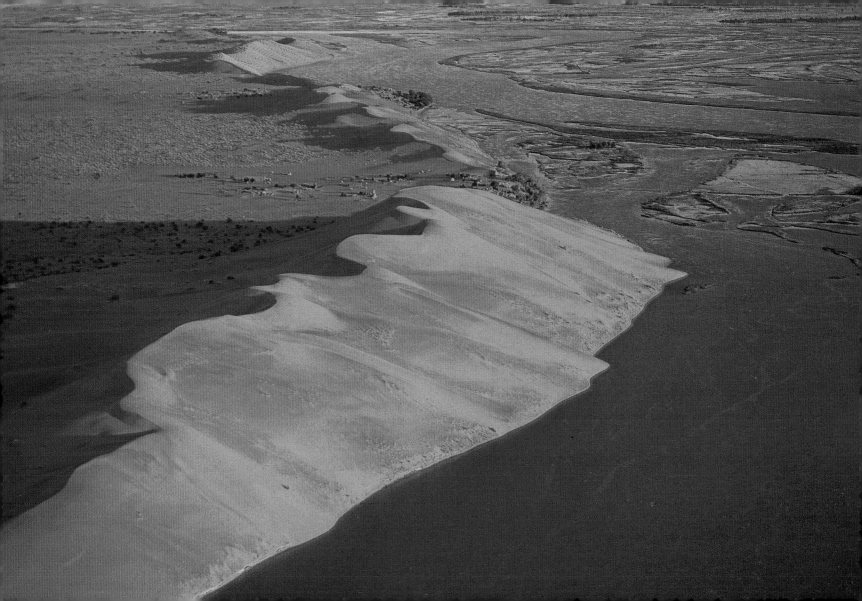

Guatemala. Agricultural landscape northwest of Guatemala City.

The capital of Guatemala, Guatemala City, is located at an elevation of 1,500 meters (5,000 feet) in a mountainous zone made up of 33 volcanoes, some of them still active. Covered with fertile volcanic soil, the valleys of the region are watered by abundant and regular rains from May to October. Agriculture is the mainstay of Guatemala, employing 55 percent of the active population. It is practiced on small plots, 90 percent of producers working on less than 7 hectares (17 acres) each. Maize, a staple here, and coffee, whose production represents half of all exports (Guatemala ranks ninth in the world), are the main cash crops. Guatemala also produces cannabis, opium poppies, and coca, and is a substantial supplier to the international drug trade.

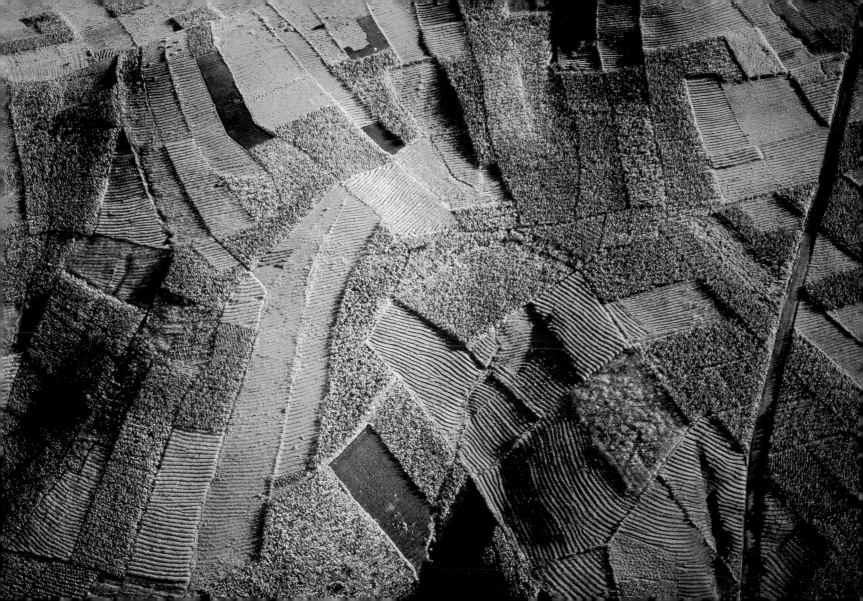

Nepal. Kingdom of Mustang. Village south of Jomson.

Perched at an altitude of 3,000 to 4,500 meters (10,000 to 15,000 feet), the kingdom of Mustang is a small enclave of 1,200 square kilometers (450 square miles) between the peaks of Dhaulagiri to the west (8,167 meters [26,786 feet]) and Annapurna to the east (8,091 meters [26,538 feet]). The second center of Buddhism after Lhasa and the rear base of the Tibetan Resistance, Mustang has been open to foreigners since 1992. Its 7,000 inhabitants live in the valley of the sacred river of the dark deity Kali. The parched climate means subsistence agriculture, which is based on barley, consumed as porridge or griddle cakes known as *tsampa*, and as a very alcoholic beer called *tchang*. After the summer harvest, the barley is put in sheaves and then hulled on the terraced roofs. The pebble walls mark out the irrigation system and protect the crops from wind and erosion. The timber in the middle of the oasis is reserved for funeral rituals and construction; the dung of goats, yaks, and sheep supplies domestic fuel. Mustang exemplifies a human community capable of living in balance with its environment, however harsh.

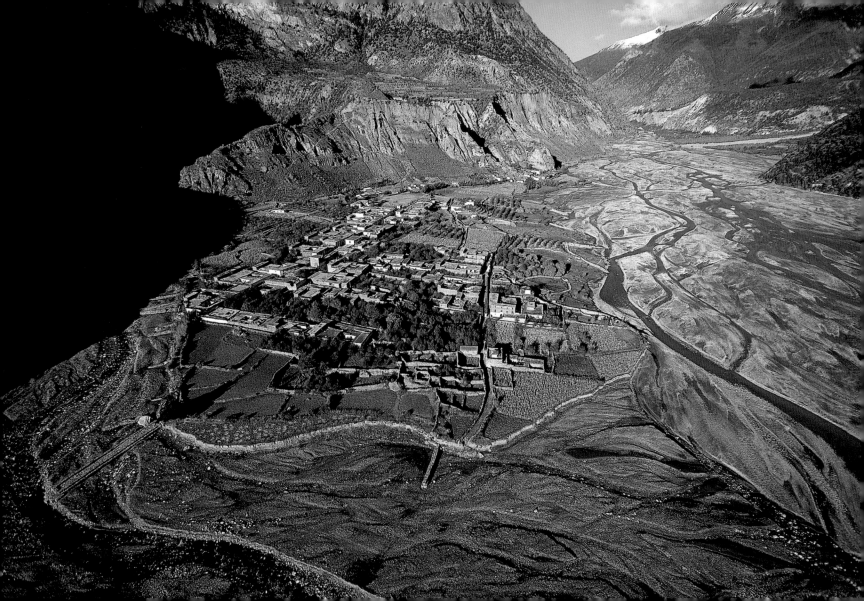

Oman. Palm trees in the mountains of the Musandam Peninsula.

The limestone mountains dominating the Sultanate of Oman were once part of the ocean floor, raised high and dry by the tectonic collision between the Arabian Peninsula and the floor of the Tethys Sea during the Cretaceous period. At these desolate heights, vegetation is rare, sometimes nonexistent, yet it is on the mountains of Musandam that the Shihuh villagers pasture their livestock after the rainy season. As in the valley, they have planted date palms, protecting them from the voracious goats with a small wall. While the mountains represent 15 percent of the country, a full 80 percent is desert, which limits agriculture to a tiny proportion of the territory. Today, only 600 square kilometers (230 square miles) of Oman are cultivated, one-third of which is devoted to dates.

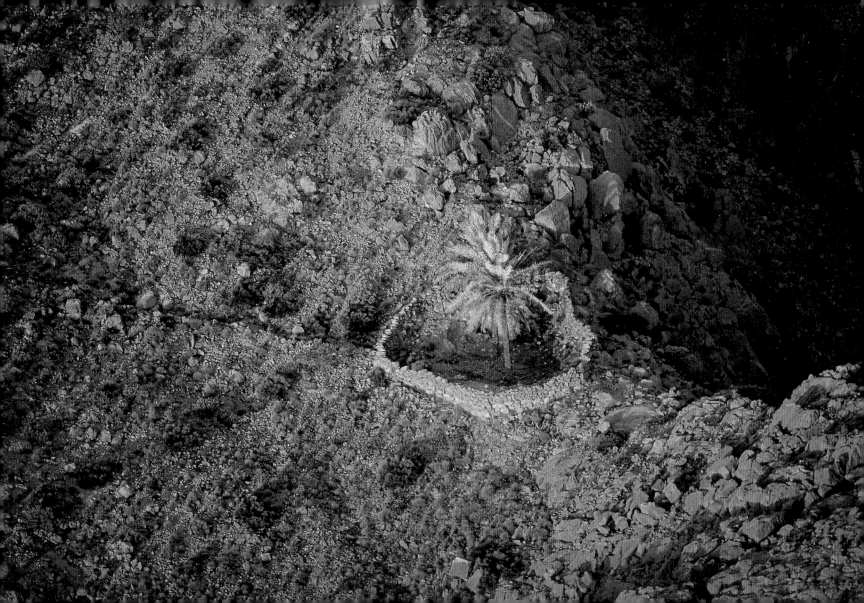

Philippines. Visayan Islands. Island of Bohol. Boat near Tagbilaran.

The Philippine Archipeligo consists of 7,107 islands divided into three geographical zones: Luzon, the Visayas, and Mindanao. The eleven largest islands (including Bohol) account for 95 percent of the country, which has a total land area of about 300,000 square kilometers (115,000 square miles). The inhabitants of Bohol (4,000 square kilometers [1,500 square miles]), like those of the rest of the Philippines, make their living from fishing and agriculture. The Philippines thus exports fish (anchovy, herring, mackerel, sardines), sugar, coconut (of which Bohol is a large producer), hemp, and rice, primarily to the United States, but also to its Asian neighbors. The country's position as a crossroads explains the importance of its trade with Japan and China. It accounts also for the country's cosmopolitan population, which consists of more than 100 cultural and linguistic groups. Its location has also influenced its history, characterized by waves of settlement: Chinese had already settled by the fourth century, Arab merchants arrived in the thirteenth, Spanish conquistadors in the sixteenth, British in the eighteenth, and Americans at the end of the nineteenth century.

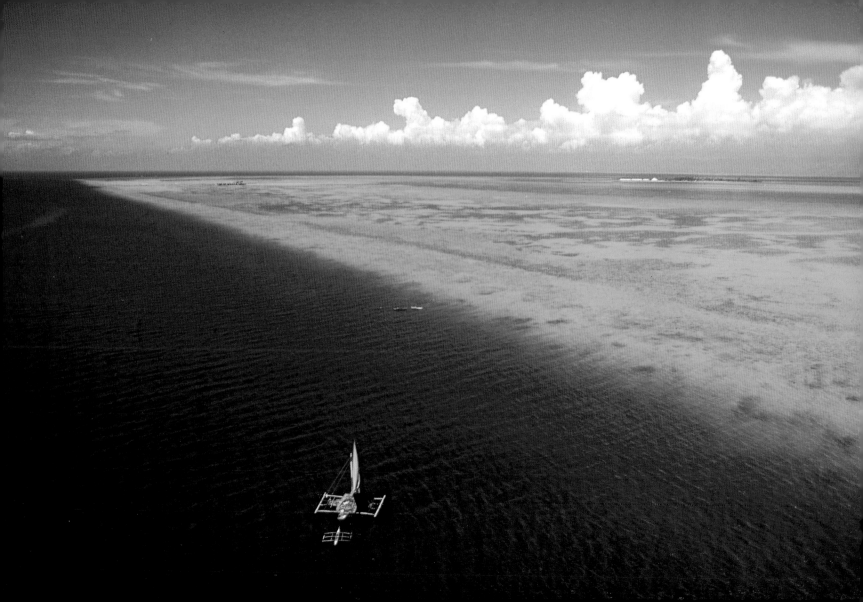

Kenya. Lake Magadi.

Lake Magadi is located on a fault of the East African Rift Valley, and contains an exceptional concentration of caustic sodium carbonate, produced naturally by the transformation of the sediments when water entering the lake comes into contact with the molten lava under the lake. The soda concentration is so strong and the lake so shallow that a thick crust of soda crystals partly covers it, giving rise to the oldest mining firm in Kenya, the Magadi Soda Company, founded at the beginning of the twentieth century. Once upon a time the lake's water was fresh like that of its neighboring lakes, Naivasha and Baringo. It was inhabited by hippopotami, crocodiles, and fish. All that survives today is a limited fauna of microscopic fish and primitive algae that attracts flamingoes. However, the flamingoes are actually threatened by the soda. When it does not rain enough, the lake dries and what water remains turns into a thick soda gel; it solidifies around the feet of the chicks, which then can only be rescued by the national parks service teams. Changes to the planet's character are thus not merely the handiwork of the sorcerer's apprentice, man. There is also a natural, autonomous dynamic, in which volcanoes, among other natural phenomena, play an essential role.

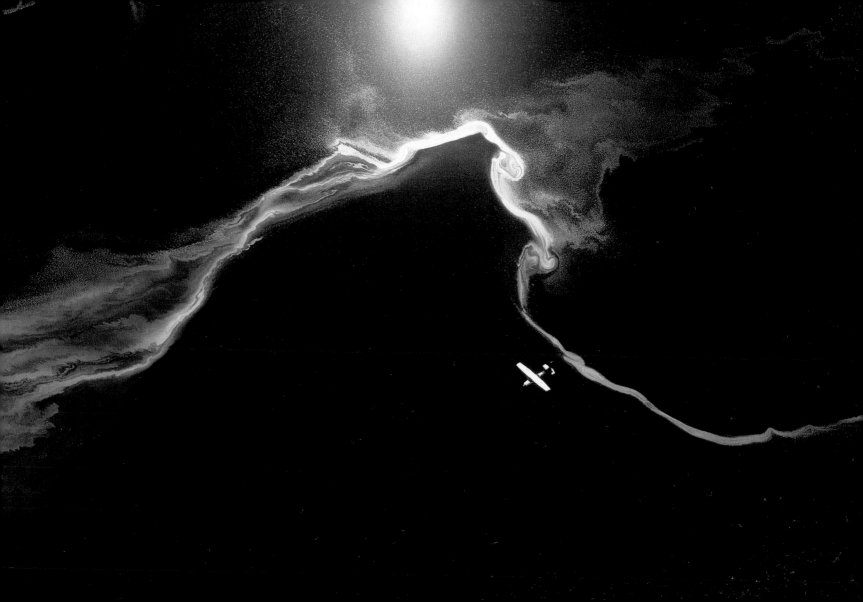

Honduras. Bay Islands. The isle of Guanaja laid waste by Hurricane Mitch.

Hurricane Mitch left its mark on 1998 as one of the most violent storms of the entire century. Its main target was Central America: Honduras and Nicaragua. Mitch certainly took more than 20,000 victims, but the exact number will never be known. The economic and ecological destruction ran to millions of dollars – though how can one put a monetary value on the effects of such a cataclysm? While the natural mechanism of hurricanes is fairly well understood now, many climatologists correlate the violence of Mitch with that of other classic, yet particularly brutal, weather phenomena occurring at the turn of the millennium. In additional to a global rise in temperature, one effect of human activity on the planet's climate may be the amplification of extreme meteorological incidents such as droughts, storms, hurricanes, and the like.

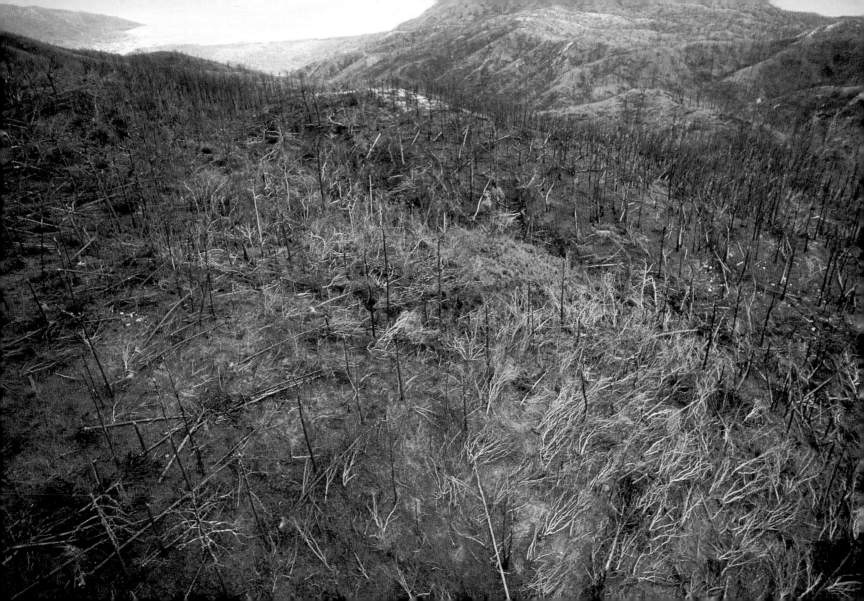

Greece. Cyclades. Village on the northern point of Santorini (Thira).

The village of Oïa crowns a volcanic cliff that plunges 200 meters (650 feet) down to the sea below. The volcano exploded 3,500 years ago leaving a waste crater, only the rim of which still remains above sea level. Houses and chapels of the village have been built on this loose accumulation of ash and volcanic debris, as if re-creating the labyrinth of nearby Crete. In 1967, the archaeologist Spiros Marinatos discovered the remains of a sophisticated culture similar to that of Minos in Crete: elegant frescoes, a system of drains, antiseismic joints, and the remains of white and red stone walls like those of Atlantis as described by Plato in *Critias*. Marinatos deduced that Plato used the explosion on Santorini as the model for the swallowing-up of Atlantis. Although it is unlikely that it destroyed the mythical Atlantis, the gigantic explosion was undoubtedly responsible for the disappearance of the brilliant Minoan culture, and possibly for the seven lean years in Egypt spoken of in the Pharaoh's dream in the Bible. The explosion must have caused a tidal wave and clouds of ash, shutting out a portion of the sunlight for several years.

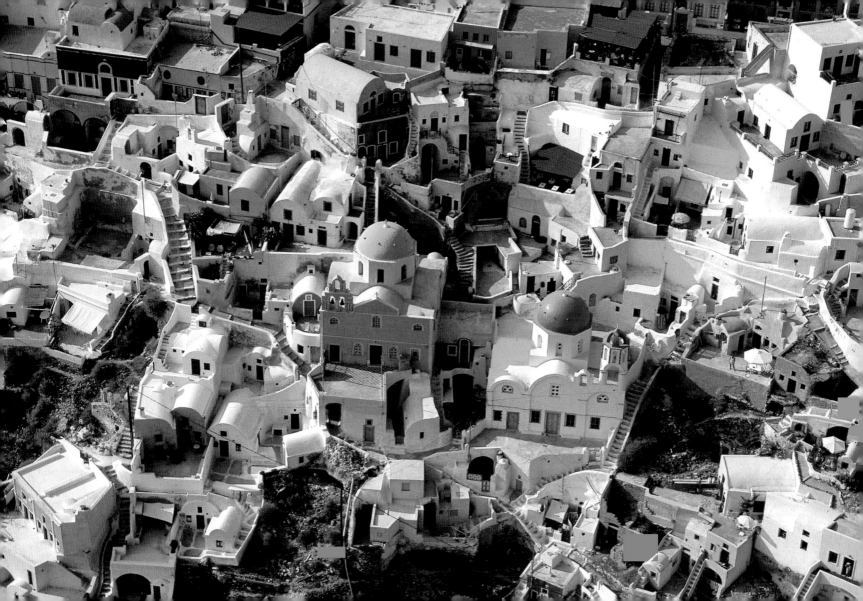

Norway. The Folgefonn Glacier, on the high plateaus of Sorfjorden.

At 212 square kilometers (82 square miles), the Folgefonn Glacier, lodged between the Hardangerfjord and Sorfjord in southern Norway, is the third largest of the 1,500 glaciers in Norway. This glacier is typical of those in regions with a temperate climate, consisting of a flat icy dome sliding over a film of water forming between the rock and the ice. In summer, the melting ice feeds silt and clay into the water of the fjords, giving them a characteristic green color. Independently of the seasons, the glaciers are progressively shrinking as a result of the natural warming of the planet following the Ice Age, as well as the increasing greenhouse effect caused by pollution. The melting ice raises sea level, but at the same time it causes the land to rise by lightening its load. The whole of Scandinavia is estimated to be rising at the rate of 1 centimeter (0.4 inch) per year.

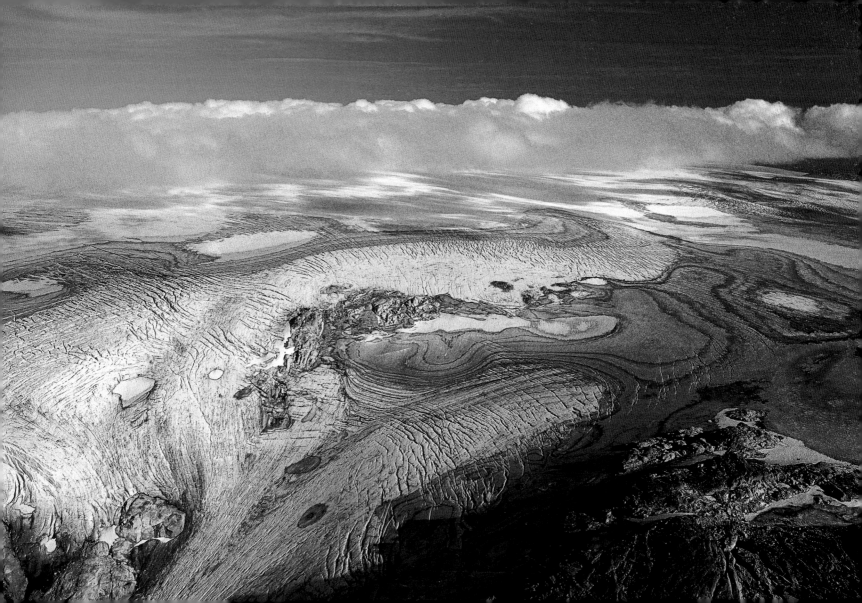

USA. Monument Valley Park.

Monument Valley Park encompasses almost 12,000 hectares (30,000 acres) of desert along the border of Utah and Arizona. Officially run by the Navajos since 1958, Monument Valley represents the culmination of many histories. First, there is its landscape of buttes, plateaus (mesas), and enormous sandstone chimneys, some of which reach 600 meters (2,000 feet) − witnesses to the geological upheavals the region has known, and sculpted by erosion for the past 70 million years. Second is the mid-nineteenth-century conquest of the West, represented by the likes of Kit Carson, who tried unsuccessfully to expel the Navajo Indians and enclose them in a reservation. A third story is that of the rush for gold and silver in the second half of the nineteenth century, after the Indian Hoskamini discovered seams under Navajo Mountain. The ensuing struggle between the Indians and two former members of Kit Carson's band has left its mark on the park, as two of the finest buttes in Monument Valley bear the names of the two murdered men. Last of all, since the 1940s, Hollywood has adopted its unique decor as the scene of many of its great westerns, a symbol of all its violent past, that of nature and men alike.

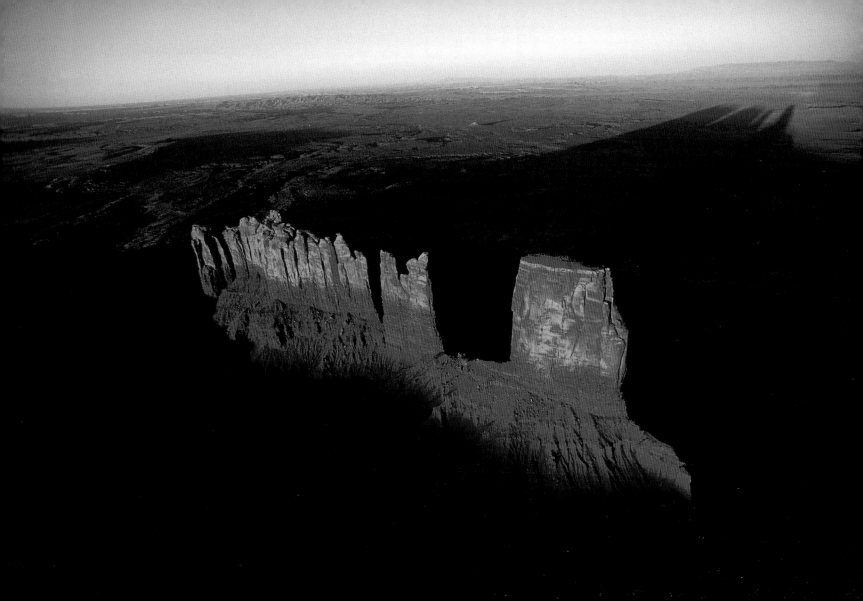

Brazil. Mato Grosso do Norte. Deforestation in Amazonia.

Brazil holds 27 percent of the world's tropical rain forest, notably the celebrated Amazon Rain Forest which has always been a rich resource for its human inhabitants. Today, however, overexploitation is threatening this natural habitat and bringing environmental and social problems, including degradation of ecosystems, depletion of resources, and destruction of native lands. The rate of deforestation increased in the last years of the twentieth century, and by the end of 1999 more than 560,000 square kilometers (215,000 square miles) had been cut down. The reasons are many and include farming, mining, and building dams, but the primary cause of the forest's disappearance is the unchecked logging of tropical hardwoods, which produces no real benefit for the local people. These woods are bought by rich countries, and feed the ferocious demand of multinational logging companies. Eight companies already have access to more than 10 million hectares (25 million acres), while the Brazilian government has no real control. The exhaustion of forests in Africa and central Asia means that Amazonia has become the timber industry's primary source of tropical hardwoods for the coming decades. Industrial logging is costly for the planet: two-thirds of the felled timber is wasted, while building roads and clear-cutting open the way to illegal occupation of the land by poor farmers, leading to further deforestation and land degradation.

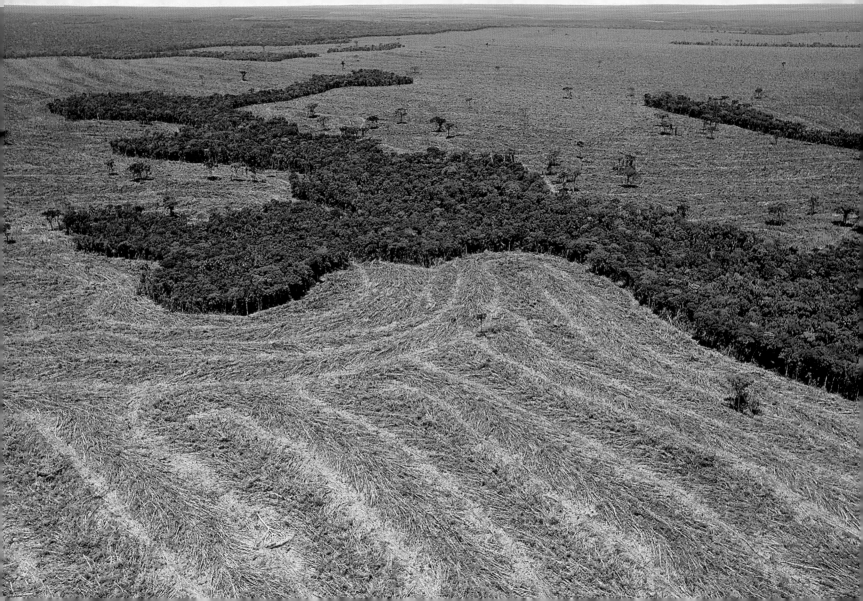

Turkey. Anatolia. Hattushash. The ruins of the Hittite city.

Like most civilizations that made their mark in ancient history – and indeed in more modern times – the Hittites emerged from the fusion of several groups, including natives of central Anatolia (the proto-Hittites or Hattis) and invaders from Persia and perhaps even India. The Hittites appeared at the beginning of the second millennium BC around Caesarea (the Turkish city of Kayseri), not far from the present-day city of Bogazköy (Hattushash), which they made their capital about 1600 BC. Although they are cited in the Bible and were creators of monumental architecture (especially at Hattushash, the ramparts around the Acropolis, the temples and sanctuaries with their grandiose bas-reliefs), the Hittites remained virtually unknown to historians until the early twentieth century. The archaeological digs undertaken at Hattushash between 1906 and 1912 led to the discovery and deciphering of the clay tablets used for official records. They revealed a civilization contemporary with the Mycenaean Greeks and a degree of social, political, and cultural development rivaling that of Egypt and Babylon. UNESCO designated Hattousa a World Heritage Site in 1986.

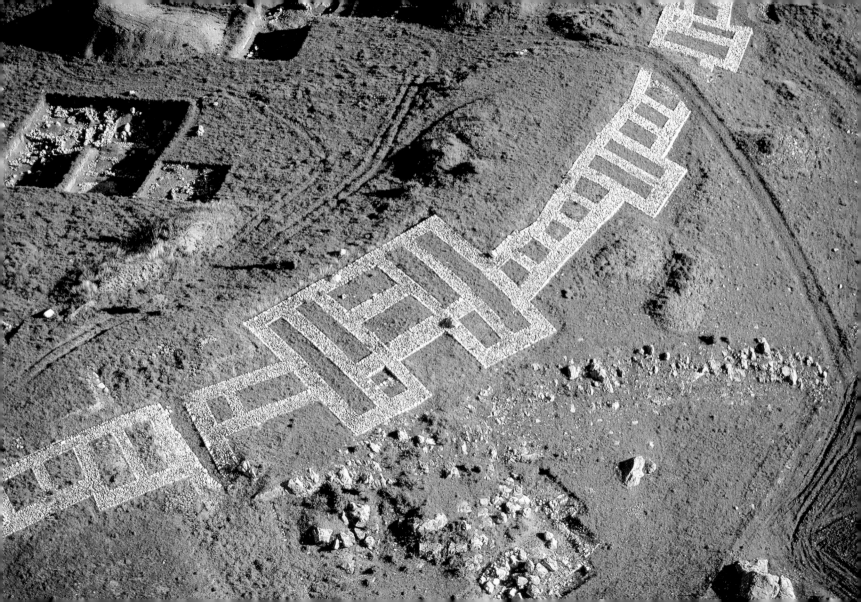

Greece. Macedonia. Salonica region. Orchard amid the wheat.

The fertile plain of Salonica, the largest in Greek Macedonia, is particularly suitable for wheat, commonly in conjunction with fruit trees. In view of the uneven topography of the Hellenic Peninsula, farms remain small and divided, in spite of programs to aggregate farmland and establish agricultural cooperatives. The surface under cultivation, which represents one-third of the territory, is still insufficient to enable Greece to make the best of its agriculture (which brings in 16 percent of its Gross National Product) and become truly competitive within the European Union. Since the substantial industrial development of the country in the 1970s, the agricultural population has shrunk considerably and now represents only one-quarter of the active population. All the same, it is still the highest proportion in Europe.

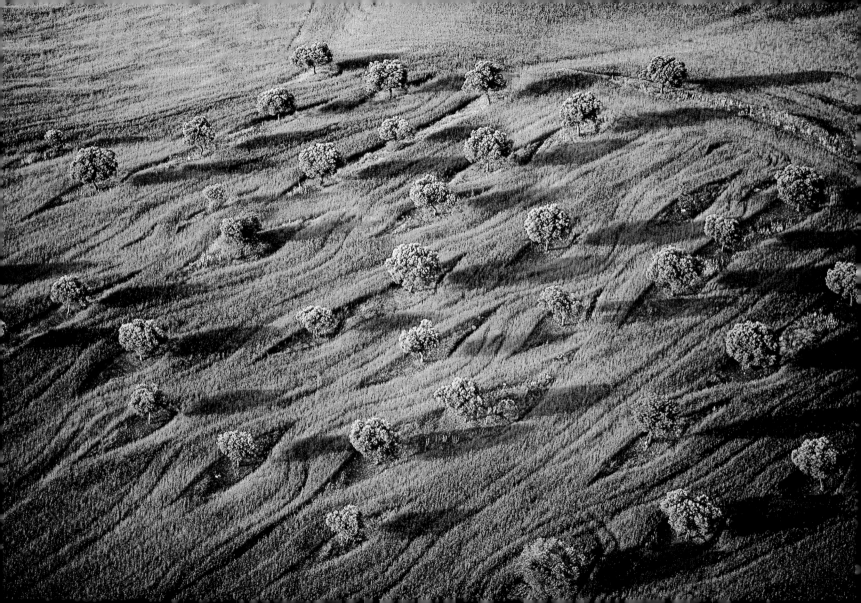

Venezuela. Barrios at Caracas.

Founded in 1567 by the conquistador Diego de Lozada, Caracas, whose name is taken from the fierce Indians, Los Caracas, who lived in the region, has seen enormous development in the last forty years. Attracting numerous South Americans, the city progressively invaded the narrow valley, before scaling the steep sides of the neighboring hills. The new districts, the *barrios* or *ranchos*, two words used to indicate the shantytowns, accommodate about one-quarter of Caracas's inhabitants in houses of bricks and mortar that are eventually fitted with electricity and running water. This fragile habitat is a real trap when tropical storms hurl down their lashing rain. The floods and mudslides of the winter of 1999 took tens of thousands of victims. The gap between rich and poor never ceases to grow in the great cities of the emerging countries, foreboding urban revolt or strict segregation. In Caracas, as in São Paulo and Bogotá, entire streets are privatized and controlled by private security guards.

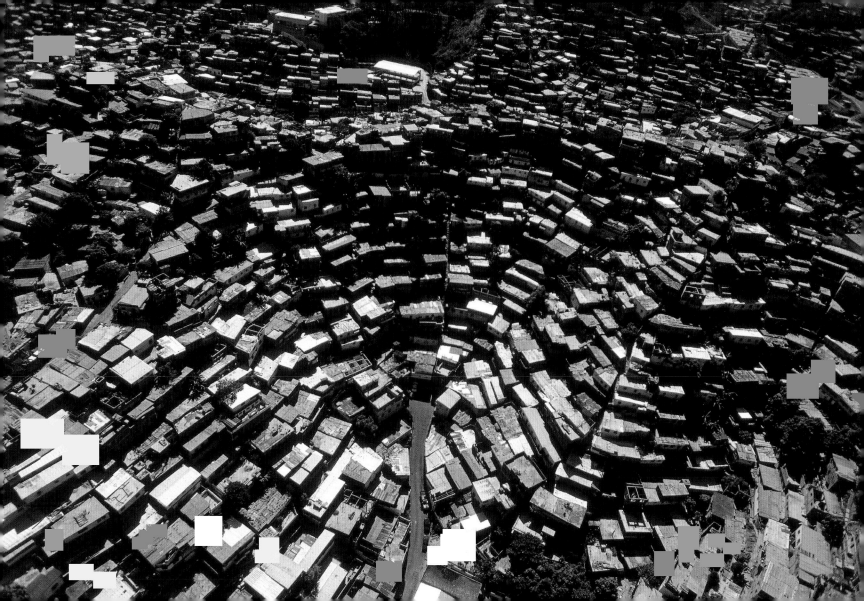

Argentina. Misiones. Confluence of the Rio Uruguay and one of its tributaries.

Much of Argentina's tropical forest has been cut down to make room for farming; in places, it no longer offers the protection against erosion that it once did. The annual rainfall of 2,000 millimeters (80 inches) scrubs the ground of the Misiones Province, washing quantities of iron-bearing soil into the Rio Uruguay, which takes on a rusty color. Swollen by its tributaries, the 1,600-kilometer (1,000-mile) river flows into the Atlantic alongside the Rio de la Plata, forming the largest estuary on Earth at 200 kilometers (125 miles) across. There the river deposits its sediment, blocking up the shipping channels into the port of Buenos Aires, which must be dredged regularly to remain navigable. Where it is allowed to build up, alluvium deposited in the mouths of rivers such as the Rio de la Plata changes the landscape, forming deltas or new areas of land.

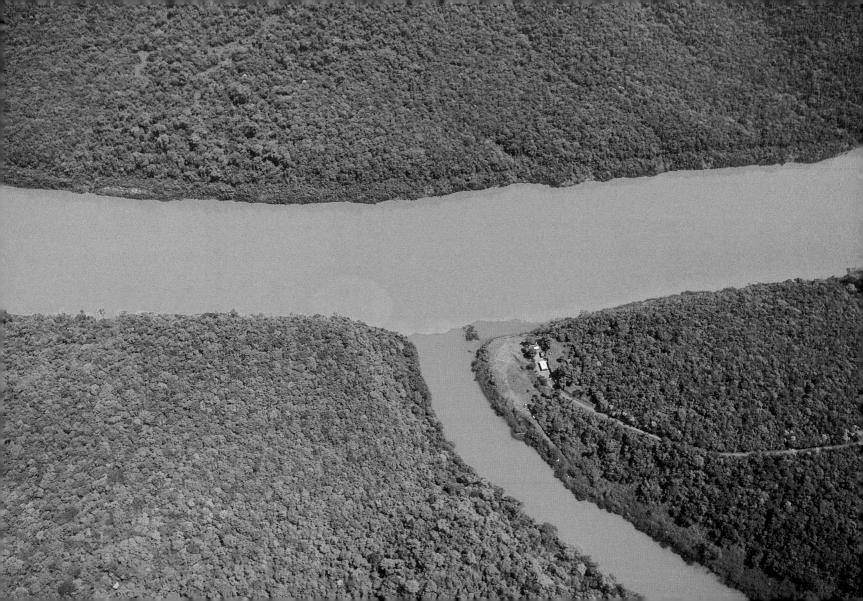

Namibia. Kaokoveld region. View of a Himbas village.

In the far north of Namibia lie the 50,000 square kilometers (20,000 square miles) of Kaokoveld, a vast territory of arid mountains crossed by unpaved roads and devoid of infrastructure. Given these geographical factors, in addition to the inhabitants' way of life, Kaokoveld illustrates what Namibia must have been like before the Europeans arrived. The population is a mere 16,000, of which half belong to the tribe of the Himbas, "those who ask for things" – in other words, beggars. The Himbas are seminomadic herders of cattle, sheep, and goats; they live in small, strictly-organized clans of about 50, in huts covered with a mixture of mud and dung, within fortified villages (*kraals*). Their lifestyle is, in fact, less ancient than one might think. It was only two centuries ago, influenced by the great Bantu stock-herders, that the Himbas, like their Dobe Kung neighbors, ceased their hunter-gatherer activities in favor of herding livestock. And since the 1980s, the development of tourism and the changes of the modern world have started to threaten their current way of life.

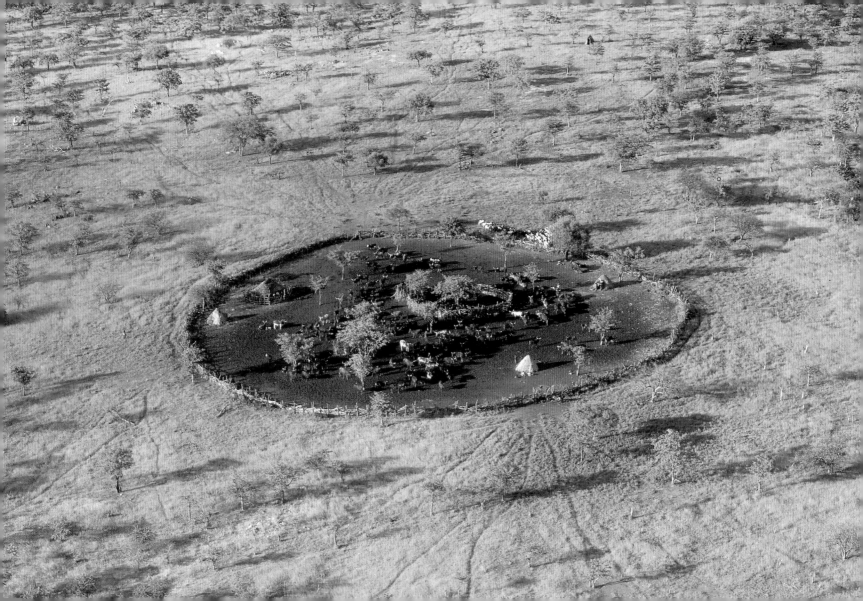

Ivory Coast. Bouna region. Deep well in a village near Doropo.

Everywhere in Africa, as here near Doropo in the north of the Ivory Coast, collecting water is a role that generally falls on women. Deep wells equipped with manual pumps are gradually replacing traditional village wells, and canaries (large earthenware jars) and gourds are being supplanted by plastic, enamelware, or aluminum containers to transport the precious resource. Drawn from underground sources, the water in these wells presents fewer health risks than traditional wells, which hold water that is, in more than 70 percent of cases, unfit for consumption. At the opening of the third millennium, three-quarters of the world's population does not have running water and about 1.6 billion does not have water fit to drink. Illnesses due to unhealthy water supplies are the largest cause of infant mortality in the developing world.

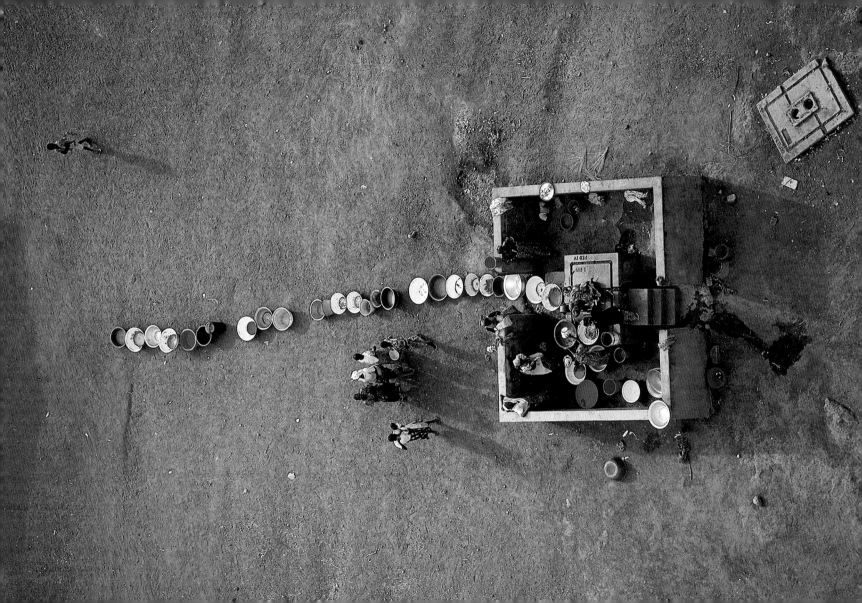

Nepal. Mount Everest.

Currently 8,850 meters (29,028 feet) above sea level, the highest peak on Earth is growing about 4 millimeters (0.16 inches) taller each year. Known in Tibetan as Chomo Lungma, "mother-goddess of the world," in Nepalese as Sagarmatha,"whose head touches the sky," and in English first prosaically baptized "Peak 15" by the British, the Himalayan peak was christened "Everest" after George Everest, the surveyor-general of India who mapped the country in 1852. The growth in popularity of Himalayan mountain climbing has transformed the lives of the Sherpas. These Mongol herdsmen, who once lived a nomadic life on the mountainsides at altitudes of 2,500 to 4,000 meters (8,000 and 13,000 feet), have been enlisted as porters and guides. In fact, the first to reach Everest's summit was the Sherpa Tenzing Norgay, who guided Edmund Hillary's expedition in 1953. High-altitude tourism has also caused a proliferation of garbage and other waste, which litters these marvelous landscapes, threatening their fragile ecology. Like other forms of tourism, mountaineering has had significant effects on both the environment and the lifestyle of the local people.

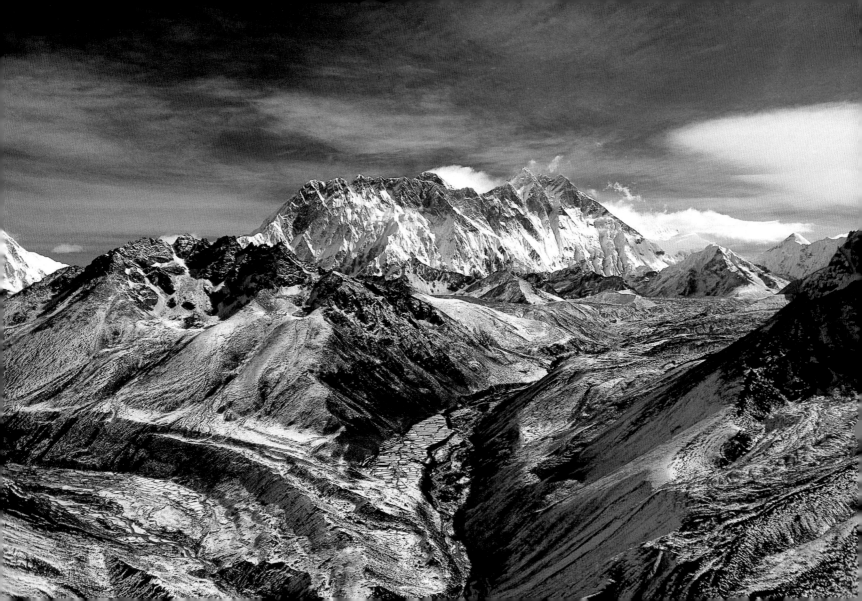

Tunisia. Governorate of Tataouine. Valley of the Ksour, between Matmata and Tataouine.

In order to flee the invasions of Bedouin Hilalians from Libya in the eleventh century, the Berber populations in the south of Gafsa left the plains and took to the rocky peaks, where they constructed fortified, virtually inaccessible villages called *kalaa*. At Guermessa, perched more than 300 meters (985 feet) up, as in other *kalaa* such as Chenini and Douiret, one finds *ksour*, fortified houses and granaries. Nowadays southern Tunisia is a cul-de-sac, but in the past it was a real corridor for invaders: Phoenicians, Carthaginians, and Romans to begin with; Muslims led by Uqba ibn Nafi in 670 and Ibn al-Numan in 700; Fatimide armies from Kabylia coming the other way in 910; and the Berber irredentism of the Kharidjites adding to the confusion. Calm returned with the Hafside Kingdom, followed by the Ottoman conquest. The Berbers came down from their mountain hideouts and settled in caves in the mountainsides, where their descendants have lived up to modern times. Today, many are leaving the countryside for the cities of Sfax, Gabès, and Tunis.

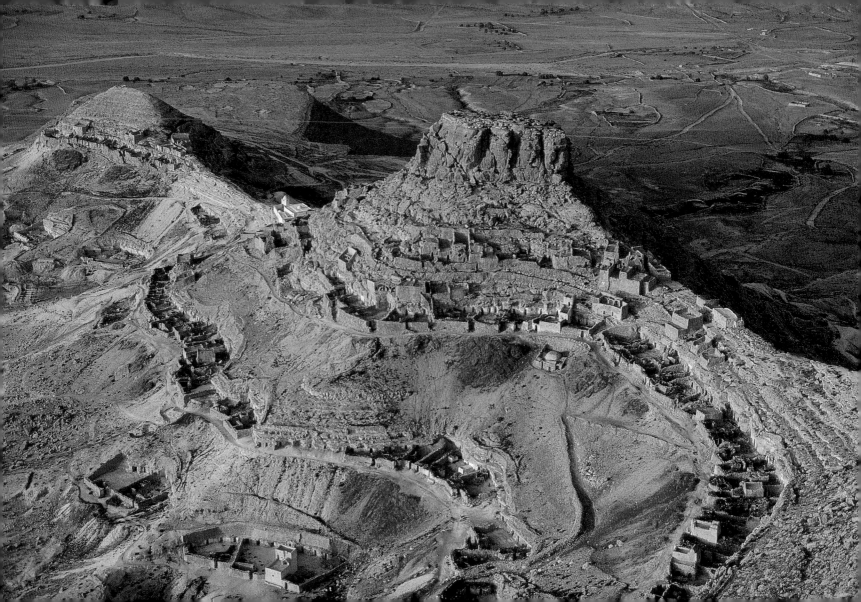

Greece. Ionian Islands. A boat beached on the north of the isle of Zakynthos.

Sixteen kilometers (10 miles) off the Peloponnese coast lies Zakynthos (also known as Zante), the southernmost and second largest of the Ionian Islands, which owes its name to the abundant wild hyacinths growing there. Part of the island has imposing calcareous cliffs veined with white gypsum; the cliffs are continuously worn away by wave erosion and earthquakes (the most powerful in recent times occurred in 1953) forming beaches of fine sand below. Here the loggerhead sea turtles *Caretta caretta* lay their eggs. Currently, these animals are threatened by boat propellers, pollution, urbanization of the coastline, and tourists. The numbers of turtles coming to breed on Zakynthos have diminished from almost 2,000 individuals at the end of the 1980s to fewer than 1,000 at the end of the 1990s.

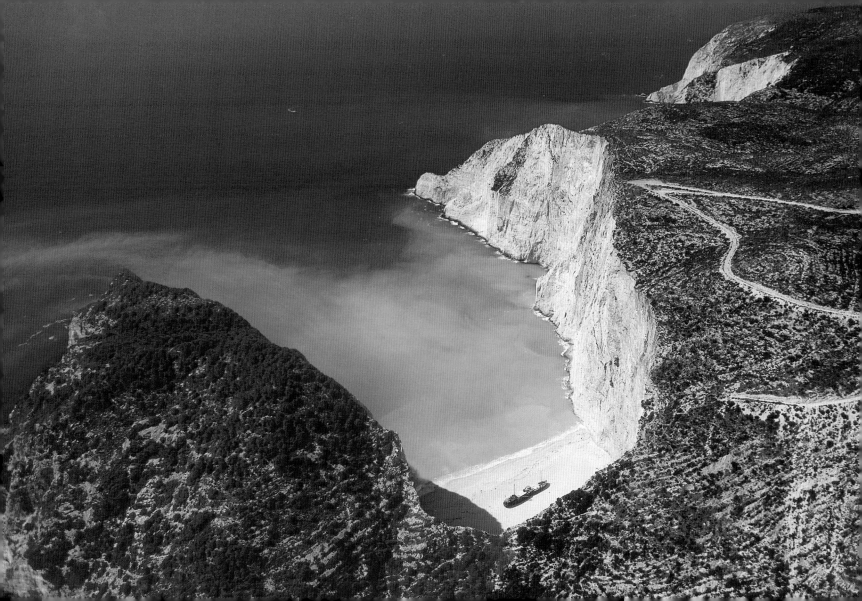

Peru. Fields on the Anta Plateau, east of Cuzco.

The region of Cuzco, 3,600 meters (12,000 feet) up, in the middle of the Andes Mountains, lies in the heart of the former Inca lands. On its cold soils in the valleys, grains such as wheat and barley, fruit trees, and even alfalfa are cultivated. The Inca regime was particularly authoritarian, but was therefore able to be equitable in its distribution of land. To this end, it conducted statistical inquiries using *quipos*, thin ropes with knots tied in such a way as to describe the possessions and composition of the peasant households. The pattern of fields of the high Peruvian plateaus retains the memory of this peasant equality, which contrasts with the extraordinary inequality between great estate-holders and poor agricultural laborers. Introduced by the Spanish conquerors, it is an inequality seen today between the shantytowns and districts of luxury villas in the great cities of Peru.

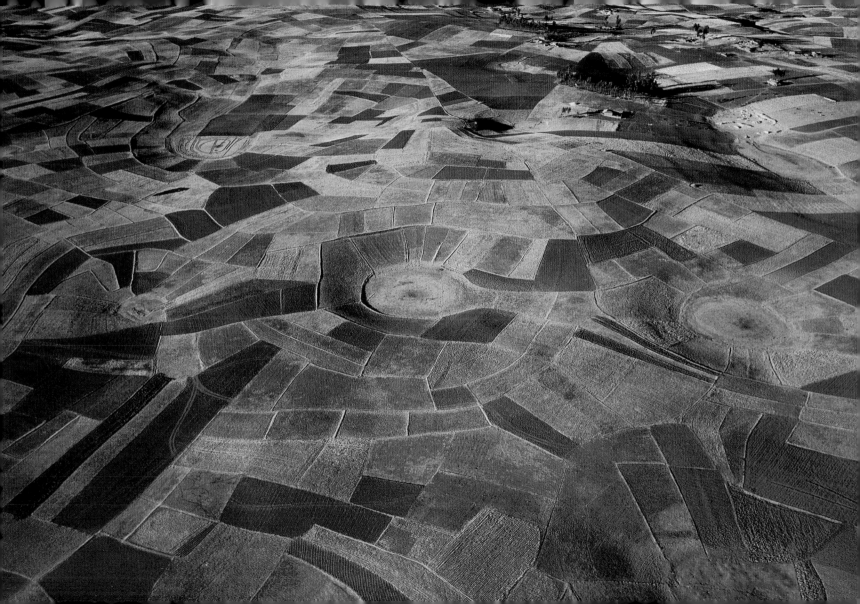

Indonesia. Bali. Islet among the rice terraces.

Organized into agricultural cooperatives (*subaks*), the people of Bali have exploited their island's volcanic relief and approximately 150 watercourses with a vast system of irrigation that enables them to grow rice. The water retained in the hills is guided into the terraced fields by a network of channels that run according to the contours. Indonesian farmers regard rice as a gift from the gods, warranting considerable religious rituals. At every stage of the harvest, offerings are set out in temples built within the rice fields in honor of Dewi Sri, the goddess of rice. The introduction of a new fast-growing variety in 1976 has led to three rather than two harvests per year, and Indonesia is now the world's third largest producer – 51 million tonnes (56 million tons) in 1997, or 20 percent of world production – after China and India.

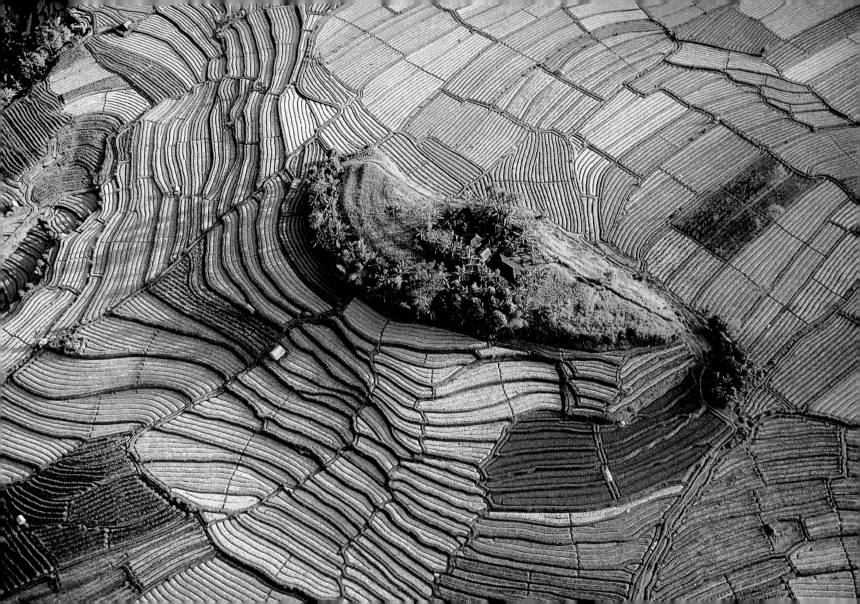

Kenya. Masai Mara Reserve. Masai cows. The dried-up Lake Amboseli.

At the end of the nineteenth century, after bovine plagues, periods of drought, and fratricidal warfare, the Masai, a tribe of herders then still 250,000 strong, negotiated to continue their activities on their ancestral lands, the Mara, which means "multicolored." They still rear cattle, which is important primarily for ritual use and for its precious milk which is the essential base of Masai nutrition. They also have flocks of sheep and goats, whose meat they prefer over that of cows. Though deprived of some of their territory, the Masai still take their flocks over long distances. One of their areas is the northern region of Lake Amboseli, dry eleven months of the year, a place of dust storms and mirages. Salty dust from the dry lake bed blows around, seriously damaging nearby soils. Tourists who show little respect for the environment in their off-road minibuses make the situation worse. Yet tourists may be the park's only chance of survival – if the financial manna they provide can be used wisely.

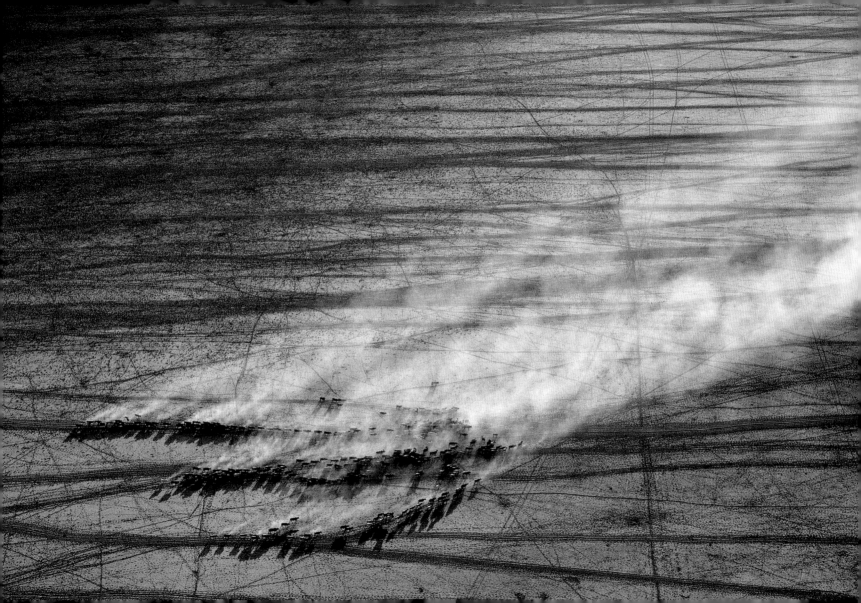

Brazil. Pará State. Shantytown at Belém.

Shantytowns appeared in Rio de Janeiro at the beginning of the twentieth century, when soldiers, released after quelling a rebellion in the northeast, settled in encampments on a hillside near the center of the town, which they named after their garrison at Bahia. This precarious form of housing spread quickly to other cities around the entire continent. At Belém, capital of the state of Pará and the main river port of the Amazon, more than half of the two million inhabitants are heaped together in shantytowns known here as *baïxadas*. The Brazilian shantytowns, like those of other large cities in the developing world, consist of precarious dwellings made out of recycled materials (wood, metal sheeting, plastic, cardboard, and the like), yet these towns are not as lacking in structure as might appear at first sight. They contain streets of shops, private lots, and localities of craftsmen. Frequently, they are planned by associations along with a clerical sympathizer with liberation theology. Shantytowns have been said to be towns like any other, except on a reduced scale, with ceiling heights, room size, wall thickness, and road widths half the normal. Life, too, is shorter here.

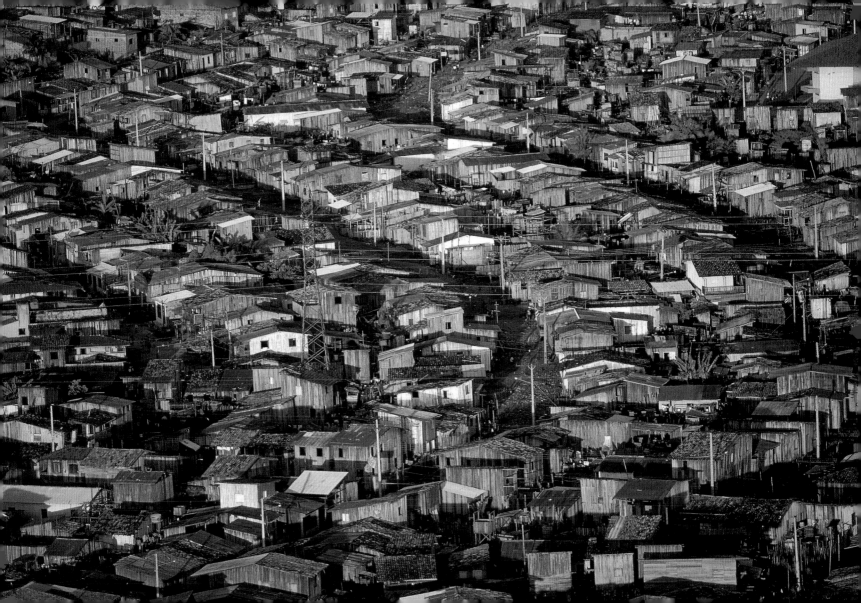

Venezuela. Islet in the reservoir in Guri.

The second largest hydroelectric dam in the world is Guri in the southeastern Venezuelan state of Bolivar. Its construction began in 1965 on the Caroní River, and it has created a huge artificial reservoir of about 18 million cubic meters (4.75 billion gallons) with a surface area of more than 4,000 square kilometers (1,500 square miles). With a production of 10 million kilowatt-hours, satisfying three-quarters of the country's needs and able to supply neighboring countries such as Brazil and Colombia, Guri is one of the most important hydroelectric plants in the world. Like wind and sun, rivers produce energy without creating greenhouse gases. Though dams are often criticized for ruining the landscape, they can, as here, create splendid lakes full of fish. Lake Guri contains the two tastiest species of freshwater fish in Venezuela. Nevertheless, one can imagine water wars resulting from the exploitation of great rivers for energy production – between Egypt and the Sudan concerning the Nile, between Israel and Jordan regarding the Jordan, and among Turkey, Syria, and Iraq over the Tigris and Euphrates.

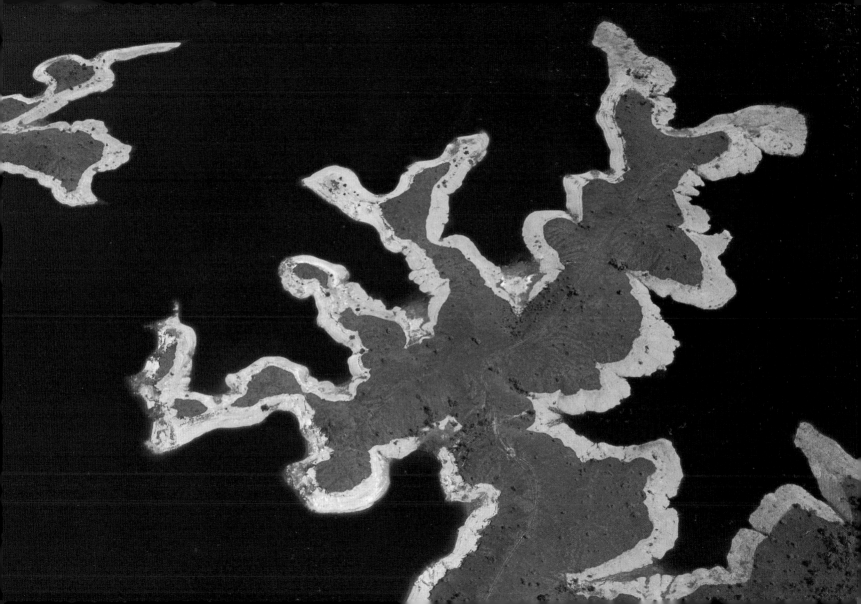

Bangladesh. Flooded houses south of Dacca.

Traversed by a vast network of 300 rivers, including the Ganges, the Brahmaputra, and the Meghna, which rush down from the slopes of the Himalayas on their way to the Bay of Bengal, Bangladesh is a deltaic plain subject to summer monsoon rains. From June to September, the volume of the rivers can increase as much as 50,000 cubic meters (13 million gallons) per second; the rivers burst their banks and flood almost half the territory, creating ruin wherever they go. Some people live on *chars* in the rivers, small transitory islands made of sand and silt accumulated by the currents; these, however, are regularly razed and carried away by the waters. Each year, 1,000 to 2,000 people die in the floods and almost one-quarter of the 123 million people of Bangladesh are made homeless. On the other hand, it is these annual floods that provide the nutrients that make the flood plains so fertile, supporting a country that is 80 percent rural. Bangladesh is one of the most densely populated in the world, with nearly 850 people per square kilometer (2,200 per square mile). It is also one of the poorest, with a per capita income of only $260 per year.

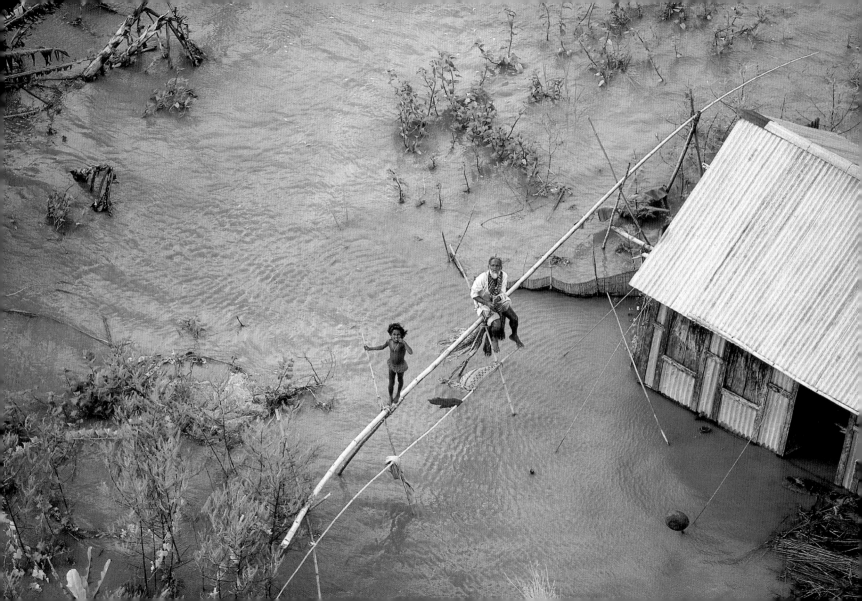

Kenya. Lake Nakuru. Flamingoes.

There are some three million flamingoes in Kenya, which move among the country's five salt lakes: Magadi, Elmenteita, Turkana, Bogoria, and Nakuru. During the rainy season, the flora and fauna in the lake proliferate, attracting the flamingoes, which make it their main food. Dwarf flamingoes are able to filter particles measuring no more than several tens of microns (one-thousandth of an inch or so), using the fine silk that covers the inside of their beaks; unable to sieve microscopic organisms, pink flamingoes feed instead on small crustaceans. The ancient Greeks referred to them poetically as "birds with wings of flame," and it is now known that the color of flamingoes' wings primarily comes from pigments in the food they eat. At Lake Nakuru, small tilapia fish have been introduced, attracting pelicans alongside the flamingoes, which are gregarious but not exclusive.

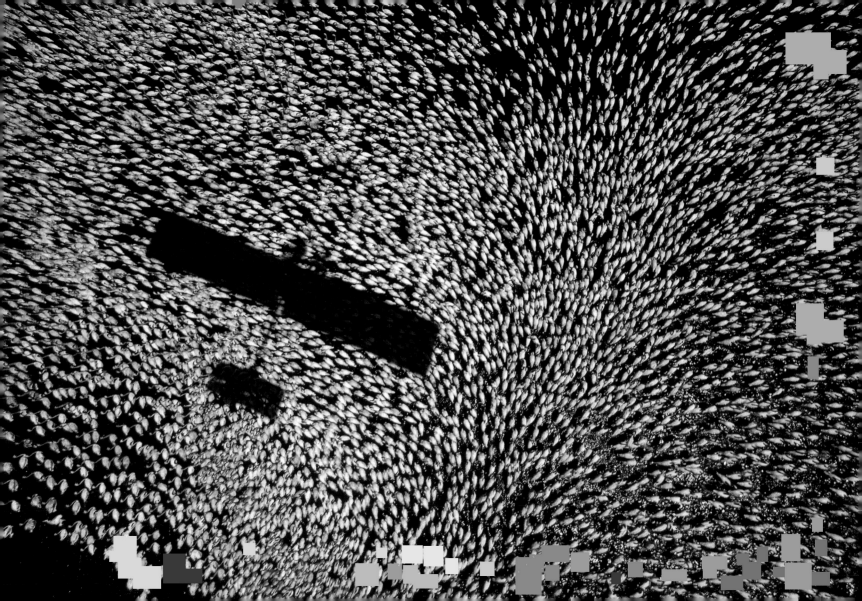

Morocco. Agricultural landscape between the Rabat and Al Massira Dams.

In its concern to improve agricultural yields, Morocco is encouraging the development of a modern agriculture over vast areas, based on intensive production of grains such as wheat, barley, and maize. As many parts of the country do not have sufficient rainfall, irrigation is often necessary. Richer in watercourses than other countries in the Maghreb, Morocco long ago began building large dams that made it possible to water significant areas of farmland – up to 1,000 square kilometers (385 square miles). Almost 800,000 hectares (2 million acres), 11 percent of the country, are now irrigated. The construction of new dams, like that of Mjaàra, the largest in the country, should make it possible to increase this amount even further.

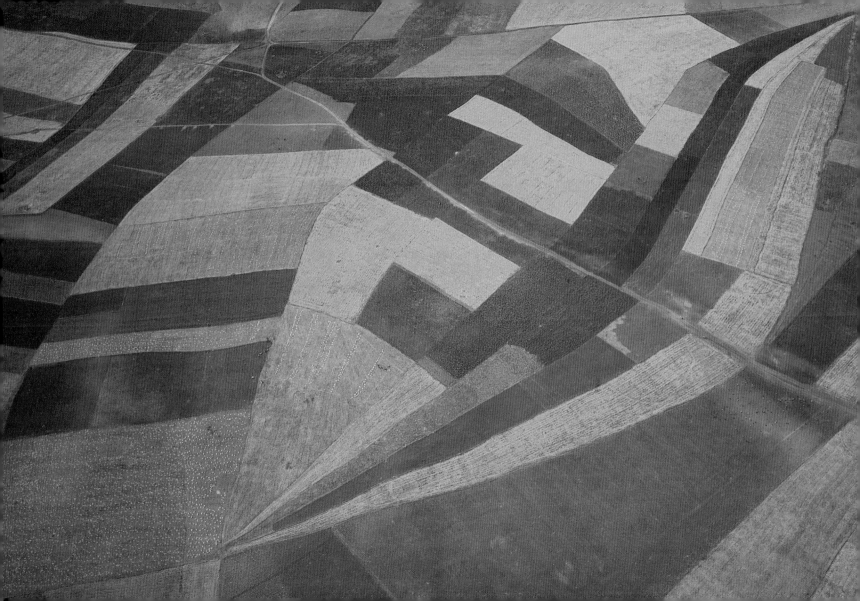

Mali. Village near Kidal.

When the French explorer René Caillié finally reached Tombouctou (Timbuktu) in the 1820s, sick and exhausted from a terrible journey, he was disappointed. There he found just a "pile of badly built houses, where a great silence reigned." He might have said the same of Kidal, a nearby settlement inhabited by Tuaregs (300,000 of whom live in Mali) and by Songhais. But we must take into account the harsh climate, with summer daytime temperatures that reach 43°C (109°F) and freezing winter nights; nor must we forget the violent *harmattan*, the desert wind. The enclosed brick houses with their roof openings provide shelter from the weather, and roof terraces can be used for storage, as the rains last only a few weeks. The settlement's layout with its irregular, narrow lanes also provided protection from the many invaders who passed by Kidal. Indeed, the layout is similar to that of the *ksour* of southern Tunisia. This is actually no coincidence: in order to control the salt trade, the Berbers from the northern Sahara dominated this region south of the Adrar des Iforhas more than once.

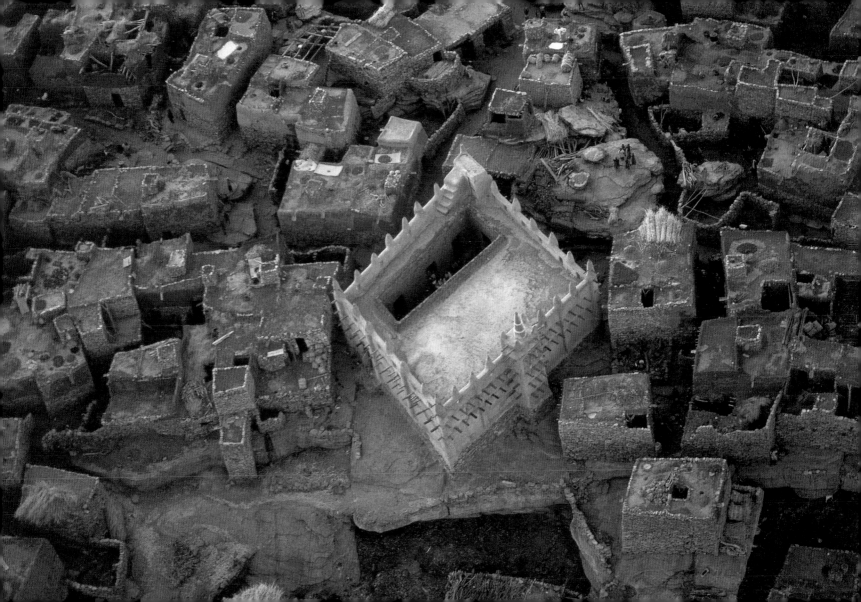

Bolivia. Salar de Uyuni.

At an altitude of 3,800 meters (12,500 feet), the central Andean Altiplano extends 1,500 kilometers (950 miles) from Lake Titicaca south to the Salar de Maricunca in Chile. In the middle lies the white plain of the Salar de Uyuni, the largest *playa* (beach) in the world, covering 12,000 square kilometers (4,600 square miles). This dry lake bed consists of a thick sequence of evaporites, layers of minerals deposited from successive inundation and evaporation of the area. A closed basin for at least the past 10,000 years, the lake is now fed by only one major river, the Rio Grande de Lipez. Halite (comon table salt) dominates the surface layer and is exploited on a small scale, but the deeper layers are rich in potassium, lithium, and boron salts, which could make Bolivia a rich producer of raw materials. The country is, however, wary of riches of this sort, as they have left more people poor than rich. Bolivia's export trade was long dependent on the tin mines of the Patino family. Their nationalizations and denationalizations provided a rhythm to Bolivian political life with its successive pro- and anti-American coups d'état. The result today is not wonderful. Bolivia is the poorest and least literate country in South America.

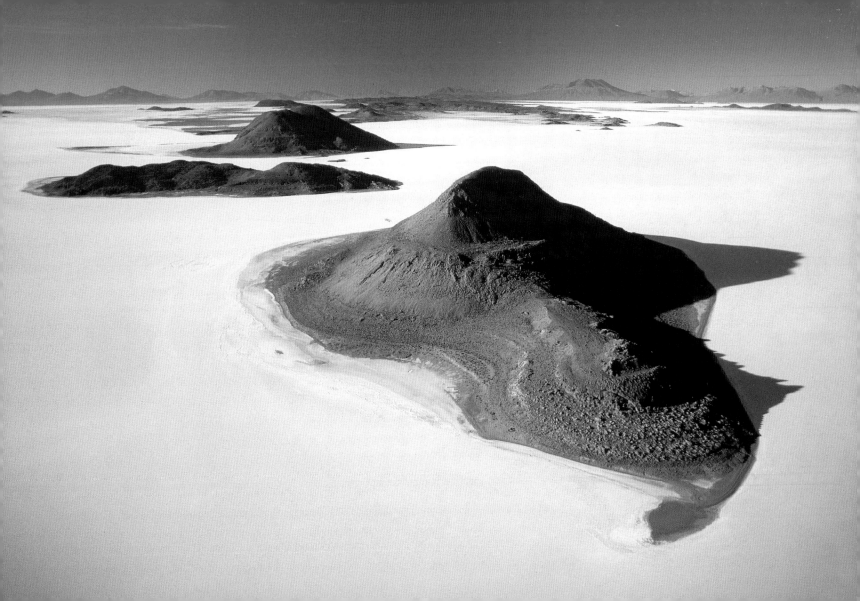

Australia. West Kimberley. Buccaneer Archipelago.

Off the jagged and eroded coast of northwestern Australia are thousands of small islands that have remained wild, like those of the Buccaneer Archipelago. As the shore line has little in the way of agricultural or industrial activity, the water of the Timor Sea surrounding the islands is relatively free of pollution, allowing fragile species like the oyster *Pinctada maxima* to develop in prime conditions. Set apart within their natural environment on the seabed, these mollusks are exploited for the production of cultured pearls. Australian pearls represent 70 percent of South Seas production, and with an average diameter of 12 millimeters (half an inch), they are twice as big as Japanese pearls. Even though Japan pioneered the activity in the early twentieth century and is the foremost producer, Australian pearls, according to the experts, are more beautiful.

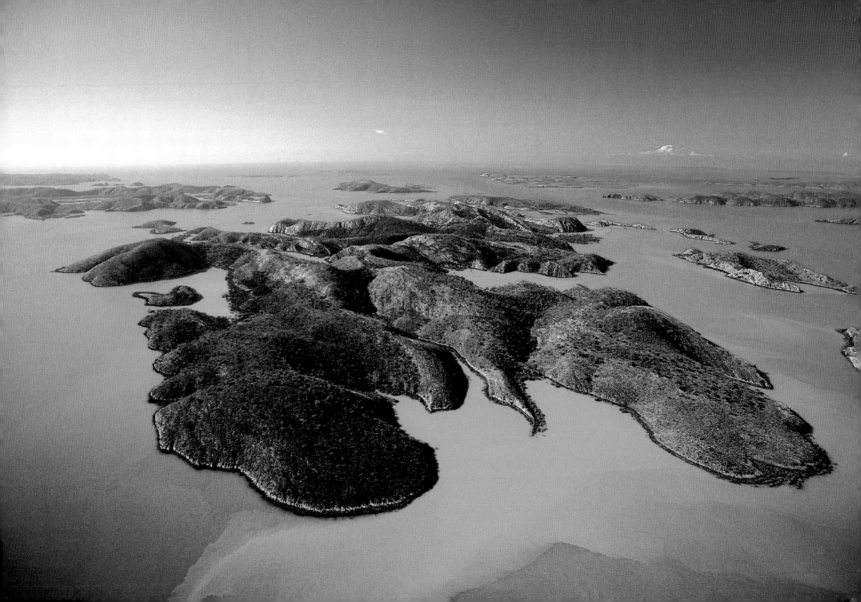

Oman. Agriculture in the Djebel Akhdar.

It is not enough to describe the Sultanate of Oman in terms of its insular character, bordered though it is on three sides by the sea and on the fourth by the desert. Oman is not just a maritime facade with its 1,700 kilometers (1,000 miles) of coastline, or an immense desert even though desert accounts for two-thirds of the country. What really defines the landscape are the massifs, including the Al Hajar Range in the north, where the Djebel Akhdar Massif reaches 3,000 meters (10,000 feet), and the Dhofar Massif in the south. They play an essential role in the life of the people who have settled on the plateaus, in the gorges, and on the valley floors. For more than two thousand years an agriculture based on a complex system of water distribution and irrigation by canals, named *falaj*, has enabled them to grow dates and lemons, and to continue to live in these apparently inhospitable mountainous regions. Thanks to the falaj, Oman has a considerable agricultural potential that distinguishes it from its Gulf neighbors.

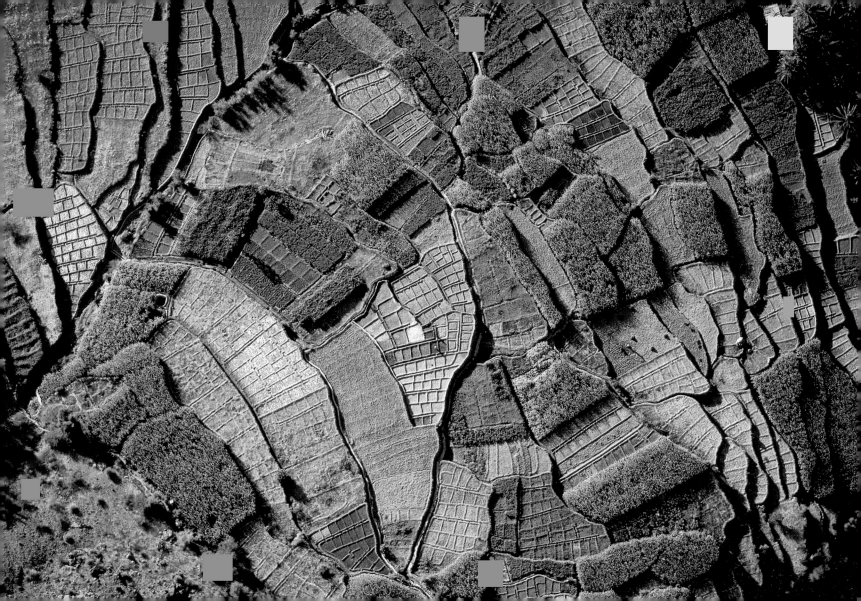

India. Uttar Pradesh. Brickworks east of Agra.

Numerous brickworks have developed on the outskirts of Agra, a city of 1.2 million people in Uttar Pradesh, a state accommodating one-sixth of India's population. These small firms provide work in a region which, like the rest of India, is greatly afflicted by unemployment and under-employment. In 1996, India ranked 129th in the world for per capita GNP (including allowances made for the cost of living). The production of these terra cotta bricks is intended for urban centers, as rural areas generally make do with *pisé* (packed clayey earth), a less expensive though less resistant material. The significant urban growth of the Agra metropolitan area, which has seen its population increase by half in twenty years, bodes well for businesses supplying building materials to the region.

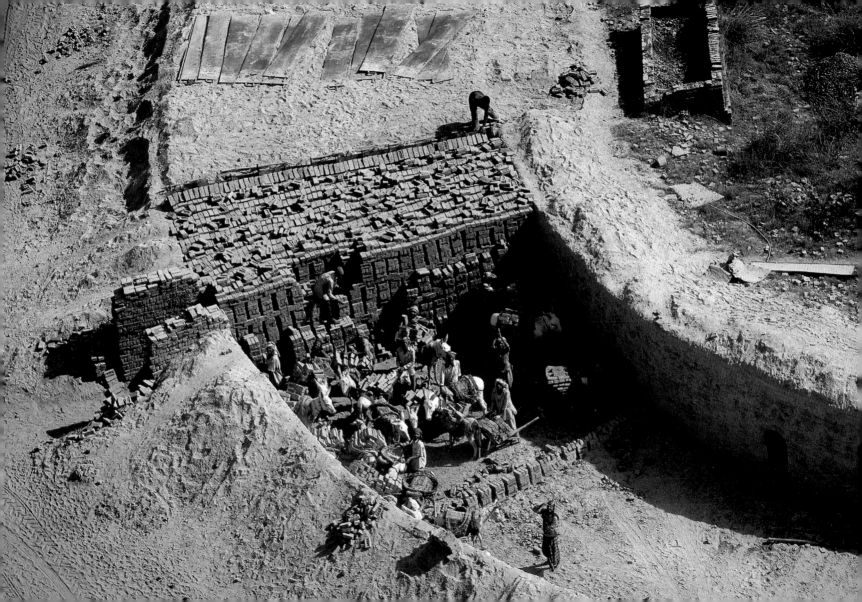

Bahamas. Exuma Keys. Islet and seabed.

The Bahamas is an archipelago of more than 700 islands (of which only 29 are permanently inhabited) and some 2,400 rocky islets surrounded by coral reefs known as "keys." The archipelago extends almost 1,200 kilometers (750 miles) along the Florida and Haitian coasts and covers 280,000 square kilometers (110,000 square miles). Because the islands are generally flat and surrounded by a shallow sea, one of Christopher Columbus's men called them "baja mar" in Spanish, which means "shallow waters," a description that the English corrupted into "Bahamas." Occupied by the English in the seventeenth century, the Bahamas gained independence in 1964. The archipelago is divided into several groups. One of these, the Exumas, is a string of islets scattered over 160 kilometers (100 miles), southeast of the capital, Nassau. The few that are inhabited accommodate tourists. The islands also serve as reservations for protected species of birds (at Salt Key), sea riches in the form of fish shoals, and marine caves whose water's deep blue color contrasts with the dominant blue-green of the surrounding sea.

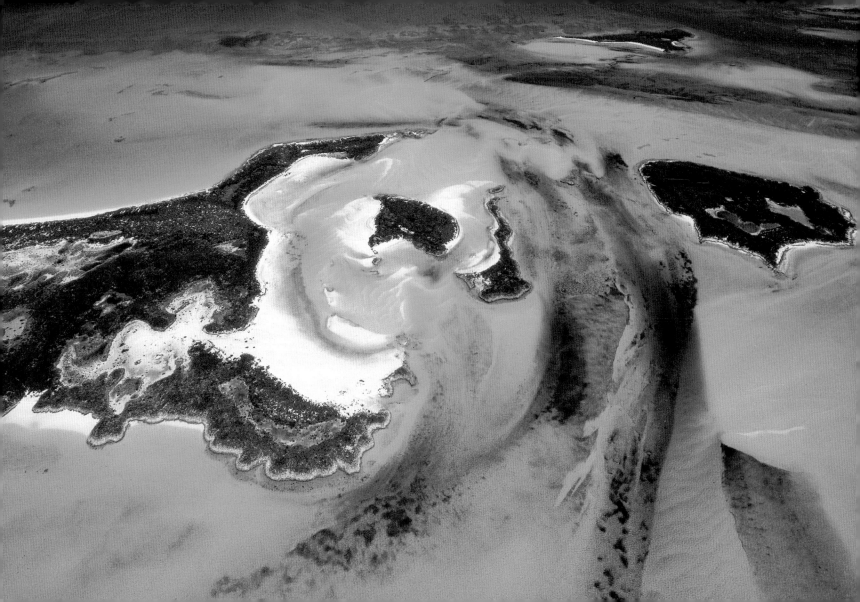

England. Dorset. The Giant of Cerne Abbas.

This 55-meter (180-foot) giant armed with a heavy bludgeon looks very modern, with his round eyes, eyebrows, mouth and no nose, well-aligned fingers, delineated nipples and ribs, penile cover secured with string, and well-formed calves. It could be a hermaphrodite with an erection. The image was first publicized in 1764 and maliciously attributed to papists. Other interpretations see him as a fertility god from before the beginning of the first millennium or as a half-Roman, half-Celtic Hercules from two thousand years ago. The design certainly testifies to the desire to depict a warrior. It is equally an invitation addressed to outside forces, and accords with a mental outlook that continues to reside in the minds of many human beings.

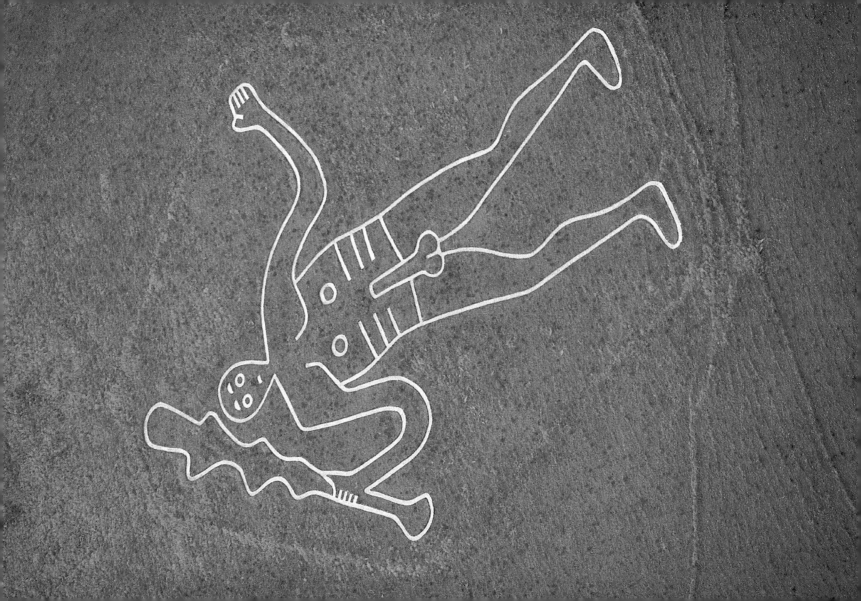

Thailand. Working in the fields between Chiang Mai and Chiang Rai.

Rice plantations, which dominate the landscape as far as the valleys of the north, around the cities of Chiang Mai and Chiang Rai, occupy almost 15 percent of Thailand. Generally harvested by traditional methods on small family units, the crop is beaten manually in the middle of the fields before being taken to the villages, where it is stocked and then sold. Although Thailand ranks only seventh in the world for rice production, in rice exports it is the leader, selling some 5 million tonnes (5½ million tons) abroad, one-quarter of its annual production. With almost 120,000 varieties, rice is consumed all over the world. Though traditionally associated with Asia, it is an equally vital basic foodstuff in many emerging countries.

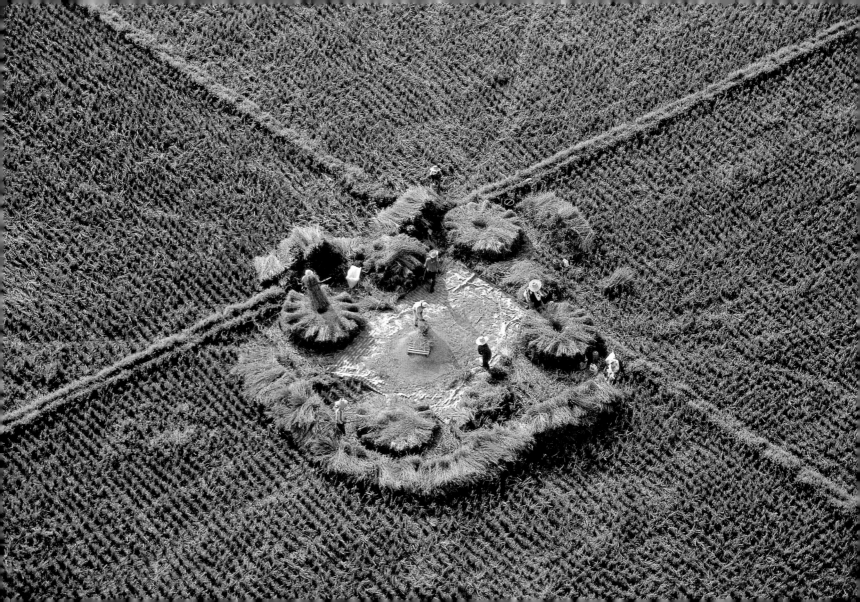

Japan. Kyoto. The Golden Pavilion.

Kyoto simply means, "the capital." For over one thousand years, between 794 and 1868, the city was the residence of the all-powerful shogun, a kind of prime minister or major domo. In 1397, the shogun Ashikaga Yoshimitsu had the Kinkaku-Ji, or Golden Pavilion, built for meditation, and after his death it became one of the most famous Buddhist temples in Japan. The great writer Yukio Mishima said of it, "There is nothing in the world to equal the Golden Pavilion in beauty." It did, however, fail to impress some, and in 1950 a disturbed monk set fire to the pavilion, destroying it completely. Rebuilt identically five years later, it glows again resplendent in all its glory, without troubling the Japanese, who do indeed from time to time reconstruct their temples, considering the ancient and antique to be synonymous with dilapidated. Around this tiny island of peace is the modern city of Kyoto, with its 1.5 million inhabitants. With Osaka and Kobe it is one of the capitals of Kansai, a megalopolis of 35 million people. The separation between immense megalopolises and almost empty natural sanctuaries is likely to be accentuated in the twenty-first century.

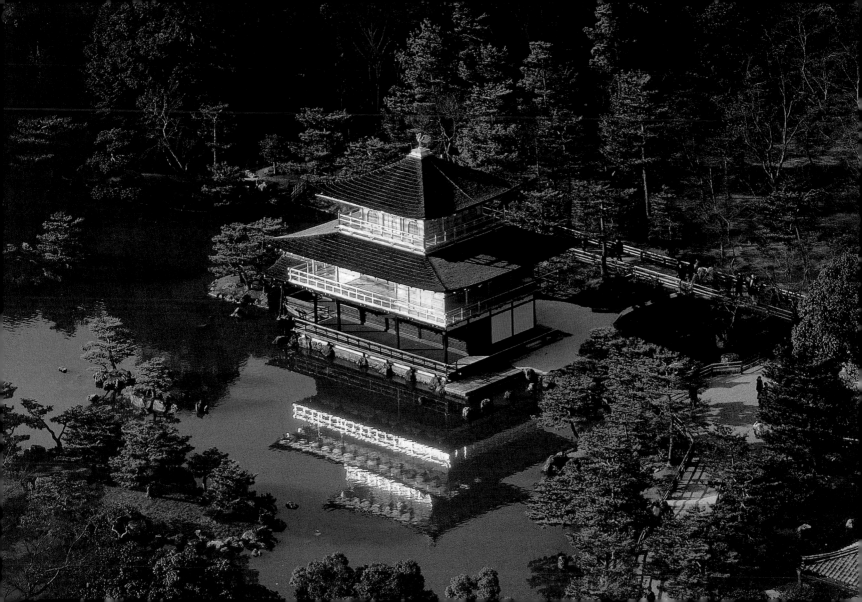

Australia. Northern Territory. Gosses Bluff impact crater.

About 142 million years ago, a meteorite collided with the Earth and exploded, laying waste to more than 400 square kilometers (150 square miles) in what is now Australia's Northern Territory. What remains today is Gosses Bluff, or by its Aboriginal name, Tnorala. A ring of hills 5 kilometers (3 miles) wide and 150 meters (500 feet) high, it is the remnant of the central uplift of a complex impact crater. Now eroded, the original crater was about 22 kilometers (14 miles) in diameter and perhaps 1,500 meters (950 feet) deep. Small meteorite falls are frequent phenomena, and thousands occur every year. Generally less than a meter across, they do not cause much damage. In fact, most debris from outer space burns up in the Earth's atmosphere and never makes it to the surface. Altogether rarer and more problematic are the impacts of meteorites of more than 10 meters (35 feet) across. These can cause serious damage. One of the most recent occurred in Madagascar in 1977: the ground was marked by two craters, one of which was more than 40 meters (130 feet) across.

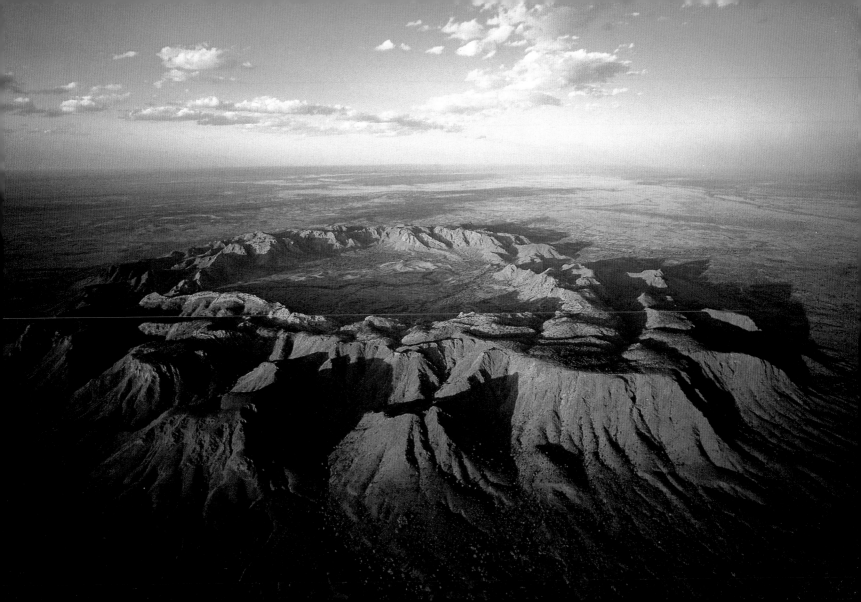

United States. Montana. Tractor in a field near Bozeman.

Montana has a surface area of 380,000 square kilometers (145,000 square miles) and a population of fewer than one million. The state, nicknamed "Big Sky Country," with its landscape of canyons, mountain ranges, and impenetrable forests, remains partially unexplored, and its few towns are scattered over vast distances. Like Bozeman, named after a gold prospector, most of Montana's towns were founded in the nineteenth century by prospectors seeking gold, silver, or copper. It is hard to conceive of overpopulation in these immense empty or virgin spaces. Yet it is the rest of the crowded world that requires the vigorous agriculture of the plains of Montana. Modern and mechanized, it produces amazing yields in crops intended in great part for the world market, the United States being the largest exporter of agricultural produce in the world. To a large extent, the fluctuations of the world food market mirror the fluctuations in American agricultural policy.

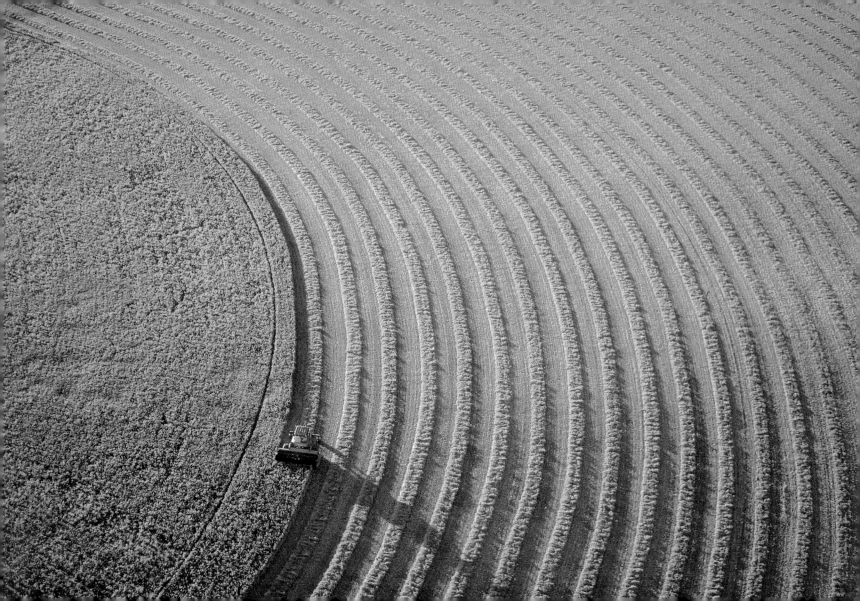

Tunisia. Governorate of Zaghouan. New olive-tree plantations.

The levees created to contain run-off water and limit soil erosion highlight the relief like contours on a map. The plantations of olive trees are on plowable land, often on the fringes of hilly ground as here at the foot of the Djebel Zaghouan, 1,295 meters (4,250 feet) high, in northeastern Tunisia. Suited to the climate, olive trees have been grown in the Mediterranean since antiquity and are of great economic importance. The fruits are edible and the oil is known for its dietary and medicinal virtues; annual world consumption of olive oil exceeds 2 million tonnes (2.2 million tons). Olive branches are also used as fodder for sheep and goats. Tunisia, which produces half a million tonnes (550,000 tons) of olives per year (1997), ranks fifth in the world after Spain, Italy, Greece, and Turkey, but second in terms of exported volume (198,000 tonnes [218,000 tons]), behind Spain.

Senegal. Fish market at Saint-Louis.

In the Senegalese economy, fish holds second place in exportable riches, after ground nuts, and is an essential element in the national diet. Although certain coastal zones are heavily involved in commercial fishing, others remain little exploited save that for local consumption. Fishing with canoes still predominates, being well suited to the material and human context, low-cost in terms of equipment and operating expenses, and extraordinarily adaptable. But there is competition today from industrial fishing. The victims of the race for productivity between the two methods are the fish, whose numbers off the coast of Senegal are quickly diminishing. In certain areas, fishermen have resorted to radical methods such as throwing sticks of dynamite into shoals of fish and harvesting the dead that float to the surface. Far from encouraging restrictions, the increasing rarity of products often leads to a catastrophic acceleration in exploitation.

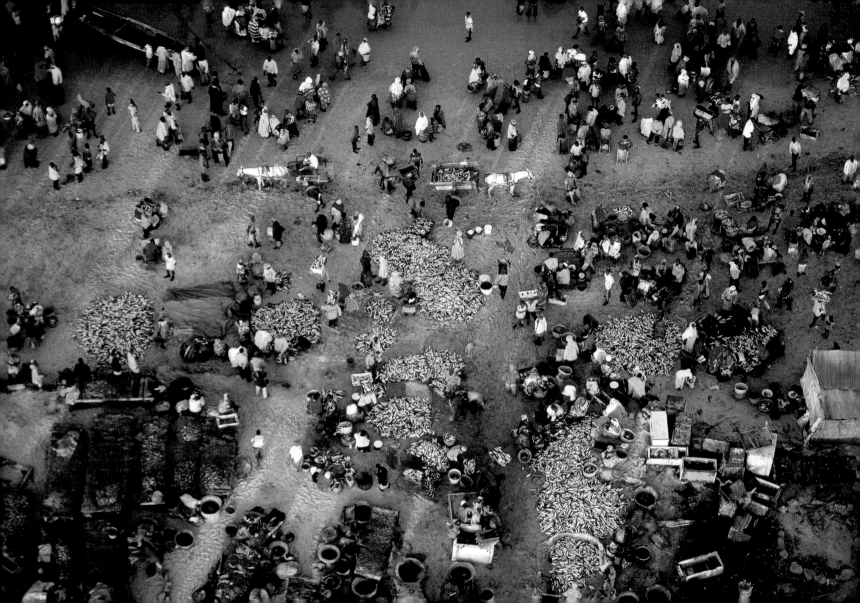

Philippines. Islands of the Samales group.

In the southern Philippines, notably in the Sulu Archipelago, which includes the Samales group of islands, live the Badjaos, popularly known as "gypsies of the sea." While some live permanently on their boats, which are real floating homes, others inhabit isolated villages built on stilts over the water, as here where they have carved a channel in the coral reef in order to reach the open sea in their craft. They make their living from harvesting shellfish and pearl oysters extracted during breathless dives to depths of more than 80 meters (250 feet); they also practice fishing and maritime trades. The 30,000 Badjaos belong to a Muslim minority of the Philippines, the Moros, who represent only four percent of the population and are concentrated in the south.

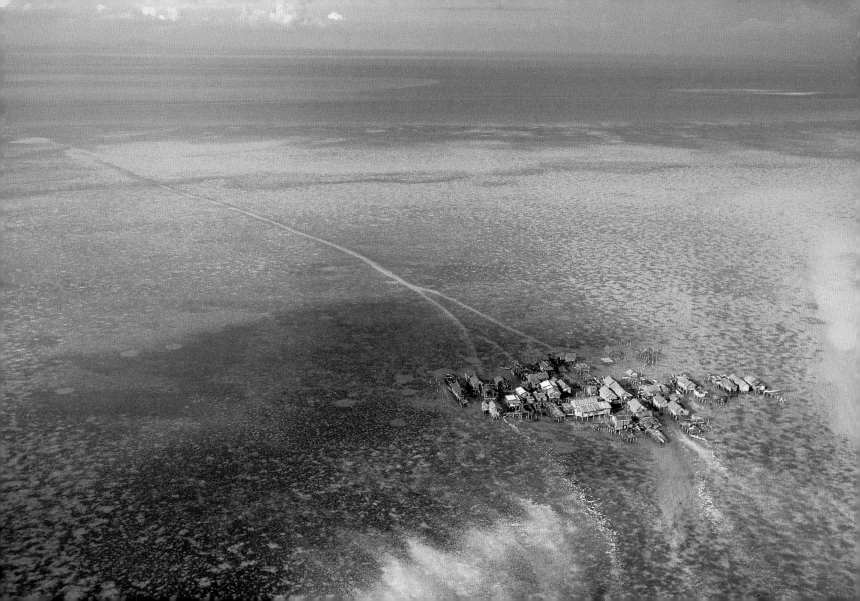

France. Indre-et-Loire Department. Gardens of the Château de Villandry.

The Château de Villandry was built in 1532, at the end of the Loire Valley's great period of artistic and architectural expression. Restored at the beginning of the twentieth century by Joachim Carvallo, the gardens surrounding the château are a unique example of a painstaking and documented restoration of an ornamental French-style garden of the Renaissance. In sixteenth-century Europe, garden design belonged to the Fine Arts. Inspired by both the monasteries' tradition of enclosed vegetable gardens and the Italians' love of clipped thickets, Villandry is a perfect illustration of the poet Jacques Delille's definition: "To my eyes a garden is a vast painting." Set out in symmetrical patterns, mixing architecture with domestic vegetation, the plants here are like decorative accessories. Every era stages its conception of nature. In the age of Louis XIV, it was embroidered flower beds and exotic plants placed in orangeries. In the Age of Enlightenment, it was factories and romantic ruins. Today, wild nature is taking center stage with the "nomadic garden."

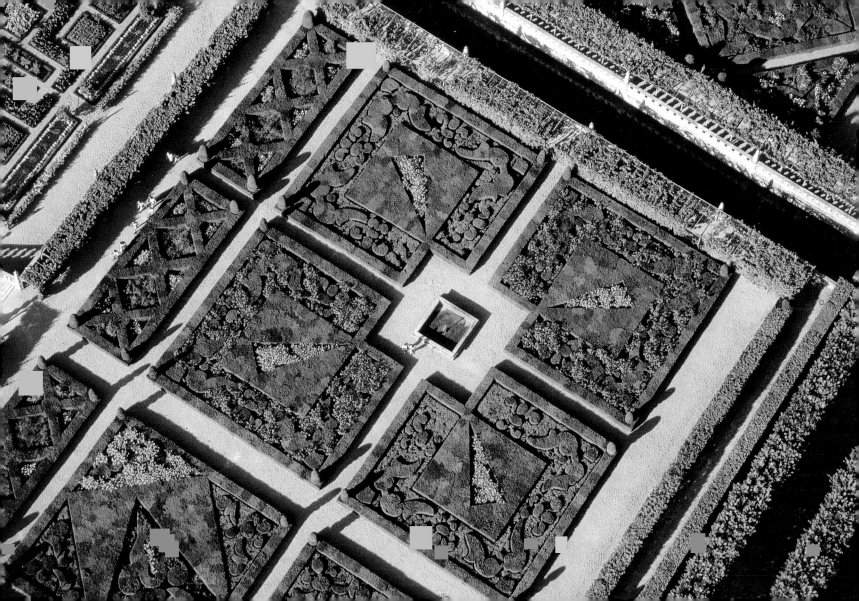

Morocco. Working in the fields near Agadir.

The port of Agadir is an important tourist center on the frontier between the populous and Westernized north of Morocco and the traditional drier south. Nine-tenths of the population lives northwest of the Atlas Mountains, from the south of Agadir to Oujda in the northeast. Agadir is in the Anti-Atlas (or Lesser Atlas), the lowest, southern part of the range. Here on the moist, ocean-ward side of the mountains, fruit trees and grains are grown. Morocco remains preeminently an agricultural country, with half the population living off the soil. Of an estimated 71 million hectares (175 million acres), 40 million (100 million acres) are devoted to agriculture. However, agriculture accounts for only 17 percent of the country's GNP and provides only 12 percent of its exports. The reason lies in the uncertainties of the climate. The lack of water that threatens a wide band of land from Morocco to Pakistan is more a problem of the vast fluctuations from year to year than of the average rainfall over many years.

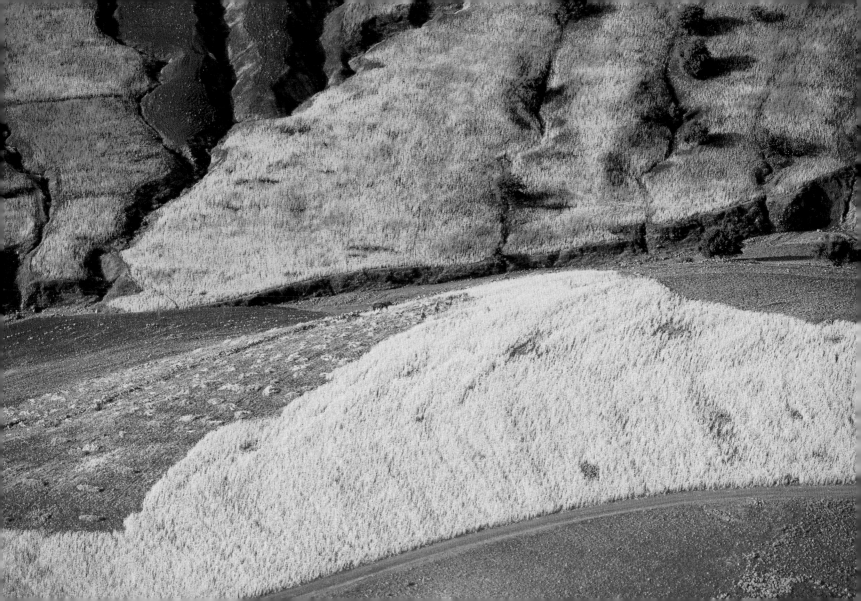

Indonesia. Bali. Harvesting seaweed.

Water, no less than soil, can produce marketable commodities: aquaculture alongside agriculture, and fish-farming as well as poultry farming (both aquaculture and fish-farming are often referred to as "off-soil activities"). With its rows, ridges, and furrows, seaweed farming (algoculture) has become analogous to grain farming. It is a profitable way to put otherwise unpromising space to good use and supply additional nutrition to growing populations. Agriculture, fishing, aquaculture, and silviculture occupy 55 percent of the Indonesian working population aged 15 and over, 40 percent of whom are female.

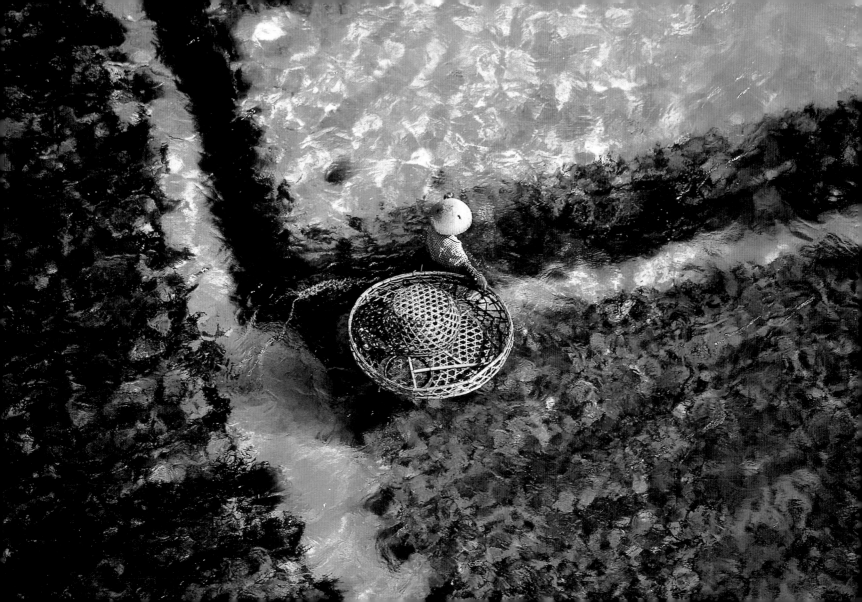

Kenya. The dried-up Athi River, in the west of the Tsavo National Park.

Like most of the watercourses in Kenya, the Athi River, which crosses the Tsavo National Park, does not flow all year round. In dry periods, the Masai herders nevertheless lead their flocks of cattle and goats to the dry river bed so that the animals can drink from the puddles left in the rocky basins. The Masai are seminomadic herdsmen whose subsistence is wholly dependent on their animals. According to their beliefs, they were given their cattle by Enkai, the creator of the world. There are still 15,000 who continue to travel long distances between Kenya and Tanzania in search of water and pasture for their flocks. Current "development" programs, however, are encouraging the Masai to switch to agriculture and become sedentary.

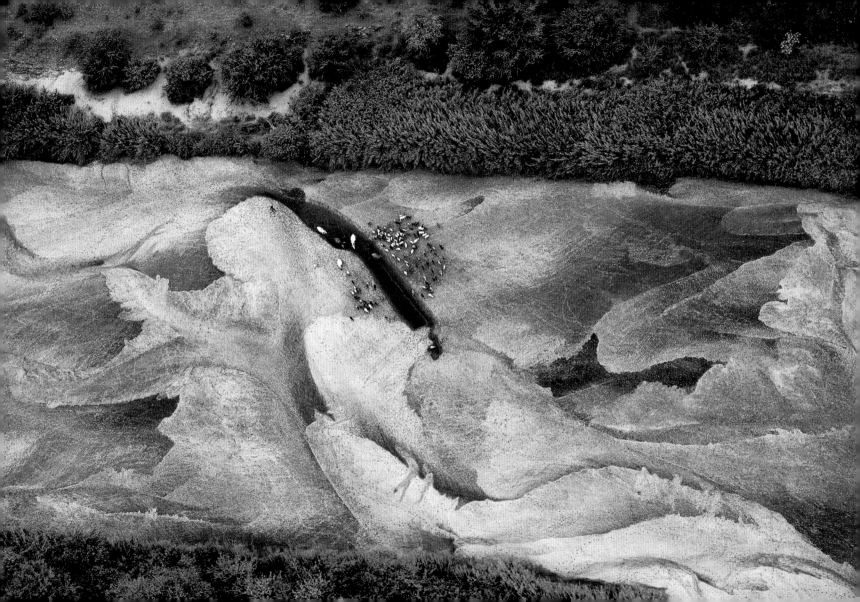

Thailand. Island of Phuket. Phi Phi Le.

The Phi Phi Archipelago, in the Andaman Sea 40 kilometers (25 miles) off the coast of Thailand, is made up of the islands chains Phi Phi Don and Phi Phi Le, which were once refuges for pirates. Phi Phi Le is uninhabited and therefore well-conserved. However, it is exploited by fishermen seeking a rare delicacy: swallows' nests. The nests are found in the high caves hollowed out of the limestone cliffs rising as high as 374 meters (1,225 feet); the fisherman make their approach using fragile and precarious bamboo scaffolding. The swallows' nests – "white gold" – are made of hardened saliva, and because they are so highly valued for their reinvigorating properties, they can sell for as much as 12,000 French francs per kilogram (about $750 per pound). The Thai government is currently trying to clamp down on this illegal trade. The island's beauty has also caused it some problems. Phuket recently hosted the production of a major motion picture, sparking a huge environmental controversy. The filmmaking team had flattened the dunes and planted sixty palm trees in order to create Eden. The company was required to restore the site to its original condition and committed itself to cleaning up the island. In 1999, a tropical storm of rare violence wiped out all its efforts, strewing the beach with assorted debris.

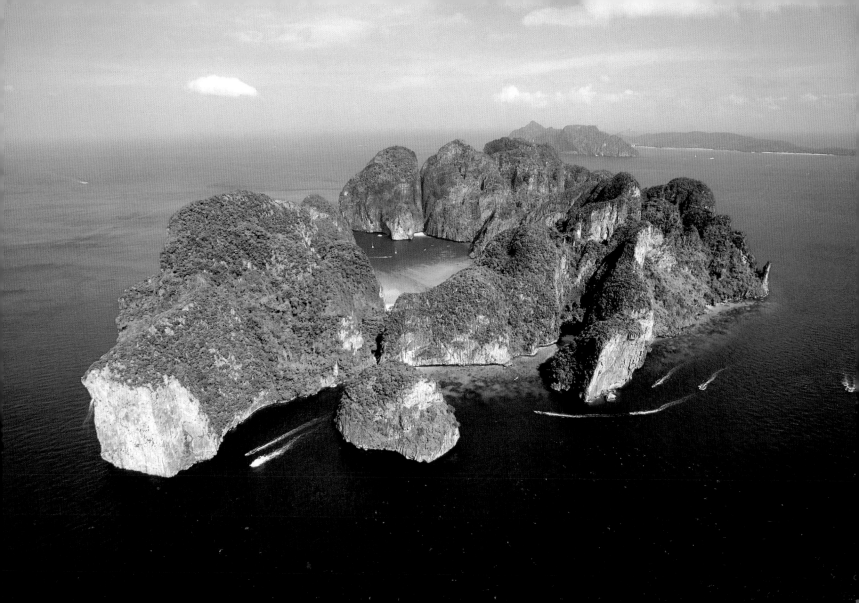

Honduras. Bay Islands. Guanaja. Village ravaged by Hurricane Mitch.

Originating to the south of Jamaica, Hurricane Mitch reached full force four days later with gusts of 288 kilometers per hour (179 miles per hour), before tearing into Central America on October 30, 1998. The whole of Honduras, including the island of Guanaja, was severely damaged by the hurricane, swept for two days by destructive winds, torrential rain, and mud slides that flattened whole towns, killing several thousand people and leaving more than one million victims. Over the months that followed the disaster, the population had to face shortages of drinking water and outbreaks of epidemics. Mitch was the most destructive hurricane to hit Honduras since Fifi in 1973. It destroyed 70 percent of the plantations of bananas and coffee, the main export crops, and plunged the country, already one of the world's poorest, into economic chaos.

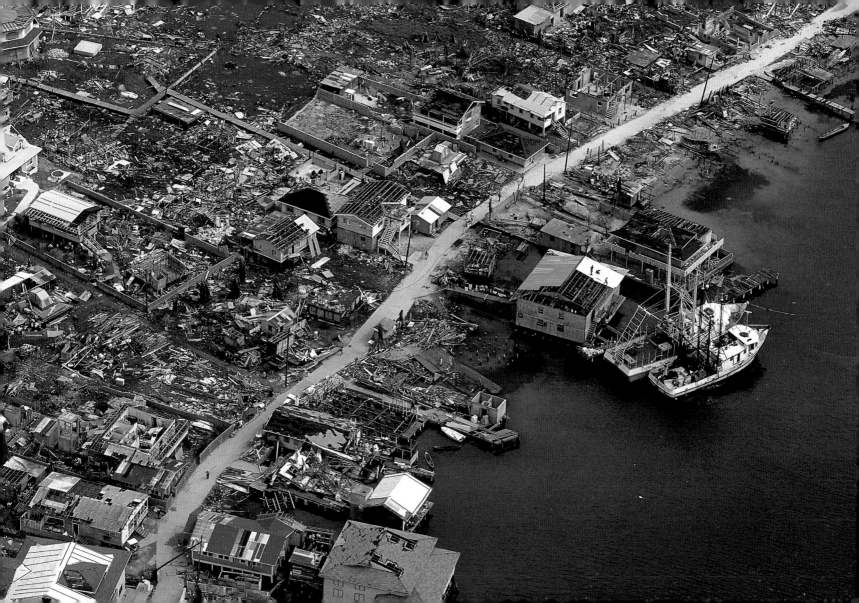

Jordan. Ma'an region. Mountainous landscape. Wadi Rum.

Wadi Rum, the longest wadi in southern Jordan, has given its name to this region. Its peaks, blond dunes, and cliffs tinged with ocher, red, and violet, were described with crushing grandeur by Lawrence of Arabia. As a young sublieutenant, Lawrence led the English support of the great Arab revolt against the occupying Ottoman Turks, which began in this region in 1916. The rock monuments of the desert abound in mysterious inscriptions. Since ancient times the region has been an important corridor for nomads and traders in spices between Southern Arabia and the consumer region of the Mediterranean. The Nabataeans of Christ's time have yielded to today's Haoueitate Bedouins. By designating the 510 square kilometers (185 square miles) of Wadi Rum as a natural reserve in the 1980s and entrusting it to the Haoueitates, the Jordanian authorities were not simply obeying ecological imperatives, but also aiming to make this Bedouin tribe sedentary.

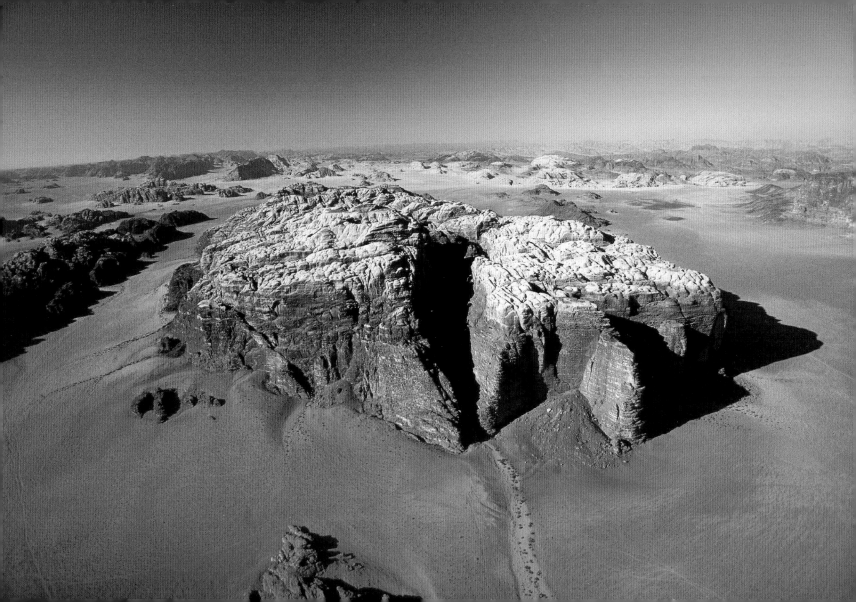

India. Rajasthan. Working in the fields north of Jodhpur.

At 342,000 square kilometers (132,000 square miles), Rajasthan, in northwestern India, is the second largest state in the country. Sixty-five percent of the state is covered in sandy desert formations, the scarcity of surface water accounting for the poor productivity of its land. Nevertheless, the creation of irrigation systems has enabled some agricultural development; millet, sorghum, wheat, and barley are all grown in the area. Harvesting these grains at the end of the dry season normally falls to the women, who, even when working in the fields, wear the traditional *orhni*, the long brightly colored shawl specific to the region. In India, more than half the territory is devoted to agriculture, and 27 percent of the arable land is irrigated. Every year the country harvests about 240 million tons of grain, or more than 10 percent of world production.

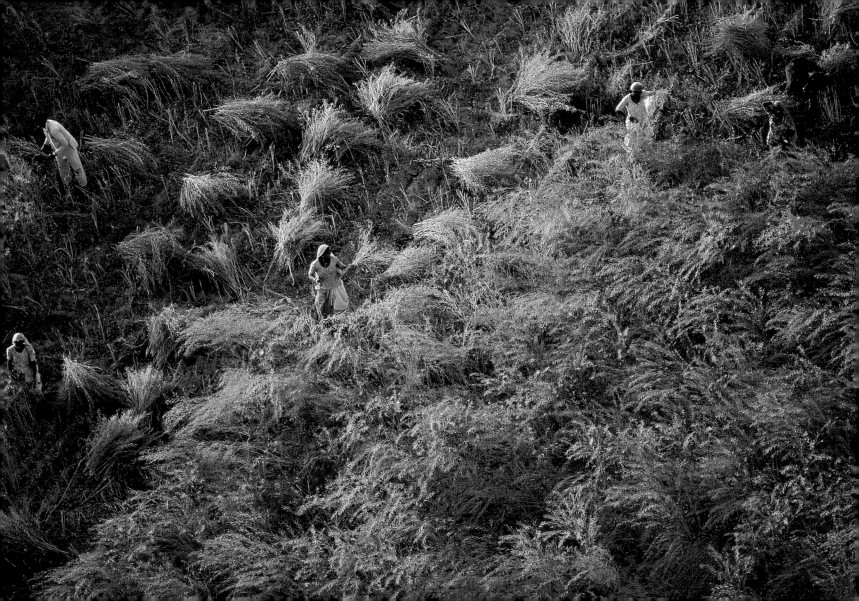

Namibia. Damaraland region. Mountains in Brandberg West.

Not far from the desolate shore of the Skeleton Coast in the northwest of Namibia are the high plateaus and the region of Damaraland, where arid plains alternate with granite mountains. The Brandberg Massif (the "Mountain of Fire") owes its name to the red color with which its face blazes at sunset. At 2,573 meters (8,440 feet), its summit, the Königstein, is the highest in Namibia. It was here, descending the mountain in the early twentieth century, that German surveyor Reinhardt Maack came upon beautiful rock paintings roughly 4,000 years old. The best known, the so-called White Lady, depicts a procession with a Bushman warrior at the center. A member of one of the tribes that arrived in Namibia probably during the eighth millennium BC, his body (neither white, nor female) is decorated with ritual painting. The discovery is representative of two episodes in Namibia's history: its ancient settlement and its colonization by Germany. In spite of the end of apartheid, the coexistence of Bushmen, Bantus, Europeans, and South Asians, all of whom arrived at different periods, remains a major problem in southern Africa.

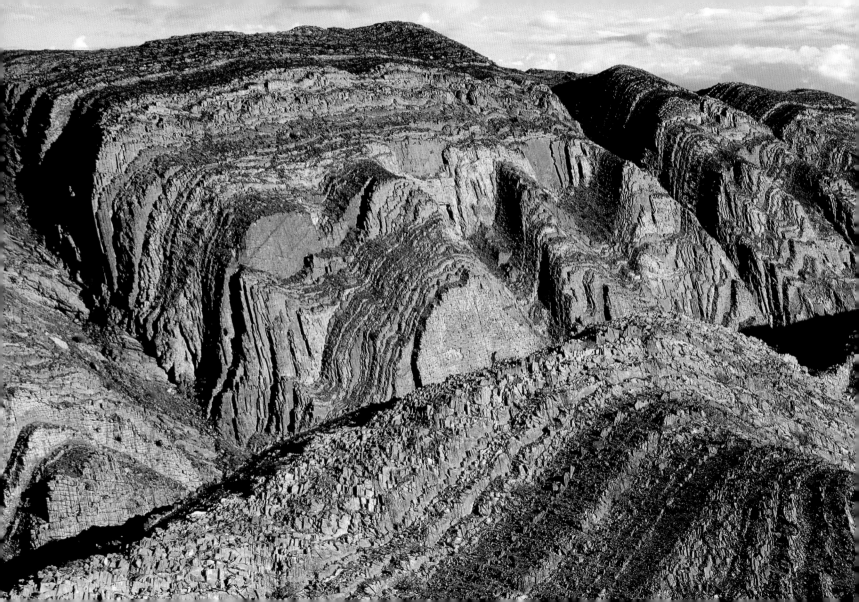

Egypt. Valley of the Nile. Dates drying on a palm plantation south of Cairo.

Date palms only grow in hot, dry zones that possess water resources, such as oases. Four million tonnes (4½ million tons) of dates are produced in the world every year. Most dates produced in the Middle East and the Maghreb are for internal consumption, with exports comprising only five percent. Egypt is the world's second largest producer, annually harvesting some 650,000 tonnes (715,000 tons), consumed domestically at the annual rate of 10 kilograms (22 pounds) per person. Most of these dates are preserved in small-scale units: separated by variety, they are dried in the sun, protected from wind and water by a small wall of earth and branches, then placed in baskets woven from palms. Although most dates are consumed as such, the fruit is also processed on an industrial or craft basis, to make a number of derived products, including syrup, flour, paste, vinegar, sugar, alcohol, and pastries.

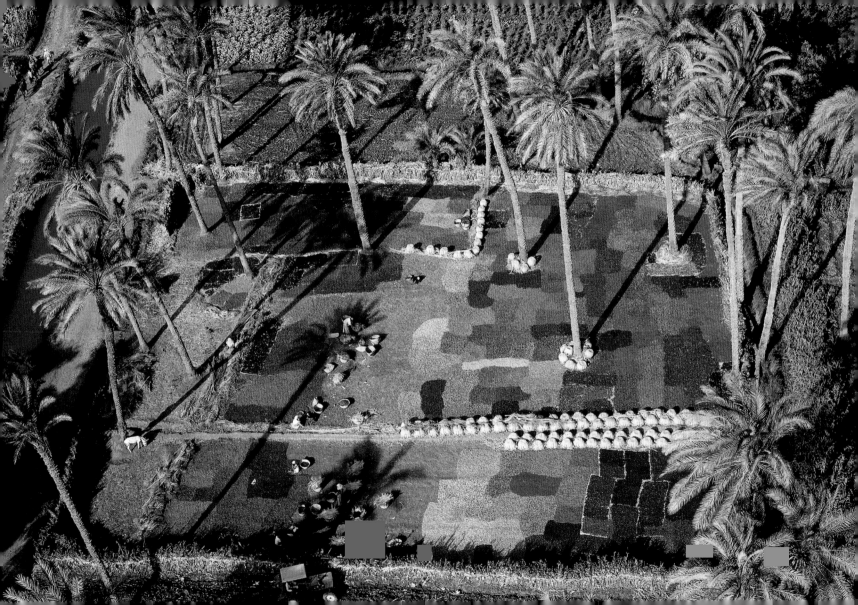

Venezuela. Gran Sabana region. River on the Auyantepui.

The region of Gran Sabana in southeastern Venezuela is a vast plain covered by savannah and dense forest, out of which rise imposing tabular reliefs of sandstone called *tepuis*. On the Auyantepui or "Mountain of the Devil," which rises to 2,580 meters (8,460 feet) and covers over 700 square kilometers (270 square miles), snakes the Churun River. When it reaches the tepui's edge, it plunges 979 meters (3,211 feet) to form Angel Falls, the highest free-falling waterfall in the world. With its rich deposits of gold and diamonds, the Gran Sabana and its numerous watercourses have lured many prospectors since 1930, attracted in particular by towns like Icabaru, famous for the discovery of a diamond of more than 150 carats, and El Dorado, whose very name evokes the conquistadores.

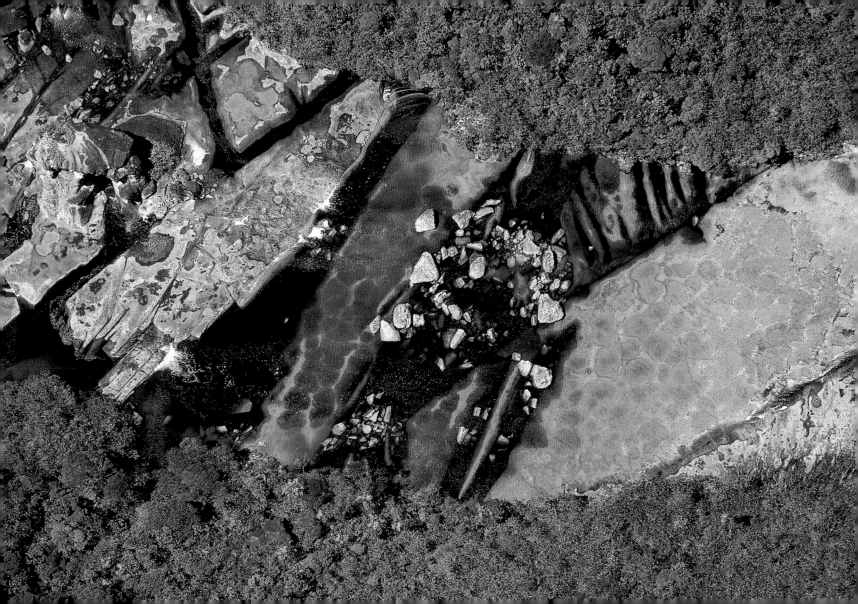

Morocco. Ar-Rachidia region. High Atlas. Village in the Rhéris Valley.

A succession of fortified villages along the valley of the Rhéris, similar to those along most other wadis in southern Morocco, was inspired by the Berber architecture that was originally designed to protect against invaders. The menace of raids having disappeared, the interlocked dwellings, the narrow windows, and the terraced structure of the roofs covering houses and thoroughfares are now primarily intended to protect the occupants from heat and dust. The adjoining flat roofs are used for drying crops. Perfectly integrated into the landscape, the houses are generally built of clay and chalk (*pisé*) available on the spot. Although they look robust, these constructions are fragile because the material used is so friable. Half the buildings dating from fifty years ago are in ruins.

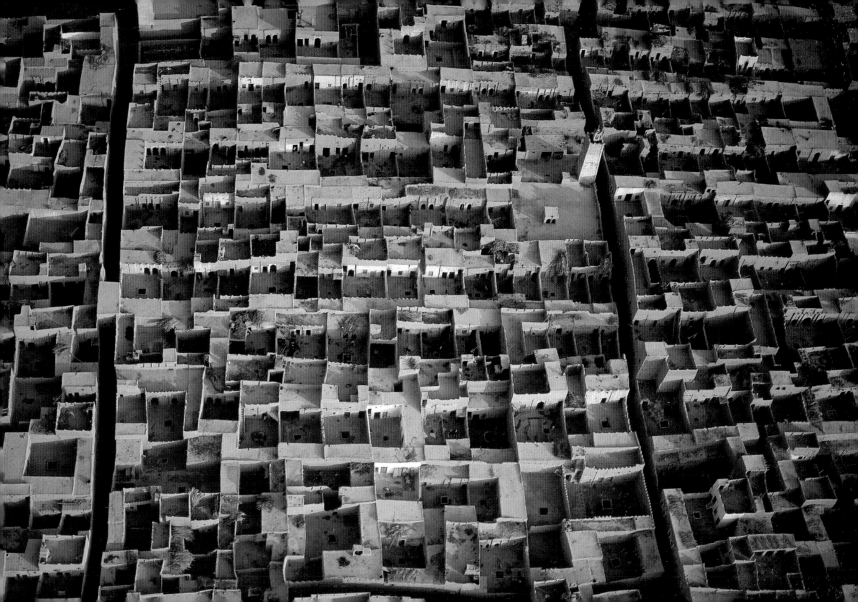

Maldives. North Male Atolls. The islets of Vabbinfaru.

Some 500 kilometers (300 miles) west of Sri Lanka lie the Maldives, a scattering of atolls comprising between 1,120 and 2,000 islands, depending on the movements of the sandbanks. Kalhuhuraa, which supported rich palm plantations one hundred years ago, has disappeared. Kuda Huraa has just been cut in two. Atolls (*divehi* in the Maldive language) are made of coral reefs that have built up along the edges of volcanic islands. As Charles Darwin correctly hypothesized in the 1830s, atolls begin as fringing reefs around volcanic islands. As the volcanic peaks slowly erode and subside on the ocean floor, the corals keep growing, maintaining depths of less than 20 meters (65 feet). What is created is a thick reef surrounding a lagoon. The Maldives contain a record number of atolls, including the largest on Earth: Huvadhoo is 70 kilometers (44 miles) around, 53 kilometers (33 miles) wide, and its lagoon is 86 meters (282 feet) deep.

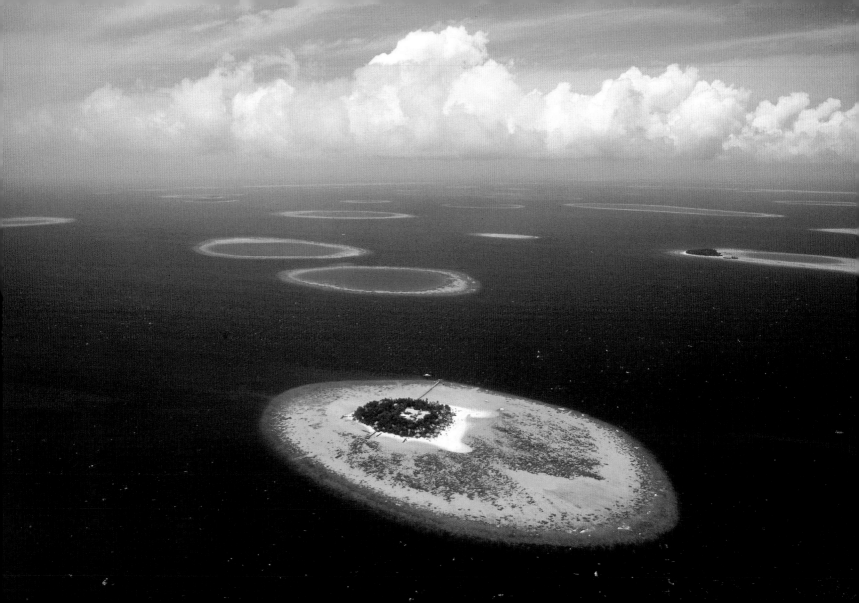

Greece. Thessaly. Monastery on one of the Meteors.

On the plain of Thessaly in Greece are the Meteors, peaks of calcareous rock and sandstone sculpted by rivers during the Tertiary era. In the fourteenth to sixteenth centuries, anchorite monks built 24 monasteries on these rocky prominences overlooking the valley of the Piniós, perched between 200 and 600 meters (650 and 2,000 feet) high. For a long time, access to these buildings was difficult save by ropes and winches; only from 1920 were steps and footbridges installed allowing tourists to visit these sites. Most of these *meteorisa monastiria* (hanging monasteries) are in ruins today, and only four of them are still occupied by Greek Orthodox communities. In 1988 the monasteries were added to UNESCO's list of World Heritage Sites.

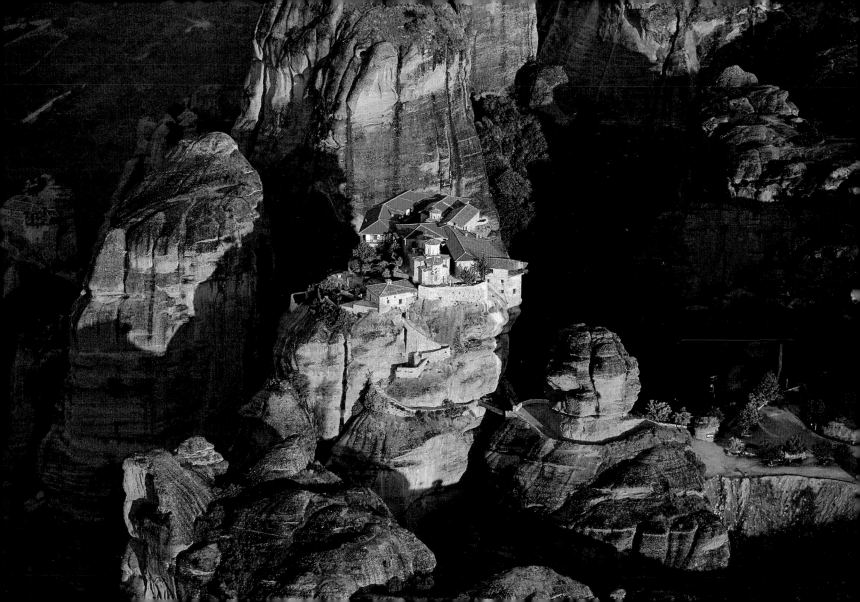

Japan. Honshu. Fishermen's island in Hiroshima Bay.

A country of islands, Japan has always exploited the riches of the sea. In addition to fishing, the Japanese have bred oysters and cultivated seaweed since the seventeenth century, and Japan is one of the world's largest consumers of seafood. This "sea civilization," as the French geographer François Doumenge called it, was born on Japan's east side, on the coasts of the Pacific Ocean and the Setonaikai (Inland) Sea, but is now developing throughout the country. Japan is now the world leader in all economic activities linked to the sea, and is the largest producer of fish and seafood. Along with Norway, it is also one of only two countries that still practice commercial whaling. Many species of whales have been hunted almost to extinction, and are now protected by an international moratorium. Nevertheless, and in spite of constant international condemnation, the Japanese fleet continues whaling on an industrial scale, often on the pretext of scientific research. Hundreds of these animals end up as delicacies on Japanese dinner tables every year.

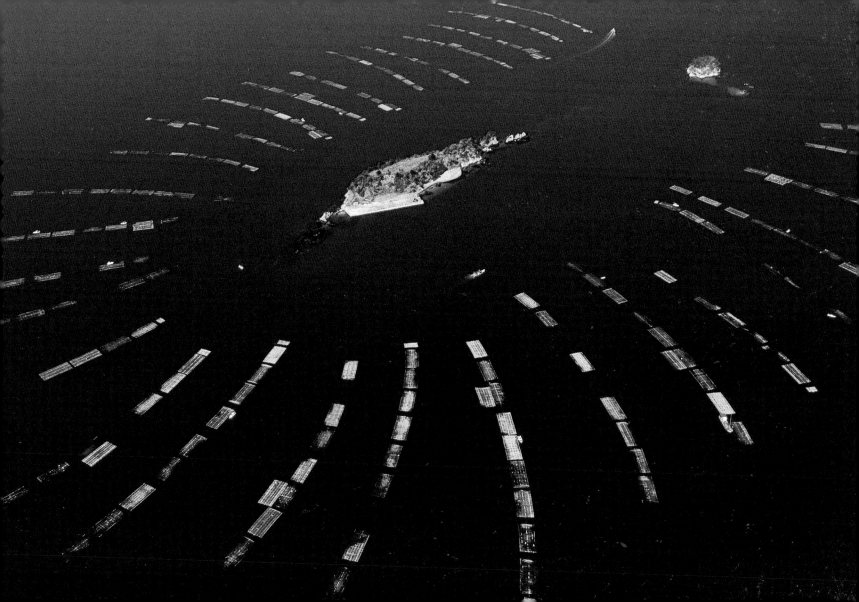

Antarctica. Terre Adélie. Iceberg.

The gigantic Antarctic polar cap extends a long way into the sea, where its vast glaciers break off into enormous icebergs, some of which are as large as Corsica and can be more than 500 meters (1,600 feet) high. Their size makes them less dangerous than the small icebergs of the northern hemisphere, derived from the Arctic ice that does not exceed 10 meters (33 feet). As the icebergs of the Antarctic are frozen fresh water, some people have suggested that they could be towed north to irrigate hot arid countries. These extravagant projects have not had any more success than those aiming to create an interior Saharan sea by driving a canal through from the Mediterranean to the Chotts Basin. With the warming of the planet, many climatologists fear that part of the ice cap two kilometers thick could slip into the ocean and melt, raising sea level by more than 10 meters (33 feet). Less pessimistic scientists point out that this sort of event, though fast in geological time, would still take several hundred years, perhaps leaving humanity time to prepare.

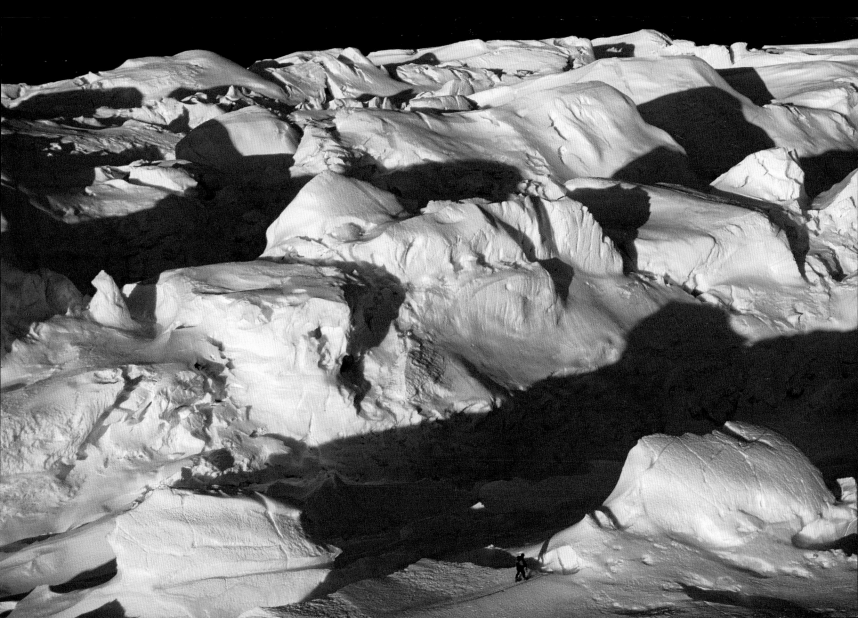

Turkey. Anatolia. Cappadocia. Troglodyte dwellings near Uçhisar.

Cappadocia, in the heart of Anatolia, has several volcanoes that are now extinct, but which have in the past deposited substantial amounts of ash over the region. The solidified volcanic tuff, as it is known, has been eroded over time to create a landscape of domes, cones, and needles. From the Bronze Age, they have been hollowed out by people to form troglodytic dwellings. Beginning in the fourth century, eremitic Christian communities lived in the area, carving out monasteries, churches, and underground cities used for refuge during the Arab invasions of the seventh century. Designated a UNESCO World Heritage Site in 1985, the carved rock of Cappadocia is one of the major attractions of Turkey, a country which at the present time attracts almost nine million visitors annually.

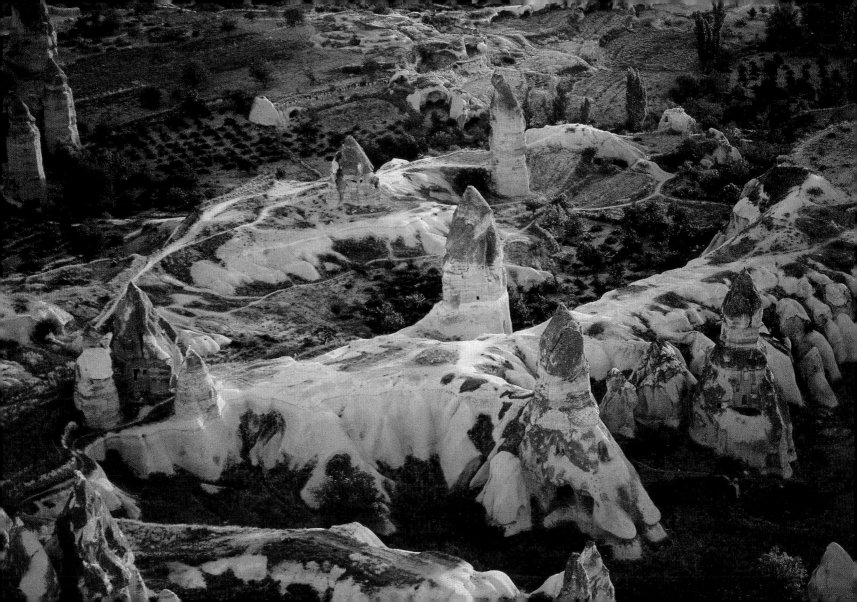

Australia. West Kimberley. Mount Trafalgar in Prince Regent Reserve.

The wild region of Kimberley, between the Timor Sea and the Gibson Desert, today harbors fewer than 20,000 inhabitants. It is the quintessential "outback," the vast and inaccessible recesses of western Australia whose arid zones cover one-third of Australia and support only 1.8 million inhabitants. Prince Regent Reserve runs along the river of the same name and has been designated a UNESCO Biosphere Reserve because of its tropical dry or deciduous forest. There crocodiles await the return of water and floods in the summer season, when the monsoon rains come to refresh the stifling climate. Around the reserve extend the territories of the Aborigines, "those who were there from the origins." Nearly wiped out by the Europeans, their numbers are now estimated at 265,000, of whom three-quarters are of mixed race. To the Aborigines of the region, Mount Trafalgar symbolizes the harmony between one part of the Earth – the rocks and living beings created by the spirits of the ancestors, and another – that of mankind, whose oral tradition and movements keep alive the memory of the "Dreamtime," of the Creation.

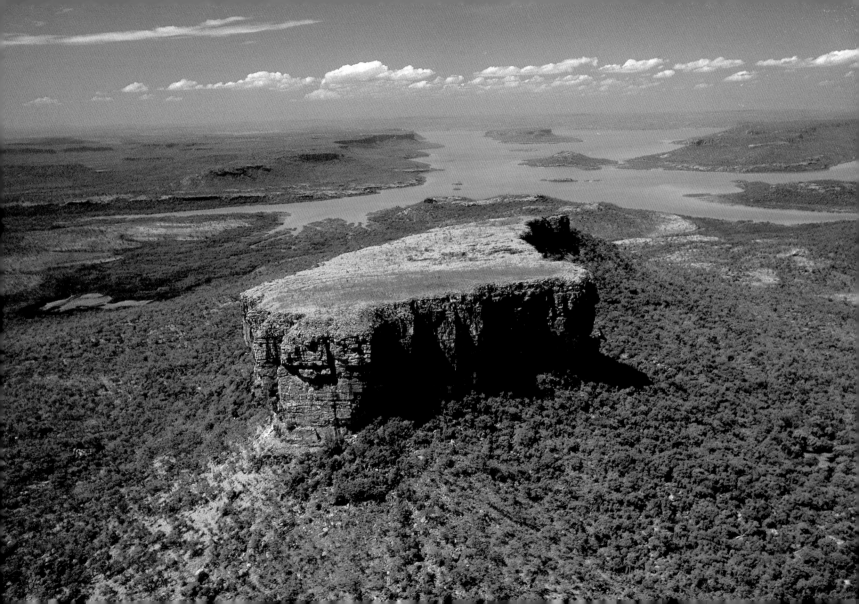

India. Uttar Pradesh. Varanasi. The ghats. Ritual bathing in the Ganges.

The *ghats* (steps leading down to the river) of Benares, now known as Varanasi, have attracted Muslim pilgrims since time immemorial. Varanasi, whose name means "the city between the Varuna and Asi Rivers," is a sacred city dedicated to Shiva, the god of both destruction and reproduction in the Hindu pantheon. The god's hair contains Ganga, the goddess of the Ganges, the River of Life. Like six other religious centers, the city is a *tirtha*, a stage between the world of suffering and the world of the divine. In their lifetime, pilgrims immerse themselves in the river to purify themselves and fulfill their religious service, the *puja*. Offerings, prayers, and meditation accompany the ablutions. Varanasi is also a place for the dead, and people come to the city to offer the cremated remains of their relatives back to the river. It is said that pilgrims who actually die at Varanasi have a better chance of attaining *moksha*, the spiritual salvation that frees one from the cycle of reincarnation. In addition to their practical function, the ghats represent the immense plateaus that descend in tiers to the river from the Himalayas. Hinduism, the religion of 800 million Indians and of 20 million in Nepal, Bali, Mauritius, and Fiji, is the third largest religion in the world.

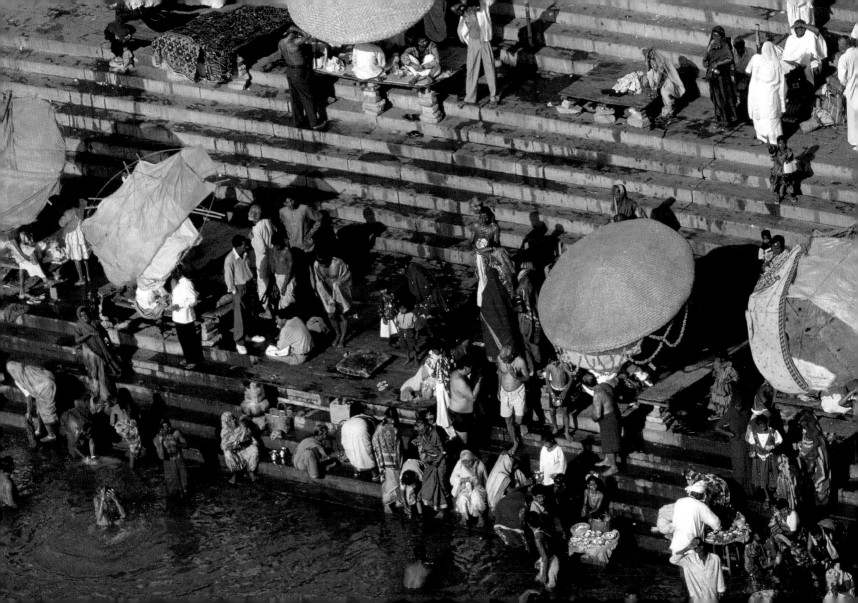

Russia. Kamchatka. Lake in a crater of the Mutnovsky volcano.

Born of four coalescing stratovolcanoes, Mutnovsky, in southern Kamchatka rises to 2,324 meters (7,623 feet) with two crater lakes at its summit. Over the past 150 years, this volcanic group has experienced about fifteen explosive eruptions, the last dating from 1961. Today, its activity is limited to the emission of ash and sulfurous gases as hot as 600°C (1,100°F). Extremely young geologically speaking, with less than one million years in existence, the Kamchatka Peninsula is located over a subduction zone, where the Pacific tectonic plate is diving beneath the Eurasian plate. It contains 160 volcanoes, 30 of them active, designated World Heritage Sites since 1996. It is estimated that some 1,500 volcanoes in the world could erupt in the near future. Sixty percent of them make up the "Ring of Fire" along the Pacific Rim.

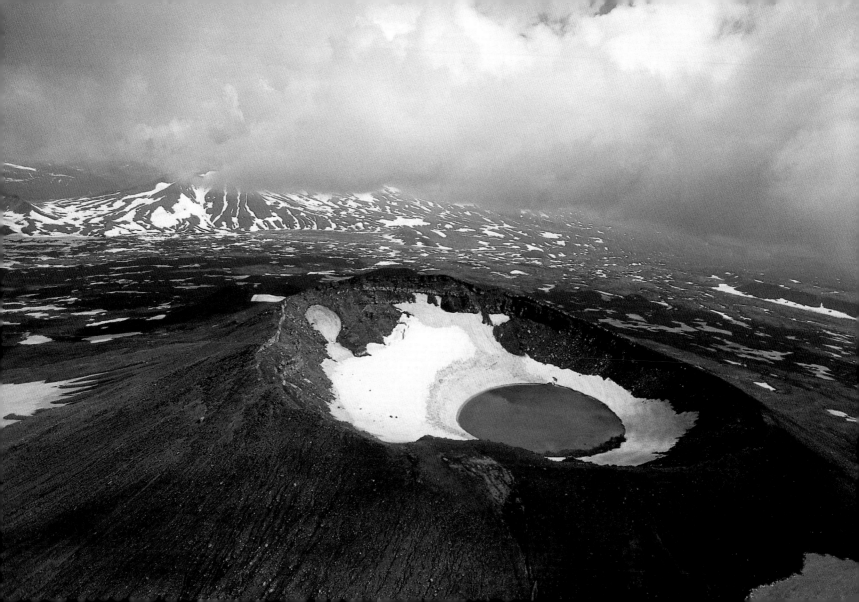

Philippines. Luzon Island. Village of Bacolor buried under a mudflow.

In 1991, after lying dormant for more than six centuries, Mount Pinatubo on Luzon Island in the Philippines erupted. It threw out 12 cubic kilometers (3 cubic miles) of lava, volcanic blocks, ash, and gas, the smallest particles reaching heights of 40,000 meters (25 miles). Pouring down the mountain and raining back down on the surrounding land, they destroyed all visible life within a 14-kilometer radius. In the days that followed, torrential rain mixed with the loose ash that was scattered over several thousands of square kilometers (a few thousand square miles), causing major mudflows, known as lahars, which engulfed entire villages. Each time there is a tropical storm, these raging torrents of mud, rocks, and boulders swallow more villages, like Bacolor in 1995. The current toll of the Pinatubo eruption is estimated at one million victims, including 875 dead. Nearly 600 million inhabitants of our planet live under the immediate threat of volcanoes, and every year more than 700 people are killed as a result of volcanic eruptions.

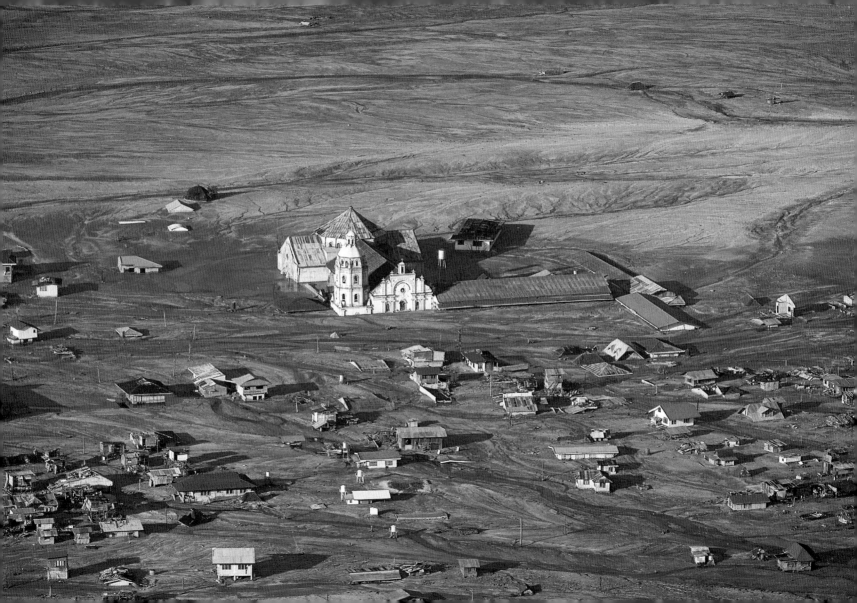

Peru. The "Candelabra" of the Paracas Peninsula.

Commonly known as the "Candelabra," this design carved into the cliffs on the Paracas Peninsula on the Peruvian coast may be, according to specialists, the representation of a cactus or the constellation of the Southern Cross. While bearing some similarities to the famous lines at Nazca, approximately 200 kilometers (125 miles) to the southeast, it is the work of an earlier civilization, the Paracas, who have left a necropolis of 429 mummified bodies, or funerary *fardos*, in the region. Reputed for their cloth, embroidery, and ceramics, the Paracas, whose civilization flourished about 650 B.C., were primarily a fishing people. As the "Candelabra" is visible from far out at sea, it was undoubtedly a landmark for navigation, as indeed it still is for sailors.

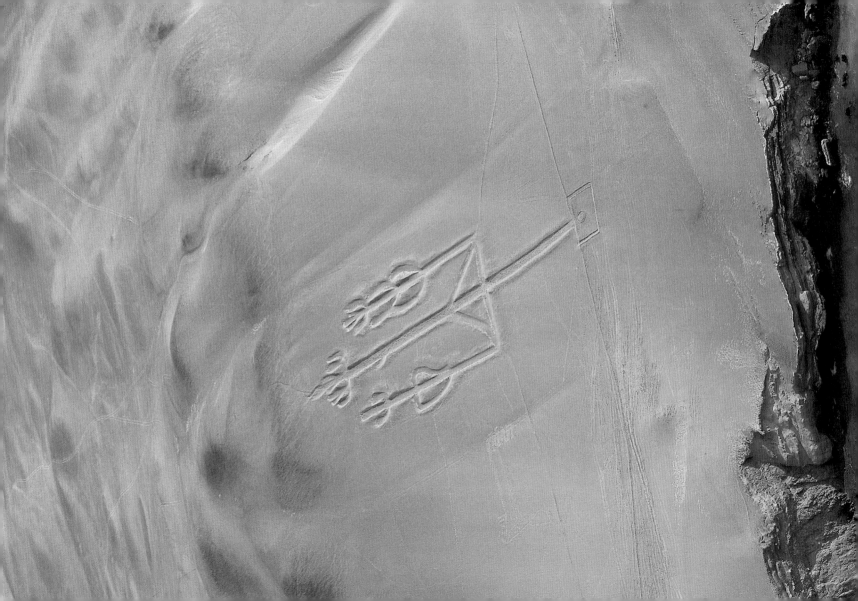

England. Wiltshire. Agricultural graphics.

Southwest of London, the large grain fields of Wiltshire have once again upset the rural landscape. The invading Angles, Danes, and Saxons of the sixth to eighth centuries imposed on the landscape a system of open fields characteristic of northern Europe. Small landholders did not enclose their plots in such fields, but cultivated in common. From the sixteenth century, the landlords took over the plots and enclosed them with hedges, forcing poor peasants off the land. This was the "Period of Enclosures." But after World War II the process was reversed, when grain farming became profitable and open fields were once again created. Thus this apparently ancient landscape punctuated by mysterious circles is actually very recent. During the Napoleonic War, England feared it might be unable to feed its 10 million people, but with a current population of 56 million, it is now a net exporter of grain.

Ireland. County Clare. Isles of Aran, the cliffs of Inishmore.

The isles of Aran-Inishmore, Inishmaan, and Inisheer-whose cliffs rise 90 meters (200 feet) above Galway Bay, protect the bay from the violent winds and currents of the Atlantic. Inishmore, the largest at 14.5 by 4 kilometers (9 by 2½ miles) is also the most populous, with almost one thousand inhabitants. For centuries, the populations have raised the fertility of the soils by regularly spreading a mixture of sand and seaweed over the rock in order to form the fine layer of humus needed for agriculture. To protect their plots from wind erosion, the islanders have built a large network of small wind-break walls, totaling nearly 12,000 kilometers (7,500 miles); they give the land here a gigantic mosaic appearance. Although they derive the main part of their living from fishing, agriculture, and rearing animals, the islanders of Aran host a growing number of tourists, many of whom are attracted by the island's numerous archaeological sites.

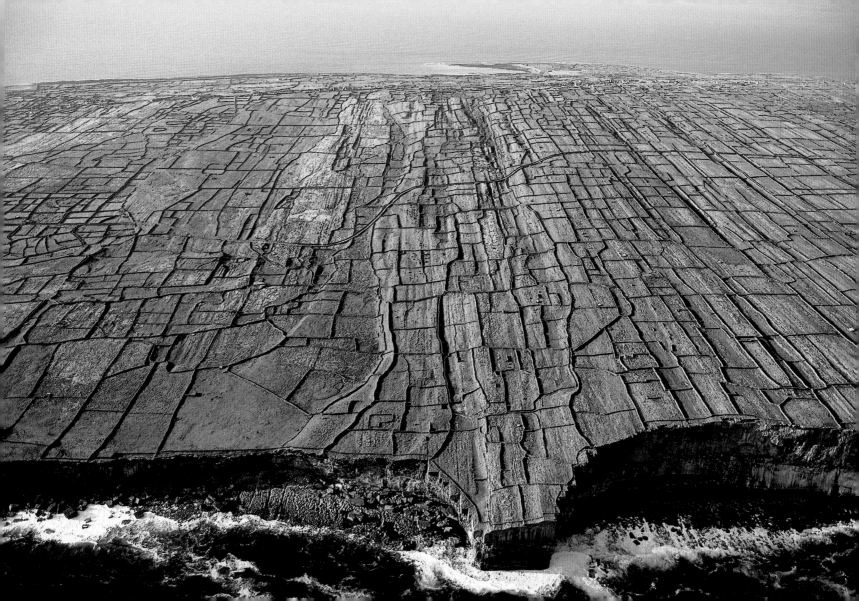

Japan. Honshu. The streets of Tokyo.

Tokyo became Japan's only capital in 1868, when Emperor Meiji Tenno settled here in order to modernize the country. At first sight, this city of 12 million people herded together on 2,000 square kilometers (750 square miles) lacks charm. Fires, earthquakes, and bombings have destroyed it several times over the past century. In 1923, an earthquake of magnitude 8.2 on the Richter scale destroyed 575,000 houses. In 1944–45, U.S. raids killed over 400,000. After the war, the Japanese thought of reconstructing it according to Le Corbusier's grid plan and something of an affinity to that remains. The very wide boulevards and stacked highways create districts whose more irregular streets themselves enclose smaller districts (*Chome*) that are all but villages where, to the surprise of foreigners, many of the houses are wooden and have no addresses. In the very heart of their metropolises, the Japanese have constructed intimate, private spaces that avoid the inhuman standardization of other cities' tower-block projects.

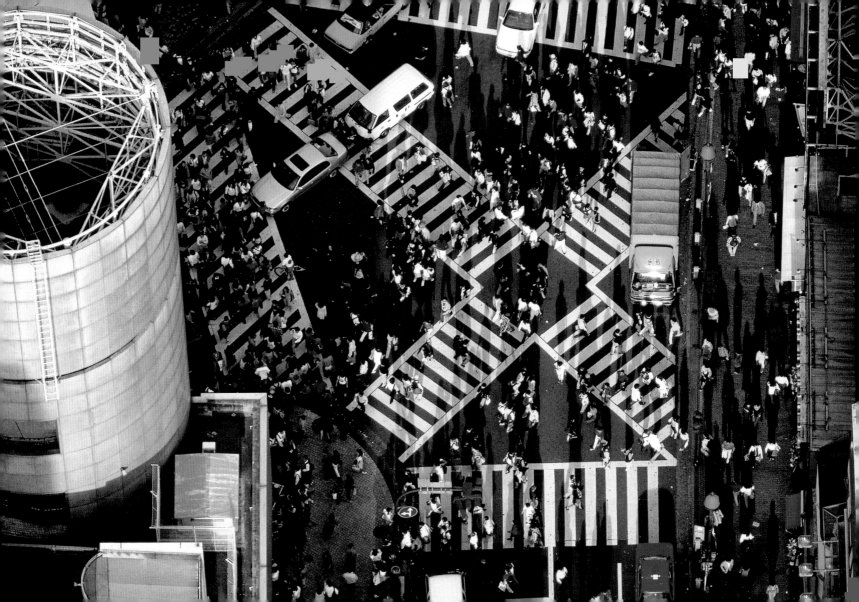

Kazakhstan. Aralsk region. Beached boat on the Aral Sea.

In the early twentieth century, the Aral Sea in Kazakhstan had a surface area of 66,500 square kilometers (25,700 square miles), making it the fourth largest interior sea in the world, and a place where trawling was a normal activity. After the construction in the 1960s of a vast system of irrigation intended for the monoculture of cotton in the region, the flows of the Amou Dar'ya and Syr Dar'ya Rivers slacked off to a worrying extent; the sea lost half its surface area and three-quarters of its water. The gradual drying out has, over the past 30 years, led to an increase of salinity to three times the original level, currently 30 grams per liter (4 ounces per gallon – almost as high as seawater), and the subsequent loss of a score of fish species. In addition, salty wind-borne dust from the lake bed is destroying the vegetation over several hundred kilometers (several hundred miles) all around, contributing to desertification of the environment. Although it is one of the best examples of the phenomenon, the Aral Sea's case is not unique: some 400,000 square kilometers (150,000 square miles) of irrigated land in the world are excessively saline.

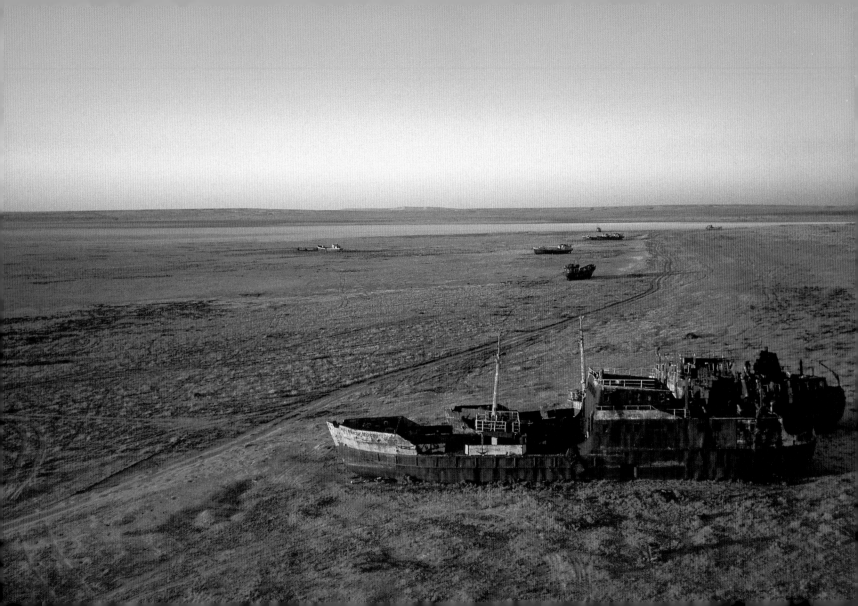

Iceland. Detail of the Pjorsa River.

The Pjorsa (or Thjorsa) River, which flows at a rate of 385 cubic meters (100,000 gallons) per second over 230 kilometers (140 miles), is the longest in Iceland. It flows over a volcanic landscape, bringing to the sea mineral detritus which gives the river its characteristic pale blue color. The entire country is covered by a vast network of non-navigable rivers, most of which issue from subglacial torrents whose tortuous routes migrate over time, making permanent constructions such as bridges and dams impossible. Iceland is the largest island on the Mid-Atlantic Ridge, a submarine volcano that runs down the center of the Atlantic Ocean floor. In the North Atlantic, the ridge marks the boundary between the North American and European tectonic plates. As these plates diverge, magma wells up to fill in the space, and the ocean floor grows a few centimeters wider each year. Because Iceland straddles the ridge, it too is stretching and growing; current volcanic activity runs down the center of the island.

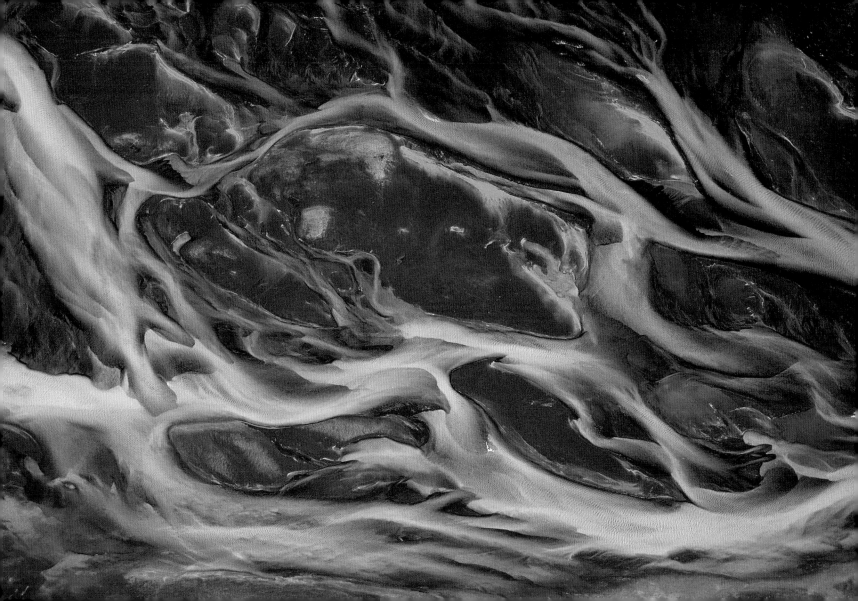

Egypt. Valley of the Nile. Modern tombs in a cemetery at Asyût.

Asyût, the capital of Middle Egypt, 400 kilometers (250 miles) south of Cairo, lives with its dead. The tombs and cemeteries at its gates retrace its history and that of Egypt since the Pharaonic period. The tomb of Hapidjefa I (prince of the province of Asyût under Pharaoh Sesostris I of the Twelfth Dynasty) is at the southwestern limit of the city. The tombs of the Middle and New Empire have been found 6 kilometers (4 miles) to the south. The tombs of the past two millennia are separated into two groups: the Christian tombs are close to the Coptic cemetery of El Deir, while the Muslim tombs are grouped about the princely tomb of Hapidjefa I. The common feature of all these cemeteries is that they resemble cities. Such was already true of the great necropolises – cities of the dead – of Luxor in the time of Amenophis IV, Ramses II, and Nefertiti, and it remains true even in the heart of Cairo, where the huge cemeteries of the Mamluk period have been recolonized by the poorest, who live in the funerary monuments.

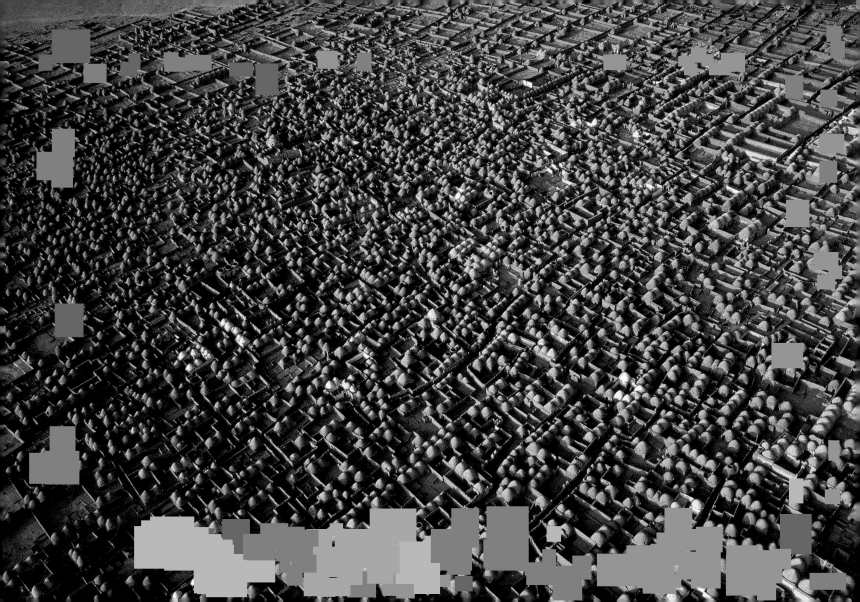

United States. Washington State. Agriculture near Pullman.

Although it is known as the "Evergreen State," Washington has been developing its wheat culture for decades. Today attempts are being made to adapt wheat production to the topography in order to manage soil that has been damaged by former erosive practices. Agribusiness, which marries agriculture, industry, research, and financial investment, keeps the United States at the head of world grain production (40 percent of the world total). Seventy percent of U.S. grain production is used to feed cattle, as opposed to 2 percent in India. The agribusiness industry has recently begun to genetically modify wheat, corn, and rice seed in order to create varieties with high resistance to parasites and disease. Although such genetically modified organisms (GMOs) are widespread on the American continent, they are the object of bans and significant controversies in the European Union, which is generally much more skeptical about their use and is demanding that industries ascertain the full environmental effects of these crops before setting them loose.

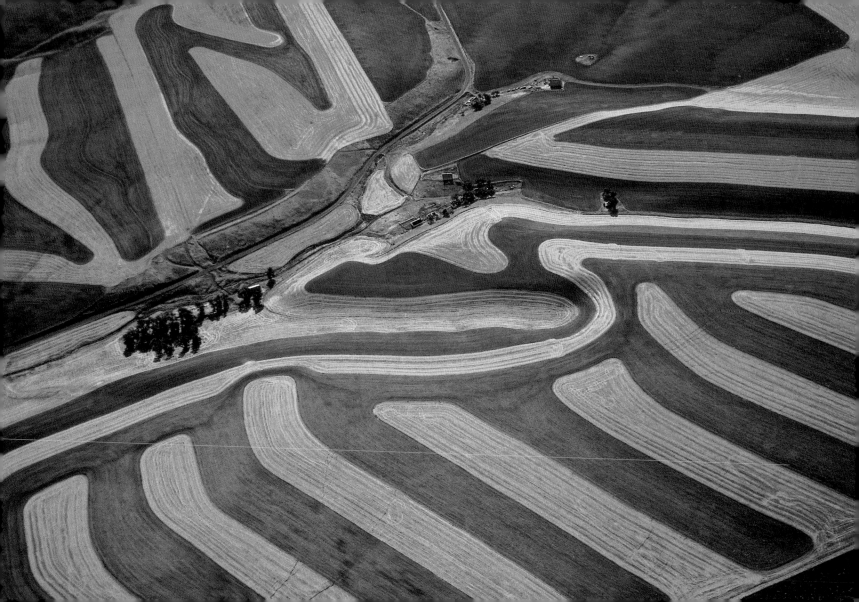

Australia. Queensland. White Haven Beach at high tide.

Whitsunday Island is one of the 74 islands of the Whitsunday Island group off the east coast of Australia. The island owes its name to Whit Sunday 1777, the day Captain Cook reached the archipelago. Today it is uninhabited, but Aborigines appear to have lived there from the beginning of the Neolithic period, when sea level was lower and the island was still part of the mainland. White Haven Beach, fringed with mangroves, has sand of a rare quality: at 98 percent silica, it is said to be the purest in the world. The few swimmers who visit (tourism is strictly controlled) rub shoulders with manta rays, saltwater crocodiles, turtles, and schools of dolphin. The islands are part of the Great Barrier Reef Marine Reserve, a UNESCO World Heritage Site, which stretches for 2,300 kilometers (1,400 miles) along the Australian coast. About 20 percent of the reef's coral has been damaged by growing numbers of a species of starfish, a fierce predator. In fact, almost all the world's coral is in poor health, which is gradually leading to a loss of biodiversity in the surrounding waters – a process similar to desertification on land.

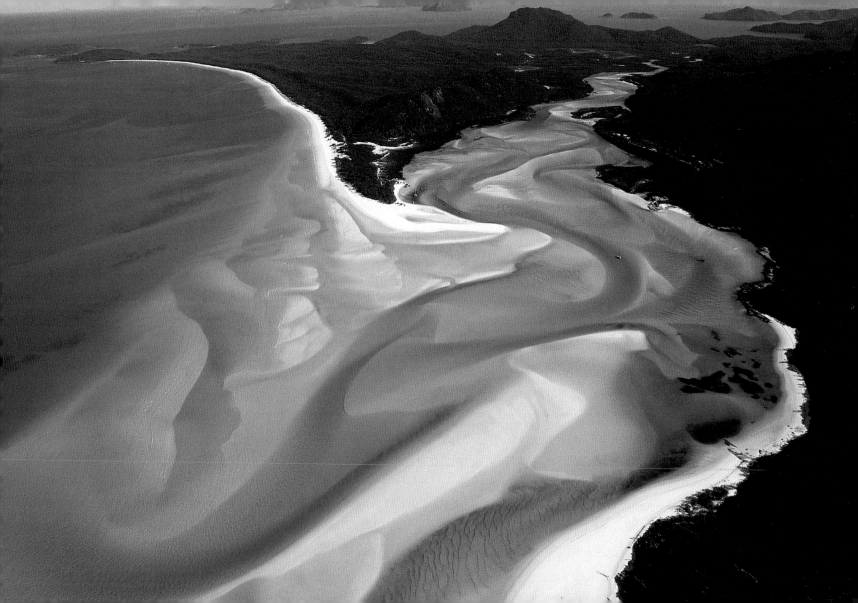

Mali. Market gardening near Tombouctou.

In the arid region of Tombouctou (Timbuktu) in the heart of Mali, market gardening is difficult. The soil is not very fertile, daily temperatures can reach as high as 50°C (122°F), and rainfall is rarely more than 150 millimeters (6 inches) per year. Planted out in plots of about 1 square meter (11 square feet) and watered sparingly, the vegetables produced in these sandy gardens (including peas, beans, lentils, cabbages, leafy vegetables, and ground nuts) are intended primarily for local consumption. The growing development of market gardening in Mali is a consequence of the great droughts of 1973–75 and 1983–85, which ravaged the livestock of nomads in the north of the country and forced some of them to settle down as farmers.

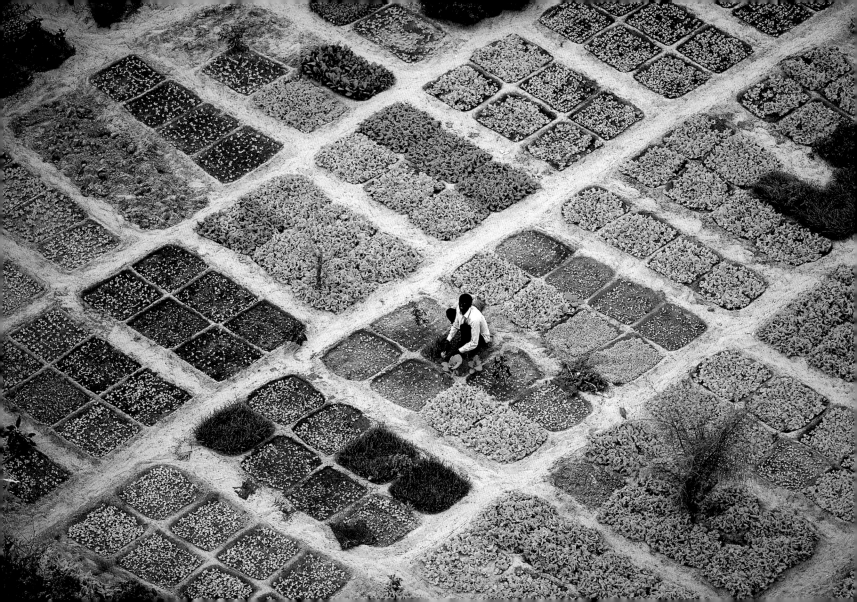

Réunion Island (France). Eruption of Piton de la Fournaise.

At two million years old, the Indian Ocean island of Réunion is a relative youngster compared to its ten-million-year-old neighbor, Mauritius. It owes its existence to the basaltic lavas that built up on the sea floor, culminating in two major volcanoes – Piton des Neiges, now 3,069 meters (10,066 feet), and Piton de la Fournaise at 2,632 meters (8,633 feet). Piton de la Fournaise is the only active volcano on the island. It entered history when French naturalists scaled its sides in the eighteenth century. On July 17, 1791, an explosive phase modified the volcano's shape, creating the Dolmieu Crater, a vast hole 200 meters (650 feet) in diameter, 40 meters (130 feet) deep, and still active. On Monday, March 18, 1986, the volcanological observatory recorded volcanic tremors and alerted the population of Saint-Philippe. The next day, while the entire island was celebrating La Réunion's fortieth anniversary as a French department, the volcano joined in the festivities. Spreading out from its natural frontiers amid the fortunately empty houses, it added 25 hectares (60 acres) to the island, demonstrating that the island's formation is not yet complete.

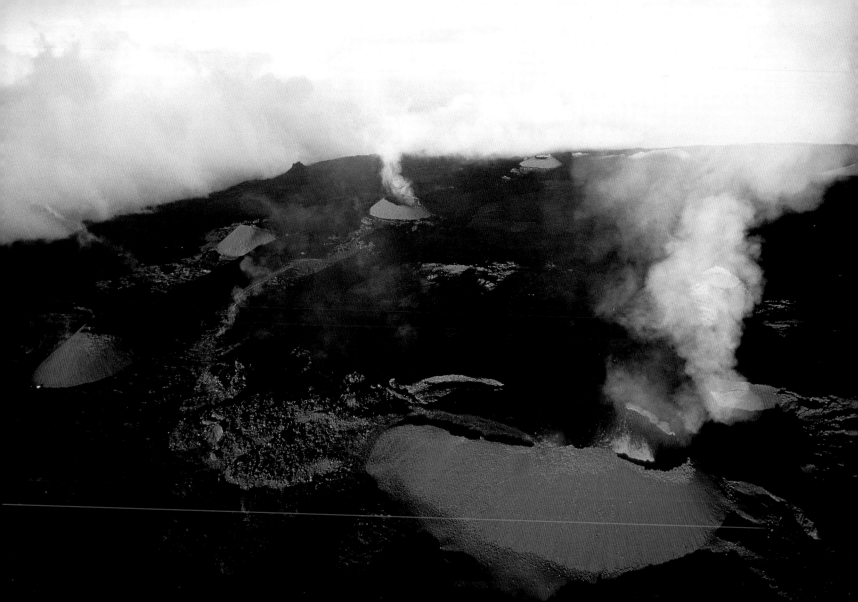

Tunisia. Nefzaoua. Kebili Oasis.

Kebili is the principal oasis of Nefzaoua, in southern Tunisia. Surrounded by sand, this fertile zone is irrigated, like all oases, by an outpouring of the ground water which gives birth to many springs. Motor pumps used to exploit ground water enabled farmers to expand and multiply irrigated areas, transforming the pre-desert steppe into a modern agricultural space. But the shallow ground water supplies quickly ran dry, and when deeper layers were drilled, they in turn also ran dry. The dash ahead, or rather down, will soon come to an end. What has been overlooked is that some water supplies are nonrenewable. It is not so much a matter of the desert advancing as the steppe being degraded by human activity. The abandoned areas are invaded by small sand dunes driven by the wind. Gradually the dunes link up, like moth-holes in a garment, until there is nothing left but desert. Natural and human causes thus join together in advancing the Sahara; in the Sahel, to the south, similar activities are taking place with similar effects.

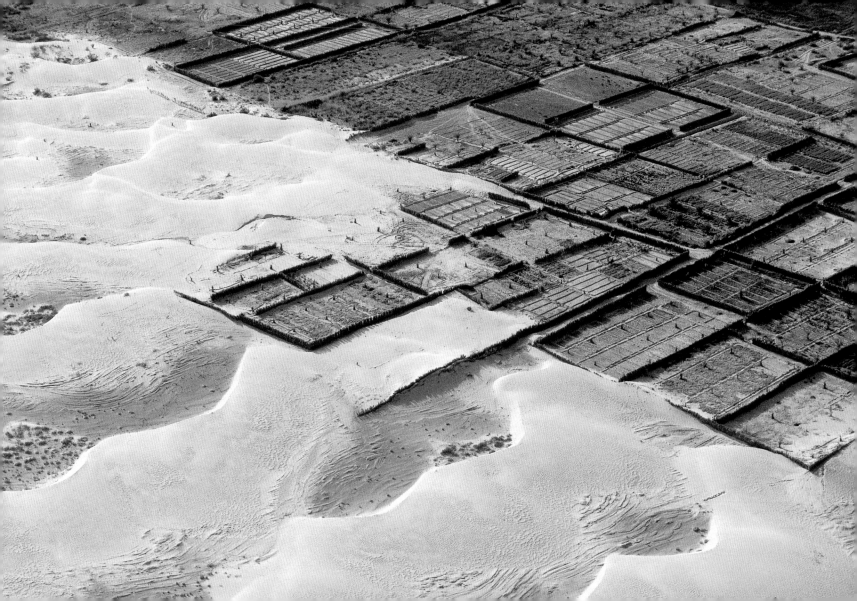

Somaliland. Somalia. Crops grown in terraces. Shiik Abdal area.

In these regions, prone to malnutrition and among the poorest in the world, growing melons and tomatoes in terraces where the ground is hilly is rather unusual. Foodstuffs are generally grown on the very rare arable sites in flat zones. With only 400 millimeters (16 inches) of rain per year, falling in the interval between two dry seasons, water is the primary factor limiting the survival of agricultural populations. Here in Somaliland (Somalia, Djibouti, and eastern Ethiopia), it is stocked in reservoirs (*hafir*) and transported short distances to feed microirrigation systems. Here, as in Yemen across the Red Sea, competing with foodstuffs for arable land is khat (*Catha edulis*), a hallucinogenic plant of the Celastraceae family. Most men over 18 chew khat up to three times a day. As a bunch of khat sells for two or three dollars, addiction to the drug is at the center of a considerable economic circuit.

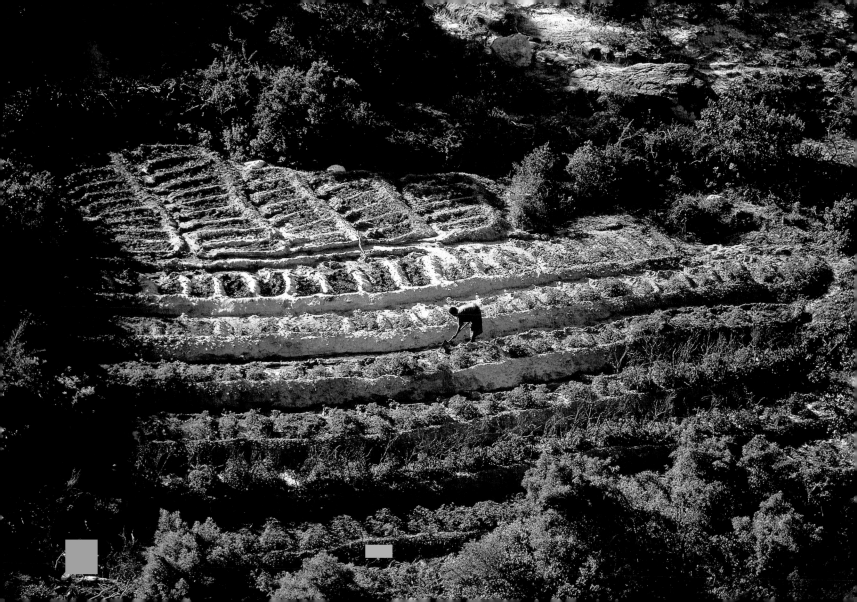

Madagascar. Antananarivo region. Laboring in the rice fields on the shore of Lake Itasy.

During the past two hundred years, the Lake Itasy region has shifted over to intensive rice production controlled by large landowners. One of the results of this switch from polyculture to irrigated monoculture has been the spread of malaria to the island's high plateaus. The growing period for rice coincides with the reproduction period of the *Anopheles funestus* variety of mosquito, an excellent carrier of the disease. The practice of irrigating without drying regularly helps the larvae hatch and thrive. Although malaria was controlled in the 1950s by nivaquine and DDT, Lake Itasy has remained a reservoir for the disease. Political disorder, interrupted or irregular treatments, shortages of medicines, and most importantly the increasing resistance of new strains, led to a new epidemic in the 1980s, which is beginning to kill tens of thousands of people each year. There is a worldwide struggle going on between the rate at which new treatments are discovered and the speed at which microorganisms mutate. Sanitary conditions and, above all, the social and political situation will be major factors determining the future health of the region.

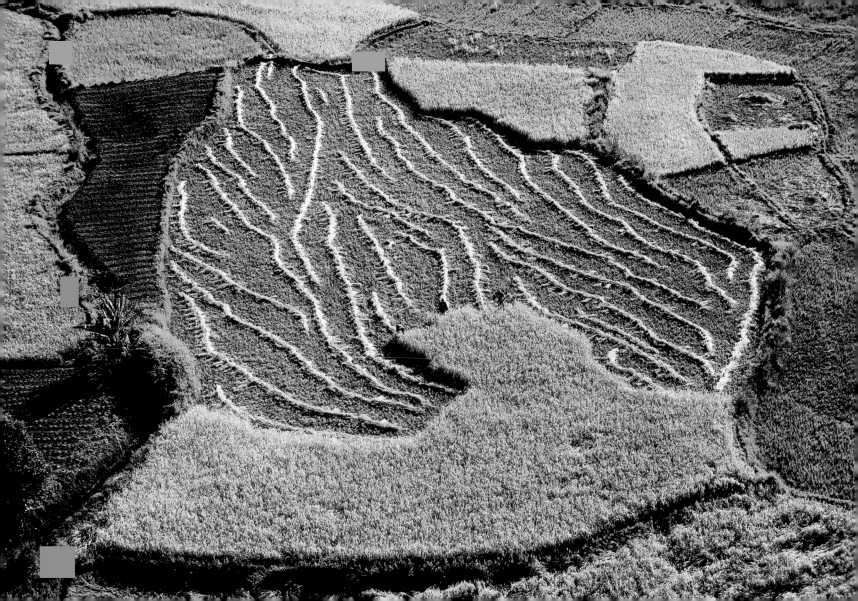

Japan. Tokyo. Shinkuju District.

Our world is changing. Cities are springing up, expanding, swallowing vast areas of land and bringing together millions of people. Tokyo now has 28 million inhabitants and stretches for 70 kilometers (45 miles). It is the world's largest urban center, but it will soon be overtaken by Cairo, Lagos, Bombay, or São Paulo—it is in poor countries that the largest urban areas the planet has ever seen are now growing. A significant proportion of tomorrow's 5 billion town dwellers will be concentrated in the 25 megalopolises of 7 to 30 million people that the planet is predicted to accommodate in 2025. Three-quarters of these will live in southern countries, and by then Tokyo will be the only city in a developed country still on the list of the world's 10 largest cities. Urban growth has been largely uncontrolled. It is now necessary to create a new urban civilization that respects both its citizens and environment, and strives towards sustainable development.

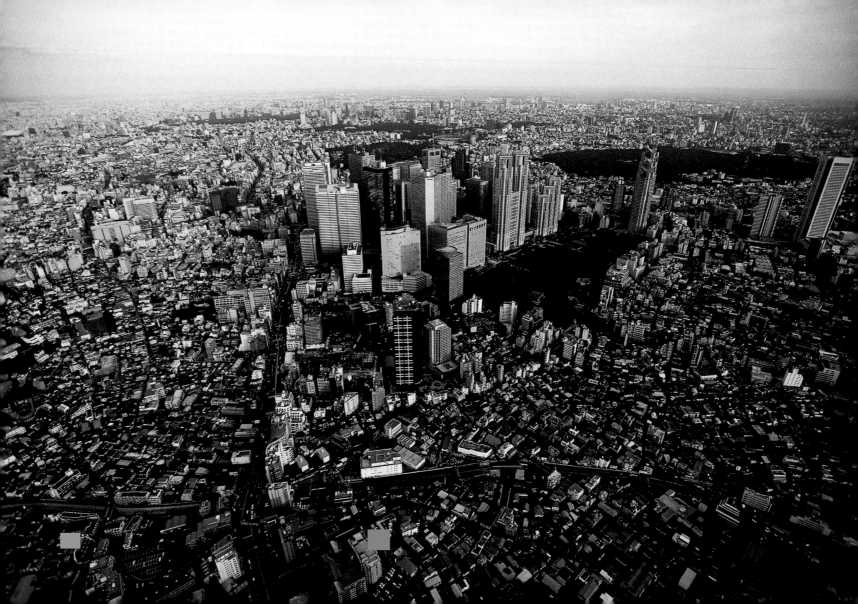

Niger. Aïr Massif. Minaret on the great mosque at Agadez.

The great mosque at Agadez, on the Aïr Massif in the center of Niger, was built in the sixteenth century, when the city was at its height. The mosque is made of dried earth in the "Sudanese" style, topped by a pyramid-shaped minaret 27 meters (90 feet) tall, and spiked with thirteen rows of stakes to strengthen the structure and serve as scaffolding when the structure periodically needs its facade renewed. Agadez is the last large urban center before the Sahara to the north, and an important commercial crossroads, located where the great trans-Saharan caravan routes intersect. It is one of Islam's holy cities and the majority of its inhabitants, like 99 percent of Niger's population, are Muslim. Today, there are more than 1.1 billion followers of Islam, making it the second largest religion in the world.

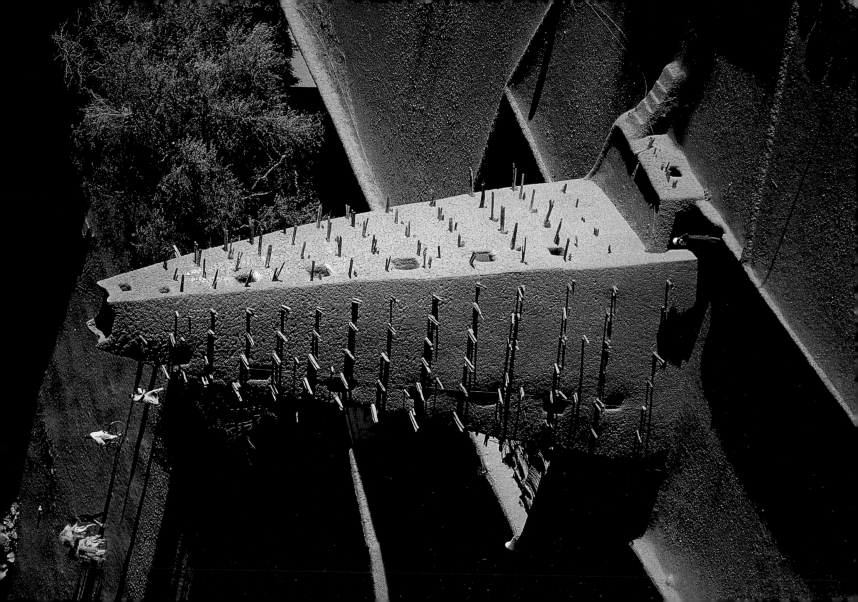

Kazakhstan. Kazalinsk region. Burnt land near Kazalinsk.

Beyond the Ural River, from the Caspian Sea to Sin-Kiang, the Kazakh steppes extend out of sight. Fewer than 10 million Mughal-Turks inhabit these 2.7 million square kilometers (1 million square miles), which have traditionally served as a buffer zone between China and Russia. The last uprising of rebel hordes (which is what *kazakh* means in Turkish) ravaged the country between 1783 and 1796. Then in 1846, in order to protect Siberia, the Russians annexed the region and began sending colonists whose descendants now form 35 percent of the total population. In 1941, Stalin deported some of the Germans who had been settled on the Volga by Catherine II in the eighteenth century. They introduced grain agriculture to the region, and for a while it seemed that a new breadbasket had emerged in the East. However, with the return of ethnic Germans to the Federal Republic after the collapse of the USSR, the Kazakhs returned to their traditional agricultural methods, which yield barely 1,500 kilograms per hectare (1,350 pounds per acre) and fail to preserve their soil from wind erosion. Neither men nor plants, nor the very earth seem capable of staying put in this country.

India. Uttar Pradesh. Wheat harvest in the Mathura region.

Watered by the Ganges and its tributaries, which are fed continuously by the Himalayan snows, northern India is a fertile plain, one of the country's largest agricultural regions. Wheat grown for local and national consumption is harvested by hand—chiefly, as here, by women. Working within families, growing, gathering, and preparing food for their immediate circle, the women are usually unpaid. When they are paid as farm laborers, women are always at the bottom of the earnings scale, and of the pecking order. Very rarely are they employers; moreover, women own less than one percent of land worldwide. In most of the world's poorest rural areas women have neither the right to work the land in their own name nor access to bank loans. With mechanization and the industrialization of agriculture, the number of farm workers in the world is constantly shrinking. Globally, however, this statistic only applies to men. Women make up a growing proportion of the agricultural workforce.

Brazil. Amazonas state. The Amazon Rain Forest near Manaus.

Slightly longer than the Nile at 7,025 kilometers (4,365 miles), the Amazon has the largest river basin in the world: almost 6 million square kilometers (2.3 million square miles) extending across six Latin American countries. The fastest-flowing river in the world is also the most navigable, allowing easy exploitation of the Amazon Rain Forest. With more than 3,000 species of trees identified, 30 of which are commercially valuable, the rain forest is Amazonia's most important resource. Clearing the land of forest might be expected to allow farmland to expand, but it is hindered by the poor quality of the soil. Logging in the Amazon rain forest has proved extremely destructive. Huge areas are cleared and felled trees are dragged into piles, causing permanent damage to the soil as the chains used to pull them destroy the extremely thin layer of humus. With no plant cover left to soak it up, the rains wash the ground clean, causing many of the Amazon's tributaries to silt up. While the rice paddies of Asia can bear the pressure of 1,000 inhabitants per square kilometer (2,590 people per square mile), this lovely rain forest, with one-thousandth of that population density, is under threat.

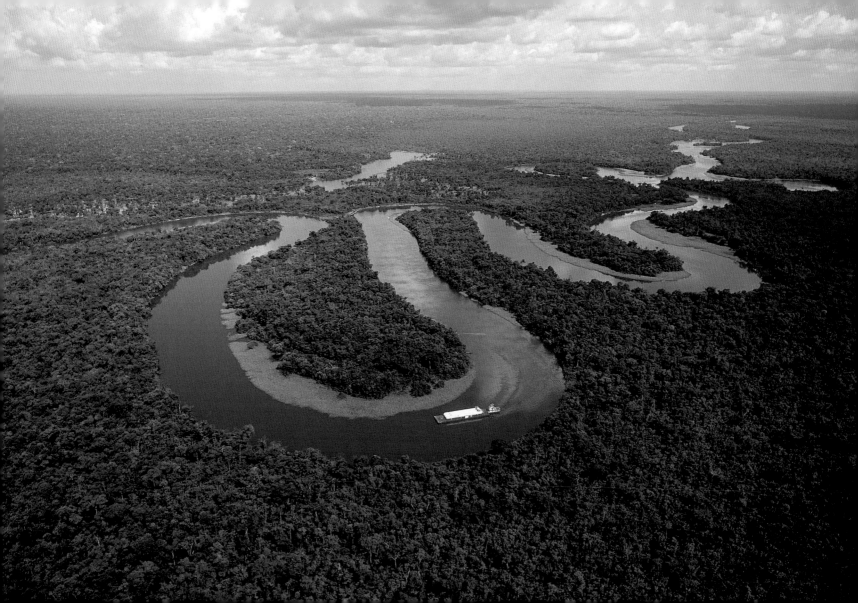

France. Puy-de-Dôme. Range of volcanoes in the Auvergne. The Puy de Côme.

In the heart of the Massif Central is a range of about 80 extinct volcanoes, the Puys, or Dômes, which testify to the recent volcanic activity (15,000 years ago) of the region. Named after the old French *Puy* or Celtic *Duma*, which both convey the impression of height, they have also been described as "textbook volcanoes," being remarkably well preserved with well-defined summit craters. The pristine quality of this natural heritage is linked to the sparse population, the reforestation of areas deserted by the rural exodus, and the persistence of the old customary legal framework which has always favored collective property over private parcels of land. The creation of the Parc Régional des Volcans in 1977 reflects the increasing wildness of the region, but equally illustrates that there are contradictions in "managing" nature. As the forest grows, it is gradually encroaching upon the volcanoes' summits, obscuring their classic form. In addition, the interests of green tourism do not necessarily coincide with those of sheepherders wanting to enclose their pastures. All it will take is the reintroduction of wolves before there will be general conflict.

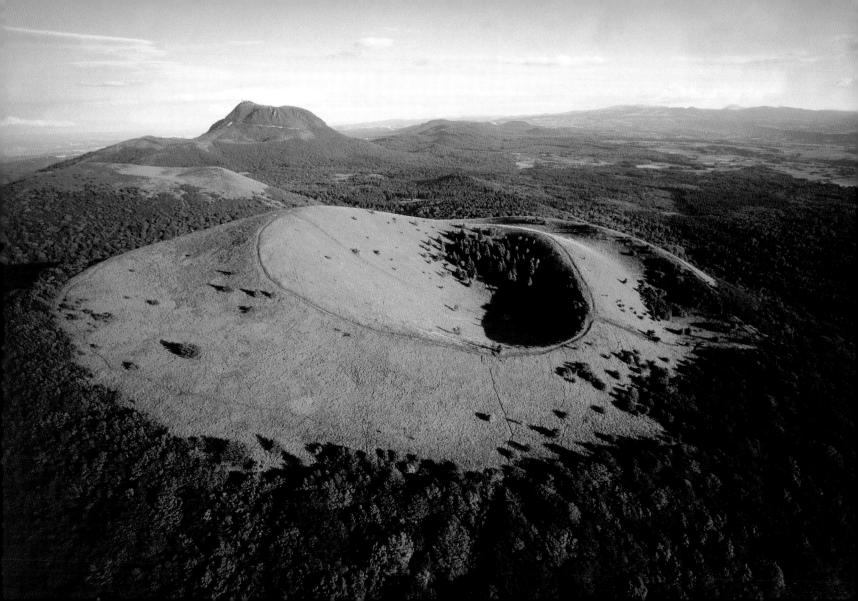

United States. Alaska. Wooded islet on a lake of the Kenai Peninsula.

With 1.5 million square kilometers (600,000 square miles), Alaska is the largest state, accounting for one-fifth of the total land area of the United States. The Kenai Peninsula, on the southern coast, is, unlike the greater part of the region, protected from permafrost by a temperate ocean climate. It consists of landscapes of forests and lakes whose clear waters reflect the sky before winter covers them with ice. The lakes are full of fish, teeming with rainbow trout and Nordic pike and above all, salmon, which swim up the peninsula's rivers and streams in summer to the delight of the black and grizzly bears of the region. The salmon are equally pursued by fishermen, both leisure and commercial. Ten million salmon are caught every year and supply the Alaskan preserving industry, whose output makes up half the canned salmon consumed in the world.

Italy. The city of Venice.

Venice is not one island, but an archipelago of 118 islands separated by 200 canals and spanned by more than 400 bridges. The Grand Canal – "the most beautiful street I believe in all the world," according to Philippe de Commynes in the fifteenth century – is its main artery. On the banks of the canal, the Venetian aristocracy built the most beautiful of Renaissance and Baroque palaces, as well as the city's main churches. Such edifices, and many of the city's other famous spots, such as Saint Mark's Square, the Doges' Palace, and the Teatro La Fenice, are symbols of *La Serenissima's* exceptional destiny, which was connected primarily to its mastery of the sea. From A.D. 1000, Venice strove to impose its supremacy, establishing commercial outposts, first over the Adriatic and then the entire Mediterranean as far as the Black Sea. Up until the seventeenth century, before the continental powers came to the fore, maritime powers such as Athens, Rome, Genoa, Venice, the Netherlands, and England carried the day. Some think that the twenty-first century will see the return of great maritime powers – Europe, the United States, and Japan – as much for commercial reasons as because populations are localized close to seas and oceans.

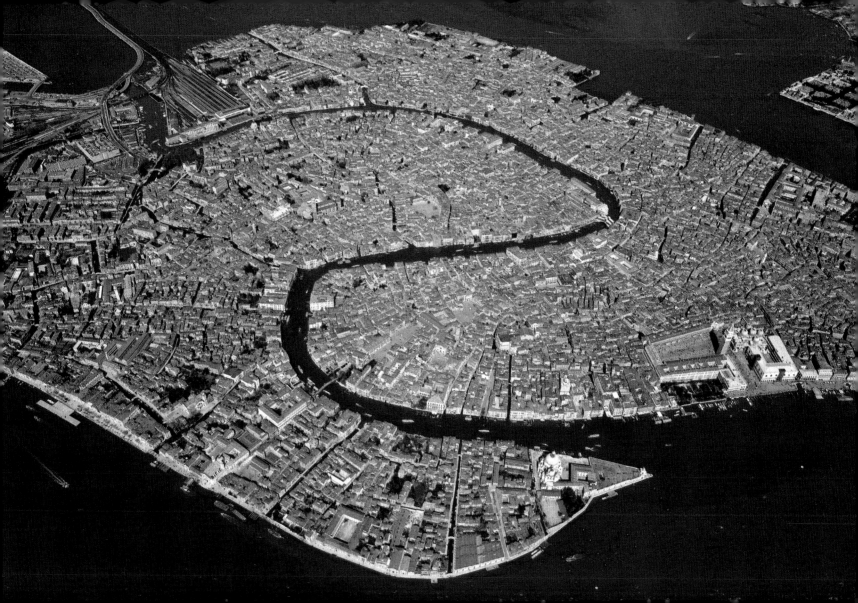

Spain. Andalusia. Landscape of fields.

The clay hills south of the Guadalquivir Valley are ideal for grain crops. For thousands of years they have been terraced, first by the Iberians, then by the Romans, and finally by the Muslim Berbers who occupied the region in 711 and remained for seven centuries. The only ones who did not cultivate crops were the Vandals, who left behind only their name: "Vandalusia" became "Andalusia." With its six million inhabitants, Andalusia is the most densely populated region of Spain, and marks the transition between Europe and Africa. Bananas and sugar cane are grown in the subtropical climate of the plains, while grains such as barley, rye, and durum wheat are sown on the high ground, as they are in Kabylia, Algeria, and in the Rif of Morocco. The desert in the rain shadow of the Sierra Nevada in the east of the region is an ideal location for filming Westerns. Today, Africa's presence is felt in the form of thousands of Moroccans who try to cross the Strait of Gibraltar to seek employment in Europe. In 2000, 456 of them drowned in the attempt.

United States. California. Wind turbines in Banning Pass, near Palm Springs.

This superb landscape of aeolian stars is becoming a classic sight in North America and northern Europe. (Germany currently leads in terms of installed output.) The use of wind power, albeit marginal in a world energy context (approaching 10,000 megawatts in early 1999), saw exceptional growth during the last three years of the twentieth century. Projects that have already begun should bring the world output to more than 20,000 megawatts by the end of 2002. Totally renewable and nonpolluting, wind power is harnessed using the most modern of methods developed by the aeronautics industry.

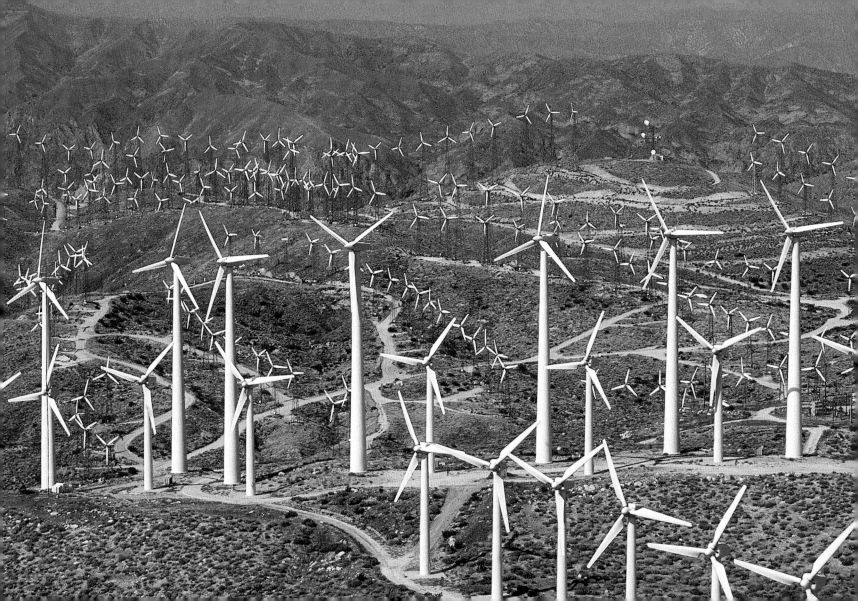

Russia. Kamchatka. The snow-covered flanks of the Kronotskaya volcano.

The eastern extremity of Siberia, the Kamchatka Peninsula, stretches over 370,000 square kilometers (140,000 square miles). With fewer than 1 person per square kilometer (less than 2½ per square mile), this very mountainous region of the Russian Federation is dominated by nature. With its many volcanoes (more than 100, of which about 20 are still active), it forms part of the Pacific "Ring of Fire." Kronotskaya is one of the highest at 3,528 meters (11,500 feet), while the remainder vary between 1,000 and 1,600 meters (3,000 and 5,000 feet). The region also contains numerous hot springs, geysers, violent rivers, waterfalls, and torrents. It also includes the 9,000 square kilometers (3,500 square miles) of the Kronotski Nature Reserve, inhabited by Kamchatka brown bears, lynx, sables, and foxes. Separated from Kamchatka by the Bering Strait is Alaska, which has a similar topography. During the Ice Age when the narrow strait was dry land, small bands of people and numerous animals left Kamchatka and progressively settled the Americas. The Sioux, the Incas, and the Guarani Indians are their descendants.

Brazil. The Corcovado towering over Rio de Janeiro.

Perched on a 704-meter- (2,310-foot-) high rocky peak known as the Corcovado ("the Hunchback"), the statue of Christ the Redeemer dominates the Baía de Guanabara and its famous "Sugar loaf," as well as the whole of the Rio de Janeiro metropolitan area. The city's name (River of January) was the result of a mistake by the first Portuguese sailors who cast anchor there in January 1502; they thought they had found the mouth of a river. The capital of Brazil from 1763 to 1960, Rio de Janeiro is now a megalopolis that extends out over 50 kilometers and has a population of over 10 million. The statue of Christ the Redeemer on the Corcovado is a reminder that Brazil is the largest Catholic country in the world, with 121 million baptized. Worldwide, the Catholic Church, with its 1 billion members, is the largest group within Christianity, itself the largest religion in the world with 2 billion followers.

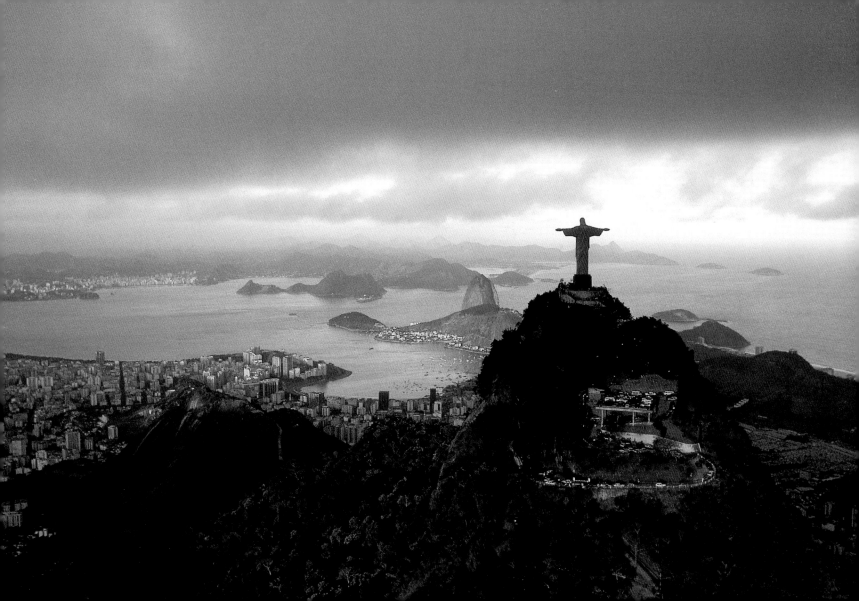

Japan. Honshu. Greenhouses between Nara and Osaka.

Since the 1960s, Japan has undergone important changes in agriculture, including the development of dairy farming and fruit production, and the increase in industrial production of meat. These changes are reshaping the rural Japanese landscape. Vinyl greenhouses for the intensive farming of fruit and early vegetables have multiplied in the suburban areas of the main cities such as Tokyo and Osaka. They have even extended into such traditional rice-growing areas as the plain of Nara, the island of Honshu, and even Okoyama, to the point of supplanting rice altogether. Traditional crops such as blackberries, tea, wheat, and barley are diminishing to such an extent that Japan must import large quantities of wheat, barley, and silk. Just 30 years ago, Japan was the largest silk exporter in the world.

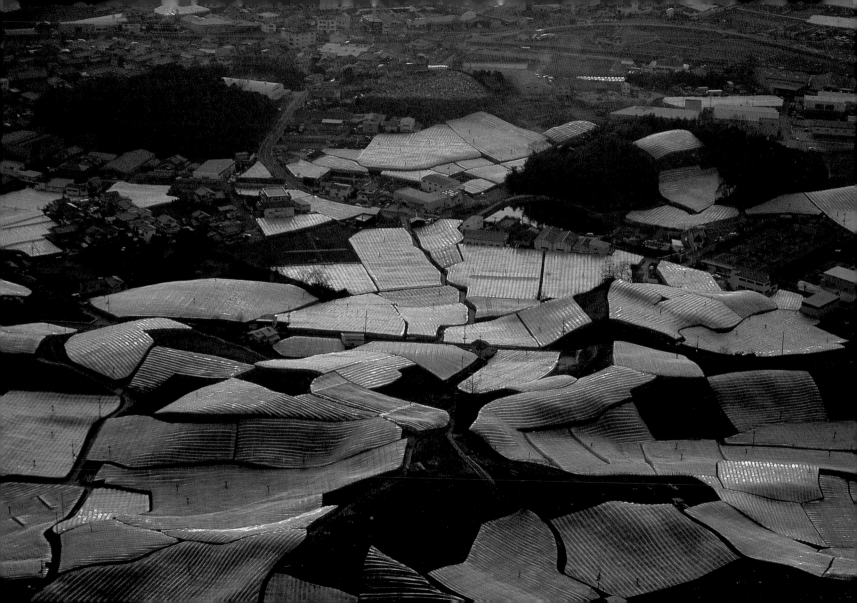

Tunisia. Governorate of Nabeul. Agriculture near the town of Hammamet.

Tunisia has a long tradition of irrigation. But thousands of years of exploiting the soils has made them fragile, and salinization has gradually sterilized them. The depletion of near-surface groundwater reserves is forcing residents to exploit ever deeper sources. Despite these unfavorable conditions, discernible for three decades, irrigation, with all its advantages, is a permanent feature and a priority of Tunisian agricultural policy. Thirty to 40 percent of the country's agricultural investment goes toward providing substantial infrastructure to mobilize, transfer, and distribute water. The amount of area irrigated has increased fivefold over the past 30 years and currently stands at more than 250,000 hectares (600,000 acres). The production of fruits and vegetables has gradually replaced grains, and now satisfies domestic demand. Export markets are developing quickly, led by the supply and demand for dates and citrus fruits. Tunisia could become one of Europe's market gardens, rather like Italy and Spain 40 years ago.

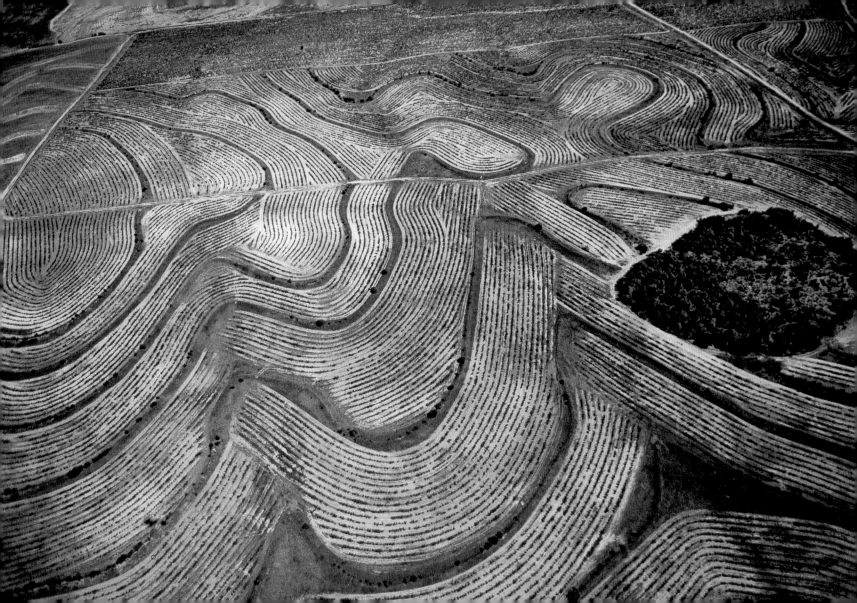

France. Yvelines. The Château of Versailles at sunset.

In 1661, King Louis XIV of France ordered a palace to be built at Versailles near Paris – the construction of which, on boggy ground, would take 50 years. Erected in the middle of an estate of 800 hectares (2,000 acres), adorned with sumptuous gardens, 34 pools, and 600 fountains, the château covers 55,000 square meters (180,000 square feet). For a few years it housed 1,000 aristocrats and 4,000 servants, but was pillaged during the 1789 Revolution and then abandoned. Since the end of the nineteenth century it has gradually been restored and refurnished, primarily thanks to the gifts of 400 patrons and grants from the French state. Designated a UNESCO World Heritage Site in 1979, the Château of Versailles is now largely restored and receives more than 2.5 million visitors every year.

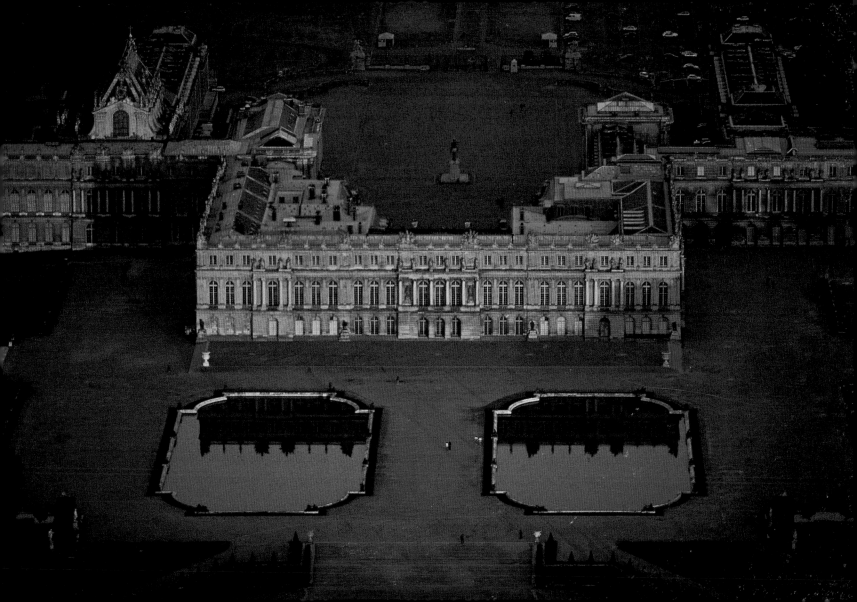

Iceland. Myrdalsjökull region. River near Maelifellssandur.

Fed by thawing glaciers and an annual rainfall of 1,200 millimeters (47 inches), the rivers of Iceland, as here in the region of the Myrdalsjökull, all follow a glacial pattern: low water levels in winter and maximum volumes in summer when the big thaws occur. The rivers are interrupted by waterfalls and rapids, as the young volcanic shape has not yet been softened by erosion. They are adored by fishermen, who come from all over the world to catch salmon and trout; the visitors often pay large sums for daily permits to the landowners whose farms they run through. Two hundred years ago, salmon and trout were no less plentiful in the rivers of France. The contracts of agricultural laborers forbade their masters from serving them salmon more than twice a week. Although it may not be as obvious, our rivers have been modified no less than our landscapes by agriculture and industry.

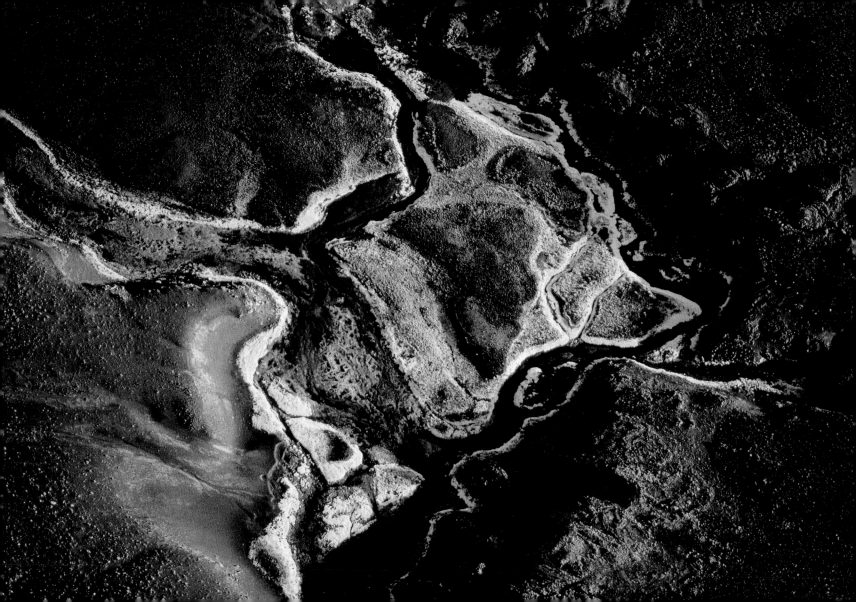

United States. Utah. Lake Powell. Arm of the San Juan River, western part.

Located on the Utah-Colorado border, Lake Powell is one of the largest artificial lakes in the world. With its surface area of 65,000 hectares (160,000 acres), depth of 170 meters (560 feet), length of 300 kilometers (185 miles), and shoreline 3,500 kilometers (2,200 miles) long, it is truly on an American scale. The lake originated with the construction of the Glen Canyon Dam in 1956, but did not become a lake proper until 1980, filled by water from rivers such as the Colorado, San Juan, Escalante, and Dirty Devil. The successive stages of its creation evoke the region's history, that of the mythical West and of its Indians, whom the nineteenth-century European colonists on the east coast went west to conquer. Before it was lost under Lake Powell, the land here belonged to the Navajos, who were forced to swap it for another territory in southern Utah, of the same size though much less useful. The future may bring some justice, however. There are now more than five million Native Americans in the U.S., and their numbers are rapidly increasing. Many groups are successful in reclaiming their ancestral lands, and Lake Powell could soon become Navajo territory once more.

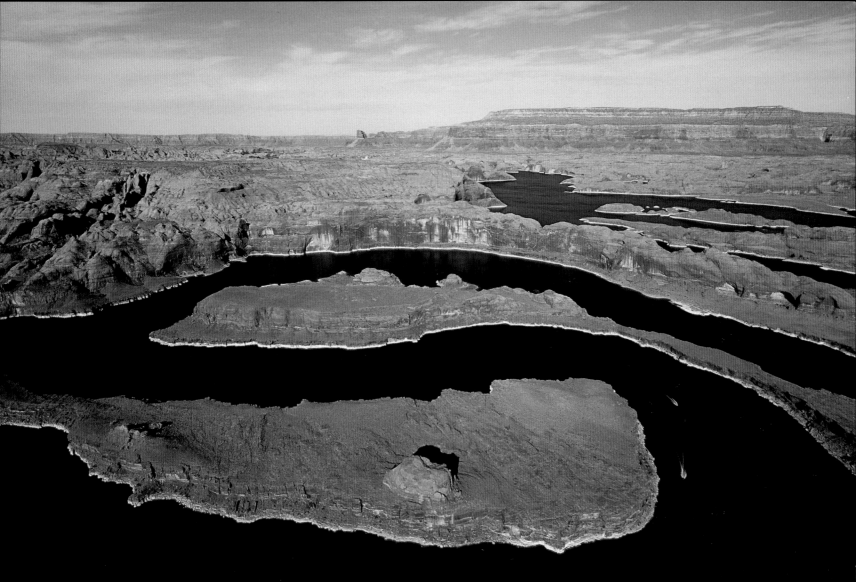

Kenya. Pink flamingoes on Lake Nakuru.

Lake Nakuru, with its 62 square kilometers (24 square miles) within Lake Nakuru National Park, is home to almost 370 species of birds, among which the lesser flamingo *(Phoeniconaias minor)* and pink flamingo *(Phoenicopterus ruber)* are the most numerous. The high salt content of the water encourages the growth of algae, plankton, and shrimp, which constitute the essential food for these birds. However, the chemicals used in local agriculture have slowly polluted the lake, limiting the growth of its vegetation and habitat for small animals. The flamingo, which numbered 2 million here in the 1970s, have gradually deserted the lake, and more than two-thirds have now migrated to other lakes. It is estimated that this region, the East African Rift Valley, is home to more than half the world's flamingoes.

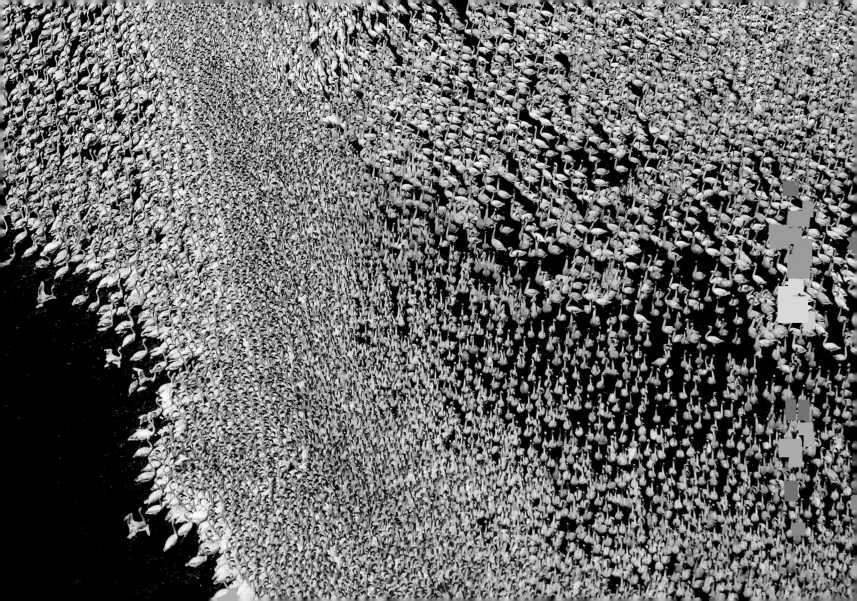

United States. New York Marathon crossing the Verrazano Bridge.

Are sports a concern of only the privileged few? Regrettably, one might think so, for playing sports improves quality of life, while its educational benefits are universally recognized. Nevertheless, involvement in athletics is largely dependent on a good standard of living, and poor people whose basic needs are not met are largely excluded from it. The great sporting nations, after all, are the richest countries. At the 1984 Los Angeles Olympics, 687 medals were awarded: 597 (87 percent) to 26 industrialized countries and 90 (13 percent) to 21 developing countries. It is precisely the same gulf that separates north from south in the world economy. Nevertheless, competitive spectator sports are a passion shared by the entire planet. The great tournaments that attract vast crowds are also a mirror of countries' social and political situations; these contests increasingly reflect the hostilities between nations. The political stakes are increased by the addition of economic stakes, with money an ever present fixture of the games. Plagued by these problems, as well as by drugs and corruption, world athletics need to face up to these issues if they are to remain of benefit to the population as a whole.

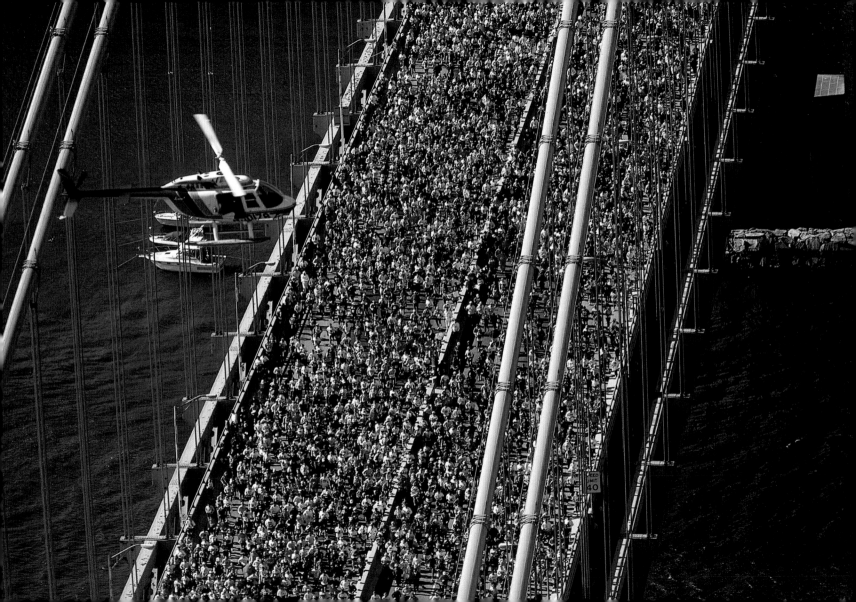

Réunion Island (France). Helicopter in the Cirque de Salazie.

In the middle of the French department of Réunion Island is the Cirque de Salazie, whose steep sides are punctuated by a series of waterfalls known as the Bride's Veil. Nowadays this vast, 10,400-hectare (26,000-acre) crater, which is overlooked by the extinct volcano Piton des Neiges, 3,069 meters (10,066 feet) high, is the most accessible of the island's three *cirques* – natural amphitheaters formed by erosion of the volcano. Nevertheless, the isolated conditions in which people used to live there remain legendary. At the end of the eighteenth century, the French settlers who came to exploit the resources of the Bourbon island were excluded from working on the sugar plantations and driven back into the highlands. This resulted in the cultural isolation of a group that came to be known as the "Petits Blancs," as opposed to the "Grands Blancs" who grew rich by growing sugar in the lowlands. The highlands were not opened up until 1946, when a road was built across the cirque. At that point many of the "Petits Blancs" emigrated to the coast, and then to France. The development of mass tourism has trapped those who remain into an "exotization" of their famously old-fashioned culture, thus perpetuating the "curse of the Cirques" in a different form.

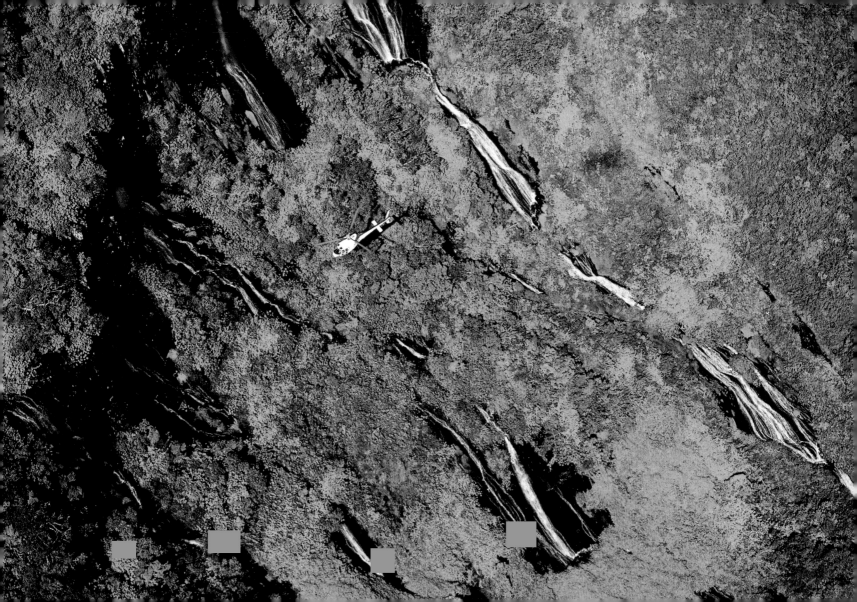

Morocco. Carpets in Marrakech.

Morocco's world-famous carpets sell well abroad. Most are machine-made in factories, but small-scale and family business manufacturing are still a thriving tradition in Morocco. The carpets are traditionally woven in wool, which symbolizes protection and happiness, commonly mixed with silk, cotton, and sometimes camel or goat hair. Different regions produce their own traditional colors and designs, and the High Atlas, which towers above Marrakech, produces the warmest tones of red, orange, and yellow. Ninety percent of the High Atlas carpets are made in the towns of Tazenakht and Amerzgane, almost exclusively by cheap, female labor. In spite of a constitution that (in theory) guarantees equality between the sexes, the place of women in Moroccan society, as in all Muslim countries, is not an enviable one. The law on personal status particularly discriminates against women. If a divorce is granted, the husband retains the right to reject the wife and children without compensation, often condemning them to a life of shame and poverty. Polygamy is still common among men, while women cannot marry without the consent of their guardian. In cases of inheritance, women are entitled to just half of what men receive. Human rights organizations have been greatly encouraged by the decision of the young King Muhammad VI to improve women's legal status in Morocco.

Bangladesh. Flooded village south of Dacca.

With 850 inhabitants per square kilometer (2,200 per square mile), Bangladesh is the most densely populated nation in the world, three times more so than India and seven times more than China. It is also one of the poorest countries, with a GNP of $260 per inhabitant. Situated on a very fertile but extremely low-lying deltaic plain with some 300 waterways flowing through it, Bangladesh has always had to face up to the devastating flood waters of the great Himalayan rivers, the Ganges and Brahmaputra. During the summer monsoon it is not unusual for two-thirds of the country to be under water. The flooding has become more serious as a result of the deforestation of the Himalayas, notably in Nepal. Agriculture, on which four-fifths of the population depends for a living, has reduced the vegetation cover (which used to limit the extent of the floods) to less than 10 percent. Every year these floods claim numerous lives and render one-quarter of the population homeless. The worst disasters, such as those in 1970 and 1991, occur when cyclones pass through accompanied by extremely high tides, resulting in several hundred thousand deaths. Bangladesh is at particularly high risk from the increasing frequency of tropical storms and the slow rise in sea level that are accompanying global climate change.

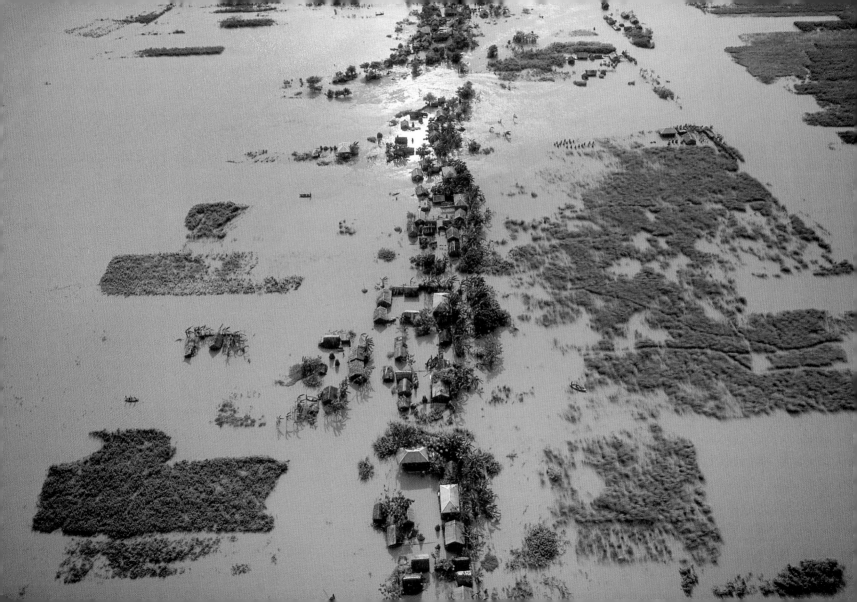

Mauritania. Caravan of dromedaries near Nouakchott.

In Mauritania as in all the countries bordering on the Sahara, the dromedary is the domestic species best adapted to the arid environment. Known as "the ship of the desert," it can go without water for long periods, even for several months in winter if it is on good grazing land. In summer, however, the heat and exertion are such that it can only survive for a few days without drinking (albeit in conditions in which a human being would die of dehydration within 24 hours). The reserves of fat in its single hump provide the animal with both energy and water. Other unique adaptations allow it to conserve body water and it can, for instance, withstand excessive increases in body temperature without sweating. In Mauritania, the Moors rear the dromedary for its milk and meat as well as for its leather and wool. At the end of the 1990s, the country's dromedary population was said to number about one million.

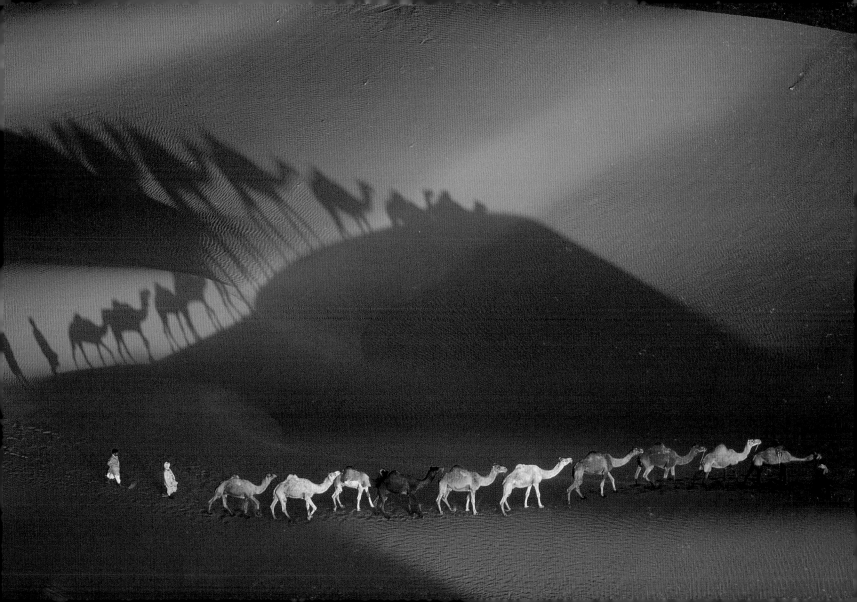

Turkey. Anatolia. Crater near Ilhara.

The chain of volcanoes in Anatolia takes up 8 percent of the land in Turkey. One of them is the Hasan Dagi, which is situated not far from Ilhara, and is a gently sloping volcanic cone rising to a height of 3,268 meters (10,700 feet). In the Neolithic era, the prosperity of this region depended largely on the exploitation of obsidian, a sharp volcanic glass which was invaluable for making weapons and tools. Volcanic activity is also the indirect source of an extraordinary geological formation in the Anatolian landscape, the fairy chimneys. These cavities were carved out of peaks sculpted by the erosion of the layer of tuff (formed over the centuries by the ash and mud belched out by volcanoes) which covered the ground. They were used by the hermits of early Christianity for shelter, then as richly decorated chapels which have now been abandoned. Volcanism and seismic activity remain particularly active in this region; in August 1999 a major earthquake killed several thousand people.

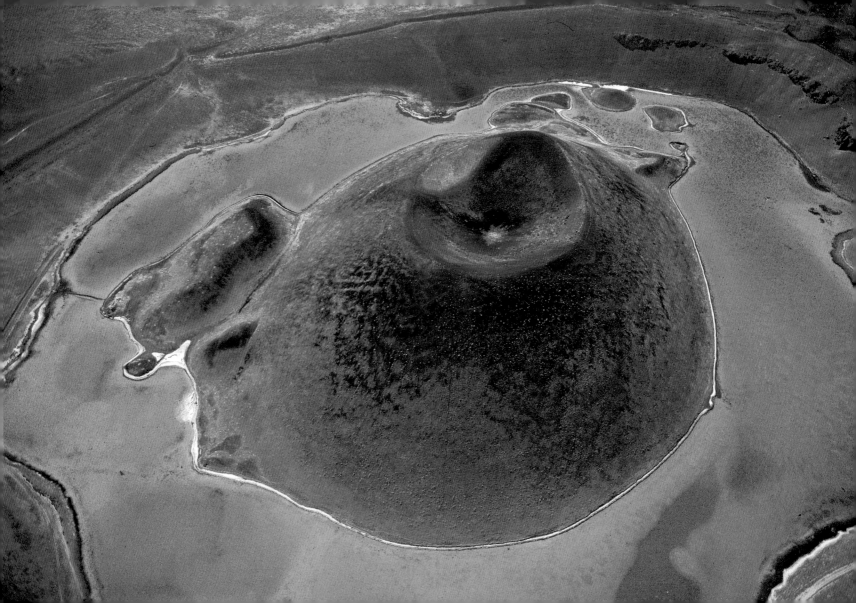

France. Gironde Department. Nature reserve at the Arguin Sandbank.

At the mouth of the Arcachon Basin, between Cap-Ferrat and the Pilat Dune (at 106 meters [350 feet], the highest sand dune in France), the Arguin Sandbank shows through the waters of the Atlantic Ocean. It is composed of a group of sandy islets that change their shape and location according to the winds and ocean currents, following a fairly regular cycle of about 80 years, and with a surface area varying from 150 to 500 hectares (375 to 1,250 acres). Classified as a nature reserve in 1972, the site is a port of call, a wintering- or nesting-place for many species of migratory birds, including a colony of 4,000 to 5,000 pairs of terns (*Sterna sandvicensis*), one of the three largest in Europe. Despite its protected status, the nature reserve is threatened by the onslaught of tourism and the increase in oyster-farming on its perimeters.

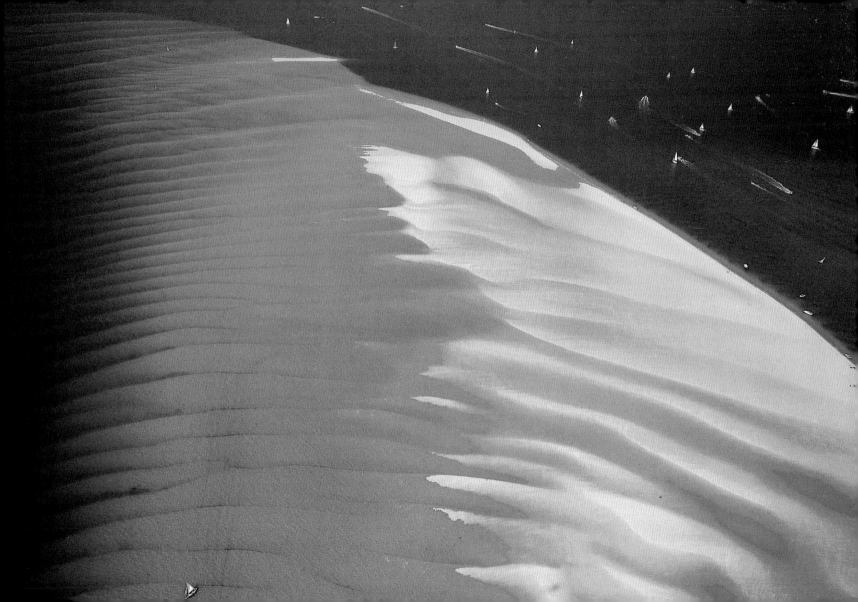

Brazil. Detail of an apartment building in São Paulo.

More than 5 million Paulista – inhabitants of São Paulo – live in underequipped working-class suburbs, in shabby apartment buildings known as *cortiços*. With a population of 18 million, which increases by 600,000 every year, this is the largest megalopolis not only in Brazil, but in the whole of South America. São Paulo is an industrial city and a true driving force of the national economy, with more than 36,000 firms that supply half of the country's manufactured products and employ nearly 45 percent of the Brazilian labor force. Although it is the most prosperous city in the country, almost 1 million of its children (one in five) are said to be living in the street, engaged in begging, petty crime, and prostitution. It is believed that between 7 and 9 million minors have been left to fend for themselves in the streets of the large urban centers of Brazil.

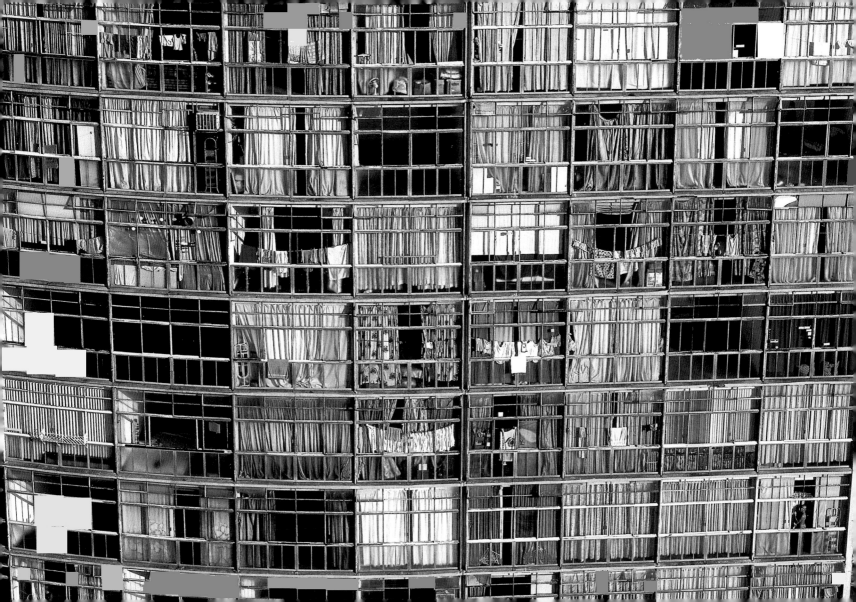

United States. Massachusetts. Brockton, tracks on a frozen lake.

Twelve thousand years ago, the layer of ice on Brockton Lake, located 30 kilometers (20 miles) south of Boston, was much thicker than it is in winter today. It was at the front of the ice cap that covered the whole northern part of the American, Asian, and European continents. This gigantic continental glacier was not stationary, but was slowly moving southward, scraping away at the land beneath as it went. There is remarkable evidence of this to be seen in the Brockton area, including shallow lakes and drumlins, those thousands of streamlined, inverted spoon-shaped hills pointing in the direction of the glacial flow that deposited the coarse sediments that form them. The same glacial action formed similar landscapes in Scotland, Sweden, and in some parts of Siberia.

Lesser Antilles. Saint Vincent and the Grenadines.
Islands of the Tobago Keys, near Union Island.

Seven kilometers (four miles) northeast of Union Island, the southernmost of the Saint Vincent and the Grenadines group, are four barren, rocky little islands and a few reefs which together are known as the Tobago Keys. Protected from the Atlantic Ocean by a coral barrier, their creeks and white sandy beaches fringed by palm trees attract the yachting fraternity, while the richness and diversity of their seabeds have earned them a reputation as the best scuba-diving location in the Caribbean. Their success has been so enormous, however, that the politicians in charge of this independent state of the British Commonwealth have been prompted to take steps to control yacht anchorage and prohibit the removal of any marine flora and fauna. The Tobago Keys have been declared a national park.

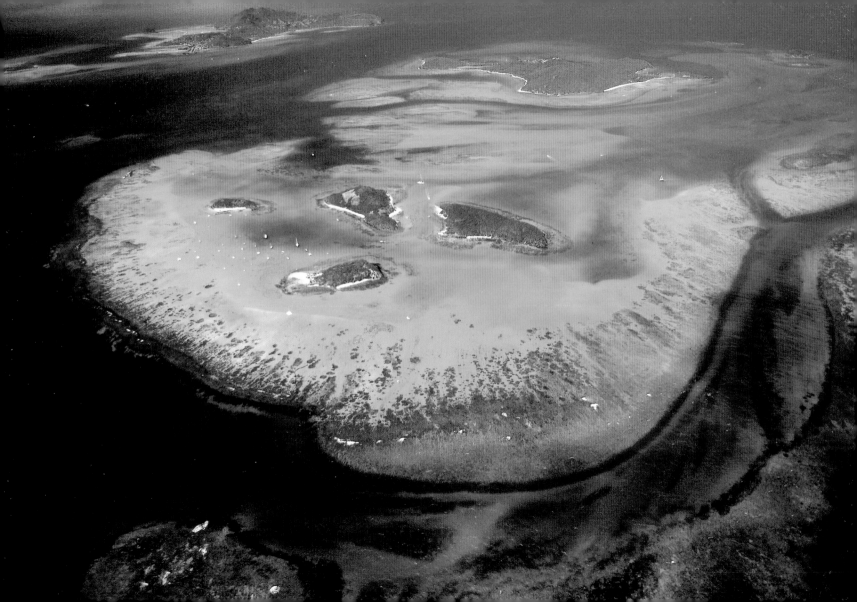

India. Rajasthan. Udaipur. Lake Palace and City Palace.

The city of Udaipur, founded in A.D. 728, entered its heyday in 1567 when Maharajah Udai Singh II made it the capital of the Mewar. The Mewar is a fertile area in the southeast of Rajasthan, and is separated from Marwar, the "land of death," by the Precambrian Aravalli Mountain Range, which stretches 700 kilometers (450 miles) from north to south and divides Rajasthan in two. The western half of Rajasthan has the benefit of the ocean's moisture, whereas the area lying to the east of the mountains, shielded from the clouds and rain by their peaks, is a barren region receiving only 200 millimeters (8 inches) of rainfall per year. In Udaipur, the Moguls irrigated the city, which has three lakes that regulate the urban climate. Udai Singh II constructed a dam to enlarge Lake Pichola before erecting the City Palace on its banks. In 1746 Jagat Singh II built the Lake Palace, a marble gem set on a small island and used as a summer residence by the royal family. This fabulous palace, which has been converted into a hotel since India gained its independence, makes great play of the alternation between water and marble. Its facades are reflected in the water, which ripples all around the building in a succession of fountains, ponds, and hanging gardens. With this creation the maharajahs succeeded in turning the mirage of the floating palaces in the Thar Desert into a reality.

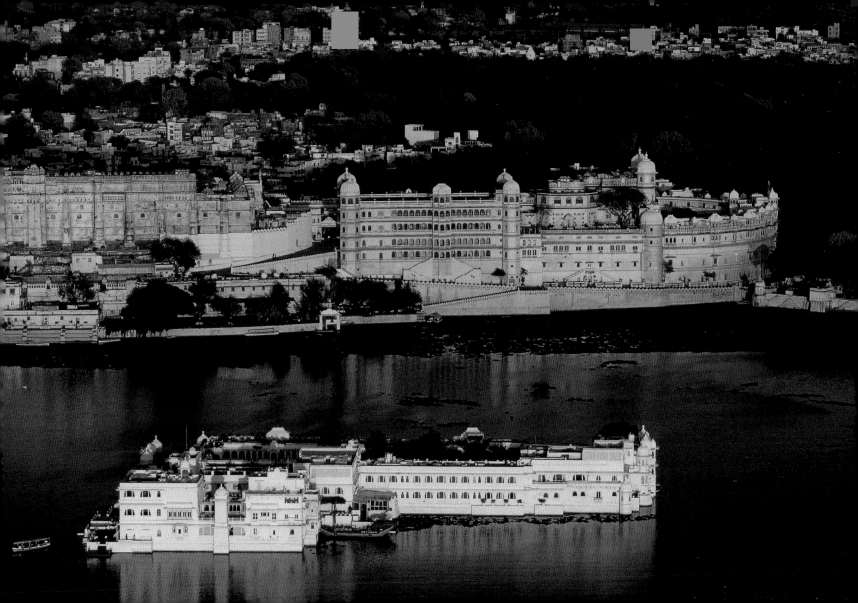

Turkey. Anatolia. Marshes at Kaunos.

The marshes downstream from Lake Köycegiz are very close to the Aegean Sea, facing the Greek island of Rhodes. In the vicinity, near the little fishing port of Dalyan, are the ruins of ancient Caunus, a Carian city in the Rhodian Perea whose ramparts, tombs, and above all, 20,000-seat theater attract many tourists. On the edge of the marsh is a beach that is home to a population of loggerhead sea turtles. Initiatives taken in the 1990s to protect these tortoises from the effects of mass tourism seem to be symbolic of a new ecological awareness in Turkey. Attracting more than seven million visitors each year, tourism is a major economic resource for Turkey.

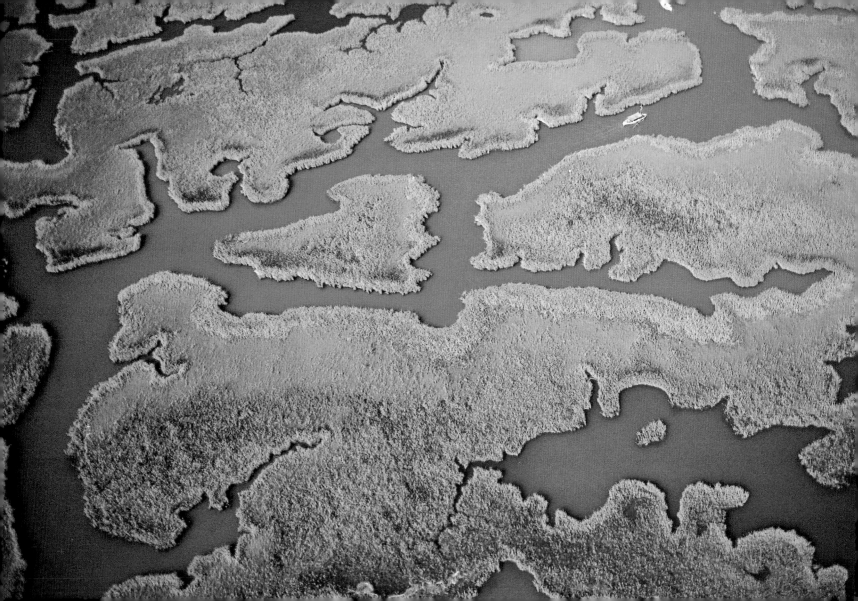

Kenya. Tsavo East National Park. "The Tree of Life."

This acacia in the Tsavo East National Park is a symbol of life in the midst of vast, desolate spaces. Tracks of wild animals which have come to take advantage of leaves or its shade, converge on the tree. Both the main highway and the railway line from Nairobi to Mombasa run through the park. The western side is open to the public, while two-thirds of its more arid eastern part is reserved for scientists. In the 1970s, Tsavo, which was already famous for its many elephants, experienced an even greater influx of pachyderms fleeing from drought and poachers. Crammed into the limited area of the park, they caused serious damage to its vegetation, thus provoking a controversy over the necessity for a selective cull. In the end the poachers put an end to the debate by wiping out almost 80 percent of the 36,000 elephants in the park. Today the Tsavo National Park receives 100,000 visitors each year.

United States. New York City. 570 Lexington Avenue.

The Park Avenue district, and in particular its Midtown area (located between 42nd and 55th Streets, and including Madison and Lexington Avenues), is unquestionably emblematic of New York City. Built between the First and Second World Wars, skyscrapers such as the former General Electric Building (originally the RCA Building) shown here, the Waldorf Astoria, and the famous Chrysler Building are irresistibly captivating to the eye. Their architects made a point of creating distinctive upper stories with a profusion of complex shapes, spires, bartizans, mosaics, or Art Deco motifs – as if their personal touch did not begin until the 30th or 40th floor. Paradoxically, these skyscrapers, which for generations of travelers and immigrants symbolized the New World, are not really representative of an American city, which is in fact, generally made up of millions of private homes scattered around suburbs many of which are far-flung. Future urban development will no doubt be characterized throughout the world by the colonization of vast areas for individual housing. Skyscrapers will generally be limited to ever more concentrated business centers.

Senegal. Dakar area. Small boats on the Pink Lake.

About 20 years ago, the Pink Lake, previously known as Lake Retba, was still fed by the winter rains, which progressively restored the ground water held in the surrounding dunes. Its waters were protected and full of fish, attracting a number of Peuls to settle in the region and set up permanent villages. A subsequent drought, however, halted the supply of fresh water to the lake and dramatically reduced its surface area. This considerably increased its salinity, which today is comparable to that of the Dead Sea, with 320 grams of salt per liter (43 ounces per gallon) – 10 times that of seawater. Some inhabitants of the area say that this natural "disaster" is the vengeance of a spirit-woman who became angry when she saw fishermen stealing the fish from her lake. As a result of the disaster, people who once fished for a living now exploit the salt, collecting more than 30 tonnes (33 tons) every day. The salt-workers use a stick to break up the crust of salt on the bottom of the lake. They then pick up blocks, pack them into a number of plastic containers, and tie them round their waists so that they follow them as they move around. It is possible to take up to 500 kilograms (1,100 pounds) back to the shore and thus earn 1,500 CFA francs (about $2) a day.

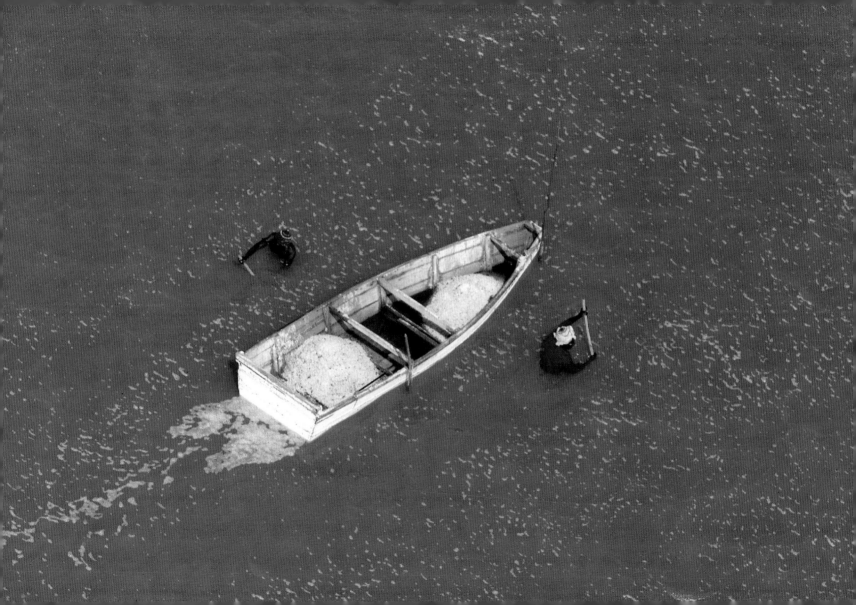

Kenya. Crystalline formation on Lake Magadi.

The East African Rift Valley, extending over almost 7,000 kilometers (4,400 miles), is the result of a rupturing of the Earth's crust that began about 40 million years ago and continues today. Bordered by high volcanic plateaus, the valley is a vast, collapsed gulf, running in a series of depressions from the Red Sea to Mozambique. A string of great lakes, including Turkana, Victoria, and Tanganyika, and other stretches of water such as Lake Magadi (the most southerly in Kenya) fill these depressions. Lake Magadi is fed by rains that leach through the neighboring volcanic slopes, bringing down minerals which give the lake a high salt content. Here and there its surface is mottled with licks, which are crystallized saline deposits mingled with brackish water. Inhospitable though this environment may seem, it is not devoid of life; millions of little flamingoes come to feed on the microalgae, shrimp, and other shellfish which thrive in the waters of the lake.

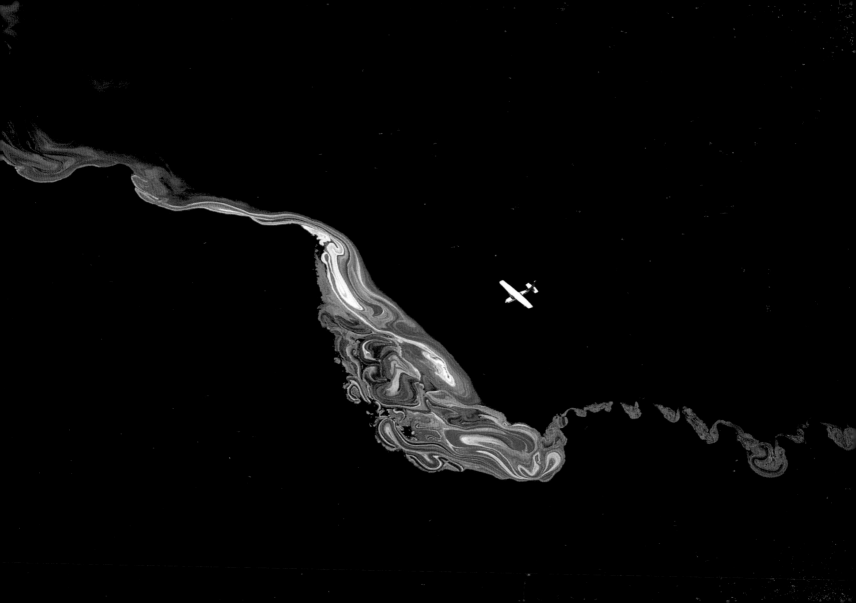

England. Wiltshire. White horse at Westbury.

To the west of London in the county of Wiltshire is the figure of a white horse, carved into the chalk on a hillside near Westbury. This is one of about ten white chalk horses in the region, the most famous of which is at Uffington. The characteristic style of the elongated, clearly separated limbs of the Uffington horse has been linked to drawings on certain Late Iron Age coins. It has been suggested that it was the emblem of one of the tribes of the pre-Roman era, the Dobunni or the Atrebates. For the other white horses, there is no similar evidence that might indicate their origin. Some believe that they are effigies of the dragon fought by Saint George. They were all recarved in the eighteenth century and have been regularly maintained since, the occasions marked by local festivities. Celebrated by the English author Thomas Hughes, who saw them as pale, silent fragments of a pale, silent world, they continue to give rise to the most diverse interpretations. Whatever the truth may be, they show that since very early times man has sought to shape the landscape and leave on it a lasting mark of his power or his dreams.

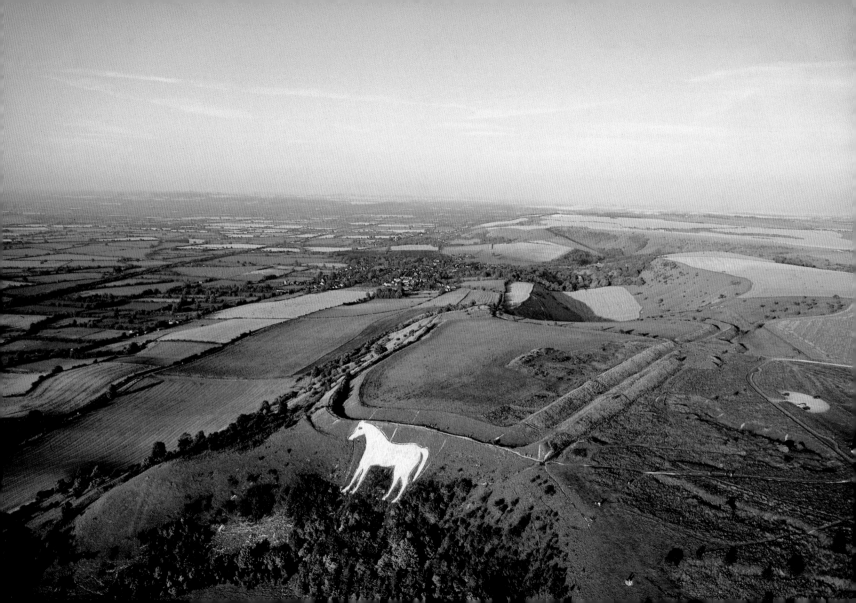

Argentina. Tea-growing in the province of Corrientes.

The fertile red earth and regular rainfall of the Corrientes region of northeastern Argentina provide optimal conditions for growing tea. In order to protect the soil against erosion, the tea is planted along the topographical contour lines and is protected from the wind by hedges. In Asian and African countries the young shoots are harvested manually, but in Argentina the picking is done mechanically, primarily with tractors that move to and fro around the regular rows of bushes. The hybrid Indian Assam variety of tea that is cultivated in this region is produced only in limited quantities of about 50,000 tonnes (55,000 tons) per year. Harvested in summer, tea complements the large winter production of traditional maté, a sort of holly drunk as an infusion and known as "Jesuits' tea." Tea is currently grown in 40 countries, with India, China, Sri Lanka, and Kenya supplying 60 percent of world production.

Japan. Honshu. Temple south of Tokyo.

If one had to find just one word to define the spirituality of the Japanese, it would be "syncretism," a combination of different religious beliefs and practices. Rather than a single religion, theirs is more a fusion of the native animist and polytheist beliefs and the monotheist doctrines imported from abroad: Shintoism, Buddhism and its many sects, Confucianism, and to a lesser extent, Christianity (to which more than 1 million of Japan's 121 million inhabitants subscribe). In the course of the day, the Japanese may equally well stop off and meditate in a Shinto sanctuary, a Buddhist temple, or a Christian chapel, all of which may stand immediately next to one another. They are aware of this diversity, and joke that their country has 300 million believers: at birth they believe in Shintoism, the cult of life; at marriage they subscribe to Christianity for its pomp and ceremony; and at death, Buddhism offers them a gentleness that no other can rival.

Mali. Pirogues on the Niger River at Gao.

The Niger River is an important artery in Mali, providing a commercial link between the outskirts of the capital, Bamako, and Gao 1,400 kilometers (850 miles) to the northeast. Even so, ships of average size cannot travel along it except during the high-water period from July to December; for the rest of the year it can only be navigated by boats drawing quite shallow water. The Bozos are traditionally a fishing people who have become the "masters of the river" by providing local transport in their wooden boats. These large, fragile-looking dugout canoes make frequent trips to and fro in the harbor at Gao, and can each transport several tons of merchandise. In particular they go from one bank of the Niger to the other, carrying large quantities of *bourgou,* a fodder plant that grows in the river and is used to feed the transhumant livestock in the region.

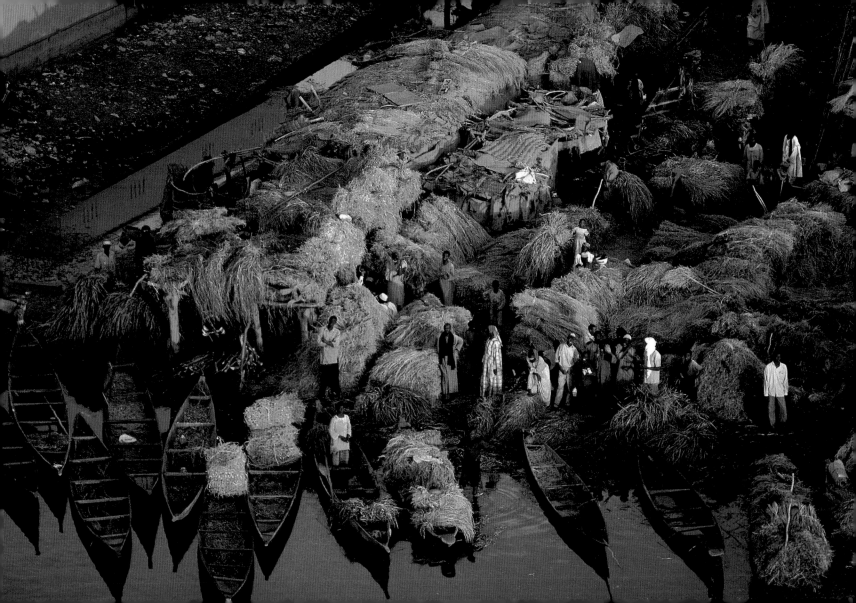

Tunisia. Governorate of Médenine. Lagoon on the island of Djerba.

Low, flat Djerba, its highest point 50 meters (165 feet) above sea level, is none other than the ancient Phoenician, then Roman, island of Meninx: the mythical "Island of the Lotus-eaters" that Ulysses was so reluctant to leave. Despite frequent foreign incursions, the population, consisting of Berbers and heterodox Muslims (the Kharidjites) in addition to one of the oldest Jewish communities in North Africa, has managed to maintain a special identity and a balance that are now under threat. With its international airport and causeway linking it with the continent, this mecca of Tunisian tourism (the largest in the Maghreb region) has become a leisure factory, while its traditional activities of fishing and farming have stagnated. The Djerbians, who earn only a small amount of the money spent by tourists, tend to emigrate to the large urban centers of the area where they run their business. In addition, this exceptionally beautiful place is beginning to be affected by the oil pollution that extends into the Gulf of Gabès, and from Bizerte to the Gulf of Tunis. Exodus and pollution are a common price to pay for rampant tourism.

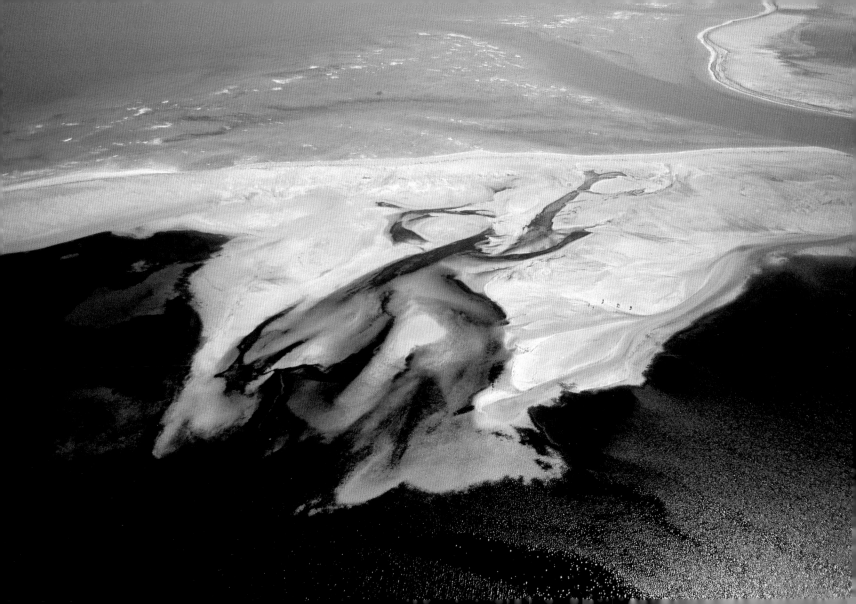

Réunion Island (France). Eruption on the Piton de la Fournaise.

Rising to 2,631 meters (8,630 feet) in the southeast of Réunion Island, the Piton de la Fournaise (Furnace Peak) is one of the most active volcanoes on Earth. It has been active for more than 500,000 years, and erupts on average every 14 months; in the great majority of cases, however, the ejections of magma rise no higher than the three sets of steep caldera walls that surround it. The calderas, large circular depressions that form after a volcano has erupted so much material that it caves in, have formed over the past 250,000 years. More violent eruptions, such as those in 1977 and 1986, do occur, producing devastating lava flows that sweep through the wooded slopes and inhabited parts of the island. Today, of the roughly 1,500 active volcanoes on the planet, only about 140 are kept under constant surveillance. These include the Piton de la Fournaise which, since the installation of a volcanic observatory in 1979, is without doubt one of the most closely monitored in the world.

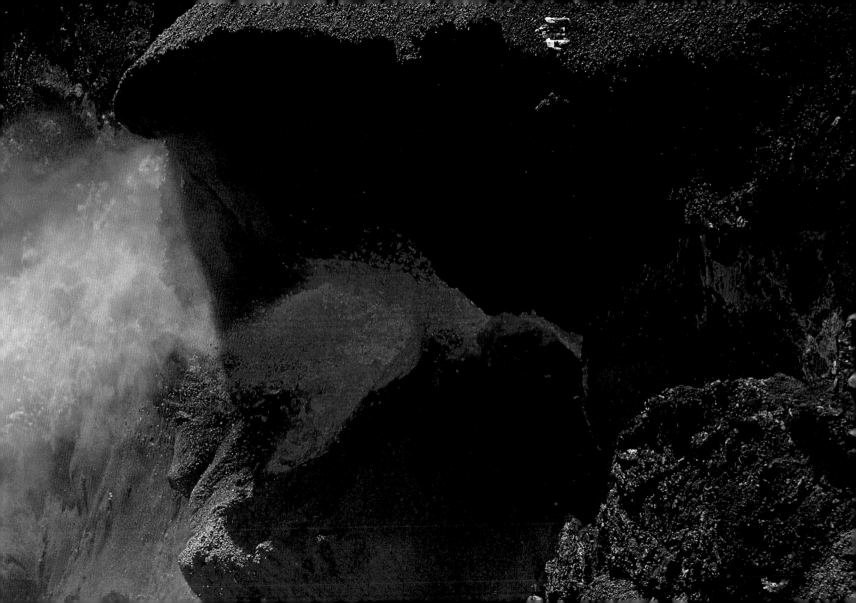

France. North Gascony. Wreck of the oil tanker Erika.

On December 11, 1999, a dilapidated oil tanker flying the Maltese flag and manned by an Indian crew asked the port of Saint-Nazaire permission to dock because it had suffered slight damage. The port authorities refused. The *Erika* was forced to continue its voyage along the Breton Coast, where heavy seas eventually broke it in two. The ship sank and more than 10,000 tonnes (11,000 tons) of crude oil spread out in slicks which drifted at sea for two weeks before polluting more than 500 kilometers (300 miles) of France's Atlantic coast. Sadly, this is not the worst oil spill in recent years. In 1993 the tanker *Braer* spilled 85,000 tonnes (94,000 tons) of crude oil off Shetland, and in 1996 the *Sea Empress* leaked 65,000 tonnes (72,000 tons), which washed ashore on the coast of Wales. But the greatest oil spill damage is not measured in tonnes, but in the rare species it destroys. The disaster that recently hit the Galapagos Islands, involving a few hundred tonnes of fuel oil, is a sad omen of this. The International Oil Pollution Act of 1990 has imposed more stringent safety measures on oil transportation, including the requirement that by 2010 all tankers have a double hull.

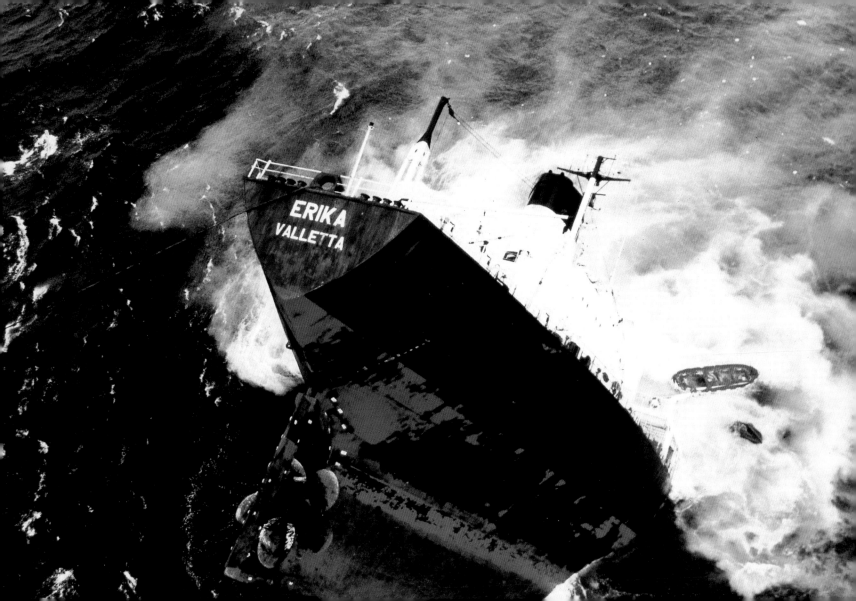

Kuwait. Al Khiran. Lakes of oil near Al Burgan.

This landscape of desolation is one feature of the crisis and then war that followed the Iraqi invasion of Kuwait on August 2, 1990. In the course of this conflict, 300 million tonnes (330 million tons) of oil were burned, amounting to more than one-tenth of the world's annual consumption. The Middle East holds two-thirds of the world's oil reserves, and one-third of its natural gas reserves. On an everyday basis, oil exploitation causes devastation in the places where it is carried out, and pollution as a result of transport, refining, and eventual use. It is at this final stage that the most serious damage is done to the environment: at the level of huge urban areas in which motorized transportation poses continual and growing problems for human health, and on the global scale, where the by-products of burning fossil fuels play a major role in altering the chemical composition of the atmosphere and modifying the Earth's climate.

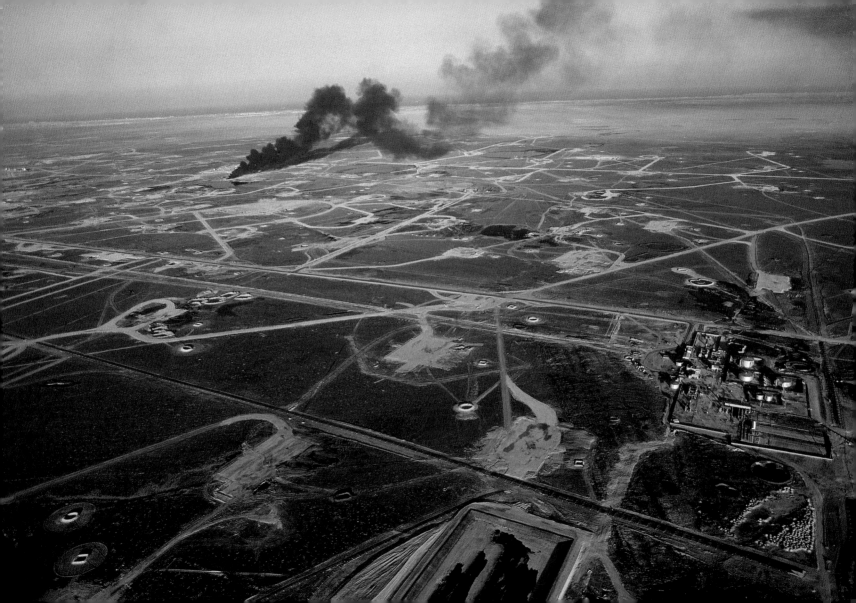

Venezuela. Bolivar region. Stubble fields near the artificial reservoir at Guri.

One of the largest hydroelectric dam in the world is situated at Guri, in the state of Bolivar in southeastern Venezuela. In the area surrounding it and its vast reservoir, small farmers grow manioc and corn on stubble fields, using intensive methods and with little concern for soil conservation. They are contributing to a process of destruction that extends through the whole of South America. One result of the hasty and ill-applied agrarian reform that took place here was that these farmers finally obtained some land. They took on debts to buy seed and equipment, and in order to repay them have now become involved in a spiral of loans at extortionate interest rates. In a few years' time they will have no option but to sell their plots of land at a low price to a large landowner or a company that will then put them together to form a huge estate or *hacienda*. The exploitation of the soil will go from small-scale to systematic, until nothing is left but a crust of hard, sterile laterite. Thus in the space of a few years one of the richest soils in the world will have become an arid steppe traversed by herds of emaciated animals. Five hundred years after its colonization by Europeans, South America still has not found a "sustainable" method of agriculture.

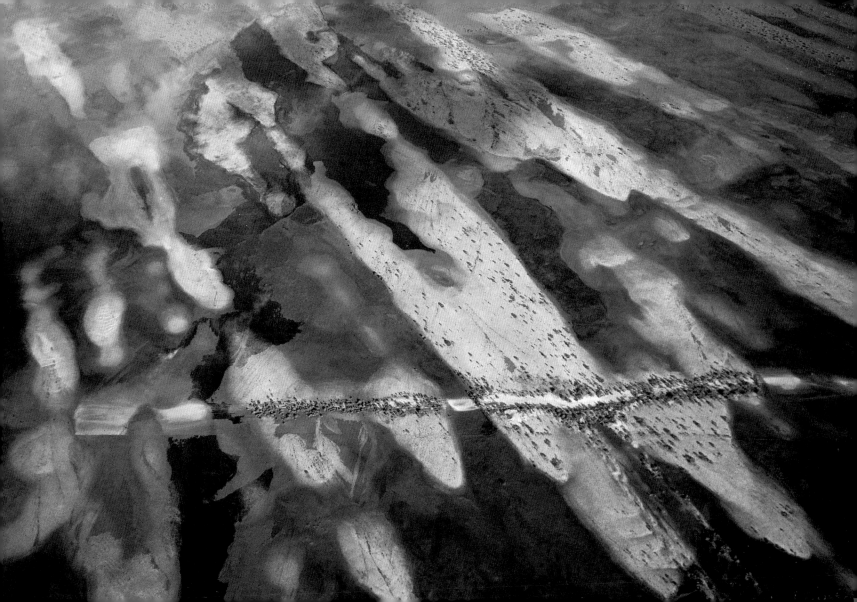

Brazil. State of Amazonas. Manaus area. Wood floating on the Amazon.

In this region where the density of the vegetation cover allows no other means of access to the areas being exploited, the most profitable way to transport wood is to float it. The logs are tied together, then piled on to the Amazon River before being towed off to the sawmills. The exploitation of wood, which is a major contributor to the Brazilian economy, is carried on at the price of a worrisomely high level of deforestation (nearly 19,000 square kilometers [7,500 square miles] per year). As a result, the Amazonian forest has already lost 10 percent of its original acreage. Its progressive destruction threatens not only the habitat of indigenous populations, but also environments that give shelter to half of the diverse species of the world. Asia and Africa also over-exploit their forest resources; of the 18 million square kilometers (7 million square miles) of tropical forest on the planet, 120,000 (45,000) are disappearing every year.

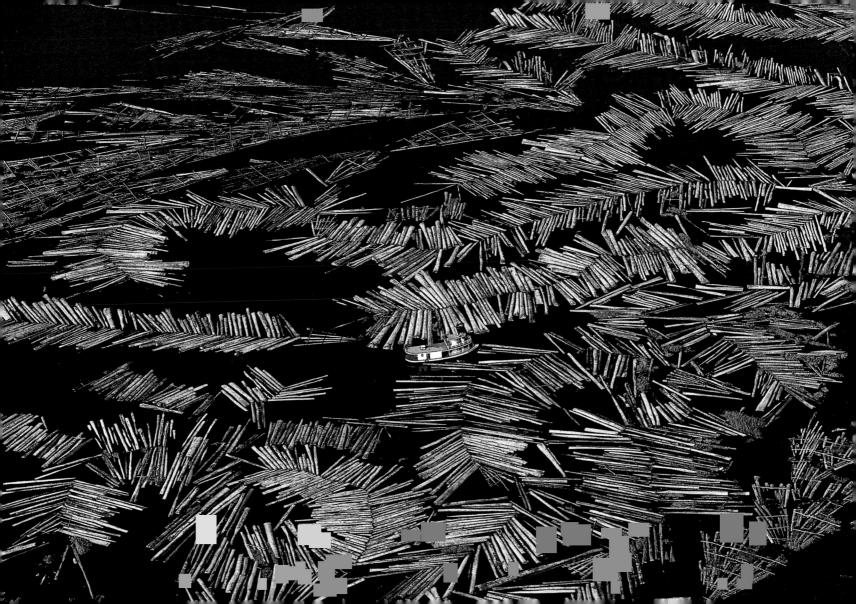

France. Haute-Savoie Department. Roped party of mountaineers climbing Mont Blanc.

The Alps, which form the largest mountain range in Europe, began forming about 65 million years ago. At 4,807 meters (15,765 feet), Mont Blanc is their highest peak. In the sixteenth century it was known as the Montagne Maudite (accursed mountain), representing a chaos of rocks and sterile, dangerous glaciers for the shepherds of the Chamonix Valley. For all but a few intrepid chamois hunters and mineral collectors, it remained so until the end of the eighteenth century. In 1787, Jacques Balmat, Gabriel Pacard, and Horace Bénédict de Saussure made an arduous, two-day climb to the summit. Since then there have been many more ascents. One hundred fifteen people reached the summit between 1787 and 1860. The scientific motivation of the Enlightenment gave way to the quest for physical achievement, then in more recent times to tourism. The summit is equipped for hikers, and receives a stream of up to 300 visitors a day. The site, which is extremely fragile, is now deteriorating. This tourist boom, which represents the primary economic resource for the people of the valley, may result in its own demise. It is not only large cities or rich plains that suffer from the presence of humans, but extreme places – deserts and high mountains – as well.

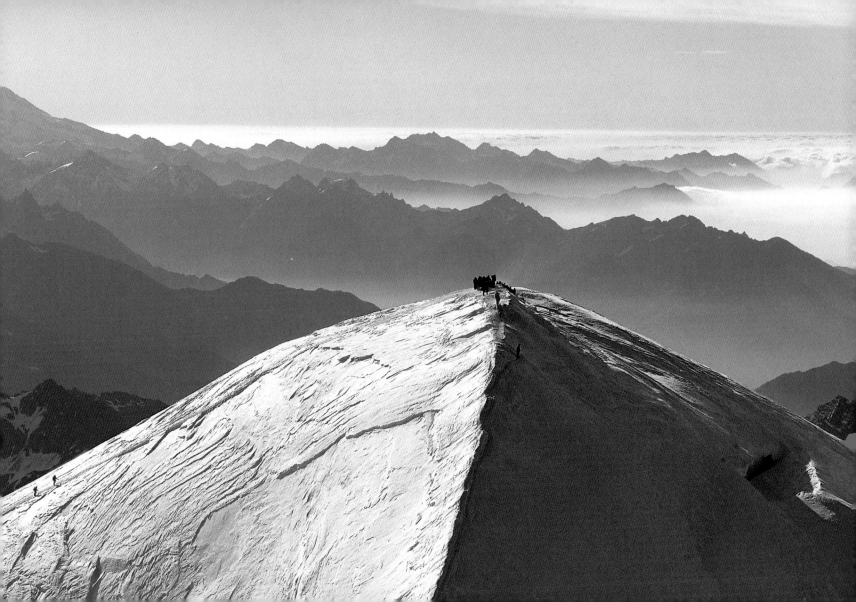

China. Beijing area. The Great Wall near Gubeikou.

From the beginning, the presence of the Great Wall, along with the silk trade and matrimonial alliances, defined the way Chinese dynasties conducted their border relations with the nomadic horsemen from the steppes of the North. Although the earliest walls date from the third century B.C., the fortifications that can be visited today date from the sixteenth century, when the Ming emperors decided to keep the Mongol federations at bay by building a static defense system extending over more than 2,000 kilometers (1,200 miles). In certain periods (from A.D. 550 to 577 and from 1410 to 1430, for example), construction of the wall mobilized up to 100,000 men. Over the past three centuries the Great Wall has become quite mythical. The current Chinese government has turned it into a national emblem, and some Chinese see it as a long dragon which, even while lying down, protects the country from continental adventurers.

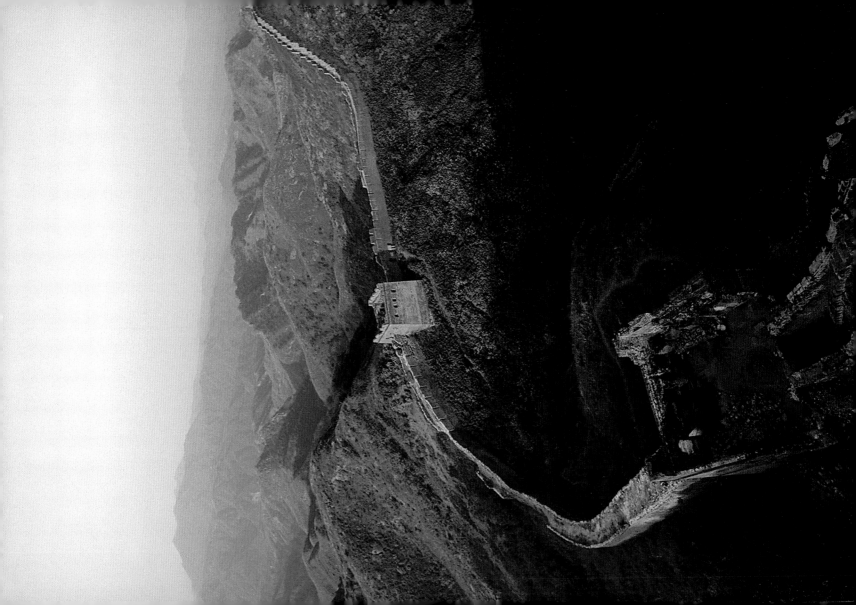

India. Uttar Pradesh. The Taj Mahal at Agra.

The Taj Mahal was built between 1632 and 1653 at the behest of the Mogul emperor Shāh Jāhan, and is dedicated to his wife, Mumtaz Mahal (the "Chosen One of the Palace"), who died giving birth to their fourteenth child. Its pinnacle towers 74 meters (242 feet) above the Yamuna River in Agra, India. Decorated with semiprecious stones and fine sculptures of Koranic verses and floral and geometric motifs, this white marble mausoleum is the work of about thirty architects and 20,000 laborers, and in 1983 was listed by UNESCO as a World Heritage Site. Threatened by the industrial pollution of the twentieth century, 212 factories in Agra were closed in 1993 in order to preserve its whiteness, which in the Muslim religion is a symbol of purity of the soul. Although Islam (India's second largest religion with about 100 million followers) is dominant in some areas of Uttar Pradesh, more than half of the Hindus in the world live in India, making up 80 percent of the Indian population.

Botswana. Okavango Delta. Antelope beside a pool.

Botswana's policy of protecting fauna began before its independence in 1966, with the "Fauna Conservation Act" of 1963. Hunting in Botswana is permitted (excluding the elephant and brown hyena), but strictly regulated. It represents a major source of income for the country, which issues three types of permits: free of charge to those for whom hunting is a traditional means of subsistence; cheap for other Botswanians; and very expensive for foreign tourists. Subsistence hunting pays the highest dividends, as it is estimated that 90 percent of the animals killed are used for food. At the same time, foreigners bring in revenue not only from the hunting permits issued, but also from export taxes and entrance fees to national parks, which cover 17 percent of the country. In addition, many nongovernmental organizations work to promote and protect the wealth of fauna (164 species of mammals, 550 species of birds, and 150 species of reptiles). All have schemes to limit poaching, the real scourge of the African national parks.

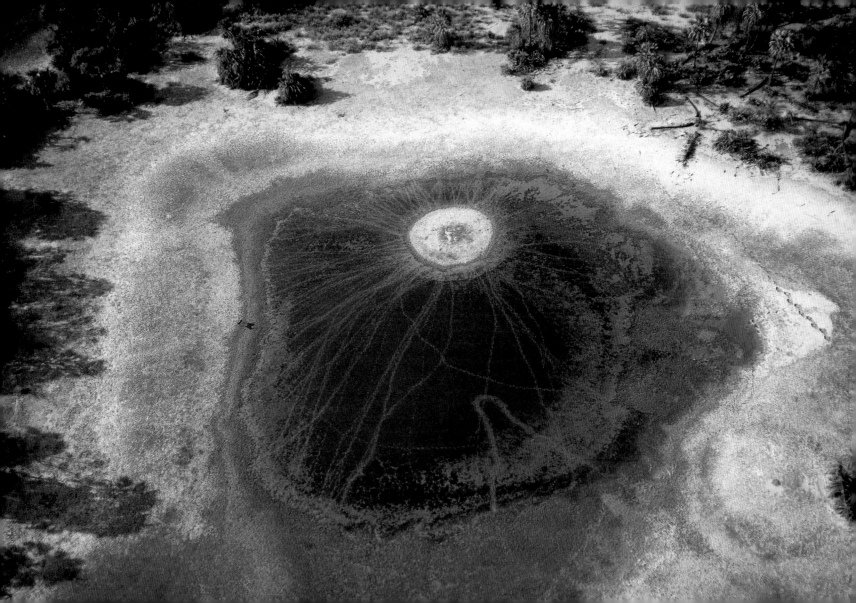

Egypt. Nile Valley.

Road cut off by a dune.

Derived from old fluvial sediments or lake alluvium that has accumulated in depressions and been sifted by thousands of years of winds and storms, grains of sand build up next to the slightest obstacle, forming dunes and then sand mountains. At present all of the sand mountains are relatively stable. Only small dunes, described as "free," are changing position, migrating in the direction of the prevailing wind, in some places covering infrastructures such as this road in the Nile Valley. The force of the desert winds can mobilize the small, spherical sand grains to such an extent that some dunes move at a pace of up to 10 meters (30 feet) per year. The areas on the perimeter of the Sahara also face violent sandstorms that destroy the vegetation and thus contribute to the aridification of the region.

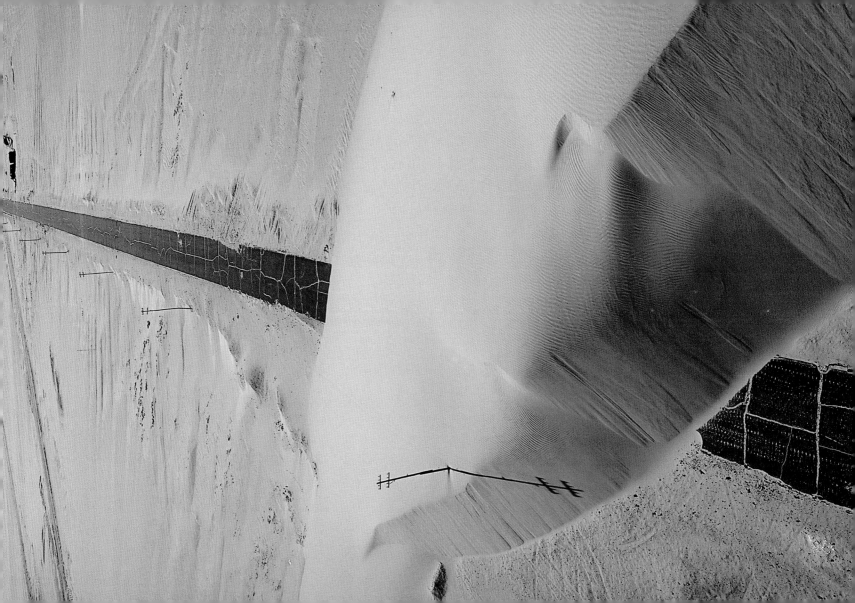

France. Seine-et-Marne Department. Maincy. Embroidery-style beds at the Château de Vaux-le-Vicomte.

The "oriental carpets" or embroidery-style beds formed from box hedges, along with the rest of the park at Château de Vaux-le-Vicomte, are the work of architect-gardener André Le Nôtre (1613–1700). The château was built in five years by some 18,000 workers, for Nicolas Fouquet, the Superintendent-General of Finance for Louis XIV. The garden has several ornamental lakes and fountains, and offers a vista of 2,500 meters (8,200 feet) created through the destruction of two hamlets. When the young King Louis XIV was invited here by Fouquet in 1661, he was so offended by the pomp of the festivities that he ordered an inquiry into the superintendent's activities and had him imprisoned. Le Nôtre, on the other hand, was awarded the title of Controller-General of the King's Buildings. He created other classic "French-style" gardens for the châteaus at Saint-Germain-en-Laye, Saint-Cloud, and Fontainebleau, but his masterpiece remains the gardens at Versailles, the palace of the "Sun King," Louis XIV.

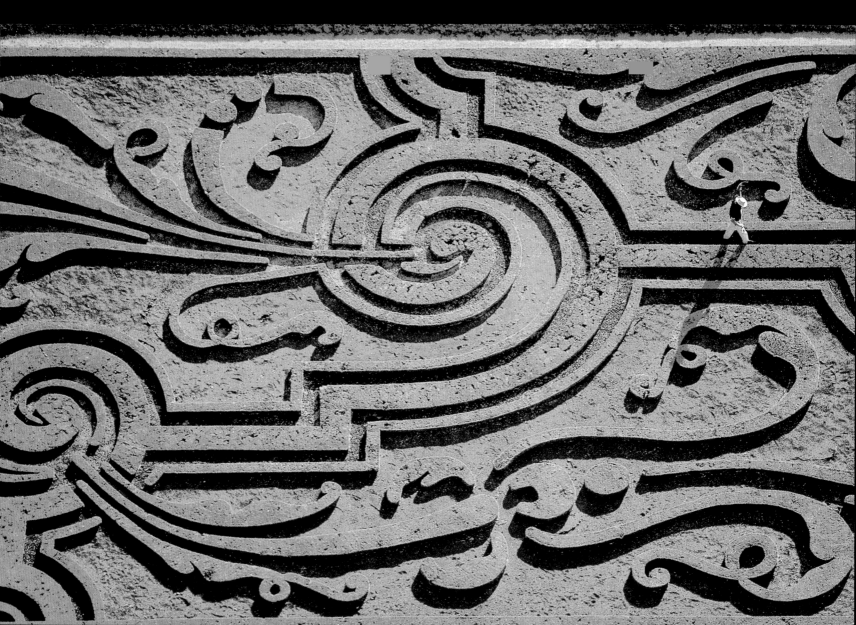

Brazil. State of Amazonas. Meeting of the waters of the Negro and the Amazon.

It is only downstream from Manaus, after it has been joined by the 2,200-kilometers- (1,350-mile-) long Negro River, that the Solimões officially takes on the name Amazon. In Amazonas a distinction is made between "white rivers," whose muddy waters arise in the Andes, and "black rivers" whose waters are transparent but tinged with decomposed vegetation of a brown-red color that appears black once the water is more than a meter (a few feet) deep. Interestingly, the waters of the Solimões and the Negro do not mingle at the point where the two rivers meet. For more than 80 kilometers (50 miles), the silt-laden water of the Solimões flows in its own bed alongside the water of its tributary, with only a few coffee-color patches appearing. This phenomenon occurs because the rivers are flowing at different speeds. Just before they meet, the Negro spreads out into a vast maze of lagoons and secondary branches weaving in and out of 400 islands, half of which are submerged by flood waters for months at a time. These are the Anavilhenas, the largest fluvial archipelago in the world. Thus when the Negro River reaches the enormous moving stream of the Solimões, its speed is virtually nil, and it is unable to merge with the other river. The differing density of the water in the two rivers, one thick with sediment, also makes it difficult for them to mix. It is therefore quite some time before they do eventually merge, and the Amazon River finally comes into being.

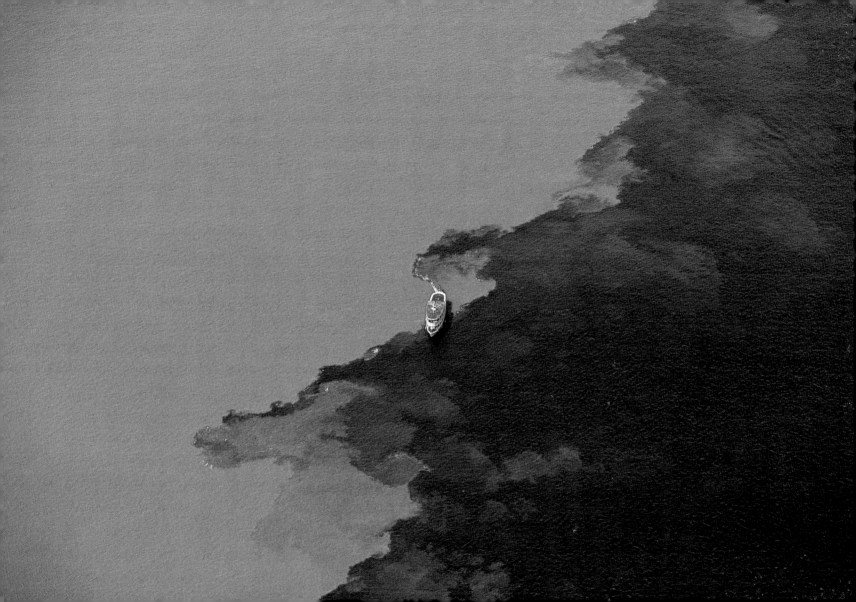

Djibouti. The islands of Maskali (foreground) and Moucha (background).

The islands of Maskali and Moucha are located in the Gulf of Tadjoura, about an hour's journey by sailboat from the capital. With their mangrove swamps and fine, sandy beaches, they are one of the main tourist areas of the Republic of Djibouti. Surrounded by coral reefs, the islands and their fish-filled waters have always attracted underwater fishing enthusiasts, and have even been used on several occasions as the site for the underwater hunting World Championships. Much of their marine fauna is very rare and some species are endemic to the area. To protect these fauna, which include some endangered species, the government of Djibouti has regulated underwater hunting; to the east of Moucha and Maskali is an underwater national park where all hunting and fishing activity (catching tortoises and their eggs, in particular) is strictly prohibited.

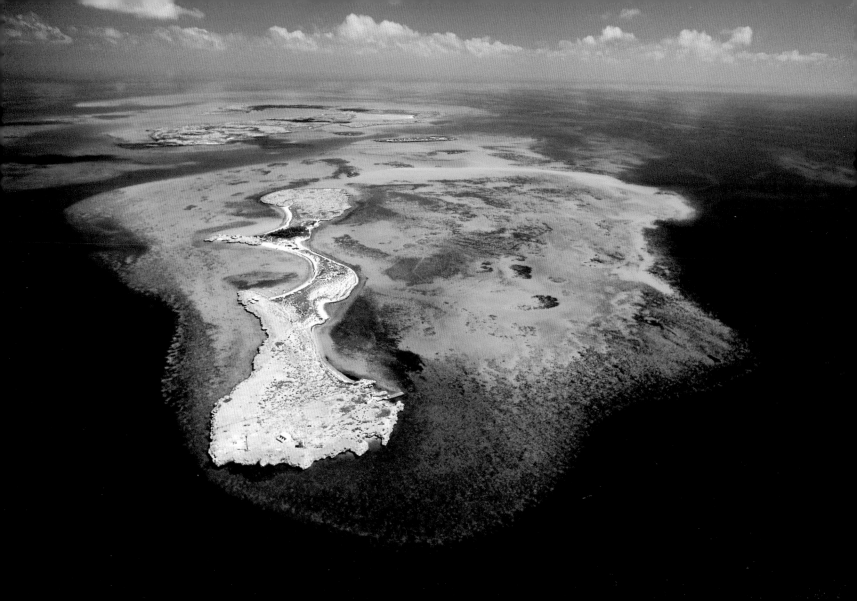

Egypt. Water hyacinths clogging up the Nile.

 Found growing wild early last century in the Nile Delta of Egypt, and in Natal, South Africa, the invasive water hyacinth (*Eicchornia crassipes*) was brought to Africa from Brazil as an ornamental plant. In less than 100 years it has colonized more than 80 countries in the world, growing particularly vigorously near sewage outfalls. It interferes with boat traffic and increases the silting-up of watercourses and river banks, as well as blocking irrigation channels and the intakes of hydroelectric plants. Blanketing the water surface, taking advantage of the high concentrations of organic chemicals in the water, it leads to eutrophication – depletion of the water's oxygen content – which asphyxiates fish and amphibians. Worse still, water hyacinths carry many microorganisms that cause diseases transmissible to humans. On the positive side, the plants absorb excessive quantities of nitrates, as well as sulfur and some heavy metals.

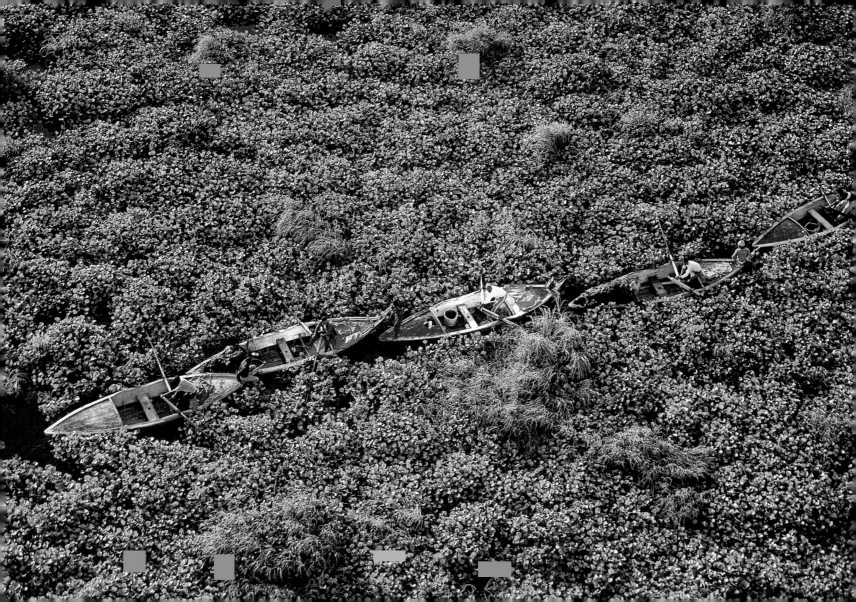

Antarctica. Adélie Coast. Adélie icebergs and penguins.

The climate in Antarctica is extreme. At the latitude of the Adélie coast (about 65°S), the average temperature is −10°C (14°F), ranging from 0°C (32°F) in summer to −25°C (−13°F) in winter, with continual icy, stormy winds. This continent has a surface area of 12 million square kilometers (4.5 million square miles), and is almost completely covered by a layer of ice with an average thickness of 2.5 kilometers (1.5 miles), comprising two continental glaciers. The continent is extended a further 1.5 million square kilometers (600,000 square miles) by vast, 400-meter- (1,300-foot-) thick ice platforms that float on the sea. Animal life abounds here, with seals and many species of birds, including the Adélie and emperor penguins, the best-known marine birds in Antarctica. The penguins' rudimentary wings do not allow them to fly, hence their French name "manchot" (armless person). They can, however, swim, dive, and move around with ease on the sloping ice. At 70 centimeters tall (2.2 feet), the Adélie penguins are smaller than the 1.1-meter (3½-foot) emperors, and do not arrive in Antarctica until spring. They reproduce there, then leave again in winter, making way for the emperors.

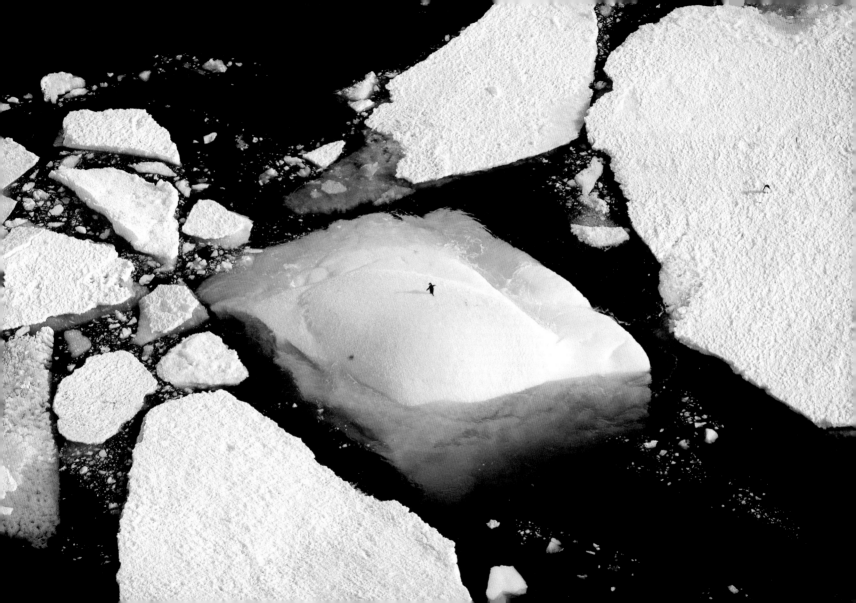

Argentina. Neuquén Province. Beech trees on the Traful Mountains.

In the middle of Nahuel Huapi National Park on the Chilean border in the southern part of Neuquén Province in Argentina, there are many high-altitude lakes of glacial origin, whose intense blue waters bathe the feet of the mountains and rocky peaks of the Andes Cordillera. The humidity of the region favors the growth of beech trees (*Nothofagus pumilio* and *antartica* varieties), which have colonized the sides of the mountains, covering them with bright, flamboyant colors in the autumn. Farther south the altitude decreases noticeably, and the beech forests steadily thin out, giving way to the Patagonian steppe. The section of the Andes Cordillera between Argentina and Chile is about 5,000 kilometers (3,000 miles) long, making it the longest natural terrestrial boundary on the planet.

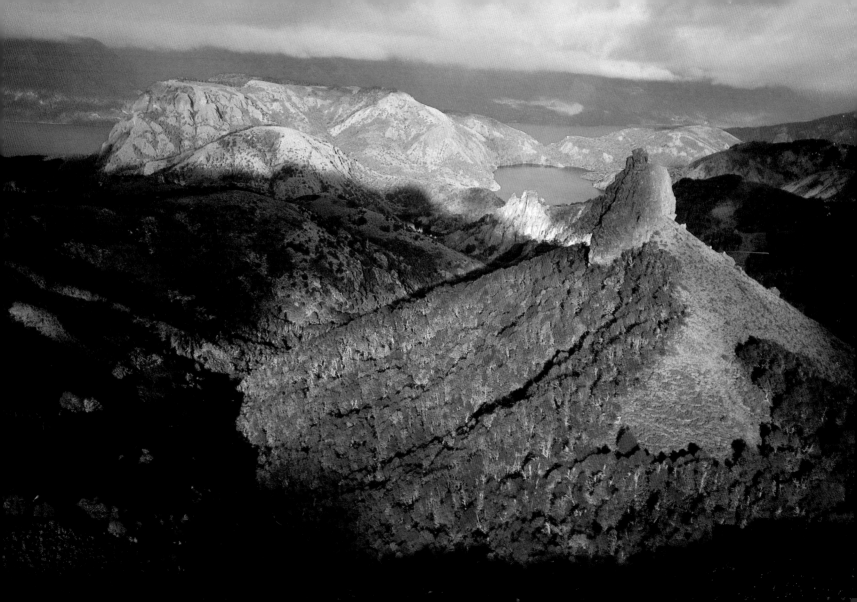

Turkey. Istanbul. The Saint Sophia Basilica.

Flowing through Istanbul, formerly known as Byzantium and then Constantinople, is the Bosporus Strait, which separates Europe from Asia. On its western bank stands the Saint Sophia Basilica, which was built between A.D. 532 and 537 in the reign of the Byzantine emperor Justinian, and was for a long time considered to be the most important holy building in Christendom. Rising to a height of 56 meters (184 feet) and crowned by a majestic dome over 30 meters (100 feet) in diameter, its construction represents an astonishing technical feat for the time. After the capture of Constantinople by the Turks in 1453, Saint Sophia was turned into a mosque, and four minarets and several buttresses were added to its original structure. In 1934, the secular Turkish Republic decided to make it a museum, thus enabling the public to admire its treasures, which include some remarkable Byzantine mosaics.

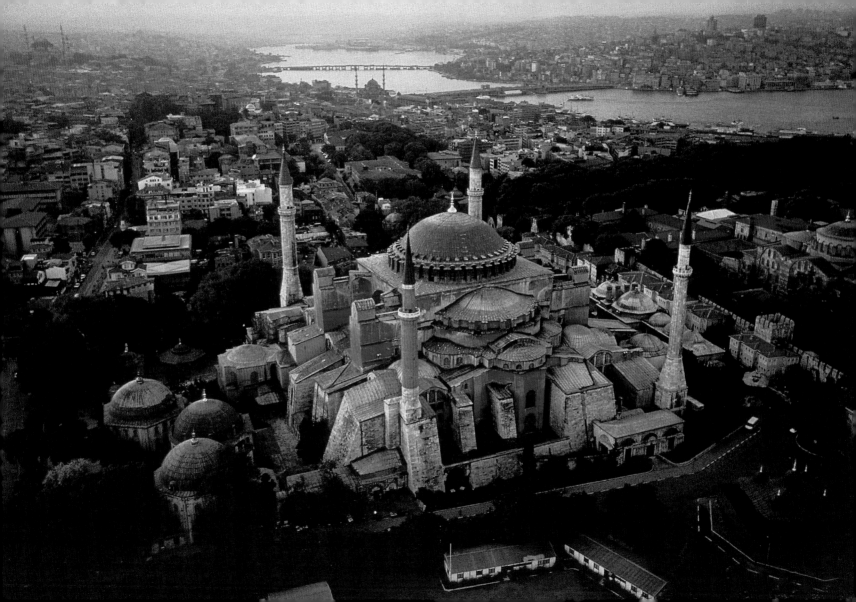

Ecuador. Quito. Agricultural landscape of small fields.

The Audiencia de Quito of the Spanish conquistadors, which in the eighteenth century was named the "Lands beneath the Equator," remains a country with a burdensome colonial heritage, as demonstrated by the state of its agriculture. Although agriculture provides a living for more than half the population, and occupies 27 percent of the land, it now represents no more than 15 percent of the GDP. The agrarian reforms of 1964, 1972, and 1978 put an end to the traditional feudal order of the Huasipungo in the Andean Sierra, which had been characterized by the large haciendas of the Spanish colonists, managed by settlers of mixed heritage and cultivated by indigenous people reduced to serfdom. Even so, the distribution of land remains particularly unegalitarian. While the small farmers who run the *minifundias* on the high plateaus can barely survive, the best land, which is situated in the valleys and near the coast and is used for growing export crops (bananas, cocoa, coffee), is still concentrated in the hands of rich landowners. Add to that the exhaustion of the oil reserves and the extensive damage caused by recent weather phenomena, and all the ingredients for a social explosion are in place.

Namibia. Swakopmund area. Oryx in the Namib Desert.

Formed 100 million years ago, the Namib Desert is considered to be the oldest in the world. It runs along all 1,300 kilometers (800 miles) of the Namibian coastline, and extends inland almost 100 kilometers (60 miles), occupying one-fifth of the country. The Namib consists primarily of stony plains, but also has 34,000 square kilometers (13,000 square miles) of sand dunes which, at 300 meters (1,000 feet), are the tallest in the world. The Namib only receives rainfall every five to 20 years, but a thick fog, resulting from cold air currents coming in from the Atlantic and meeting warm winds from the center of the continent, makes the orange-red sand damp for nearly 100 days per year. Thanks to this, many species of plants and animals, such as this large antelope known as the oryx or gemsbock, can survive in the Namib Desert.

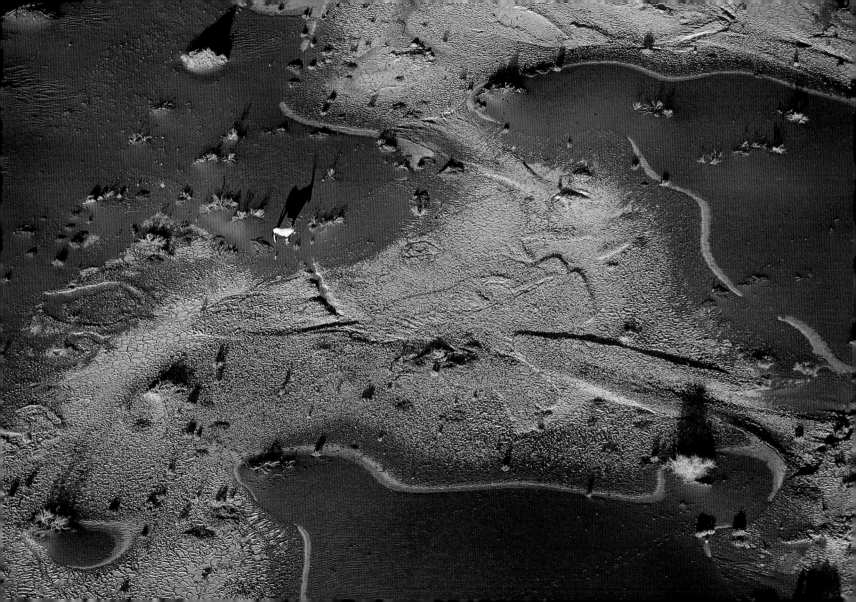

Greece. Dodecanese. Chapel on an islet off the coast of Kos.

Not far from the coast of Turkey lies the Dodecanese Archipelago of Greece. As its name suggests, it is a group of 12 islands (of which Kos is one of the largest) and numerous islets. As with the majority of Greek islands, most are uninhabited; of a total of 437, only 154 have a permanent population. This multitude of islands (which makes up 20 percent of the country's surface area) is a reflection of the unusually jagged relief of the Aegean Sea, partly a result of Alpine mountain-building. The presence on certain uninhabited islands of small, isolated buildings, Greek Orthodox churches in particular, is a common phenomenon that represents another special feature of this country: the predominance of the Greek Orthodox religion, which is practiced by more than 97 percent of the population. It was this that made the maintenance and cohesion of Hellenism possible during the centuries of Ottoman rule, and also ensured the survival of the Greek language.

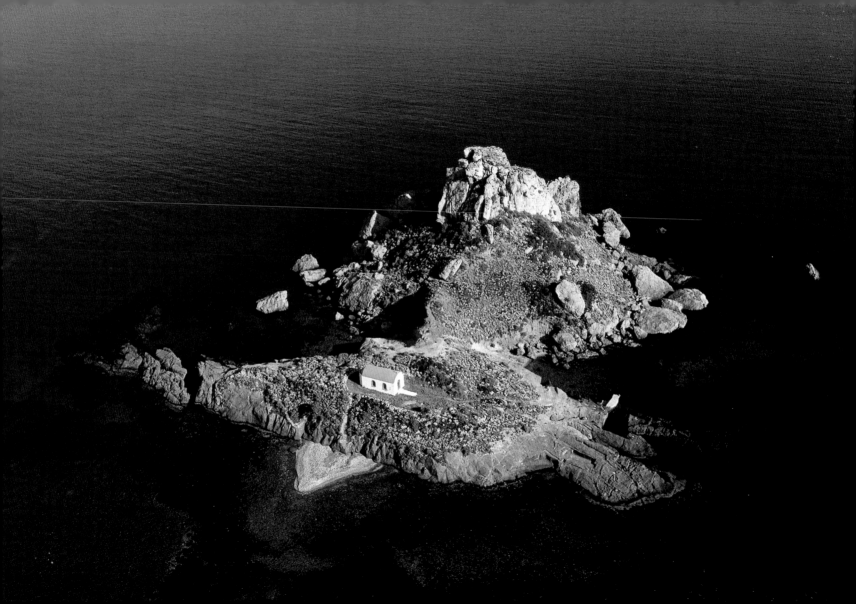

Réunion Island (France). Gorges of the Bras de Caverne.

Access to the central part of Réunion Island is made difficult by numerous gorges, such as those of the Bras de Caverne River, which hollows out its bed along the volcanic fractures of the Cirque de Salazie. Some sites were not explored until very recently; the Trou de Fer (Iron Hole), a 250-meter- (800-foot-) deep ravine, was visited for the first time in 1989. Free from human control, the tropical forest with its abundance of ferns, lichens, and giant heathers has retained its original state on the volcanic topography of the island. The low-altitude forest, on the other hand, has disappeared. More than 30 species of animals and plants, including about 20 which were endemic, have become extinct in the last 400 years. Island systems are commonly biologically diverse, but because of the limited habitability, their species are generally at greater risk of extinction than those of continents.

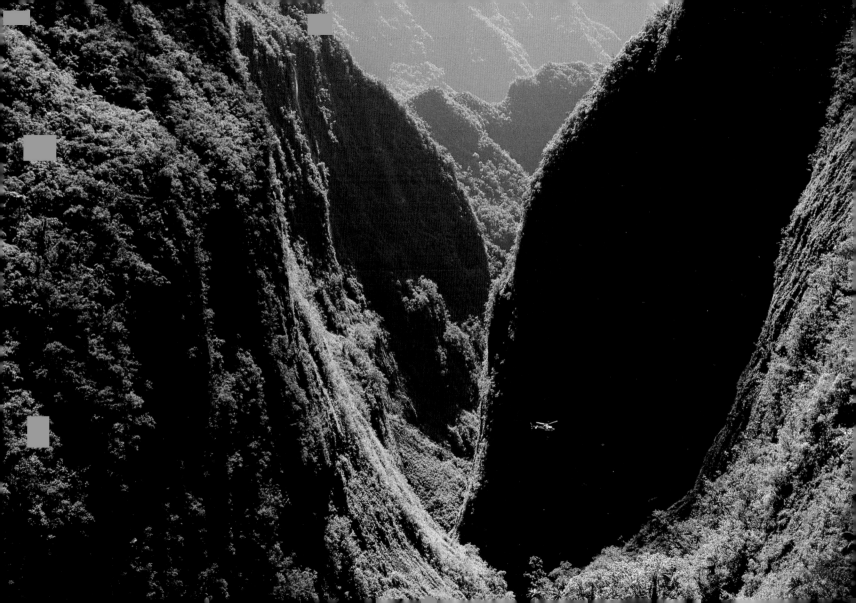

Argentina. Tierra del Fuego. Flock of sheep.

Separated from Patagonia by the Strait of Magellan, the Tierra del Fuego Archipelago was discovered by Europeans about 1520, and is said to owe its name to the fires that used to be lit on the coast by the indigenous people. With the arrival of the Europeans, these people were progressively wiped out (the last representative of the Onas died in 1960). Meanwhile this *finis terrae*, still largely unexplored, became a mythical place for adventurers and scholars; Darwin went there during his voyage on the *Beagle*; E. Lucas Bridges, the son of a missionary born on the island, wrote an English-Yamana dictionary that enabled the language to survive despite the extinction of the ethnic group; Gisèle Freud produced photographic coverage of the islands for *Life* magazine in 1943. After the missionary period, between gold fever and the first drillings for oil, sheep-raising became the chief activity in the north of the main island. The *cabañas* (sheep pastures) are huge sheep farms with 1½ hectares (3½ acres) of land per head of livestock. But in spite of the promotion campaigns for "Patagonian lamb," its consumption does not count for much on the local market, with beef remaining the Argentineans' favorite meat.

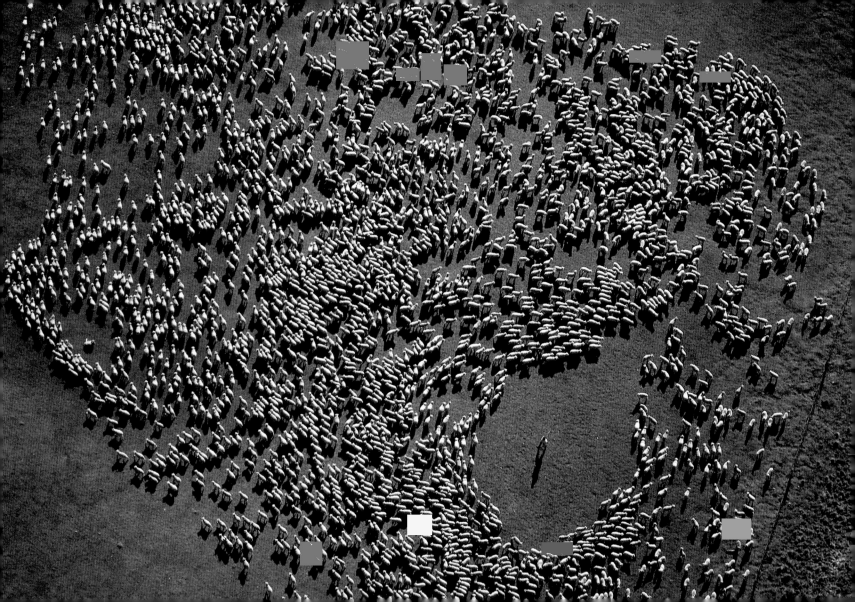

Peru. The Andes Cordillera between Cuzco and Arequipa.

The Andes Cordillera and its foothills cover one-third of Peru. In the south of the country, between Cuzco and Arequipa, the mountains rise to a height of more than 6,000 meters (20,000 feet) and progressively give way to the Puna, a region of high Andean plateaus perched at altitudes of 3,500 to 4,000 meters (11,500 to 13,000 feet). Along with the Tibetans, the people who live here are the only settled populations in the world to live at such high altitude. The Andes began forming more than 200 million years ago, although it may not have been recognizable as the great volcanic mountain range it is now until about 20 million years ago. The cordillera stretches for 7,500 kilometers along the Pacific Coast of South America, crossing seven countries from the Caribbean Sea to Cape Horn. It is the only mountain range that maintains a high altitude without interruption over such a long distance.

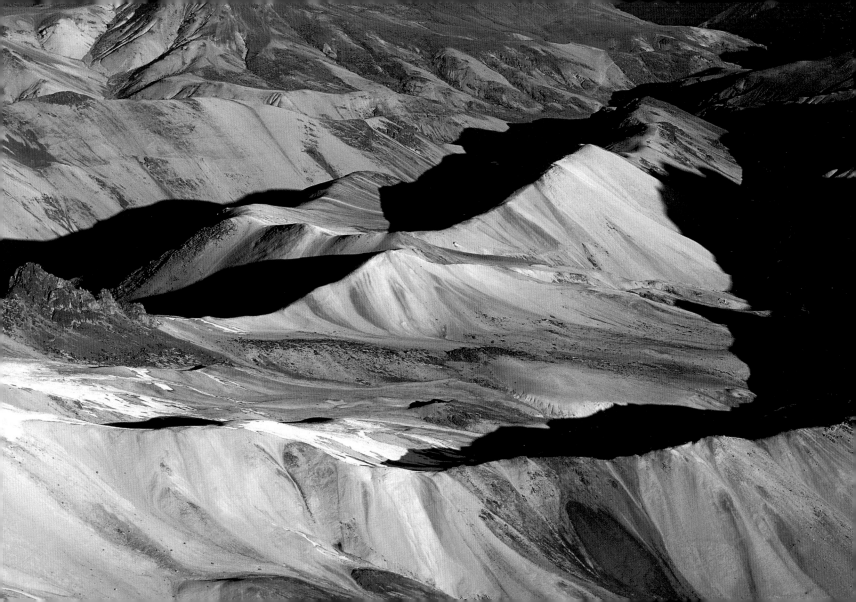

France. Indre-et-Loire Department. The largest maze in the world, at Reignac-sur-Indre.

In 1996, the year the largest plant maze in the world was created at Reignac-sur-Indre in Touraine, 85,000 visitors came to admire and lose themselves in the middle of its 4-hectare (10-acre) expanse. Each year, a maze of corn or sunflowers emerges from the ground over the summer, is harvested in the autumn, and then reappears the following year in a different form, thanks to a well-proven technique of sowing and marking out. This site takes its inspiration from an older tradition in the art of landscaping. During the Renaissance, Italian gardens spawned an abundance of mazes in which people could walk, get lost, hatch plots, and exchange gossip. This lightheartedness somewhat dispelled the sacred and sometimes threatening character of the great old labyrinths associated with Gothic cathedrals and with the Minotaur in Greece, or further back still the hundreds of stone labyrinths known as "Troy Towns," which are scattered along the shores of the Baltic. Were they used for sun rituals, for dancing, as Stations of the Cross, for initiation rites? The modern maze retains a little of the symbolic mystery attached to the "Streets of Jerusalem" and the "Walls of Jericho."

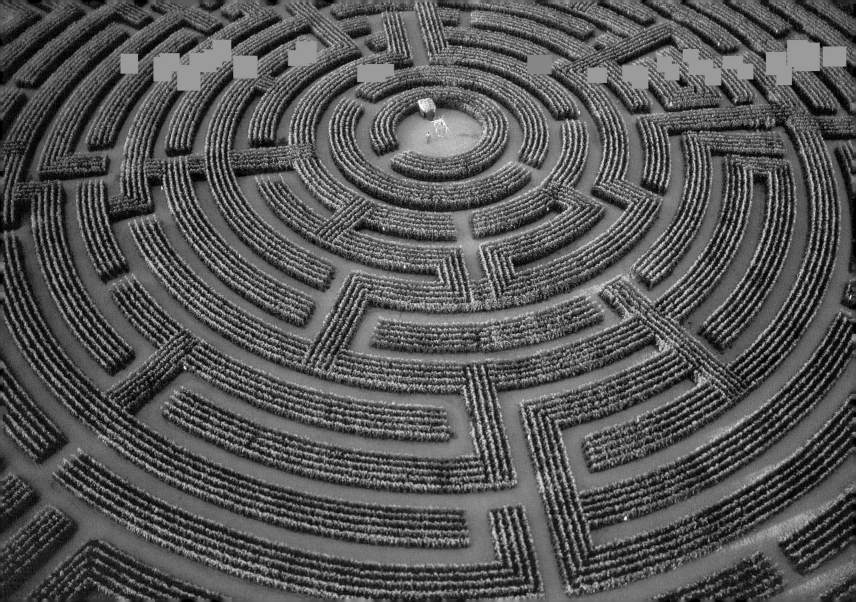

Botswana. Elephants in the Okavango Delta.

The Okavango Delta is a vast, marshy area in the center of Botswana. The rich variety of wildlife includes several tens of thousands of elephants. The African elephant (*Loxodonta africana*), the largest land mammal on Earth, has come very close to extinction as a result of being hunted intensely for its ivory. Between 1945 and the end of the 1980s, the number of elephants on the continent diminished from 2.5 million to fewer than 500,000. In the face of this dramatic decline, CITES (the Convention on International Trade in Endangered Species) ruled in 1989 that international trade in ivory should be completely banned. In 1997, however, an export permit to Japan was granted to three countries: Botswana, Namibia, and Zimbabwe. Expert opinion remains divided as to the impact of this partial resumption of the ivory trade on a species that is still threatened.

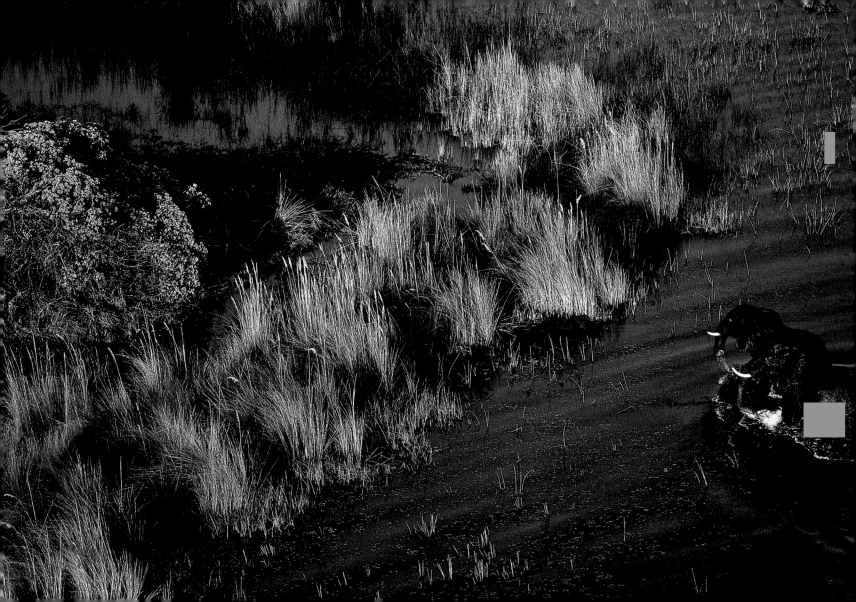

Japan. Honshu. Detail of Himeji Castle to the west of Osaka.

Literally the temple "of the daughter of the Sun," the Himeji Castle is known to the 500,000 inhabitants of the city of Honshu, which stretches out below it, as "White Heron Castle" for its elegance and immaculate white walls. Although it is the largest feudal castle in Japan, with dozens of turrets and a labyrinth of corridors, secret passages, and internal alleyways, it is too advanced to be categorized as a fortress. Built in the 1570s by Toyotomi Hideyoshi, the Supreme General of the Empire, its construction was completed at the beginning of the seventeenth century by Ikeda Terumasa, son-in-law of Shogun Tokugawa Ieyasu. It combined military efficiency with an aesthetic refinement that heralded the era of royal palaces. The top story of the keep, for instance, contains carvings of *shachinoko*, ornamental dolphins that protect the roof from fire. In the West, medieval fortresses had given way to beautiful Renaissance palaces nearly a century before, perhaps for the same reason as they eventually did here: unable to withstand cannon-fire, fortified castles were no longer suitable for defense purposes. As a result, the Himeji Castle was transformed from a defensive station into a center for art and pleasure.

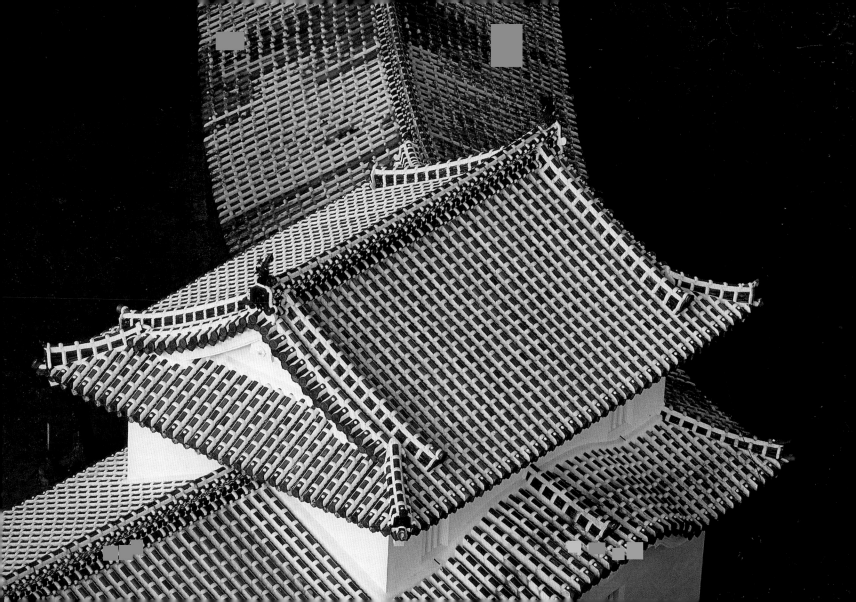

United States. Arizona. B-52 bombers at Davis Monthan
Air Force Base near Tucson.

Several hundred American B-52 Stratofortress bombers, kept as a source of
spare parts, are stockpiled at the Davis Monthan Air Force Base in the heart of
the Arizona desert. In service since 1952, this aircraft has seen action in the
Vietnam War (1964–75), the Gulf War (1991), and in 1999 in the Balkans. It
is a symbol of the power of the world's strongest armed forces, which today
see themselves as the guardians of a "new world order." The beginning of the
twenty-first century is indeed marked by the unquestioned domination of the
United States in the military sphere. Since the Gulf War, the country's role in
conflicts has grown, and its dominance influences international bodies such as
NATO. From the Bosnian conflict to that in Kosovo, the United States has
dominated military decisions and action. A growing number of countries, including
most European countries, are trying to moderate this power and become more
independent of the United States, which is pursuing its own strategic goals.
However, military strength is only one of the many aspects of the American
influence which, from business to culture, spans the entire world.

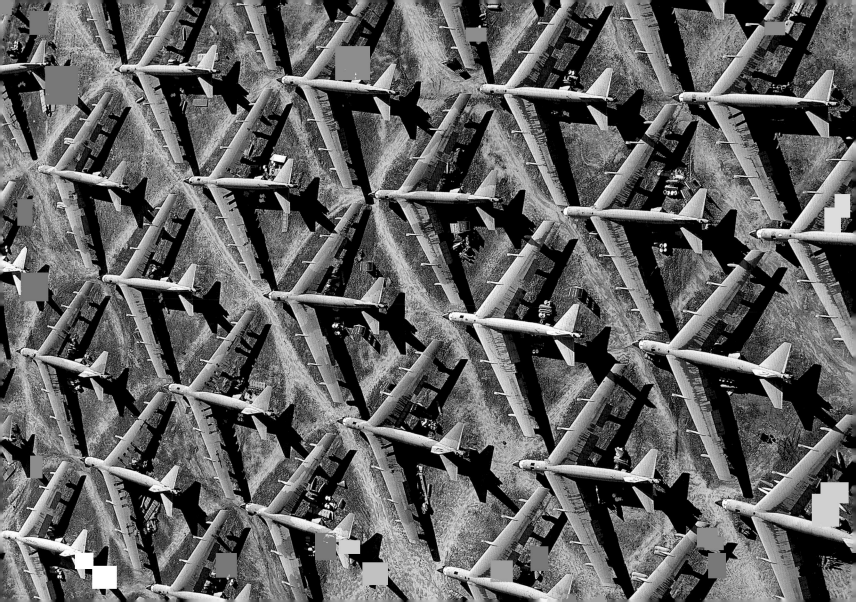

Mali. Mopti area. Village on the banks of a branch of the Niger.

As it crosses Mali, the Niger River branches out to form a vast inland delta in the Plain of Massina. Flowing at a rate of 7,000 cubic meters per second (1.85 million gallons per second), it is a godsend to the inhabitants of this arid region, most of whom have settled on the banks of its numerous branches. Here they practice river trade, fishing, animal raising, and agriculture at a pace determined by the seasonal floods that occur between August and January. The Mopti region has become not only a major commercial center, but also a meeting point for the various populations of the region, including Bozo fishermen, nomadic Peul shepherds, and Bambara farmers, as well as Songhaï, Tuaregs, Dogons, and Toucouleurs. In this country where 90 percent of the population is Muslim, the central building in each town or village is generally the mosque, dominating in its imposing stature.

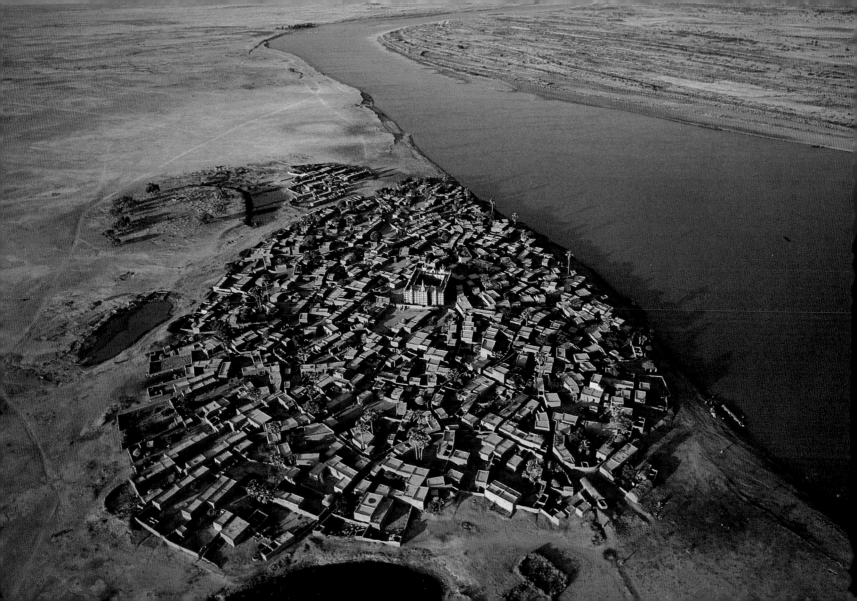

Australia. East Kimberley. Diamond mine at Argyle, south of Kununurra.

Situated on the Kimberley Plateau, the open mine at Argyle is the only diamond mine in Australia, but it is the most productive in the world. The seam supplies one-third of commercial diamonds, and virtually all the pink diamonds found on the Earth's surface. The area's name is borrowed from the famous diamond-bearing region of Kimberley, South Africa, which has also given its name to kimberlite, the volcanic breccia that brought diamonds to the Earth's surface from their birthplace deep in the crust and mantle. The diamonds at Argyle range in quality; most are used for industrial purposes, although a much smaller proportion is gem-quality stones such as the champagne diamond, with a gradation of yellow and ocher colors, and the pink diamond, the rarest of all. Every year more than seven million tonnes (almost eight million tons) of rock, containing about 30 million carats, are extracted from the mine. By the end of the year, only 400 carats (just 80 grams, or 2 ounces) of sparkling pink diamond will be set in jewels and sold at prices as high as several hundred thousand dollars per carat.

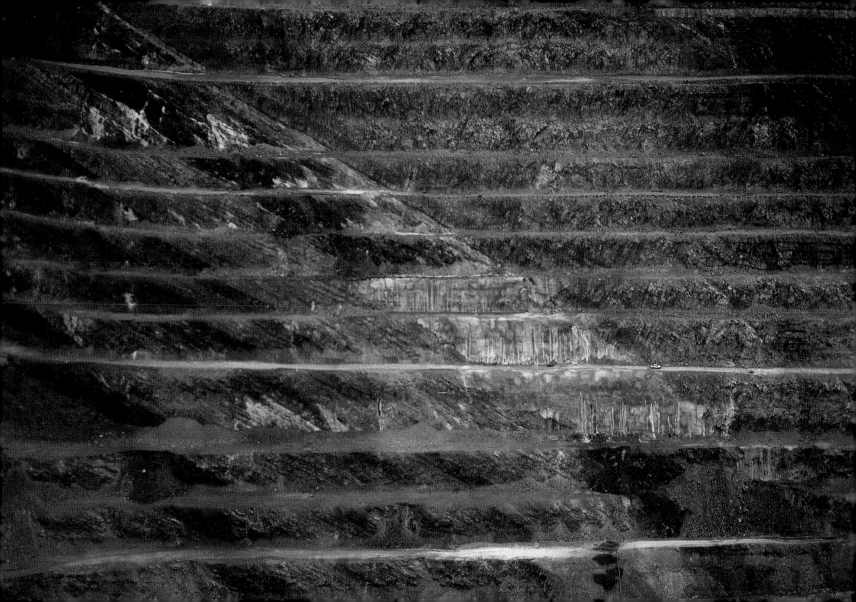

Iceland. The Maelifell volcano on the edge of the Myrdalsjökull Glacier.

Created by one of the many eruptions that have taken place on the outwash plain of the Myrdalsjökull Glacier in southern Iceland, the Maelifell is a volcanic cone consisting of an accumulation of materials ejected from the volcano. Little by little this mound has gradually become covered with *Grimmia*, a moss that proliferates on cooled lava and whose color varies from silver-gray to luminous green depending on the amount of moisture in the soil. This moss is one of the few plants that have been able to grow in Iceland, a country characterized by a certain botanical impoverishment, with fewer than 400 listed species of plants and only 25 percent of its land covered by permanent vegetation. Geologically very young, Iceland has existed for 23 million years and has more than 200 active vents and many glaciers, occupying almost one-eighth of the island's surface area.

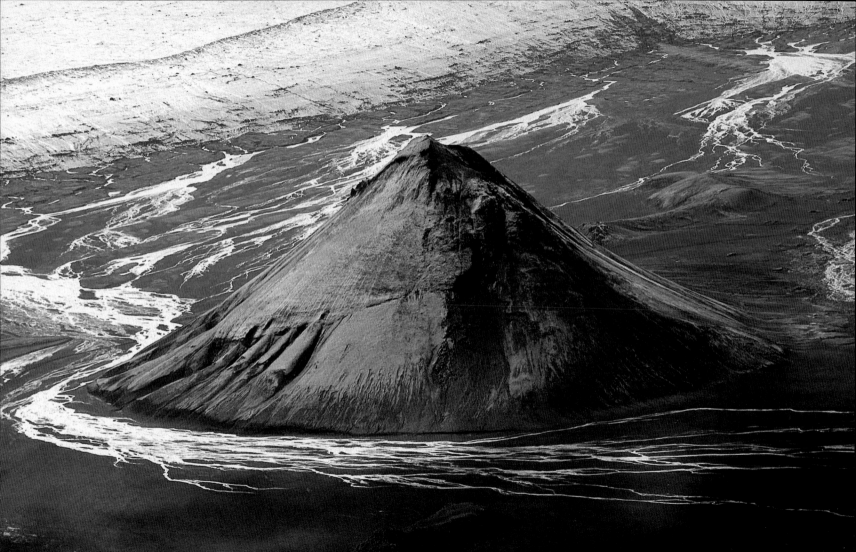

Tunisia. Governorate of Tozeur. Marabouts in Jebel Krefane.

Ifriqiya (now Tunisia) was conquered by the Arabs at the end of the seventh century, but conversion to Arab and Islamic culture began quite slowly, and it was only from the eleventh century on that they took on a definitive character. Maraboutism (the worship of saints) appeared under the Hafsides Dynasty (thirteenth to sixteenth centuries) and became an essential element of devotion, resulting in the domed tombs (marabouts) that are scattered all over towns and landscapes. The marabout originally pertained to a resident of a ribat (*murabit*), a warrior monk living in a fortified monastery. It then came to refer to both the saint and the mausoleum (also termed *zawiya*) that his descendants, then all his followers, came to celebrate with musical ceremonies involving singing and dancing. For the people, the local saint represents an essential element of popular devotion, especially for women; favors are obtained in exchange for offerings and various homages. No one should be under any illusion about this traditional expression of popular faith, however. Of all the countries south of the Mediterranean, Tunisia has gone furthest in separating religion and the state.

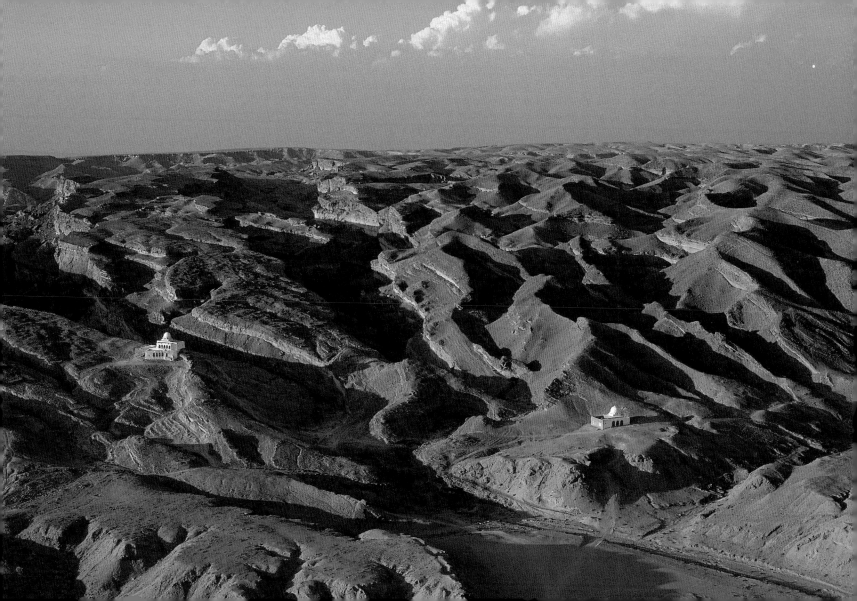

Argentina. Santa Cruz area. La Leona River.

In Patagonia, east of the Los Glaciares National Park, is the La Leona River. Originating south of Lake Viedma, it winds for about 50 kilometers (30 miles) through the Andes Mountains, then flows into Lake Argentino, the largest lake in the country. La Leona is a glacial river fed by blocks of ice that have broken off the glaciers. The river's distinctive milky blue color, known by the Argentineans as *dulce de glaciar*, "glacier cream," comes from a suspension of rock powder ground extremely fine by the glaciers. The contrast of colors is all the more striking because the river banks, having been subjected to a succession of floods, are virtually devoid of vegetation. The river was baptized La Leona in 1877 by the Argentine explorer Francisco Pascasio Moreno after one of his expeditions in this region, during which he survived an attack by a female puma, *la leona* (a lioness). Like the majority of waterways in Patagonia, La Leona is rich in a diverse species of fish, notably salmon and trout.

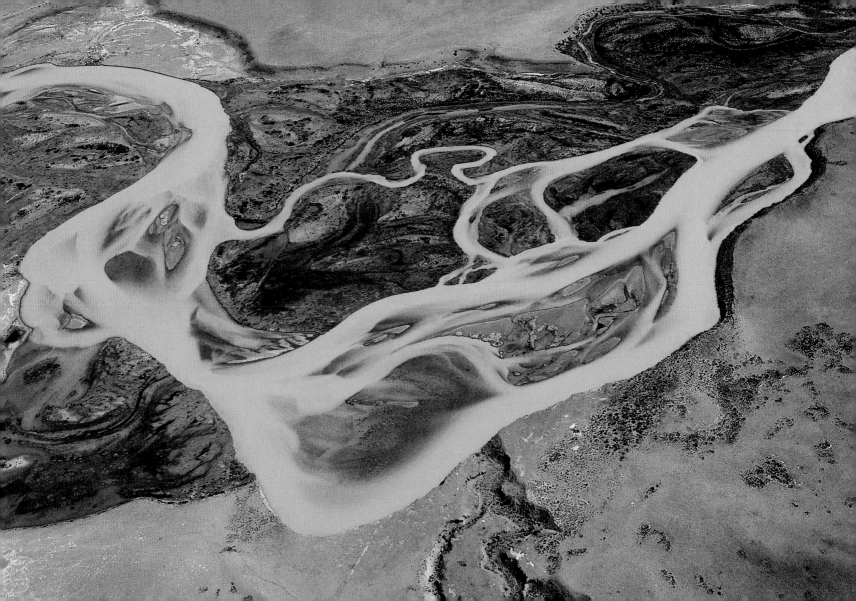

Kenya. Small African fields.

The soil in the highlands of Kisii, in southwestern Kenya, is exceptionally fertile. It is exploited by the Gusii, Bantu farmers who quickly grew to relative prosperity, contributing to the national economy with their production of tea, coffee, and pyrethrum. In contrast to the large farming concerns in the north, which are supported by international capital from Kericho, the production of the Gusii and their neighbors is in the hands of small farmers. A high birth rate and intensive growing methods have in fact led to properties being divided into smaller and smaller plots. In some cases the Gusii have had to emigrate for lack of work. Nevertheless, as the agronomist Leslie Brown predicted in the 1970s, the small-scale method of farming has stood the test in the face of the traditional model of large plantations. Today Kenya is the third largest tea producer in the world, after India and Sri Lanka, and more than half of its production comes from small properties.

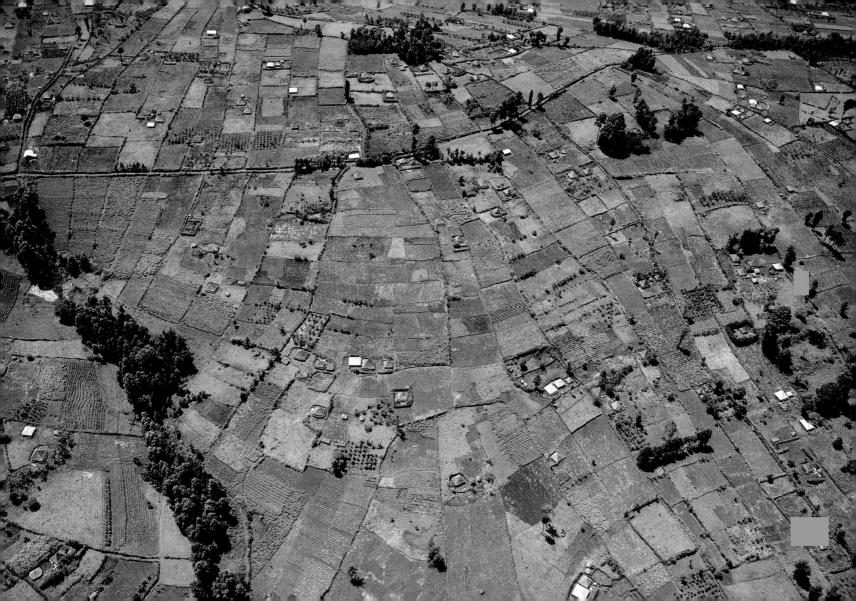

Tunisia. Flock of sheep in a field.

One-third of the active population in Tunisia still works in agriculture. An important part of this is raising sheep, which number about seven million. Sheep's meat is still the most popular meat here. Thirty-two percent of breeding is concentrated in the north, in the governorates of El Kef (where rotation between corn and fallow land predominates) and Béja. In the center and south of the country, the main areas engaged in this activity are the governorates of Kasserine, Kairouan, and Sidi Bouzid. Here on the poor pastures of the steppes, sheep can only be reared extensively, and limited yields are made lower still by drought and animal disease. The state invests in creating water reserves for dry periods, but overall it loses money by doing so. Tunisia is confronted by the same dilemma that the English were at the end of the eighteenth century: whether to subsidize their own corn growers or their livestock, whose production would enable them to buy corn from Poland. No doubt the Tunisians will do as the English did then, and abandon their sheep because of the rapid globalization of the food market.

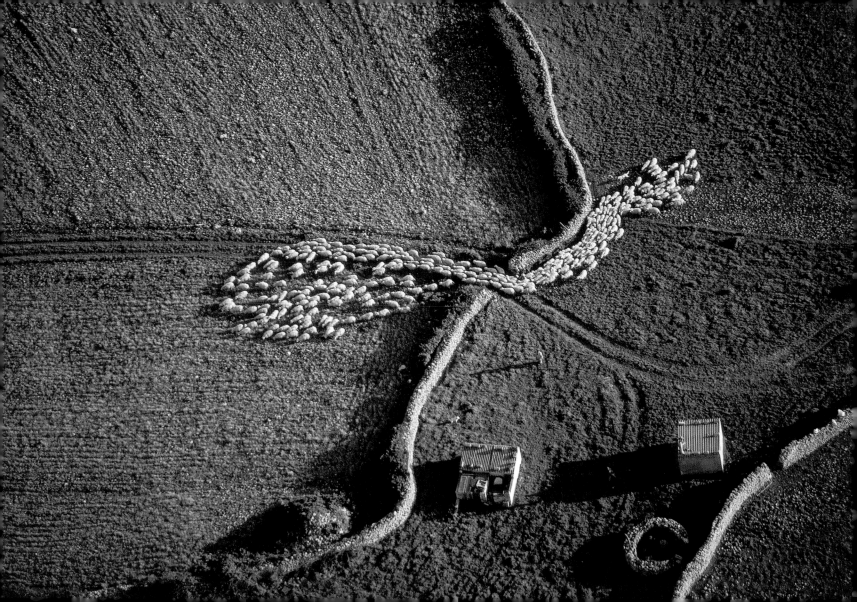

France. Saône-et-Loire Department. Subaquatic vegetation in the Loire near Digoin.

The Loire rises in the Ardèche in southeastern France, then flows for 1,012 kilometers (625 miles) across a large part of the country before finally reaching the Atlantic in the west. This waterway, which is considered to be the last French river still in its natural state, is subject to a very irregular pattern of major rises and drops in the water level. In the summer, certain parts of it might be reduced to narrow threads of water flowing between sandbanks. In some areas in these shallow waters, subaquatic plants proliferate, as here near Digoin. In the winter, the river's high water levels can cause large-scale flooding in the towns and villages along its banks. In order to tame this unpredictable river while preserving its ecological balance, a ten-year management plan was instituted in 1994, notably with the aim of demolishing old dams and building new ones on certain tributaries.

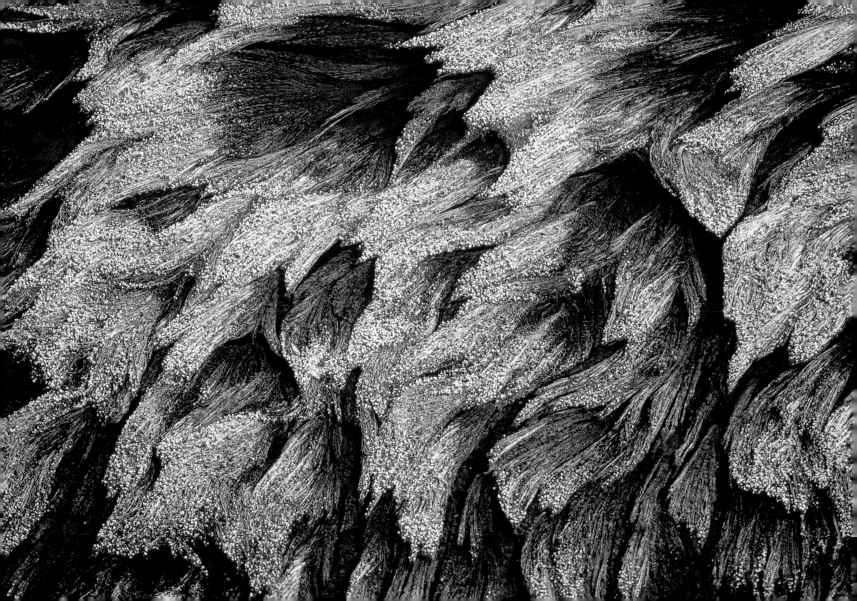

Brazil. Mato Grosso do Norte. Herd of zebu on a road near Cáceres.

The state of Mato Grosso is Brazil's third-largest, and its central plateau is a landscape of savannah (*campos* in Portuguese), scattered here and there with trees (*campo serrado*). The temperature averages 20°C (68°F), and most of the rain falls in the summer. Supporting livestock, cotton, and coffee, Mato Grosso is now one of the country's richest agricultural regions. In Brazil, agriculture and livestock farming are extensive, practiced on vast ranges known as *fazendas* belonging to a small number of rich landowners. Less than three percent of the population owns more than two-thirds of Brazil's arable land, while more than 25 million peasants live precariously, by casual work. This situation has brought about violent clashes that are now a regular occurrence: more than 1,000 people have died in the fighting over the past 10 years. Their driving force, the Movimiento Dos Sem Terra (Landless Peasants' Movement), which campaigns for a fairer division of land ownership, is Latin America's most powerful protest movement. Over the past decade, squatters have forced the government to grant land ownership to more than 250,000 families. Speaking for thousands of socially excluded people, the movement is a challenge the Brazilian government can no longer ignore.

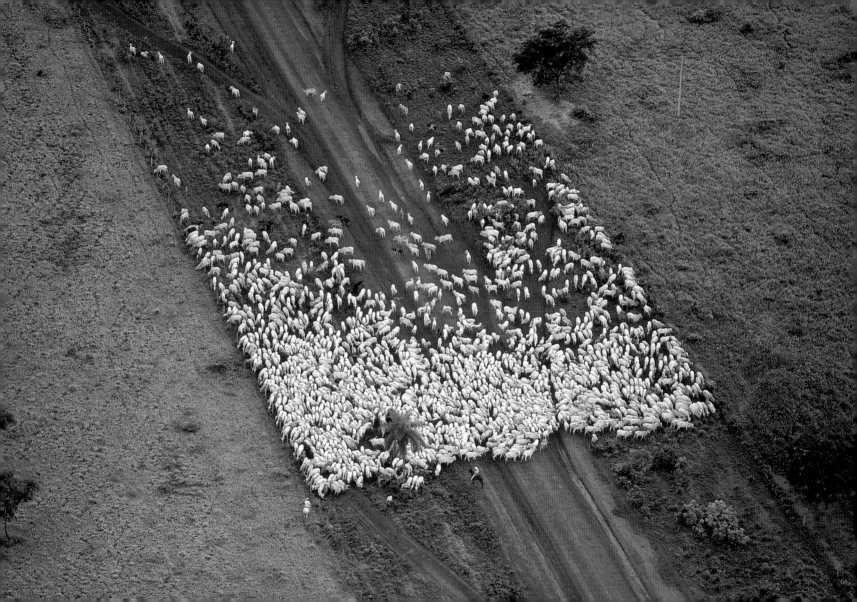

United States. Los Angeles, California. Interchange between the Pasadena and Santa Monica Freeways.

With car traffic growing continuously, roads and expressways proliferate like tropical creepers. In Europe, for example, the length of the average journey from home to work has doubled in the last 20 years. In the United States there is an average of nearly two cars per household. These vehicles are directly responsible for 20 percent of greenhouse gas emissions. Indirectly, they are responsible for emission related to concrete and asphalt production, road building, and car manufacturing, which accounts for 14 percent of the carbon dioxide output of developed countries. There are 280 million Americans today. What will happen if the Chinese and Indians, who number 2.3 billion, achieve the same level of car ownership? What right would anyone have to prevent them from doing so? These were some of the questions at the center of the Kyoto Conference on reducing greenhouse gas emissions; the United States has thus far refused to ratify the agreement.

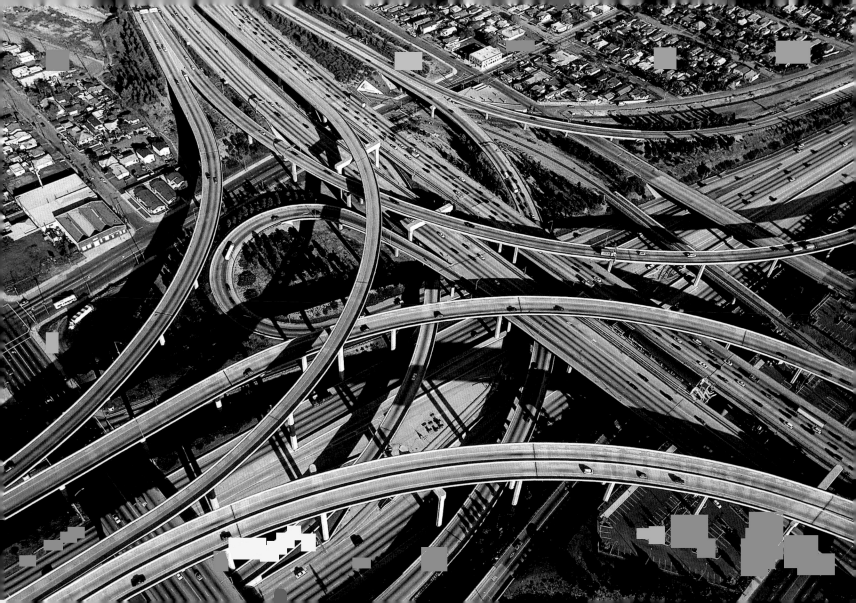

Argentina. Neuquén Province. Fall landscape at Traful.

In northern Patagonia, the area around Lake Traful takes up 750,000 hectares (1.85 million acres) of the Nahuel Huapi National Park, which was created in 1934. The region is known as "the Switzerland of Argentina" both because some parts of it resemble the Alps and because of the distinctive nature of its population. An early Jesuit mission, founded here in 1670, was massacred by the Mapuche Indians, who themselves were subjugated (and eventually decimated) at the end of the nineteeth century. They were followed by a great diversity of European colonists: Spaniards, Italians, Scots, and English in the Negro River Valley; and Germans, Swiss, and Welsh in the Bariloche area. This city on the shores of Lake Nahuel Huapi is the perfect example of a type of "Europeanism" in Argentina; this refers of course to its population, but also to its style and architecture (its 1930s administrative center, chalets, and impeccable shop windows), and some occupations that may seem surprising (pottery and chocolate making). This "Europe at the ends of the Earth" got a bad reputation by taking in escaped Nazi war criminals after 1945. Erich Priebke, who was responsible for the Ardeatine Caves Massacre in Rome, was arrested here in 1995.

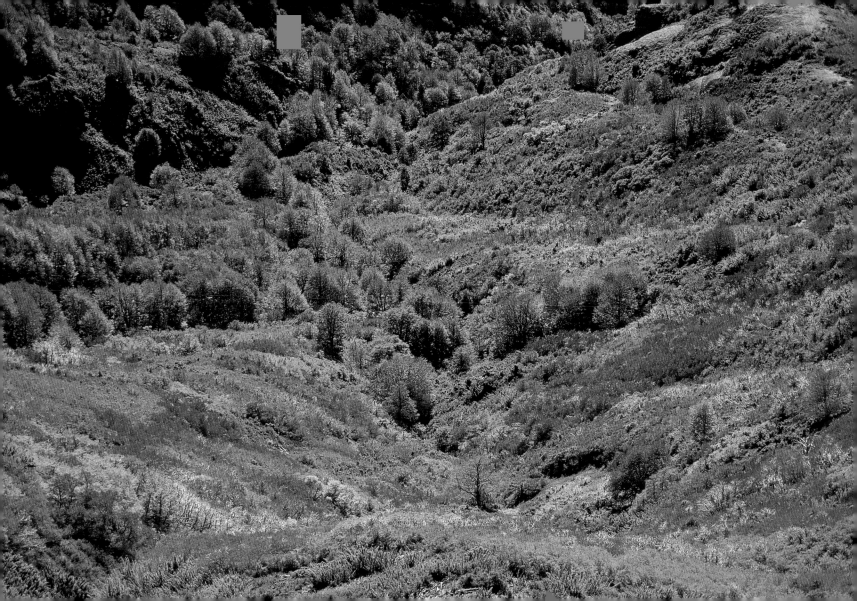

Kenya. Suguta Valley. Pink flamingoes on the shores of Lake Logipi.

The white crystallized natron (sodium carbonate) on the black volcanic banks contrasts with the blue-green algae that proliferate in the salty, alkaline water of Lake Logipi. Seen from the air, this part of the shore looks oddly like a giant oyster. Pink flamingoes come here in large numbers to feed on the algae, shellfish, and insect larvae that abound in the lake's shallow waters. Normally these waders gather in huge colonies around most of the lakes in the Rift Valley, but they deserted the region during the terrible drought that plagued eastern Africa until 1998. At the beginning of that year, heavy rainfall encouraged small and pink flamingoes to return to the Rift Valley, where there are now nearly three million.

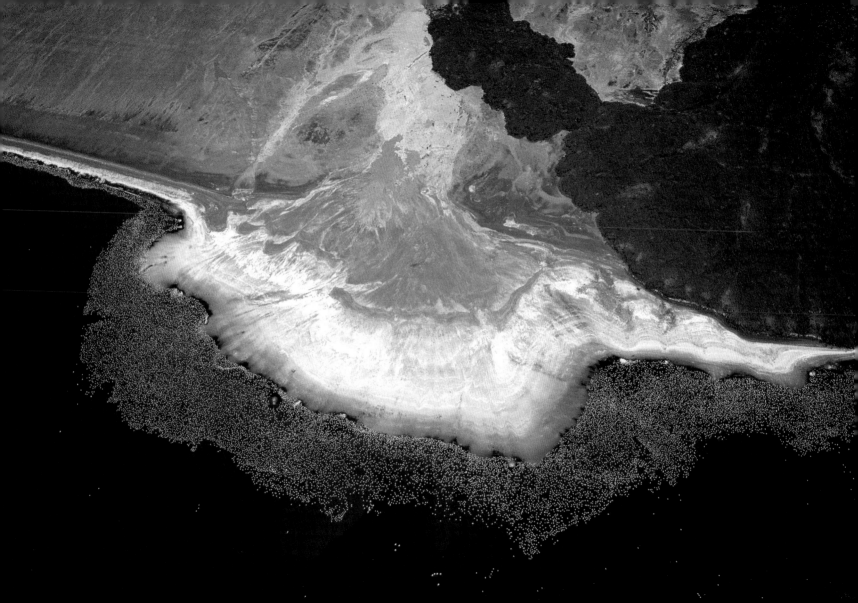

Mexico. Garbage dump in Mexico City.

Mexico City is the most polluted capital in the world owing to its heavy industrial emissions, and also has to deal with almost 20,000 tonnes (22,000 tons) of household garbage produced every day by its 16 million inhabitants. Only half of this garbage is incinerated; the rest is heaped on to open-air garbage dumps that are visited daily by the most destitute members of society looking for what they can salvage. Household waste is piling up on every continent, and is one of the major problems of large urban centers; however, it is in the industrialized countries that people throw away the largest quantities of garbage: from 300 to 870 kilograms (650 to 1,900 pounds) per inhabitant per year, as opposed to 100 kilograms (220 pounds) in the majority of developing countries. Nowadays, industrial recycling techniques are used more and more to solve the problems associated with the accumulation of waste.

Mauritania. Near Nouâdhibou. Pink flamingoes on the Banc d'Arguin.

The Banc d'Arguin is a landscape of sandbanks and shallows which in 1816 was responsible for the shipwreck of the French frigate *La Méduse*, an event that inspired Theodore Géricault's famous painting *Le radeau de la Meduse* (*The Raft of Medusa*, 1818–19). Between migratory birds, including Camargue flamingoes and other species from Siberia, and marine mammals such as baleen whales, killer whales, and dolphins, there are some 280 species in this nature reserve, which became a national park in 1976 and has been a UNESCO World Heritage Site since 1989. The richness of the Banc d'Arguin's fauna is said to result from the combination of true underwater grassland and the phenomenon of "upwelling" of cold, nutrient-rich water from the deep ocean to the surface. In addition, this long stretch of 12,000 square kilometers (4,600 square miles), situated on the Mauritanian coast between Nouâdhibou in the north and Cape Timitris in the south, is virtually uninhabited. Only a few village encampments of traditional Imraguen fishermen can be seen here and there. How much longer can it escape the tourist influx?

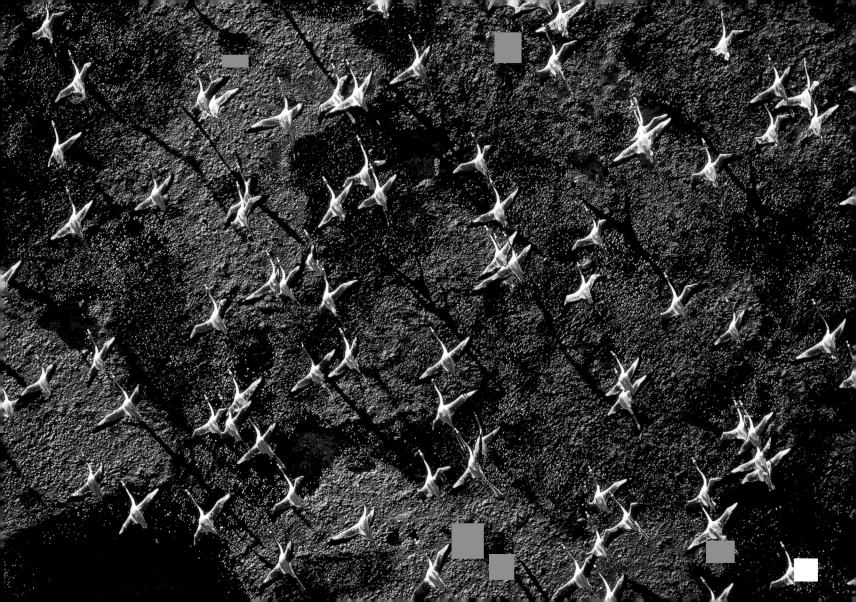

Philippines. Mindanao Island. Gold-digging near Davao.

Exploiting the Mindanao Island gold seam, Philippine workers occupy precarious shelters made from branches and canvas sheets, clinging to the mountainside. These slopes have been excavated relentlessly, carved into a fragile network of galleries that frequently collapse in the torrential monsoon rains, causing the deaths of dozens of miners. The precious metal is often extracted using rudimentary tools such as hammers and scissors, at a rate of 40 kilograms (90 pounds) per day. Of the 150,000 tonnes (165,000 tons) of gold that have been extracted from the Earth since the prehistoric era, one-third has been used to manufacture objects, another third hoarded by governments, and the rest lost, mainly by wear. At present, 3,000 tonnes (3,300 tons) are mined every year, mainly in South Africa, the United States, and Australia.

Brazil. Amazonas State. Marshes on the banks of the Amazon in the Anavillanas region.

Two million years ago, a shallow inland sea covered most of Amazonia, and the freshwater dolphins which can still be seen in the Amazon bear witness to the existence of marine fauna long ago. The sea has gradually been silted up by alluvium carried down from the Andean Cordillera, and forest has replaced lagoons. The last of the great lakes disappeared 10,000 years ago, leaving behind a great flood plain, the *varzea,* which has been widely coveted. Farmers would welcome the draining of this vast expanse of rich mud, oil prospectors' vessels prowl in search of deposits, and poachers trap rare birds which they sell in North America. Globalization comprises not only the unconstrained flow of industrial products and capital, but also the impact of the dominant economy on every square meter of the Earth's surface, no matter how remote, inaccessible, and apparently wild.

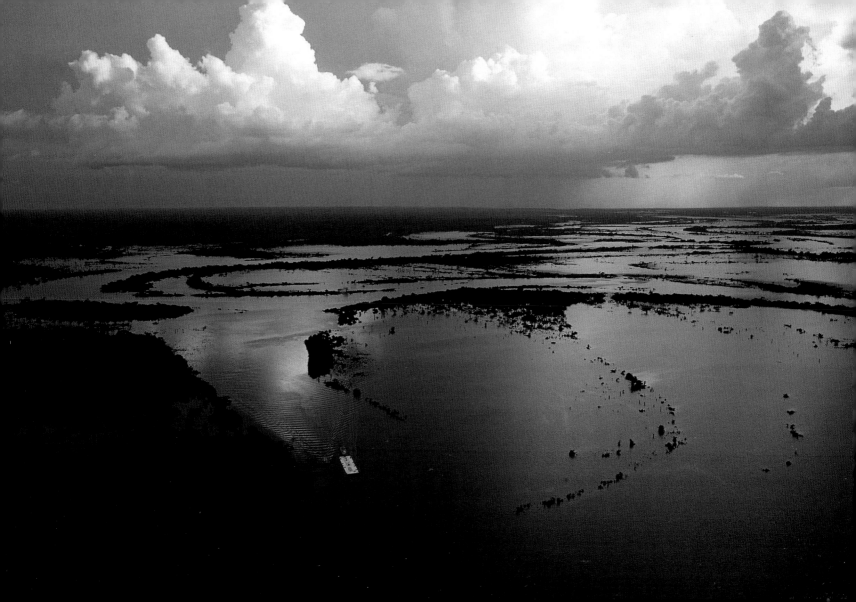

Malaysia. Kuala area. Oil palm plantation.

Originally from western Africa, the oil palm was introduced to Malaysia in the 1970s in order to diversify the agriculture, which relied almost exclusively on growing hevea (rubber trees). The palms have replaced over 20,000 square kilometers (7,700 square miles) of the country's equatorial forest, and are grown on hillsides where they are arranged in terraces that follow the contour lines to avoid erosion caused by streaming water. Malaysia is now one of the leading producers and exporters, supplying two-thirds of the palm oil consumed in the world. World production of this commodity has quadrupled in 50 years, and it has now become the second most frequently used vegetable oil, after soya oil. Although primarily intended for cooking, it is also used in the manufacture of soap, cosmetics, and pharmaceutical products.

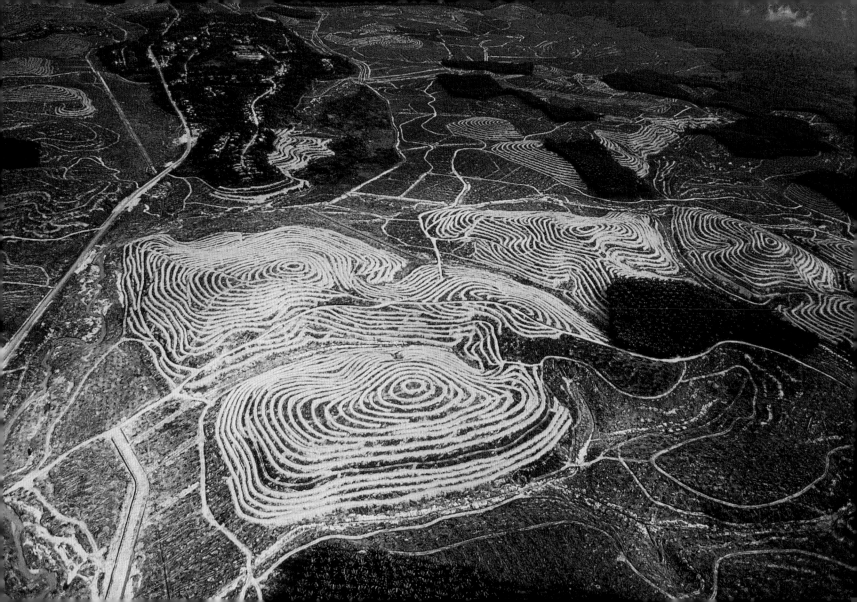

Senegal. Fish market in the Dakar area.

With the benefit of a seasonal alternation between warm equatorial currents and cold currents that bring a wealth of nutrients from the Canary Islands, the 700 kilometers (450 miles) of the Senegal coast are favorable to a rich, varied marine fauna. Intense exploitation of fish resources has developed here, with an annual production of 360,000 tonnes (400,000 tons). Eighty percent of the marine fishing is carried out on a small scale, in baobab or kapok-wood canoes called pirogues, using lines or nets. Fish are Senegal's primary economic resource, and mainly supply the local market; most of the tuna, sardines, and hake are sold straight from the beach where the pirogues come in to land. In Senegal, as in many developing countries, fish supplies 40 percent of the protein consumed by the population.

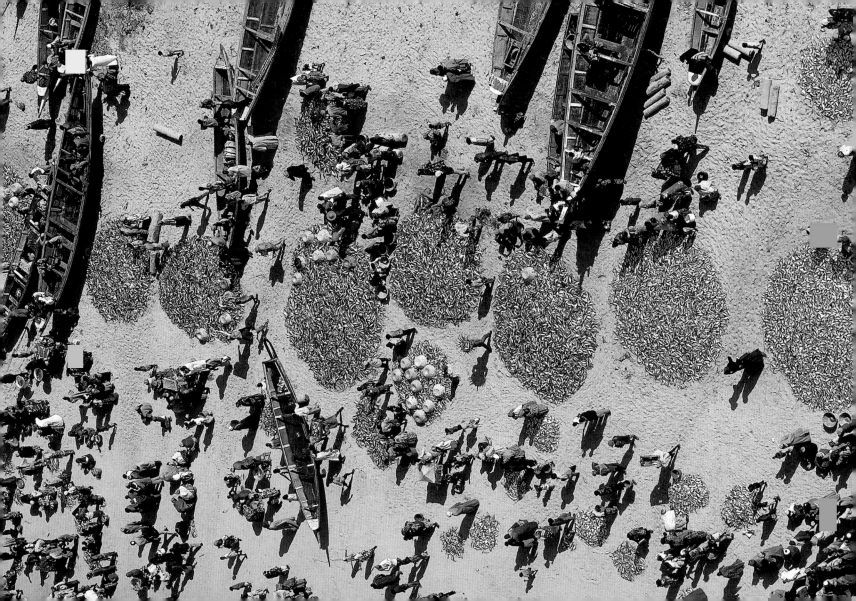

Albania. Landscape in the Kukës area.

The highest mountain range in Albania, culminating in Mount Jezerces (Maja e Jezerces) at 2,693 meters (8,833 feet), rises in the Kukës area in the northeastern part of the country. This mountainous enclave bordered by the Drin Valley has always been a pocket of resistance to political upheavals in Albania. Over the centuries, the huge patriarchal family clans that live here ignored first Ottoman rule and the decrees of the sultans, then the laws of King Zog, all the while continuing to apply the Kanun – a customary law of Byzantine origin, based on "blood vengeance." The Kanun is superbly described by the Albanian author Ismaïl Kadaré, who characterizes the north of the country as a "universe of legends," the land of "fairies and oreads, rhapsodists, the last Homeric hymns in the world, and the Kanun, terrible but so majestic." This traditional world also survived communism and Maoism following the Second World War, and became the temporary refuge of Kosovars fleeing the oppressive demands of the Serbs in 1999. The clans of Kukës pose a sensitive question: to what extent is cultural diversity compatible with European unity?

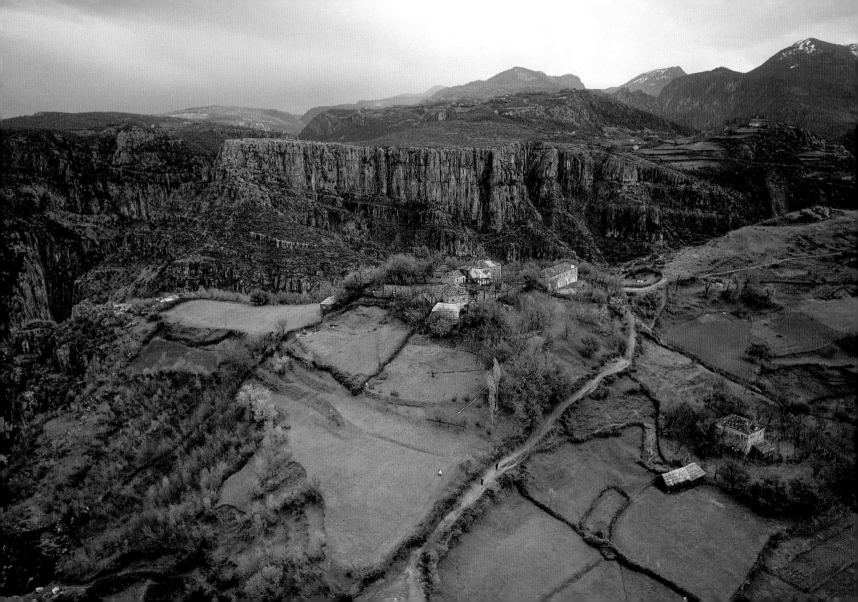

Spain. Balearic Islands. Almond harvest on the island of Majorca.

In Spain's Baleares Archipelago, as in all Mediterranean countries, almond-growing is an ancient activity. Here it has remained traditional. The almonds are usually harvested by hand, shaken down onto canvas sheets stretched out under the trees. The limited productivity of 2 to 5 kilograms (4½ to 11 pounds) of nuts per tree is generally compensated for by the large size of the areas planted; this has diminished considerably, however, since very few of the old trees have been replaced. Almonds from these islands used to represent the bulk of production in Spain, but with the current harvest of just 7,000 tonnes (7,700 tons) per year, they now make up barely 3 percent of the nation's output. Nevertheless, Spain is the second largest almond producer in the world, with an annual production of about 227,000 tonnes (250,000 tons), 80 percent of which are consumed throughout Europe.

Djibouti. Lake Assal.

The Republic of Djibouti is in one of the most tectonically unstable regions of the world. It is situated at the junction between two great fractures in the Earth's crust: the East African Rift Valley, where the African plate is beginning to split in two; and the mid-ocean faults in the Red Sea and Gulf of Aden, where the African and Arabian plates are separating, widening the seafloors. The movement of these plates – slabs of the Earth's crust and underlying mantle – results in the volcanic phenomena that are very common here, and in the uneven terrain which rises almost 2,000 meters (6,600 feet) in some places, and is as low as 155 meters (509 feet) below sea level here in salty Lake Assal, the lowest point in Africa. The hot, arid depths of the Lake Assal basin resemble a furnace which speeds up evaporation and increases the concentration of salt to the point where it can no longer dissolve in the water, but instead floats on the surface in crusts. The same phenomenon can be seen at the southern end of the Dead Sea and on ancient lakes in northern Kenya. A natural phenomenon aggravated by human activity, salinization can also be observed in poorly drained irrigation channels in many parts of the world, such as in Bihar, India, and Jalapa, Mexico. It often results in environmental devastation as very few forms of life can withstand excessive concentrations of salt.

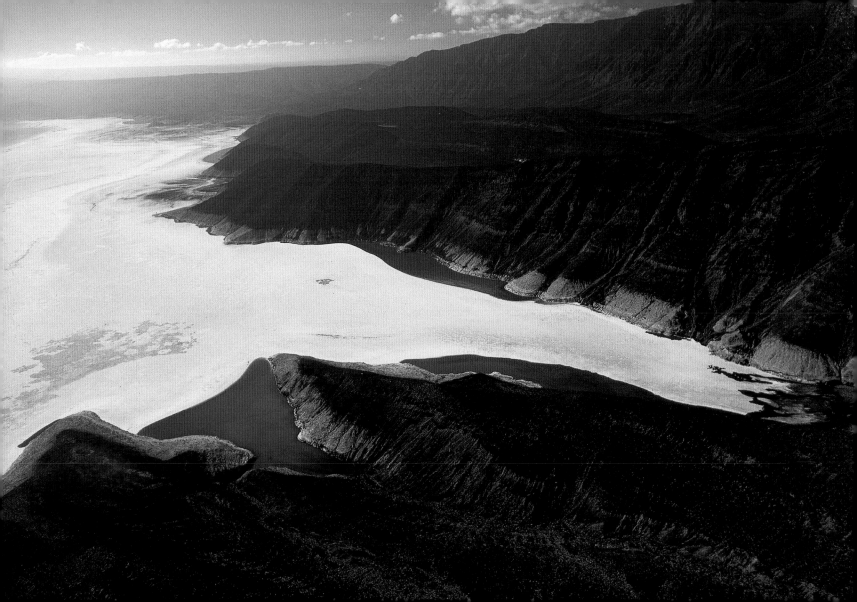

Namibia. Kaokoveld. Himba couple.

Spread out along the Cunene River, in the Kaokoveld region in northern Namibia, are 3,000 to 5,000 Himbas. The Himbas are a nomadic people of cattle and goat breeders who have maintained their traditions, living cut off from the modern world. During the 1980s they suffered from both a long drought that killed off three-quarters of their livestock, and from the effects of the war between the South African army and SWAPO (the South West Africa People's Organization). Today the Himbas face an equally menacing threat: the plan to build a hydroelectric dam on the Epupa Falls. This would make it possible to supply energy to a water desalination plant in a country that imports almost 50 percent of its electricity and is sorely lacking in water resources. At the same time it would also result in the flooding of hundreds of square kilometers (hundreds of square miles) of pasture, thus forcing the Himba herdsmen to migrate.

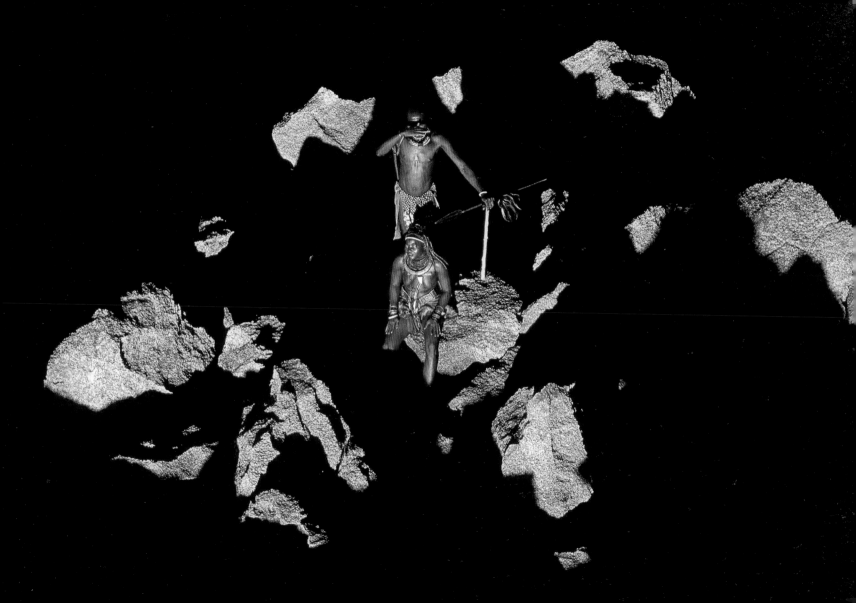

Norway. The high plateaus of Hardangervidda. Lake area.

With a surface area of almost 8,000 square kilometers (3,000 square miles) and an altitude of 1,100 to 1,400 meters (3,600 to 4,600 feet), the Hardangervidda is the largest high plateau in Europe. There is very little vegetation here because of the harsh climate (violent winds, frequent storms, and a winter that is as icy as that in the north of the country). The Hardangervidda is actually above the timberline, and marks the southern limit for many Arctic plants. Half of this high, desert plain forms the largest national park in Norway. It shelters 21 species of mammals – including wild reindeer – and about 100 species of birds. This vast protected area is well equipped with marked paths, ski slopes, and mountain chalets to accommodate those who come here to enjoy hiking, winter sports, or the excellent fishing offered by its lakes.

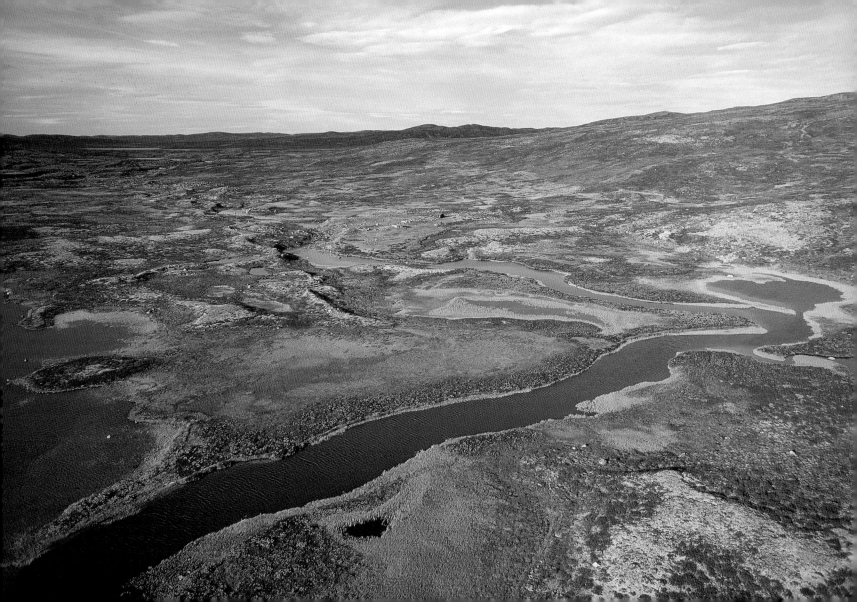

Jordan. Ma'an region. Petra (al-Batra). Temple of Ed-Deir.

In spite of being almost entirely landlocked, Jordan occupies a strategic position between the Mediterranean and the Red Sea. In the sixth century B.C., the Nabataeans, a nomadic trading people, began to carve a city out of the pink and yellow sandstone in the south of the country. Petra, "stone" in Greek, was to become their capital. They made a living from the taxation of caravan routes and from trade in rare goods such as incense, spices, ivory, and precious metals and stones. Before coming under the yoke of Rome in A.D. 106, their civilization spread its influence well beyond the trans-Jordanian region. On the heights of the city stands the temple of Ed-Deir, which was built between the first and second centuries and whose imposing dimensions (47 meters high and 40 meters wide [155 by 130 feet]) tower over Petra's 800 or so other buildings. From the beginning it was a place of worship, and after the decline of Nabataean civilization, it was taken over by Byzantine Christian monks, hence its name Ed-Deir – "The Monastery." Petra, which was listed as a UNESCO World Heritage Site in 1985, has for some years been faced with a worrying threat: salt blown in from the Dead Sea is encrusting the rock, and slowly weakening the buildings.

India. The old town of Jodhpur, in Rajasthan.

Standing at the gateway to the ancient kingdom of Marwar, "The Land of Death," Jodhpur defies the great Thar Desert with its bluish tinge. The Brahmans are said to have painted the houses blue in order to make them cooler inside. As a result, the old city of Jodhagarh took on the color of water, that most precious of resources in this arid region. Founded in 1459 by the Rajput Rathor clan, which was forced to withdraw to the edge of the desert after being chased out of Uttar Pradesh by the Afghans, the city was once a very prosperous oasis on the caravan route from Delhi to Gujarat and from central Asia to China. The old town, densely built and hemmed in by thick walls, rises in terraces at the foot of the sandstone fortress. Its maze of alleyways offers shade to craftsmen, specialized markets, and visitors, of whom there are many – Rajasthan remains the most popular state in India for tourists. In spite of the strong sense of history felt in places like these, visitors would be wrong to think that they have stepped back in time. With an economic growth rate of seven percent per year for the last 15 years, India has become a modern country, whose educated middle class is highly sought after.

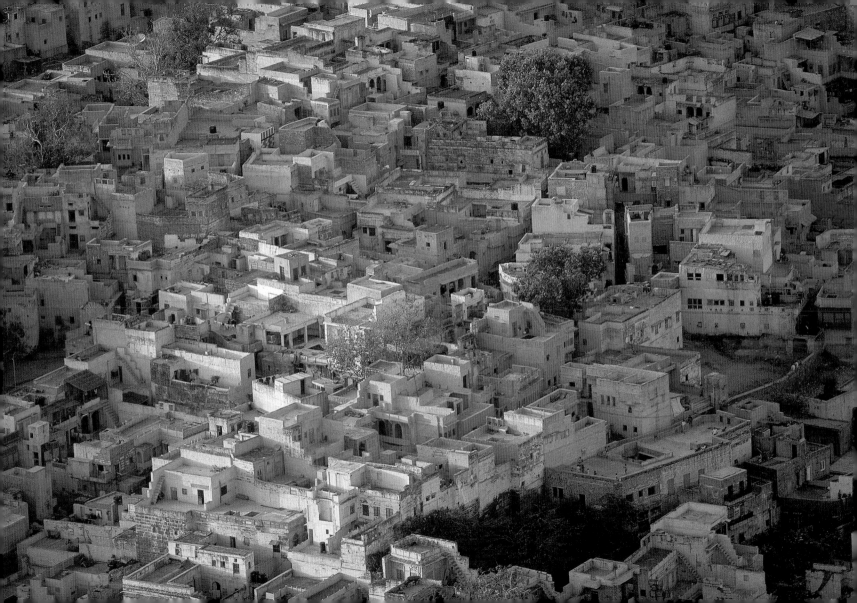

France. Bouches-du-Rhône Department. Cracked mud flat in the Camargue.

Before flowing into the Mediterranean Sea, the 812-kilometer (505-mile) Rhône River divides into two branches that form a delta known as the Camargue. Forty percent of this vast wetland covering 750 square kilometers (300 square miles) consists of marshes and brackish or freshwater ponds (up to 12 grams per liter of salt [1.6 ounces per gallon]). Some of the areas, known as "low ponds," dry up in summer, revealing a silty soil which in the heat of the sun forms a cracked surface covered in saline deposits. The Camargue, part of which has been listed as a nature reserve since 1927, hosts a variety of wildlife, and in particular a large number of birds, including waders, ducks, and mudlarks. This is also a rich environment for human activity, which takes various forms in the delta: in addition to horse and bull breeding, there is rice growing, wine growing, fishing, and exploitation of the salt from over 100 square kilometers (40 square miles) of salt marshes – the largest area in Europe – from which almost one million tonnes (just over one million tons) of salt are extracted each year.

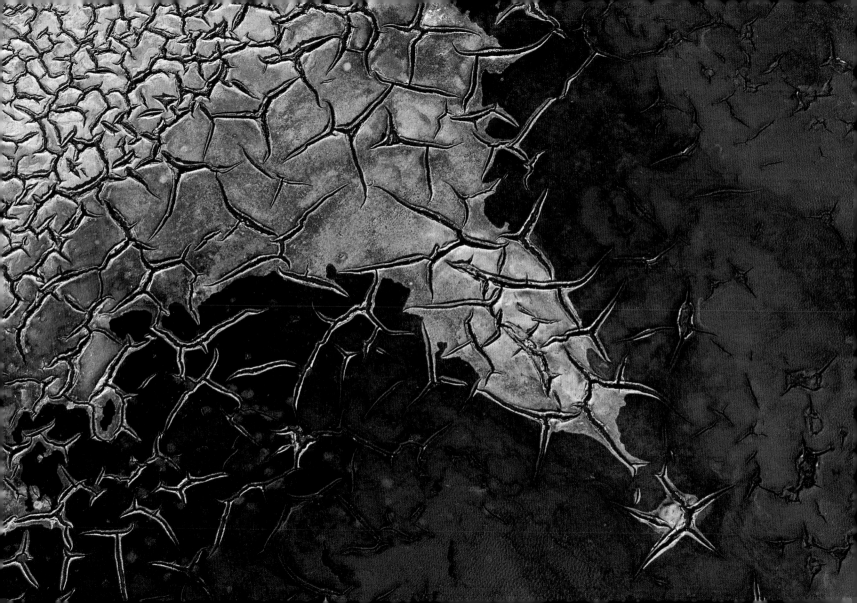

Australia. Queensland. Bowling Green Bay National Park, south of Townsville.

The marshes of Bowling Green Bay on the east coast of Australia occupy an area of over 35,000 hectares (85,000 acres). The lowest part of the marsh is alternately covered and uncovered by the sea, and is made up of salty mudbanks on which no vegetation can grow. The slightly higher parts, on the other hand, are colonized by mangrove swamps. This coastal marsh has important ecological functions. It is visited by half of the populations of migratory birds from Japan and China – 244 species, 13 of which are rare or endangered. The submerged, muddy part of the marsh is a spawning-ground for fish. The marsh also absorbs the excess rainfall and controls flooding, while the mangroves retain sediment and check coastal erosion. Bowling Green Bay is a Wetland of International Importance, one of the international sites listed by the Ramsar Convention, which met in 1971 to discuss the ecological role of wetlands and the possible ways to protect them. The marshes do indeed face various threats from urban, agricultural, and industrial practices, as well as a possible rise in sea level. About half of the wetlands in Australia have dried out since the arrival of the Europeans.

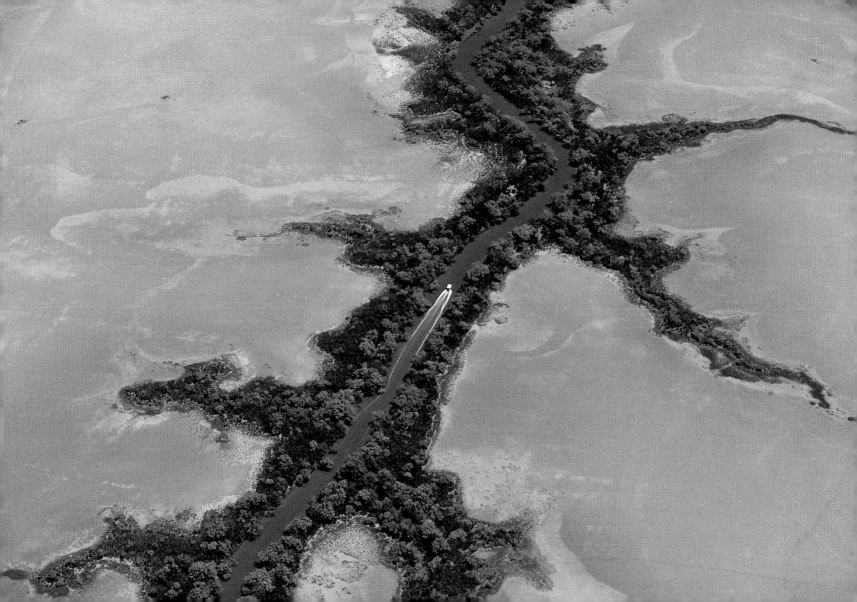

Mali. Pirogue on the Niger River in the Gao area.

Rising in the Fouta Djalon Mountains in Guinea, the Niger River flows for 4,185 kilometers (2,600 miles), making it the third longest waterway on the African continent. It travels for 1,700 kilometers (1,100 miles) across Mali, forming a long loop that reaches the southern limit of the Sahara and supplies water to large urban centers such as Timbuktu and Gao. The short rainy season stimulates the regeneration of aquatic vegetation seen here. Pirogues nagivating through the plants provide the area with means of transportation, travel, and trade. With its seasonal pattern of flooding, the Niger also irrigates almost 5,000 square kilometers (2,000 square miles) of land used for rice growing and market gardening. It is the main source of water for nearly 80 percent of the population of Mali, who live by farming and animal raising.

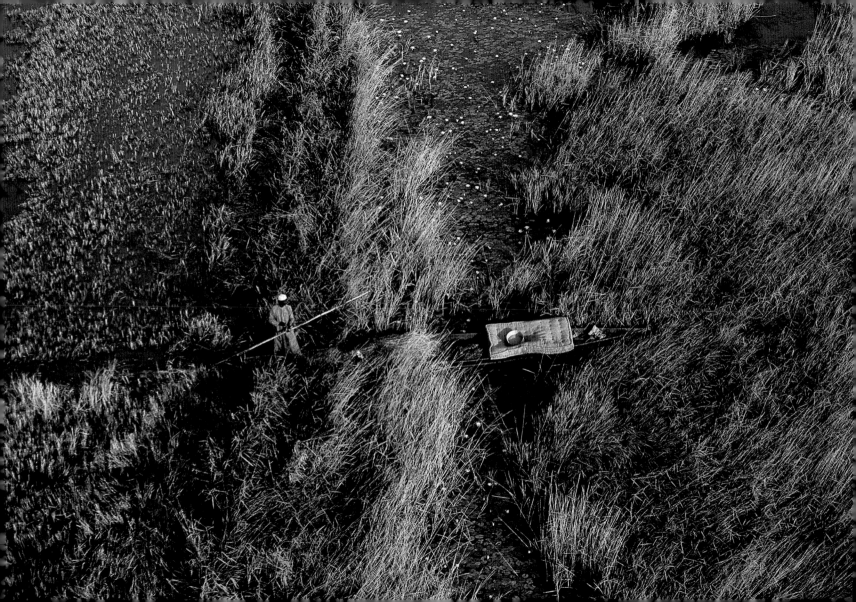

Morocco. Fishing nets on the sand at Moulay Bousselham.

Fish is a limited resource whose global exploitation has peaked at 92 million tonnes (100 million tons). As a result Europe, the United States, and Japan, which consume 80 percent of world fish imports, are beginning to fight over them. Since fishing is increasingly regulated in their own waters, they are looking farther and farther away for supplies. The European Union has made about 30 agreements with developing countries prepared to allow access to their fishing areas. Although this brings compensation payments, payments for fishing rights, and foreign currency into poor countries, it also deprives their inhabitants of the protein resource that fish normally supply. This really can be described as "halieutic [fishery] colonialism." The sea's resources are indeed becoming more and more unavailable to the bordering countries that are unable to line up modern fleets. In the Merdja Zerga Lagoon near Moulay Bousselham, however, modern trawlers cannot operate, and fishing continues to be carried on by simple, traditional methods that send tourists into raptures, but also bear witness to the underlying domination to which the southern countries are being subjected.

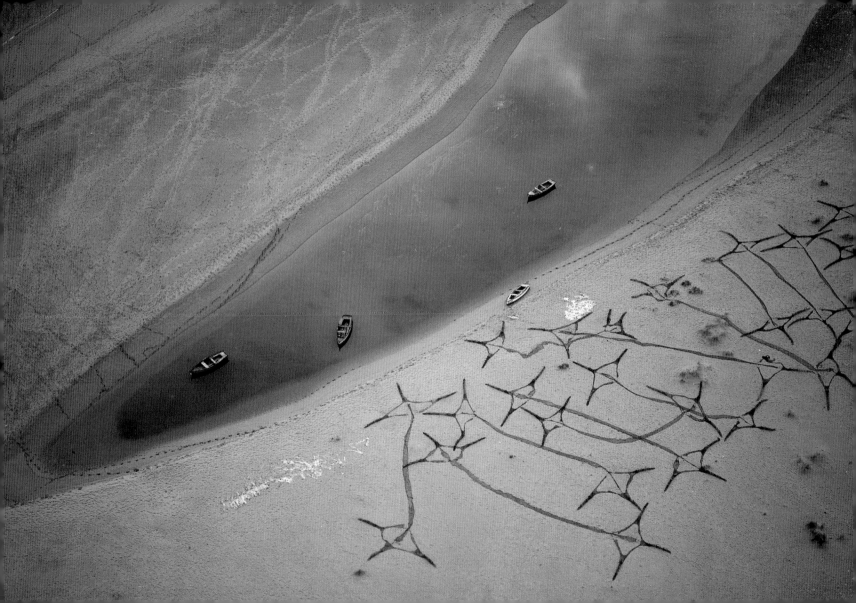

Philippines. Luzon Island. Mount Pinatubo. Fluvial erosion features in volcanic ash.

When Mount Pinatubo erupted in July 1991, it sent several billion cubic meters (several billion cubic yards) of ash into the atmosphere. The finest particles traveled around in the upper atmosphere for three years and caused a slight cooling of the climate by intercepting some of the sunlight. Most of it fell close by, however, burying the landscape under a sort of permanent, artificial snow. When the heavy Luzon rains fell on this ash, they reproduced within a few weeks the sort of topography that running water normally takes millennia to create on harder terrain. As can be seen, the hydrographic network takes a "fractal" form – small features mimic the patterns of larger features and of the landscape as a whole. Without the people in it for scale, it would be difficult to distinguish this aerial view from a close-up shot of one of the tiny branches. Since they were first described by Benoît Mandelbrot in 1975, people have shown that fractal forms occur very frequently in nature – on indented coastlines, snowflakes, the network of bronchial tubes in the lungs, and even the distribution of stars and galaxies in the universe.

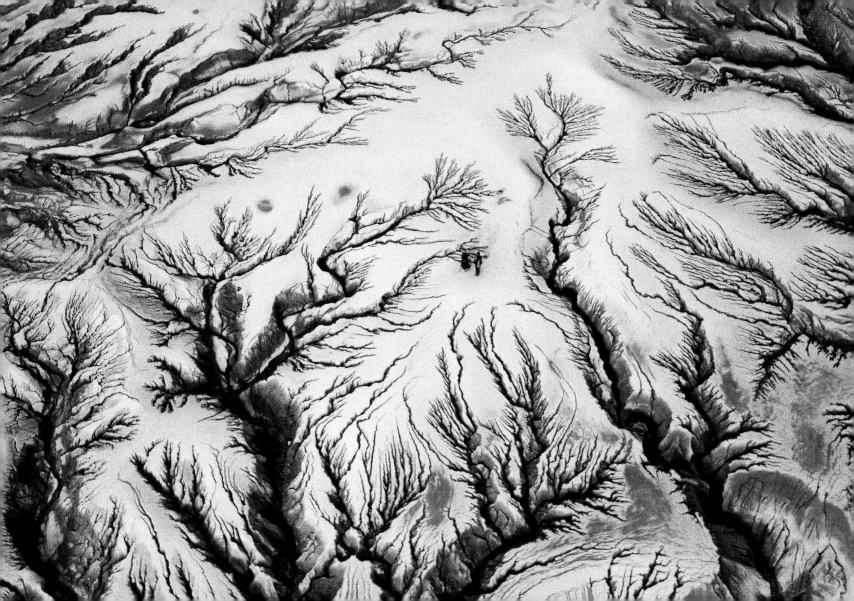

Bahamas. Exuma Keys. Islets and seabed.

The Bahamas Archipelago extends in an arc covering more than 14,000 square kilometers (5,400 square miles) of land emerging from the Atlantic Ocean. It comprises more than 700 islands, fewer than 50 of them inhabited, along with several thousand coral reefs called "keys." It was here, at Samana Key, that Christopher Columbus landed on October 12, 1492. An important base for pirates in the sixteenth and seventeenth centuries, the Bahamas was a British territory from 1718 until it gained its independence in 1973. In its role as a tax haven, the archipelago derives essential income from banking activities (20 percent of GNP), but tourism is the most important business, employing two-thirds of the islanders and bringing in 60 percent of the country's GNP. In addition, more than a thousand ships, three percent of the international merchant fleet, are registered here under the Bahaman flag of convenience. The Bahamas have also become an interchange point in the transmission of drugs such as cannabis and cocaine to the United States.

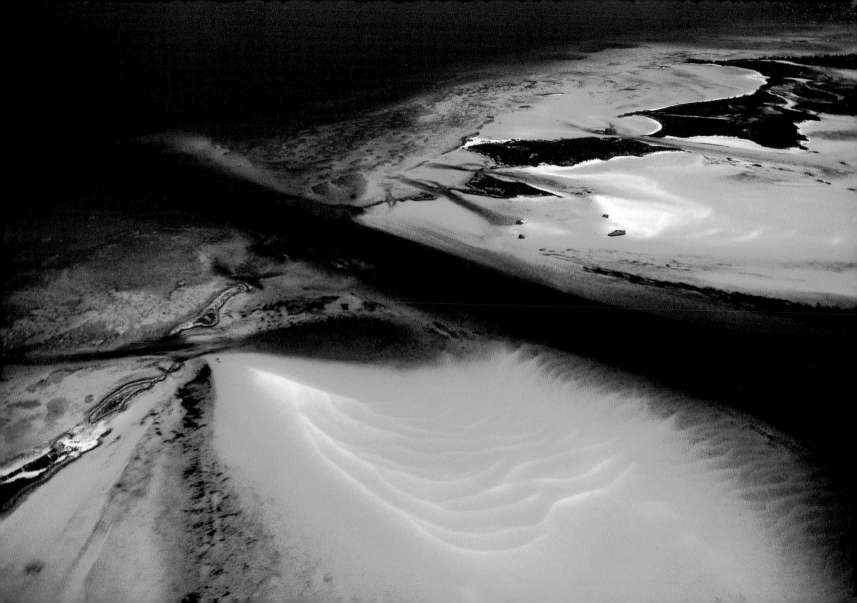

Turkey. Anatolia. Agricultural landscape between Ankara and Hattushash.

The area between the modern Turkish capital, Ankara, and Hattushash, the capital of the ancient Hittite Empire that dominated the region 3,000 years ago, sums up the evolution of Turkish agriculture over the last few decades of the twentieth century (and of the Near East in general over the last few millennia). The expansion and diversification of crops (ornamental plants, fruits, and grains) have restricted the activities of animal breeders. Under pressure from government and the market, they have focused on cattle-raising, resulting in a rapid decrease in the number of sheep and goats. Transhumance and nomadism are on their way to extinction. Today Turkey has fewer than 100,000 nomadic people, all of whom belong to tribes in eastern Anatolia or the Taurus in southern Turkey. These changes in agriculture also herald the end of 10,000 years of agriculture and animal raising (the oldest traces have just been found in Cyprus) evolving together and fighting one another.

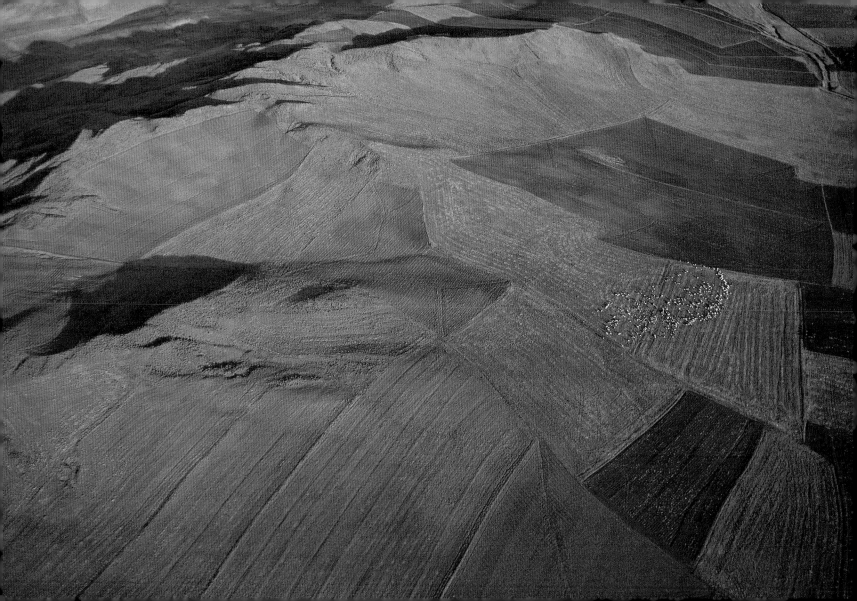

England. Oxfordshire. White Horse at Uffington.

On a limestone hill in Oxfordshire, down below the ruins of Uffington Castle, is the 111-meter (364-foot) outline of a horse that was probably carved out by the Iron Age Celts in about 100 B.C. According to local tradition, this is the stylized representation of a dragon, created in homage to Saint George who, as legend would have it, brought the monster down on a hillside very close by. A more likely hypothesis, however, is that the carving is dedicated to the goddess Epona, who was generally depicted in the form of a horse. A certain number of similar carvings of men and animals can be seen in England and in Scandinavia, but most of them have been permanently obliterated by vegetation. The White Horse, like the other chalk figures in England, needs regular maintenance to remain pristine.

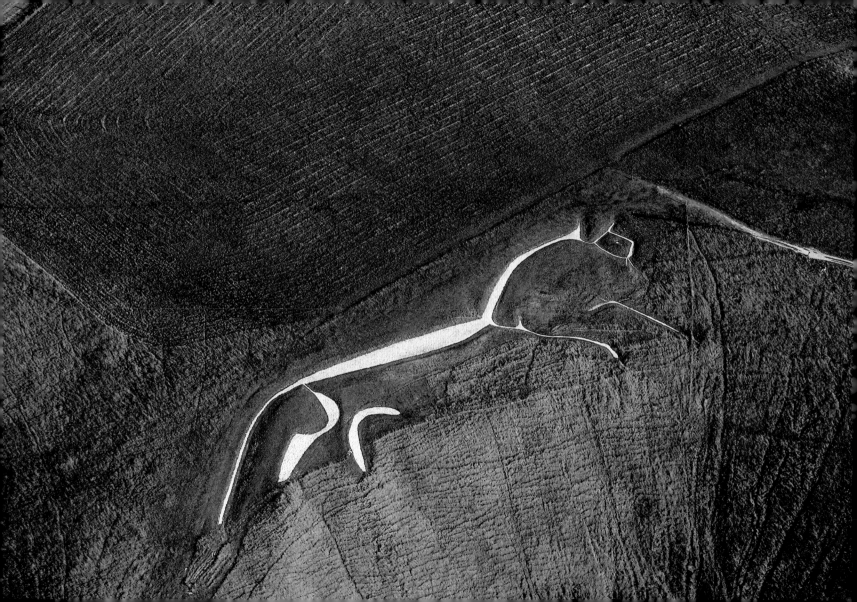

Spain. Canary Islands. Hierro Island. Agricultural landscape near Frontera.

The Canaries form an archipelago of seven volcanic islands off the Moroccan coast. They were rediscovered in the fourteenth century, and were soon conquered by the Spanish; their Berber population, the Guanches, was completely wiped out, making way for permanent colonization and appropriation. Hierro (iron island), which lies in the far southeast of the archipelago, is the youngest and smallest of the Canaries at 278 square kilometers (107 square miles). The difficulty presented by the landscape is that its rapid succession of steep and gentle slopes makes terrace cultivation impossible. Traditional methods of farming by irrigation (*huertas*) are neglected in favor of farms scattered among the ashy volcanic cones and supplied with water either by reservoirs (*aljibes*) or by wells, as precipitation here is rare. It is difficult to recognize this as one of the Hesperides where Hercules came in search of the golden apples of immortality, one of those fortunate islands thought to be left over from the legendary Atlantis – but extreme islands are always a source of dreams.

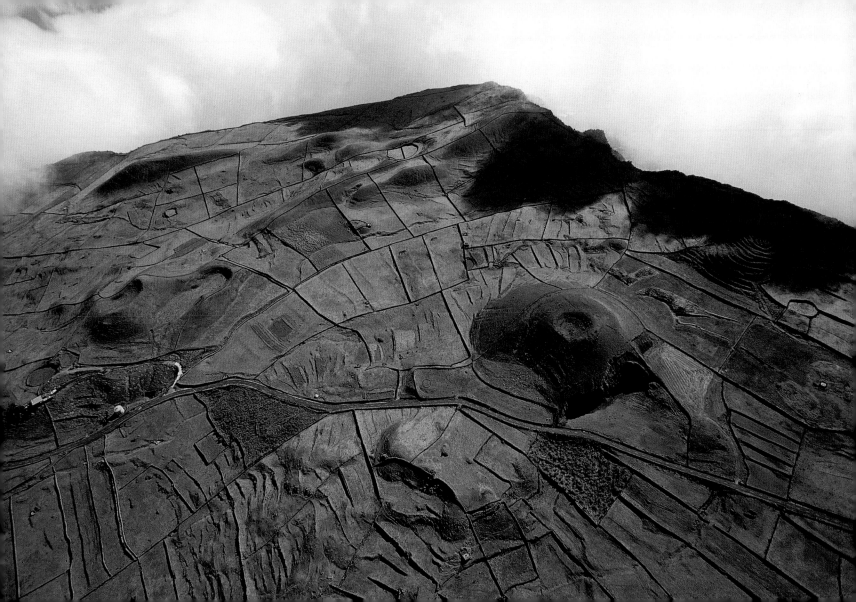

Egypt. Nile Valley. A fellah binding corn into sheaves.

For centuries the farmers, known as fellahs, in Egypt's Nile Valley have been using the same ancestral methods of agriculture: plowing the fields with hoes, harvesting the corn with sickles, and transporting the sheaves on the backs of donkeys or camels. The Nile Valley is a particularly fertile ribbon of land that runs north–south through the country. Arable land in fact covers only 3 percent of Egypt, and this area contains the most densely concentrated population of farmers in the world. Although corn production is rising (increasing 37 percent between 1990 and 1997), primarily thanks to the use of fertilizer, it still supplies less than half the needs of a rapidly growing population. Egypt is one of the largest grain importers in the world, bringing in 7.8 million tonnes (8.6 million tons) in 1997.

United States. California. Carrizo Plain. San Andreas Fault.

The San Andreas Fault is more than 1,000 kilometers (600 miles) long – running from Baja, California, past Los Angeles, through San Francisco, and off into the Pacific Ocean. The San Andreas is a "transform fault" (actually a fault zone up to 100 kilometers [60 miles] wide) linking two sections of the submarine volcanic mountain range known as the mid-ocean ridge. Like the ridge, it marks the boundary between two plates, the Pacific plate to the west and the North American plate to the east. Its surface expression, so well-defined here in the California desert, is a result of the continuous northward movement of the Pacific plate with respect to the American plate. The Los Angeles and San Francisco metropolitan areas are directly threatened by earthquakes that accompany this tectonic shifting. Suspension bridges and skyscrapers are evidence that it is possible to live without a care among the bulging folds of the hills and the trace of a fracture that bear witness to the fact that with one brutal start and in a matter of seconds, the Earth can destroy a century of construction.

Argentina. Southern right whale off the Valdés Peninsula.

After spending the summer feeding in the Arctic, southern right whales (*Eubalaena australis*) return in winter to the South Seas, where they reproduce. From July to November, the coast of the Valdés Peninsula in Argentina becomes a breeding and birthing ground. Baleen whales (11 species in all) are migratory marine mammals, and have been the victims of intensive exploitation for several centuries, leading them to the brink of extinction. Since 1931 international measures have been taken to protect whales, and from 1986 there has been a succession of moratoria on the hunting of whales for commercial purposes. Numbers have now stabilized, but the populations are still not sufficiently large to exclude all danger of extinction. There are only a few thousand of each species, 10 to 60 times fewer than was estimated at the beginning of the twentieth century.

France. Trees blown down by a storm in the Vosges Forest.

On the morning of December 26, 1999, the Vosges Département awoke to find that 348 of its 515 communes had no electricity, 10 percent of its forests were flattened, trains were immobilized, and 60,000 telephone lines had been cut. The storm, which was to cross France twice, killing 79 people, had taken one of its heaviest tolls in this region, where winds had exceeded 148 kilometers an hour (92 miles an hour). The cause of this disaster seems oddly insignificant: two small whirlwinds that formed on an undulating Arctic front—one 10,000 meters (33,000 feet) above the Earth, the other at ground level—happened to come together, one above the other. This rare coincidence accelerated them exponentially. It is feared that such random events may be linked to global climate change. A few degrees more or less may not seem significant on a day-to-day basis, but long-term, it results in dramatic climatic changes. In some parts of the world, a slight warming or cooling will have little effect, while in others it can be drastic. One example can be seen in Greenland, which was colonized and farmed during the eighth century. Archaeologists have recently discovered ruined houses containing the stunted bodies of the colonizers' descendants, who died of cold and hunger two centuries later, following a slight change in climate.

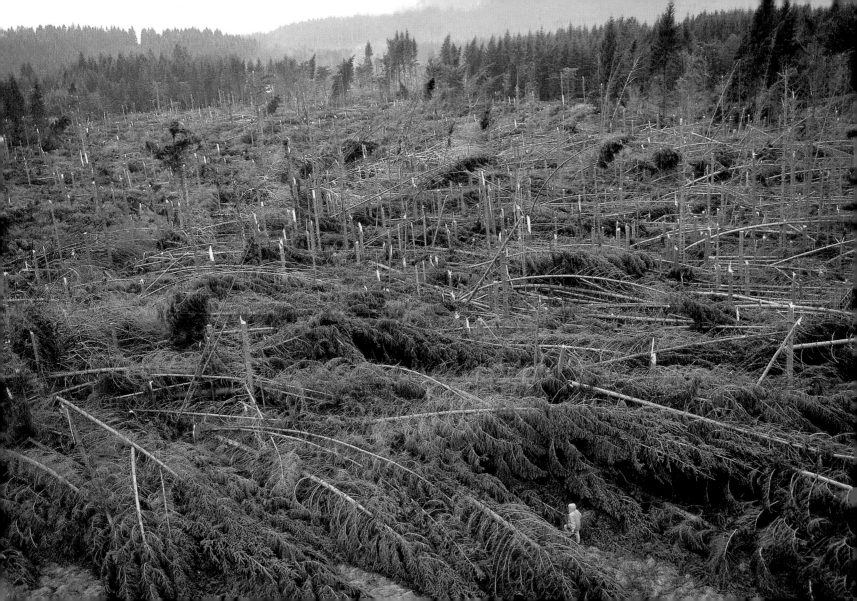

Niger. Village near Tahoua.

To the south of Niger, the Sahel gradually gives way to bushes and food crops that are made possible by a short but abundant rainy season. The Aderawa farmers who live in the area around Tahoua speak Haoussa, linking them to the very extensive group that dominates from northern Cameroon to northern Nigeria. Their main crops, millet and sorghum, produce no more than 500 kilograms per hectare (450 pounds per acre), which is paltry compared to Asian and European yields of 4,000 to 8,000 kilograms per hectare (3,500 to 7,000 pounds per acre). This is not due to negligence, but to traditional agriculture; the fields are used simultaneously for several crops and for bushes. They feed families, or *gida*, often consisting of several groups of related couples who aim to leave as much free time as possible for their family and social life rather than increase their commercial yields. The Danish economist Ester Boserup has shown that ancient populations favored time over yield. As we judge them by kilograms per hectare, they judge us by the amount of spare time we have.

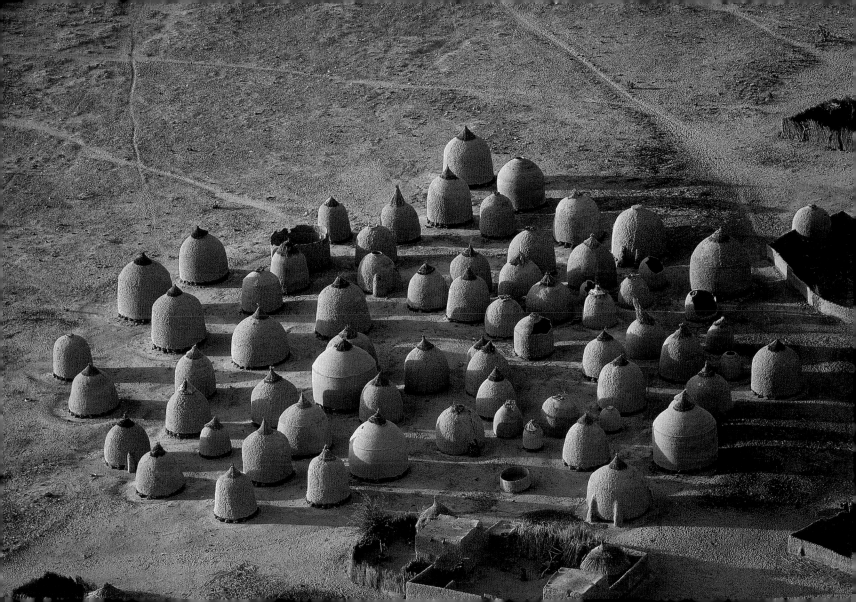

Iceland. Pingvellir Fault to the east of Reykjavik.

The waterside residents ought to know that these young faults will remain active and that the landscape, broken by enormous tension within the Earth's crust, will continue to fracture far longer than the life span of ten generations. Our Earth is so constructed that the scale of its movements is fundamentally different from that of human activities. Just like the houses at the water's edge, the little road running alongside the graben indicates that the people here have the same lack of concern as is usual in human societies, and, paradoxically, that they put their trust in nature.

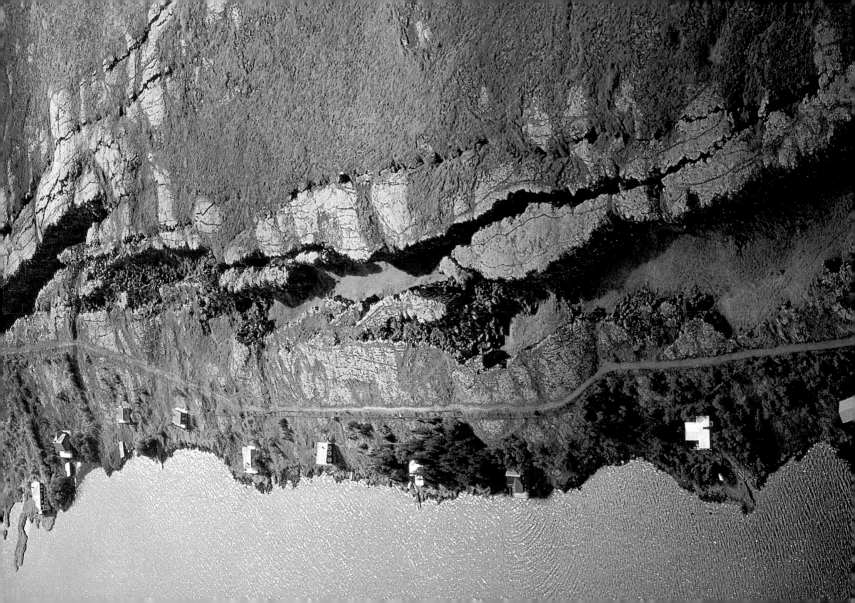

Namibia. Swakopmund region. Oryx in the dunes of Sossusvlei.

The Namib is believed to be the oldest desert in the world. It stretches for 1,200 kilometers (750 miles) along the Atlantic coast, from the Angolan border in the north to the mouth of the Orange River in the south. Near the two seaside towns of Swakopmund and Walvis Bay, Sossusvlei, a vast clay basin surrounded by red dunes, is the most accessible area for tourists. It also marks the limit beyond which they are not permitted to explore – since 1994 the desert to the south of Sossusvlei has been closed to the public. This measure was taken to ensure the protection of the dunes, and also of the plant and animal species such as sand vipers, beetles, and the oryx, a variety of antelope well-adapted to intense heat and aridity. The large diamond companies, which have made claims in this region otherwise uninhabited by humans, are using nature as a pretext for preventing diamond hunters from prospecting on their immensely valuable land. The interests of finance and nature are often locked together, usually in combat, but in this case in harmony.

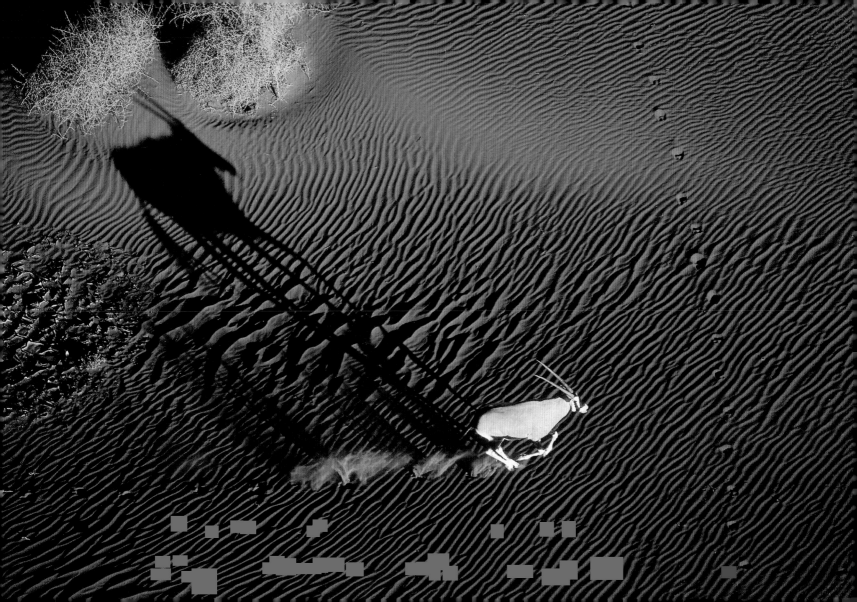

Madagascar. Traditional village north of Antananarivo.

What is extraordinary about successful models is that they enable us to make the connection between tangible representations of reality and the images we have in our minds. This settlement is both a paleo-village and a proto-city. It is a paleo-village in that in many civilizations, the circular form and radiating paths defined the space where evolution toward the city slowly took place. As a proto-city its layout combines the most common ingredients needed to evolve toward a city: a "wall," a gate and gardens, well-positioned houses, the beginnings of a central square, and even a suburb just outside the "wall." It remains the case that a city is first and foremost a body of functions and above all of relationships.

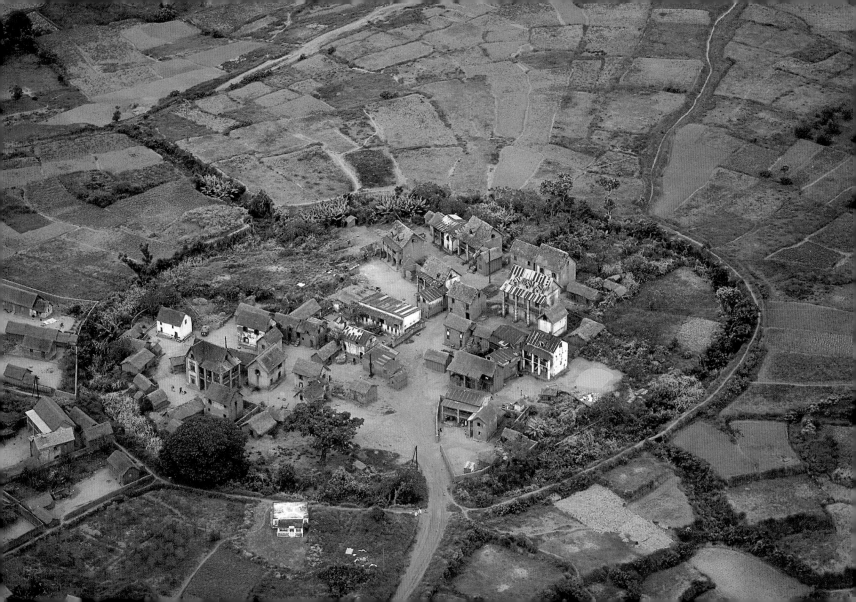

Nepal. Rice field north of Pokhara.

Two hundred kilometers (125 miles) to the northwest of Katmandu, and below the Annapurna Mountains, the Pokhara area is cultivated intensely by those who work extremely hard for limited yields. The fertile alluvial soil, subtropical climate, and heavy monsoon rains that bring 4,000 millimeters (150 inches) per year are all favorable to growing rice, which is the country's chief agricultural product. There is a shortage of investment, however, and the division of land forces farmers to practice subsistence agriculture in an economy that is still based largely on barter. For a long time the land was in the hands of 450 of the kingdom's great families, but in the 1970s, after the failure of agrarian reform, it was handed over to the heads of the village cooperatives. The average size of a cultivated plot, from which an entire family must live, is about half a hectare (just over an acre). To feed all the people in the country, rice must be imported. To make the picture even gloomier, the population of Nepal continues to grow at one of the fastest rates in the region; women here still have an average of 4.5 children, whereas in neighboring India the figure is three, and in China it is fewer than two.

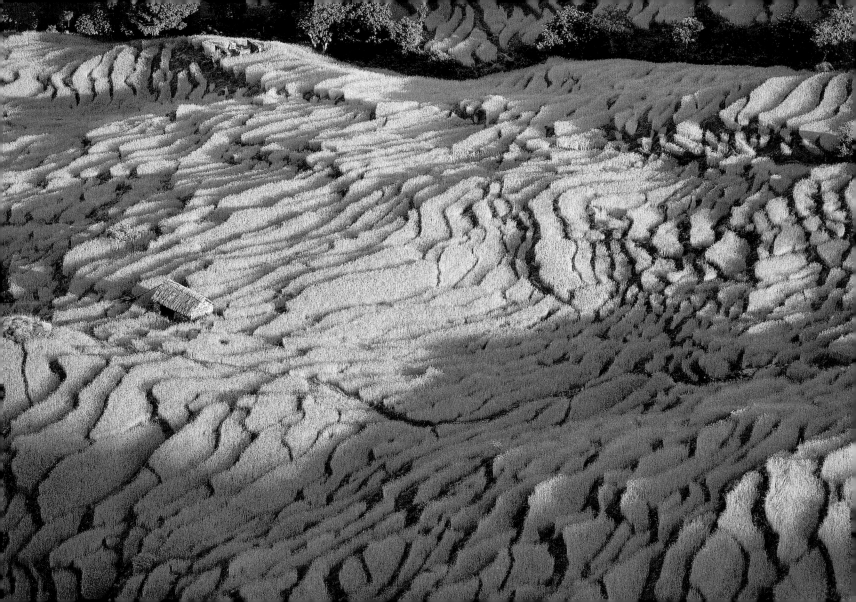

Peru. Outline of a hummingbird at Nazca.

Two thousand years ago, the Nazca people dug furrows into the desert soil of the Peruvian pampas, producing drawings of impressive geometric figures and stylized representations of plants and animals. This hummingbird measuring almost 98 meters (320 feet) is one of 18 outlines of birds on this site, which was placed on the World Heritage List by UNESCO in 1994. Thanks to the tireless efforts of German astronomer and mathematician Maria Reiche, who from 1945 until her death in 1998 devoted herself to bringing these drawings to light and then to maintaining and studying them, we can still admire what was probably an astronomical calendar. The Nazca site is threatened today by the *huaqueros*, who loot Pre-Columbian tombs, and also by tourism, erosion, and industrial pollution.

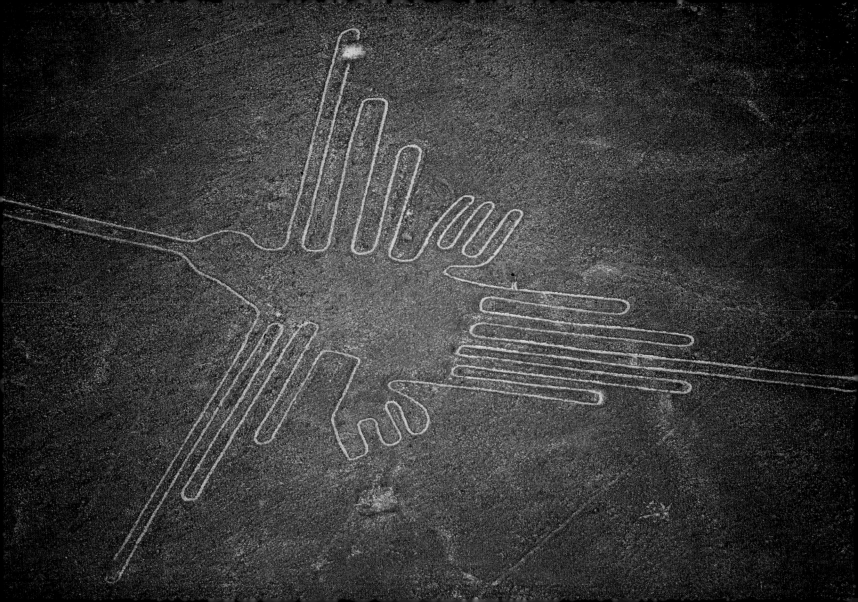

Morocco. Knifis (north of Laâyoune). Marshes.

In southern Morocco, after threading its way through the Atlas and Lesser Atlas Mountains along the Saghro Jebel, the Oued Draa (Draa Wadi) eventually reaches the vast, sandy Débaïa Basin. When the fall floods come, it divides into numerous temporary channels that irrigate the whole of the basin, and for a short time make it possible to grow crops here. By the time the Draa has crossed the Débaïa it usually has no water left to continue its descent toward the sea. The Draa was known to the ancients. Pliny called it the Darat, while Polybios and Ptolemy spoke of the Darados. Both wrote that it was infested by crocodiles, but today the river bed is dry and pebbly and there are no crocodiles. From this historical evidence we can infer how much the climate has changed in this region in the last 2,000 years. We may also reflect that, with or without the human-induced greenhouse effect, it is possible that such changes will continue to take place in the near future. It is therefore wise not to make habitat and agriculture completely dependent on the current climate, and to leave the door open for evolution in case changes do occur.

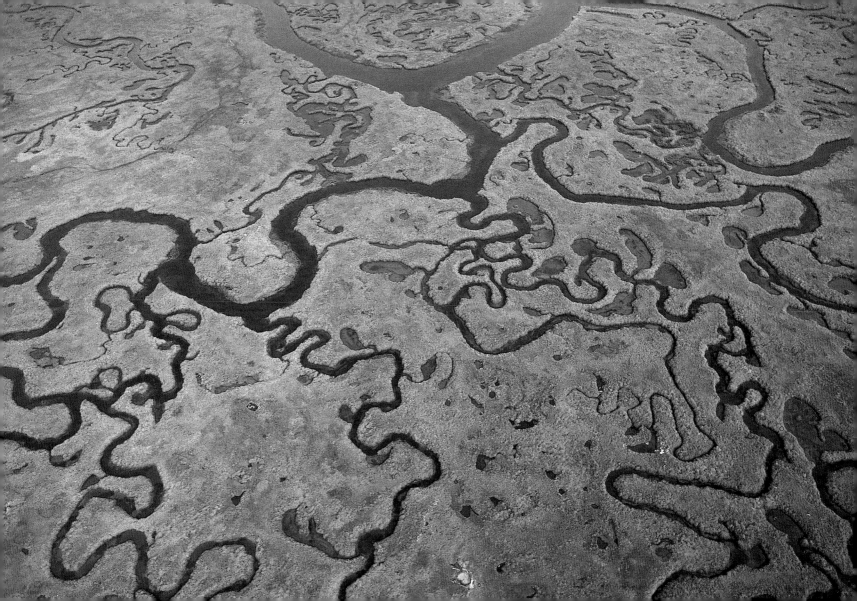

Madagascar. Fianarantsoa Region. Locust swarm near Ranohira.

Locusts have always been seen as a scourge, and even figure in the Bible as one of the seven plagues visited upon Egypt. Over the centuries in Madagascar, locusts have chronically devastated grain fields and pastures. For a long time their ravages were confined to the southern, semi-arid part of the country, but since 1992 the swarms have become denser and have advanced towards the northern part of the island. These migratory and nomadic species (*Locusta migratoria* and *Nomadacris septemfasciata* respectively) can form clouds several kilometers (several miles) long, containing up to 50 billion individuals. Traveling 40 kilometers (25 miles) per day, they devour all vegetation in their path. A medium-sized swarm of just 150 million insects can consume 100 tonnes (110 tons) of vegetation each evening. The most common weapon in the war against these invasions are insecticides, sprayed over large areas by airplanes or helicopters. Unfortunately, this approach has its drawbacks: populations of locusts that become resistant to the chemicals are not significantly reduced, while the insecticides themselves cause havoc in the environment, killing many other organisms. Most insecticides are also toxic to humans. However, there is hope for a weapon against locusts that spares the environment: a recently-discovered natural pesticide based on a fungus known as "Green Muscle." Unlike synthetic insecticides, it presents no known significant dangers to users, animals, other insects, or the wider environment.

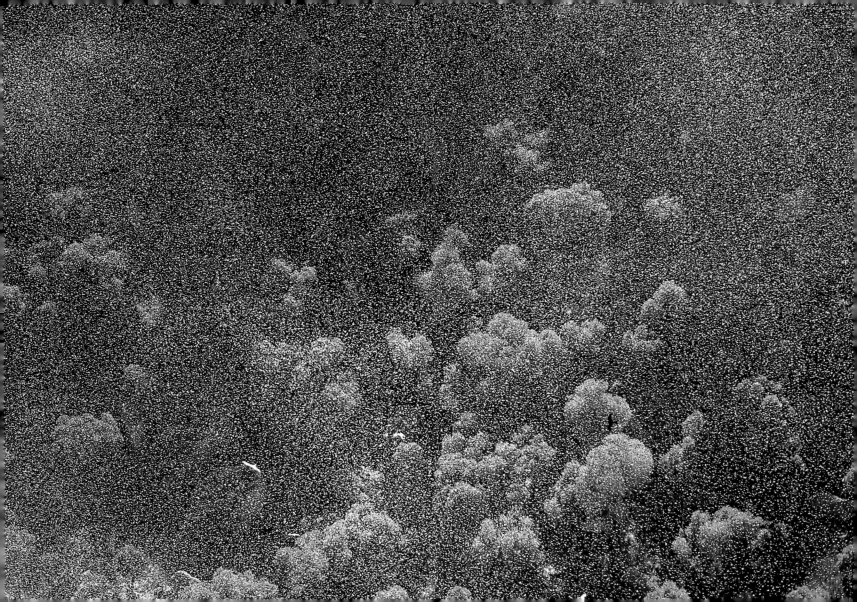

Mali. Homes on a small island in the Niger River, between Bourem and Gao.

As the Niger River worms its way through the sand on its steady progress toward the southern Sahara, it forms a large loop known to the local populations as the "camel's hump." In the high-water period (August to January) following the rainy season, it floods vast expanses of land, leaving only a few small islands peeking through. Known as *toguéré*, some such as this one between Bourem and Gao are inhabited. Although it occupies less than 15 percent of the country, the Niger Basin contains nearly 75 percent of Mali's population, as well as the majority of its large urban centers. This river, which supplies water to four countries in western Africa (Guinea, Mali, Niger, and Nigeria), is said to take its name from the Berber expression *gher-n-igheren*, "the river of rivers."

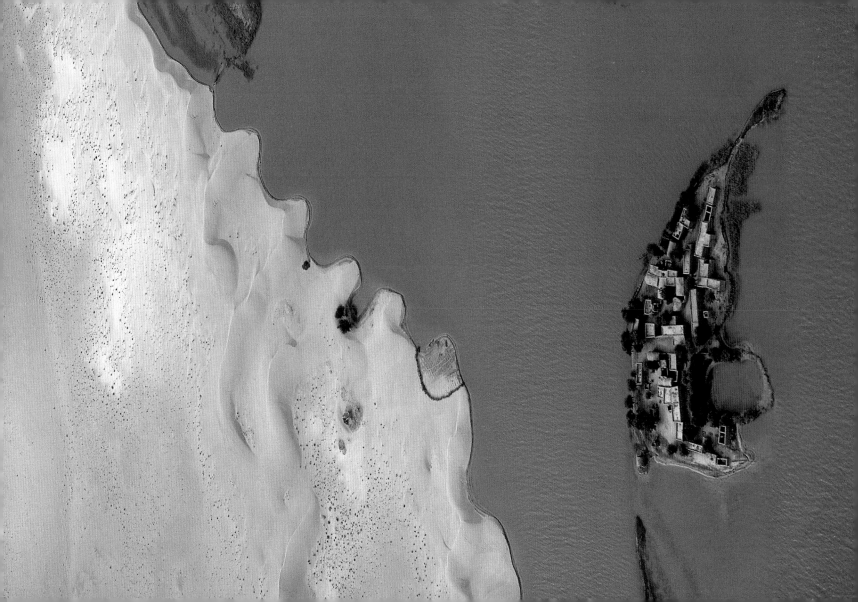

Nepal. Himalaya Mountains. The Everest Range.

The highest peak in the world, Mount Everest, is difficult to see because it is masked by other very high peaks that surround it – the Changtse, Khumbutse, Nuptse, and Lhotse. This is indeed a tormented geological region that is unique in the world. Forty-five million years ago, two continental plates began to collide: India, which had separated from Africa, and Eurasia. As the Indian plate crashed into Eurasia, the rocks folded and piled on top of each other. Because the borders of the two plates had different outlines, the northern point of India acted like an awl, causing a pucker in the mountainous folds. This is where Mount Everest is located.
In addition to the unique geological conditions here, there is also an unusual environment. Subzero temperatures and thin air mean that life is limited. Less has been said about the the ferocious wind, which has been difficult to measure with much precision (considering attempts at the summit are only made in the best weather). Because of the wind, the relatively small amount of snow that falls here (the climate is semiarid) cannot lie, except in the crevices in the rock face. This accentuates the strange character of a place that is regarded in Hindu and Buddhist cosmology as the center of the world.

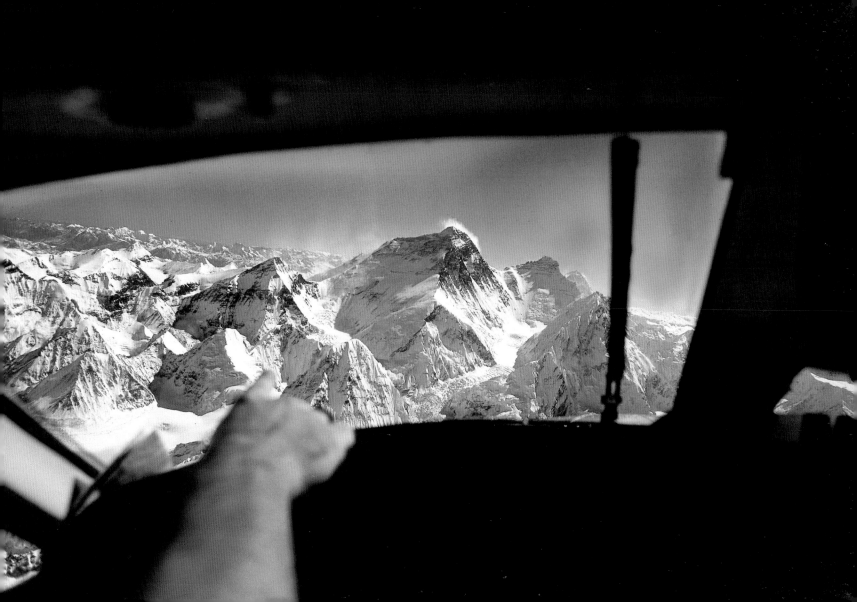

Peru. Ica. Dunes east of Nazca.

Between the Pacific Ocean and the first slopes of the Andes Cordillera lies a narrow, 2,300-kilometer (1,400-mile) band of coastal desert, which continues on further south into the Atacama Desert of Chile. The cold Humboldt ocean current flowing up from southern Chile cools and stabilizes the coastal air masses, which cannot rise up to the slopes of the mountains. For at least half the year an intense fog, the *garua*, forms, causing high humidity, but rarely accompanied by rain. This climatic stability is disrupted every four to seven years by the arrival of the warm current known as El Niño, "the child," (referring to the infant Jesus). Around Christmas, when warming of the surface waters creates a strong convection over the equatorial Pacific, trade winds die down and allow a warm current to pass through to the coast of Peru, bringing with it torrential rain that causes serious damage. Without the upwelling of the cold, nutrient-rich water, the anchovy banks disappear, devastating the fishing industry. Although it has its roots in the Pacific Ocean, the El Niño phenomenon can affect weather on a global scale.

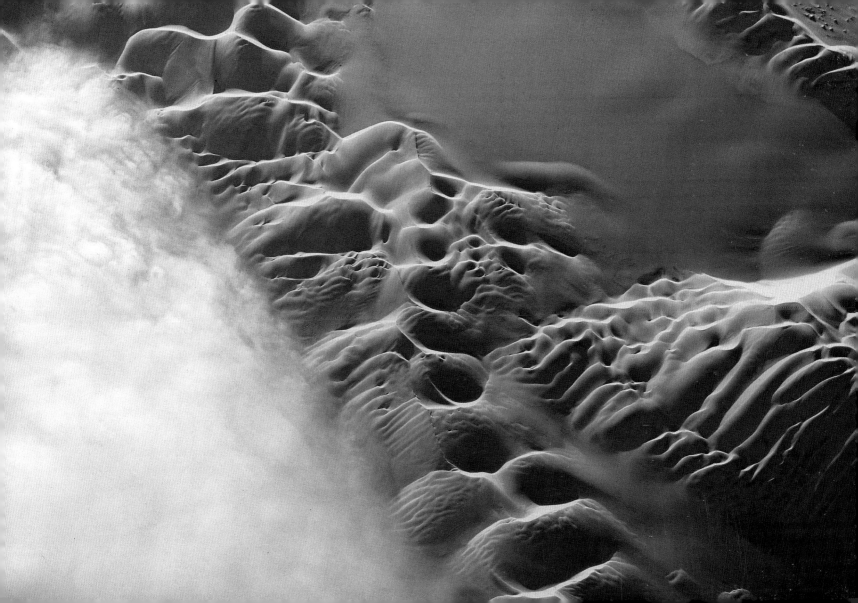

Philippines. Gold mine waste on the shore of Mindanao Island.

A small boat fishes among the effluent from the workings of gold-bearing rocks on the island of Mindanao, in the southern Philippines. The Philippine Islands produce more than 8 tonnes (9 tons) of gold per year. The waste, known as *haldes,* contains chemicals such as mercury and hydrochloric acid which are used to clean and refine the gold particles, and which are highly toxic to marine life. Mercury, for example, builds up in the food chain, and becomes very concentrated in fish. Then ingested by people, mercury causes serious nerve damage and irreversible deformities in unborn children. Even worse, the waste from the gold mines clouds the sea water both inshore and farther offshore, endangering the coral whose survival depends on sunlight. Coral, which lives in all tropical seas up to a depth of 80 meters (260 feet), is endangered everywhere by pollution, harvesting, fishing, and tourism. The forecasted warming of the seas presents another threat to its survival: a rise of 1°C (1.8°F) is enough to kill a coral reef. Given the urgency of the situation, the International Coral Reef Initiative was founded in 1995 by eight countries, along with several international bodies and non-government organizations.

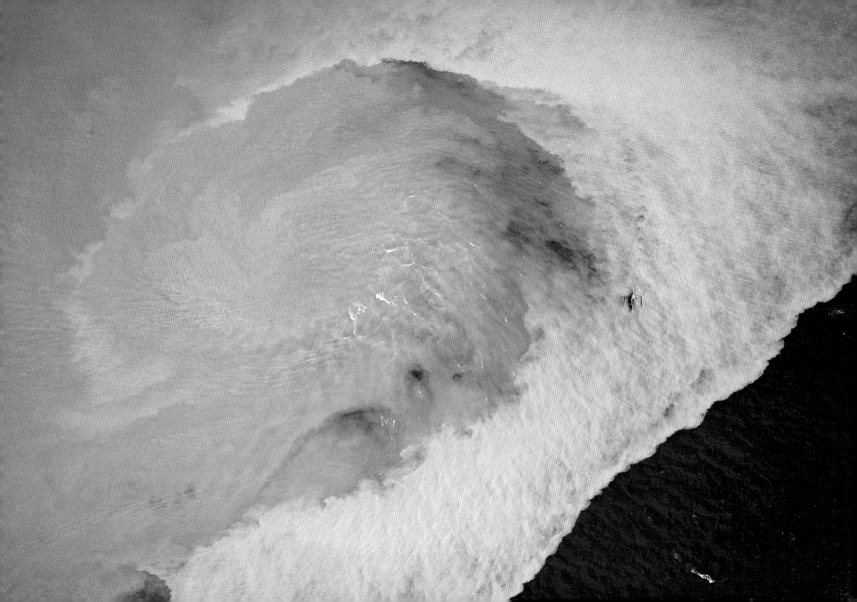

Namibia. Windhoek region. Edge of the Namib Desert, west of Gamsberg.

On the road between Windhoek, Namibia's modest capital, and the seaside town of Walvis Bay, is the Gamsberg Pass at 2,334 meters (7,656 feet). The pass marks the beginning of the Namib Desert, which stretches out at the foot of the Gamsberg Range for as far as the eye can see. This is one of the most arid deserts in the world, and also the oldest (its formation dates back 100 million years). It represents a unique ecosystem, containing many species of plants and animals that have managed to adapt to survive its extreme aridity, high temperatures, violent winds, and limited food resources. The thick fog generated when the warm winds from central Africa meet the cold Benguela current flowing up from Antarctica helps species survive in an otherwise barren region.

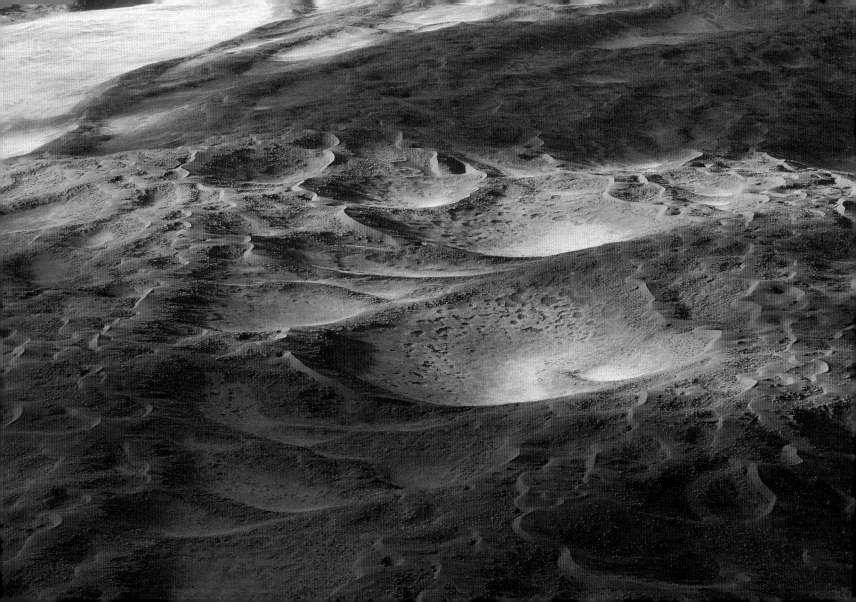

Morocco. Rabat area. Cows in a marshy river.

Like the rest of the northern part of the Atlantic coast of Morocco, the Rabat area benefits from the relatively abundant rainfall of up to 800 millimeters (31 inches) per year. In this part of the country, one of the best-drained in Morocco, the November and March rains supply the waterways and produce major rises in river levels. From May on, however, a hot, dry, southeast wind, the *chergui*, gradually dries up the river beds. These temporarily become marshy, covered with a carpet of grasses and flowers, over which a few cows (having escaped from the surrounding herds) roam in search of food. There are a little over 2.5 million cattle in Morocco, most of them local breeds raised for both milk and meat. They are greatly outnumbered, however, by goats (4.4 million) and particularly sheep (17.6 million).

Venice. Fishermen's houses.

Sailing around the Venetian Lagoon, one frequently comes upon modest wooden buildings set up on stilts. These are the homes or warehouses of the fishermen who continually ply the shallow, fish-filled waters of the lagoon in their small crafts. These constructions cannot but recall an earlier time; fishermen's huts were first established in this marshy area in the seventh and eighth centuries.
In them we see the very history of Venice, a city born from the fragile balance between land and water. This balance is in jeopardy, however, as the water is always liable to gain the upper hand over the land, as it did during the flood of November 4, 1966, and in less dramatic fashion on several other occasions over the past six centuries. In addition to this "high-water" phenomenon, Venice has to struggle against the fact that the floor of the lagoon is steadily sinking by 2 to 2.7 millimeters (0.08 to 0.1 inch) per year.
If global warming causes a rise in sea level, the water level could rise 40 cm (16 inches) in 50 years.

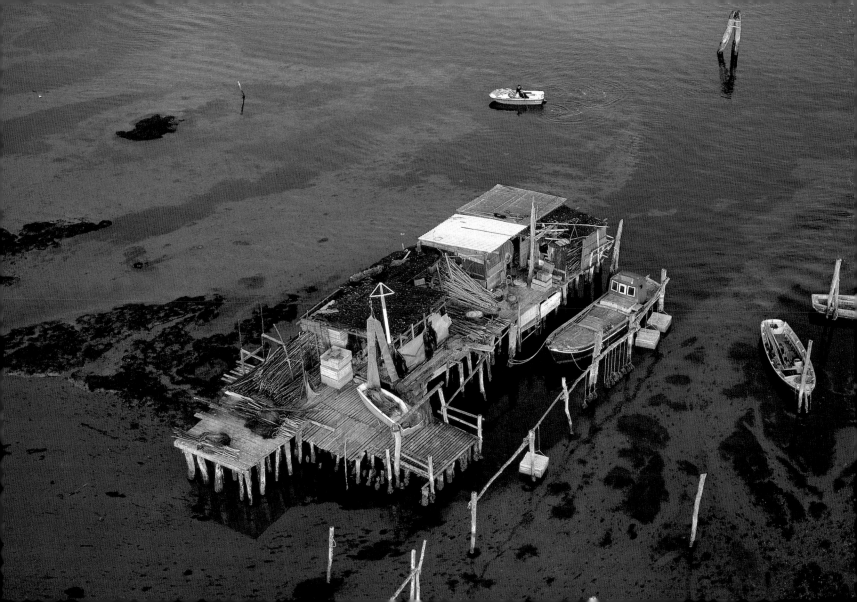

Oman. Muscat area. Daymaniyat Archipelago.

The Batinah region extends from the Al Hajar Mountain Range to the Gulf of Oman. It consists of a scattering of several islands and a flat, narrow band of land, about 25 kilometers (16 miles) wide, which runs along the north coast of Oman from its capital, Muscat, to the border with the United Arab Emirates. Arabic for "hidden being," the name Batinah sums up the distinctive character of this area; from out at sea it is barely visible next to the imposing mountains around it. Crops such as dates and limes are grown intensively in the Batinah, and it is also the nation's granary. Its 600,000 inhabitants (nearly one-quarter of the country's population) reap the benefits of the sea as well as the land, thanks to sardine fishing, which they practice on a large scale. However, Batinah's high population density and the overexploitation of its waters are compromising a fragile ecological balance, increasing the salinity of the water and thus threatening agricultural production. Oil reserves have transformed this region into an El Dorado. But when the food and energy resources inevitably run out, they may well leave behind a bleak landscape that is more barren than before.

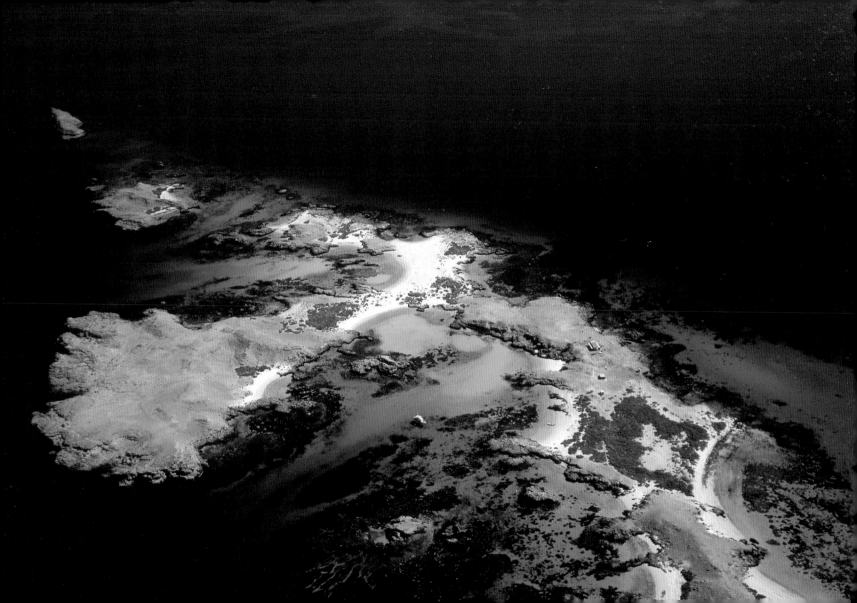

Venezuela. Bolivar State. Sandbank on the Caroní River.

The Caroní River flows for 690 kilometers (430 miles) from the north to the south of Bolivar State (more commonly known as Guayana) in Venezuela, and plunges down a series of waterfalls, meeting broad sandbanks on its way. The Caroní, and all the other rivers that run through Guayana, are rich in alkaloids and tannins derived from the decomposition of plants in the dense forest. Because of their dark color, they are referred to as "black rivers," as opposed to "white rivers," which flow down the Andes Mountains carrying large amounts of sediment. Before finally flowing into the Orinoco River, the Caroní feeds the Guri hydroelectric dam (brought into service in 1986), which is one of the largest in the world and supplies 75 percent of Venezuela's electricity.

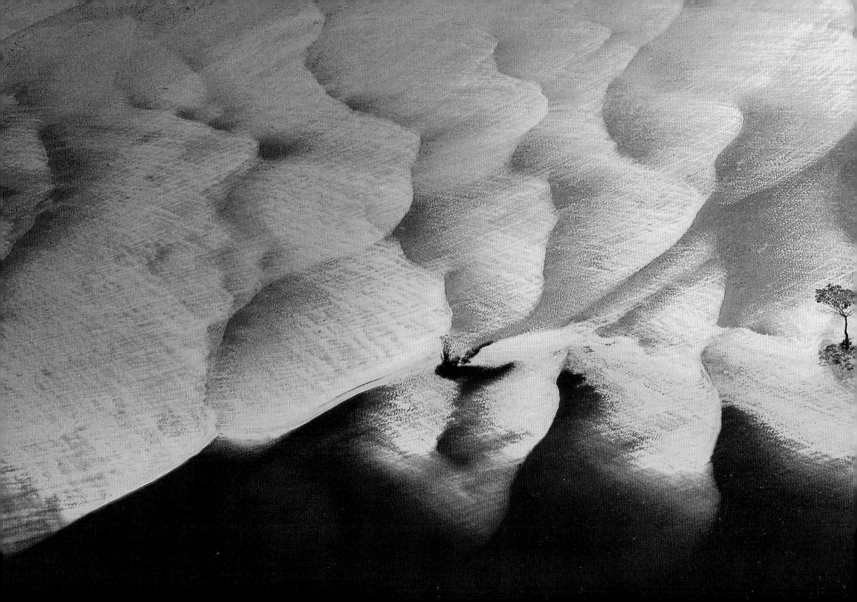

Norway. Boknafjorden. Fish farm.

Located between Stavanger and Bergen in southern Norway, Boknafjorden is the southernmost of the great fjords. These deep coastal indentations were created by glaciers. As the glaciers carved finger-like projections into the hard, ancient bedrock of Scandinavia, the sea gradually crept in. The water in these nearly enclosed bays is much calmer than in the open ocean. Rainwater brings mineral nutrients from the continent, which enable the algae and plankton here to form one of the most productive ecosystems on the planet. The warm Gulf Stream current also contributes to its success in aquaculture, or fish-farming. As one of the world's largest oil producers, extracting three million barrels a day from the North Sea oil fields, Norway also has the capital needed to fund these installations. In spite of its success in fish-farming, Norway is still one of the greatest killers of marine mammals on the planet, with annual quotas of 30,000 seals and 750 minke whales.

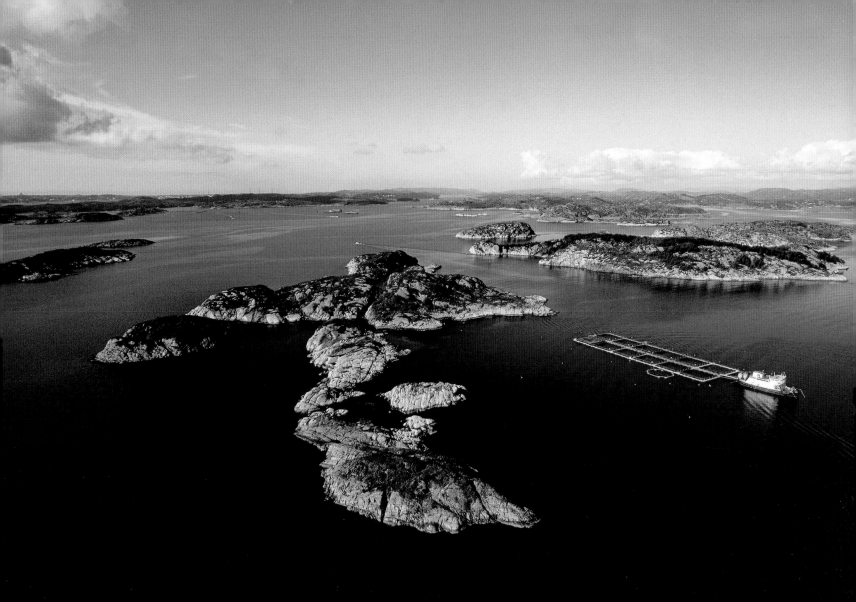

Jordan. Mafraq. Traces of an ancient trap, between As Safawi and Qasr Burqu.

These low stone walls, several thousand years old, were built by groups of Neolithic hunters who joined together to trap herds of wild animals. This is the final section of a trap, consisting of two walls forming a funnel that narrows into a corral of sorts. Driven into the funnel, the least powerful animals had very little chance of escaping their captors. Panic-stricken, they ran into the corral, where various groups of hunters were waiting for them in their shelters, armed with spears, bows, or nets.

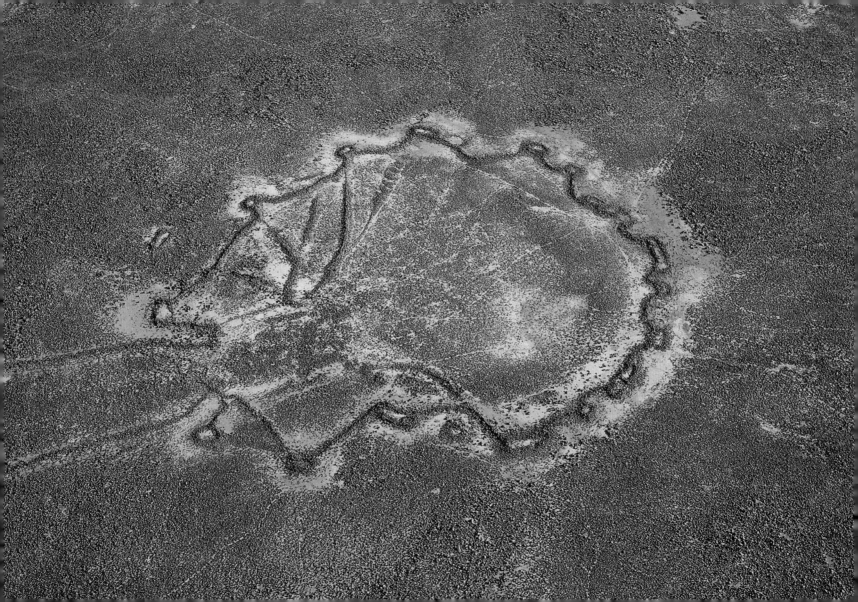

Peru. Fields of cauliflowers near Lima airport.

Receiving very little rainfall, Peru's narrow strip of Pacific coast is barren. Economic life here is concentrated in about 40 oases of varying size, dotted here and there at the foot of the Andes Mountains. Although the rest of the country, with its high mountains, Amazonian forest, and low population density of 20 inhabitants per square kilometer (50 per square mile), would seem to favor subsistence agriculture, Peru in fact plays an integral part in the world food market. It is the world's top producer of fishmeal, which it sells to American cattle-breeders in exchange for grains, which it does not produce in sufficient quantities. Likewise it has borrowed a number of plants, including cauliflowers, from European market-gardeners – perhaps in exchange for maize, beans, potatoes, and other crops Latin America has "exported" to Europe over the years. For a long time, people were the only species to inhabit every continent. Now others are following our example and becoming global: Argentinean ants, Asian gray rats, and germs, not to mention corn, and in this case cauliflowers.

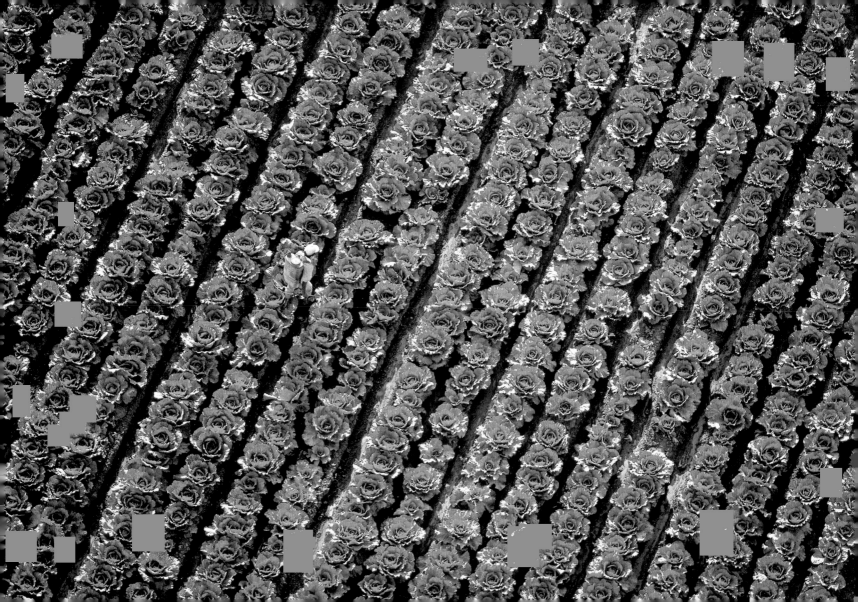

Morocco. Village in the Ourika Valley.

At the heart of the Atlas Mountains, 75 kilometers (45 miles) from Marrakech, the Ourika Valley offers a singular contrast to the peaks all around it. Tourists come here in winter for skiing and other winter sports. In these arid regions where few materials are available, the earth is a precious resource. It requires no special equipment, is easily molded, provides perfect insulation, recycles itself, and also blends in with the colors of the landscape. The houses here are built from adobe, a compact material consisting of crude, damp, more or less clayey earth, mixed with straw and gravel. This traditional construction material is widespread in rural environments, in the mountains, and in the dry regions of the south; in low humidity, it proves to be very solid. In landscapes where water is scarce and plains are rare, terrace cultivation has developed at the foot of the mountain slopes.

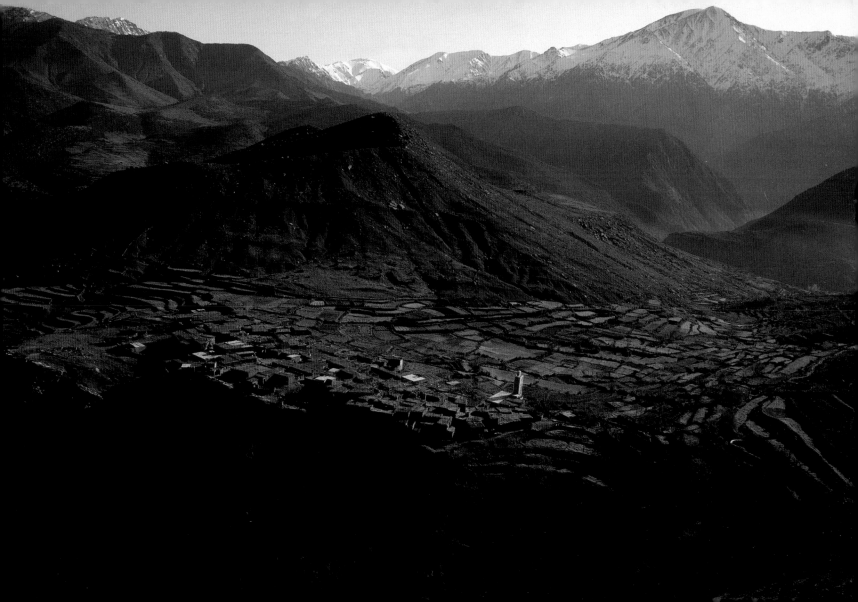

Maldives. North Male Atoll. The Eye of the Maldives.

The Eye of the Maldives is a faro, a ring-shaped reef surrounding a lagoon. Without a submerged volcano beneath its lagoon, a faro is not a true atoll, but instead forms part of the rim of a barrier reef or a larger atoll. Since the formation of coral requires high water temperatures of about 20°C (70°F), atolls form in tropical regions. The Maldives Archipelago in the middle of the Indian Ocean consists of 26 large atolls comprising more than 1,200 islands or islets, 420 of which are inhabited either permanently or in the tourist season. With the highest point no more than 2.5 meters (8 feet) above sea level, the Maldives Archipelago is the lowest country in the world, and has suffered the devastating effects of several tidal waves. The Maldives will be the first to go if (or when) sea level rises.

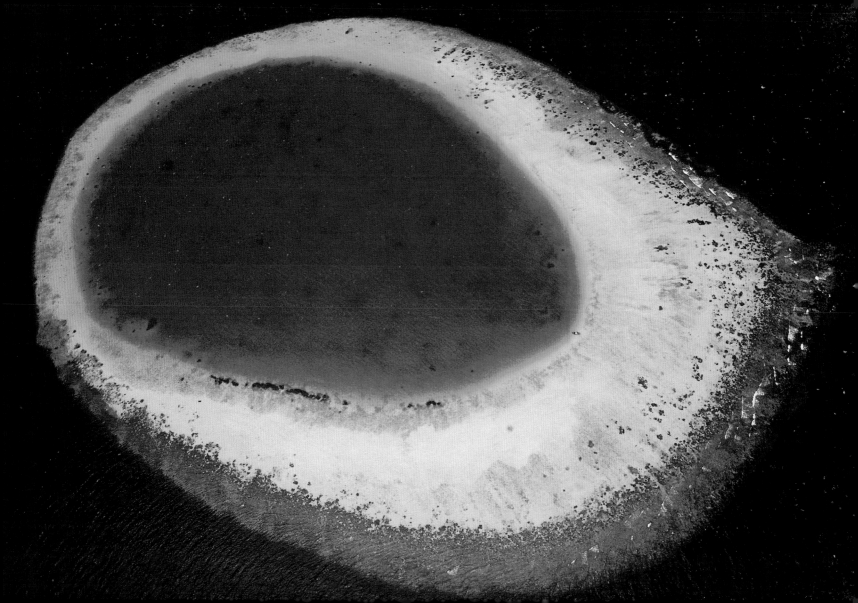

Namibia. Beached boat in the Lüderitz region.

Permanently subject to heavy swells and violent ocean currents, the Namibian coast, with its alternating beaches and reefs, and thick fog that often hides its shape, strikes fear into the hearts of mariners on their way to the Cape of Good Hope. As early as 1846, Portuguese sailors dubbed it "the Sands of Hell," and since 1933 it has been known as the Skeleton Coast – littered with dozens of rusting wrecks of freighters, steamers, trawlers, and warships. Some of these, such as this one near the town of Lüderitz, are stuck in the sand several hundred meters (one-quarter of a mile) from the shoreline, bearing witness to the violence of the wrecks. Nearly 6,000 vessels (about half of them yachts) are shipwrecked around the world every year.

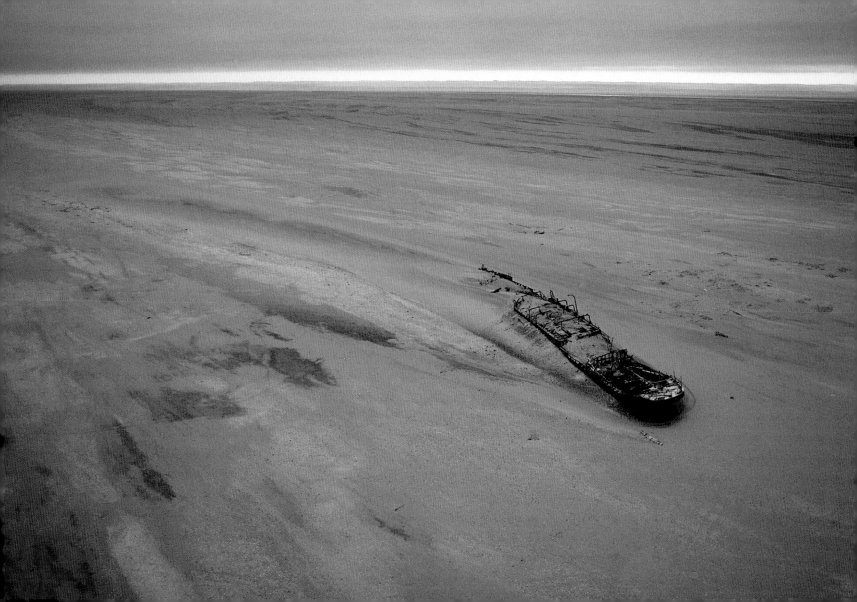

Japan. Honshu. Cattle-raising near Fukuyama (east of Hiroshima).

Honshu, the largest industrial city in the Hiroshima area of Honshu Island, is known for its ultra modern steelworks. Its development replicates Japan's economic rise on a smaller scale, notably in terms of the weight given here to industry (which employs 41 percent of the active population) and in particular to iron and steel, of which Japan is the second largest producer in the world. Honshu is an example of *omote nihon*, "obverse Japan," representing the progressive aspect of the Pacific coasts and the interior sea, as opposed to the *ura nihon*, "reverse Japan," the stagnant economy of the mountains and the Sea of Japan coast. In "reverse Japan," agriculture is still traditional, and crafts have not been supplanted by industry, whereas in "obverse Japan," industrialization has devoured both crafts and agriculture. All products there, be they cars, clothes, beef, or milk, are manufactured with the same sort of industrial processes. This uniform treatment corresponds to a Japanese philosophy of space, the Bashô ethic according to which men, animals, and things must yield to the spirit of the place.

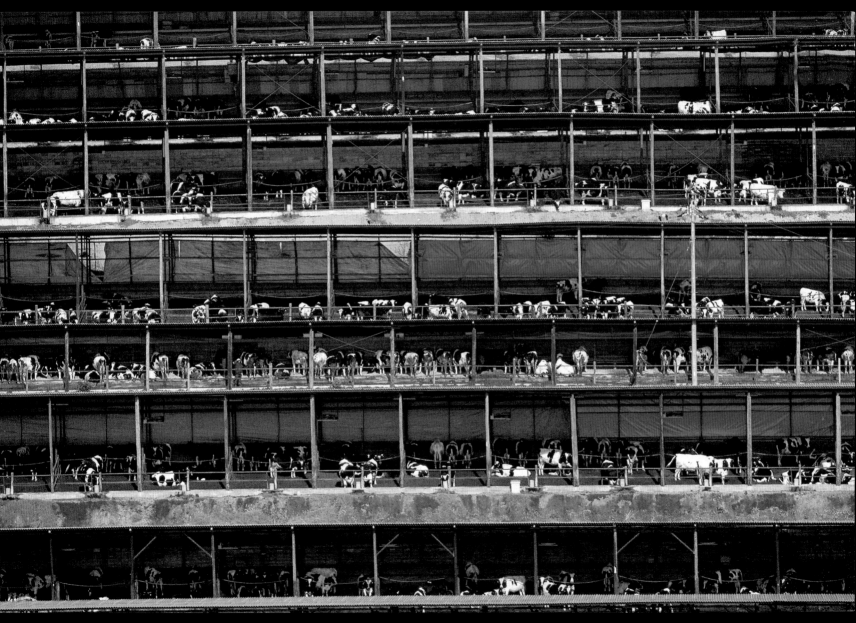

Ivory Coast. Bouna. Ashes of a tree near the Gorowi Kongoli Mountains.

In the northeast of the Ivory Coast, in a region covered by vegetation of the type found in the Sudan – bushy savannah and sparse forests – this tree, brought down by wind or lightning, was reduced to ash when a bush fire passed through. These fires are very common in West Africa, and can run through 25 to 30 percent of the entire bush every year. Although some are caused by lightning, most are part of the traditional techniques used in agriculture, animal-raising, and hunting in the savannah. Fire passing through provides the soil with a natural organic fertilizer (ash) and contributes to the rapid regeneration of certain bushes and fodder plants. At the same time, it eliminates tall grasses, making it easier to approach game or drive it during collective hunts. Unfortunately, most of the fires are started late in the dry season and become uncontrollable, gradually destroying the wooded stratum and accelerating the process of erosion. This menace is all the more worrying in the Ivory Coast which, with 6.5 percent of its forest destroyed every year, has the highest rate of deforestation in Africa (0.6 percent of the African forest as a whole is destroyed each year).

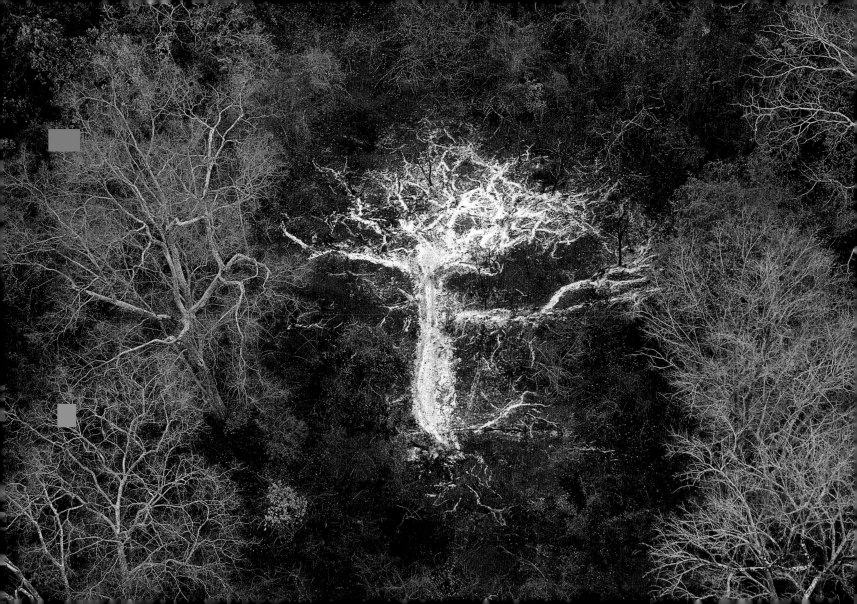

Philippines. Village near Panducan Island.

The Panducan region, situated in the Pangutaran group of islands, is part of the Sulu Archipelago, which was long regarded as a center for piracy, smuggling, and trafficking of every kind. Ninety-five percent of the population is Muslim, a minority group in the country overall, who for a long time were in conflict with the central authorities. Among others living on these islands are the Tausug, the "people of the sea currents," who live here and there in the little hamlets of bamboo houses on stilts, dotted along the coast. Erstwhile smugglers and blacksmiths, they now grow rice, but live primarily from fishing and trading. Unfortunately, the ever more widespread practice of fishing with cyanide or explosives has had a devastating effect on marine wildlife here, especially on the coral reefs.

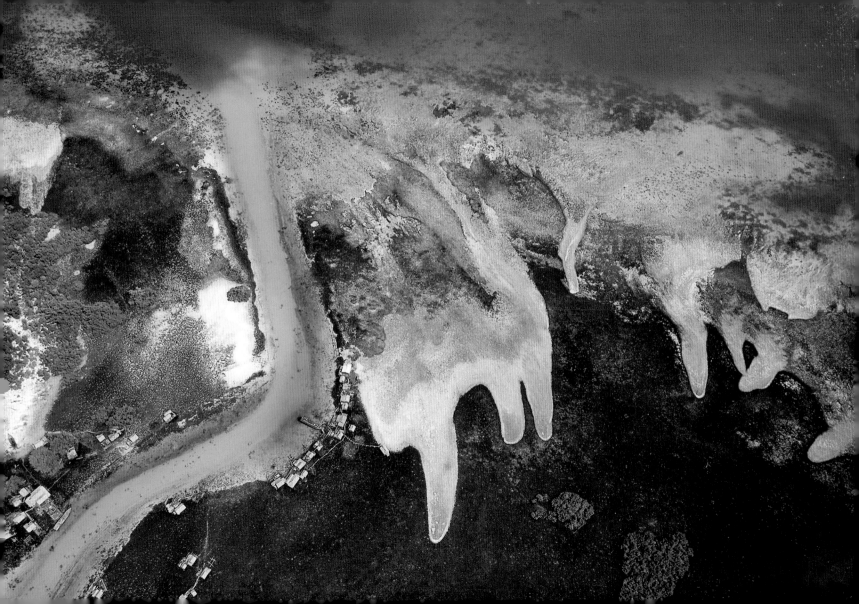

France. Department of Finistère. House of Keremma, in the
Kernic Cove at low tide.

On the cost of the English Channel in Brittany, the narrow strip of granite
sediment on which this house was built is an extension of the Keremma dunes.
It almost fully surrounds Kernic Cove. Edged by vast stretches of sand during
low tide, it is almost entirely surrounded by water when the tide comes in.
During this time, boats can enter the bay only through a narrow pass. The rough
currents and the daily changes in tide (approximately 25 ft. in amplitude) are
gradually eroding the fragile foundation of this isolated home. Tides, the daily
variations in the sea level resulting from the sun and moon's attraction, affect all
the oceans of the world. Amplitudes range between a few inches, especially in
the Mediterranean, and more than 50 feet (Bay of Fundy, Canada) in the Atlantic.

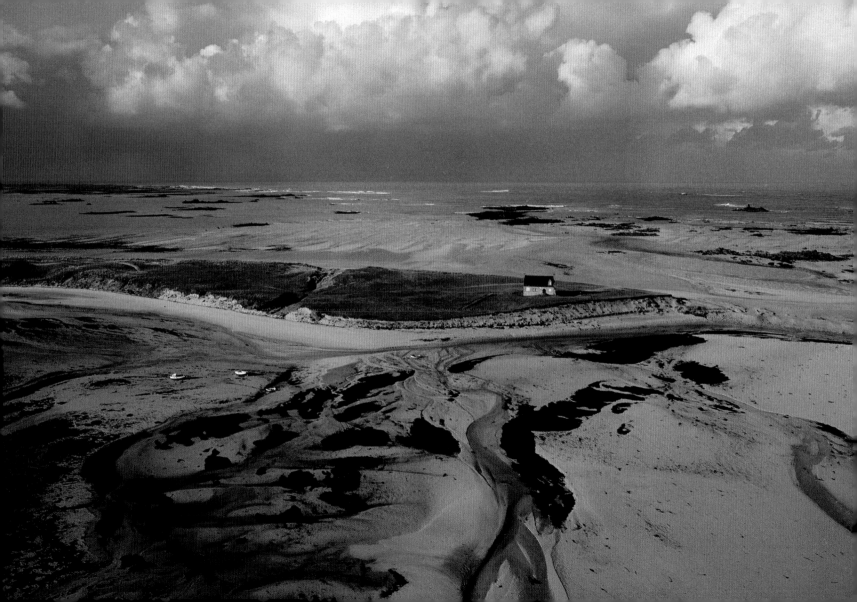

Tunisia. Governorate of Mahdia. Amphitheater at El-Djem.

Approaching El-Djem by road, one sees a vast, cylindrical, entirely mysterious structure rising up in the distance. Only as one gets closer does one discover a sleepy little town beneath it. Here the ancient world seems to overshadow the modern world completely. The amphitheater, probably dating from the beginning of the third century, is famous for its size − 148 meters (485 feet) long, 124 meters (407 feet) wide, and with a perimeter of 427 meters (1,400 feet) − and its state of conservation. The ancient Roman city of Thysdrus had initially made do with an amphitheater carved out of the soft volcanic tuff. The growth of the city's population (probably to several tens of thousands in the second to third centuries) and its increase in wealth thanks to olive-growing, demanded the construction of this prestigious edifice whose architecture is similar to that of the Coliseum in Rome. El-Djem serves as a reminder that in ancient times the population south of the Mediterranean was as large and prosperous as that to the north, and suggests that the same demographics could return without causing a catastrophe. As impressive as it is now, the El-Djem amphitheater would appear small next to skyscrapers around it.

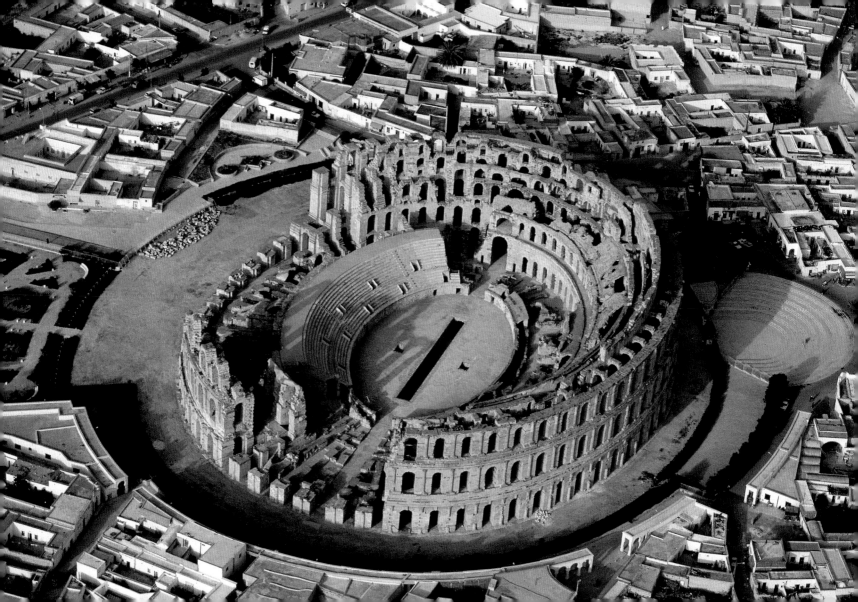

United States. Los Angeles, California. Young sportsman at Torrance Cornerstone Elementary School.

Because he lives in a developed country, this young American practicing basketball on a map of his country in his school playground, has a good chance of entering higher education. As we enter the third millennium, education is one of the areas which has seen great progress: with the exception of a few countries, all children in the world must by law attend school for 6 to 10 years. However, big disparities in access to education remain. It is estimated that 113 million children in the world do not attend elementary school, and many others finish school unable to read or write. Today almost 880 million adults on the planet are illiterate—two-thirds of them women. Indeed, there is great inequality in education between the sexes, and in developing countries fewer girls than boys attend school. The United Nations, aware of the problem and believing that education for all is the key to sustainable development as well as to peace and stability within and between countries, initiated its Literacy Decade in 2000. This includes action to meet the educational needs of all and to ensure that by 2015 all children, particularly girls, have access to primary schooling.

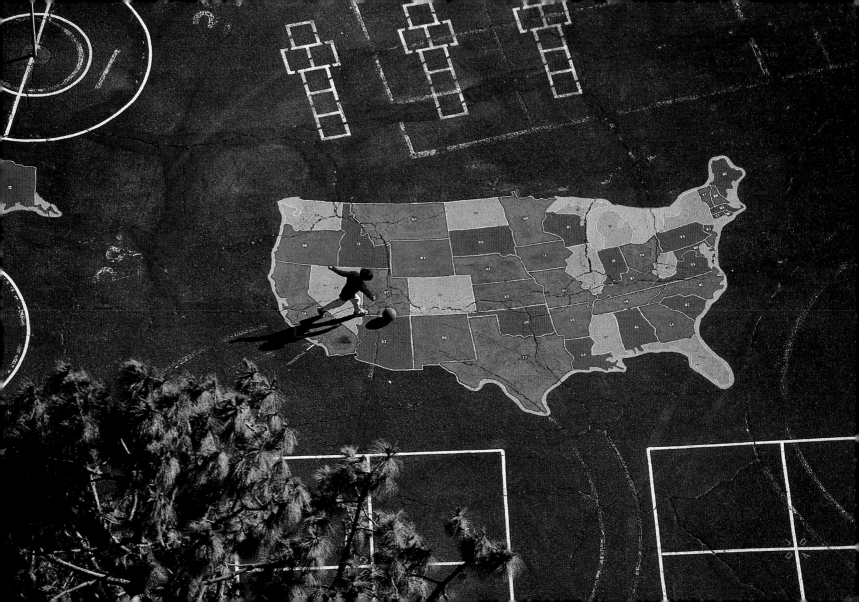

France. Haute-Savoie Department. The Aiguille du Midi in the Mont Blanc Range.

At the heart of the Alpine Mountains, forming a natural border between France and Italy, is the Aiguille du Midi (Needle of the South), whose central peak (topped by a television relay station) rises to 3,842 meters (12,600 feet). One of the highest cable car services in the world makes regular trips between the peak and Chamonix in the valley. Every year, more than 300,000 visitors go to the top of the needle, where they have an incomparable view of Europe's highest peak, 4,807-meter (15,767-foot) Mont Blanc, which 3,000 mountaineers climb each year. The Franco-Italian road tunnel that runs for 11.6 kilometers (7.2 miles) through these mountains was, until a disastrous fire in 1999, used annually by nearly 2 million vehicles, including more than 700,000 trucks, whose exhaust fumes are responsible for the high level of pollution in the surrounding valleys.

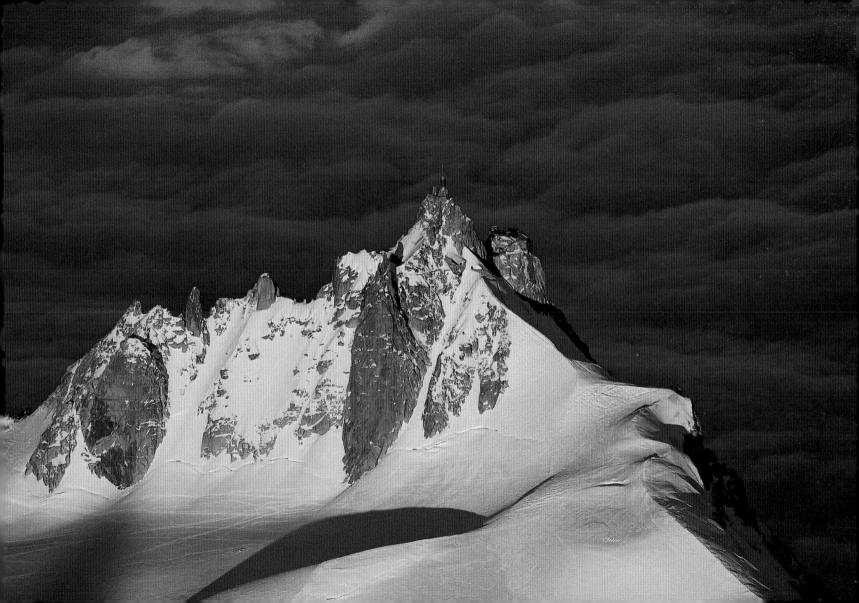

Namibia. Damaraland region. Spitzkoppe Mountains at sunset.

The northwestern part of Namibia, and in particular the wild, desert region of Damaraland, embodies the history of this country as a whole. With several prehistoric sites, it is thought to be the land of earliest modern humans (paintings and carvings more than 27,000 years old have been discovered in the Spitzkoppe Mountains). It bears the name of one of the oldest ethnic groups in Namibia, the Damaras, who make up 7 percent of the current population of Namibia, one-quarter of whom live in the region. It is one of the few areas of Africa outside national parks and protected reserves where antelopes, giraffes, elephants, zebras, and even black rhinoceroses live in freedom. And finally, it contains two high mountain peaks, the Gross Spitzkoppe at 1,728 m (5,668 feet) and the Klein Spitzkoppe at 1,584 m (5,196 feet), which are granitic vestiges of volcanoes that erupted 120 million years ago, at a time when Brazil and Namibia were coterminous, part of the huge supercontinent Gondwana. Everything on Earth changes, but at different speeds; people, animals, mountains, and everything else will go on drifting at their own pace, species as well as continents.

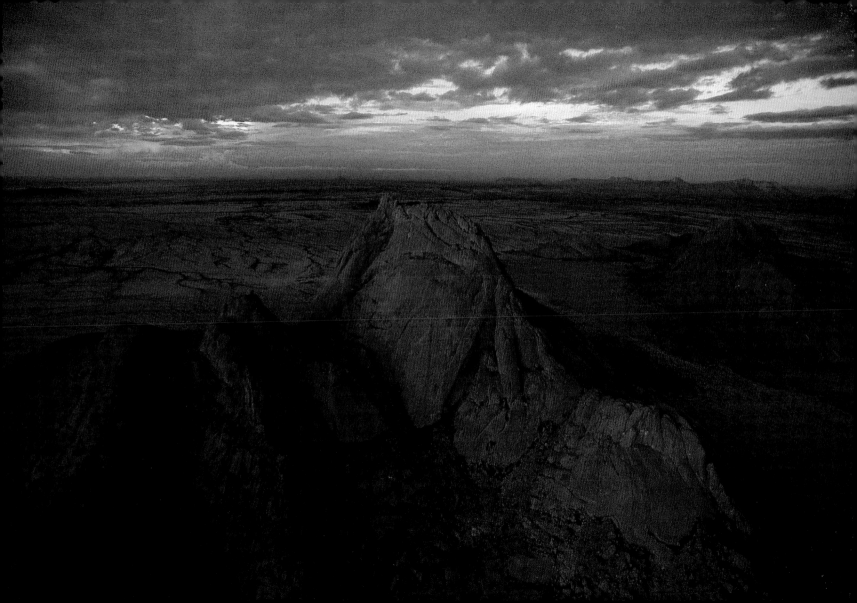

Ivory Coast. Korhogo region. Cotton bales at Thonakaha.

Cotton-growing in West Africa began in the nineteenth century with the introduction of the first seeds of *Gossypium hirsutum,* the variety that still makes up 90 percent of the world crop. In the eighteenth century, cotton came chiefly from the southern United States, where the extremely labor-intensive activities of harvesting and processing were done by slaves. In the Ivory Coast, cotton is still harvested by hand, at the rate of 15 to 40 kilograms (30 to 90 pounds) per day, while the rest of the process is mechanized. Cooton is grown for both it fibers, used in textiles, and it seeds, which are used to make cattle cake and oil for human consumption. Today cotton accounts for 47 percent of the world textile market, and the Ivory Coast is the world's eighteenth-largest producer. In Africa cotton is a cash crop, like cocoa or coffee. Unlike food crops that feed a population, cash crops bring in revenue that can be used to pay off foreign debt or import other goods. Most African countries face the dilemma over whether to produce food crops in order to remain self-sufficient, or produce cash crops to pay back the Western countries.

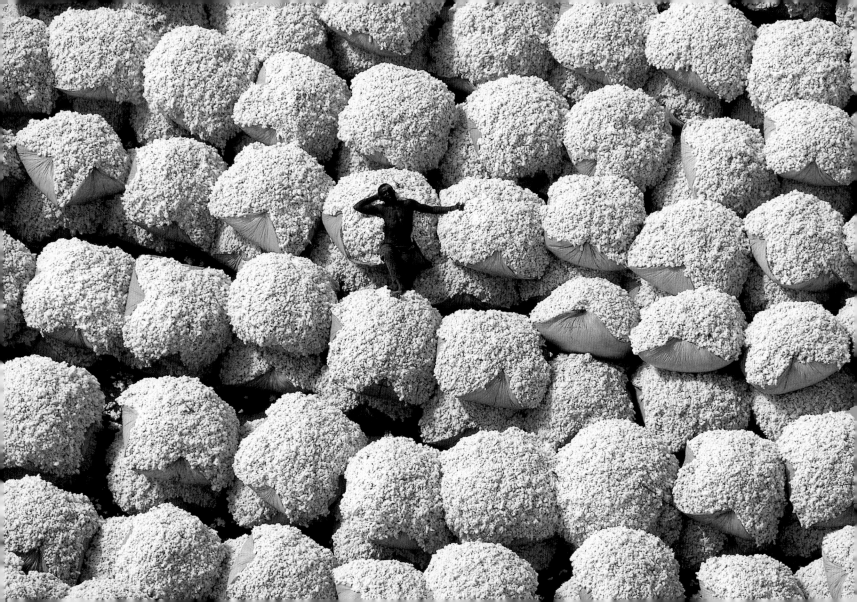

Australia. Northern Territory. Kakadu National Park.

With nearly 20,000 square kilometers (7,700 square miles) of land, Kakadu National Park is one of the largest in Australia. It was placed on UNESCO's World Heritage List in 1981, not just for its natural features, but for its cultural interests – Aboriginal rock paintings – as well. In the north, its grassy plains are drained by several waterways (alligator rivers), and are flooded each year by the October rains. Kakadu has a wealth of flora and fauna, comprising almost 1,000 plant species, 77 fish, 300 birds, 120 reptiles and amphibians, and numerous mammals. Because Australia broke away from the rest of the continents at a relatively early stage, about 150 million years ago, its species evolved independently. Australia (and some of its neighboring islands) is home to many plants and animals that exist on no other continent. Some of the most interesting of these endemic animals are marsupials such as the kangaroo and koala, and the monotremes, which include the duck-billed platypus and echidna.

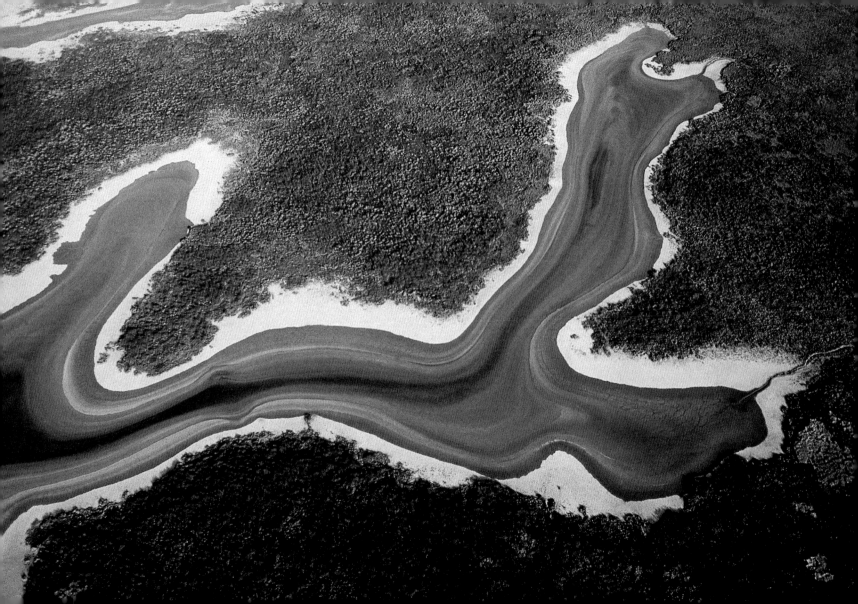

Turkey. Agricultural landscape between Ankara and Hattousa.

The natural conditions of the high, wet Anatolian Plateau of northern Turkey make it particularly favorable to agriculture. One is immediately struck by the regularity of the landscape here, with its well-ordered and clearly divided fields, its well-marked furrows, and its diverse crops, including both grains (corn and barley) and sugar beets. These fields illustrate the tremendous agricultural development that has taken place in Turkey over the last few decades of the twentieth century, thanks to the expansion of cultivated areas, the rise of mechanization, and the creation of monoculture areas and large farming concerns. These have all enabled the country to break the vicious cycle of food dependence, and progressively become an exporter of agricultural produce. The growing intervention by people and machines should not make us forget the areas that have resisted monoculture, where many small farms still survive. Here and there they interrupt the symmetry, punctuating the landscape with trees and copses.

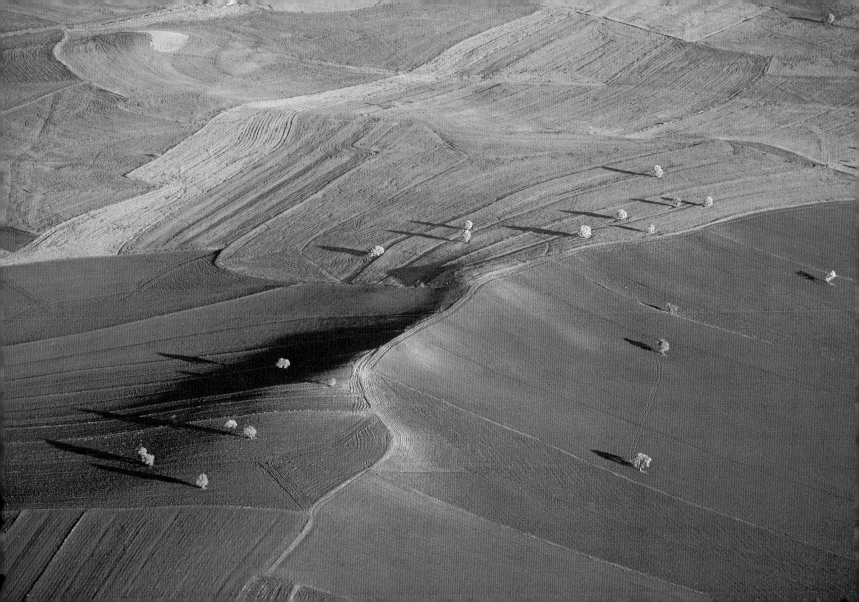

Philippines. Luzon Island. Summit crater of Mount Pinatubo.

The eruption of Mount Pinatubo in 1991 was the largest in the twentieth century, ejecting about 30 million tonnes (33 million tons) of sulfates into the atmosphere to heights of almost 40 kilometers (25 miles), and forming a veil of aerosols that temporarily reduced the amount of solar energy available to the planet by 2 percent, from 200 to 196 watts per square meter. As a result, average temperatures on Earth fell several degrees for the following year or so. Over the twentieth century, scientists became increasingly aware of the environmental effects of violent eruptions, including those of Mount Agung, Indonesia, in 1963, and El Chichón, Mexico, in 1982. Even so, the atmospheric and climatic effects of relatively insignificant events such as these only last for a short time. We should not be tempted to forget or dismiss the long-term dangers of global warming caused by our own activities, in particular deforestation and the increasing consumption of fossil fuels.

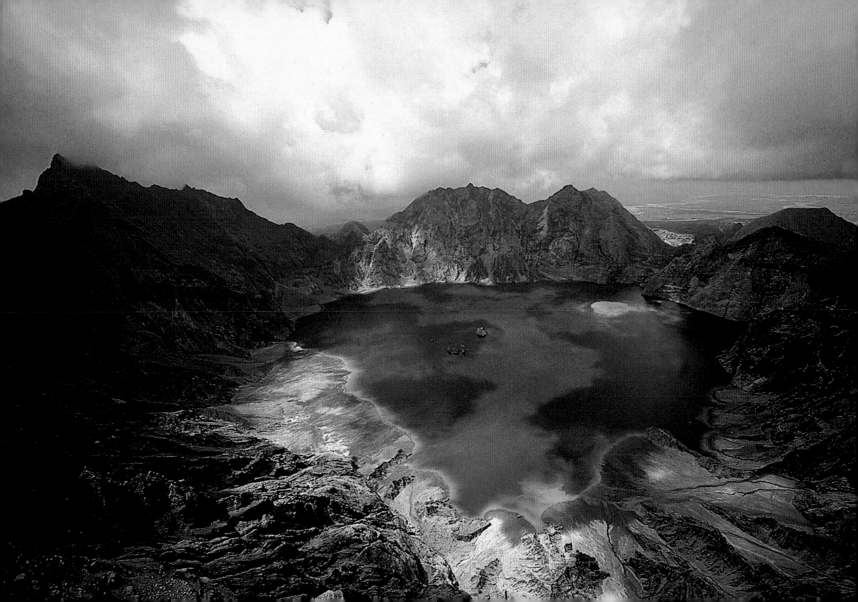

Thailand. Working the fields between Phitsanulok and Sukhothai.

The kingdom of Sukhothai, whose name means "dawn of happiness," which developed in the twelfth century, was the first great Thai kingdom of the center of Siam. Between the valleys of the Yom and the Nan, the plains are given over to growing rice. Small and medium-sized farms using very little machinery harvest their crop twice a year. Despite a fairly low yield of 1.5 to 2 tonnes of rice per hectare (1,200 to 1,600 pounds per acre), rice takes up three-quarters of the country's arable land and is its chief export; Thailand alone supplies 40 percent of the world market. This success has been achieved at the price of very rapid expansion of the areas devoted to agriculture, to the detriment of the forest. The trend has accelerated since 1960, with crops being grown on stubble by landless peasants. In 1961 the forest occupied 57 percent of the country's surface area, but by 1992 it covered only 20 percent. Since the disastrous floods of 1989, Thailand has prohibited forest-clearing and has been importing wood from Laos, which in turn is cutting into its forest resource. Thus step by step, Asia is being deprived of the forests that used to stabilize its rainfall and climate, as well as its soil.

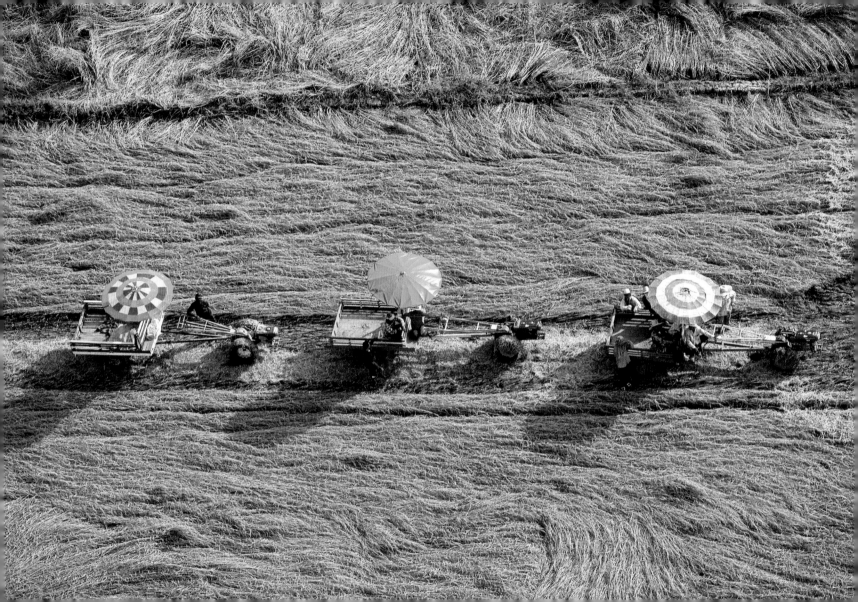

Canada. Quebec. Fall forest in the Charlevoix area.

The hills in the Charlevoix area, bordering the Saint Lawrence River in Quebec, are dominated by a forest of both deciduous and coniferous trees, 4,600 square kilometers (1,775 square miles) of which were classified as a UNESCO Biosphere Reserve in 1988. Covering nearly two-thirds of the province, the Quebec forest is boreal in the north and temperate in the south, and has been exploited since the end of the seventeenth century. Today it contributes to the economic prosperity of Canada, which ranks first, second, and third in world production of newsprint, wood pulp, and lumber. Not only has the Canadian forest been over exploited for far too long, it has also been eaten into by parasitic insects and acid rain, and its surface area has decreased considerably. Nevertheless it still covers 3.4 million square kilometers (1.3 million square miles), and reforestation schemes have now been put into action in order to preserve it.

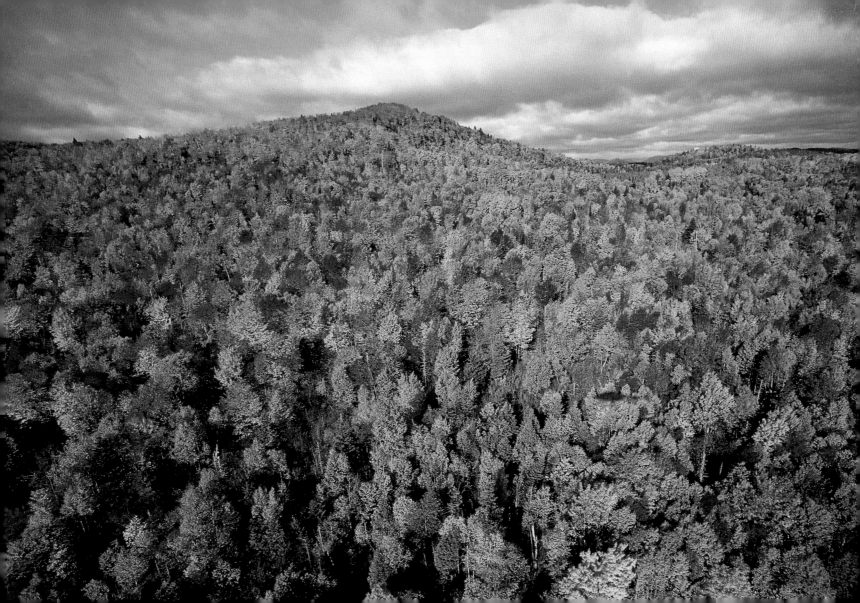

Kenya. Market near the Masai Mara National Reserve.

Local villagers and the region's Masai nomads will travel many miles to get to this little impromptu country market held regularly near the village of Lolgorien, between the Masai Mara National Reserve and Lake Victoria, Kenya. Laid out on mats on the ground, most of the wares being offered are secondhand clothes originally from aid organizations, along with basketwork, pottery, and jewelry traditionally made only by women. Markets like this one, which generally occur spontaneously on the edges or at the intersections of tracks, are an important source of supplies for Kenyans. The country has few large urban centers, with 70 percent of the population living in rural areas, in small villages or encampments scattered over Kenya's 583,500 square kilometers (225,000 square miles).

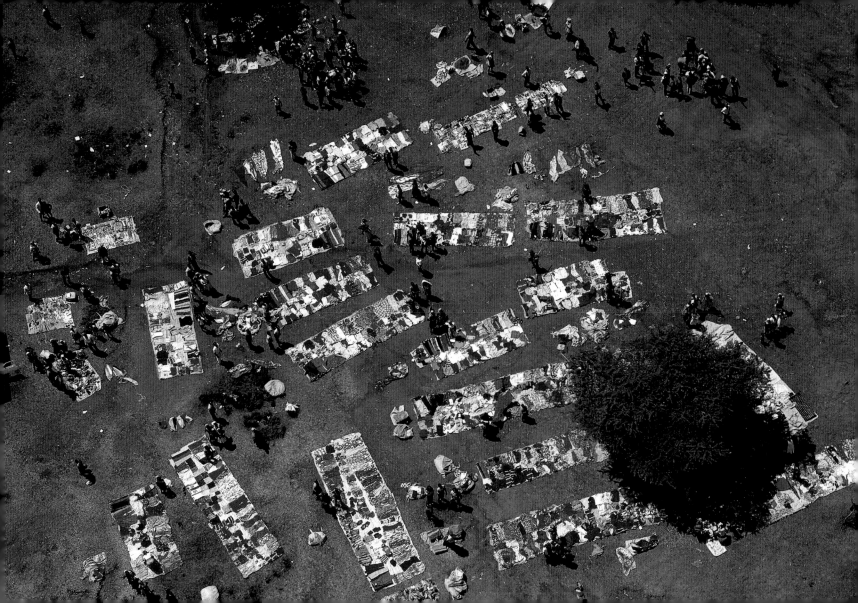

Australia. Queensland. Sand dune amid the greenery on Fraser Island.

Fraser Island, off the coast of Queensland, is named for a woman who was shipwrecked off the island in 1836. It is the largest sand island in the world – 120 kilometers (75 miles) long and 15 kilometers (9½ miles) wide. Curiously, a tropical rain forest thrives on its apparently barren soil, the wind driving great dunes deep into its heart. With almost 200 freshwater lakes, Fraser Island is home to varied fauna including marsupials, birds, and reptiles. The island's timber resources were tapped from 1860, notably for the building of the Suez Canal, and in the 1970s the island was much coveted by sand extraction companies. Today it is a protected area, and since 1992 has been a UNESCO World Heritage Site.

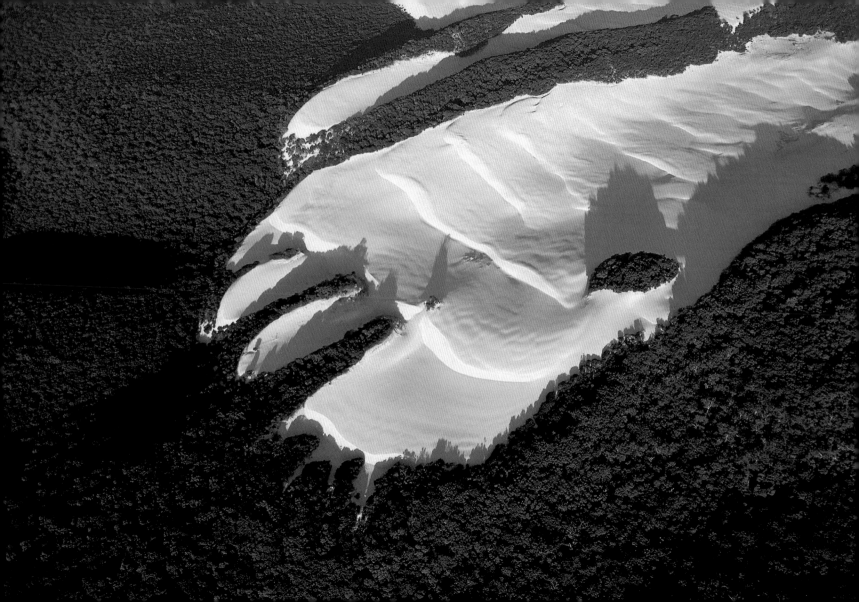

Tunisia. Governorate of Tataouine. Valley of the Ksour, between Matmata and Tataouine.

Deep in southern Tunisia, the Valley of the Ksour contains a number of these Berber settlements, most of them derelict. *Ksour* is the plural of *ksar*, a term that refers to both a kind of dwelling and an economic system. Ksour are generally perched on hilltops to discourage attackers, and were originally a sort of collective granary, later used as living accommodations. Their basic buildings block is the *ghorfa* (room or chamber), a cell 4 or 5 meters (13 or 16 feet) deep and 2 meters (6½ feet) high, divided into alcoves in which grain, oil, or cheese were stored. The ghorfas were built one above the other, sometimes six stories high, facing inwards around a central courtyard. These "hilltop granaries" bear witness to the Berbers' long resistance to invaders, and their size reminds us that in former times a wetter climate than today's allowed a larger population to grow food on what is now the fringe of the Sahara. From even earlier times, frescoes discovered in the 1950s by French archaeologist Henri Lhote in the Tibesti Massif deep in the desert are indicative of the wider extent of Saharan oases in ancient times.

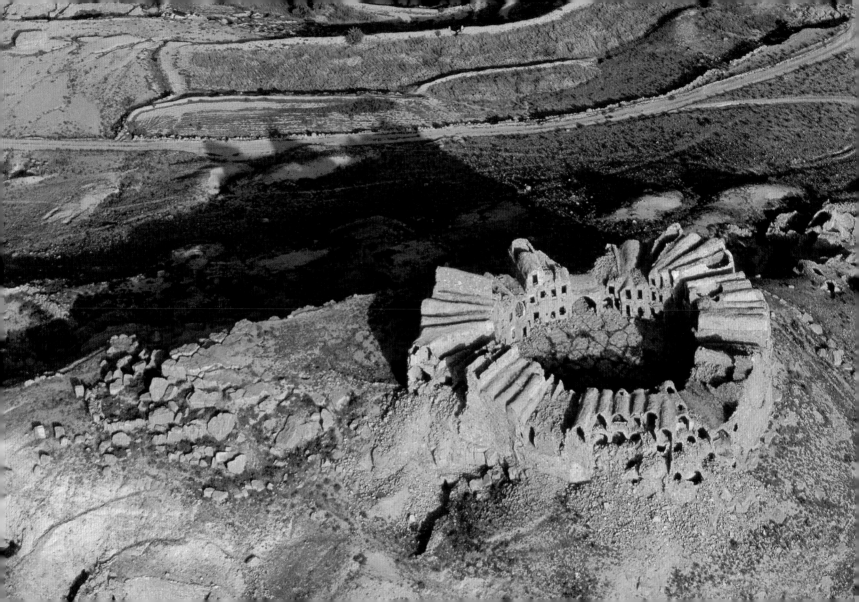

Morocco. Dyers' workshops and vats in Fès.

The dyers' district in Fès, Morocco, has retained its character over the centuries as ancestral dyeing techniques have been handed down through the generations. Woven cotton or woolen cloth, and the tanned hides of sheep, goats, cows, or dromedaries are soaked in earthenware vats filled with dye, where they are stomped on by fullers. The dyes are prepared in mills along the Fès Wadi from natural pigments: poppy to produce red, indigo for blue, saffron for yellow, date stones for beige, and antimony for black. The colored materials will be used to manufacture the celebrated rugs and leather goods that constitute Morocco's main handicraft exports.

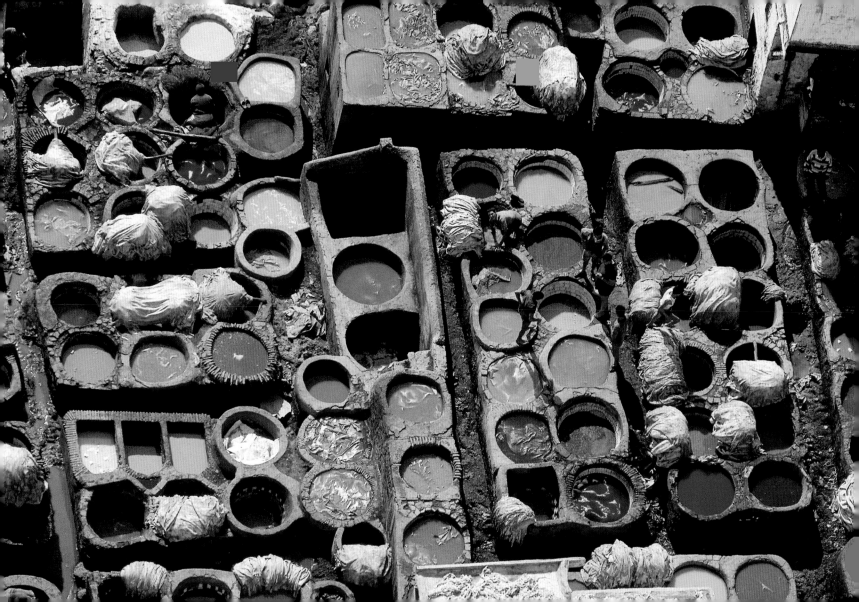

Iceland. Vestmannaeyjar Archipelago. Eldey Island. Colony of northern gannets.

At the crossroads between America, Europe, and the Arctic, Iceland boasts a varied bird population: 70 species nest there, and 300 more visit regularly. And every year the island of Eldey, a 70-meter- (230-foot-) high rock and nature reserve 14 kilometers (9 miles) off the south coast, is host to one of the world's largest colonies of northern gannets (*Morus bassanus*) – almost 40,000 strong. The birds come to the island in January and February to nest, each pair rearing a single chick, and leave in September to winter off the coast of Africa, a continent to which almost a quarter of the Palearctic's bird species migrate. To get there the gannets fly more than 300 kilometers (almost 200 miles) per day, braving natural dangers such as headwinds and predators, as well as human-made ones such as pesticides and the destruction of their natural habitats. It was on Eldey Island that the last two surviving individuals of the great auk (*Alca impennis*, a once widespread species now extinct) were killed in 1844.

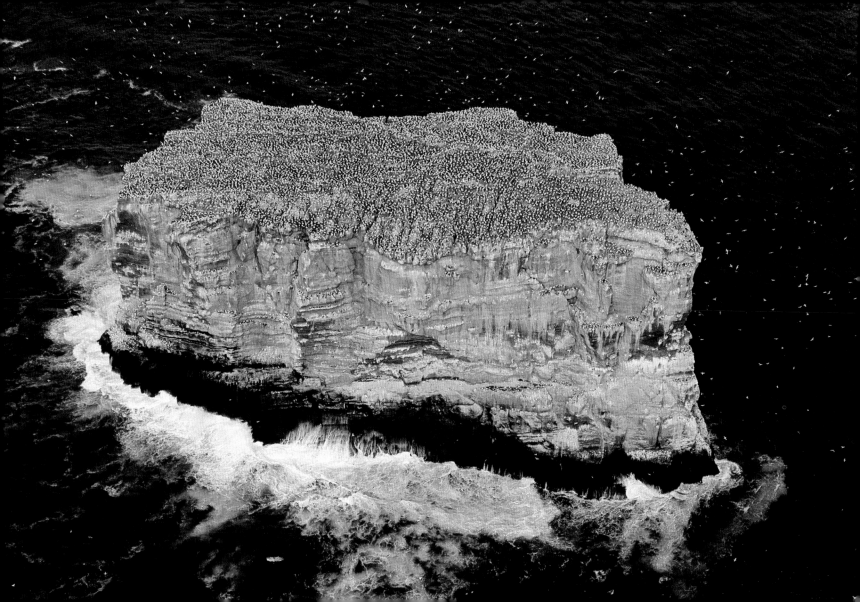

India. Rajasthan. Jamwa Ranghar Tal, northeast of Jaipur.

Two-thirds of the state of Rajasthan is taken up by the great Thar Desert. But the remainder, east of the Aravalli Mountains, which catch the summer monsoon rains, presents a green, fertile landscape shaped by the people. This has, however, required large-scale irrigation projects. Since the time of the maharajahs many dams have been built, their artificial lakes storing monsoon water for irrigating farmland. Although the high salinity of the water – whether from the lakes or from aquifers deep underground – reduces soil fertility, large irrigation projects have been extended into the Thar Desert via the Ganges Canal and the 650-kilometer (400-mile) Rajasthan Canal, now being built. It is a race against the desert, which is advancing northward at the rate of 13,000 hectares (32,000 acres) per year. This ambition to green the Thar using water from the Himalayas is reminiscent of similar projects on desert fringes, including the Aswan Dam, the Tigris-Euphrates Canal, and the tapping of aquifers in the Egyptian desert at Bahriya. World-wide, about 70 percent of water use goes toward agriculture, and lack of water is the chief factor limiting agricultural production.

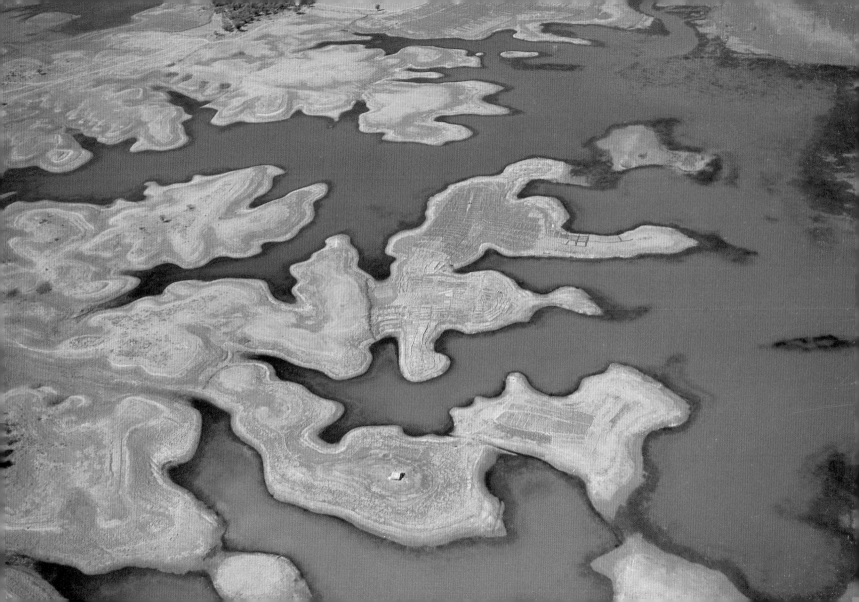

Kenya. Mida Creek, south of Malindi.

With its safaris and its seaside resorts along a coast sheltered by a coral reef, Kenya is Africa's top tourist destination. In the ornithological paradise of Mida Creek, surrounded by mangroves and home to marabou storks, flamingoes, herons, and other birds, tourists can go scuba diving (the site is a marine reserve and is inhabited by a protected species of giant grouper), or take a trip on a dhow. For more than 1,000 years dhows have been the primary means of transportation and trade in eastern Africa. The Persians and Arabs introduced this type of sailing craft when trade links were first established with the region. Taking advantage of the winter monsoon winds, which blew from the northeast, sailors came laden with textiles, corn, wine, and small items of glassware, and left with cargoes of fine hardwoods, ivory, rhinoceros horns, and above all, slaves. From June to October, before the monsoon, the dhows sailed back toward the northeast. Today, the only coastal trade route that survives is that between Somalia and Tanzania.

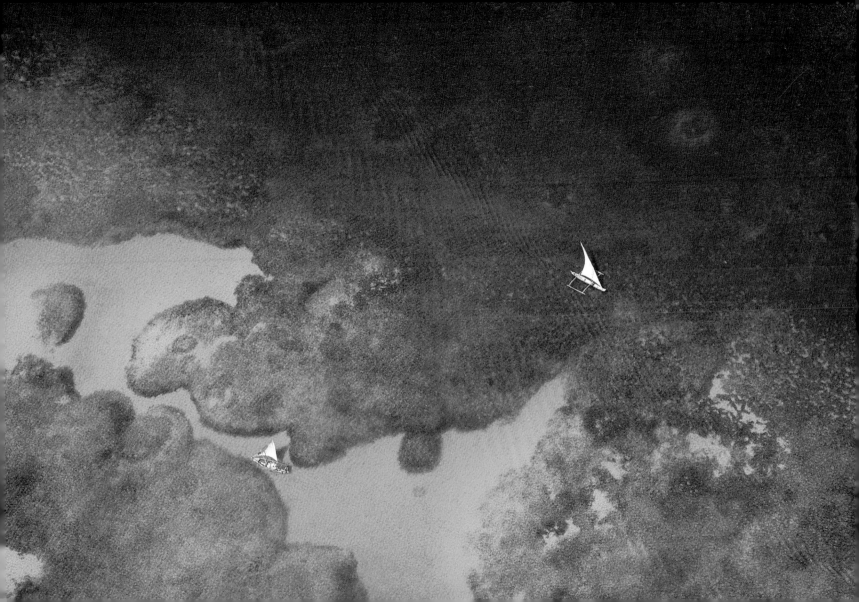

Egypt. Aswan. The unfinished obelisk.

The motionless power of the obelisk, stretched out on its rocky bed, its base seeming to spring out of the shadows of the bowels of the Earth, is the power of a symbol that is in the process of being created and yet still part of nature. Only when it is extracted from the Earth, carried to its rightful place and erected will the obelisk attain its full significance and take its place in the procession of great symbols of human civilizations. Raised in majesty, whatever inscription is finally engraved on its base, it will bear eloquent witness to the ingenuity and vanity of a people. This obelisk was abandoned after a crack developed while it was being hewn from the pink granite at Aswan. Had the monument remained intact, it would have weighed over 1,000 tonnes (1,100 tons).

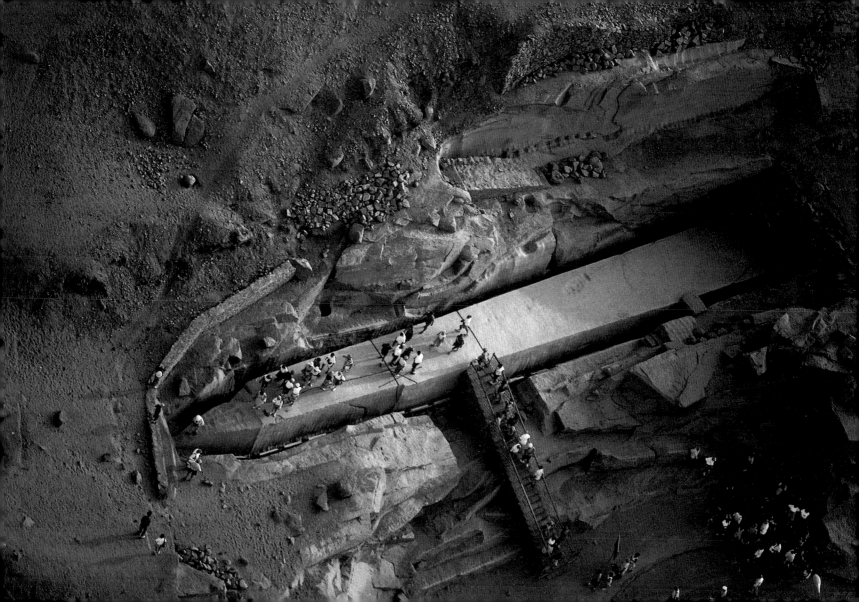

Namibia. Lake shore in the Etosha National Park.

Seen from the air, the indentations in this lake's shoreline, encrusted in salt deposits, have the appearance of fantastic plants and animals. One of Africa's largest protected areas, covering 22,270 square kilometers (8,600 square miles), the Etosha National Park is centered on the Etosha Pan, a huge 6,000-square-kilometer (2,300-square-mile) basin covered in salt deposits. For a few weeks each year, during the rainy season, the basin becomes a lake. The water is too brackish for mammals to drink, but it allows the blooming of a blue-green alga that is a favorite food of tens of thousands of pink flamingoes, which come to nest by the lake. When the water evaporates, grasses cover the basin, providing food for the park's large herbivores. There are more than 13,000 protected areas (such as national parks and reserves) like Etosha in the world today, totaling more than 6.1 million square kilometers (2.35 million square miles) or 8.9 percent of the Earth's land surface.

France. Paris. The Palais-Royal. Buren's Columns.

In 1986 the French artist Daniel Buren created a 3,000-square-meter (32,300-square-foot) sculpture in the great courtyard of the Palais-Royal. "Buren's Columns" provoked a furious debate over the integration of contemporary art and historic buildings. Long considered the heart of Paris, the Palais-Royal was built in 1635 by the architect Jacques Lemercier at the request of Cardinal Richelieu, as an expression of the growing centralization of power within the monarchy. Of the original building, known at the time as the Palais-Cardinal, only the gallery of the Prows survives. The present buildings essentially date from the Restoration (1814). The Palais-Royal's architecture, altered many times, is a résumé of several centuries of art. Almost all of the many dignitaries who occupied it left an artistic trace as a mark of their power. When the ministry of culture commissioned Daniel Buren to work on the Palais-Royal's great courtyard, he joined an old political and architectural tradition. A couple of years later, I.M. Pei's pyramid, commissioned by François Mitterrand, opened in the courtyard of the Louvre, just a stone's throw away.

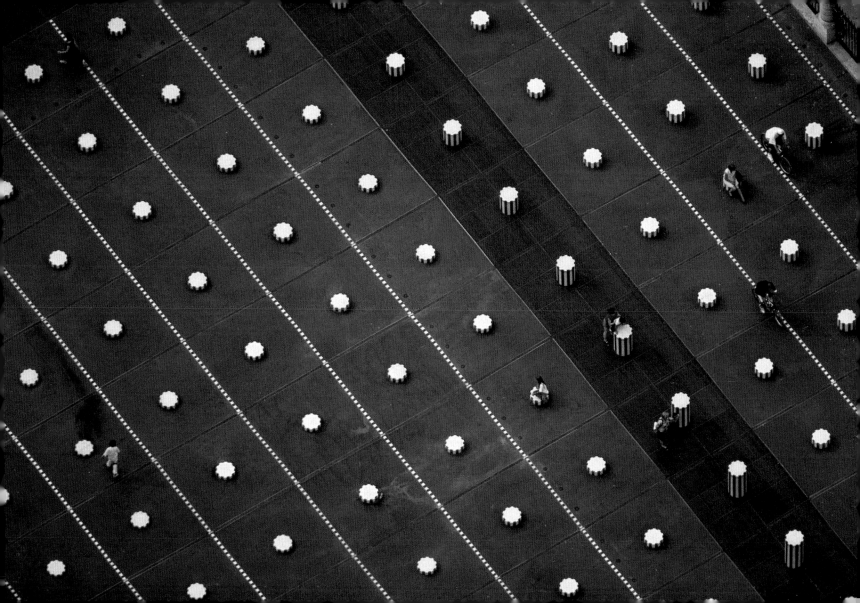

United States. Florida. Tornado damage in Osceola County.

On February 22, 1998, an F4 tornado, with winds of 300 to 400 kilometers per hour (200 to 260 miles per hour), ended its course in Osceola County after devastating three other counties in central Florida. It swept away several hundred dwellings, killed 38 people, and wounded 250. Such violent tornadoes are fairly rare in Florida, and are generally linked to the El Niño climatic phenomenon, which causes extreme weather events all over the world every five to seven years. The period from April 1997 to June 1998 saw a number of weather-related disasters: tornadoes in the United States, cyclones in Mexico and Tahiti, drought in Indonesia and the Amazon basin, torrential rains in Somalia and Kenya. Although it is diffucult to determine whether or not any particular event is linked to El Niño (there were just as many tornadoes in the La Niña year following this one), the results of El Niño are thought to have caused the death of more than 200,000 people worldwide.

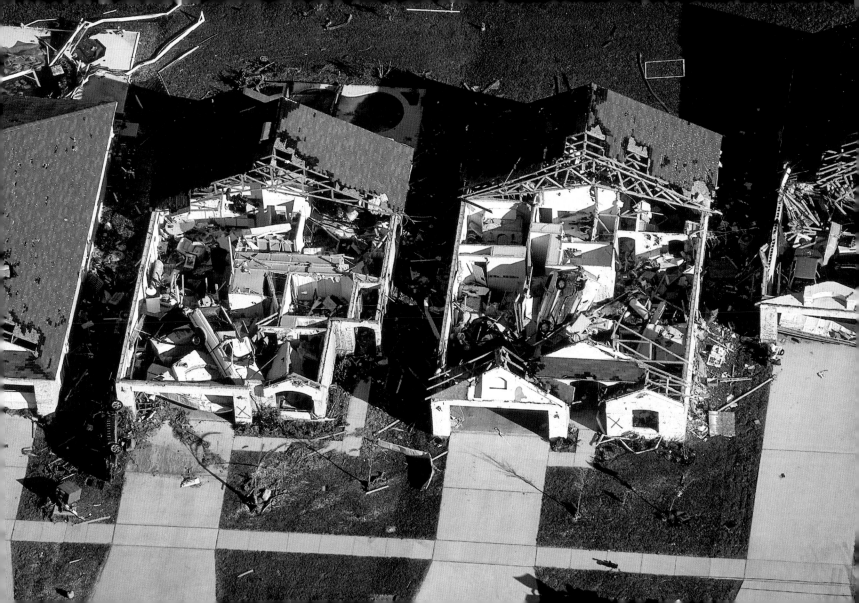

Japan. Honshu. Cemetery in Kyoto.

Both through their view of suicide and through their funerary rites, the Japanese have made a true ritual out of death. In their eyes, "determined death" follows the code of honor and loyalty espoused by the samurai warriors, of whom kamikaze pilots were a recent example. Japanese funeral rites are governed by a range of rules and traditions, from the direction in which the burial vault and the deceased should face (northward) to the organization of the funeral itself, of the meal that follows it, and the use of salt to purify the mourners. Cremation is widespread among Buddhists, and is accompanied by various rites such as picking out the bones from the ashes using two rods of unequal length and leaving them on the domestic altar for longer than a month before burial at the cemetery. This interest in death is matched by an equal lust for life, for the Japanese live longer on average than almost anyone else in the world: the women 83 years, the men 78.

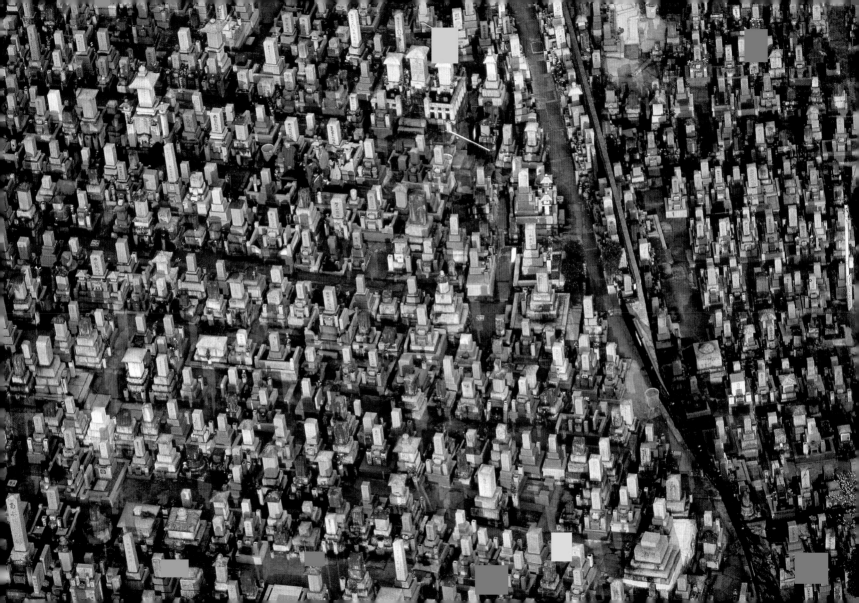

Kuwait. Jahra region. Waste from a desalination plant at Al-Doha.

The two desalination plants at Al-Doha in Kuwait produce 1,200 and 6,000 cubic meters (320,000 and 1.6 million gallons) of fresh water per day, using a distillation process known as flash evaporation. After treatment, the waste water is returned to the sea where, taking on the image of a tentacled monster, it mingles with that of the Persian Gulf. For a long time Kuwait depended on small wells and imports from Iraq for its drinking water, but it now possesses several plants that produce more than 400 million liters (100 million gallons) of desalinated water a year, meeting 75 percent of the country's needs. Because desalination plants use large amounts of energy, they are only feasible in countries with plentiful resources, notably oil. The Arabian peninsula has about 40 plants, producing more than half the world's desalinated water.

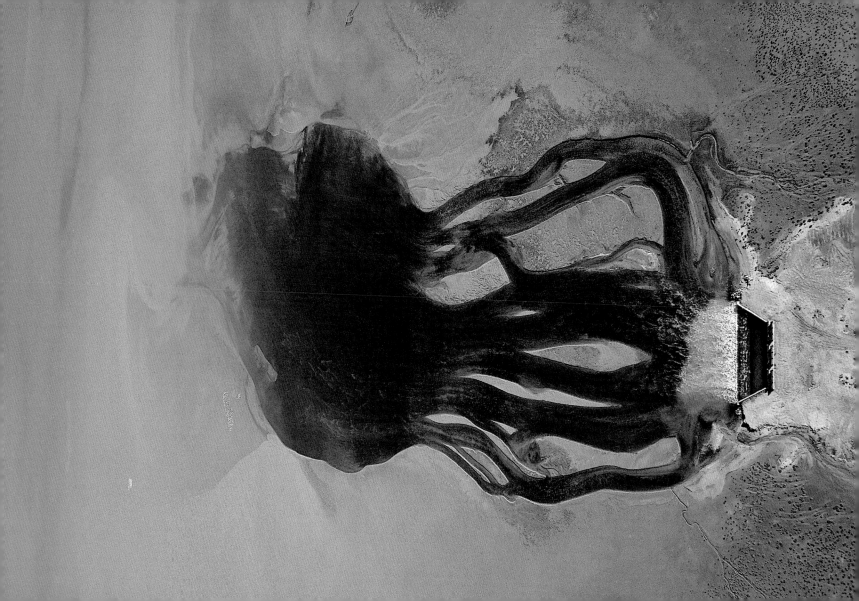

Iceland. Reykjanes Peninsula. Blue Lagoon, near Grindavik.

The volcanic Reykjanes Peninsula in Iceland contains many hot springs. The Blue Lagoon (or *Blaá Lònidh*) is an artificial lake fed by surplus hot water from the geothermal power station at Svartsengi. The water is tapped 2,000 meters (6,500 feet) underground where magma has heated it to 240°C (460°F), and then is brought to the surface. Here, at a temperature of 70°C (160°F), it is used to provide heat to towns in the area. The lagoon's milky color is due to a blend of rock powder, combined with decomposing algae in the water. Rich in mineral salts and organic matter, the Blue Lagoon is well known for its therapeutic properties in treating skin diseases. Geothermal energy has only recently been tapped as a renewable resource, but is used increasingly: in Iceland, 85 percent of the population uses it for heating.

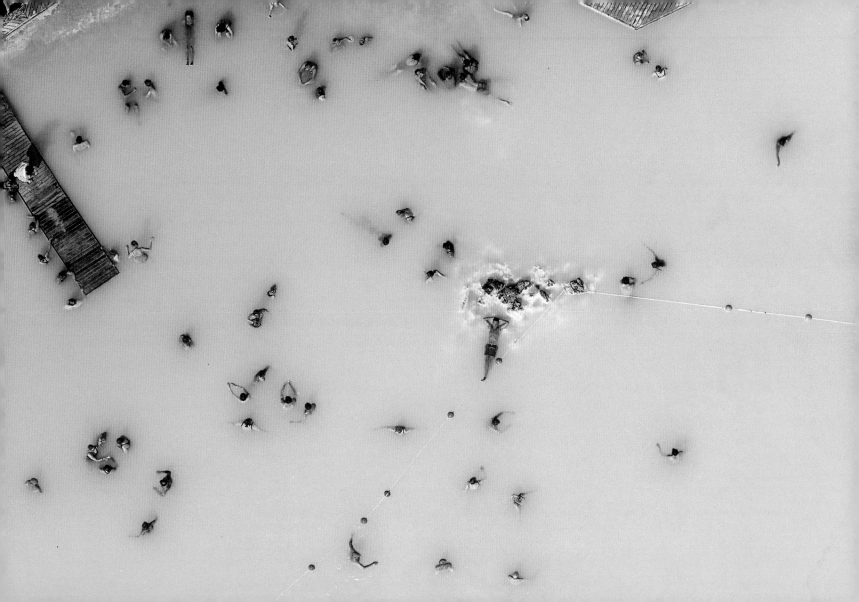

India. Uttar Pradesh. Well at Fatehpur Sikri.

In 1573 the Great Mogul Akbar, Emperor of India, built the town of Fatehpur Sikri to commemorate his victory over the Afghans. There, 38 kilometers (24 miles) from the imperial city of Agra, he installed his court in the splendor of red sandstone palaces built on a rocky plateau. It has often been said that Fatehpur Sikri is to Agra what Versailles is to Paris. However, the similarity ends there, for Fatehpur Sikri was abandoned just 15 years after it was completed. This ghost town contrasts sharply with the Ganges Plain over which it towers, one of the most heavily populated regions in the world. The abandonment of Fatehpur Sikri has been attributed to the Mongols' nomadic lifestyle. Indeed, the town's layout recalls that of the camps set up by those invaders from the steppes. But a more likely explanation is that the upkeep of parks and lakes quickly exhausted groundwater supplies, a theory supported by the deep wells still used by farmers in the area. Irrigation, which has allowed the green revolution to provide adequate food supplies in many previously unarable regions, uses up groundwater; in the long term, some heavily populated areas run short of it, and thus of food as well.

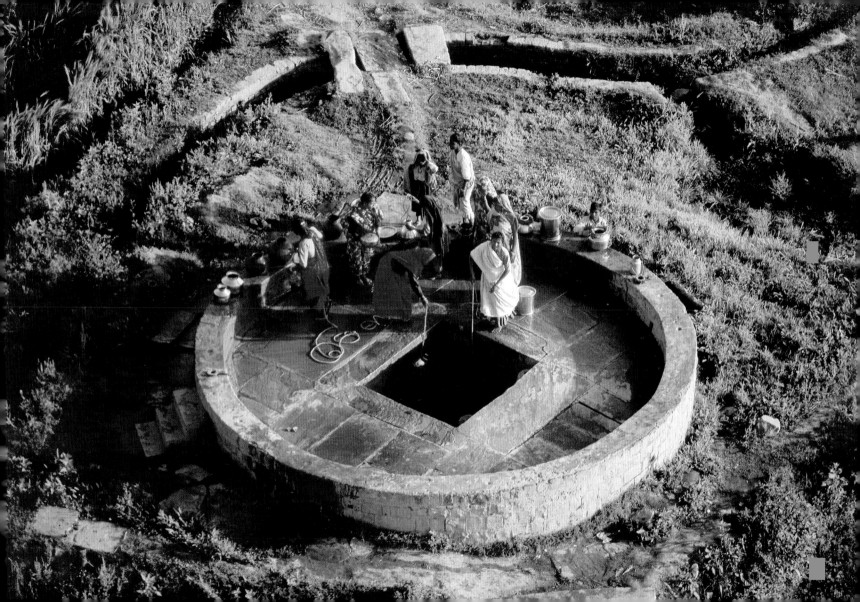

Morocco. Fishermen's nets in the port of Agadir.

At Agadir, Morocco's biggest fishing port, nets several hundred meters (several hundred yards) long are laid out on the ground to be repaired before the next expedition. With a coastline 3,500 kilometers (2,200 miles) long, the country has great fish stocks at its disposal. Its waters are home to almost 250 species, notably sardines, which migrate along the coast, taking advantage of rising water currents rich in food. Seventy-five percent of Morocco's fishing is on a non-industrial scale, with trawlers and small motor boats. Sardines account for 80 percent of the catch, and Agadir has become the world's largest sardine center. Since 1970 the world fishing fleet has increased six fold, and the catch doubled. If the trend continues, fish stocks – 60 percent of which are already subject to overfishing – are in danger of being wiped out.

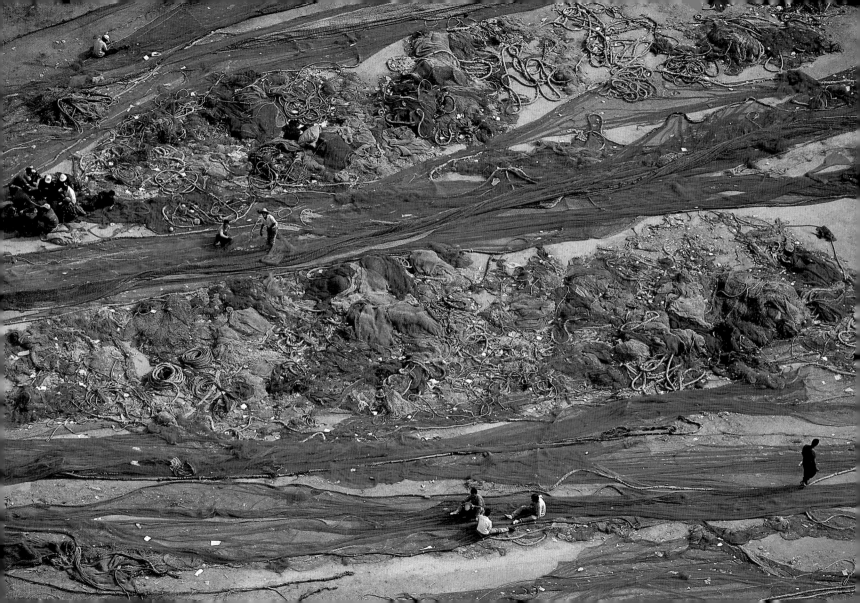

France. Charente-Maritime Department. Oyster beds near Marennes.

At Marennes it is not sand but mud that the Atlantic Ocean washes over and then uncovers with each tide. In the nineteenth century, peasants, sailors, and shore dwellers found a way to supplement their income by intensively raising oysters, taking advantage of the disappearance of the salt pans driven out of business by Mexican imports. At the behest of Napoleon III, who wanted to establish a model of production in the converted basin, the shoreline between the high and low tide marks soon became a mosaic of *claires*, basins fed by both fresh and sea water. This way of breeding oysters between land and sea, originally unique to the Marennes area, became widespread. The oysters are fed by the rising and falling tides which bring a nutritious slime – a microscopic blue alga, *Navicula ostrearia*, whose pigment gives the oysters' flesh its characteristic greenish color. People and nature collaborate so closely here that they end up living according to the same rhythm. In Marennes, people use the lunar calendar dictated by the tides, rather than the solar one used by agricultural civilizations since the dawn of time.

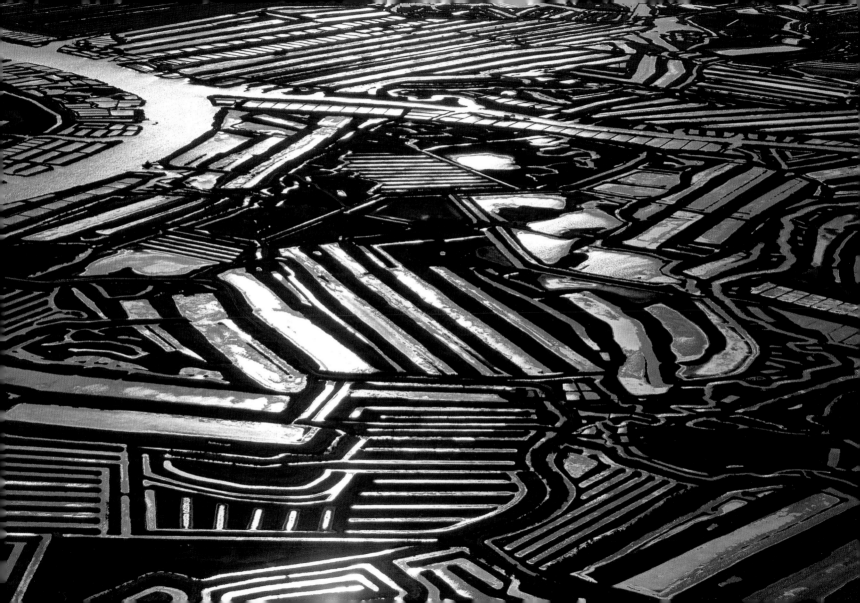

Thailand. Phuket Island. Koh Pannyyi Village, Phang Nga Bay.

Thailand's western coastline is deeply indented by a series of bays, washed by the Andaman Sea and fringed with many islands. Once an arid area of dry land, Phang Nga Bay was formed by rising sea levels when sea temperatures rose and glacial ice melted some 18,000 years ago, submerging all but the tops of the limestone mountains, since covered by tropical forest. The bay was made a marine reserve in 1981. The topography is one of karstic peaks of limestone, similar to those found elsewhere in southeast Asia, most notably in Halong Bay in Vietnam and around Guilin in China. Sheltered from the monsoon by the mountains, the village of Koh Pannyyi floats on bamboo pontoons, and its 400 inhabitants live by traditional fishing methods. It is estimated that about 95 percent of the world's fishermen live in developing countries, and 85 percent of them in Asia. The continent brings in one-third of the world's catch of fish.

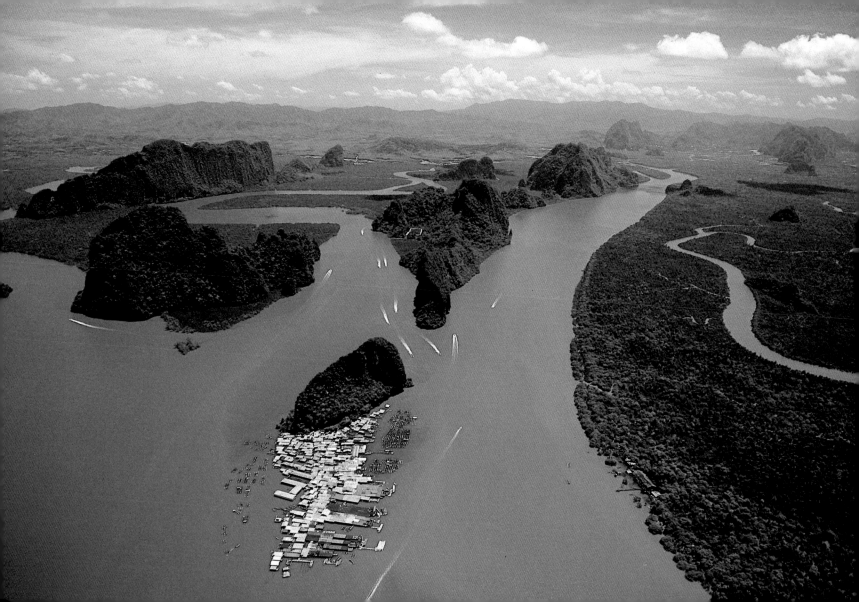

Brazil. Bird's eye view of São Paulo.

Where Jesuits founded a small mission in 1554, there now rises the continent's largest megalopolis, with at least 26 million inhabitants. The city, which already covers 8,000 square kilometers (3,100 square miles)—an area little more than half the size of the state of Connecticut—is growing at the rate of 60 square kilometers (25 square miles) per year. It is growing upwards too, its lower houses having been replaced first by the *predio alto* (multi-story buildings), then the *edificio* (towers), and finally the proud *arranha ceu* (skyscrapers). Inevitably, this concentration of people has brought an influx of cars and traffic jams which, equally inevitably, have worsened air pollution. In this respect the air in São Paulo has become as unbreathable as that in Mexico City, which is vulnerable because of its altitude, and in Athens, where the inversion of air currents causes the toxic greenish smog to stagnate. In London, the smog which brought with it bronchitis, asthma, and fatal lung diseases disappeared after a law passed in the 1960s made filters in chimneys compulsory. Will anyone ever have the courage to regulate use of the car, the goddess of modern times, and thus dramatically reduce pollution?

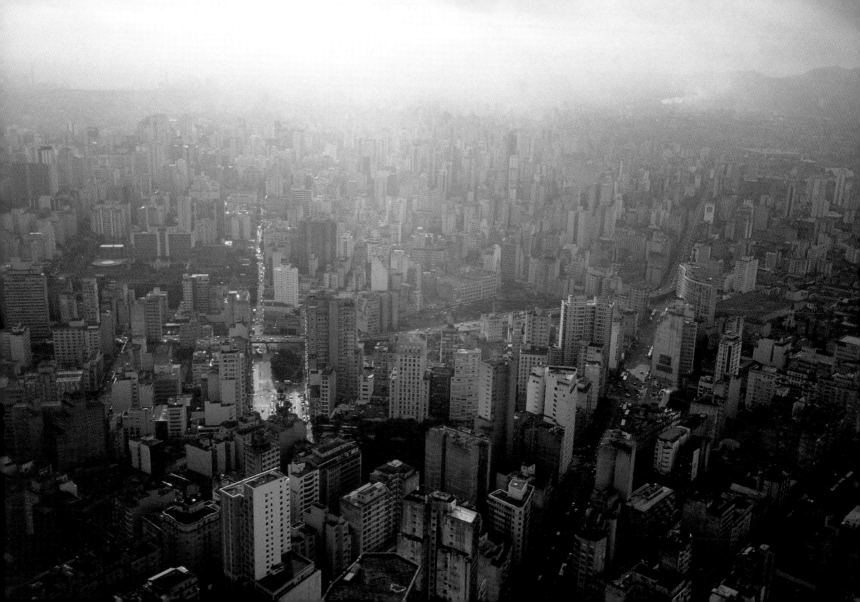

Mali. Village of Araouane, north of Tombouctou (Timbuktu).

In the Saharan part of Mali, 270 kilometers (170 miles) north of Tombouctou, the village of Araouane lies on the great caravan route that links the north of the country with Mauritania. There are several nomadic encampments set up around wells on its edge. However, little by little, Araouane is disappearing as sand dunes driven by the wind swallow its houses. Extending across 10 African countries, the Sahara's eight million square kilometers (three million square miles) make it the world's largest hot desert. It contains not only sand, but also eroded areas covered with stones, known as *reg*, and rocky plateaus known as *tassili* and *hammada*, as well as high mountain massifs (such as the Ahaggar, Aïr, and Tibesti) that cover 20 percent of its area. The Sahara was not always a desert; less than 8,000 years ago it was covered with vegetation and was home to a variety of tropical animals.

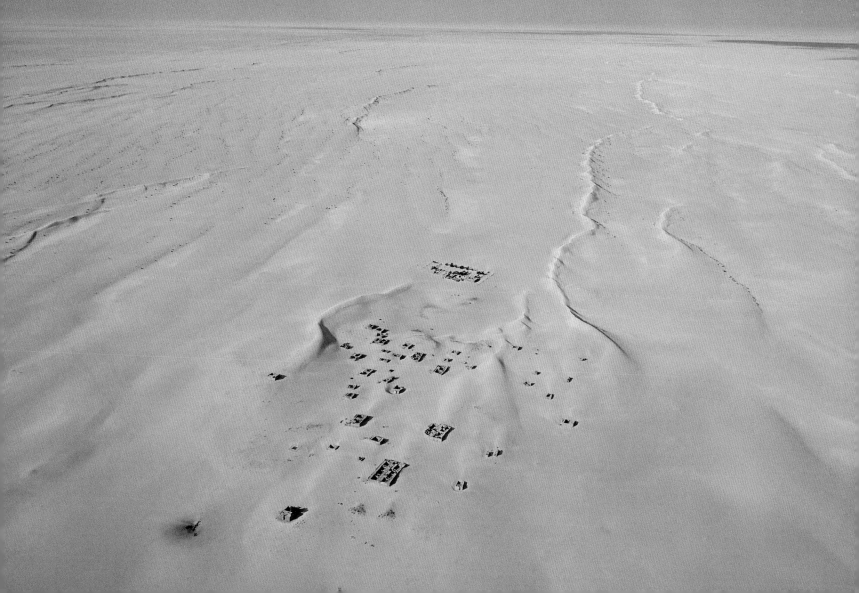

Morocco. Gorges of the Dadès River.

Between the High Atlas and the Lesser Atlas Mountains is the vast river plain of the Dadès. In the verdant hollows between the high rock faces and rugged and chaotic scree, nestle the villages made up of *kasbas*. These are fortified houses constructed of *pisé* (clayey packed earth), typical of the gorges of the Dra and Dadès. The houses wear the same shades as the multicolored rocks and soils of the region, ranging from red to mauve and ochre. The many gardens, cultivated for local use, green the landscape and soften the rough universe of the Berbers of the High Atlas, where the least plot of arable soil is exploited thanks to the wadis, those intermittent rivers of arid regions. The trees and shrubs in this valley – almonds, walnuts, and poplars – planted for generations, differ from those normally encountered in Morocco. This art of living is sustained by a persevering work force little attracted by the modern way of life and therefore increasingly rare. But as younger people go off to the cities in the north, places like these are threatened with desertion.

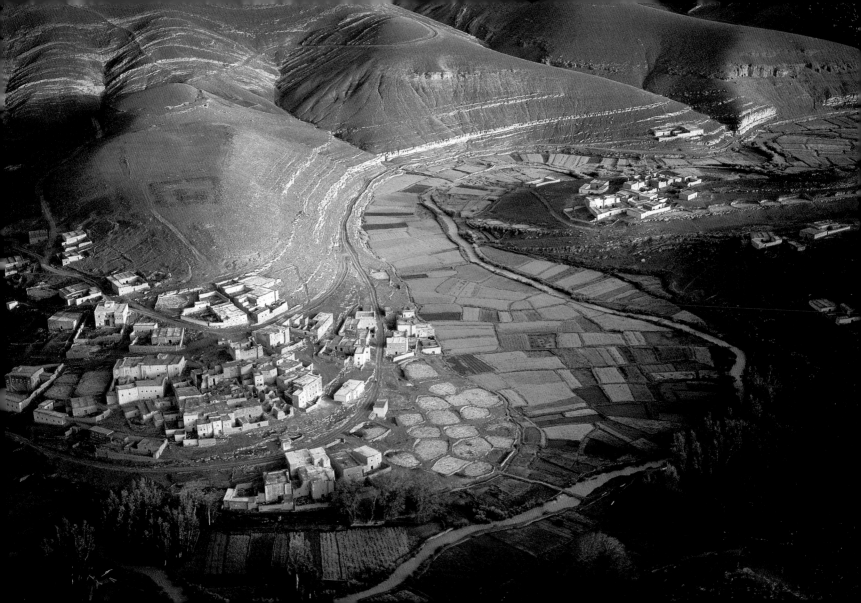

Jordan. Ma'an. Wadi Rum. Carousel irrigation.

In 1952 the American Frank Zybach invented the automatic carousel irrigation system, originally intended for pleasure gardens. Since then his invention has been adopted throughout the world, and through tapping ground water supplies, it has allowed crops to be grown in deserts. Here in the southern Negev Desert carousel irrigation is done on the dry banks of the Wadi Arab, which forms a natural border between Jordan and Israel. The two countries have competing claims over the scarce water resources of the area. From the Syrian border southwards, the waters of the Jordan River are used by both sides, while south of the Dead Sea, ground water is the bone of contention. Irrigation accounts for almost three-quarters of the world's water consumption, and ground water and rivers have become strategic resources as vital as hydrocarbon reserves. They have heightened tensions in the Middle East: Iraq is closely watching Turkish and Syrian plans to dam the upper Tigris and Euphrates Rivers, while Sudan has plans to use water from the Nile, which would affect its flow into Egypt. There is a risk that wars over water may break out in the future.

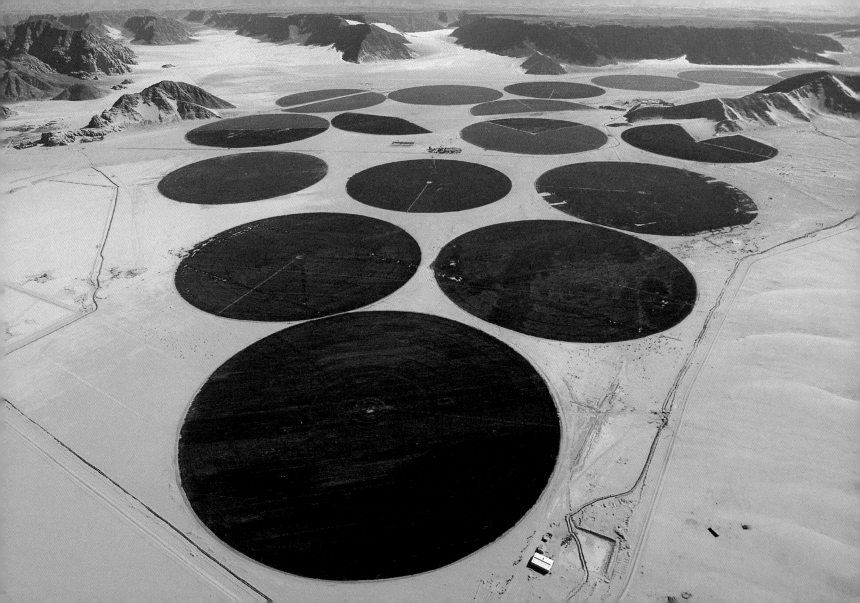

SEPTEMBER 23

Niger. Aïr Massif. Waste from the Arlit uranium mine.

In the heart of Niger lies the Aïr Massif, ancient land of the Kel Aïr, a tribe of Tuaregs who once dominated the entire western Sahara. In the early 1960s the discovery of uranium ore in this arid region drew people from all over West Africa to exploit what was soon to become a vital resource for Niger (it now accounts for 70 percent of its exports). Some of the *imageren* ("free men" in the Tuareg language) abandoned their nomadic life and settled down in the new towns of Arlit and Alokhan. However, the collapse in the demand for uranium and subsequent drop in price has left them trapped there. In response, they have tried to revive their centuries-old way of life. These people, for whom "a house is a living tomb" and who have no word for foreigners (they talk of the *imedochan* – "those who enter" – that is, those who are welcomed into the tent), have set up the Democratic Union for Social Progress in Agadez. But they are being defeated by politics. The former masters are now the rootless inhabitants of modern cities, an underclass dominated by the people of southern Niger who were once their slaves.

France, New Caledonia. Mangrove swamp of Coeur de Voh.

Mangroves are amphibious wooded formations that are commonly found in tropical and subtropical coastal regions. They develop where the ground is salty and muddy and exposed to the changing tide. They consist of various halophyte plants (plants able to grow in soil with high salt contents). They exist in four continents, covering a total area of 105,570 square miles (170,000 km^2), that is, almost 25% of the world's coastal areas. New Caledonia, the group of islands in the Pacific over 11,535 square miles (18,575 km^2), includes 124 square miles (200 km^2) of a rather shallow mangrove (25 to 30 feet), but it is very dense, especially along the west coast of the largest island, Grande-Terre. In certain places on land—where seawater is only present at high tide— vegetation is replaced by barren and salty stretches of land, known as *tannes*. These are abundant in the areas surrounding the city of Voh, where nature has drawn a clearing in the shape of a heart. Rich in biological diversity, the mangrove is a fragile habitat that undergoes the pressures of various human activities: overexploitation of natural resources, agricultural expansion, coastal urbanization, pollution, etc.

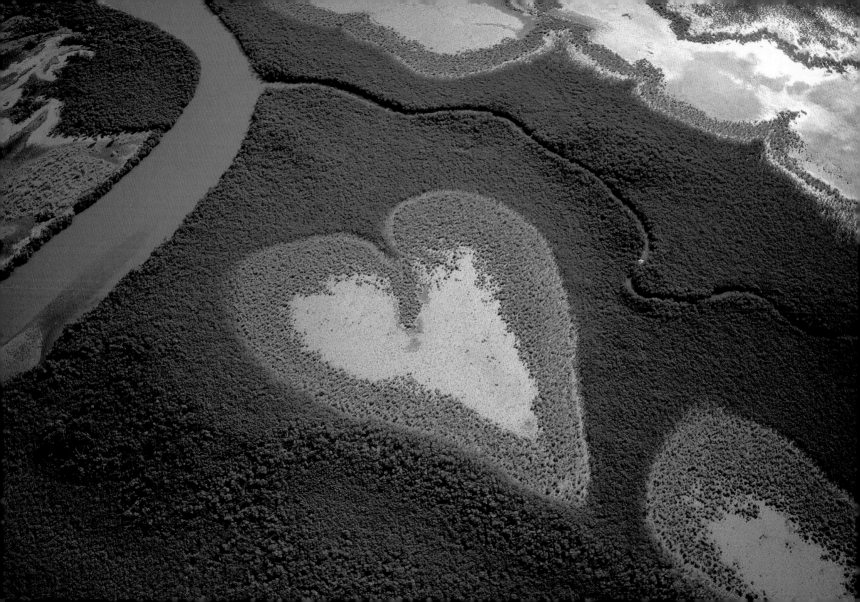

France. Charente. Farmland near Cognac.

In the nineteenth century the vineyards of the great wine-producing region of Charente were devastated, as were almost half of those in the rest of France, by phylloxera, a parasitic insect. Many of the area's vines were replaced with grains, which still dominate the region today. Nevertheless, vineyards have gradually been replanted near the town of Cognac, where production of the eponymous brandy has never ceased growing. In this chalky soil, the *ugni blanc* grape variety locally known as *saint-émilion*, yields a wine which, distilled and aged in oak barrels, produces cognac, a name that can only be applied to brandy from this area. With more than 10,000 growers working 900 square kilometers (350 square miles), the Cognac region produces more than 190 million bottles of this prestigious liqueur every year. More than 90 percent is exported, mostly to the U.S. and Japan, but also to other European countries.

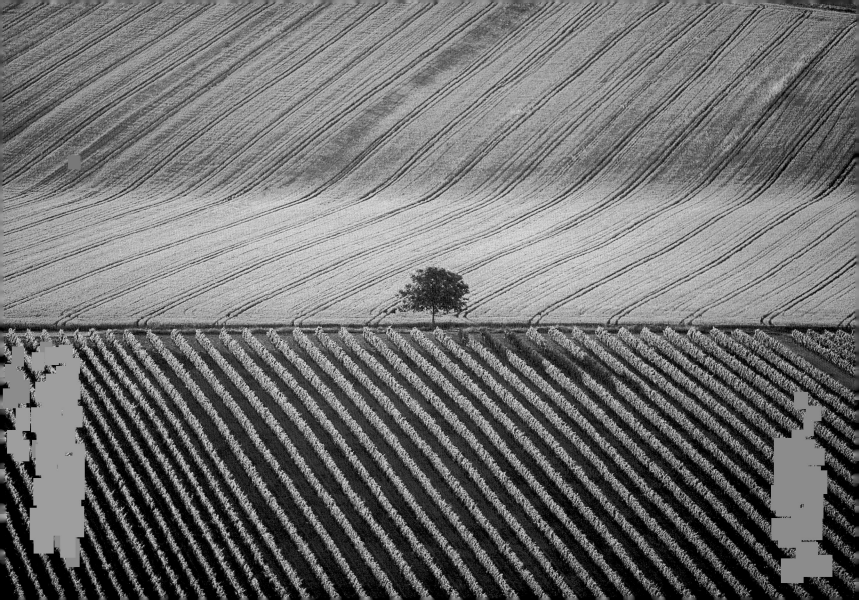

Denmark. Seeland. Housing estates near Brøndby, outskirts of Copenhagen.

These developments on the southwestern outskirts of the Danish capital aim to combine sensitive planning, comfort, and security. Each household in the perfectly circular units has a plot of 400 square meters (4300 square feet), with a garden that must be crossed in order to reach the house. This type of development, which meets people's demands for housing, and is both functional and pleasant, is increasingly common on the edges of large cities and centers of employment. In most countries, industrial development and population growth have caused an increase in the proportion of the world's town-dwellers by more than 13 percent over the last 50 years. Almost half the planet's population (45 percent) lives in cities; in developed countries the proportion is 75 percent.

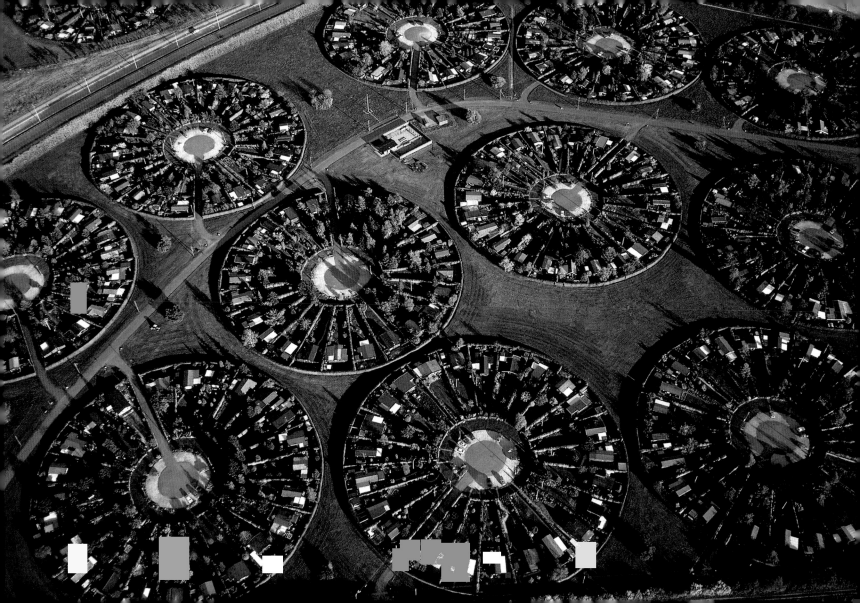

Madagascar. Toamasina region. Coral reef near Nosy Boraha.

Nosy Boraha, also known as Sainte-Marie, in the north of Tamatave Province ("Toamasina" in Malagasy) is a long strip of land that runs parallel to the Madagascan coast, about 40 kilometers (25 miles) offshore. With its beaches, corals, and lush vegetation, it is one of Madagascar's most alluring spots. The island's straight, sandy east coast, which stretches for more than 1,000 kilometers (600 miles), is fringed here and there by reefs that make docking easier, most notably at the island's biggest port, Tamatave. The Portuguese, the first Europeans to land there, probably gave it its name, Toamasina being a reference to Saint Thomas. Madagascan legend, however, gives a more prosaic explanation: Radama I, coming down to the sea from the highlands for the first time, tasted the water there and said, "Toa masina!" ("It's salty!") The resistance of the Madagascan people (who originate from Mozambique and southern Asia) to Europeans goes beyond etymology. In 1947 the north of the island saw a violent revolt against the colonizers, which was quelled only after a bloodbath.

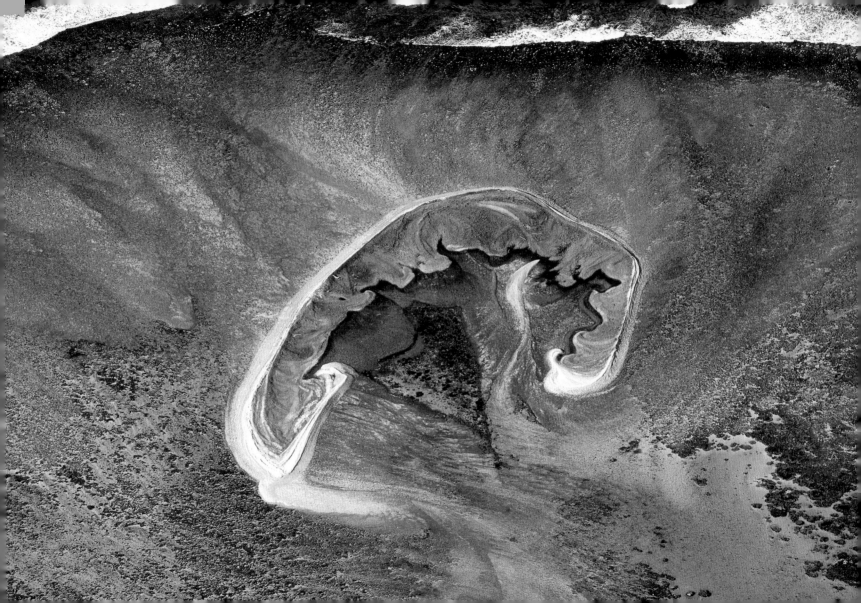

Ecuador. Galapagos Archipelago. Chinese Hat Islands. Volcano on the west coast of San Salvador Island.

The crater of a volcano rising above its lava flows is reminiscent of a lunar landscape. Such a harsh, sterile land surrounded by a vast expanse of water brings us face to face with the mystery of life's origins. What elements here gave birth to it? What combination of molecules? What pressure and heat? How could a once fiery throat, towering above its ancient outpourings now eaten away by the waves, have nurtured anything other than the shapes formed when its molten rocks cooled? In March 1998, a law came into force that strictly limits tourism on the Galapagos Islands; some sites can only be visited by groups of no more than 12 people accompanied by a licensed guide. Nevertheless, visitor numbers continue to rise; that same year, 62,000 people visited the islands.

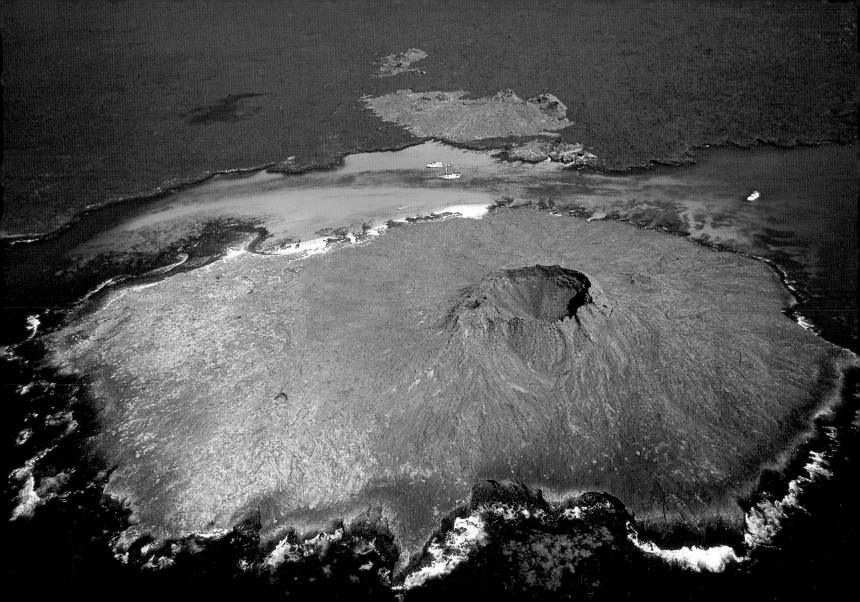

Peru. Ica. The Nazca trapezoids.

The coastal desert of Peru looks like an endless field of stones, similar to the *reg* of the Sahara. But a little digging reveals a wide network of underground aqueducts, the *puquios*, built by the Nazcas, who lived here 2,300 years ago. They drew vast shapes on the ground, with lines 10 to 30 centimeters (4 to 12 inches) deep and sometimes several meters (several yards) wide. Some represent animals – a hummingbird 60 meters (200 feet) long and a 46-meter (150-foot) spider. Others, such as this trapezoid, are purely geometric. Since the Nazcas had neither stone chisels as did the Incas, nor modeling clay as the Chan Chan Indians, they used the sole medium at their disposal: the countless pebbles of the desert. Are the Nazca trapezoids, as the astronomer Maria Reiche believes, a giant map of the heavens, whose shapes represent constellations? Or are they representations of Nazcan deities? As mythology often associates gods with stars and planets, the two theories are not incompatible.

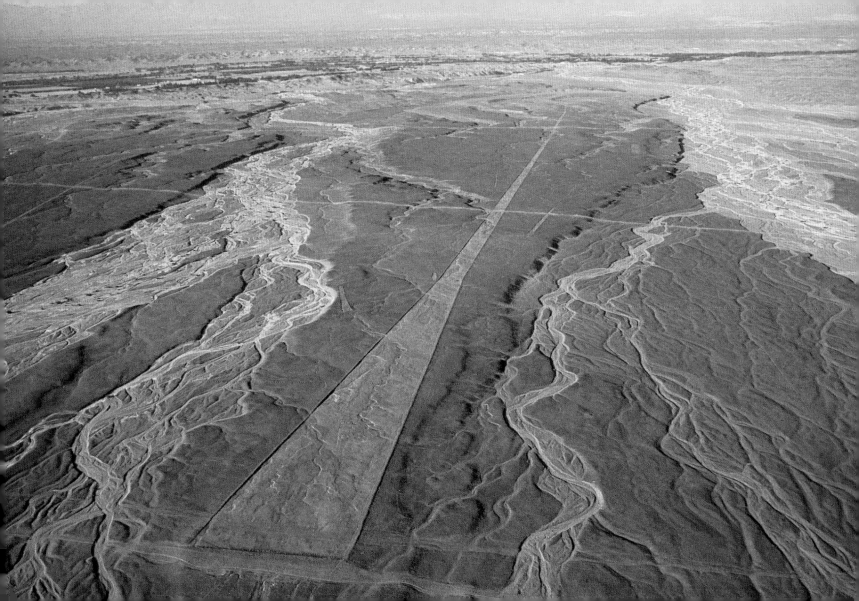

Kenya. Elephants in the Meru National Park.

The Meru National Park, east of Mount Kenya, is one of the country's largest, covering 870 square kilometers (340 square miles). Thanks to the 19 watercourses that cross it, its vegetation is especially lush. It is also notorious for having suffered heavy poaching, especially that supplying the ivory trade. In the 1960s, the government enacted laws to protect and reintroduce threatened species, such as leopard. However, in spite of these laws, elephant numbers fell sharply and the white rhinoceros disappeared altogether in the two decades that followed. Nevertheless, the park remains an excellent environment for elephants. While the bulls find perfect conditions in the damp, marshy areas (a bull eats 150 to 200 kilograms [330 to 440 pounds] of foliage and drinks 100 to 300 liters [25 to 80 gallons] of water daily), the cows and calves gather in the dry savannah in the south of the park. In a country that saw the world's highest population growth between 1970 and 1980 (four percent per year, and an average of eight children for every woman), and whose prime land has been appropriated by settlers or private companies, wildlife protection has faced heavy odds.

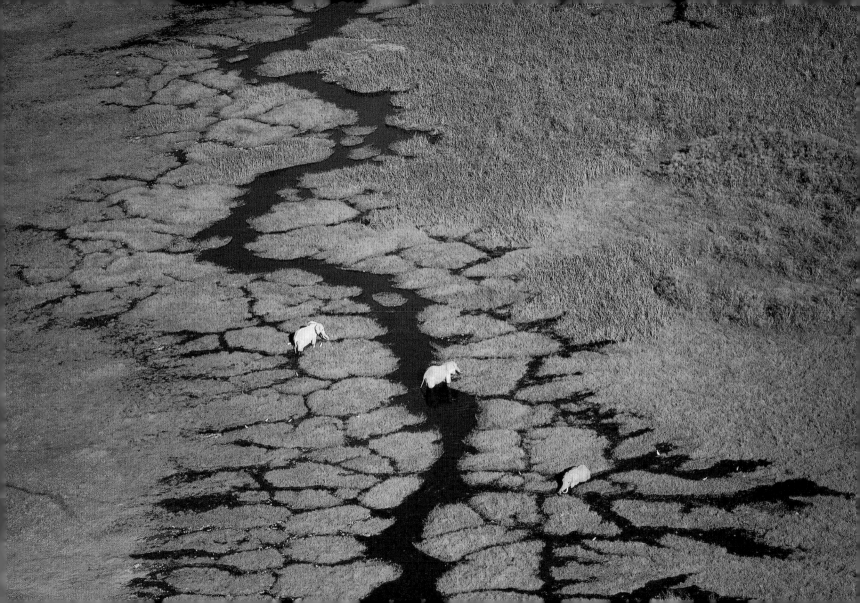

Albania. Refugee camp northwest of Kukës.

At the end of March 1999 social tensions in Kosovo, the province of Serbia whose population is 90 percent ethnic Albanian, reached breaking point as a result of discrimination by the Belgrade government. The Western powers took military action against Serbia, inflicting heavy aerial bombardment on the country, while the Serbian army and police provoked and organized an exodus of hundreds of thousands of Kosovars. Almost one million refugees were taken in by neighboring countries – chiefly Albania, which took 440,000, and Macedonia, which took 250,000 – and accommodated in appalling conditions in camps such as the one pictured here. In addition to Kosovar refugees, there were almost 50 million displaced people in the world at the beginning of the twenty-first century.

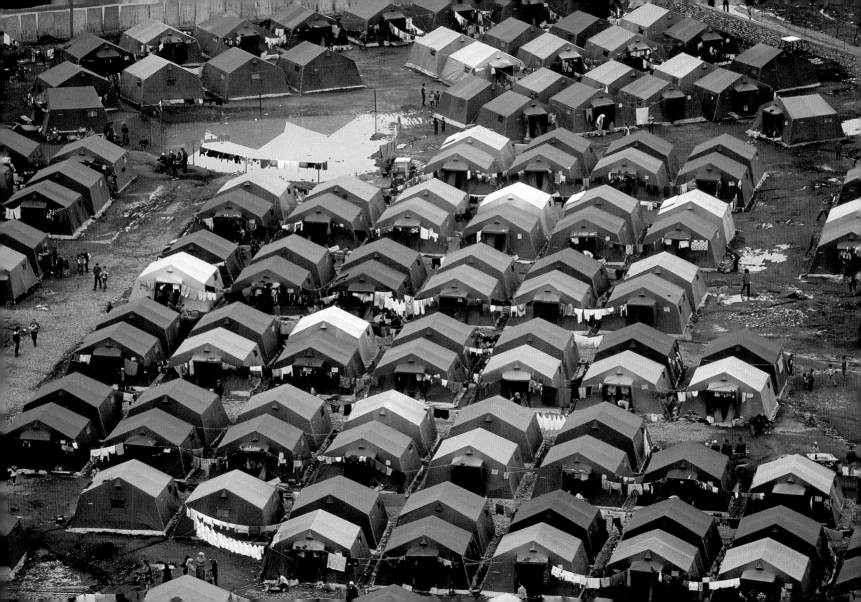

Japan. Honshu. Expressway interchange near the port of Yokohama.

Yokohama is Japan's second largest city after Tokyo, and its main international port, handling one-fifth of all imports and exports. It is also the largest port in Asia, and the inevitable entry point for visitors to the Land of the Rising Sun. As in most industrialized countries, the expressways that ring the city are characteristic of an economic development largely based on road transport. Following this dominant pattern, the total mileage of expressways has increased all over the world. The number of vehicles has reached almost 700 million, most of them concentrated in developed countries: 30 percent are in the United States alone, and only 2.5 percent in all of Africa. Car ownership is also unequally distributed, with 760 cars per thousand people in the United States and just 6 per thousand in India. This discrepancy is a source of friction between developed and developing countries. Given the enormous amount of pollution—particularly of greenhouse gases—generated by car transport, it seems unlikely that the world can survive an increase in motor vehicles to the extent that developing countries have as many cars as rich countries. With some foresight, the future may hold a boom in alternative, "green" forms of transportation, for both mobility and a healthy environment are important conditions for sustainable development.

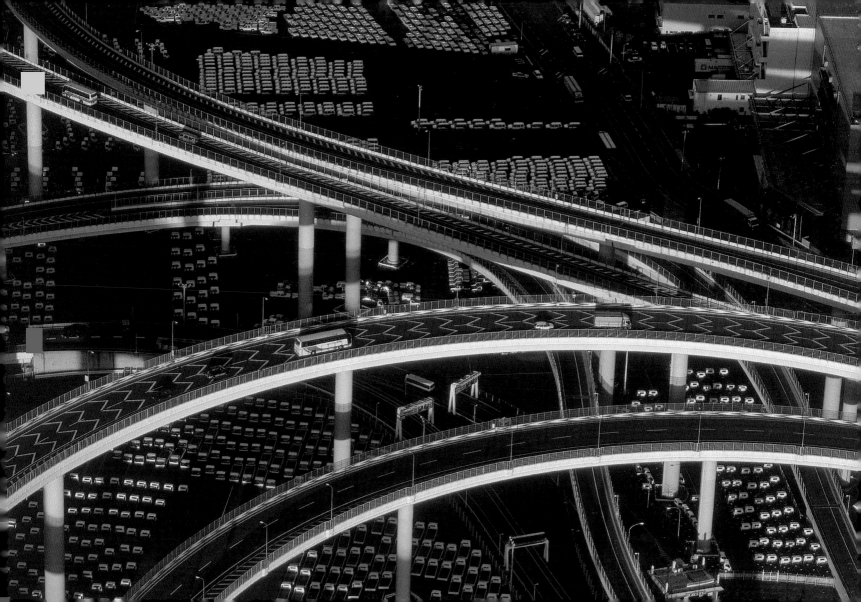

Antarctica. Icebergs off Terre Adélie.

Drifting with the currents, these icebergs have recently broken off the Antarctic ice sheet, as indicated by their flat, unmelted shape and the layers of ice visible on their angular sides. Only a small part of each iceberg breaks the surface; more than 80 percent remains underwater. Like the rest of the 2,000 cubic kilometers (500 cubic miles) of ice that break off the Antarctic every year, these icebergs will be gradually eroded by the wind and waves before finally melting away. Antarctica is a continent of extremes: it covers 13.7 million square kilometers (5.3 million square miles), temperatures can drop to −70°C (−94°F), and winds reach 300 kilometers per hour (185 miles per hour). Ninety percent of the world's ice and 80 percent of its freshwater reserves are stockpiled here. From the nineteenth century Antarctica was subject to many territorial claims, but under the 1959 Washington Treaty only peaceful scientific work is allowed there.

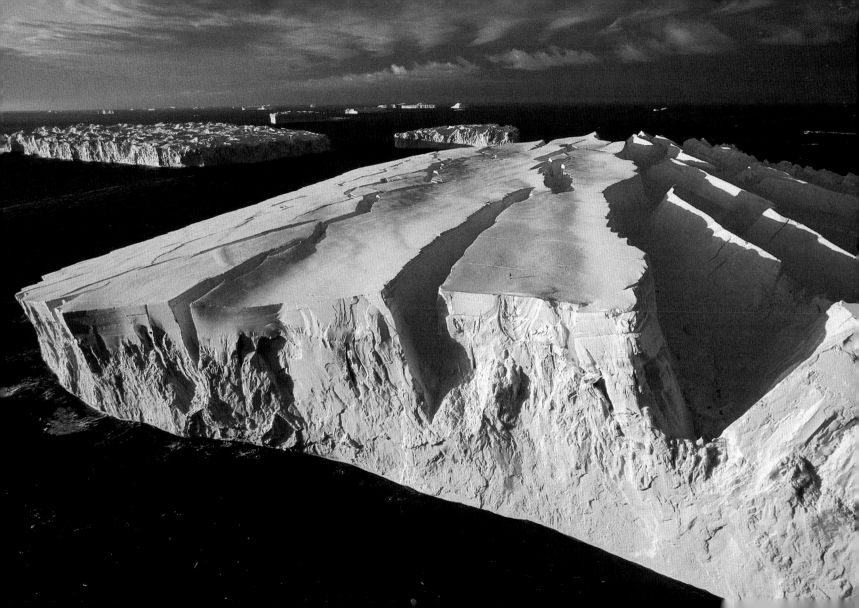

Venezuela. Orinoco Delta. Houses on stilts at Fisherman's Point.

The European adventurers who landed at the Maracaibo Lagoon at the end of the fifteenth century christened this land Venezuela – literally "little Venice." Just a few years earlier the crews of Christopher Columbus's caravels, who also dropped anchor not far from the Orinoco Delta, had been struck by the landscape that stretched out before them. Their description of its countless estuaries, deep forests, canals, and mangroves could, in part, be a description of Venice. And in the southern Orinoco Delta these *palafitos*, houses on stilts in which 15,000 Warao Indians live, also recall Venice and the modest wooden dwellings of its lagoon fishermen. The world's great rivers, deltas, and seashores are now home to their traditional inhabitants as well as a growing proportion of the planet's population, all of whom threaten these fragile ecosystems.

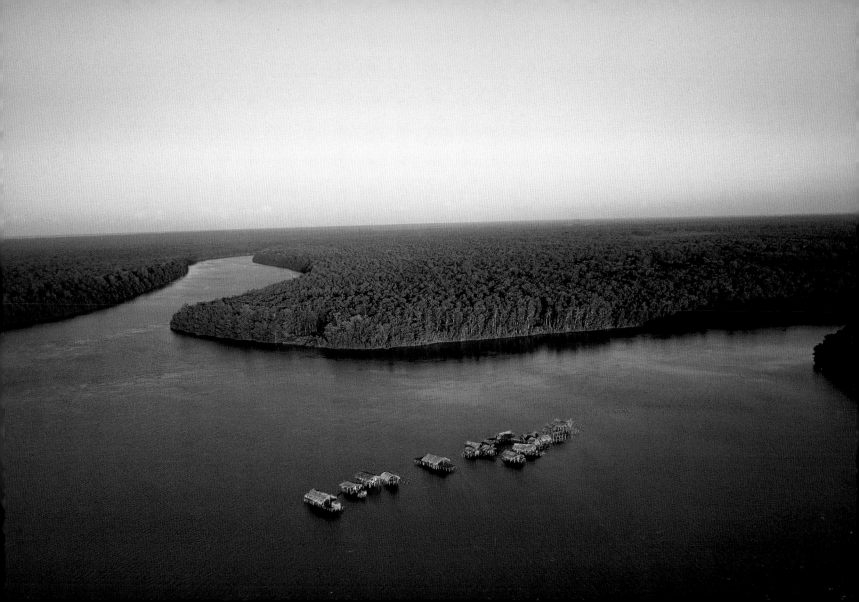

Madagascar. Majunga region. The Behamara Tsingy.

With a surface area of 587,000 square kilometers (225,000 square miles), Madagascar is the world's fourth largest island. In the arid west of the island is the strange stone forest of the Behamara Tsingy. This rock formation, known as *karst*, formed as acidic rainwater gradually dissolved the limestone plateau, leaving sharp peaks 20 to 30 meters (65 to 100 feet) tall. Humans have not found this remote environment welcoming; in fact, *tsingy* is Malagasy for "walking on tiptoe." The area, which was made a nature reserve in 1927 and a UNESCO World Heritage Site in 1990, has its own peculiar fauna and flora, reflecting the biodiversity of the island as a whole. For Madagascar, which was detached from the African continent more than 100 million years ago, has seen its species evolve in complete isolation, offering an outstanding example of endemism – the existence of species that are confined to a given area. More than 80 percent of the 10,000 plant species and almost 1,200 animal species identified on the island are found nowhere else in the world. Almost 200 of them are in danger of extinction.

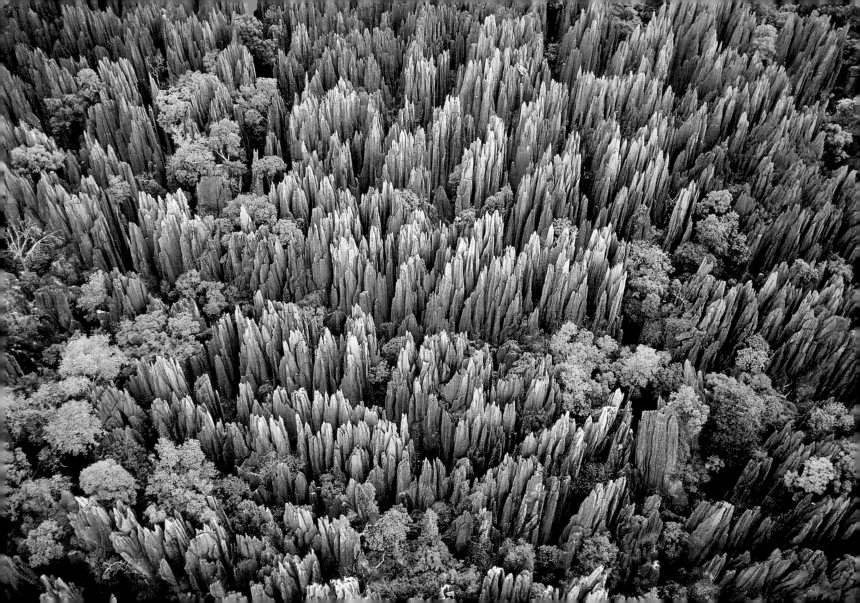

Argentina. Buenos Aires Province. Near Mar del Plata.

Meadows separated by hedges, isolated trees in the fields, a whitewashed house with a tiled roof ... Is this northern Portugal? The southwest of France? The Basque country? Or even the Italian Piedmont? None of the above! It is the middle of the vast, damp Pampas, where the famous Argentine cattle are raised. The resemblance is not accidental, however, for Argentina was colonized by Italians, Spaniards, and in smaller numbers, Portuguese and French. After disembarking at La Boca in the port of Buenos Aires, they soon rediscovered their agricultural vocation, penetrating deep into the Pampas, becoming gauchos, those legendary free peasants. They also drove out and exterminated the native people. Some of the Guarani people remain near the Paraguayan border, but the Fuegians and Arapeche have disappeared. The word "amo" cut into the grass expresses the Argentines' ambivalence, for it means both "I love" and "master." Their love of the land created a tradition, but by imposing themselves as overlords they wiped out those who preceded them.

Ivory Coast. Fisherman on Lake Kossou, near Bouaflé.

Kossou, which covers 1,500 square kilometers (600 square miles) in the center of the Ivory Coast, is an artificial reservoir built to control the flow of the Bandama River and allow the construction of a hydroelectric dam farther downstream. When the reservoir was filled with water between 1969 and 1971, 200 villages were submerged and 75,000 people displaced. At the same time, a vast rehabilitation and development program went into action on the shores of the lake. 63 villages were built to house the evacuees, new farming methods were introduced, fish farms were built, and 3,000 local peasants trained in fishing techniques. In the year 2000 there were more than 36,000 dams in the world, more than half of them in China. The largest artificial lake on Earth is in the Ivory Coast's neighbor Ghana. Lake Volta, formed by the Akosombo Dam, covers 8,482 square kilometers (3,275 square miles).

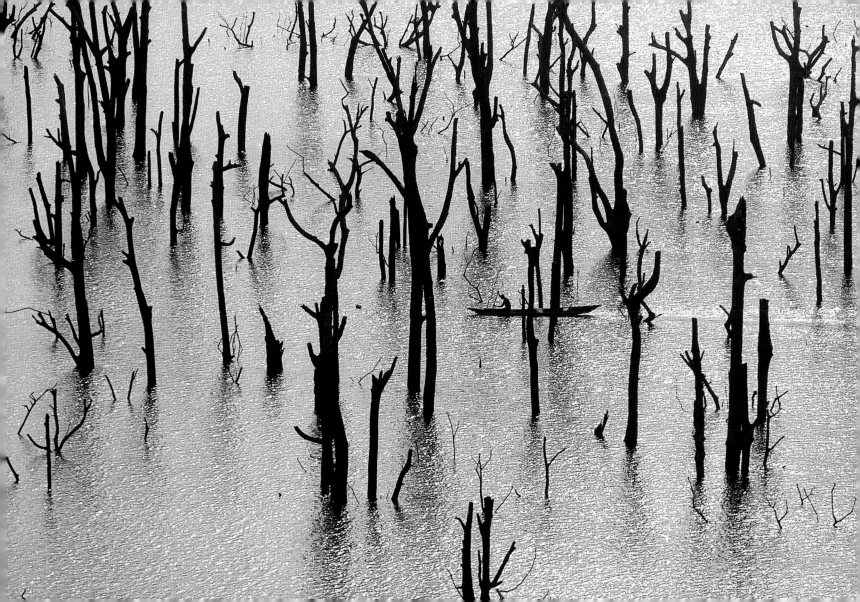

Madagascar. Antananarivo region. Cultivation on the slopes of a volcano.

West of Antananarivo (Tananarive) and the Ankaratra Mountains stretch the high Madagascan plateaus, at an altitude of 1,000 to 1,600 meters (3,300 to 5,250 feet). From the eighteenth century onward the land was brought under intensive cultivation, and forests were cut back to make room for grazing cattle and growing rice in terraces on the valley hillsides. In order to leave the best land free for farming, the villages were built between the paddy fields and the pastures. The development of irrigated paddies at the end of the eighteenth century allowed King Andrianampoinimerina to establish and extend his power, a policy continued by his son Radama I, who took control of two-thirds of the island. The conquered were enslaved and set to work clearing the high ground for cultivation, and the profits from rice exports in turn allowed the government to buy more arms. The yield from this forced form of agriculture is now so poor that Madagascar must import food, and two-thirds of the population has barely enough to survive. At the current rate of deforestation – 1,500 square kilometers (600 square miles) are burned annually by landless peasants to grow rice and cassava – the island could become completely devoid of forest cover by the year 2020.

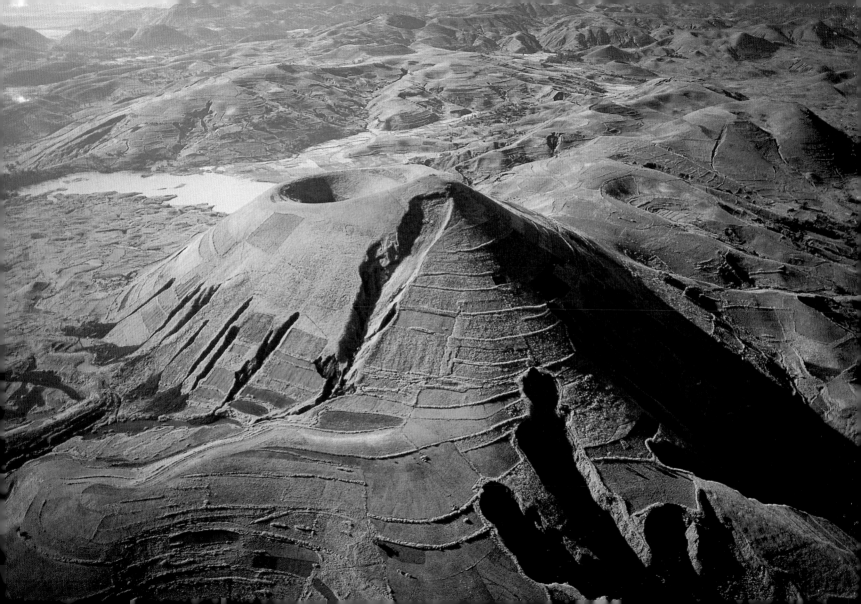

Canada. Nunavut Territory. Frozen landscape.

Nunavut, in Canada's far north, covers 1.9 million square kilometers (735,000 square miles) of islands, water, and ice. In winter, when temperatures can plunge as low as −37°C (−35°F), the permanent ice sheet of the central Arctic joins the coastal ice sheet in the frozen estuaries and bays to form an unbroken, frozen landscape that can be crossed by dogsled or snowmobile. In summer, sea currents and wind melt and break up the sheet, producing the floating platforms known as drift ice and freeing up migration routes for whales and other marine mammals. Nunavut, whose name means "our land" in Inuktitut, the Inuit language, is home to 20,000 Inuit, who make up 85 percent of its population. Once the eastern two-thirds of the Northwest Territories, Nunavut was granted its own territorial status in 1999. The Inuit people are spread across the region north of the Arctic Circle: 55,000 in North America (Alaska and Canada), more than 42,000 in Greenland, and 20,000 in Siberia.

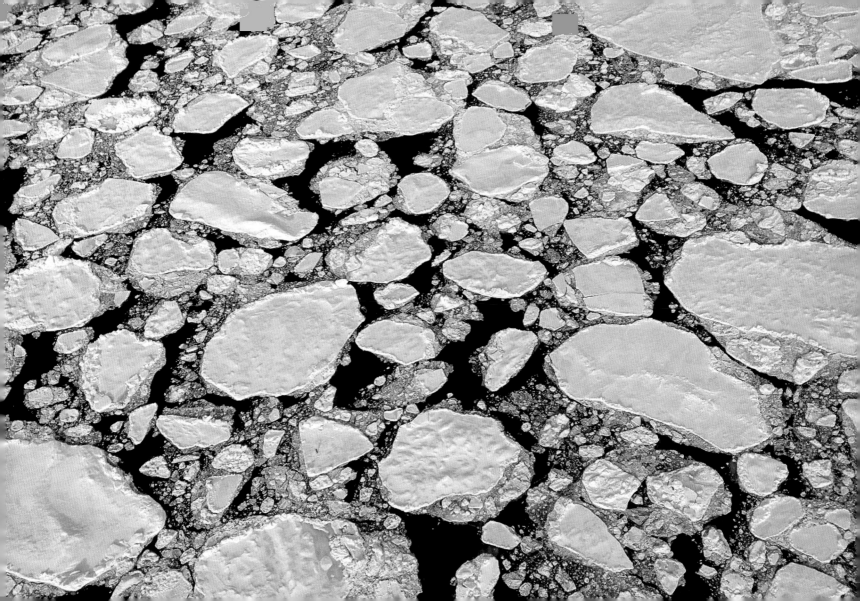

Djibouti. Goubbet Bay. Guinni Kôma volcano.

Surrounded by steep mountains, Goubbet Bay is 20 kilometers (12 miles) long and 20 kilometers (12 miles) wide, and forms the end of the Gulf of Tadjoura. It is part of the region of the Republic of Djibouti bordered by Lake Assal, a site of great geological activity: indeed, this region marks the junction of three tectonic plates (Indian, African, and Eurasian) that are slowly moving apart, fracturing the crust. One of the many effects of this titanic rupturing was the appearance in 1978 of a new volcano, Ardoukoba. This happened when Africa and the Arabian Peninsula moved apart 1.2 meters (4 feet), and a 12-kilometer (7½-mile) fault opened up between Lake Assal and Goubbet Bay. The violence of the region's seismic and volcanic activity is no doubt responsible for the legend that Goubbet Bay, known in Djibouti as the "chasm of devils," is the home of evil spirits who will drag down to their death anyone who dares sail upon its waters. The name of the islet Guinni Kôma (Devil's Island), which is the eroded remains of an ancient volcano, also harks back to legend and ancestral fears.

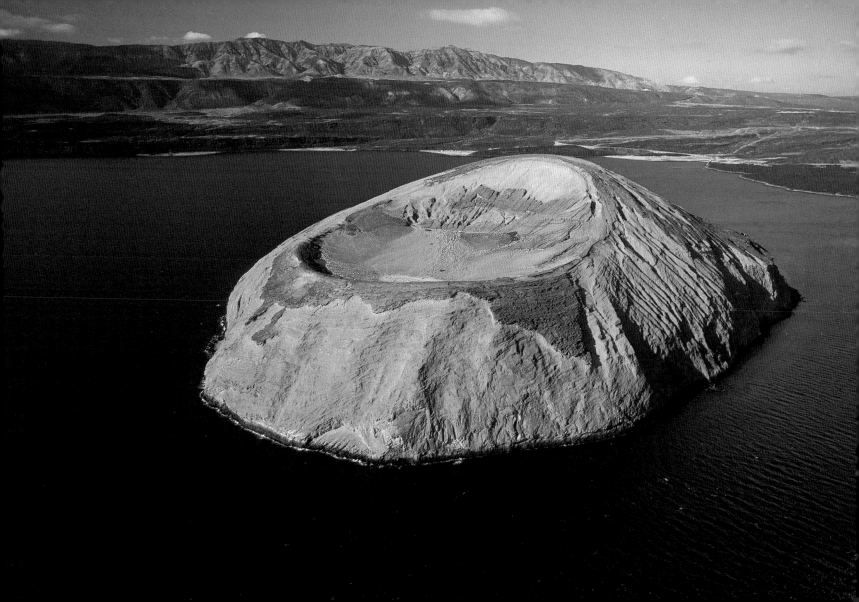

Ecuador. Sierra region. Fields near Quito.

Between the Western and Royal Cordilleras, the plateaus of the Quito region enjoy the sierra's mild, damp climate, which supports the cultivation of potatoes and grains such as maize, wheat, and barley. Agriculture, which primarily consists of food crops for the home market, dominates the economy, employing almost one million people and contributing 30 percent of the country's gross domestic product. It also shapes the landscape; one-third of the country is covered by arable land and pasture. The expansion of farmland, which in some areas more than doubled in the 1990s alone, has been at the expense of forest, which presently covers almost half the country. Three-fifths of the world's tropical rain forests are in Latin America. Everywhere they are threatened by agriculture and unsustainable logging, and are disappearing worldwide at the rate of one percent per year.

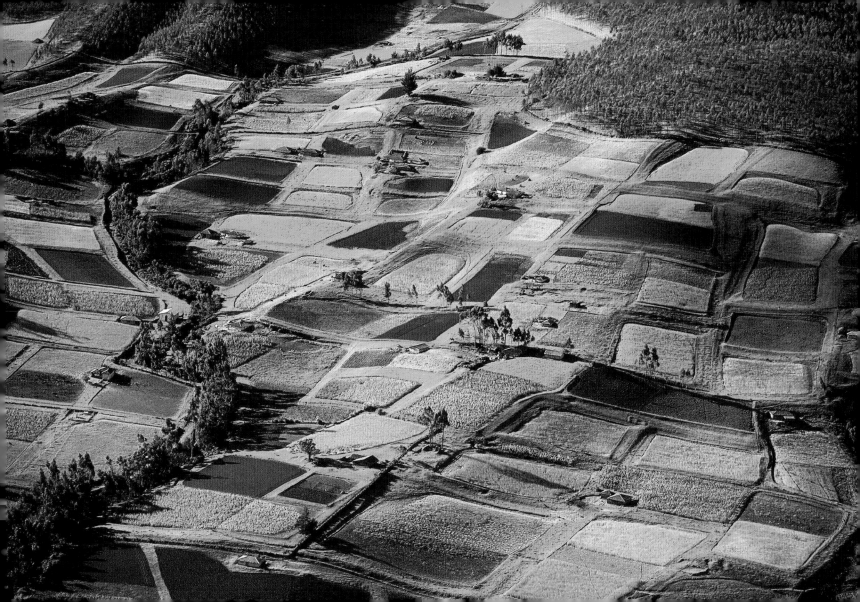

United States. Idaho. Power lines in a field near Idaho Falls.

The concentration of the United States population on the Atlantic and Pacific coasts has left the vast lands in between relatively empty. The Great Plains and the Rocky Mountains are tapped to provide energy and resources for the people living on the coasts. Thus it is in Idaho, north of the Rocky Mountains, where the Snake River has been dammed to generate electricity and store water to irrigate rich farmland. Both dam building and farming are carried out on a grand, highly mechanized scale by large companies or cooperatives which, paradoxically, recall the unlamented collective farms of the Soviet Union. High productivity and low labor intensiveness allow America to remain competitive and to be the largest grain exporter, dominating the world market.

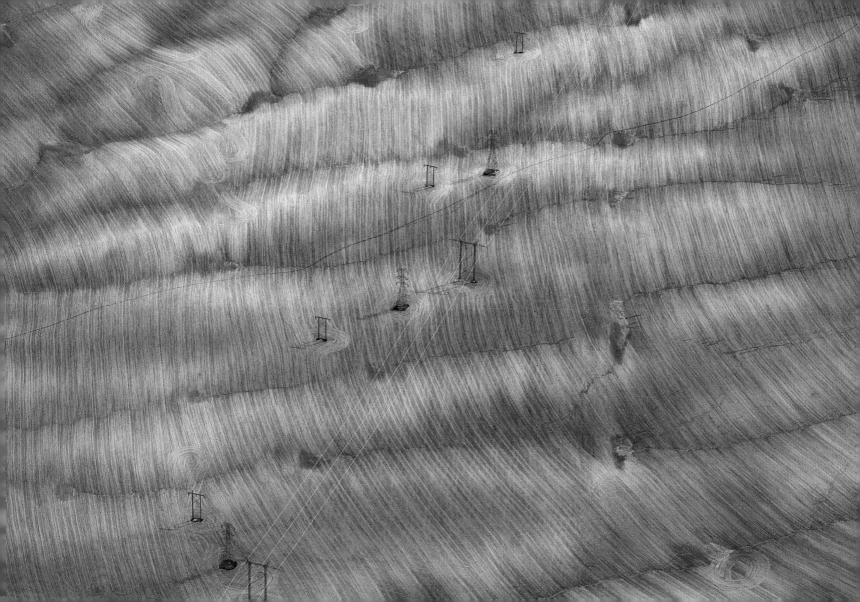

Spain. Canary Islands. Lanzarote. Vines in the Geria region.

Of the seven islands of the Canary Archipelago, Lanzarote is the largest and the closest to Africa. Its desert climate, and the complete absence of springs or rivers anywhere over its 973 square kilometers (376 square miles) are a daunting obstacle to any form of agriculture. However, thanks to its volcanic origins, the island has a rich, black soil made up of volcanic ash and lapilli (lava fragments) on a clay subsoil that is not very permeable. These conditions have led to a unique way of growing vines: each is planted at the center of a hollow dug in the lapilli, so that it can tap the moisture collected there, and each is sheltered from the northwesterly and Saharan winds by a low semicircular stone wall. The Geria Vineyard produces a sweet red malmsey type wine. Spain contributes about 13 percent of the 275 million hectoliters (7.26 billion gallons) of wine produced worldwide every year, making it the world's third largest producer and exporter, after France and Italy.

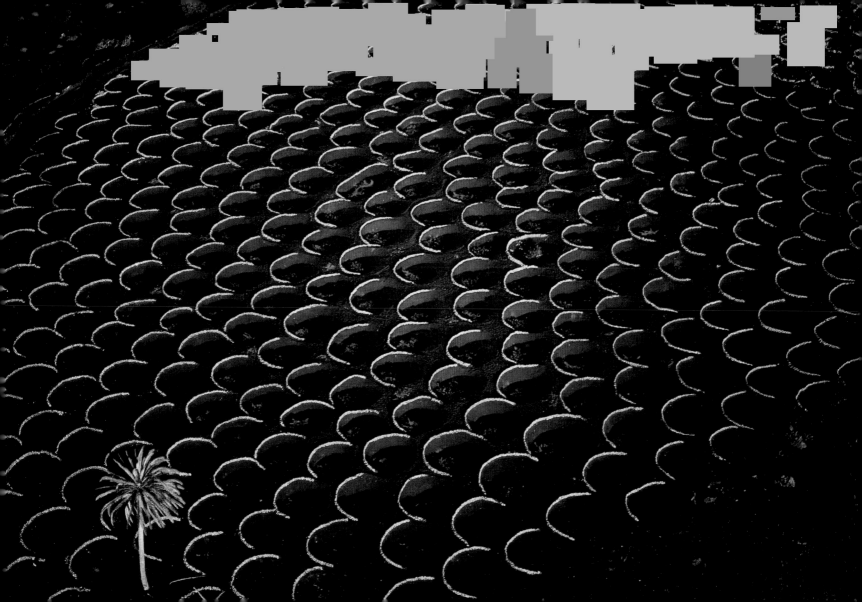

Australia. Queensland. Sand dune on the shore of Whitsunday Island.

With 109 square kilometers (42 square miles) of land, Whitsunday Island, off the east coast of Australia, is the largest of the 74 islands that make up the Whitsunday Archipelago. This beach at White Haven with its exceptionally white sand composed of fragments of coral eroded from the Great Barrier Reef a few kilometers (a few miles) to the east, is typical of the islands' shores. Dunes of white coral sand, blown by the wind, have formed along the irregular coastline, and the waters of the Pacific wash between them at high tide. Discovered in 1770 by the English explorer James Cook, most of the islands have remained uninhabited and undeveloped. Since 1930, however, a few have been turned into seaside resorts.

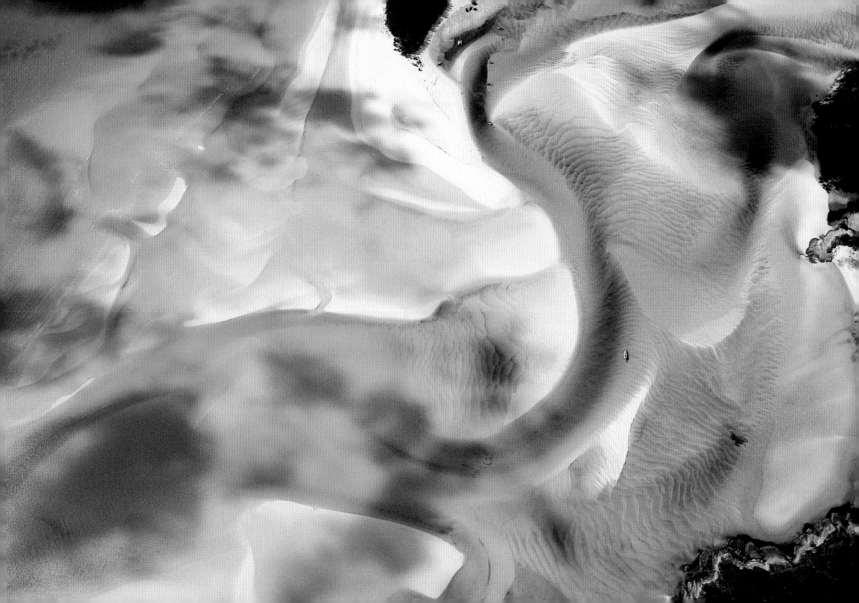

Argentina. Neuquén Province. Fording the River Chimehuin.

This herd of Hereford cattle framed by *gauchos* is returning to its home range (*campo*) after its seasonal trek to the high pastures of the Andes Cordillera. Partly covered by thorn bush steppe, Neuquén Province has like the rest of Patagonia favored raising sheep over cattle, which are in the minority in the region. Farther north, in the vast grassy plains of the Pampas, live the bulk of the country's cattle – almost 50 million head, mostly of French or British breeds. Argentina is the world's fifth largest beef producer and one of its biggest consumers; each Argentinean eats an average of 70 kilograms (155 pounds) every year.

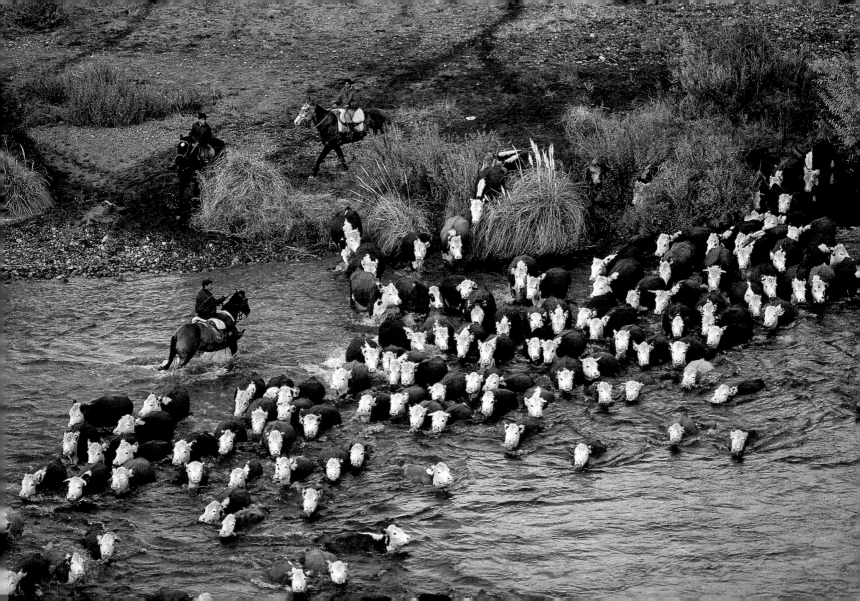

France. Yvelines Department. Detail of the Gallo-Roman ruins at Pontchartrain.

One of the largest Gallo-Roman sites in ancient Gaul, Pontchartrain, which means "bridge of the Carnutes," marks the entry point of the Roman road that crossed its lands. The ruins were discovered when the Route Nationale 12 bypass was being built around the town of Pontchartrain, and were subsequently protected to allow excavation. The idea that such sites are part of French heritage is a recent one. Roman and even Gothic ruins were often used as sources of building stone, and minor finds were thrown away by treasure hunters. From the 1960s onward, a new interest in the past, combined with economic growth that was transforming the landscape, encouraged archaeological investigations and brought a sense of their importance to the nation. According to historian Pierre Chaunu, more than a billion people have lived and left their mark on French soil since the time of Cro-Magnon man.

Kenya. South of Lake Logipi. Turkana. Suguta Valley.

The southern approaches to Lake Turkana in northwestern Kenya, such as the Suguta Valley or the Gregorian Rift, are reminiscent of lunar landscapes, emblazoned with volcanoes which, geologists warn, are still active. Of varying age and size, they are scattered the length of the Gregorian Rift. Some, such as Mount Longonot, display the classic shape of a young volcano, and their irregular flows of black lava have not yet had time to produce fertile soil. The youngest of all, Teleki, is a mere century old and nothing more than a hole in the ground. Its lava was still molten when Count Teleki von Szek came to Lake Turkana in 1887. All that remains of others, like Shomboli and this volcano rising out of the dried-up Lake Logipi, are resistant fragments of the interior, the edifice having long since eroded away.

United States. Massachusetts. Harvesting cranberries on Cape Cod.

From Providence, Rhode Island, to Provincetown on Cape Cod, stretch 500 kilometers (300 miles) of beaches and salt marshes. Portuguese whalers were the first to settle in this part of New England, followed by (among others) creative artists at the beginning of the twentieth century, including the great playwright Eugene O'Neill, Charlie Chaplin's father-in-law. Behind the beaches and dunes, the poor, acidic, wind-battered soil is a perfect environment for the various types of bilberry, of which the cranberry is the most highly prized in America. The spindly shrubs, which rarely exceed one meter (three feet) in height, withstand the winter temperatures that can sink as low as − 30°C (− 22°F). The shrubs can produce as much as 8 tonnes per hectare (3½ tons per acre) and occupy almost 15,000 hectares (40,000 acres) of the American Northeast. The small red fruits are mechanically collected by shaking the branches and then heaped up in places where they finish ripening. They are used for juices and for garnishes to go with meat dishes. As so often is the case in the U.S., large-scale mechanization is unhesitatingly applied to retain modest traditions.

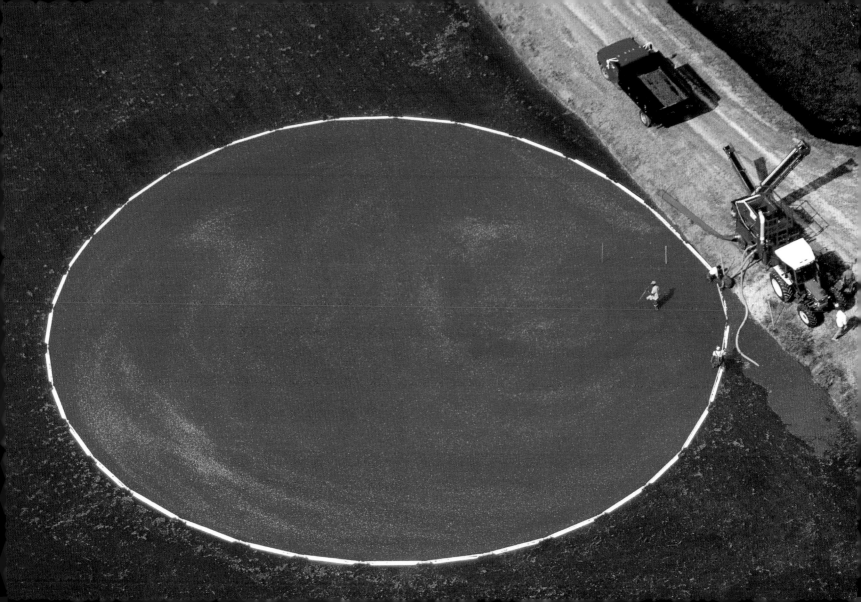

Japan. Honshu. Hiroshima. The Genbaku Dome – site of the atomic bomb explosion of 1945.

The shell of what was once the Office of Industrial Promotion is the sole building in the center of Hiroshima to have withstood – in part – the detonation of the first atomic bomb, dropped by the U.S. Air Force on August 6, 1945. It has been preserved as evidence of the scale of the act that killed 200,000 people and razed 40 percent of the city's buildings. With the Cathedral of Peace, the Peace Memorial Park, and the Museum of the Memory of Peace, the area around the Genbaku Dome is dedicated to the memory of the tragedy. The Museum of the Memory of Peace contains relics of the decimation, including tiles vitrified by the heat and watches stopped at 8:16 A.M., the time the bomb exploded. On August 9, three days after the Hiroshima attack, the U.S. dropped a second atomic bomb, which destroyed the city of Nagasaki and led to Japan's surrender. Nuclear weapons transformed international relations. Their use in 1945 was a barbaric act, but the fear of nuclear holocaust may have kept in check the Cold War confrontation between the U.S. and the Soviet Union, which lasted from 1945 until the Soviet Union was dissolved in 1991.

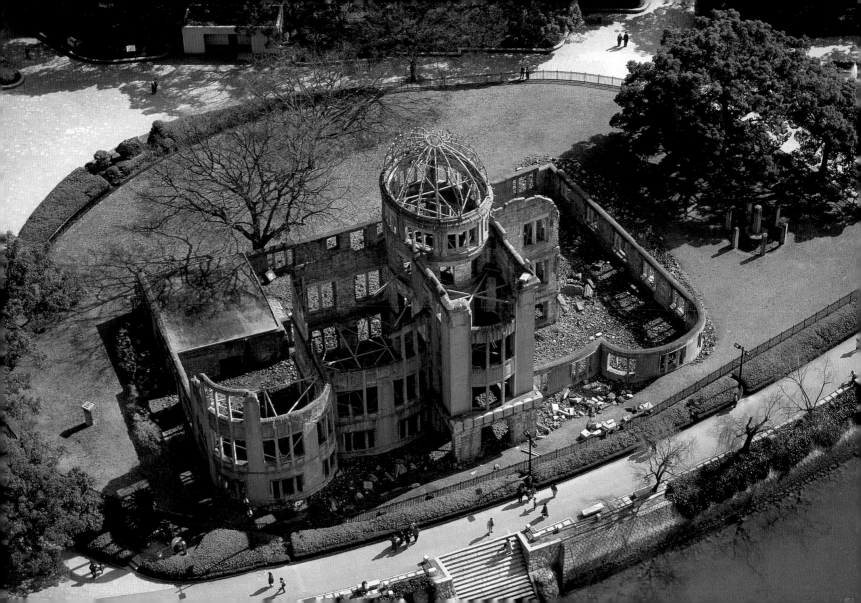

Mali. Village near Nara.

In many parts of Africa, villages consist of private enclosures, with a number of different huts on land that is traditionally collectively owned. The largest huts accommodate couples, or a mother and her young children; others are kitchens used by individual women; still others are stables, in some cases shared by unmarried youths and animals. In the courtyards are often trellises where meat is hung up to dry and people stand around and gossip. There are also granaries, which vary considerably from place to place. Built of *banco*, a type of brick made of unfired clay mixed with straw and sand, and roofed with reeds, thatch, or dried palm leaves, the huts do not withstand the elements for long. Within less than a decade they decay and are abandoned. The inhabitants then build a new enclosure after first consulting local elders, especially the "land chiefs." Although Africa is the world's poorest continent, this simple system assures relatively equal access to living space and farmland, and thus to the means of survival.

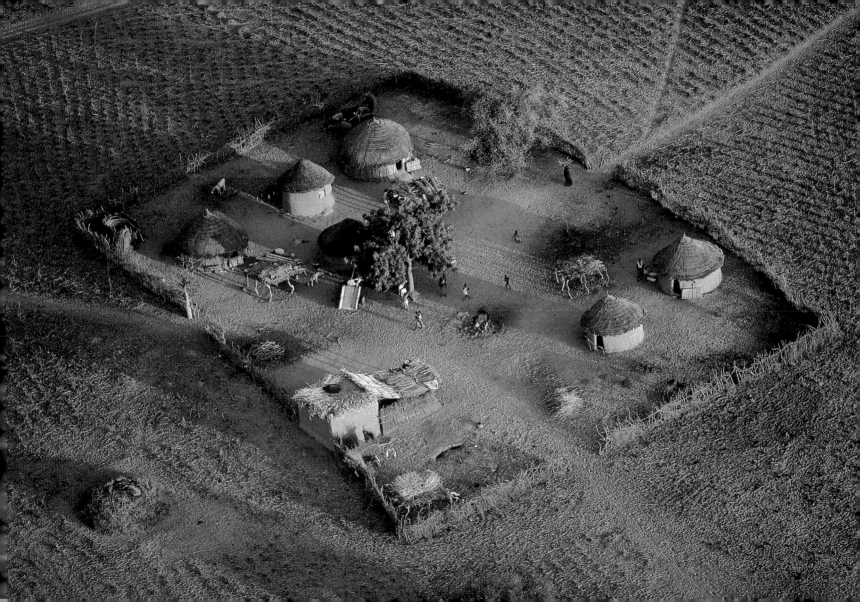

Philippines. Islet in the Sulu Archipelago.

More than 6,000 of the 7,100 islands that make up the Philippines are inhabited. This islet (nameless, as are more than half of the Philippines) is part of the archipelago of 500 islands in the south of the country that form a natural barrier between the Celebes and Sulu Seas. According to legend, they are pearls scattered by a couple of giants after a quarrel. Geologically, they are of volcanic and coralline origin, and their fauna and flora have established themselves gradually, borne there by ocean currents, winds, migrating birds, and occasionally by man. Lost in the vast blue sea, this islet is a reminder that 70 percent of our planet is covered by water.

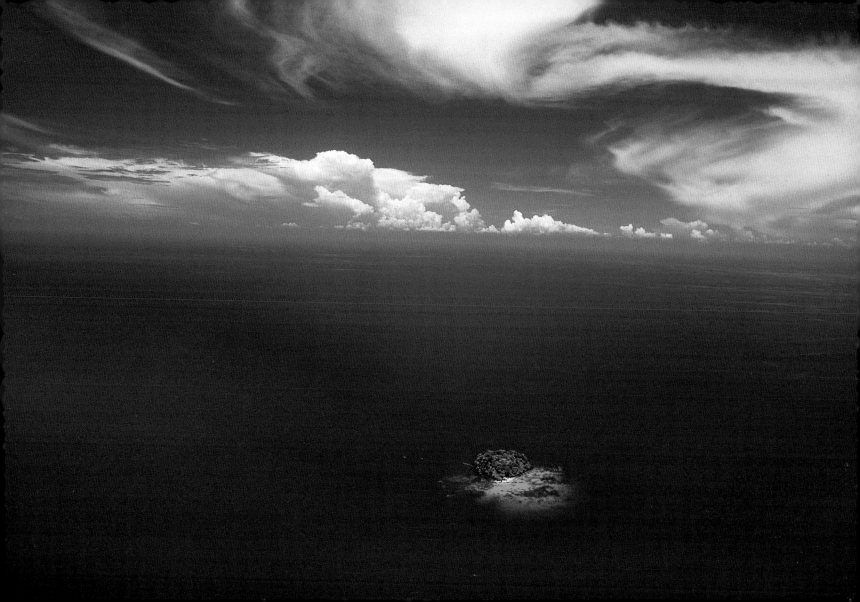

Ethiopia. Lalibela. Welo Province. Bet Giorgis monolithic church.

We are deep in the Amhara country, in the heart of the Ethiopian highlands. Just 20 kilometers (12 miles) away from Lalibela, the Abune Yosef Mountain rises to 4,190 meters (13,750 feet). For more than 15 centuries these volcanic mountains have provided a refuge for Christianity's last great heresy: Monophysitism. Monophysitism embraces the belief that Christ was both divine and human before his incarnation, but that his divine nature then left his body and only reentered it after the Resurrection. It was first professed at the second Council of Ephesus in A.D. 449, and then condemned at the Council of Chalcedon in 451 by the 520 bishops summoned there by the emperor Marcian. Monophysitism spread rapidly through Asia Minor and into Africa, and it survives in the Syrian Orthodox (Jacobite) church, the Armenian church, and the Coptic churches in Egypt and Ethiopia. Among them they account for 25 million faithful who not only defied Rome, but have also held out against Islam for 12 centuries.

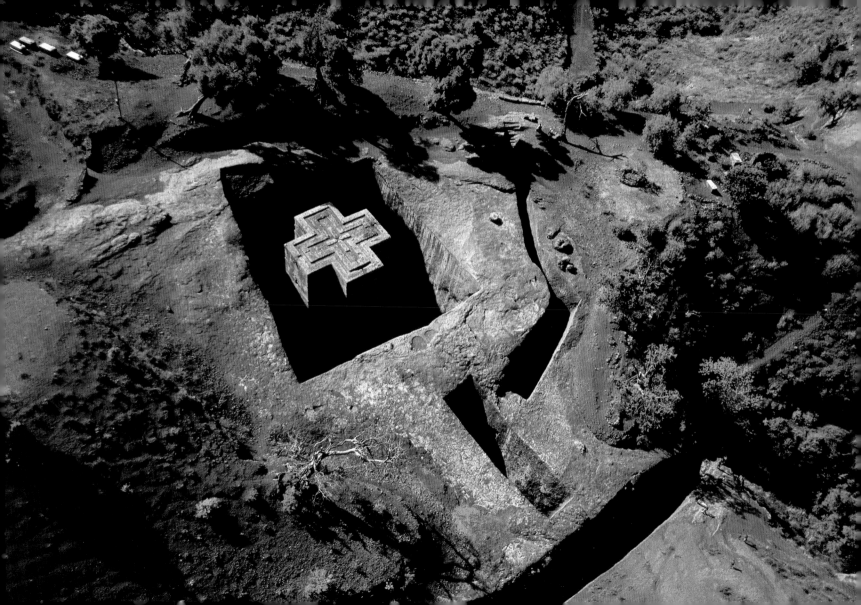

Kenya. Storm over the Loita Hills.

Kenya's rainfall is extremely irregular, alternating between the "long rains" of March to May and the "short rains" from October to December. Precipitation is often heavy and accompanied by spectacular storms, as here in the Loita Hills. This local occurrence is the end result of a long chain of weather events that may have originated thousands of miles from Kenya. It is said that a butterfly's wingbeat in Honolulu can cause a typhoon in California. The complexity of atmospheric phenomena that must be analyzed to precisely and accurately forecast the weather is unimaginable. Atmospheric phenomena are chaotic; small events continuously set off chain reactions that culminate in the larger events we experience. Global climate is a result of exchanges, interactions, and reactions, and local events are both the cause and the effect of other, distant occurrences. The processes that determine weather and climate thus reinforce the motto "think globally, act locally," a mindset that is fundamental to sustainable development. Each of our daily actions plays a part in the equilibrium and evolution of our planet.

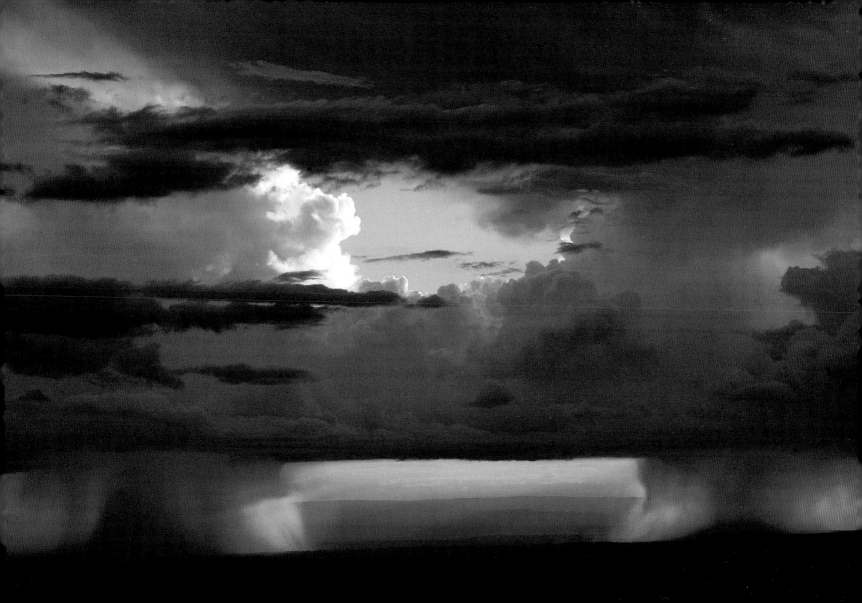

Thailand. Phitsanulok region. Farm worker.

Highly fertile and blessed with a damp tropical climate, Thailand's Central Plain, where Phitsanulok lies, is the country's rice bowl. Here, as everywhere else in the country, rice is harvested by hand. For the last 50 years Thailand has endeavored to boost its food exports, tripling the area of arable land at the expense of forest. In the 1960s, forest covered half the country; now it covers just 28 percent. Rapid deforestation leads to an alarming degradation of the exposed soil, which is soon eroded. Deforestation caused by farming is a problem throughout Asia, but is particularly evident in Thailand.

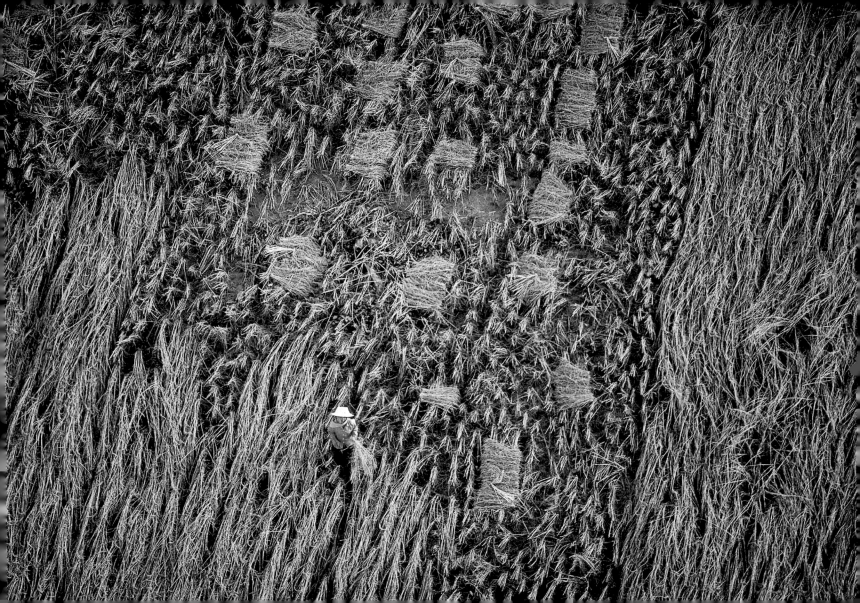

Japan. Honshu. Factory on an island east of Hiroshima.

Japan's industrial sector, the third largest in the world, is fueled by water. Its biggest industrial centers, including steelworks, petrochemical plants, car factories, and computer companies are all by the sea. They can be found in the country's main ports on the Pacific coast; in minor ports such as Hiroshima and Mizushima on the coast of the Sea of Japan; on islands transformed into gigantic factories in the Sea of Japan; and in "industrial polders," land reclaimed from the sea by draining and then converted into artificial harbors. Japan has thus increased its ability to import energy and raw materials, and to export its goods to the rest of the world.

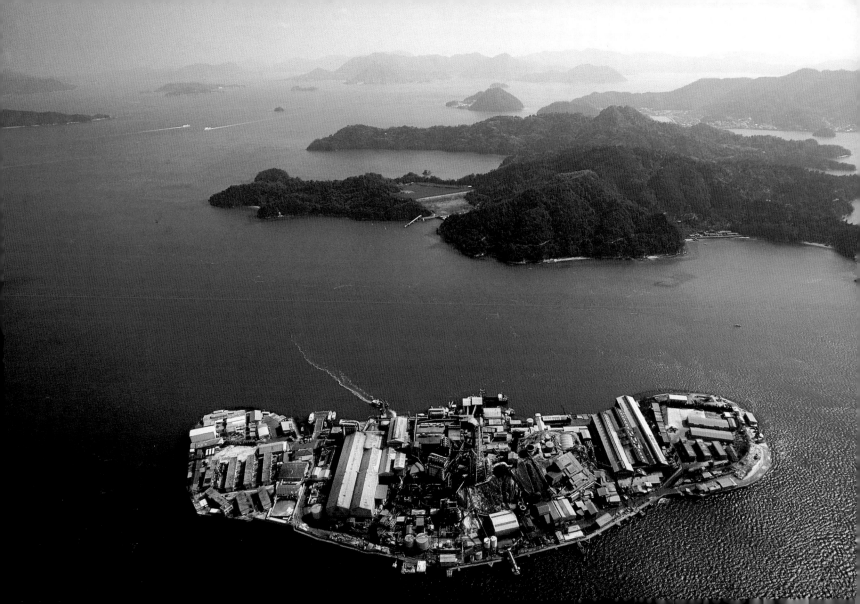

Mali. Market gardening by the Senegal River near Kayes.

In western Mali, close to the Senegalese and Mauritanian borders, Kayes is an important commercial center and a meeting place for different peoples. The Senegal River crosses the entire region, and on its banks sprout countless market gardens. Water from the river, a vital resource for the Sahel, is carried by women to the little plots where fruit and vegetables are grown for the local market. Only known as the Senegal from the confluence of the Bafing (Black River) and Bakoy (White River) just upstream of Kayes, the river flows for 1,600 kilometers (1,000 miles) across four countries. Pumping stations along it irrigate 600 square kilometers (230 square miles) of farmland, while its basin covers 350,000 square kilometers (135,000 square miles) and supplies almost 10 million people with water.

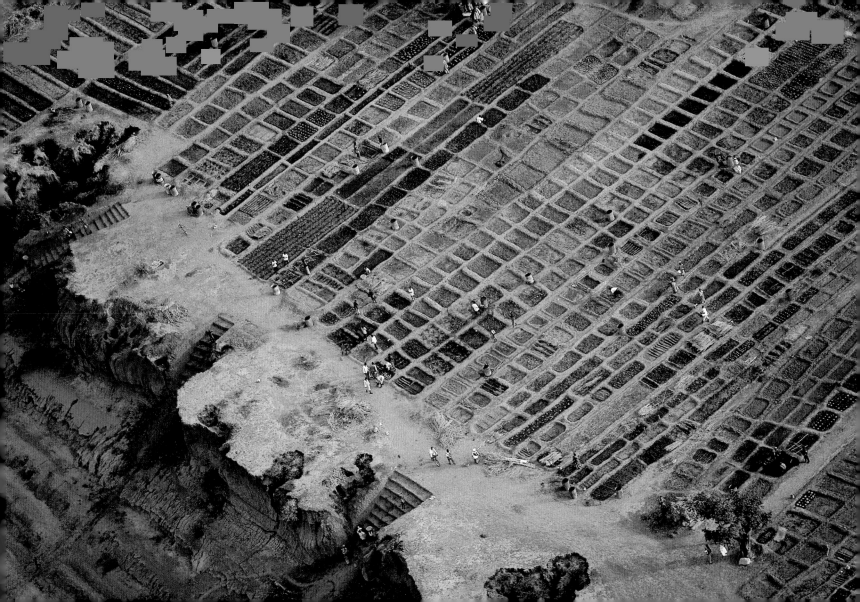

United States. Florida. Mangroves in the Everglades National Park.

Deep in the south of Florida, where fresh water from Lake Okeechobee mingles with the salt water of the Gulf of Mexico, Everglades National Park consists chiefly of mangrove swamps. Although it covers over 6,000 square kilometers (2,300 square miles), it is only a fragment of the ancient wetlands which, before drainage work began in 1880, was five times larger and covered one-third of the state of Florida. The park is home to 40 species of mammals, 347 birds, 65 reptiles, and 600 fish. It is a UNESCO World Heritage Site, and has been a Raamsar Convention Wetland of International Importance since 1976, but it is still threatened by agricultural pollutants and various hydraulic engineering projects, not to mention Florida's growing population. Since 1994 plans to improve water quality and regulate flow have been under way.

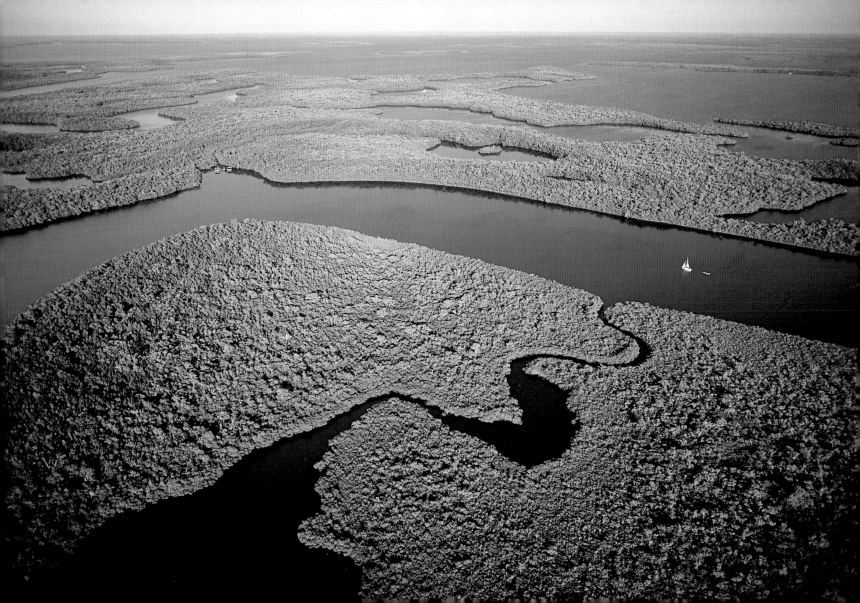

Argentina. Misiones Province. Fields near the Rio Uruguay.

Named after the Jesuit missions of the sixteenth to eighteenth centuries, this province in northeastern Argentina was once blanketed by tropical forests. But for more than a century now it has been shaped by colonists of European origin, who have deforested much of it to exploit its extremely fertile red soil. Working along the topographic contours and leaving strips of grass between plowed areas to reduce erosion, they have planted cotton, tobacco, tea, maté, sunflowers, rice, and citrus fruits. Farmers have also taken advantage of the vast network of watercourses that flow through this region. Sandwiched between the Paraná and Uruguay Rivers, it is known as Mesopotamia, Greek for "between the rivers."

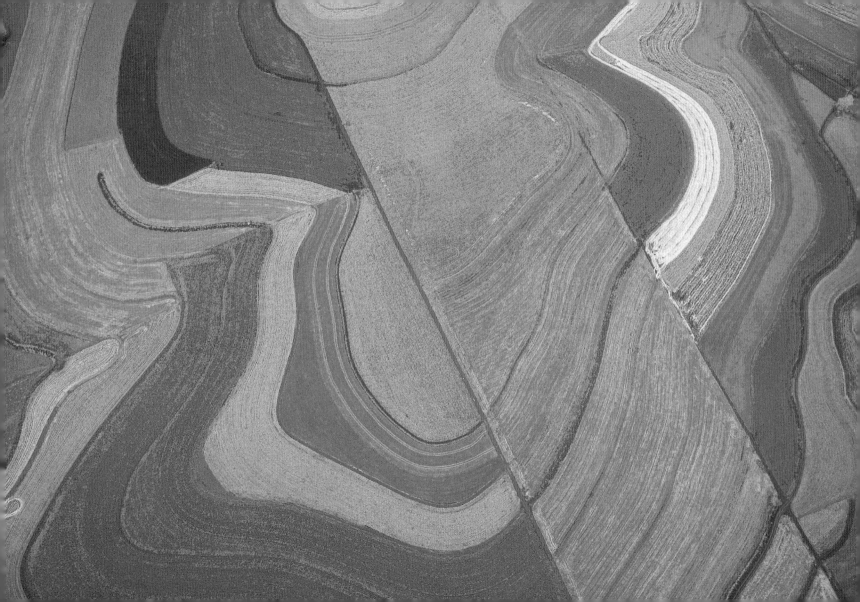

Mali. Camels at a well between Kidal and Timbuktu.

Watering places define the areas of land occupied by each group of Tuareg herdsmen, and a well serves as a meeting place for the various tribes or clans who use it collectively. Wells are dug at common borders, as a mark of the borders' permanence. Asked to describe their territory, a nomad would draw in the sand a map of the valleys and wells that demarcate it. This approach to geography is reflected in the region's myths, such as that of Ninki Nanka, the holy giant python whose journey links all the villages along the ancient course of the Niger River. One proverb states, "Even if the valleys are overflowing with water, it is the well that gives stability." The health of a herd, and therefore the wealth of its owner, all depend on *aman*, Tuareg for "water," and thus on wells. Among the Peul people, the cow is the beast of choice; among the Tuareg it is the camel. The hardships of this life compared to that in cities are driving away young people, and traditional nomadism seems doomed to vanish.

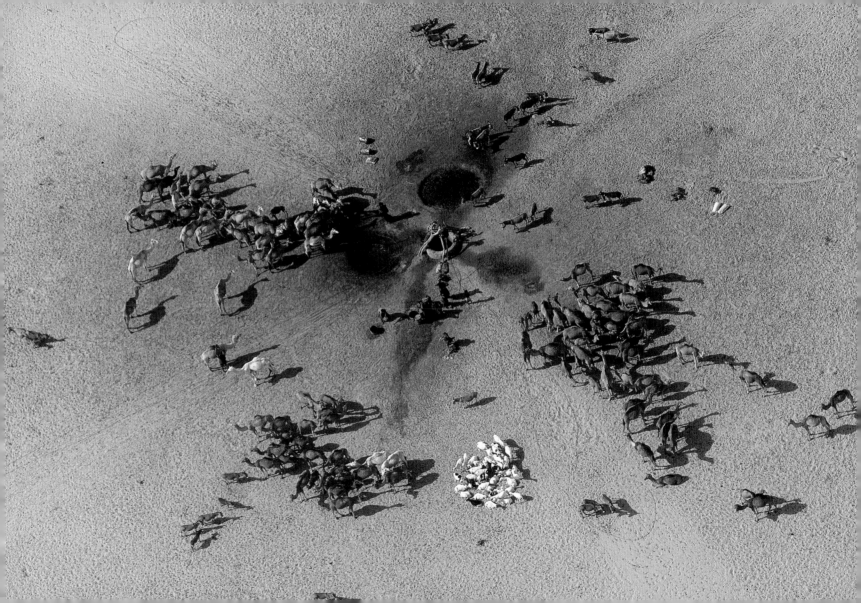

Brazil. Amazonas state. Storm over the Amazon Rain Forest near Téfé.

The Amazon Rain Forest covers 42 percent of Brazil's land area as well as most of Amazonas, the country's largest state and one of its least populous, with just 1.5 inhabitants per square kilometer (3.9 per square mile). Amazonia is the world's greatest tropical rain forest ecosystem, covering 3.3 million square kilometers (1.3 million square miles). Of the countless forms of plant and animal life it harbors, the tens of thousands classified so far account for 10 percent of all the species identified on the planet. Despite an alarming rate of deforestation Amazonia alone still contains almost 30 percent of the world's tropical rain forests. Wordwide, rain forests are home to 90 percent of the planet's biodiversity.

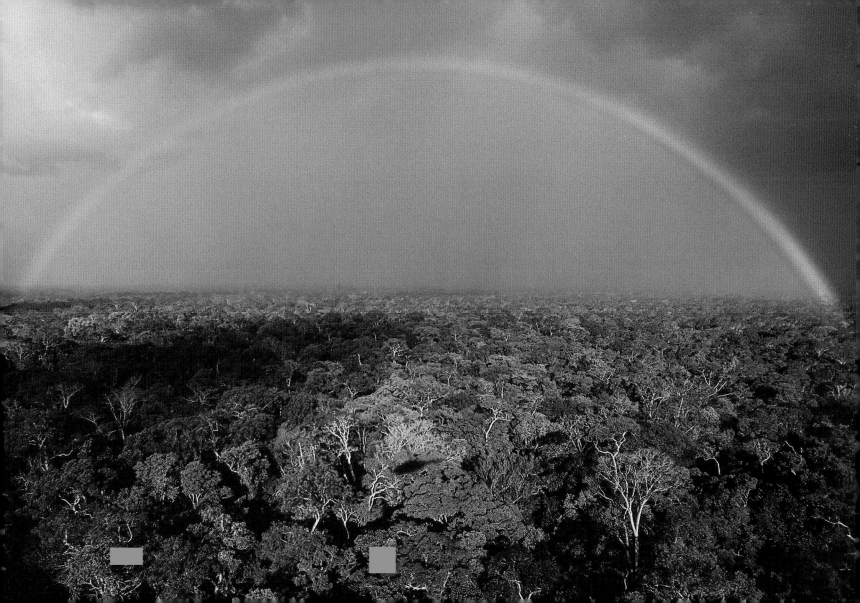

Jordan. Karak region. Boat near a potash plant on the Dead Sea.

Lying 400 meters (1,300 feet) below sea level, the Dead Sea is a landlocked stretch of water 15 kilometers (9½ miles) wide and 75 kilometers (50 miles) long, with a surface area of 920 square kilometers (350 square miles). Its greenish tinge is streaked with white owing to its extreme salinity (370 grams per liter [50 ounces per gallon] – ten times that of seawater). In addition to common salt, it contains many other mineral salts including chlorides of potassium, magnesium, and calcium. Its shores yield about 2 million tonnes (2½ million tons) of potash (potassium chloride) per year. The border between Israel and Jordan runs through the Dead Sea, and its waters, fed by the Jordan River, are coveted by both countries, leading to fears of a "water war" in the region. Since 1972 the Dead Sea has shrunk by 20 percent. Its waters have been pumped out to irrigate the Negev Desert, while the waters of the Jordan have been used for irrigation and domestic use.

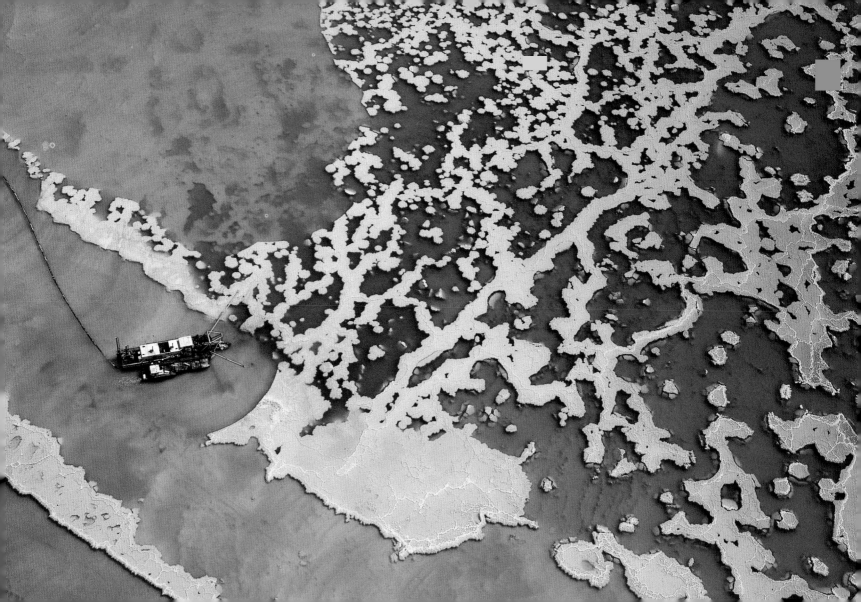

French Polynesia. Bora Bora.

This island of 38 square kilometers (15 square miles), whose name means "first born," is in fact the rim of the crater of a 7-million-year-old volcano surrounded by a coral barrier reef. On the reef islets have formed, covered almost exclusively with coconut palms. The only way out of the lagoon is the Narrows of Teavanui, which is deep enough to admit cargo ships and warships. The island was indeed used as a military base by the United States from 1942 to 1946 and, until an airport was built on Tahiti, was one of the few in the region equipped with an airstrip. Like most coral-bearing areas, of which there are 18 million square kilometers (7 million square miles) worldwide, the waters of Bora Bora have a great biodiversity – there are 300 species of fish alone. Fishing and tourism are Bora Bora's main industries.

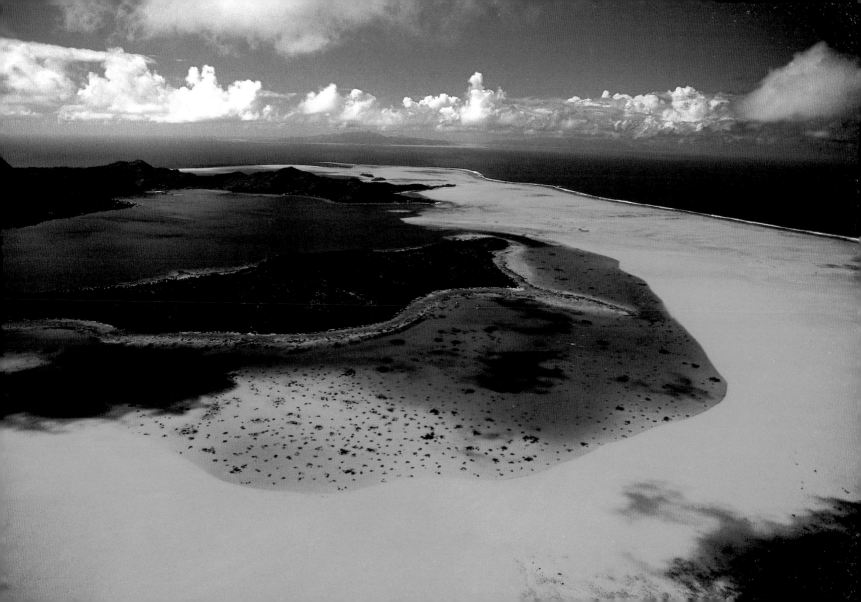

Kenya. Rift Valley. Masai village enclosure south of Narok.

The Masai believe that God (*Enkai*) has made them masters of all the cattle in the world. These seminomadic herdsmen, of Nilo-Hamitic origin, live entirely off their livestock. A family's wealth is measured by how many head of cattle it possesses, while land ownership is irrelevant. They live in villages (*enkang*) from which the men depart at dawn, leaving behind the women who are the real guardians of social order and run all aspects of daily life: maintaining the huts, keeping fires going, fetching water, and milking cattle. Today the Masai are confined to the southernmost part of the Rift Valley, which they once occupied as far as Mount Kenya. In the late nineteenth and early twentieth centuries they suffered a series of crises, and quickly accepted British protection in return for giving up the right to roam their ancestral lands – a decision from which they still suffer today. However, some of their traditions do survive, including male and female circumcision and the division of society into specialized age groups: warriors from 15 to 30, heads of families from 30 to 45, and priests thereafter.

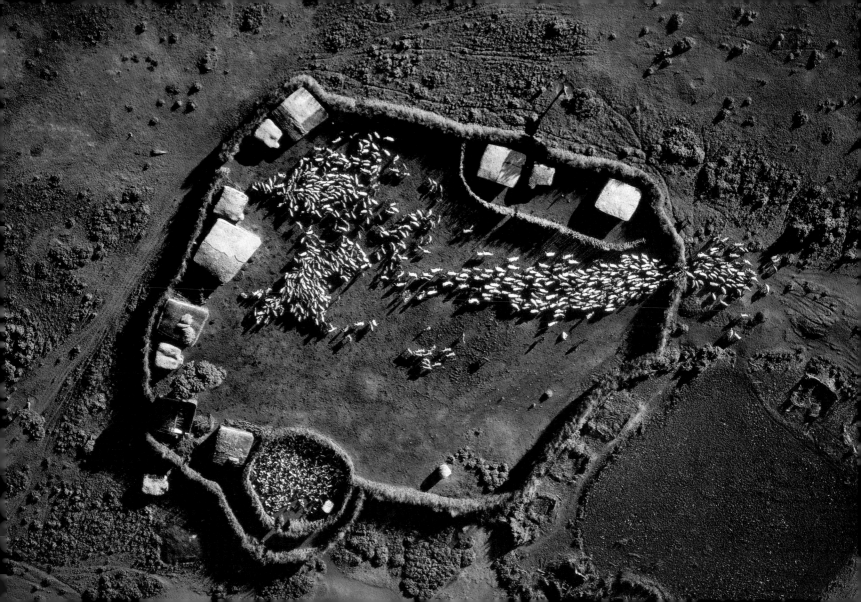

United States. New York. Spire of the Chrysler Building.

High above the heart of Manhattan, the spire of the Chrysler Building, with its four sets of six steel arches one above the other, catches the sun's rays by day and is lit up at night. William Van Allen's Art Deco skyscraper was built in 1930 for the automobile tycoon Walter P. Chrysler. At 77 stories and 319 meters (1,047 feet) high, it was the city's tallest building at the time, only to be deposed the following year by the 381-meter (1,250-foot) Empire State Building. Nonetheless, it is still one of New York's 40 tallest skyscrapers, all of which exceed 200 meters (656 feet). The growth in the population and economic importance of the world's megalopolises, combined with space constraints, is an incentive to build ever higher. In the year 2000 the record was held by the 520-meter (1,706-foot) Nina Tower in Hong Kong.

Morocco. Plowing near Marrakech.

A growing proportion of the world's food comes from a limited number of grains: wheat and rice for humans; and maize, sorghum, and soya for livestock, which consume 40 percent of all cultivated grains. These crops are not always appropriate to the climate, soil, local customs, or land management systems where they are cultivated. This is especially true of southern Morocco, with its light soil tilled by primitive plows, the overlapping land rights of farmers, village communities and transhumant herdsmen, and above all its highly unpredictable rainfall. Despite the government's efforts to increase yields, the peasants around Marrakech are adopting "anti-risk" tactics such as cutting production costs to the minimum to reduce possible financial losses, or maintaining their traditional nonintensive system (growing grains, leaving land fallow, and grazing sheep) whose flexibility is more suited to the conditions. Their actions reflect the resistance of highland Morocco to the authority of the *makhzen* Morocco of the lowlands.

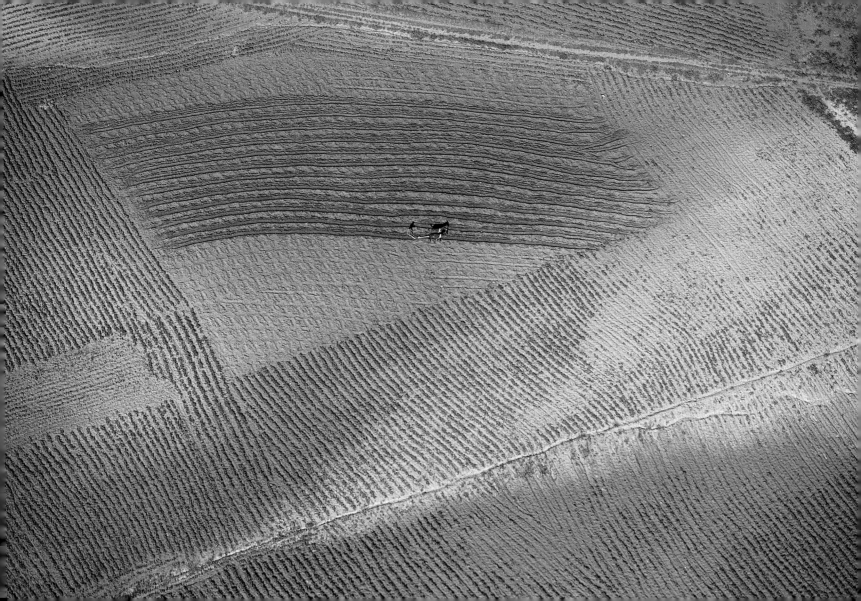

Brazil. Brasilia. View of the business district, designed by Oscar Niemeyer.

Brasilia did not develop into a capital from a town or large village that slowly matured as a society evolved; it was born of a specific idea at a given time. In this it resembles other capitals, including Chandigarh, in Punjab, India, which was founded a few decades ago, Berlin three centuries ago, and several Chinese cities in earlier times. In Brasília's case it was a question of giving the country a feeling of balance, if necessary by choosing an almost virgin site. A city built by government edict takes time to become a "real" city, and for a long time it remained a mere administrative center, surrounded by the facilities needed to sustain it. Impressive architectural complexes will never replace the fundamental quality that characterizes towns that have grown gradually and naturally: that quality is atmosphere.

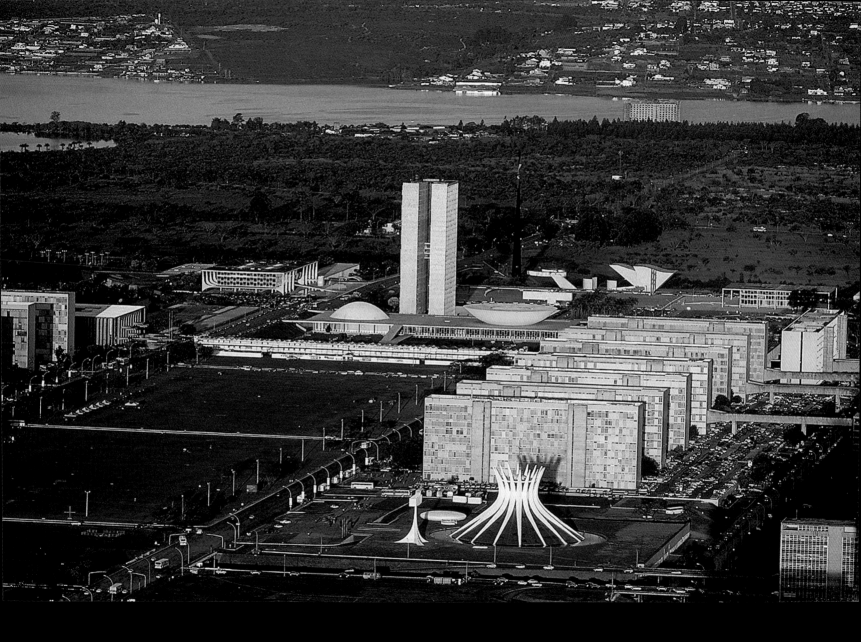

India. Rajasthan. Design in the courtyard of a village house west of Jodhpur.

In the Indian state of Rajasthan, the walls and courtyards of the houses are often decorated with patterns drawn in lime or other materials derived from minerals. This tradition, nearly 5,000 years old, is particularly strong in rural areas. Designs fall into two categories: geometrical figures called *mandana*, and representations of people and animals, known as *thapa*. Created by women, they are renewed at every festival-time on the walls and floors, which are covered with a mixture of mud and dung. The designs personalize each dwelling, and in addition to their purely aesthetic character have an important social function: they attest to the prosperity of the inhabitants and bring, it is said, happiness and good luck. Only households in mourning for a death over the previous year do not decorate their houses.

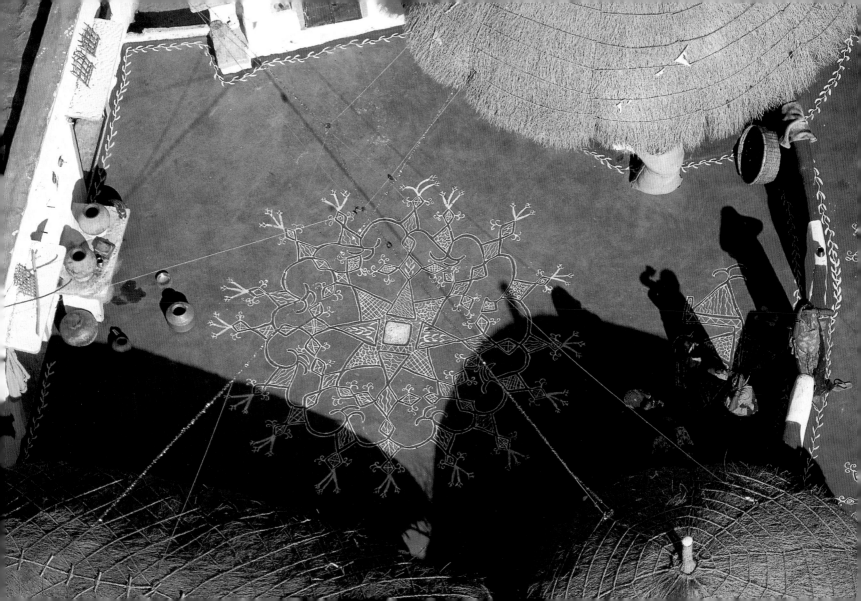

France. Charente-Maritime Department. Fishermen's huts near Talmont-sur-Gironde.

The village of Talmont sits on an isolated, rocky promontory where the Gironde Estuary takes on the appearance of a small sea. Surrounded by marshes and limestone cliffs, the estuary is also dotted with some 20 little harbors. Coastal trade has long thrived in the area, and in the nineteenth and twentieth centuries, demand from the city of Bordeaux led to a sharp increase in fishing, wiping out the once numerous sturgeon population. Fishermen subsequently turned their attention to elvers, the young eels that swim in the millions up the marshy channels from the sea every spring. The countless huts from which fishermen lower their wide nets into the water bear witness to this local passion. The inhabitants' ties to their estuary seem unbreakable and thus the tradition continues, but at what cost to the environment? European legislation that aims to protect nature commonly faces the obstacle of local customs.

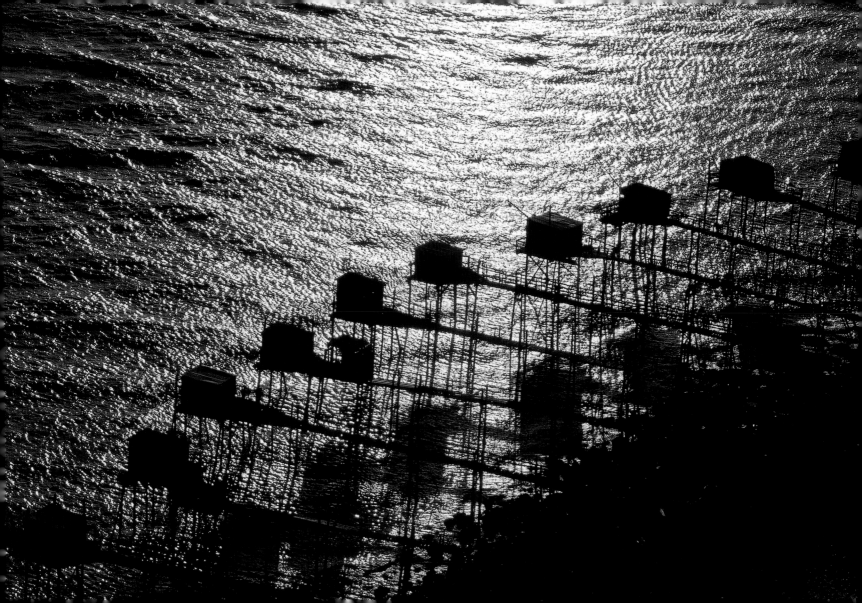

Maldive Islands. Male North Atoll. Male Islet.

Male, capital of the Maldives Republic, stands where two atolls meet. All the political, administrative, economic and cultural functions of the country are performed within its 1.8 square kilometers (0.7 square mile), and the town is also home to slightly more than one-quarter of Maldivians, about 70,000 people. With 900 inhabitants per square kilometer (2,300 per square mile), the Maldives is the seventh most densely populated country in the world. In addition to its permanent population, it also supports 170,000 tourists who visit each year. As a result, land use is highly specialized: one island acts as the capital, another houses the airport, a third is an oil depot, a fourth a prison. About 200 islands are inhabited, and 90 are reserved for tourists. The risk of a land shortage is due less to rapid population growth than to rising sea levels, for the Maldives rise no more than 2 meters (6$\frac{1}{2}$ feet) above sea level. The dangers that climate change brings to countries such as the Maldives – extreme storms and floods have already occurred – have put island states at the forefront of international climate talks, leading them to call on the major industrialized countries who emit vast quantities of greenhouse gases. In some places, work has begun on building dikes to shore up the islands for the eventualities of a warming climate and rising sea level.

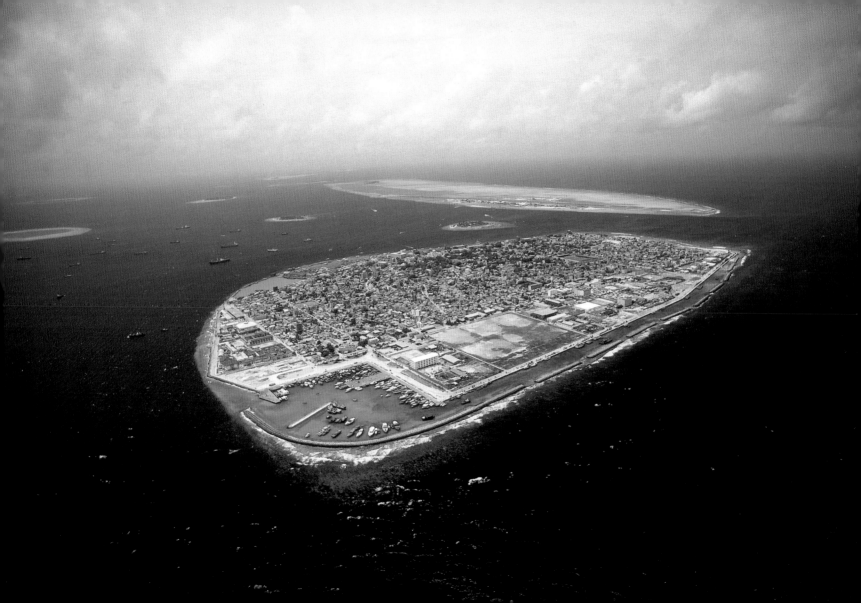

South Africa. Cape Province. Fur seals on a rock near Duiker Island.

Highly gregarious by nature, South African fur seals (*Arctocephalus pusillus pusillus*) gather in coastal colonies several hundred strong, chiefly in order to breed. These semi-aquatic mammals are more comfortable at sea than on land, and spend most of their time in coastal waters looking for fish, squid, and crustaceans. Also known as Cape fur seals, these pinnipeds numbering about 1.5 million are only found along the coast of southern Africa, from Cape Cross, Namibia, to Algoa Bay, South Africa. The South African fur seal is one of 14 species of the Otariidae family, eared seals which include both fur seals and sea lions. In addition to eared seals, pinnipeds also include the walrus (Odobenidae) and 19 species of true seals (Phocidae). Pinnipeds can be found in most of the world's seas and number 50 million in all, 90 percent of them seals.

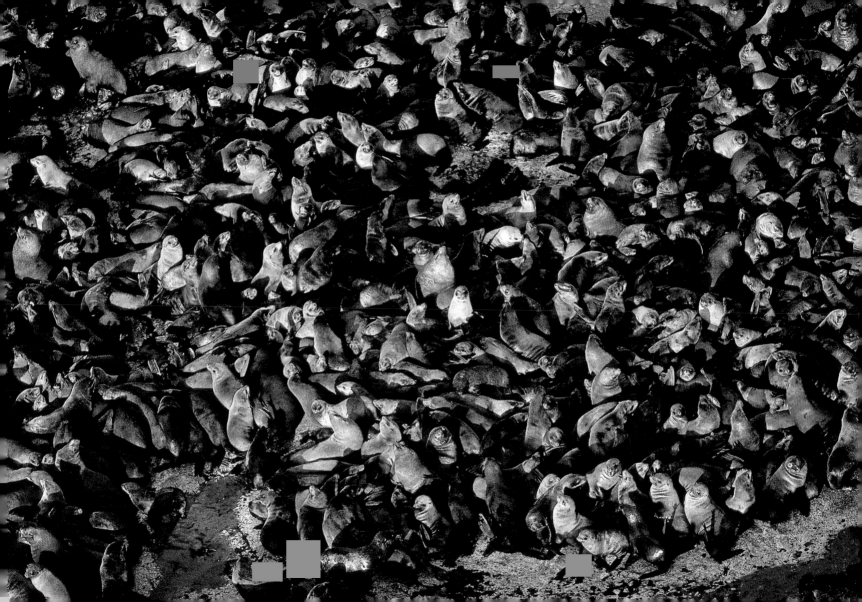

Madagascar. Toamasina region. Nosy Nato Island – its lagoon, south of Nosy Boraha.

Nosy Nato Island wraps itself around the end of Nosy Boraha, a long, narrow island that stretches for 57 kilometers (35 miles) off the east coast of Madagascar to the north of Toamasina, the country's main port. Fringed with coral beaches and tropical forests, Nosy Nato owes its name to the nato tree once used for building dugout canoes. The island's greatest claim to fame is that in the seventeenth century it was the hideout of a community of pirates who held sway not only over the Indian Ocean but over all the seas. The development of maritime police forces had forced pirates to withdraw to hideouts that were remote yet not too distant from the trade routes on which they preyed. Nosy Boraha was an ideal base from which to ambush merchant ships plying between Europe and the Orient as they rounded the Cape of Good Hope. The pirates were not the only ones to defy international law. In the eighteenth century they were joined by a group of utopians led by a Provençal intellectual named Misson and a priest called Caraccioli, who founded the short-lived Republic of Libertalia in the Bay of Antseranana (Diégo-Suarez), north of Nosy Boraha.

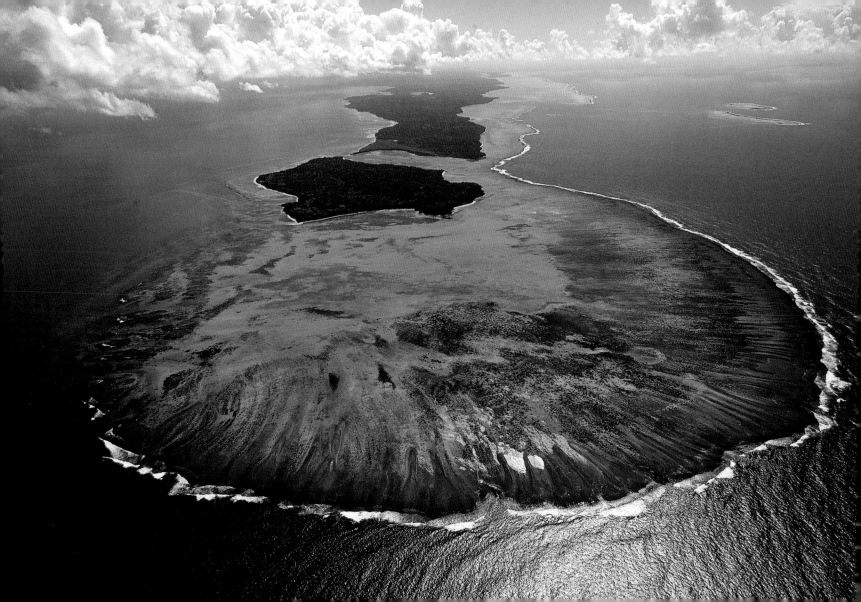

France. Meuse. American cemetery north of Verdun.

Covering some 40 hectares (100 acres) at Romagne-sous-Montfaucon, 40 kilometers (25 miles) from Verdun, the American cemetery was dedicated in 1935 by the American Battle Monuments Commission. The commission was created in 1923 at the request of General Pershing, who had taken part in the American offensive of 1918. Its aim was to undertake architectural and landscape studies in order to restructure American cemeteries and commemorative monuments in Europe. Whereas the French army chose to build permanent cemeteries where temporary cemeteries had been made during the hostilities, the American army opted to create a single cemetery. Some 25,000 American tombs scattered around Verdun were then brought together at Romagne where, after almost half the bodies were repatriated to American soil, 14,246 soldiers have lain ever since. The butchery of the Great War so shocked the United States that it built numerous pacifist commemorative monuments at Verdun and in the Somme. For similar reasons, Verdun hosted an occasion of Franco-German reconciliation in 1984, and the town has been named the Capital of Peace, Freedom, and Human Rights.

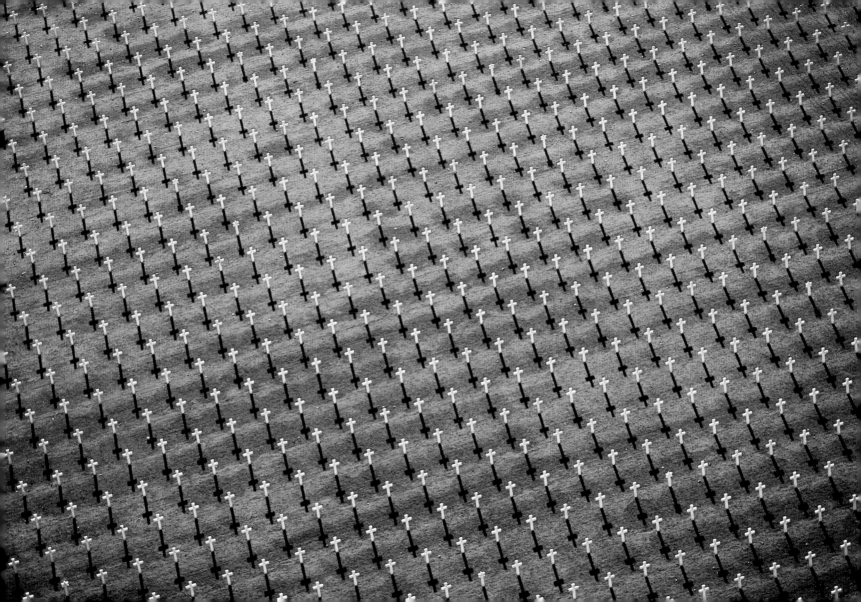

Ivory Coast. Bondoukourou region. Yam-growing north of Tagadi.

Traditionally buried under little mounds of earth, as in this field near Bondoukou in the east of the Ivory Coast, yams are grown for local consumption in most tropical countries. Rich in starch and proteins, this tuber is particularly widespread at the northern limit of forest regions in Africa, from the Ivory Coast to Cameroon. A basic ingredient in one of the main dishes of Côte d'Ivoire cuisine, *foutou* (a sort of dense purée), yams are widely eaten in rural areas, but are gradually being abandoned by town-dwellers, who now make up almost half the country's population. The Ivory Coast is the third largest yam producer in Africa, after Nigeria and Ghana. Seventy percent of Africa's working population is involved in farming, but agriculture brings in only one-quarter of the continent's revenue.

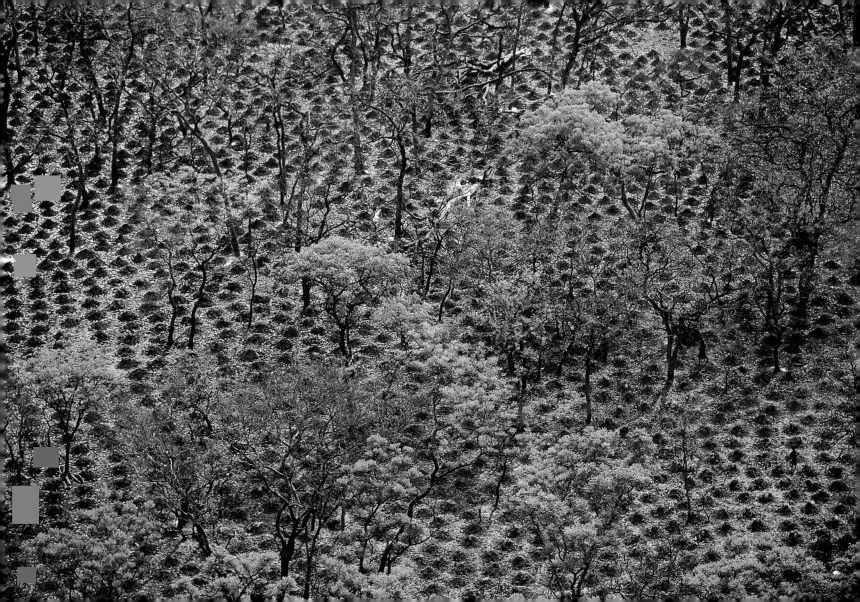

England. Wiltshire. Stonehenge.

In southern England near the city of Salisbury, stands the largest cromlech in Europe. Originally made up of four concentric rings surrounding a horseshoe, the outer three rings no longer stand. The surviving circle is 32 meters (105 feet) across, made up of blocks 7 meters (23 feet) tall and 30 tonnes (33 tons) each. The stones were quarried more than 30 kilometers (20 miles) away and probably brought to the site on wooden rollers. The four arches of the central horseshoe and the pillars of the outer circle are aligned with the rising and setting sun at the summer and winter solstices. Other stones line up with the rising and setting full moon nearest the solstices. The civilization that built Stonehenge more than 5,000 years ago needed reference points during the year to determine the farming calendar, particularly sowing time. But Alexander Thom, who measured Stonehenge's astronomical accuracy, believes this was not its only function, but that it was also used for religious rites of which no trace survives.

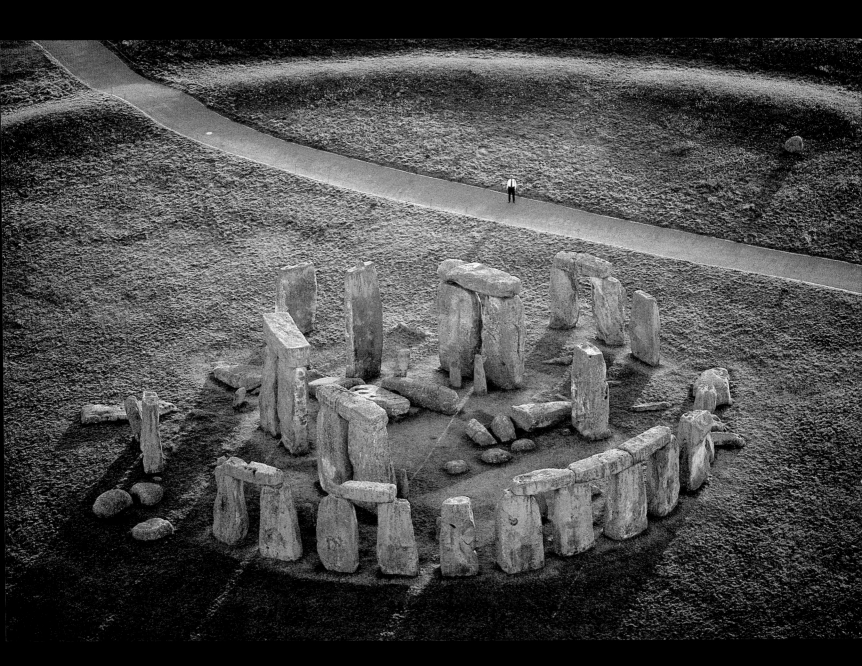

France. Saône-et-Loire. Flooded restaurant next to Lux.

The Lux district, near Chalon-sur-Saône, is very near one of the branches of the Saône River, which crosses this part of the Burgundy region. Since time immemorial, it has been a capricious river, rising regularly from its bed and stretching over the surrounding plains: but, as compensation, the rich meadows are favorable to livestock farming. Yet, floods are rarely considered to be a source of wealth. In the first third of 2001, because rainfall greatly exceeded the norm, floods seriously affected several French departments, especially in the Somme region. As with all natural catastrophes, floods cause costly damages, which fall partly under the responsibility of the community, and partly the insurance companies. But how can you evaluate the price of the distress of inhabitants, whose houses are more and more often being ruined by floods? Moreover, after these events, fingers have been pointed at town development and the fact that building has been permitted in flood regions. It is in fact urgent that we consider these issues, since, with the predicted change in climate, rainfall should increase greatly in coming years in France.

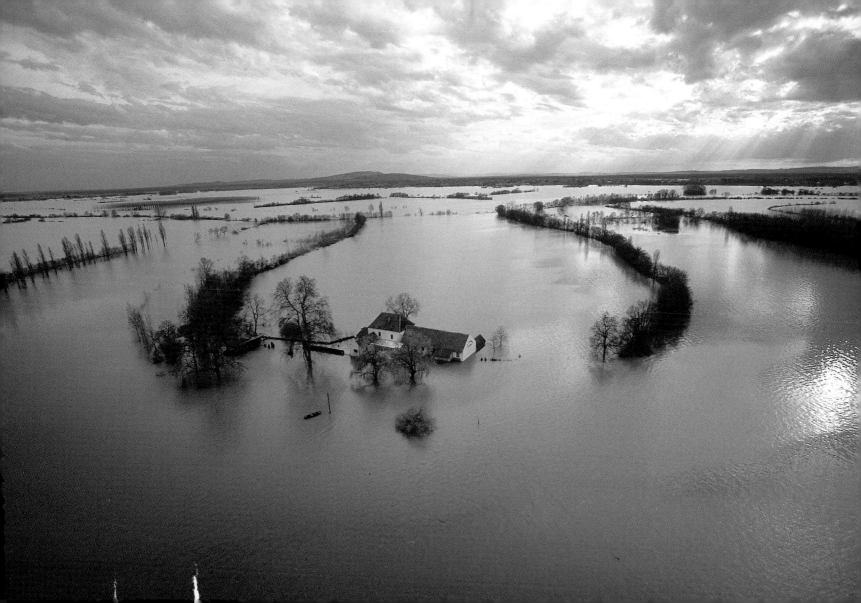

Australia. Queensland. Great Barrier Reef.

The 2,300-kilometer (1,400-mile) Great Barrier Reef, off the northeast coast of Australia, is the longest coral reef in the world. It is made up of more than 400 different species of coral and is home to a variety of other fauna, including 500 species of fish, 4,000 mollusks, and other animals such the dugong and green turtle, which face extinction. In 1979 the area was made a Marine Reserve covering 344,800 square kilometers (133,100 square miles) – 15 percent of the world's protected sea area. Both fishing and coral harvesting are controlled, and the main industry, tourism, brings in almost $750 million a year. Corals, which build up to form significant geological structures, are polyps that live in symbiosis with zooxanthellae (dinoflagellates), light-sensitive algae that collaborate with their hosts to manufacture their calcareous skeleton. One of the threats to corals is the increasing cloudiness of seawater, linked to sediments and marine pollution. Without light the zooxanthellae perish, causing the coral to whiten and die.

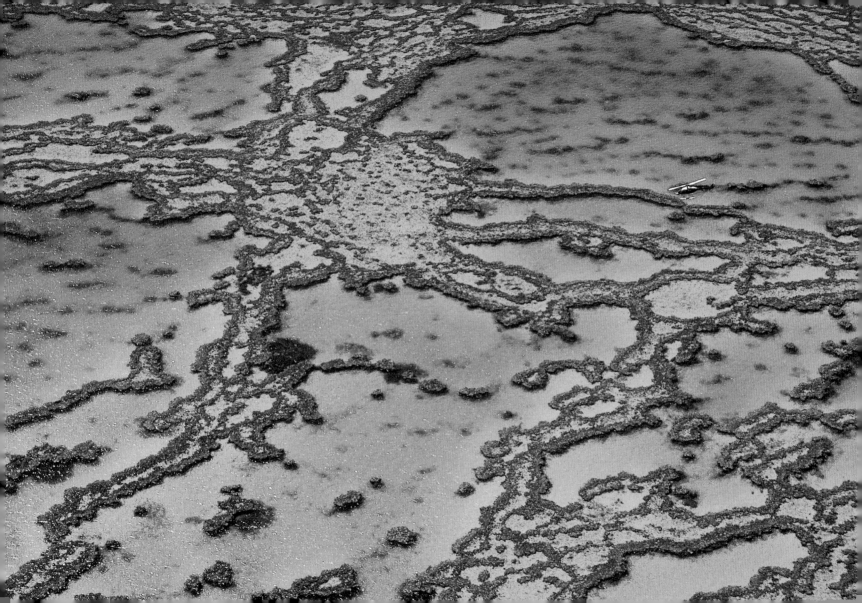

Jordan. Between Safawi and Qasr el Burqu, near Mafraq.

Unlike the rest of the country which is 80 percent desert, the landscape of northern Jordan – as here between Safawi and Qasr el Burqu – is a steppe where sand and vegetation mingle, enjoying 500 to 600 millimeters (20 to 24 inches) of rain a year. In this near-enclave, the main water resource is the Jordan River, from which the country takes its name. The tapping of this watercourse, which forms the country's western border with Israel and the West Bank, is a vital political issue in the region. Access to water is a problem for all Middle Eastern countries, especially those that do not control a river along its entire length from source to sea. Rivers in which more than one country has a stake include the Tigris and Euphrates, flowing through Turkey, Syria, and Iraq, and the Nile, which flows through both Sudan and Egypt.

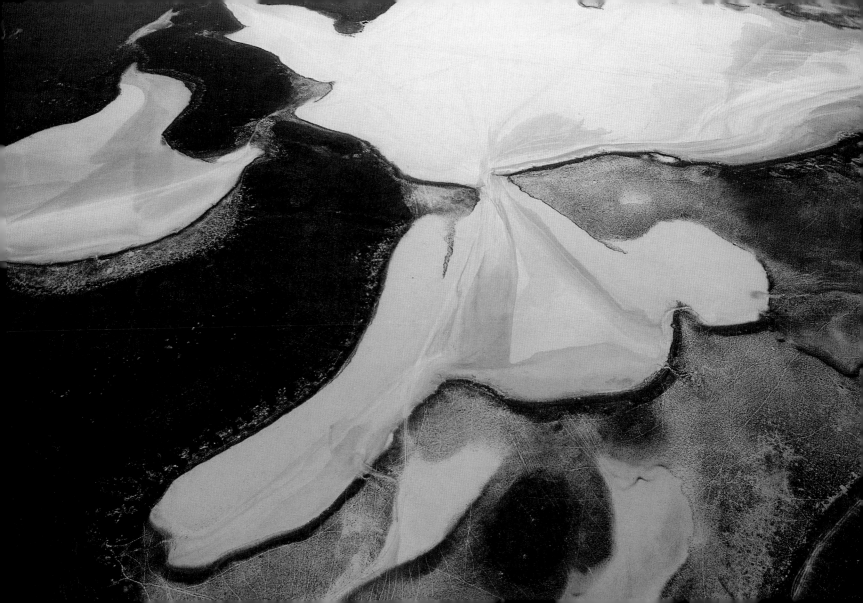

Antarctica. Terra Nova Bay. Italian base.

At the end of the nineteenth century French, American, and British expeditions set off to try to reach the magnetic South Pole. None achieved its goal, but each explored large areas of the Antarctic (beginning with the French, who in 1840 were the first to land on what is now Terre Adélie). From the start of the twentieth century the various countries involved made claims to the lands they had explored, and after World War II, expeditions resumed, ushering in an era of scientific research. After the International Geophysical Year (1957–58) and the signing of the Antarctic Treaty in 1959, 12 countries set up 48 observation bases on the continent. Today 17 countries run a total of 66 bases among them. Antarctica is now a global laboratory for geophysical, ecological, astrophysical, and climatological research – not the least of which is related to the hole in the Earth's ozone layer which opens up over the South Pole each October and which, growing ever larger as a result of pollution, threatens to deprive the planet of its protection against lethal ultraviolet radiation.

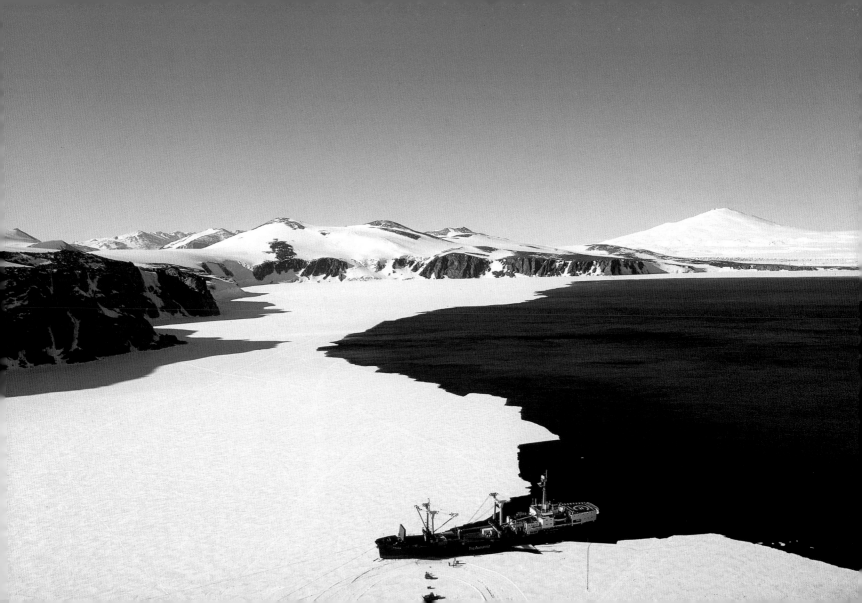

Spain. Basque Country. Guggenheim Museum in Bilbao.

In less than a century the proportion of the world's population that lives in cities has risen from 20 to 50 percent. The challenge of accommodating this influx has been central to urban planning, and partly explains the success of a rational style of architecture of which Le Corbusier and the Bauhaus style were the best known theorists, providing a dominant reference point in the building of large developments, apartment blocks, and new towns. But now the new city dwellers demand more than just accommodation and work. Their thirst for pleasant and cultured surroundings is illustrated by the renaissance of museums and cultural centers with daring architecture in city centers. Among these are the creations of Nouvel and Portzamprac in France, and of Calatrava and Gehry in Spain. Inaugurated in 1997, the Guggenheim Museum in Bilbao is the flagship of this groundswell. With a total area of 24,000 square meters (260,000 square feet), it contains 19 galleries— including one of the world's largest, measuring 100 meters by 30 meters (328 feet by 98 feet)—which contain a distinguished collection of modern and contemporary art. There are more than 40,000 museums and public collections in the world.

Iceland. Lakagigar chain of volcanoes.

The Lakagigar region of southern Iceland still bears the scars of one of the most devastating volcanic eruptions in history. In 1783 two fissures more than 25 kilometers (16 miles) long opened on either side of the Laki volcano, belching out 12 cubic kilometers (3 cubic miles) of lava which engulfed 565 square kilometers (218 square miles) of land. A cloud of carbon dioxide, sulfur dioxide, and ash blanketed the island, poisoning grazing land and surface water. Three-quarters of farm animals were killed. Two years later there was a second eruption, and one-quarter of the population – 10,000 people – died in the ensuing famine. The fissures of Lakagigar are now sealed by volcanic rock and covered by 115 volcanic vents, and the lava flows are covered in a thick carpet of moss.

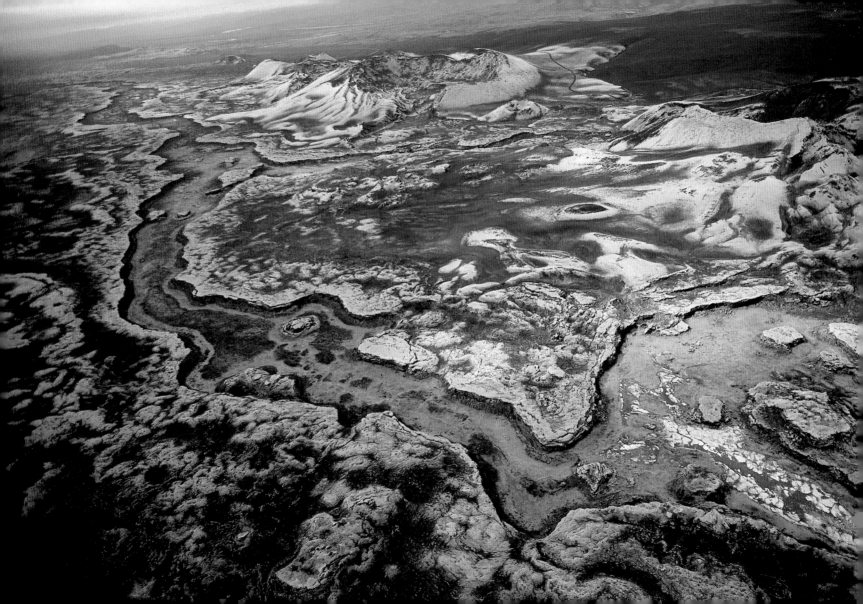

New Caledonia. French overseas territory. The Nokankoui Islets, south of Île des Pins.

In 1774 the English navigator James Cook landed on a long island in the southwestern Pacific Ocean, which he named New Caledonia, after Scotland. At the southern end of this mass of land, which its inhabitants affectionately call "the stone," Cook found Kounié, the Île des Pins. The wild, deserted aspect and luxuriant vegetation of the surrounding islets gave them the reputation of an oceanic Eden. But the Fall was not long in coming, for several of the islets were quickly transformed into penal colonies, particularly for deportees from the Paris Commune of 1871. Many convicts were given plots of land and decided to stay after serving their sentences. They and their descendants were the first European colonizers, and the only residents of the islands to hold French citizenship until the abolition of a restrictive law in 1946 granted it to the native Melanesians. The history of New Caledonia mirrors on a small scale that of its neighbor Australia, which was also colonized by convicts, and only gradually granted rights to the Aborigines.

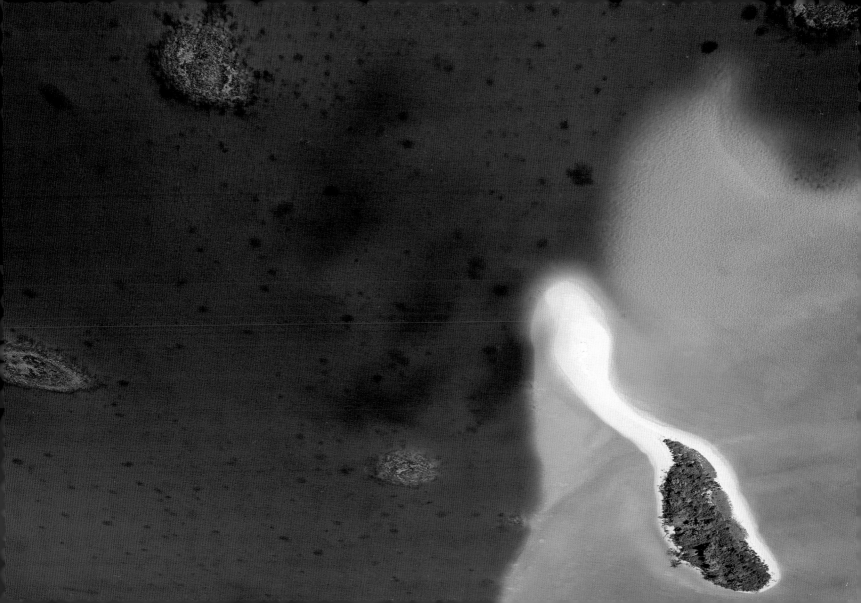

Spain. Canary Islands. Tourists on a beach on Fuerteventura, near Corralejo.

Fuerteventura, the second largest of the Canary Islands, boasts the archipelago's most extensive beaches. Taking advantage of the privacy of one of the many secluded coves, these tourists have given themselves over to the joys of naturism and the all-over tan. Inspired perhaps by local farming methods, they have built a low wall of volcanic rock to keep out the Saharan winds that sweep the coast unceasingly, to the delight of wind surfers. Fuerteventura was once chosen as the site of the world's largest hotel complex, but the ambitious project was quickly abandoned because the island is short of fresh water. Nevertheless, tourism remains the mainstay of the Canaries' economy, with four million people visiting every year.

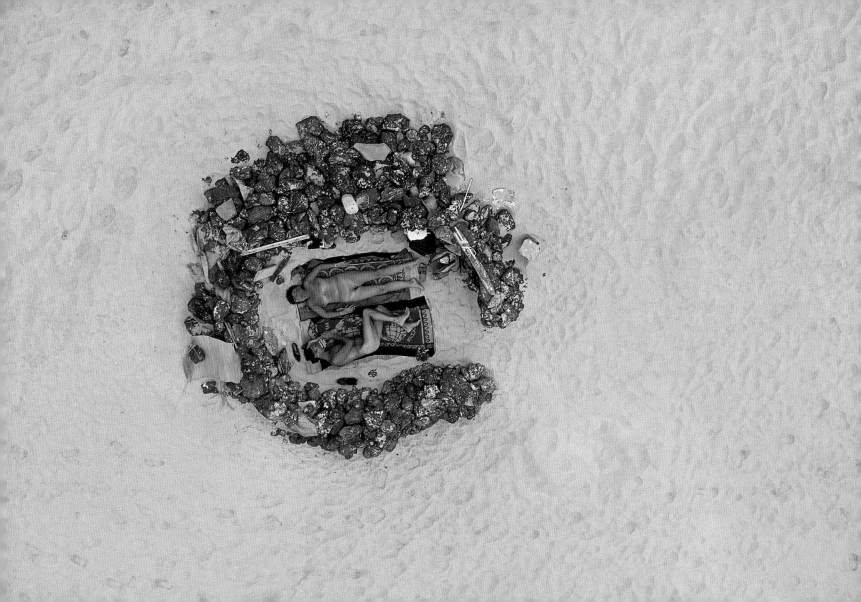

Mali. Village near Mopti.

In 1325, Mansa Musa, celebrated ruler of Mali, made a pilgrimage to Mecca. On his return he brought with him from Ghudamis in Libya the Spanish poet and architect as-Sahili. While traditional African religions sited their places of worship away from the gaze of nonbelievers, Mansa Musa, newly converted to Islam, commissioned as-Sahili to build mosques wherever Musa traveled so that he could pray conveniently. This influenced the style and location of mosques in Sudan, which soon became the focal point in towns and villages. Their unfired bricks and fine clay rendering offered great flexibility of form and gave rise to a bold architecture whose finest example, now a World Heritage Site, is at Djenne, near the large port of Mopti on the Niger River. Despite the flamboyance of their walls and enclosures, these mosques retain the traditional square layout with a courtyard and a *kibla*, the east wall against which rests the *mihrab*, the chair that faces Mecca. These buildings bear witness to the devotion of this region, where powerful religious orders organized holy rites.

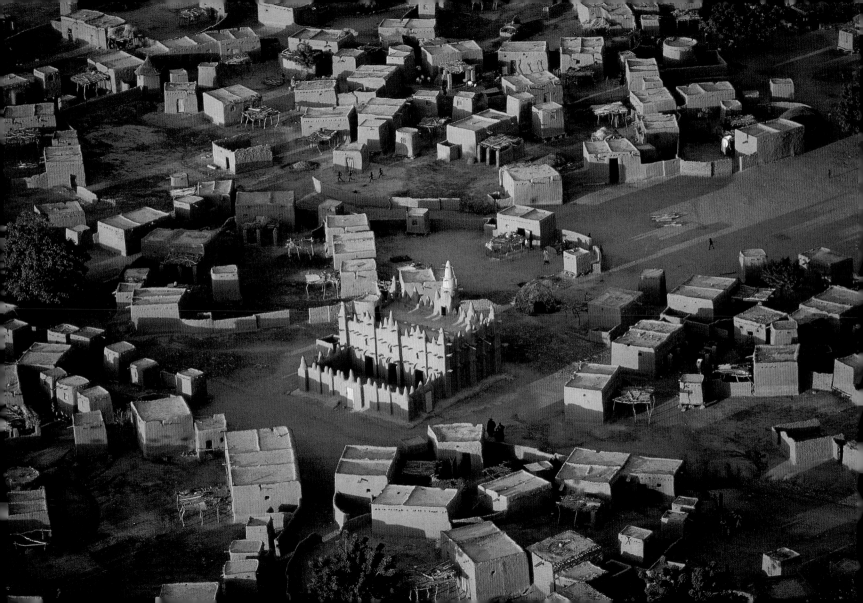

Ivory Coast. Crowd at Abengourou.

The gaiety of this youthful crowd should not blind us to Africa's depressing plight. The continent is economically insignificant, accounting for less than one percent of world trade and with a total output smaller than that of a single country such as Spain. It is also suffering a public health disaster. More than two-thirds of those living with AIDS are in Africa. New strains of malaria and tuberculosis have appeared, bringing yet more premature deaths. Life expectancy is falling below 50 in many countries and in some—such as Uganda, Sierra Leone, Zambia, and Malawi—it is even below 40, the same figure as in France 3 centuries ago. The large percentage of children is explained simply by the early deaths of their parents and grandparents. Fertility is also falling in Africa, as it is in more prosperous regions: there are now 4.5 children per woman in Kenya, down from 8.5 children 30 years ago. In South Africa the corresponding figures are 3.2 and 5. In Africa, as in other parts of the world, the population explosion appears to be levelling off.

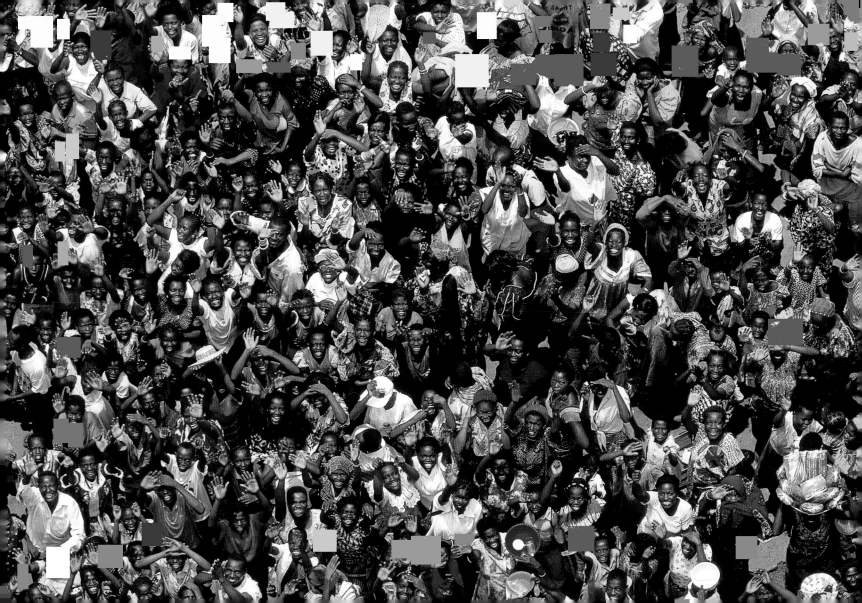

Argentina. Jujuy Province. Quebrada de Humahuaca.

Argentina's northwest is a rough jumble of valleys and high plateaus, reaching an altitude of 3,000 meters (10,000 feet) at Humahuaca. The *quebradas* are the deep valleys typical of the area. The Quebrada de Humahuaca (a name derived from the native Indian name) is 60 kilometers (37 miles) long and 3 kilometers (2 miles) wide. The Rio Grande flows through it, and it is one of the few fertile areas in the region, where tobacco, cotton, sugar cane, maize, and wheat are grown. The Incas passed through here on their way from Peru to conquer the Andes, as did the Spanish who went on to found the cities in the north. The area's population, of very mixed race, bears the marks of these successive invaders and contrasts sharply with the rest of Argentina, where the native population were brutally massacred. As late as the 1930s rewards were still offered to Pampas hunters to bring back the heads of dead Indians. The deeper we go into the valley, the more intense the colors become. Cerro de los Siete Colores (Mountain of the Seven Colors), which rises behind the village of Purmamarca ("the village of the lion" in Quechua), is a blaze of bright hues that contrast sharply with the whitewashed village and the greenery down in the valley.

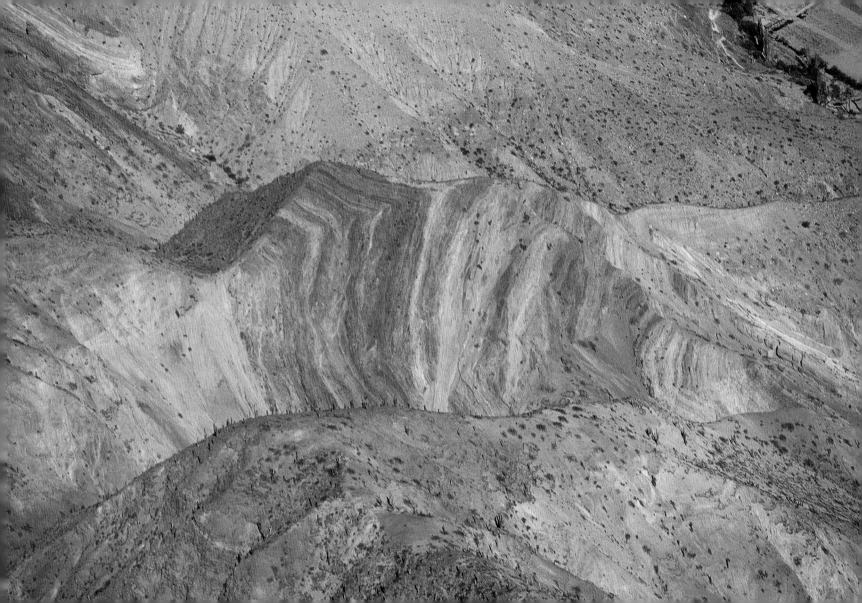

Venezuela. Amacuro Delta. Flight of scarlet ibis near Pedernales.

From the Llanos region across to the Amacuro Delta, where the Orinoco River flows into the sea, are wetlands which make up more than one-third of Venezuela's land area, and are the favorite habitat of scarlet ibis (*Eudocimus ruber*). These waders nest in large colonies in the mangroves and go no further than a few kilometers (a couple of miles) to feed. The carotene in the shrimp, crabs, and other crustaceans they eat gives the species its characteristic red color. Scarlet ibis feathers, once used by native populations to make coats and adornments, are now finding their way into the craft of making artificial flowers. Sought after both for its feathers and for its meat, the bird is now under threat. Found only in Central and South America, fewer than 200,000 individuals of the species remain.

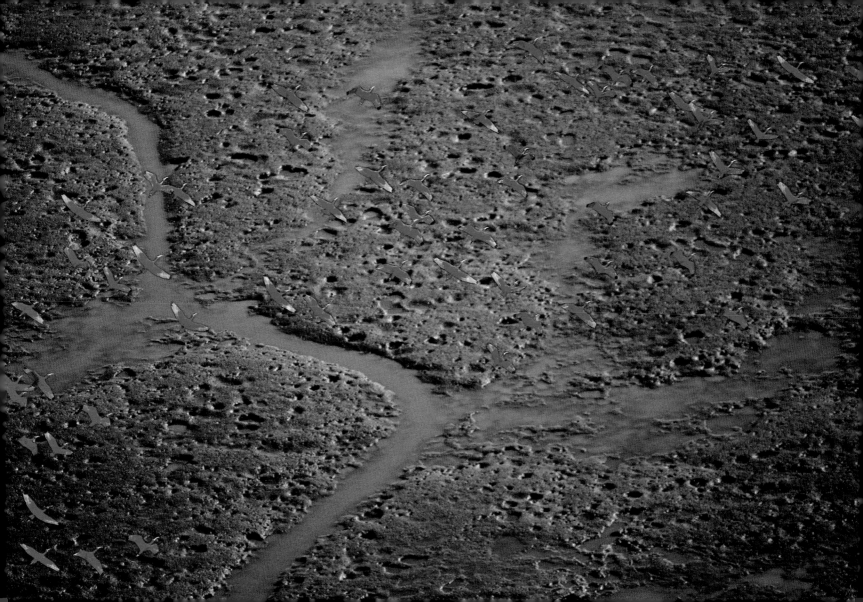

Italy. Veneto region. Venetian Lagoon. The fishing village of Malamocco.

The Venetian Lagoon is separated from the sea by a string of long, narrow islands including that of the Lido, which houses the fishing village of Malamocco. Founded 15 centuries ago, the historic city of Venice is built on 118 islands and increasingly suffers floods known as the *acqua alta* (high water). These have worsened markedly in the last 30 years, during which the city has been flooded very often and on about one hundred occasions by more than one meter (three feet) of water. An ambitious and costly attempt to preserve the lagoon, designated a UNESCO World Heritage Site in 1987, began in 1988. Known as Mosè (Moses), the scheme aims periodically to seal off the three channels that link the lagoon with the Adriatic Sea by means of about 80 movable barriers.

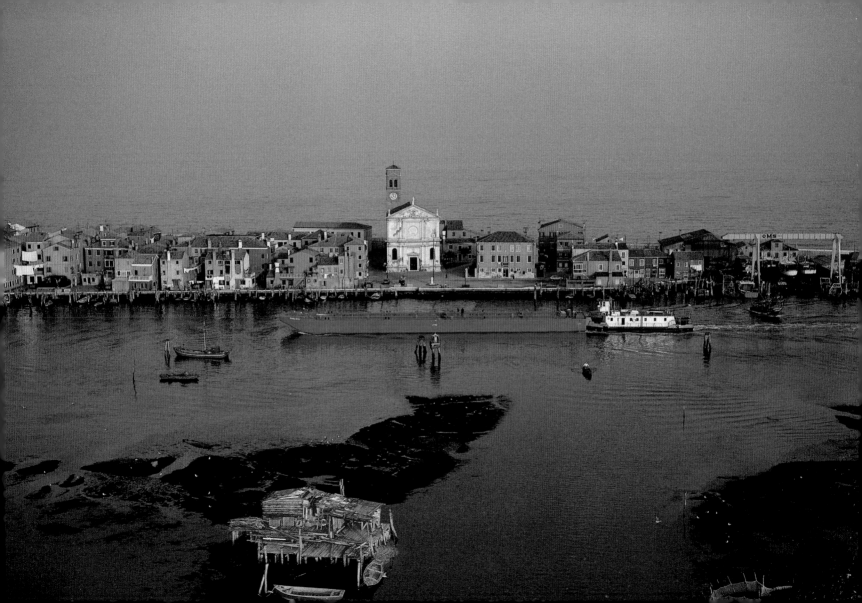

United States. Nevada. An arm of Lake Mead, in the Muddy Mountains.

Building a dam across a canyon to make an artificial reservoir is generally regarded as desirable, in that it satisfies some human needs – even though there will always be those who condemn the despoliation of a landscape they loved. Building a lake in the desert is certainly easier than saving water in a densely populated area. Modern societies face hard choices as growing populations demand better facilities. These choices will become more numerous and painful in the future. Will we one day hear some worried souls demand that other people stop taking up space, so that their own space may be preserved?

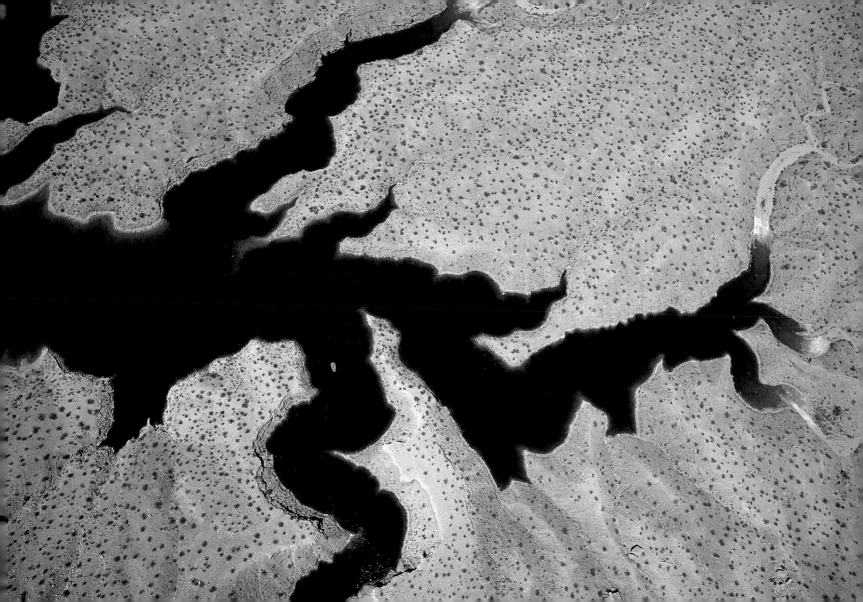

Iceland. Myrdalsjökull region. Stettjökull Glacier.

Iceland is aptly named, for 13 percent of the country is covered by glaciers. But it is also a land of fire, made almost entirely of volcanic rocks, and still growing continuously as new magma is emplaced underground and lava erupts on the surface. Eruptions in Iceland occur once every five years or so. Glaciation and volcanism work in close proximity: the heat of the volcanoes forged the country's shape that the glaciers then molded, carving the mountain ranges and scooping out the fjords of the north, east, and west coasts. The presence of an ice cap on an active volcano – as at Myrdalsjökull in southern Iceland – confirms the link. Searing lava erupted from the volcano melts part of the glacier. The water then bursts out fiercely in the spring thaw, causing devastating floods called jökulhlaups. In the summer of 1918 a torrential flood suddenly gushed from the Myrdalsjökull ice cap, producing a flow three times greater than that of the Amazon at its mouth. Such an event reminds us that volcanoes strongly affect the Earth's processes.

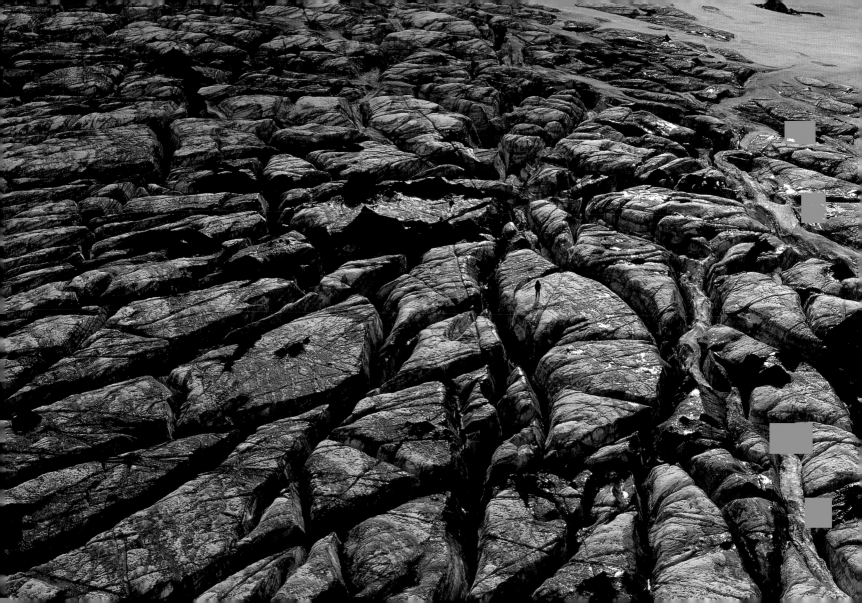

France. Paris. The Louvre pyramid.

Inaugurated at the end of 1988, this great translucent pyramid built in the heart of the Louvre Palace contains the entrance hall of one of the world's greatest museums. Standing 21.65 meters (71 feet) high and built out of 673 glass lozenges and triangles set into a metal frame weighing more than 95 tonnes (105 tons), it is a technological tour de force. However, the pyramid is just the outwardly visible part of a vast restructuring program undertaken at the Louvre by the Chinese-American architect Ieoh Ming Pei. This modern structure, set into a historic building in which many of the kings of France lived, has become the symbol of the Louvre Museum, whose 30,000 works of art are seen by almost five million people every year.

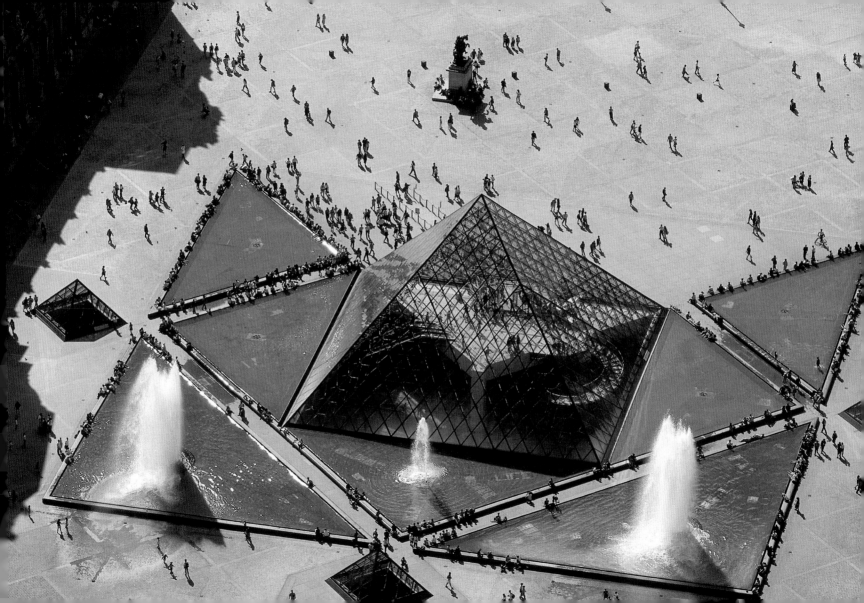

Mali. Dogon village near Bandiagara.

On the border between Mali and Burkina Faso, at the foot of the Bandiagara Cliff, lie the villages of the Dogon people. Celebrated for its subtle architecture, each village is divided into closed neighborhoods where several related families live. The layout of each neighborhood imitates that of the human body: two altars represent the feet; the two houses occupied by the women while they are menstruating represent the hands; dwellings occupy the place of the abdomen and chest; and the council chamber that of the head. The decoration of houses, grain stores, and altars, with its black-and-white checkerboard design, mimics the plan of the irrigated gardens and the pattern of woolen blankets and of masks. The French ethnologist Marcel Griaulé demonstrated the richness of the connections, which fill the daily life of the Dogon with a permanent symbolism linked to their legends and their story of creation of the world by holy twins. This is one example of the way that traditional societies make sense of their place in the mysterious and hostile world that surrounds them.

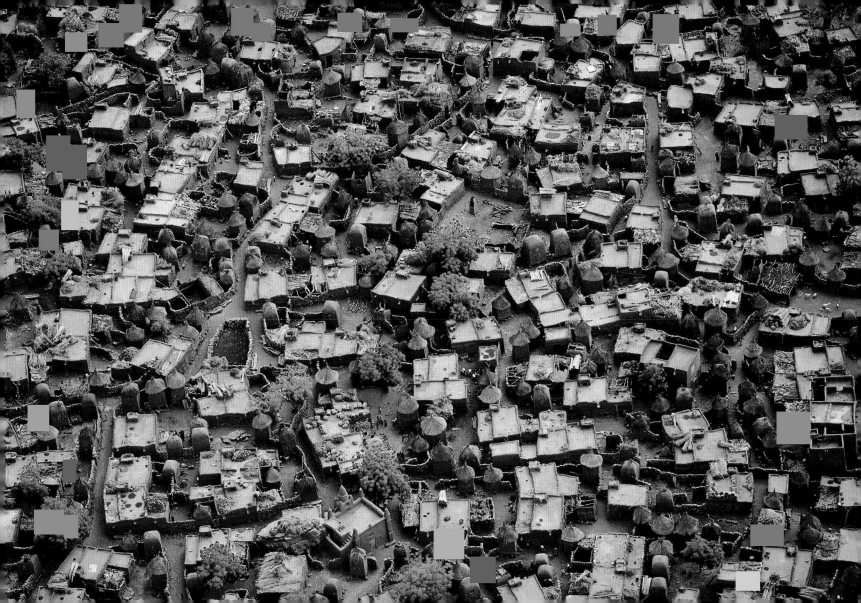

Turkey. Anatolia. Women working in the fields.

Over the last two decades of the twentieth century, farming was increasingly handed over to women, and 40 percent of the world's agricultural work force is now female. A striking example of this is Turkey, where about 80 percent of working women are employed in farming, outnumbering men. The latter have deserted the countryside for the cities in search of better-paid work and a chance to climb the social ladder, but return to help the women during the busy sowing and harvesting times. Their seasonal migration recalls that of the workers in the Creuse and Limousin regions of France, who built the Paris Metro and many of the city's freestone buildings at the beginning of the twentieth century. It is an irony of modernization that this traditional division of tasks only deepens the inequality between women and men.

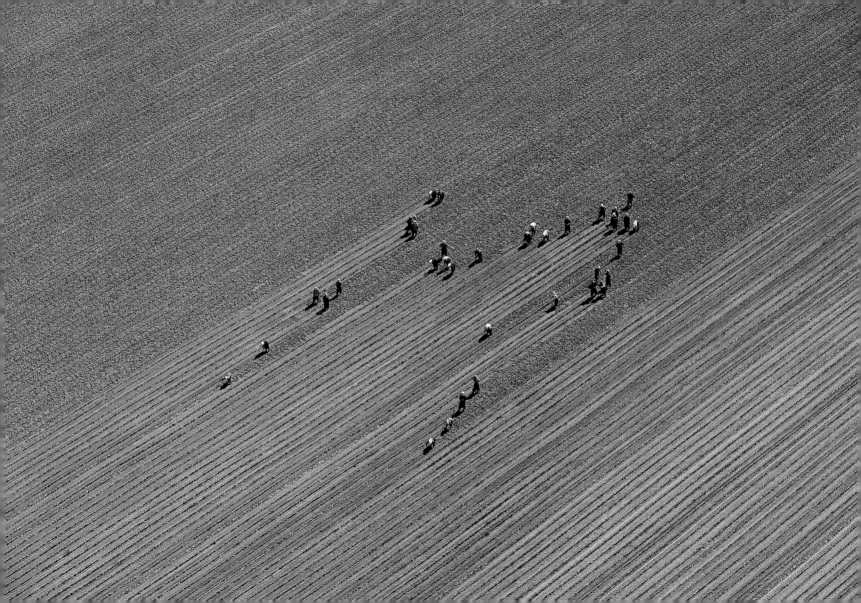

Brazil. Slums in Rio de Janeiro.

Almost one-quarter of the 10 million *Cariocas*, the inhabitants of Rio de Janeiro, live in the city's 500 slums. These *favelas* have grown at an increasing rate since the beginning of the twentieth century and are fertile breeding grounds for crime. Poor and lacking in basic services, most cling to hillsides and regularly suffer lethal landslides at times of heavy rain. On the other hand, the affluent middle classes, who make up 18 percent of Cariocas, live in residential districts on the lower ground adjoining the sea front. This stark social contrast reflects that of Brazil as a whole. The majority of the country's wealth is controlled by only 10 percent of its citizens, while almost half live below the poverty line. About 25 million Brazilians live in slums.

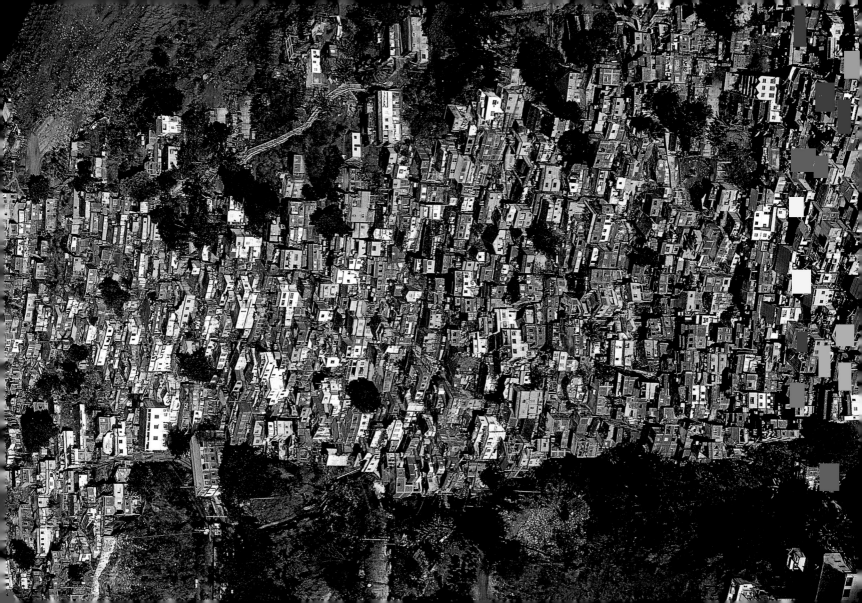

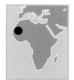

Mauritania. Caravan of dromedaries among sand dunes near Nouakchott.

Adapted to the severe desert environment, dromedaries are vital to this country bordering the Sahara, the world's largest sand desert, covering almost 8 million square kilometers (3 million square miles). Mauritania is 90 percent desert, which makes it particularly vulnerable to environmental change, natural or otherwise. Many of the borders of the vast areas of sand dunes are contained by growths of natural vegetation that can tolerate drought; this is particularly common close to slightly less arid areas where people have been able to settle. Just a slight variation in climate, or the overexploitation of plant resources on these desert fringes, is enough for the sand to start moving. Several large towns in Mauritania, notably the capital, Nouakchott, are threatened by the advancing desert.

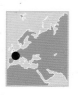

France. Seaweed in the Gulf of Morbihan.

In the 1920s, an epidemic wiped out France's most widely cultivated species of oyster, *Crassostrea angulata*. A Japanese species, *Crassostrea gigas*, was introduced, and inadvertently along with it about 30 other species of animals and algae, which are now established in the English Channel and the Atlantic. One of these is the brown algae sargassum (*Sargassum miticum*), which has taken over the native species, as seen here in the Gulf of Morbihan. Despite fears that it would take over completely, this species, though common, appears to have found its niche in the ecosystem. Nevertheless, it is being carefully monitored. Brittany has over 2,700 kilometers (1,700 miles) of coastline, 70 percent of which is developed. The Conservatoire du Littoral, the French government body in charge of seashore conservation, owns 4,000 hectares (10,000 acres) in the region, more than half of it in sites larger than 100 hectares (250 acres).

Madagascar. Toliara region. Baobabs south of Belo.

The fourth largest island on Earth, Madagascar is slightly larger than France. It separated from Africa more than 100 million years ago, and its plants and animals have since evolved independently – 80 percent of its species are endemic to the island. Among these are seven of the world's eight known species of baobab. These trees can store several thousand liters (about a thousand gallons) of water in their huge barrel-shaped trunks, allowing them to survive the dry season, which in the Toliara region lasts from April to November. Baobabs are a precious resource. Their bark is used to build huts and manufacture ropes; their fruits, similar to gourds, and their leaves, which are rich in calcium, are eaten; the seeds are crushed to extract their oil, used to make soap; and the trees' sap is used in manufacturing paper. The ingenious use of local natural resources is a reminder that many species contain precious resources (notably chemicals and pharmaceuticals). This is one argument for conserving biodiversity, as agreed at the Earth Summit held in Rio de Janeiro in 1992.

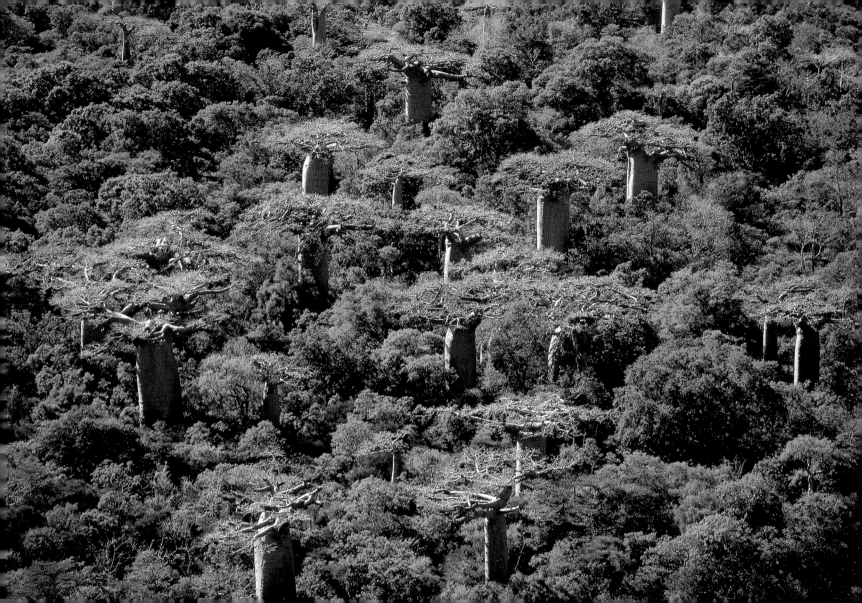

Australia. Northern Territory. Uranium mine in Kakadu National Park.

Within the boundaries of Kakadu National Park, but excluded from it by law, are three sites – Ranger, Jabiluka, and Koongarra – which together contain 10 percent of the world's uranium reserves. The sites lie on land sacred to Aborigines of the region. Against the Aborigines' wishes, Ranger has been granted a mining license; the other two have thus far been denied licenses because of controversy over the risk of pollution. In the area pictured, where uranium mining waste is dumped, large sprinklers wet the shores of the marsh in order to keep the dust from blowing around in the wind. When the water evaporates, it leaves these white encrustations of salts and sulfates. Australia possesses one-quarter of the planet's uranium reserves, and in 1996 accounted for 14 percent of world production. Most is destined for nuclear reactors.

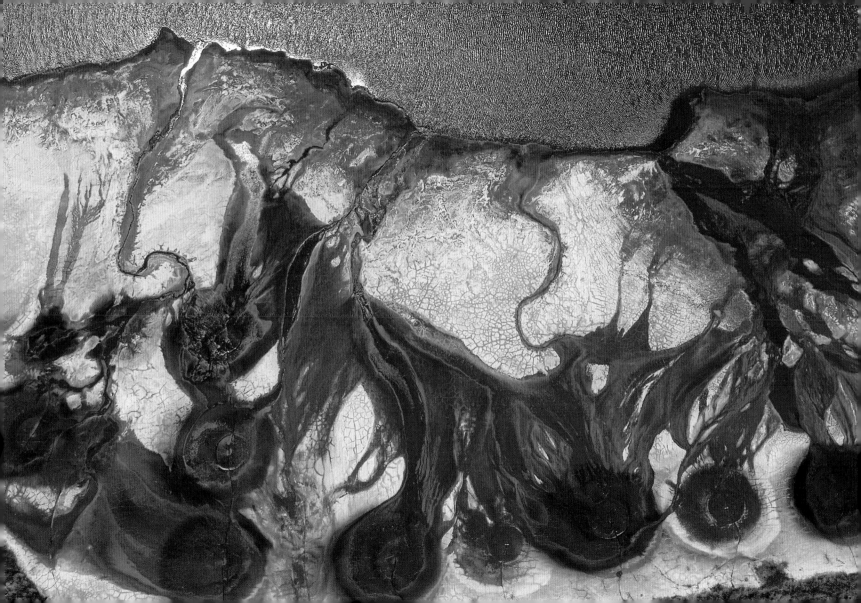

United States. Wyoming. Yellowstone National Park. Grand Prismatic Spring.

Located high on a volcanic plateau that straddles the states of Montana, Idaho, and Wyoming, Yellowstone is the oldest national park in the world, created in 1872. It has an area of 9,000 square kilometers (3,500 square miles) and contains the greatest concentration of geothermal sites in the world, with more than 3,000 geysers, fumaroles, and hot springs. Grand Prismatic Spring is the park's largest thermal pool – 112 meters (367 feet) across – and the third largest in the world. The range of colors that give the pool its name comes from different varieties of algae. The pool supports certain types of microorganisms at the center where it is hottest, and different varieties toward the edges where it is cooler. Made an International Biosphere Reserve in 1976 and a UNESCO World Heritage Site in 1987, Yellowstone receives 3 million visitors each year. The five most-visited natural sites in the world are all in the United States and Canada. North America as a whole receives more than 100 million tourists per year, or more than one-fifth of the world total.

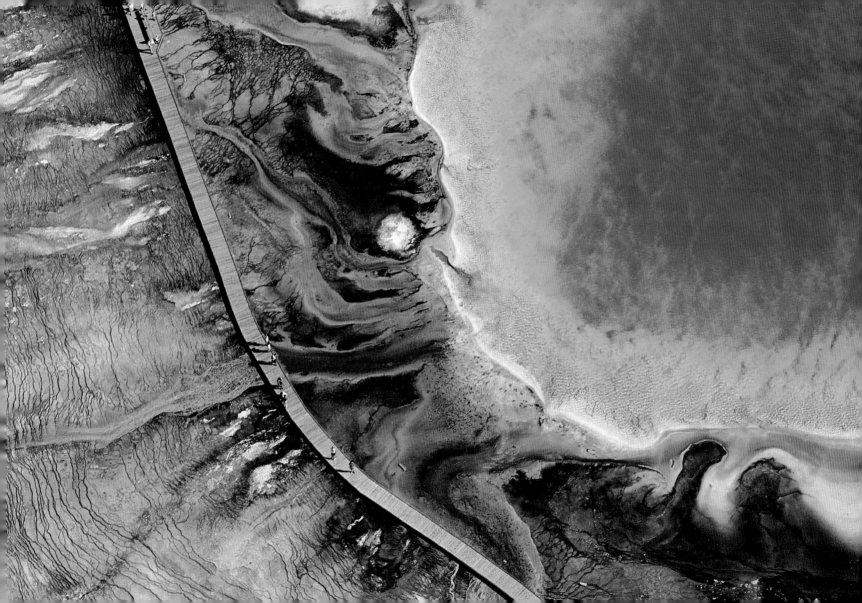

Thailand. Chiang Mai region. Wat Phra Doi Suthep above the city of Chiang Mai.

Today Chiang Mai is the capital of Thailand's mountainous northern region, and the country's second city. But from the end of the thirteenth century to the seventeenth it was the religious center of the great kingdom of Lân-na, which stretched as far as China. The temple of Wat Phra, built in the old Lân-na style at about 1,000 meters (3,300 feet) on the mountain of Doi Suthep, acted as a sentry for the city. The stupa houses relics of the Buddha. Its covering of gilded copper, and the golden one of the four parasols around it, are constantly maintained by the faithful, who earn spiritual credits for doing so. The *jaofao*, defensive barbs that decorate the roof, protect the temple from evil spirits that wander in the sky. Buddhism is practiced by 95 percent of Thais, and has cemented the country's unity. Temples were once hospices, orphanages, and education centers, and they have remained public buildings. As most Thai men live as monks for some months before beginning their working lives (and continue to support the monasteries thereafter), temples remain central to people's lives.

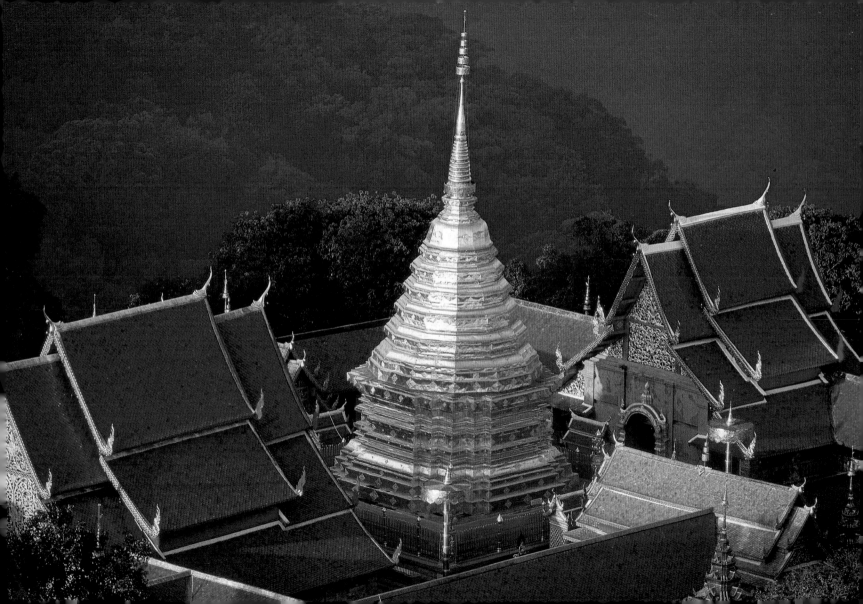

France. Yvelines Department. Horse training ground at Maisons-Laffitte racecourse.

Maisons-Laffitte, near Paris, sports one of the largest riding centers in France; its tracks and stables accommodate almost 800 horses. Swept daily with harrows, training grounds such as the Adam trail pictured here, are used to exercise young horses and train them in jumping before they are allowed onto the tracks and finally on the racecourse proper. Maisons-Laffitte runs more than 250 races a year, with almost 3,000 participants. Horse racing is an important part of the gambling industry. Worldwide, more than $100 billion is bet every year – $44 billion of it by the Japanese, the world's greatest gamblers.

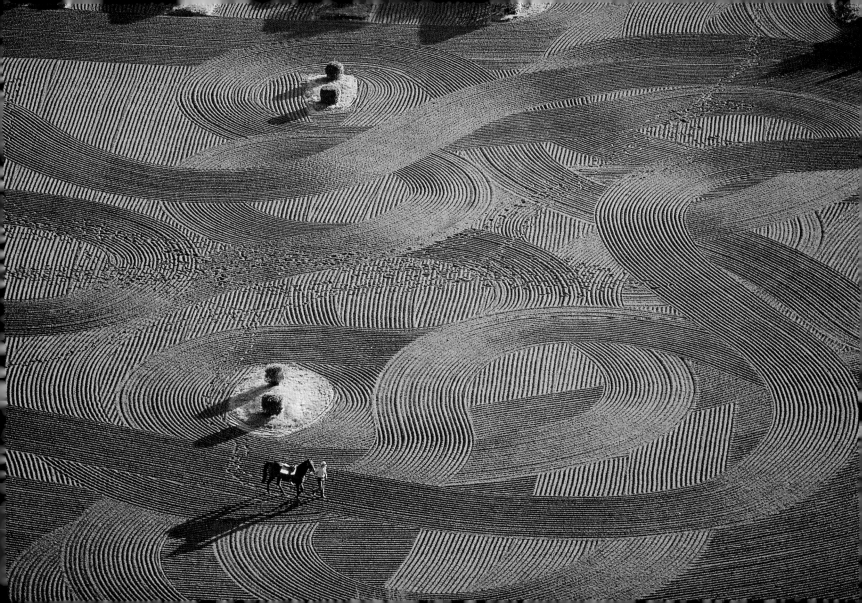

Ivory Coast. Yamoussoukro region. Goats being transported near Toumodi.

Traveling through the region of Yamoussoukro (the Ivory Coast's administrative capital since 1983), these goatherds ride in a trailer with their flocks, probably on their way to sell them at one of the country's many markets. All over West Africa, the nomadic people of the Sahel region, the Peuls in particular, traditionally devote themselves to raising livestock, much of which they export to countries on the coast. Over the last 30 years the improvement of the road network in West Africa has contributed greatly to the growth in trade, especially livestock. This is particularly true of the Ivory Coast, which since the 1970s has more than tripled the number of paved roads and now possesses the best network in the region after Nigeria's.

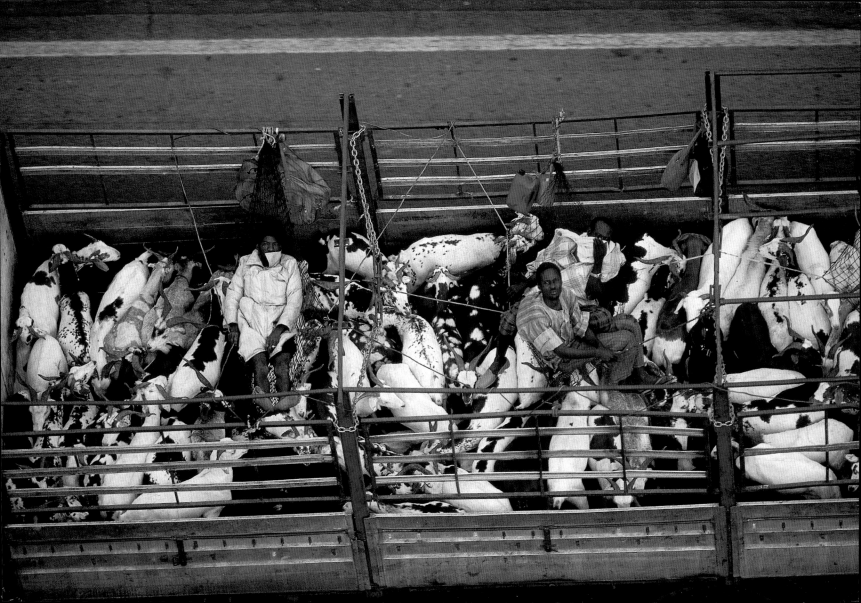

United States. New York. Chelsea Piers golf range.

Opened a few years ago, Chelsea Piers is New York City's biggest sports complex. It is located on the Hudson River at the western edge of Chelsea, a shopping district with antique dealers, bookstores, clothing boutiques, art galleries, restaurants, and delis. But above all, Chelsea is a residential area whose history is representative of the urban United States: its industrial past, with overhead subway lines, nineteenth-century residential blocks, and warehouses with cast-iron facades; and its population made up of immigrants who arrived in the nineteenth century and moved into tenements. The very existence of this vast sports complex in a city so short on space says something about of the American way of life, which holds sports in the highest esteem. One can play almost any sport here, from basketball and boxing, to volleyball, soccer, and golf. This last, far from being the privilege of the leisured classes, has long been popular with the middle and working classes. The U.S. has more golfers than any other country.

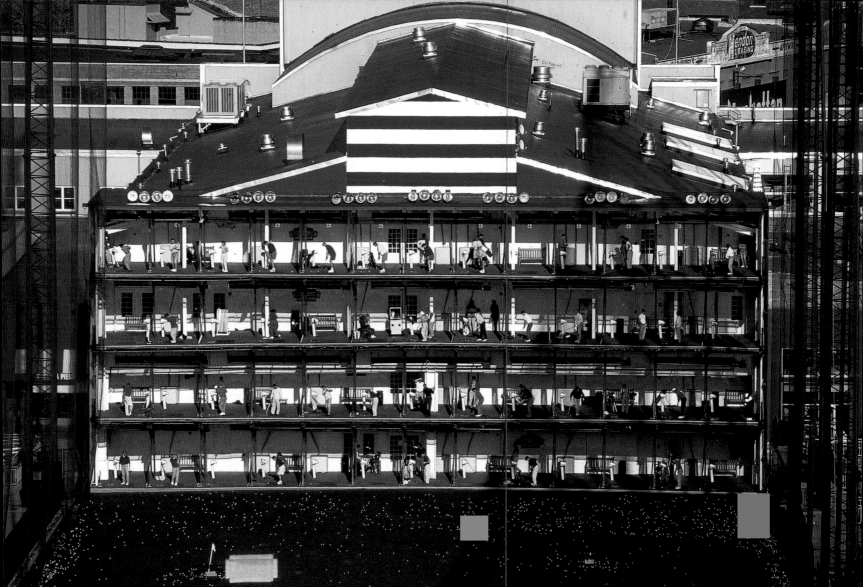

Turkey. Anatolia. Tourist in a swimming pool in Pamukkale (Hierapolis).

The healing properties of the hot, mineral-rich springs in the town of Pamukkale in western Anatolia have been famous since ancient times. In 129 B.C. the Romans built the spa town of Hierapolis, which suffered four earthquakes and was rebuilt several times before it fell into decline under the Byzantine Empire. Today its remains attract many visitors. Even a motel has been built over the ruins of a holy fountain, and its swimming pool, whose floor is strewn with fragments of Roman columns, is very popular with tourists. Hierapolis-Pamukkale was made a UNESCO World Heritage Site in 1988, but has been marred by many new hotels. Although their demolition was ordered in 1992, they remain standing.

Morocco. Western Sahara. Sebkhet Aridal, near Cape Boujdour.

The Lemnaider Wadi, which feeds this *sabkha* (a temporary salt lake) in the rainy season, has withdrawn, leaving a network of salt-encrusted channels in the sand. Typical of the arid parts of the Maghreb, sabkhas are found in southern Morocco, in the heart of the western Sahara. This desert area stretches for 2,500 kilometers (1,600 miles) along the Atlantic coast and covers 252,000 square kilometers (97,000 square miles). It was formerly a Spanish colony, and was claimed by Morocco when Spain withdrew in 1975. However, the Polisario Front (Popular Front for the Liberation of Saguia al-Hamra and Rio de Oro), supported by Algeria, subsequently declared the region independent and began an armed resistance. A Sahrawi Arab Democratic Republic (SADR) was proclaimed, became a member of the Organization of African Unity (OAU), and was recognized by 70 African and Asian states. However, it is not internationally recognized as the legitimate government of the region, and the western Sahara is still considered to be part of Morocco.

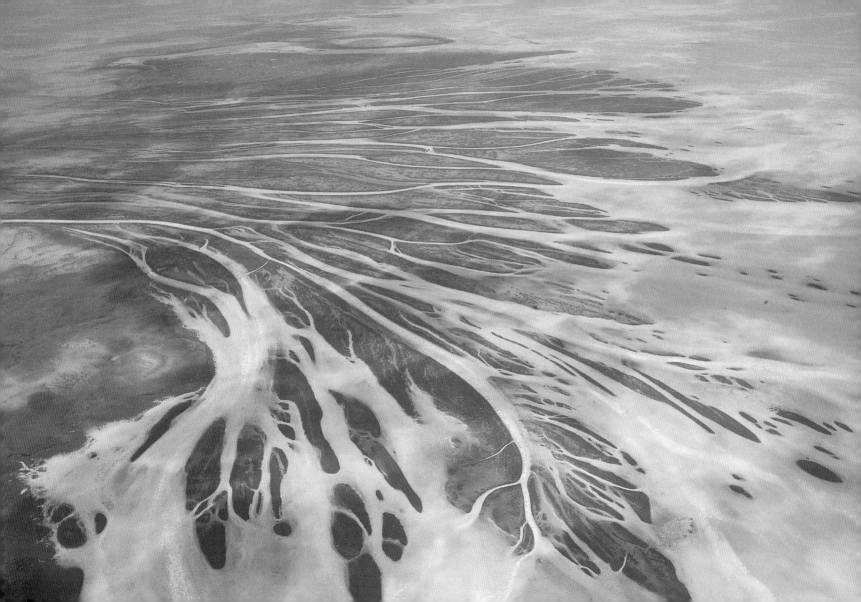

Tunisia. Governorate of Gabès. Matmata. Troglodyte dwellings.

While some Berbers in southern Tunisia were taking refuge on hilltops, others were doing so underground (*trogle* is the Greek word for "hole" or "cave") to escape both invaders and the harsh desert climate. In the underground town of Matmata where "the living live beneath the dead," tunnels lead to cylindrical subterranean courtyards surrounded by one or more stories of chambers hollowed out of the rock. The softness of the rock made it easy for the inhabitants to dig more rooms as their families grew, and this termites'-nest-like complex expanded until it numbered more than 700 dwellings. Berbers still live here, the women working at home weaving cloth on hand looms. Although they retained their language, they did convert to Islam. And their integration into the modern world will not stop there: like the Bedouin in the Nabatean Grottoes of Petra, and the inhabitants of the caves of Matera in Puglia, Italy, the Berbers may soon be prohibited from living underground, forced to move away to live, European-style, in the suburbs of Médenine or Gabès.

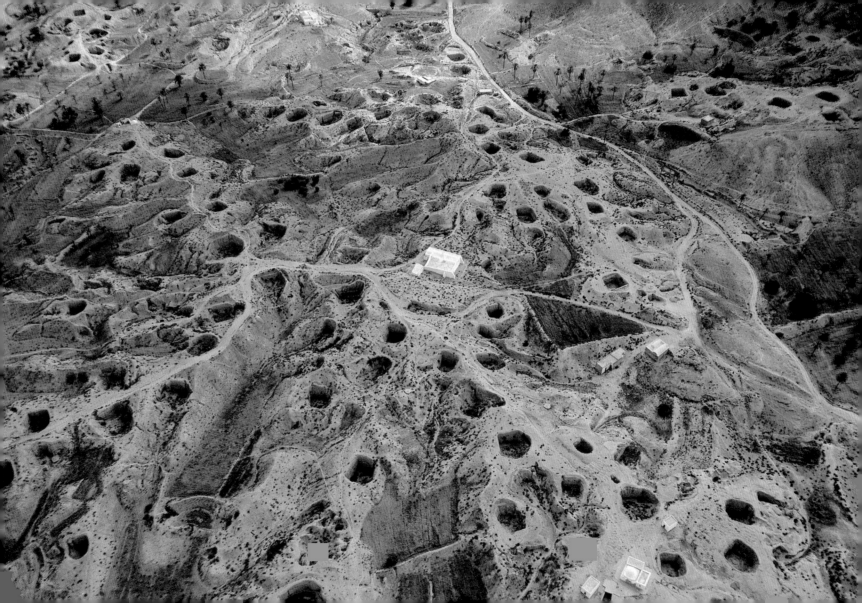

Ivory Coast. Abidjan. Washing laundry in a river backwater in the Adjamé District.

In the northern AdjamÈ District of Abidjan, hundreds of professional launderers, called *fanicos,* wash clothes daily in this backwater on the edge of the Banco Forest National Park. Using stones and old tires filled with sand to rub and wring dry the linen, they hand wash thousands of items of clothing. Like all the planet's inhabitants, these people's lives depend on the quality of their water supply. By 2025, it is likely that more than 3 billion people in the world will not have access to clean water. Distributed unequally over the Earth's surface, water is today an international issue. The countries that will be able to develop are those with access to enough water for agriculture, industry, and internal domestic needs. Consumption is growing. Consequently, access to water has become a source of friction, and control of rivers of prime importance for many countries, particularly those in the arid Middle East. More insidiously still, water, long considered a common resource, has become a traded commodity, questions of its availability leading to may problems. Drinking—that most natural and necessary of human acts—will become ever more expensive.

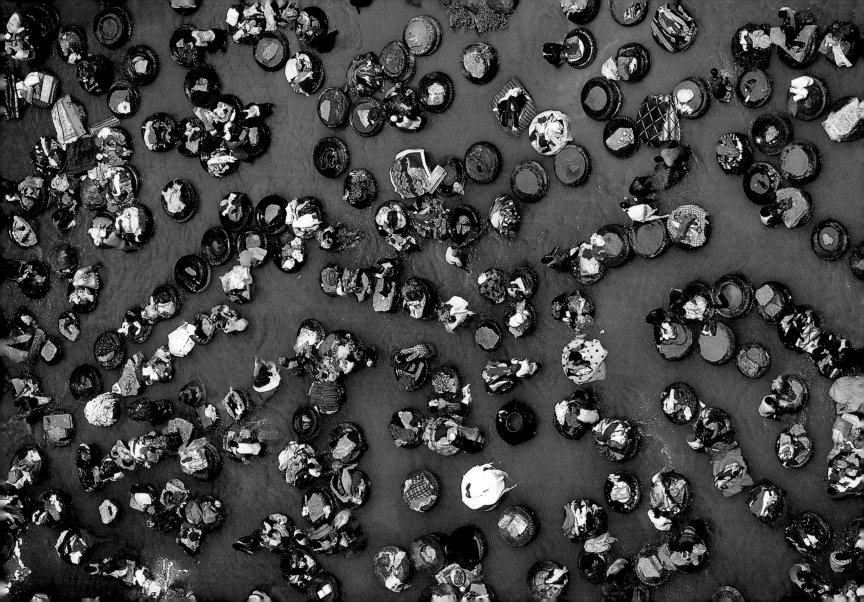

Botswana. Lechwe in the Okavango Delta.

Lechwe are marsh-dwelling antelope that find both food and shelter from predators in islets covered in vegetation. Lechwe are common in Botswana's Okavango Delta, which is home to 40 other species of large mammals, 400 birds, 95 reptiles and amphibians, 70 fish, and 1,060 plants. Two million years ago, the Okavango flowed into the Limpopo River, which drains into the Indian Ocean, but violent movements of the Earth's crust changed its course. It is now one of the few rivers on Earth that does not flow into a sea or a lake. Instead, the Okavango simply forms a vast interior delta, which covers 15,000 square kilometers (5,800 square miles) on the edge of the Kalahari Desert. The delta has been protected since 1996 when it was added to the Ramsar Convention's list of Wetlands of International Importance. The list includes over 950 wetlands worldwide.

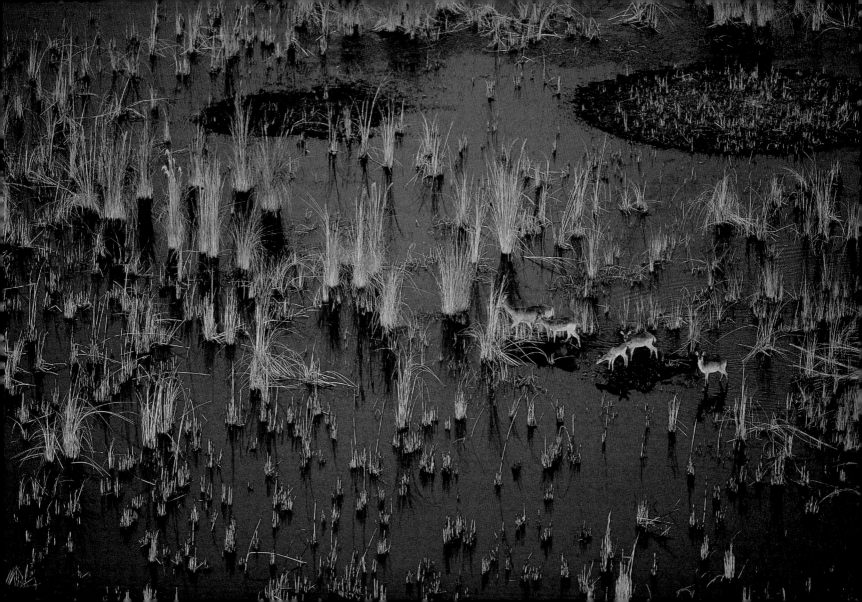

Venezuela. Amazonas region. The Orinoco River near the Esmeralda (Amazon Rain Forest).

The Orinoco is the world's fourth largest river in terms of the volume of its flow. From its source in southern Venezuela it flows into the Atlantic, collecting most of the region's other rivers and streams along the way. It is navigable over 700 kilometers (435 miles) and is still the main transport route into a region with an area of almost 180,000 square kilometers (70,000 square miles). The lack of transportation links has allowed the Amazonian forest and savannah, with their 8,000 plant species and 680 bird species, to remain relatively undamaged. Indigenous peoples have also survived – the Yanomami in particular, one of the world's few remaining populations of hunter-gatherers. But this is only a respite. Landless farmers set fire to the forest, driving away the Yanomami; poachers use them as guides when seeking rare animals for rich collectors; and gold prospectors exploit them for cheap labor. The massacre of the Yanomami is intensifying, and it seems unlikely that any of them will remain untouched by globalization.

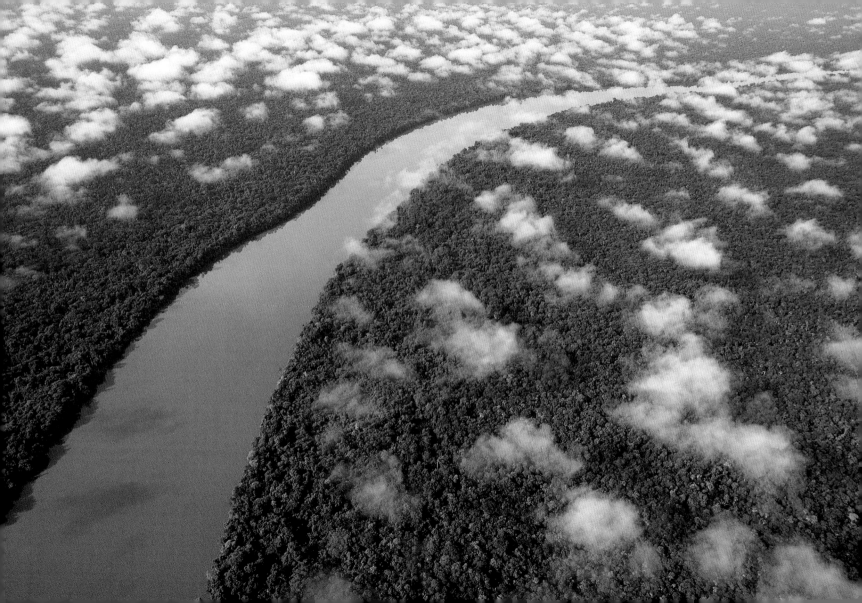

Ukraine. Pripet. Abandoned town near the Chernobyl nuclear power station.

The worst nuclear accident of all time occurred on April 26, 1986, when the Number 4 reactor of the Chernobyl power station in the Ukraine exploded, sending a radioactive cloud over the Ukraine, Belorussia, and Russia, which then spread over the entire northern hemisphere. The total cost of the damage over 30 years is estimated at several hundred billion dollars. Belorussia sets aside 20 percent of its annual budget to deal with damage; Ukraine spends up to 10 percent. The cost to people's lives has been enormous. While the exact number of victims remains widely disputed, it is estimated that several million Europeans are suffering illnesses linked to radiation poisoning. Cancer of the thyroid and congenital deformities affect a significant proportion of Belorussians and Ukrainians, especially the younger, and experts forecast an increase in leukemia over the next 35 to 50 years. This disaster puts the spotlight on nuclear safety throughout the world, particularly in Russia and the former Soviet Republics, which still use reactors of the same RMBK-type as Chernobyl. Chernobyl itself continued to function after the accident, and was only closed permanently on December 15, 2000, despite difficulties in securing and coordinating international aid. Nuclear policy is being challenged by a growing number of citizens' groups.

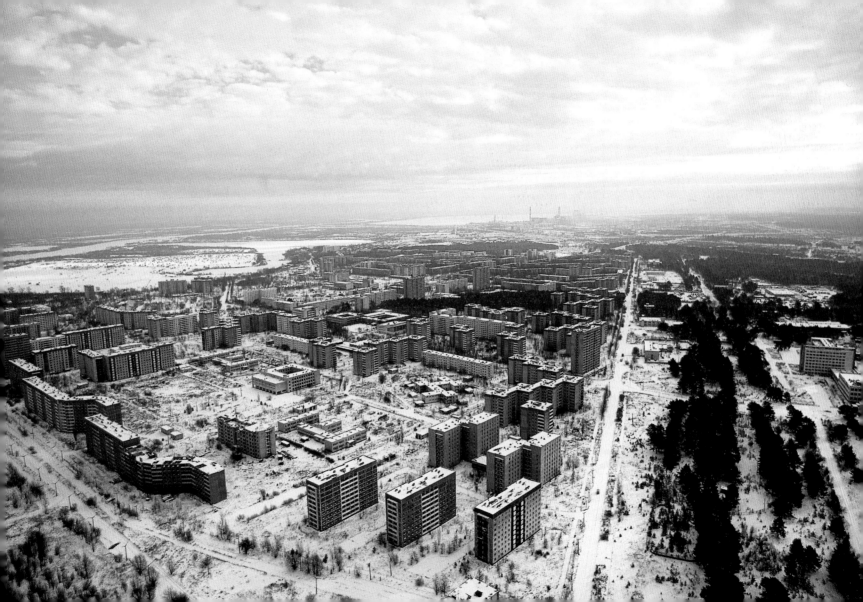

Argentina. Santa Cruz. Perito Moreno Glacier.

Established in 1937, the Los Glaciares National Park lies in southern Argentina on the Chilean border. This 4,459-square-kilometer (1,722-square-mile) protected area contains 47 glaciers that flow from the Patagonian ice sheet, the largest in the world after those in Antarctica and Greenland. A total of 5,000 meters (16,500 feet) wide and 60 meters (200 feet) thick, Perito Moreno flows into an arm of the Argentino Lake, dragging with it glacial debris of rocks scraped from its floor and banks, which themselves then erode and shape the landscape. Every three or four years the glacier dams up the regions where the two arms of the lake meet. The pressure of the water builds up and eventually shatters the ice barrier with a sound that can be heard for several kilometers (a few miles) around. Glaciers and polar ice caps cover nine percent of the Earth's land surface. They are likely to begin melting as a result of global warming brought on by human activity, raising sea levels and drowning fertile coasts.

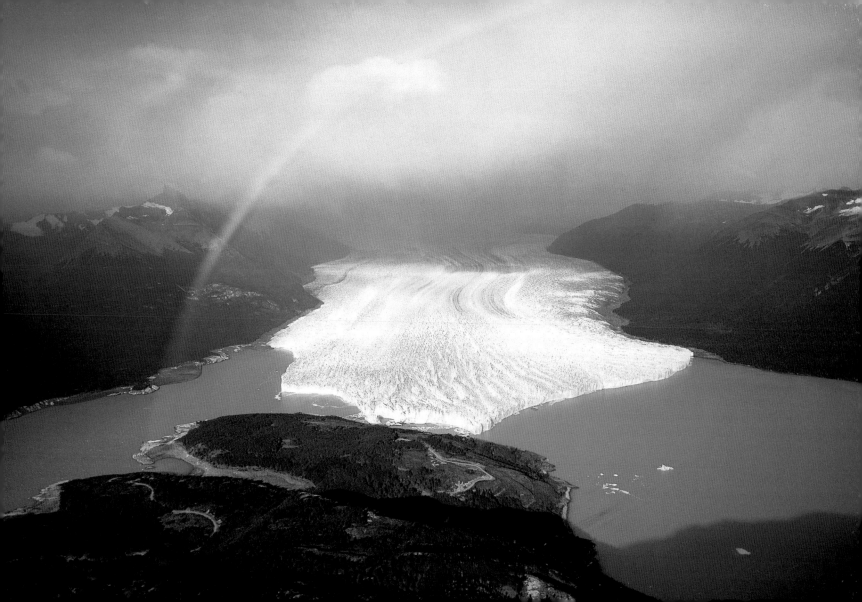

United States. New York City. Baseball player in Yankee Stadium.

In the heart of a poor area of the Bronx, Yankee Stadium retains its lovingly tended grass at a time when many American playing fields are installing synthetic turf. The 55,000-seat baseball stadium has been the home of the New York Yankees since it opened in 1923. The Yankees have been one of the most successful teams in Major League baseball, winning the World Series Championship 26 times as of October 2000. Baseball was born before 1850 in the U.S. and soon became a professional sport as well as "the National Pastime." It is the world's second most popular sport, with 80 federations and 150 million participants worldwide, and became an Olympic sport in 1986. Surprisingly, the most popular sport in the world (in terms of the number of federations and official participants) is volleyball, with 210 federations and 180 million participants.

Madagascar. Village among rice paddies, near Antananarivo.

The Merina, an ethnic group of Indonesian origin, make their living growing rice by traditional methods in the plains around their villages in the Antananarivo region of Madagascar. In an attempt to grow all their own rice, Madagascar's paddies have been greatly expanded and now cover two-thirds of the country's farmland. Rice is grown in two ways: wet, in flooded terraces and along rivers; and dry, on land cleared by burning or on steep slopes. Although Madagascar consumes more rice per person than any other nation (120 kilograms [265 pounds] per year), it is not a big producer, placing about twentieth in the world with an annual production of 2.5 million tonnes (2.75 million tons). For many years it has produced a luxury strain while importing a medium-quality one. Rice, wheat, and maize are the most popular grains worldwide.

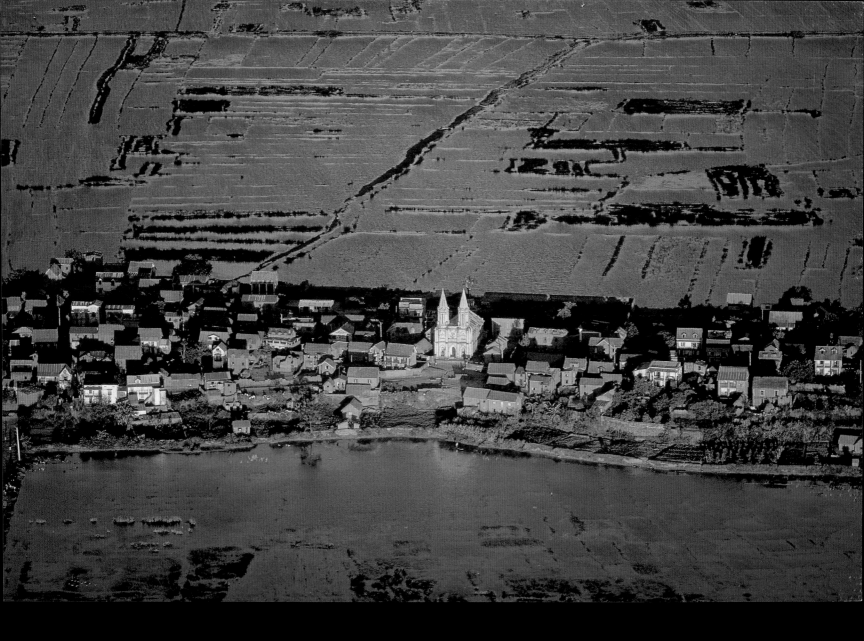

Venezuela. Miranda region. Los Roques Archipelago, north of Caracas.

The Los Roques Archipelago, 170 kilometers (105 miles) off the coast of Venezuela, still lives up to Christopher Columbus's description of it as "an earthly paradise." It is surrounded by a coral reef and consists of about 50 small, flat, sandy islands, called *los cayos* (keys), and many coral coves, all of which enclose a large central lagoon. It is an important reserve for many species including turtles, sharks, dolphins, grouper, large shellfish, and birds. In 1963 a scientific foundation was set up to protect the species most threatened by overfishing. In 1972, for the same reason and in order to more effectively protect the region from booming tourism, the Venezuelan government made the archipelago a national park. This may also have been done to guard against treasure hunters and those who plunder wrecks. For two centuries these remote islands were the haunt of buccaneers who lay in wait for Spanish galleons laden with gold from the Americas.

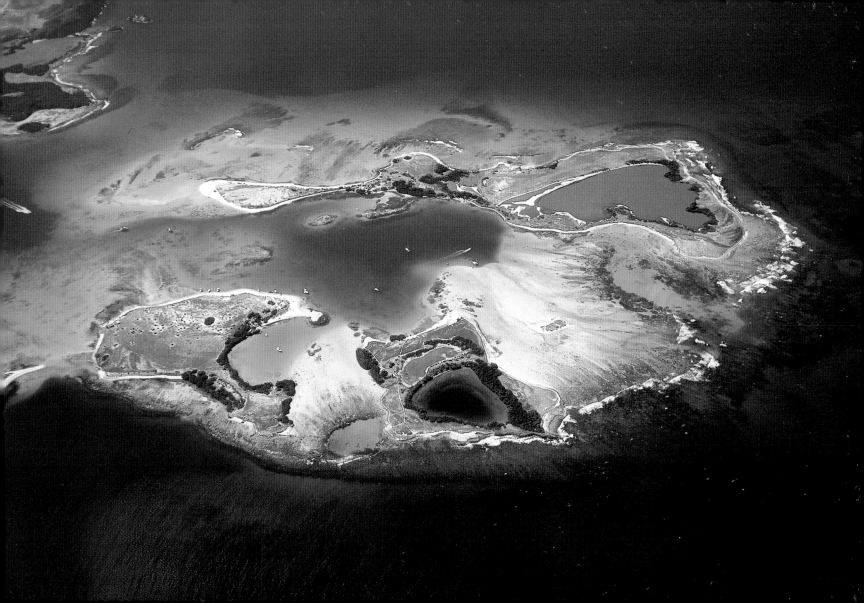

Russia. Kamchatka. Karymskaya volcano erupting.

The mountainous volcanic peninsula of Kamchatka, in the far east of Siberia, is a place apart in the Russian Federation. Not only is it 6,000 kilometers (3,700 miles) from the capital, but it also seems to be far from the minds of the Russian authorities, who have done little to encourage its economic development since the dissolution of the Soviet Union. Kamchatka nevertheless plays its part in the country's economy thanks to its natural resources (including coniferous forests, vegetables, potatoes, and dairy products), its fishing industry, and the development of its coastal cities. Its population is concentrated in towns and consists chiefly of Russians, who live alongside the region's indigenous peoples, including the Kamchadal, also known as the Itelmen.

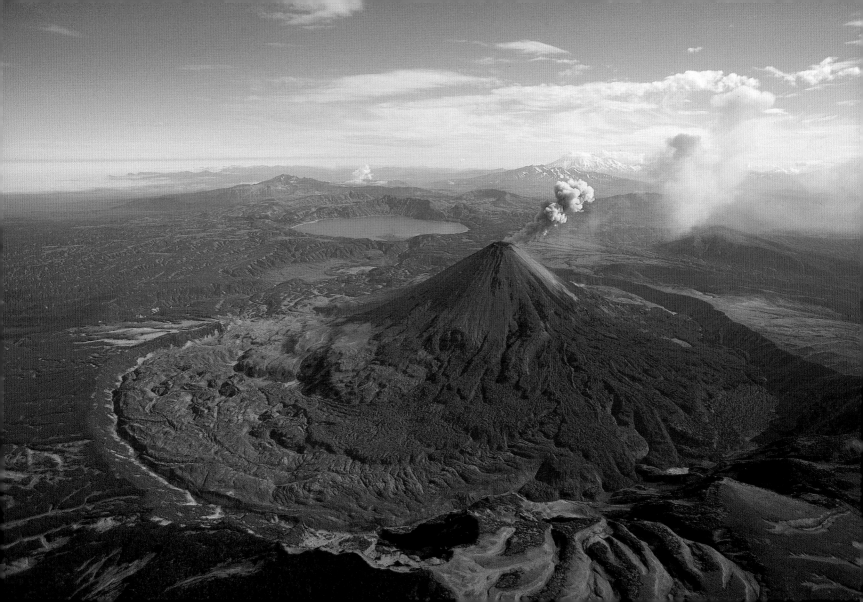

Oman. Secluded house in the mountains of the Musandam Peninsula.

 This house built of native stone melts into the landscape and appears to watch over the valley, just as the peninsula itself watches over the Strait of Hormuz. Strategically placed overlooking the trade route between the Persian Gulf and the Indian Ocean, Musandam was, for a long time, a hiding place for pirates, and coveted by both Persians and Arabs. Now part of the Sultanate of Oman, though separated from it by a 50-kilometer (30-mile) strip of land belonging to the United Arab Emirates, the peninsula adds to the country's influence by allowing it to control sea traffic, especially oil tankers, and thus reinforces its position as the guardian of the Gulf. The Strait of Hormuz has played an important part in relations among countries in the region, for example during the Iran-Iraq war of 1980–88 and the Gulf War of 1991.

Equador. Guayas. Slum in Guayaquil.

With its 2 million inhabitants, Guayaquil is one-third larger than Ecuador's capital, Quito. The prosperity of this industrial and commercial port, through which 50 percent of the country's exports and 90 percent of its imports pass, has attracted growing numbers of people from the surrounding countryside. One-fifth of Guayaquil's population lives in slums, whose houses are built on stilts in marshland. These poor neighborhoods, where the ground underfoot is made up of refuse brought in by the tide, have no sanitation and suffer alarming public health problems. In recent years Latin America's cities have been the fastest growing in the world: between 1950 and 1999, the proportion of town-dwellers rose from 41 to 77 percent.

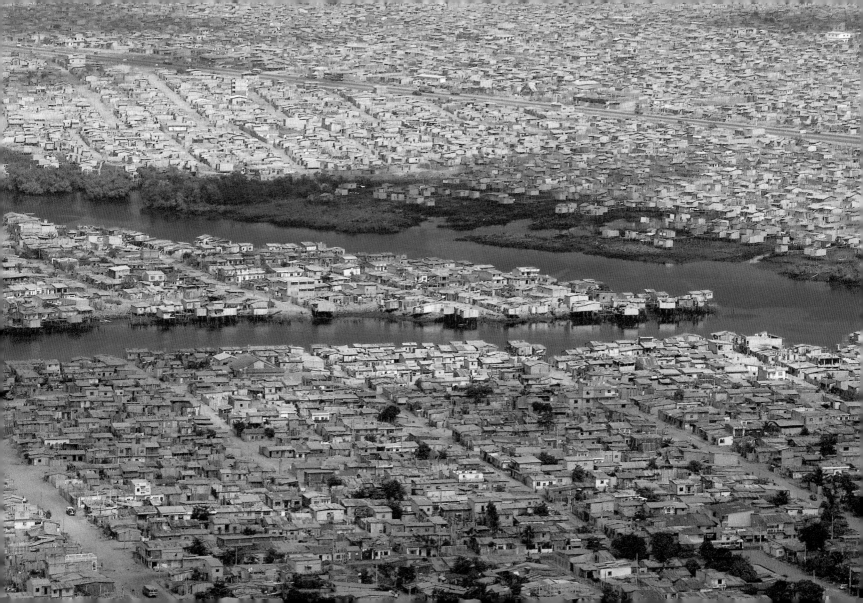

France. Côtes d'Armor. Mussel farming in the Bay of Saint-Brieuc.

The deep Bay of Saint-Brieuc, which has an area of 800 square kilometers (300 square miles), offers many kinds of fishing: gathering scallops, catching lobsters and spider crabs in pots, and trawling for ray, sole, and brill. But the ocean's bounty is not unlimited, and during the 1960s biologists warned that the oceans were being overfished. Fish-farming offered an alternative to fishing; after oyster farming came mussel farming. Growing in clusters attached to 2-meter (6-foot) poles which are covered at high tide, or in deep water on long weighted lines, the mussels are left to grow for 15 to 24 months. Each can produce several million eggs per year and the species' future seems secure, unlike that of many "wild" marine resources that are in decline. More than 8,000 years ago domestication led to the disappearance of wild horses and cattle. The same is now happening to marine species.

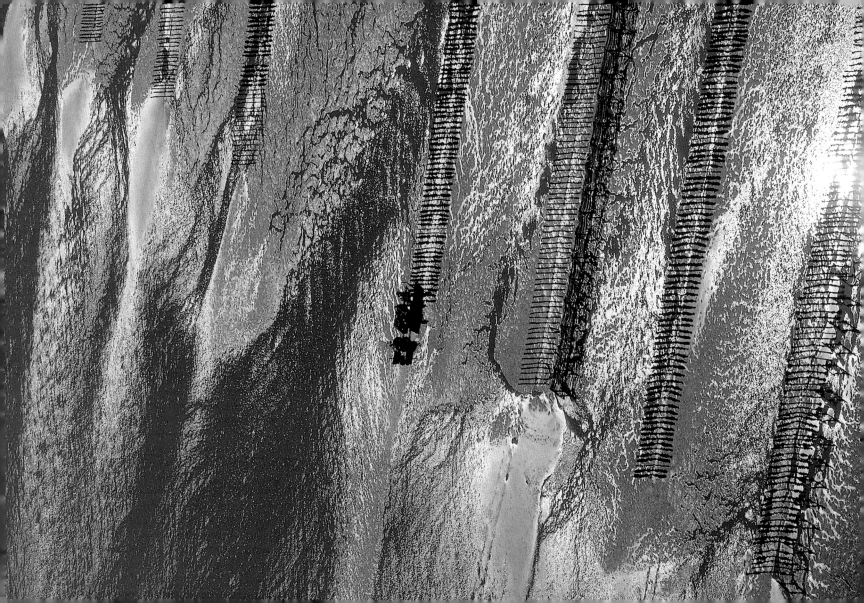

United States. Dade County, Florida. Houses near Miami.

Better known for its tourist beaches, Art Deco hotels, and luxurious residences owned by movie stars, the Miami area of Florida also has residential suburbs with unpretentious but comfortable houses. These mushrooming towns, built on former wetlands where drainage schemes have been in operation since the beginning of the century, answer the requirements of an ever-growing population. Dade County is a center for economic development, a haven for many exiles, and a favorite retirement area. It has now become the most densely populated part of Florida, with over 2 million inhabitants. At the beginning of the twentieth century, Florida was still wild, but it is now the fourth most populous state in the country. In the last 20 years its inhabitants have doubled to 14 million, 85 percent of whom live in urban areas.

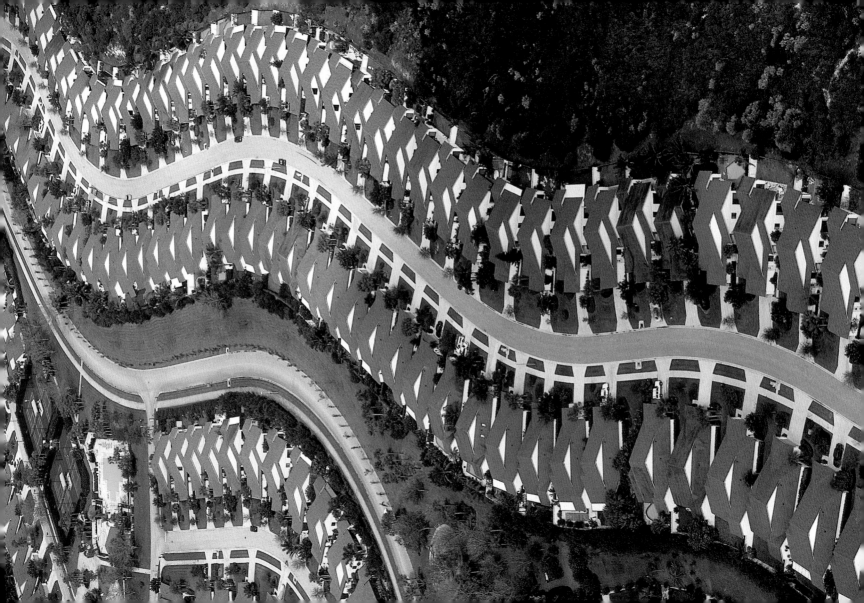

Kenya. Lamu. The village of Faza.

It is hard to believe that this large village of 1,500 people played an important role in the sixteenth century. The hiding place of the Turkish pirate Mirale Bey, it was destroyed and rebuilt by the Portuguese, who then made it into a center for controlling tropical plantations from Lamu as far as Buur Gaabo, beyond the present border with Somalia. Today, echoes of its former splendor can be seen in its attractive *macuti*-roofed houses surrounded by mangroves, and in its mixed population of Bajun (the majority), Indonesians, Chinese, and Portuguese. The traditional dhows (small boats) now carry only tourists, but the past refuses to be buried beneath the present: the donkeys and bicycles, the absence of cars, and even the traditional fabrication of coconut fiber rope (the nuts are buried until they rot, and the fibers then washed and plaited) are all tiny details through which the past may be reborn.

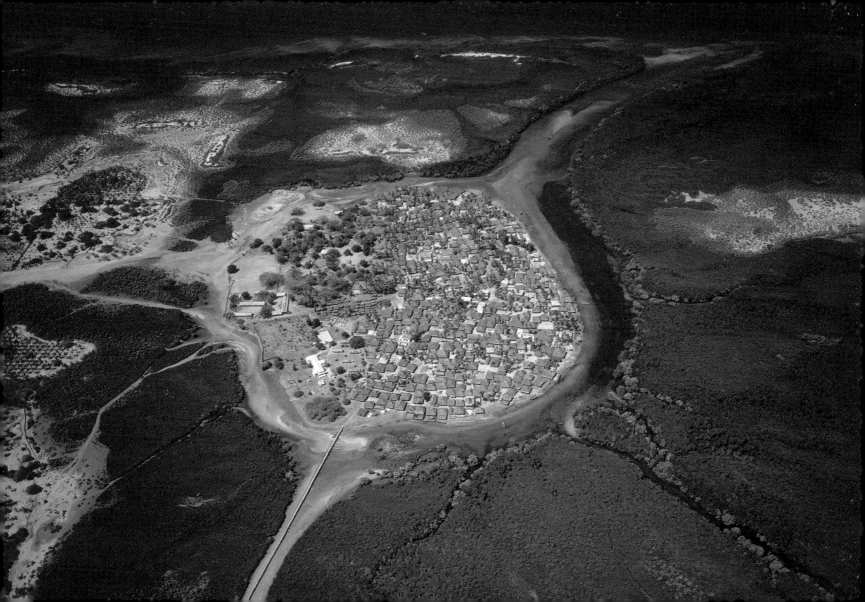

Luxembourg. Vineyard at Remich.

The grapevine originally came from Crimea and eastern Turkey. In its wild state it is a creeping and climbing plant that can form an impenetrable scrub covering several hectares (several acres). Over time it has been bred selectively, pruned, and, after the phylloxera epidemic of a century ago, grafted onto a closely-related, disease-resistant species that grew in the arid valleys of the Rocky Mountains. Without all this human intervention, the Remich hillsides above the River Moselle, on the German-Luxembourg border, would not bear vineyards as well kept as the flower beds in an ornamental garden. Vine growing in this region can be traced back to the great forest clearances of the eleventh century. The white wine produced at that time was primarily used to disinfect the drinking water in the nearby towns of Trier and Metz. Although it may be associated negatively with alcoholism, wine's first use was as a medicine, and today its many health-giving properties are being rediscovered. It is, after all, in the wine-growing regions of France that people live longest.

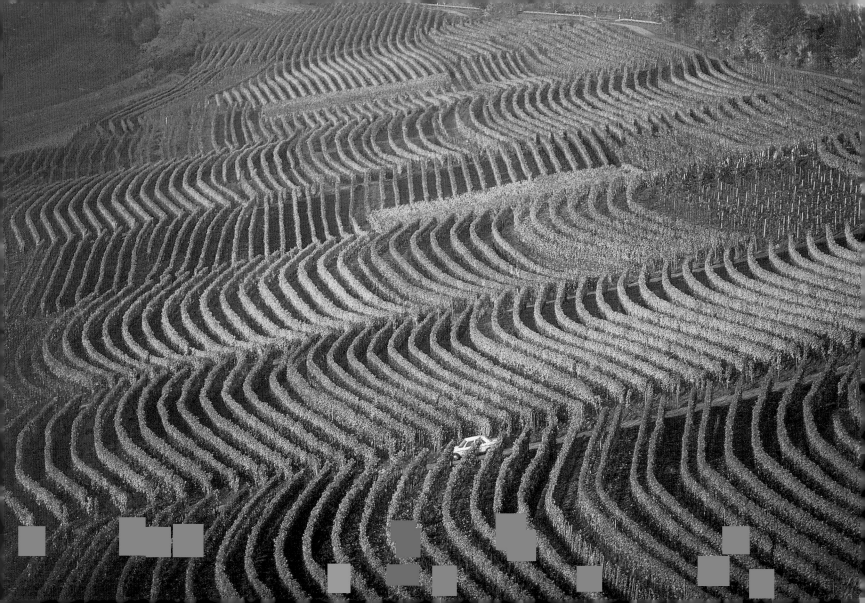

Italy. Veneto region. The Venetian Lagoon.

The Venetian Lagoon, which covers 500 square kilometers (200 square miles) between the Italian coast and the Adriatic Sea, is the country's largest wetland. Fresh and sea water mingle in this marsh of mud, sand, and clay, which is particularly rich in nutrients and attracts numerous aquatic species and birds. Today the lagoon is threatened by pollution, particularly hydrocarbons and heavy metals, from towns and industries. It also has a high concentration of phosphates and nitrates leached from agricultural land. These promote the growth of an alga, *Ulva rigida*, leading to fatal eutrophication – depletion of oxygen in the water. The concentration of nitrates in terrestrial water of industrial countries has doubled (in some places it has increased five-fold) over the last 30 years.

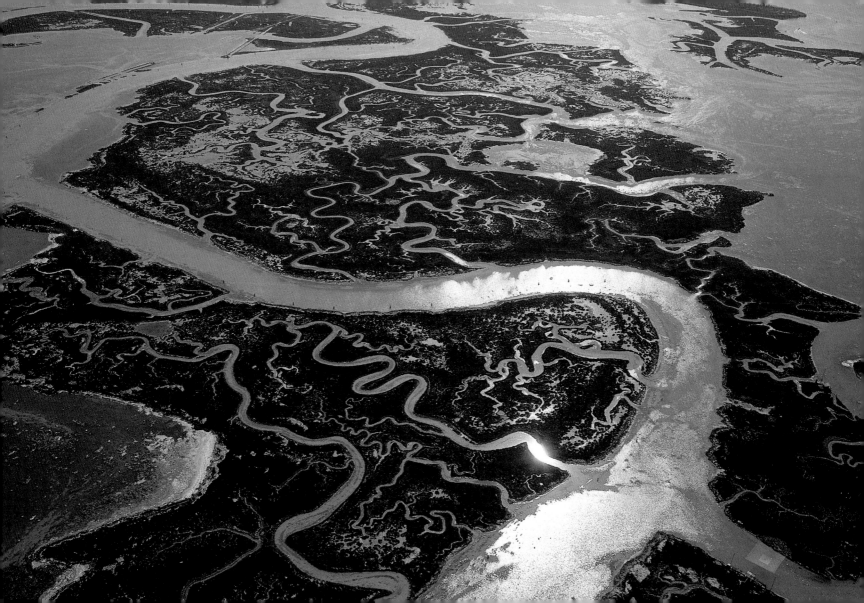

Egypt. Small boat on the Nile.

The Nile is the second longest river in the world, flowing over 6,670 kilometers (4,140 miles) through the Sudan and Egypt. It is a communication channel, used by vessels ranging from luxury floating hotels for tourists to modest craft transporting fodder and grain. Above all, however, it is the country's chief water resource, providing 90 percent of the water consumed by Egyptians. Whereas in the past the annual Nile floods only guaranteed the availability of water for three to four months, the construction of the Aswan Dam in the 1960s made it possible to control the flow of the river and supply the country with water all year round. This change has, however, created major ecological problems, depriving the river of the alluvium that used to fertilize the soil and compensate for the marine erosion of the delta, which is now retreating at a rate ranging from 30 to 200 meters (100 to 650 feet) per year.

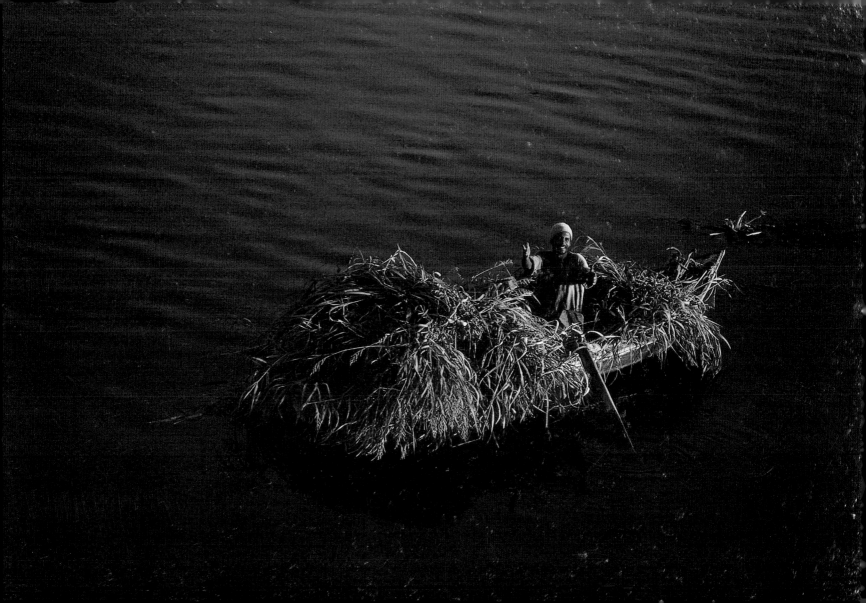

INDEX

Kuwait, January 13, May 24, September 13

Luxembourg, December 29

Madagascar, April 12, July 29, August 2, September 27, October 5, October 8, November 10, December 5, December 21

Malaysia, July 4

Maldives, March 21, August 16, November 8

Mali, January 26, February 23, April 8, May 20, June 18, July 15, August 3, September 20, October 20, October 26, October 29, November 22, November 30

Mauritania, May 5, July 1, December 3

Mexico, June 30

Morocco, January 6, February 22, March 10, March 20, May 3, July 16, August 1, August 8, August 15, September 4, September 16, September 21, November 4, December 13

Namibia, February 10, March 17, June 9, July 9, July 28, August 7, August 17, August 25, September 9

Nepal, January 5, January 11, January 28, February 12, July 30, August 4

New Caledonia, September 24, November 20

Niger, January 15, January 21, April 14, July 26, September 23

Norway, February 3, July 10, August 12

Sultanate of Oman, January 29, February 26, August 10, December 24

Peru, February 15, March 30, June 13, July 31, August 5, August 14, September 29

Philippines, January 30, March 8, March 29, July 2, July 17, August 6, August 20, August 9, October 21

French Polynesia, November 1

Réunion, April 9, May 2, May 22, June 11

Russia, March 28, April 23, December 23

Senegal, March 7, May 15, July 5

Somalia, April 11

South Africa, November 9

Spain, April 21, July 7, November 18

Thailand, March 2, March 13, August 30, September 18, October 24, December 8

Tunisia, February 13, March 6, April 10, April 26, May 21, June 21, June 24, August 22, September 3, December 14

Turkey, January 12, February 6, March 25, May 6, May 12, June 7, July 19, August 28, December 1, December 12

Ukraine, January 17, December 18

United Kingdom, January 20, March 1, March 31, May 17, July 20

United States, January 7, February 4, March 5, April 6, April 19, April 22, April 29, May 1, May 9, May 14, June 17, June 27, July 23, August 21, August 23, September 11, October 12, October 18, October 27, November 3, November 27, December 7, December 11, December 20

Venezuela, February 8, February 19, March 19, May 25, August 11, October 4, November 25, December 17, December 22

ACKNOWLEDGMENTS

UNESCO: Mr Federico Mayor, director-general, Mr Pierre Lasserre, director of the ecological sciences division, Mrs Mireille Jardin, Mrs Jane Robertson, Mrs Josette Gainche and Mr Malcolm Hadley, Mrs Hélène Gosselin, Mr Carlos Marquès, Mr Oudatchine, of the information office, Mr Francesco di Castri and Mrs Jeanne Barbière of environmental co-ordination, as well as Mr Gérard Huber who was kind enough to support our project.

As we go to press, with many happy memories from the four corners of the earth, we fear we may have forgotten some of you who helped us realize this project. We are truly sorry for this, and thank you all most warmly. Nor have we forgotten the many "anonymous" individuals who, out of the limelight, contributed to our crazy undertaking.

FUJIFILM: Mr Masayuki Muneyuki, president, Mr Toshiyuki "Todd" Hirai, Mr Minoru "Mick" Uranaka, of Fujifilm Tokyo, Mr Peter Samwell of Fujifilm Europe, and Mrs Doris Goertz, Mrs Develey, Mr Marc Héraud, Mr François Rychelewski, Mr Bruno Baudry, Mr Hervé Chanaud, Mr Franck Portelance, Mr Piotr Fedorowicz and Mrs Françoise Moumaneix and Mrs Anissa Auger at Fujifilm France

CORBIS: Mr Stephen B Davis, Mr Peter Howe, Mr Malcolm Cross, Charles Mauzy, Mr Marc Walsh, Mrs Vanessa Kramer, Mrs Tana Wollen and Mrs Vicky Whiley

AIR FRANCE: Mr François Brousse and Mrs Christine Micouleau, as well as Mrs Dominique Gimet, Mrs Mireille Queillé and Mrs Bodo Ravoninjatovo

EUROCOPTER: Mr Jean-François Bigay, Mr Xavier Poupardin, Mr Serge Durand and Mrs Guislaine Cambournac

ALBANIA: ECPA, Lt-Col Aussavy, DICOD, Col Baptiste, Capt Maranzana and Capt Saint-Léger, SIRPA, Mr Charles-Philippe d'Orléans, DETALAT, Capt Ludovic Janot; crews of the French air force, Mr Etienne Hoff, Mr Cyril Vasquèz, Mr Olivier Ouakel, Mr José Trouille, Mr Frédéric le Mouillour, Mr François Dughin, Mr Christian Abgral, Mr Patrice Comerier, Mr Guillaume Maury, Mr Franck Novak, pilots

ANTARCTICA: French Institute for Polar Research and Technology; Mr Gérard Jugie, L'Astrolabe, Capt Gérard R Daudon, Capt Alain Gaston; Heli Union France Mr Bruno Fiorese, pilot, Mr Augusto Leri and Mr Mario Zucchelli of the Italian Progetto Antartide, Terra Nova

ARGENTINA: Mr Jean-Louis Larivière, Ediciones Larivière; Mrs Mémé and Mrs Marina Larivière; Mr Felipe C Larivière; Mrs Dudú von Thielman; Mrs Virginia Taylor de Fernández Beschtedt; Cmdr Sergio Copertari, pilot, Emilio Yañes and Pedro Diamante, co-pilots; Eduardo Benítez, mechanic; squadron of the federal air police, Commissaire Norberto Edgardo; Gaudiero Capt Roberto A Ulloa, former governor of Salta province; police station of Orán, Salta province, Cdr Daniel D Pérez; Military Geographic Institute; Commissaire Rodolfo E Pantanali; Aerolineas Argentinas

AUSTRALIA: Mrs Helen Hiscocks; Australian Tourism Commission, Mrs Kate Kenward, Mrs Gemma Tisdell and Mr Paul Gauger; Jairow Helicopters; Heliwork, Mr Simon Eders; Thai Airways, Mrs Pascale Baret; Club Med Lindeman Island and Byron Bay Beach

BAHAMAS: Club Med Eleuthera, Paradise Island and Columbus Isle

BANGLADESH: Mr Hossain Kommol and Mr Salahuddin Akbar, external publicity wing of the ministry for foreign affairs; His Eminence Tufail K

Haider, Bangladeshi ambassador in Paris, and Mr Chowdhury Ikthiar, first secretary, Her Excellency Mrs Renée Veyret, French ambassador in Dhaka, Mr Mohamed Ali and Mr Amjad Hussain of Biman Bangladesh Airlines, as well as Vishawjeet, Mr Nakada, Fujifilm, Singapore, Mr Ezaher of the Fujifilm laboratory in Dhaka, Mr Mizanur Rahman, director, Rune Karlsson, pilot, and J Eldon. Gamble, technician, MAF Air Support, Mrs Muhiuddin Rashida, Sheraton Hotel Dhaka, Mr Minto

BOTSWANA: Mr Maas Müller, Chobe Helicopter

BRAZIL: Government of Mato Grosso do Norte e do Sul; Fundação Pantanal, Mr Erasmo Machado Filho and the French Regional Parks, Mr Emmanuel Thévenin and Mr Jean-Luc Sadorge; Mr Fernando Lemos; His Eminence Pedreira, Brazilian ambassador to UNESCO; Dr Iracema Alencar de Queiros, Instituto de Protecão Ambiental do Amazonas and her son Alexandre; Brasilia tourist office; Mr Luis Carlos Burti, of Burti Books; Mr Carlos Marquès, of the OPI division of UNESCO; Mrs Ethel Leon, Anthea Communication; TV Globo; Golden Cross, Mr José Augusto Wanderley and Mrs Juliana Marquès, Hotel Tropical, Manaus, VARIG

CANADA: Mrs Anne Zobenbulher, Canadian embassy, Paris, and Canadian tourist office, Mrs Barbara di Stefano and Mr Laurent Beunier, Destination Québec; Mrs Cherry Kemp Kinnear, Nunavut tourist office; Mrs Huguette Parent and Mrs Chrystiane Galland, Air Canada; First Air; Vacances Air Transat; André Buteau, pilot, Essor Helicopters; Louis Drapeau, Canadian Helicopters; Canadian Airlines

CHINA: Hong Kong tourist office, Mr Iskaros; Chinese embassy in Paris, His Eminence Caifangbo, Mrs Li Beifen; French embassy in Beijing His Eminence Pierre Morel, French ambassador to Beijing; Mr Shi Guangeng of the ministry of foreign affairs, Mr Serge Nègre, kite flyer, Mr Yan Layma

DENMARK: Weldon Owen Publishing, the whole production team of "Over Europe"

ECUADOR: Mr Loup Langton and Mr Pablo Corral Vega, Descubriendo Ecuador; Mr Claude Lara, Ecuador ministry of foreign affairs; Mr Galarza, of the Ecuador consulate in France; Mr Eliecer Cruz, Mr Diego Bouilla, Mr Robert Bensted-Smith, Galapagos national park; Mrs Patrizia Schrank, Mrs Jennifer Stone, European Friends of the Galapagos; Mr Danilo Matamoros, Jaime et Cesar, Taxi Aero Inter Islas MTB; Mr Etienne Moine. Latitude 0°; Mr Abdon Guerrero, San Cristobal airport

EGYPT: Rally of the Pharaohs, "Fenouil",

organizer Mr Bernard Seguy, Mr Michel Beaujard and Mr Christian Thévenet, pilots

FRANCE: Mrs Dominique Voynet, planning and environment minister; Ministry of Defense/SIRPA Paris police headquarters, Mr Philippe Massoni and Mrs Setzler; Montblanc Hélicoptères, Mr Franck Arrestier and Mr Alexandre Antunes, pilots; Corsican tourist office, Mr Xavier Olivieri; Auvergne tourist committee, Mrs Cécile da Costa; Côtes d'Armor council, Mr Charles Josselin and Mr Gilles Pellan; Savoie council, Mr Jean-Marc Eysserick; Haute-Savoie council, Mr Georges Pacquetet and Mr Laurent Guette; Alpes-Maritimes council, Mrs Sylvie Grosgojeat and Mrs Cécile Alziary; Yvelines council, Mr Franck Borotra, president, Mrs Christine Boutin, Mr Pascal Angenault, and Mrs Odile Roussillon; Loire tourist board; Rémy Martin, Mrs Dominique Hériard-Dubreuil, Mrs Nicole Bru, Mrs Jacqueline Alexandre; Editions du Chêne, Mr Philippe Pierrelee, art director; Hachette, Mr Jean Arcache; Moët et Chandon/Rallye GTO. Mr Jean Berchon and Mr Philippe des Roys du Roure; Printemps de Cahors, Mrs Marie-Thérèse Perrin; Mr Philippe Van Montagu and Mr Willy Gouere, pilot, SAF Hélicopteres, Mr Christophe Rosset, Hélifrance, Héli-Union, Europe Hélicoptère Bretagne, Héli Bretagne, Héli-Océan, Héli

Rhône-Alpes, Hélicos Légers Services, Figari Aviation, Aéro Service, Héli Air Monaco, Héli Perpignan, Ponair, Héli-inter, Héli Est; Réunion: La Réunion tourist office, Mr René Barrieu and Mrs Michèle Bernard; Mr Jean-Marie Lavèvre, pilot, Hélicoptères Helilagon; New Caledonia: Mr Charles de Montesquieu; Antilles: Club Med Boucaniers and La Caravelle; Mr Alain Fanchette, pilot; Polynesia: Club Med Moorea

GREECE: Ministry of culture, Athens, Mrs Eleni Methodiou, Greek delegation to UNESCO; Greek tourist office; Club Med Corfu Ipsos, Gregolimano, Helios Corfu, Kos, and Olympia; Olympic Airways; Interjet, Mr Dimitrios Prokopis and Konstantinos Tsigkas, pilots, and Kimon Daniilidis; Athens weather center

GUATEMALA AND HONDURAS: Mr Giovanni Herrera, director, and Mr Carlos Llarena, pilot, Aerofoto, Guatemala City; Mr Rafael Sagastume, STP Villas, Guatemala City

ICELAND:Mr Bergur Gislasson and Mr Gisli Gestsson, Icephoto Thyrluthjonustan Helicopters; Mr Peter Samwell, national tourist office, Paris

INDIA: Indian embassy, Paris, His Eminence Kanwal Sibal, ambassador, Mr Rahul Chhabra, first secretary, Mr S K Sofat, air brigade general, Mr Lal, Mr Kadyan, and Mrs Vivianne Tourtet; Ministry of foreign affairs, Mr Teki E Prasad and

Mr Manjish Grover. Mr N K Singh of the prime minister's office, Mr Chidambaram, member of parliament; Air Headquarters, S I Kumaran, M Pande; Mandoza Air Charters, Mr Atul Jaidka, Indian International Airways, Capt Sangha Pritvipalh; French embassy, New Delhi, His Eminence Claude Blanchemaison, French ambassador to India, Mr François Xavier Reymond, first secretary

INDONESIA: Total Balikpapan, Mr Ananda Idris and Mrs Ilha Sutrisno; Mr and Mrs Didier Millet

IRELAND: Aer Lingus; Irish national tourist office; Capt David Courtney, Irish Rescue Helicopters; Mr David Hayes, Westair Aviation Ltd

ITALY: French embassy in Rome, Mr Michel Benard, press office; Heli Frioula, Mr Greco Gianfranco, Fanzin Stefano and Godicio Pierino

IVORY COAST: Vitrail & Architecture, Mr Pierre Fakhoury; Mr Hugues Moreau and the pilots Mr Jean-Pierre Artifoni and Mr Philippe Nallet, Ivoire Hélicoptères; Mrs Patricia Kriton and Mr Kesada, Air Afrique

JAPAN: Eu Japan Festival, Mr Shuji Kogi and Mr Robert Delpire; Masako Sakata, IPJ; NHK TV; Japan Broadcasting Corp.; Asahi Shimbun newspaper group, Mr Teizo Umezu

JORDAN: Mrs Sharaf, Mr Anis Mouasher, Mr Khaled Irani and Mr Khaldoun Kiwan, Royal

Society for Conservation of Nature; Royal Airforces; Mr Riad Sawalha , Royal Jordanian Regency Palace Hotel

KAZAKHSTAN His Eminence Nourlan Danenov, Kazakhstan ambassador in Paris; His Eminence Alain Richard, French ambassador in Almaty, and Mrs Josette Floch; Prof René Letolle; Heli Asia Air and its pilot Mr Anouar

KENYA: Universal Safari Tours, Nairobi, Mr Patrix Duffar; Transsafari, Mr Irvin Rozental

KUWAIT: Kuwait Center for research and Studies, Prof Abdullah Al Ghunaim, Dr Youssef; Kuwait National Commission for UNESCO, Sulaiman Al Onaizi; Kuwait delegation to UNESCO, His Excellency Dr Al Salem and Mr Al Baghly; Kuwait Airforces, Squadron 32, Major Hussein Al-Mane, Capt Emad Al-Momen; Kuwait Airways, Mr Al Nafisy

MADAGASCAR: Mr Riaz Barday and Mr Normand Dicaire, pilot, Aéromarine; Sonja and Thierry Ranarivelo, Mr Yersin Racerlyn, pilot, Madagascar Hélicoptère; Mr Jeff Guidez and Lisbeth

MALAYSIA: Club Med Cherating

MALDIVES: Club Med Faru

MALI: TSO, Paris-Dakar Rally, Mr Hubert Auriol; Mr Daniel Legrand, Arpèges Conseil and Mr Daniel Bouet, pilot of the Cessna

MOROCCO: Royal Moroccan police, Gen El

Kadiri and Col Hamid Laanigri; Mr François de Grossouvre

MAURITANIA: TSO, Paris-Dakar Rally, Mr Hubert Auriol; Mr Daniel Legrand, Arpèges Conseil and Mr Daniel Bouet, pilot of the Cessna; Mr Sidi Ould Kleib

MEXICO: Club Med Cancun, Sonora Bay, Huatulco, and Ixtapa

NAMIBIA: Ministry of Fisheries; French co-operation mission; Mr Jean-Pierre Lahaye; Mrs Nicole Weill; Mr Laurent Billet and Jean Paul Namibian; Tourist Friend, Mr Almut Steinmester

NEPAL: Nepalese embassy, Paris; Terres d'Aventure, Mr Patrick Oudin; Great Himalayan Adventures, Mr Ashok Basnyet; Royal Nepal Airways, Mr J B Rana; Mandala Trekking, Mr Jérôme Edou, Bhuda Air; Maison de la Chine, Mrs Patricia Tartour –Jonathan, director, Mrs Colette Vaquier and Mrs Fabienne Leriche; Mrs Marina Tymen and Miranda Ford, Cathay Pacific

NETHERLANDS: Paris-Match; Mr Franck Arrestier, pilot

NIGER: TSO, Paris-Dakar Rally, Mr Hubert Auriol; Mr Daniel Legrand, Arpèges Conseil and Mr Daniel Bouet, pilot of the Cessna

NORWAY: Airlift AS, Mr Ted Juliussen, pilot, Mr Henry Hogi, Mr Arvid Auganaes and Mr Nils Myklebust

OMAN: His Majesty Sultan Qaboos Ben Saïd al-Saïd; ministry of defence, Mr John Miller, Villa d'Alésia, Mr William Perkins and Mrs Isabella de Larrocha

PERU: Dr Maria Reiche and Ana Maria Cogorno-Reiche; foreign ministry, Mr Juan Manuel Tirado; Peruvian national police; Faucett Airline, Mrs Cecilia Raffo and Mr Alfredo Barnechea; Mr Eduardo Corrales, Aero Condor

PHILIPPINES: Filipino Airforces; "Seven Days in the Philippines", Editions Millet, Mrs Jill Laidlaw

PORTUGAL: Club Med Da Balaia

RUSSIA: Mr Yuri Varobiov, vice-minister, and Mr Brachnikov, Emerkom; Mr Nikolai Alexiy Timochenko, Emerkom, Kamchatka; Mr Valery Blatov, Russian delegation to UNESCO

ST VINCENT AND THE GRENADINES: Mr Paul Gravel, SVG Air; Mrs Jeanette Cadet, the Mustique Company; Mr David Linley; Mr Ali Medjahed, baker; Mr Alain Fanchette

SENEGAL: TSO, Paris-Dakar Rally, Mr Hubert Auriol; Mr Daniel Legrand, Arpèges Conseil and Mr Daniel Bouet, pilot of the Cessna; Club Med Les Almadies and Cap Skirring

SOMALILAND: His Royal Highness Sheikh Saud Al-Thani of Qatar; Mr Majdi Bustami, Mr E A Paulson and Mr Osama, office of His Royal Highness Sheikh Saud Al-Thani;

Mr Fred Viljoen, pilot; Mr Rashid J Hussein, UNESCO-Peer Hargeisa, Somaliland; Mr Nureldin Satti, UNESCO-Peer, Nairobi, Kenya; Mrs Shadia Clot, representative of the sheikh in France; Waheed, Al Sadd travel agency, Qatar; Cécile and Karl, Emirates Airlines, Paris

SOUTH AFRICA: SATOUR, Mrs Salomone, South African Airways, Jean-Philippe de Ravel, Victoria Junction, Victoria Junction Hotel

SPAIN: His Eminence Jesus Ezquerra, Spanish ambassador to UNESCO; Club Med Don Miguel, Cadaquès, Porto Petro and Ibiza; Canary Islands: Tomás Ascárate y Bang, Viceconsejeria de Medio Ambiente, Fernando Clavijo, Protección Civil de las Islas Canarias; Mr Jean-Pierre Sauvage and Mr Gérard de Bercegol, Iberia. Mrs Elena Valdés, Mrs Marie Mar, Spanish tourist office; Basque country: office of the Basque government presidency. Mr Zuperia Bingen, director, Mrs Concha Dorronsoro and Mrs Nerea Antia, press office of the Basque government presidency office, Mr Juan Carlos Aguirre Bilbao, head of the helicopter unit of the Basque police (Ertzaintza)

THAILAND: Royal forest department, Mr Viroj Pimanrojnagool, Mr Pramote Kasemsap, Mr Tawee Nootong, Mr Amon Achapet; NTC Intergroup Ltd, Mr Ruh Phiama; Mrs Pascale

Baret, Thai Airways; Thai national tourist office, Mrs Juthaporn Rerngronasa and Watcharee, Mr Lucien Blacher, Mr Satit Nilwong and Mr Busatit Palacheewa; Fujifilm Bangkok, Mr Supoj; Club Med Phuket

TUNISIA: Mr Zine Abdine Ben Ali, president of the republic; president's office, Mr Abdelwahad Abdallah and Mr Haj Ali; Tunisian air force, Laouina base, Col Mustafa Hermi; Tunisian embassy, Paris, His Eminence Bousnina, ambassador, and Mr Mohamed Fendri; Tunisian national tourist office, Mr Raouf Jomni and Mr Mamoud Khaznadar; Editions Cérès, Mr Mohamed and Mr Karim Ben Smail; Hotel The Residence, Mr Jean-Pierre Auriol; Basma-Hôtel Club Paladien, Mr Laurent Chauvin; Tunis weather centre, Mr Mohammed Allouche

TURKEY: Turkish Airlines, Mr Bulent Demirçi and Mrs Nasan Erol; Mach'Air Helicopters, Mr Ali Izmet, Mr Öztürk, and Mr Seçal Sahin, Mrs Karatas Gulsah; General Aviation, Mr Vedat Seyhan, and Mr Faruk, pilot; Club Med Bodrum, Kusadasi, Palmiye, Kemer, Foça

UKRAINE: Mr Alexandre Demianyuk, secretary-general of UNESCO; Mr A V Grebenyuk, director of the Chernobyl exclusion zone; Mrs Rima Kiselitza of Chernobylinterinform

UNITED KINGDOM: England: Aeromega and Mike Burns, pilot; Mr David Linley; Mr Philippe Achache; Environment Agency; Mr Bob Davidson and Mr David Palmer; Buckingham Palace press office; Scotland: Mrs Paula O'Farrel and Mr Doug Allsop, Total Oil Marine, Aberdeen; Iain Grindlay and Rod of Lothian Helicopters Ltd, Edinburgh

UNITED STATES: Wyoming: Yellowstone National Park, Marsha Karle and Stacey Churchwell; Utah: Classic Helicopters; Montana: Carisch Helicopters, Mr Mike Carisch; California: Robin Petgrave, of Bravo Helicopters, Los Angeles, and the pilots Miss Akiko K Jones and Dennis Smith; Mr Fred London, Cornerstone Elementary School; Nevada: John Sullivan and the pilots Aaron Wainman and Matt Evans, Sundance Helicopters, Las Vegas; Louisiana: Suwest Helicopters and Mr Steve Eckhardt; Arizona: Southwest Helicopters and Jim McPhail; New York: Liberty Helicopters and Mr Daniel Veranazza; Mr Mike Renz, Analar helicopters, Mr John Tauranac; Florida: Mr Rick Cook, Everglades national park, Rick and Todd, Bulldog Helicopters, Orlando, Chuck and Diana, Biscayne Helicopters, Miami, Club Med, Sand Piper; Alaska: Mr Philippe Bourseiller, Mr Yves Carmagnole, pilot

UZBEKISTAN: (not flown over) Uzbekistan embassy, Paris, his Eminence Mamagonov, ambassador, and Mr Djoura Dekhanov, first secretary; His Eminence Claude Richard, French ambassador to Uzbekistan, and Mr Jean Pierre Messiant, first secretary; Mr René Cagnat, and Natacha; Mr Vincent Fourniau and Mr Bruno Chauvel, Institut Français d'Etudes sur l'Asie Centrale (IFEAC)

VENEZUELA: Centro de Estudios y Desarrollo, Mr Nelson Prato Barbosa; Hoteles Intercontinental; Ultramar Express; Lagoven; Imparques; Icaro, Mr Luis Gonzales.

We would also like to thank the companies that have allowed us to work thanks to contracts or exchanges:

AÉROSPATIALE, Mr Patrice Kreis, Mr Roger Benguigui and Mr Cotinaud

AOM, Mrs Françoise Dubois-Siegmund and Mrs Felicia Boisne-Noc, Mr Christophe Cachera

CANON, Service Pro, Mr Jean-Pierre Colly, Mr Guy d'Assonville, Mr Jean-Claude Brouard, Mr Philippe Joachim, Mr Raphaël Rimoux, Mr Bernard Thomas, and of course Mr Daniel Quint and Mrs Annie Rémy who helped us so often throughout the project

CLUB MED, Mr Philippe Bourguignon, Mr Henri de Badinat, Mrs Sylvie Bourgeois, Mr Preben Vestdam, Mr Christian Thévenet

CRIE, world express mail, Mr Jérôme Lepert and all his team
DIA SERVICES, Mr Bernard Crepin
FONDATION TOTAL, Mr Yves le Goff and his assistant Mrs Nathalie Guillerme
JANJAC, Mr Jacques Bigot, Mr Olivier Bigot, Mr Jean-François Bardy and Mr Michel Viard
KONICA, Mr Dominique Bruguière
MÉTÉO FRANCE, Mr Foidart, Mrs Marie-Claire Rullière, Mr Alain Mazoyer, and all the forecasters
RUSH LABO, Mr Denis Cuisy, Mr Philippe Ioli, Mr Christian Barreteau
And all our friends at the WORLD ECONOMIC FORUM, Davos – Mr Klaus Schwab, Mrs Maryse Zwick and Mrs Agnès Stüder

The team of "La Terre vue du Ciel", Altitude photo agency:
Photography assistants: Franck Charel, Françoise Jacquot, Ambre Mayen, and Erwan Sourget, who followed the entire project, and all those who were involved at different times during all these years of flying: Tristan Carné, Christophe Daguet, Stefan Christiansen, Pierre Cornevin, Olivier Jardon, Marc Lavaud, Franck Lechenet, Olivier Looren, Antonio López Palazuelo.

Co-ordinating office:
Production co-ordinator:
Hélène de Bonis

Editing co-ordinator:
Françoise le Roch'

Exhibitions co-ordinator:
Catherine Arthus-Bertrand

Production assistants:
Antoine Verdet, Catherine Quilichini, Gloria-Céleste Raad (Russia), Zhu Xiao Lin (China)

Editing staff: Danielle Laruelle, Judith Klein, Hugues Demeude and PRODIG, geographical laboratories, Mrs Marie-Françoise Courel and Mrs Lydie Goeldner, Mr Frédéric Bertrand

Research: Isabelle Lechenet, Florence Frutoso, Claire Portaluppi

All photographs in this book were taken on Fuji Velvia 50 ASA film. Yann Arthus-Bertrand worked primarily with Canon EOS 1N camera bodies and Canon L series lenses. Some pictures were taken on a Pentax 645N camera and a Fuji GX 617 panoramic camera.

PHOTO CREDITS

All the photographs in *Earth from Above, 365 days* are by Yann Arthus-Bertrand except:
7 January, 21 April: © Guido Alberto Rossi
24 February, 7 April, 17 July: © Philippe Bourseiller
9 May: © Alex Mac Lean
23 May: © French Navy
28 May: © Franck Charel
22 October: © Hélène Hiscocks
All these photographs are distributed by the Altitude agency

Yann Arthus-Bertrand's aerial photographs are distributed by the Altitude photo agency, 30, rue des Favorites, 75015 Paris, France
email: altitude@club-internet.fr
www.yannarthusbertrand.com

Editor, English-language edition: Margaret Carruthers
Designer, English-language edition: Brankica Kovrlija
English translation produced by Translate-A-Book, Oxford, UK

Library of Congress Control Number: 2001093031

Harry N. Abrams, Inc.
100 Fifth Avenue
New York, N.Y. 10011
www.abramsbooks.com